ANCIENT THRACE AND THE CLASSICAL WORLD

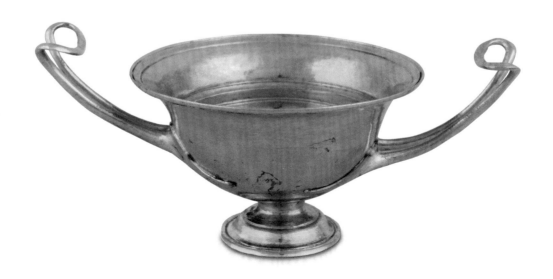

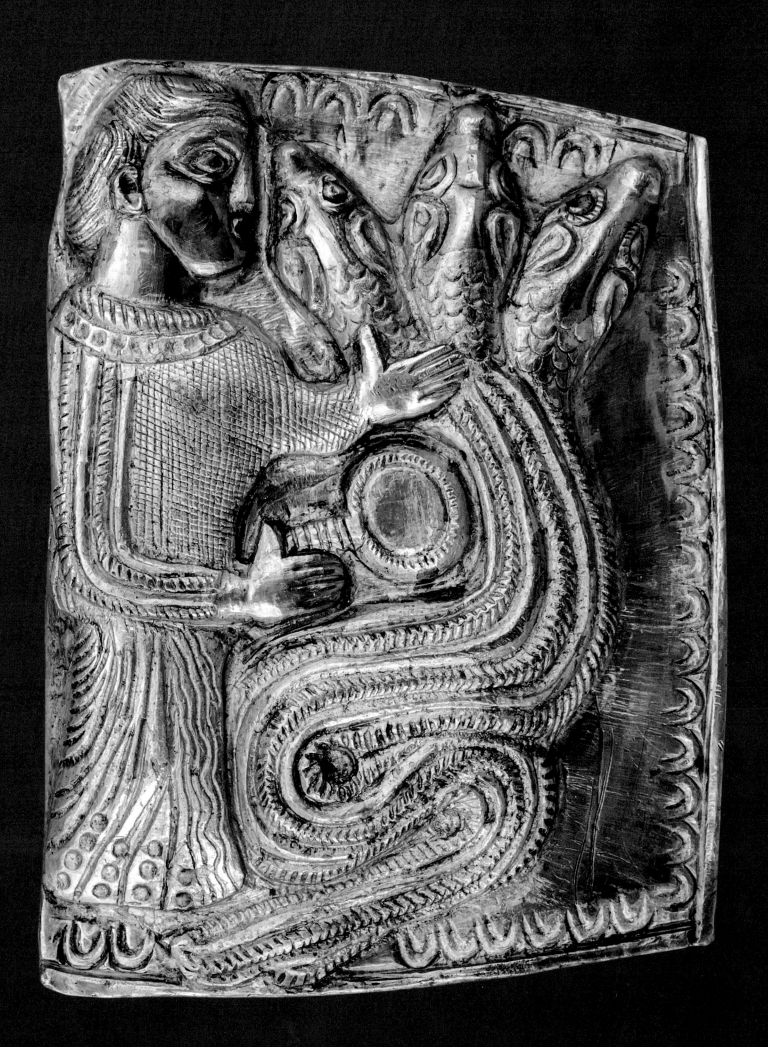

ANCIENT THRACE

AND THE
CLASSICAL WORLD

Treasures from Bulgaria, Romania, and Greece

Edited by
Jeffrey Spier, Timothy Potts, Sara E. Cole,
and Margarit Damyanov

J. PAUL GETTY MUSEUM · LOS ANGELES

This publication is issued on the occasion of the exhibition *Ancient Thrace and the Classical World: Treasures from Bulgaria, Romania, and Greece*, on view at the J. Paul Getty Museum at the Getty Villa, Malibu, from November 4, 2024, to March 3, 2025.

Organized by the J. Paul Getty Museum in collaboration with the Ministry of Culture, Republic of Bulgaria, and the National Archaeological Institute with Museum at the Bulgarian Academy of Sciences (NAIM-BAS).

With generous loans from the National History Museum of Romania, Bucharest, and the Hellenic Ministry of Culture, Education, and Religious Affairs, Greece.

This exhibition is supported by an indemnity from the Federal Council on the Arts and the Humanities.

Appraisal services for the exhibition were kindly provided by Christie's Appraisals, Inc.

Published by the J. Paul Getty Museum, Los Angeles
Getty Publications
1200 Getty Center Drive, Suite 500
Los Angeles, California 90049-1682
getty.edu/publications

Karen Jacobson and Nola Butler, *Project Editors*
Karen Jacobson, with Jane Bobko, *Manuscript Editors*
Darryl Oliver, *Assistant Editor*
Jeffrey Cohen, *Designer*
Victoria Gallina, *Production*
Nancy Rivera, *Image and Rights Acquisition*

Distributed in the United States and Canada
by the University of Chicago Press

Distributed outside the United States and Canada
by Yale University Press, London

Printed in Belgium

MIX
Paper | Supporting responsible forestry
FSC
www.fsc.org FSC® C009115

Library of Congress Cataloging-in-Publication Data
Names: Spier, Jeffrey, editor. | Potts, Timothy F., editor. | Cole, Sara E., editor. | Damyanov, Margarit, editor. | J. Paul Getty Museum, host institution, issuing body.
Title: Ancient Thrace and the classical world : treasures from Bulgaria, Romania, and Greece / edited by Jeffrey Spier, Timothy Potts, Sara E. Cole, and Margarit Damyanov.
Description: Los Angeles : J. Paul Getty Museum, [2024] | Published on the occasion of an exhibition held at the J. Paul Getty Museum at the Getty Villa, Malibu, from November 4, 2024–March 3, 2025. | Includes bibliographical references and index. | Summary: "Provides an examination of the profound artistic and cultural interactions between Thrace, Greece, and the entire northern Aegean region" —Provided by publisher.
Identifiers: LCCN 2024011675 (print) | LCCN 2024011676 (ebook) | ISBN 9781606069400 (hardcover) | ISBN 9781606069417 (adobe pdf)
Subjects: LCSH: Thrace—Antiquities—Exhibitions. | Thrace—Civilization—Exhibitions. | Thrace—Relations—Exhibitions.
Classification: LCC DR50.43 .A63 2024 (print) | LCC DR50.43 (ebook) | DDC 939/.861074—dc23/eng/20240513
LC record available at https://lccn.loc.gov/2024011675
LC ebook record available at https://lccn.loc.gov/2024011676

Front cover: Jug with Goddess on Panther (detail, cat. 60d)
Back cover: Portrait of Seuthes III (detail, cat. 53)
Page i: *Kylix* (cat. 54r)
Page ii: Breast Collar Appliqué (cat. 61c)
Page v: *Phalera* with Female Bust (detail, cat. 62a)
Page vii: *Oinochoe* (cat. 54s)
Page xiv: Yoke Fitting with Herakles Appliqué (detail, cat. 65b)
Page 114: Helmet with Appliqué (detail, cat. 54b)
Page 270: Greave (detail, cat. 51a)

Illustration Credits
Every effort has been made to contact the owners and photographers of illustrations reproduced here whose names do not appear in the captions or in the illustration credits listed at the back of this book. Anyone having further information concerning copyright holders is asked to contact Getty Publications so this information can be included in future printings.

The texts by Diana Dimitrova, Mario Ivanov, Veselka Katsarova, Lyuben Leshtakov, Yana Mutafchieva, Meglena Parvin, Kalina Petkova, Aneta Petrova, Hristo Popov, Miglena Stamberova, Totko Stoyanov (cat. 47), Daniela Stoyanova, Ruslan Stoychev, Milena Tonkova, Nartsis Torbov, and Slava Vasileva were translated from the Bulgarian by Margarit Damyanov.

The essay "Thracians on Athenian Vases" by Despoina Tsiafaki was translated from the Greek by Eriksen Translations.

REPUBLIC OF BULGARIA
MINISTRY OF CULTURE

1892 - 1921 - 1948

ИСТОРИЧЕСКИ МУЗЕЙ
ИСКРА · КАЗАНЛЪК
MUSEUM OF HISTORY
ISKRA · KAZANLAK

МУЗЕЙ · СТАРИНЕН НЕСЕБЪР ·

НАЦИОНАЛЕН ИСТОРИЧЕСКИ МУЗЕЙ

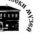

РЕГИОНАЛЕН ИСТОРИЧЕСКИ МУЗЕЙ – ВЕЛИКО ТЪРНОВО

Muzeul Național
de Istorie a României

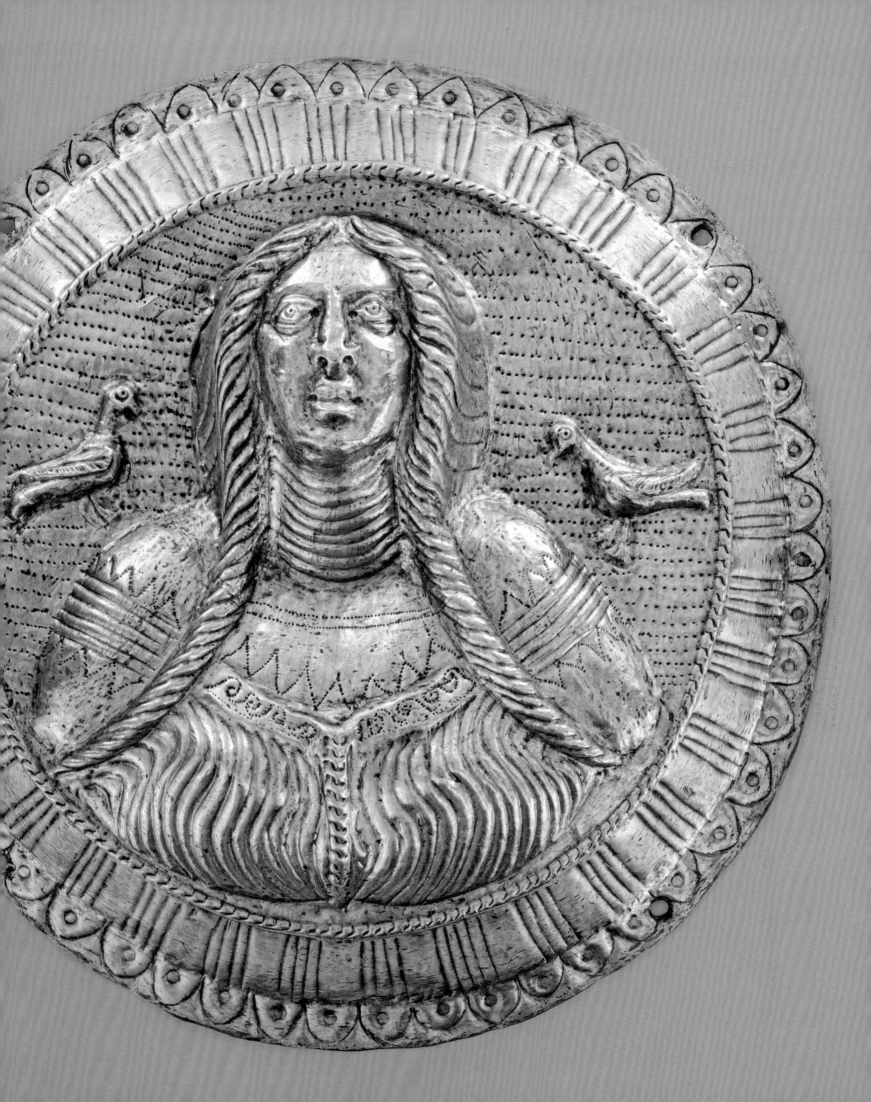

CONTENTS

CATALOGUE

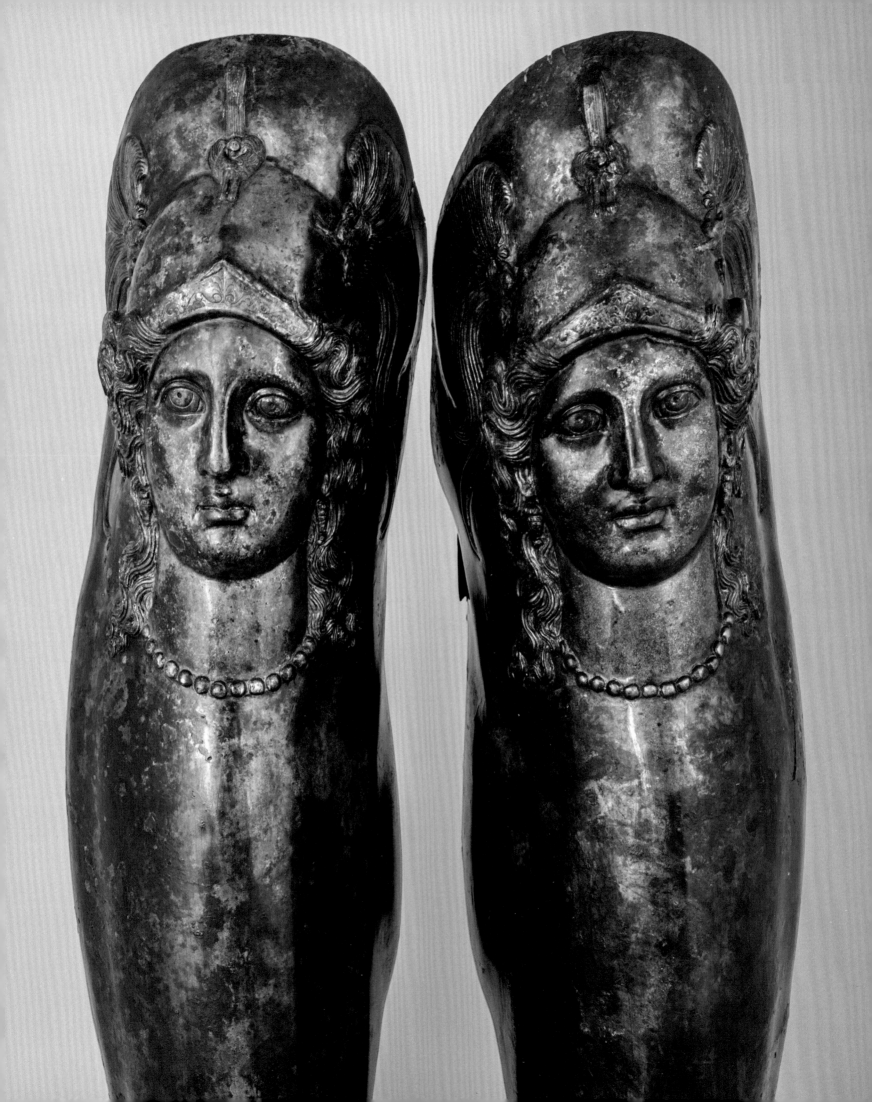

FOREWORD

TIMOTHY POTTS

Maria Hummer-Tuttle and Robert Tuttle Director
J. Paul Getty Museum, Los Angeles

The exhibition *Ancient Thrace and the Classical World* is the third in the J. Paul Getty Museum's ongoing series *The Classical World in Context*, which investigates the varied modalities of interaction that connected ancient Greece and Rome with other cultures of the Mediterranean, Near East, and beyond. Previous exhibitions explored the classical world's relations with Egypt (2018) and Persia (2022)—cultures that were geographically distant, separated from Greece and Rome by the Mediterranean Sea and Syria-Mesopotamia, respectively. Relations over such distances were inevitably highly changeable in nature, scope, and intensity, often involving many intermediaries.

The situation with ancient Thrace was very different. Encompassing most of present-day Bulgaria, southern Romania, and European Turkey, the Thracian realm lay immediately to the north of Greece, and the two peoples had close and regular contact throughout antiquity. From the eighth century BC on, the northern coast of the Aegean Sea, along with the Propontis (Sea of Marmara) and the Black Sea further east, had been heavily settled by Greek colonies, many of which functioned as trading *emporia* and conduits for active interaction with the Thracian interior. For the most part, the Greek colonies coexisted happily with their Thracian hosts, although local and regional conflicts did occur.

The Greeks and Thracians were therefore very familiar with each other and their respective cultures, lifestyles, and forms of rule. A number of prominent Greek figures of the fifth century BC were in fact of (partial) Thracian ancestry, including the Athenian statesman-general Kimon and the historian of the Peloponnesian War, Thucydides, who inherited Thracian mining interests from his father and may have been buried there. The philosophers Democritus and Protagoras were from Abdera, a Greek colony on the Thracian Aegean coast. These few examples are indicative of what must have been pervasive networks of entanglement at all levels of their societies.

In their portrayals of the Thracians, Greek authors often drew on the trope of fierce, seminomadic barbarians, with Herodotus describing them as the most populous of all peoples after the Indians. But archaeology belies this characterization, revealing numerous towns and villages throughout the Thracian realm. While the region was not as urbanized as the Greek poleis, its royal palaces, sanctuaries, and monumental tumulus burials—the finest with stone-built corbeled and vaulted ceilings—attest to the Thracians' sophisticated architectural and engineering skills.

The most spectacular aspect of Greek-Thracian interaction revealed by modern archaeology, however, is the highly active trade in metals and metalwork that is manifested in the Thracians' elite burial tumuli,

Greaves (detail, cat. 54d)

which were luxuriously equipped with gold, silver, and bronze vessels, both locally produced works in native Thracian style and imported vessels in distinctively Greek shapes, styles, and subjects. The latter category, dating principally to the fifth and fourth centuries BC, includes superbly crafted banqueting vessels with elaborate figurative scenes that are among the outstanding masterpieces of ancient metalworking. Indeed, few vessels of comparable quality and preservation have been found in Greece itself. The brief Achaemenid Persian presence in Thrace (late sixth–early fifth century BC) also left its mark on local artists, most notably in distinctively fluted metal drinking horns. Clearly, the Thracian elite had a strong appreciation of both Greek and Persian wares, alongside the local types. The spectacular fourth-century BC bronze portrait head of King Seuthes III, conceived and executed in the Greek sculptural tradition, likewise confirms that royal commissions were in no way restricted to native artistic modes of representation.

Thrace and its treasures may be less familiar to the Getty's visitors than were ancient Egypt and Persia in previous exhibitions. To the Greeks of the fourth century BC, however, it was the reverse: they had been neighbors, competitors, and collaborators for as long as could be remembered, celebrated in art and poetry alike. We hope that this exhibition will bring the extraordinary cultural and artistic achievements of Thrace, and its interactions with the Greco-Roman world, more into the mainstream of Mediterranean scholarship and art history for visitors both in the United States and from around the globe.

Amphora (detail, cat. 33)

ACKNOWLEDGMENTS

As volume editors we owe tremendous gratitude to the many individuals and institutions that made this ambitious project possible. The advances in scholarship manifest in this exhibition and catalogue are in large part due to the contributions of leading scholars pursuing their research on ancient Thrace and its international relations under the Getty Villa Scholars Program from 2019 to 2020. A number of them have written essays for this publication. We wish to thank them and all the volume's authors for their contributions, which we are confident will move the field of Thracian studies forward.

The exhibition that this volume accompanies was organized jointly by the J. Paul Getty Museum; the Ministry of Culture, Republic of Bulgaria; and the National Archaeological Institute with Museum at the Bulgarian Academy of Sciences (NAIM-BAS) in Sofia. We are especially grateful for the tireless support and patronage of the vice president of Bulgaria, the Honorable Iliana Iotova. Many individuals in the Ministry of Culture also assisted greatly, including Minister of Culture Krastyu Krastev, Deputy Minister of Culture Victor Stoyanov, Vanya Bedrova, Katya Djumalieva, and Peter Miladinov.

The Getty Museum has especially enjoyed collaborating with our colleagues at the National Archaeological Institute with Museum in Sofia, including director Hristo Popov and former director Lyudmil Vagalinski; professor Margarit Damyanov; conservators Petya Penkova, Kitan Kitanov, Marina Kalpachka, Reneta Karamanova-Zlatkova, and Chavdar Chomakov;

Krastyu Chukalev, Ivan Voykov, Petar Minkov, Kalina Petkova of the Depositories Department; and Kamen Boyadzhiev, Yana Dimitrova, Miglena Stamberova, Kaloyan Pramatarov, and Zheni Vasileva of the Exhibitions Department. Museums throughout Bulgaria have generously lent treasures from their collections, and we wish to thank these institutions and their directors and staff: Milen Nikolov of the Regional Historical Museum in Burgas; Rositsa Hristova of the Regional Historical Museum in Karnobat; Momchil Marinov and Meglena Parvin of the Iskra Historical Museum in Kazanlak; Silvia Georgieva of the Regional Historical Museum in Lovech; Todor Marvakov of the Ancient Nessebar Museum; Kostadin Kisyov, Lyubomir Merdzhanov, and Desislava Davidova of the Regional Archaeological Museum in Plovdiv; Violeta Duneva of the Prof. Mieczysław Domaradzki Archaeological Museum in Septemvri; Boni Petrunova and Petranka Nedelcheva of the National Historical Museum in Sofia; Dimitar Nedev of the Archaeological Museum in Sozopol; Nikoleta Petkova of the Historical Museum in Strelcha; Magdalena Zhecheva and Stefan Ivanov of the Regional Historical Museum in Targovishte; Ivan Tsarov of the Regional Historical Museum in Veliko Tarnovo; and Georgi Ganetsovski of the Regional Historical Museum in Vratsa. For their photography, we thank Todor Dimitrov, Krasimir Georgiev, Miglena Raykovska, Ivo Hadzhimishev, and Nikolay Genov. Additional images for the catalogue were provided by Maria Kamisheva of the Regional Historical Museum in Stara Zagora and by Chavdar

Tzochev. We would also like to acknowledge the generous support of Nancy Schiller, president and CEO of the America for Bulgaria Foundation. Special gratitude is owed to Michael Zaimov for his invaluable assistance and thoughtful advice.

We are particularly pleased that museums in Romania and Greece have made significant loans to the exhibition possible and offer our thanks to director Ernest Oberländer-Târnoveanu and curator Rodica Oanţă-Marghitu of the National History Museum of Romania, Bucharest, and to director Domna Terzopoulou and deputy director Chrysofenia Pardalidou of the Ephorate of Antiquities of Evros with the Archaeological Museums of Alexandroupolis and Samothrace. The exhibition was also supported by generous loans from other institutions, and we thank director Max Hollein and curator in charge of the Department of Greek and Roman Art Seán Hemingway at the Metropolitan Museum of Art, New York; director Laurence des Cars at the Musée du Louvre, Paris; former director Hartwig Fischer of the British Museum, London; and director Barbara Helwing and former curator Pınar Durgun of the Vorderasiatisches Museum, Berlin.

The exhibition at the Getty Villa was curated by Sara E. Cole, Jens M. Daehner, Margarit Damyanov, and Jeffrey Spier. The Getty is particularly grateful to Dr. Damyanov, whose input was instrumental to the conceptualization and development of both the exhibition and the present volume from inception to realization. Scholarly advisers to the exhibition included Zosia H. Archibald, Peter Delev, Hristo Popov, Totko Stoyanov, Milena Tonkova, Despoina Tsiafaki, and Antigoni Zournatzi.

We would also like to acknowledge the many individuals at the Getty who contributed their expertise to the exhibition: Susanne Gänsicke, Marie Svoboda, Jessie Arista, Tim Skornia, and Nick Clemens (Antiquities Conservation); Richard Hards and BJ Farrar (Decorative Arts Conservation); Carolyn Marsden-Smith and Robin McCarthy (Exhibitions); Aviva Rubin and Carolynn Karp (Means and Methods Design); Jessica Harden (Exhibition Design); Kanoko Sasao, Naomi Abe, Janet Chen, and Cherie Chen (Registrar's Office); Sahar Tchaitchian (Interpretive Content); Shelby Brown (Education); and Mike Mitchell, Marcus Adams, and their team (Preparations). In addition, the exhibition curators thank their wonderful colleagues in the Getty Antiquities Department: Claire Lyons, Kenneth Lapatin, David Saunders, Judith Barr, Nicole Budrovich, and Paige-Marie Ketner, as well as graduate intern Yusi Liu.

Editing, design, and production of this catalogue lay in the expert hands of Getty Publications: Kara Kirk, publisher; Diana Murphy, editor in chief; Nola Butler, managing editor; Darryl Oliver, assistant editor; and Karen Jacobson and Jane Bobko, freelance editors; as well as Jeffrey Cohen, lead publications designer; Victoria Gallina, senior production coordinator; and Nancy Rivera, associate rights specialist. Thanks also to Jane Friedman for proofreading and to Theresa Duran for indexing the book.

TIMOTHY POTTS
Maria Hummer-Tuttle and Robert Tuttle Director
J. Paul Getty Museum, Los Angeles

JEFFREY SPIER
Former Anissa and Paul John Balson II
Senior Curator of Antiquities
J. Paul Getty Museum, Los Angeles

SARA E. COLE
Associate Curator of Antiquities
J. Paul Getty Museum, Los Angeles

MARGARIT DAMYANOV
Associate Professor, Department of Thracian
Archaeology, National Archaeological Institute
with Museum at the Bulgarian Academy
of Sciences, Sofia, Bulgaria

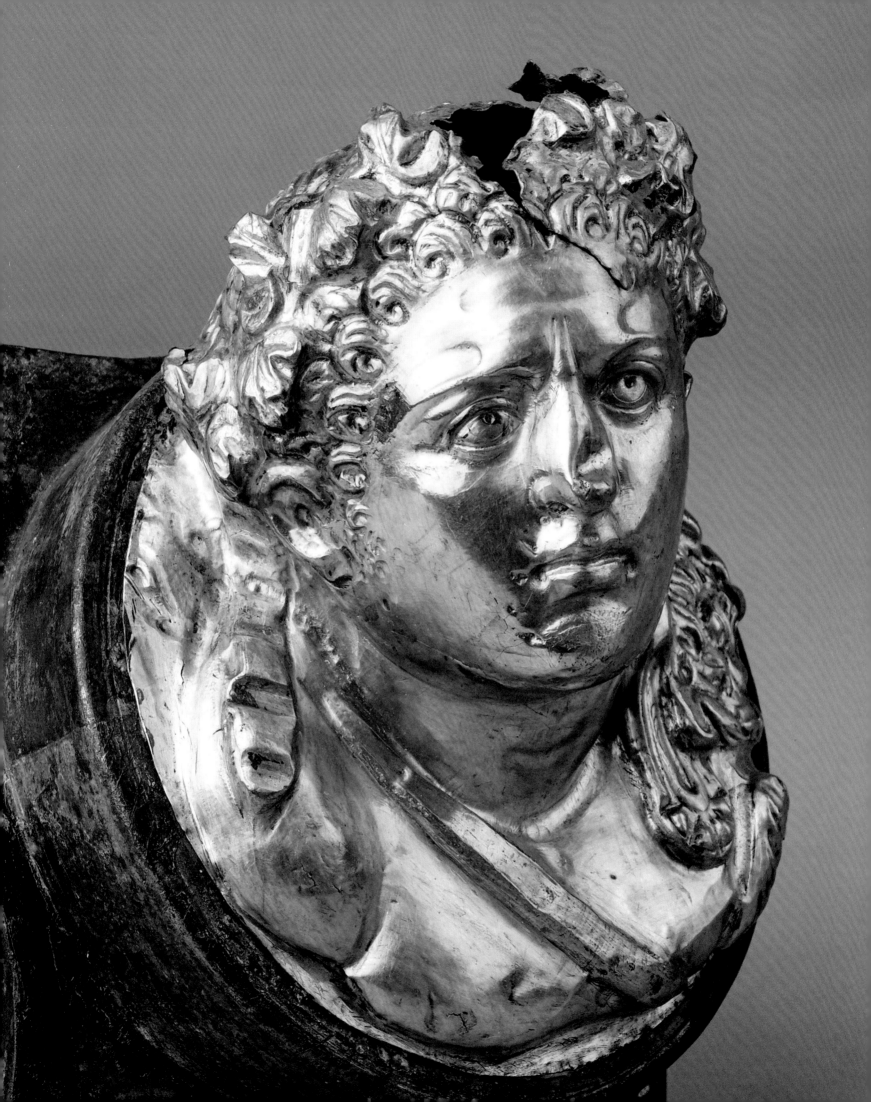

LENDERS TO THE EXHIBITION

BULGARIA
Burgas, Regional Historical Museum
Karnobat, Historical Museum
Kazanlak, Iskra Historical Museum
Lovech, Regional Historical Museum
Nessebar, Ancient Nessebar Museum
Plovdiv, Regional Archaeological Museum
Septemvri, Prof. Mieczysław Domaradzki Archaeological Museum
Sofia, National Archaeological Institute with Museum–Bulgarian Academy of Sciences
Sofia, National Historical Museum
Sozopol, Archaeological Museum
Strelcha, Historical Museum
Targovishte, Regional Historical Museum
Veliko Tarnovo, Regional Historical Museum
Vratsa, Regional Historical Museum

FRANCE
Paris, Musée du Louvre

GERMANY
Berlin, Staatliche Museen
 Vorderasiatisches Museum

GREECE
Alexandroupolis, Archaeological Museum
Samothrace, Archaeological Museum

ROMANIA
Bucharest, National History Museum of Romania

UNITED KINGDOM
London, Trustees of the British Museum

UNITED STATES
Los Angeles, The J. Paul Getty Museum
New York, The Metropolitan Museum of Art

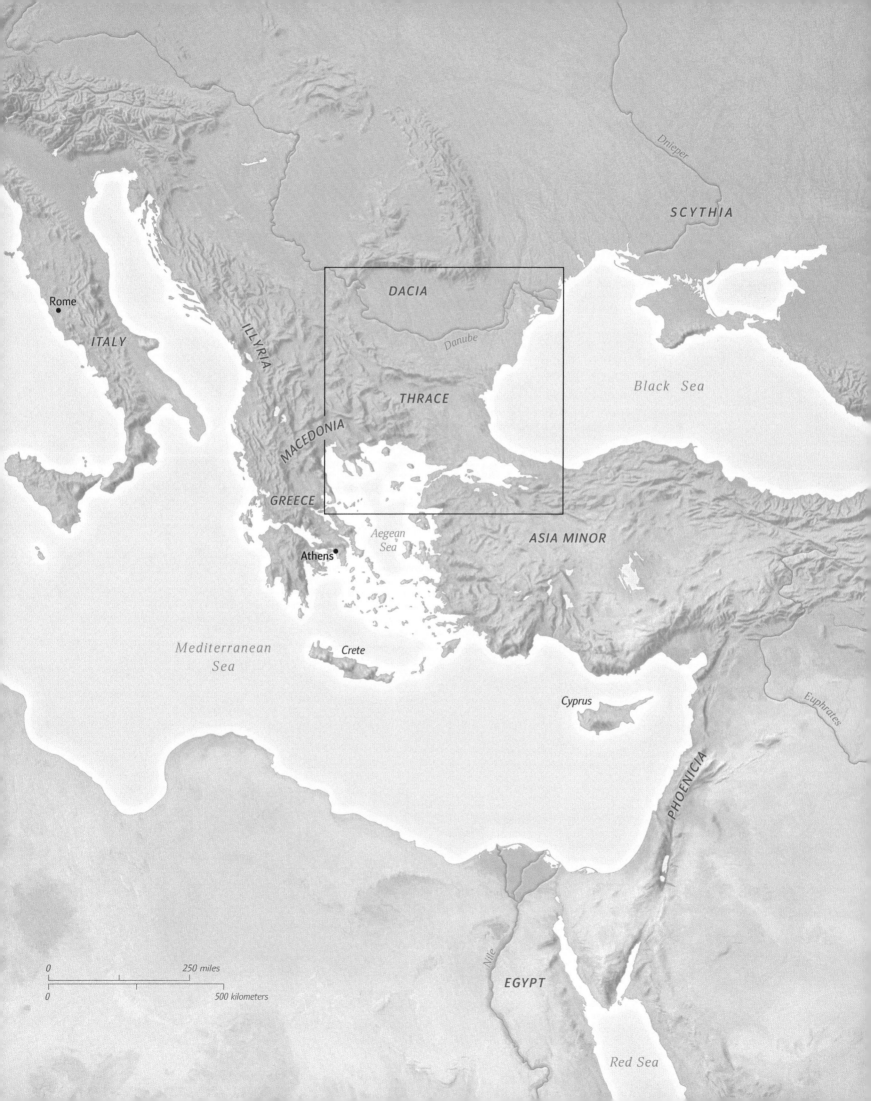

Rome

ITALY

ILLYRIA

MACEDONIA

GREECE

Athens

DACIA

Danube

THRACE

Aegean
Sea

Crete

Mediterranean
Sea

Cyprus

ASIA MINOR

Black Sea

SCYTHIA

Dnieper

Euphrates

PHOENICIA

Nile

EGYPT

Red Sea

0 250 miles

0 500 kilometers

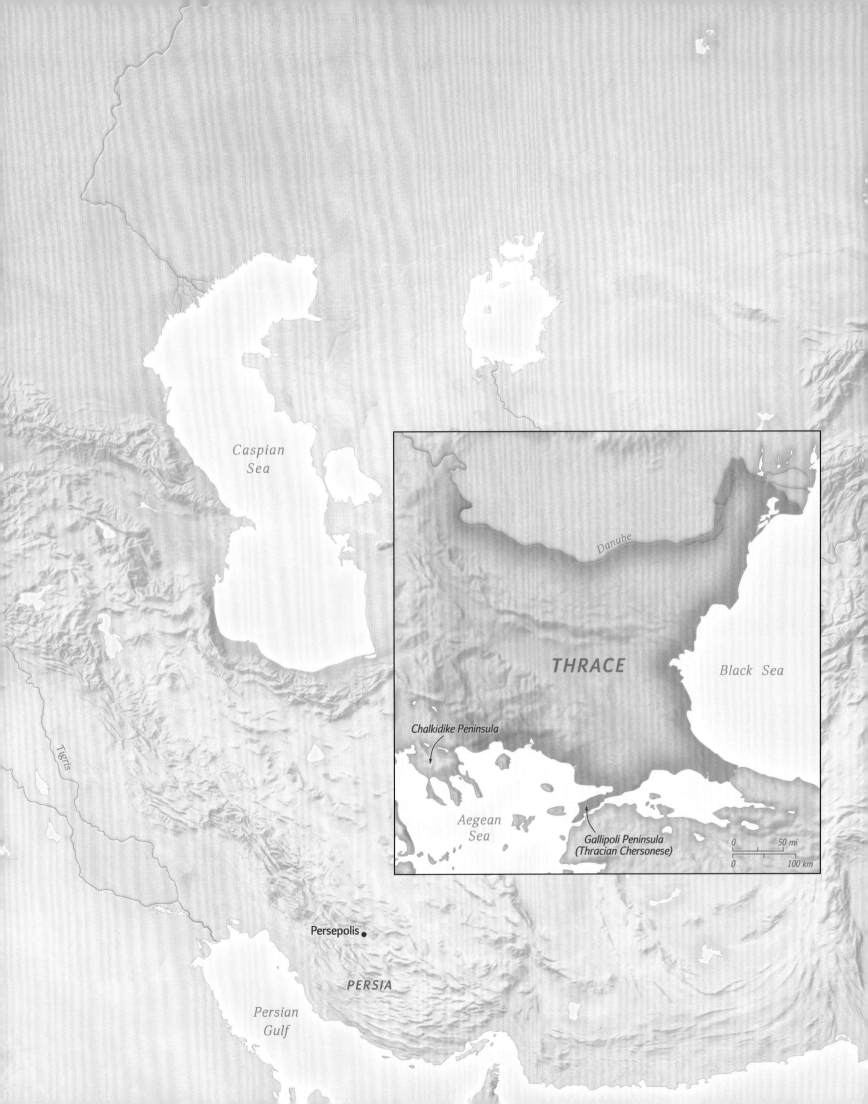

Caspian
Sea

THRACE

Black Sea

Danube

Chalkidike Peninsula

Aegean
Sea

Gallipoli Peninsula
(Thracian Chersonese)

0 50 mi

0 100 km

Tigris

Persepolis

PERSIA

Persian
Gulf

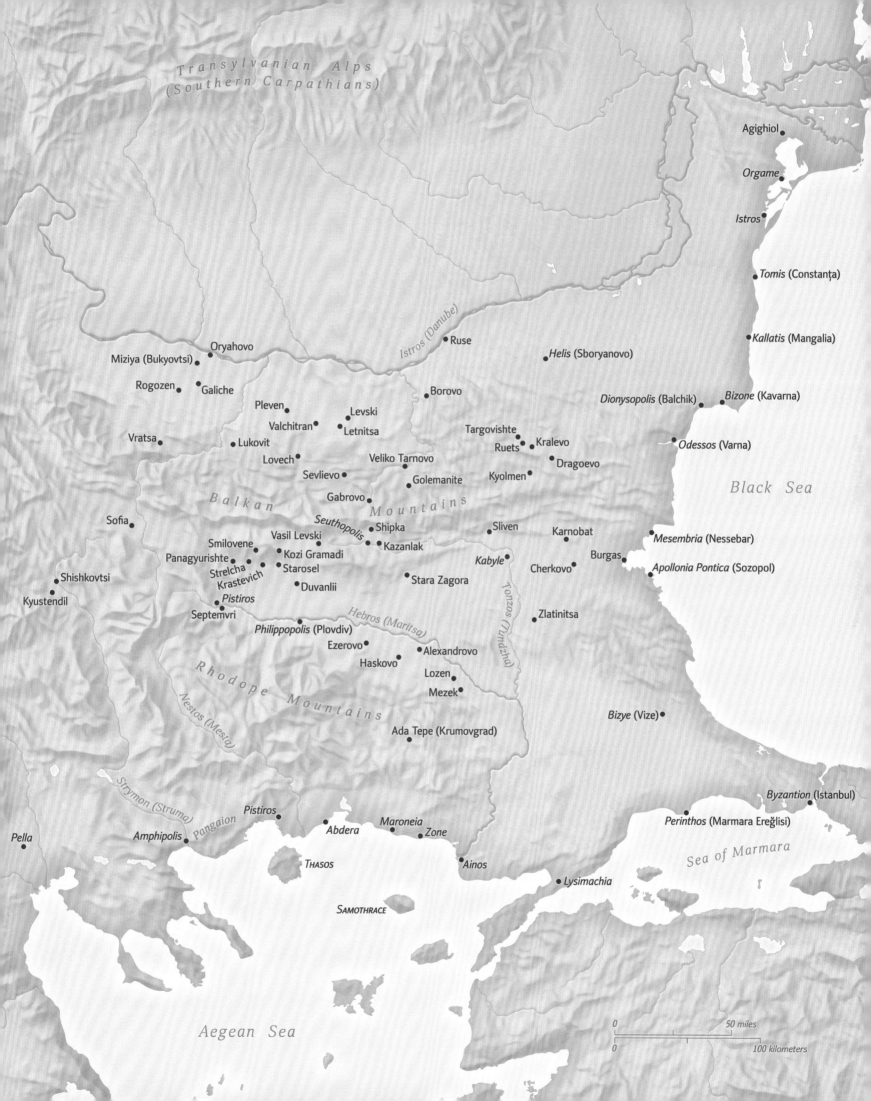

Transylvanian Alps
(Southern Carpathians)

Agighiol

Orgame

Istros

Tomis (Constanța)

Kallatis (Mangalia)

Istros (Danube) Ruse Helis (Sboryanovo)

Oryahovo
Miziya (Bukyovtsi) Bizone (Kavarna)
 Dionysopolis (Balchik)
Rogozen Galiche Borovo
Pleven Levski
Valchitran Letnitsa Targovishte Kralevo Odessos (Varna)
Vratsa Lukovit Ruets
 Lovech Dragoevo
 Sevlievo Veliko Tarnovo
 Golemanite Kyolmen Black Sea
 Gabrovo
Balkan Mountains
Sofia Seuthopolis Shipka Sliven
 Vasil Levski Kazanlak Karnobat Mesembria (Nessebar)
Smilovene Kabyle Cherkovo Burgas
Panagyurishte Kozi Gramadi Apollonia Pontica (Sozopol)
Shishkovtsi Strelcha Starosel Stara Zagora Zlatinitsa
Krastevich Duvanlii
Kyustendil Pistiros
 Septemvri Hebros (Maritsa)
 Philippopolis (Plovdiv)
 Ezerovo Alexandrovo
Rhodope Haskovo Lozen Bizye (Vize)
 Mezek
 Nestos (Mesta) Mountains
 Ada Tepe (Krumovgrad)

 Byzantion (Istanbul)
Strymon (Struma) Pistiros Perinthos (Marmara Ereğlisi)
Pangaion Abdera Maroneia Zone
Pella Amphipolis Sea of Marmara
 Thasos Ainos
 Lysimachia
 Samothrace

Aegean Sea

0 50 miles
0 100 kilometers

THRACE IN MEDITERRANEAN HISTORY

GREEK AGES	ROMAN DYNASTIES	THRACIAN AGES

3200 BC

ca. 3100–2000 BC
Early Bronze Age

ca. 3200–2000 BC
Early Bronze Age

2000 BC

ca. 2000–1700 BC
Middle Bronze Age

ca. 1700/1650–1075 BC
Late Bronze Age

ca. 2000–1600 BC
Middle Bronze Age

ca. 1600–1100/1050 BC
Late Bronze Age

1000 BC

ca. 1075–800 BC
Pre-Archaic

ca. 1100/1050–800 BC
Early Iron Age I

800–480 BC
Archaic

753 BC
FOUNDATION OF ROME

ca. 800–550/500 BC
Early Iron Age II

480–323 BC
Classical

ca. 550/500 BC–AD 1
Late Iron Age

323–30 BC
Hellenistic

0 BC/AD

27 BC–AD 68
JULIO-CLAUDIAN DYNASTY

Augustus: 27 BC–AD 14
Claudius: AD 41–54

AD 69–96
FLAVIAN DYNASTY

Vespasian: AD 69–79
Domitian: AD 81–96

AD 100

AD 96–193
NERVA-ANTONINE DYNASTY

Trajan: AD 98–117
Hadrian: AD 117–38
Marcus Aurelius: AD 161–80

AD 200

AD 193–235
SEVERAN DYNASTY

Septimius Severus: AD 193–211
Caracalla: AD 211–17

AD 235–84
THE SOLDIER EMPERORS

Maximinus Thrax: AD 235–38
Decius: AD 249–51

AD 300

NOTE Given the lack of reliable sources of information, many dates in the chronology of ancient Thrace are approximate and open for discussion. The section on the Roman Empire below includes the names and reign dates of selected Roman emperors, specifically those who had a special connection to Thrace or whose reigns marked significant periods in Thrace's history.

THRACE IN THE LATE IRON AGE

KINGDOMS AND RULERS

500 BC

ca. 480–340 BC
ODRYSIAN KINGDOM

Teres: ca. 480–ca. 450 BC
Sitalkes: ca. 450–424 BC
Seuthes I: 424–ca. 405 BC
Medokos: ca. 405–ca. 390 BC
Amadokos I: ca. 390–ca. 384 BC
Seuthes II: ca. 390–ca. 387 BC
Hebryzelmis: ca. 386–384/383 BC
Kotys I: 384/383–360 BC
Kersebleptes: 360–ca. 341/340 BC

400 BC

ca. 340–281 BC
MACEDONIAN DOMINATION UNDER PHILIP II, ALEXANDER III, AND LYSIMACHOS

Kingdom of the Getai under Kothelas and Dromichaites: ca. 340–ca. 280 BC
Kingdom of the Triballoi under Syrmos: ca. 340–330 BC
Odrysian kingdom under Seuthes III: ca. 330–ca. 300/295 BC

300 BC

ca. 278–ca. 215 BC
CELTIC KINGDOM IN SOUTHEASTERN THRACE

Komontorios (first king)
Kavaros (last king)

200 BC

ca. 150–ca. 133 BC
DIEGYLIS AND ZIBELMIOS, RULERS OF THE KAINOI IN SOUTHEASTERN THRACE

ca. 130–90 BC
MOSTIS, KING OF THE ASTAI(?)

100 BC

ca. 60–44 BC
THE KINGDOM OF THE DACIANS UNDER BYREBISTAS

ca. 30 BC–ca. AD 46
ROMAN CLIENT KINGDOM OF THRACE WITH BIZYE AS ITS CAPITAL

Rhoemetalkes I: 15 BC–AD 12
Rhaskouporis II: AD 12–19
Rhoemetalkes II: AD 19–38
Rhoemetalkes III: AD 38–46

0 BC/AD

AD 100

CONFLICTS AND CONQUESTS

500 BC

513–478 BC
ACHAEMENID DOMINATION IN SOUTHERN THRACE (PERSIAN SKUDRA)

513 BC: Scythian expedition of Darius I
492 BC: Campaign of Mardonios in Thrace
480 BC: Xerxes marches through Thrace

429 BC
CAMPAIGN OF SITALKES AGAINST CHALKIDIKE AND MACEDONIA

400 BC

342–340 BC
MACEDONIAN CONQUEST OF THRACE

363–360 BC
WAR OVER CHERSONESE BETWEEN ATHENS AND KOTYS I

335 BC
ALEXANDER THE GREAT'S CAMPAIGN AGAINST THE TRIBALLOI

323 AND 313 BC
CLASHES BETWEEN LYSIMACHOS AND SEUTHES III

ca. 293 BC
CAMPAIGN OF LYSIMACHOS AGAINST DROMICHAITES

279–277 BC
CELTIC INVASION ON THE BALKANS

300 BC

214–148 BC
MACEDONIAN WARS

200 BC

ca. 148–146 BC
CREATION OF THE ROMAN PROVINCE OF MACEDONIA

100 BC

89–63 BC
MITHRIDATIC WARS

Campaign of the proconsul of Macedonia, Marcus Terentius Varro Lucullus, against the Bessoi and the west Pontic Greek cities: 72 BC

0 BC/AD

ca. AD 15
CREATION OF THE ROMAN PROVINCE OF MOESIA

ca. AD 46
CREATION OF THE ROMAN PROVINCE OF THRACIA

AD 100

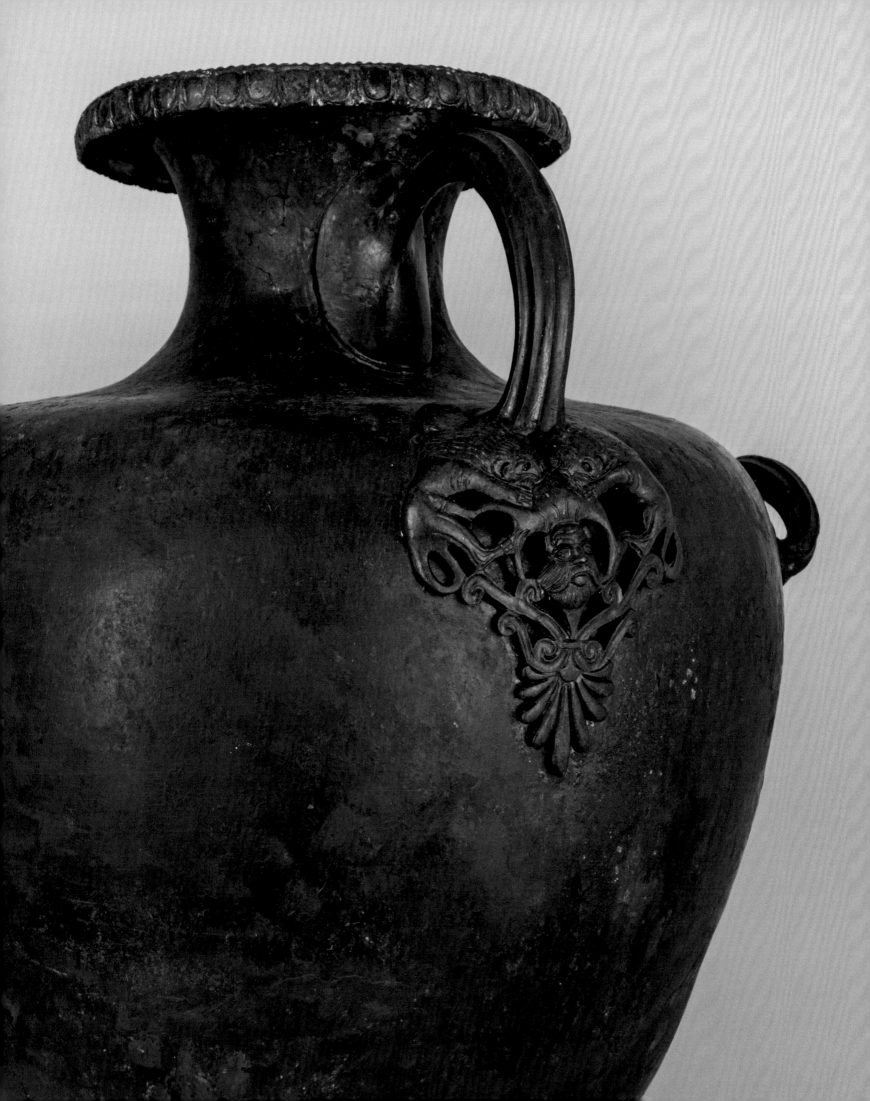

INTRODUCTION

MARGARIT DAMYANOV
JEFFREY SPIER

The ancient land of Thrace lay to the north of Greece, beyond the Aegean Sea, in an area that now comprises Bulgaria and much of Romania, as well as parts of northern Greece and Turkey. By the beginning of the Late Bronze Age (ca. 1600 BC), Thracian tribes already inhabited the Balkan region, and archaeological finds make it clear that there were contacts and trade with the Mycenaean Greeks and the Mediterranean, as well as with the neighboring peoples of Asia Minor and central Europe. Bronze rapiers and swords affirm the Thracians' reputation as formidable warriors, and spectacular hoards like the gold vessels from Valchitran corroborate an image of Thrace that had already emerged in the Homeric epics: that of a land of extraordinary riches. In the *Iliad*, King Rhesos of Thrace arrives in Troy clad in gold armor and on a chariot wrought with gold and silver and drawn by magnificent white horses. He would have been a devastating foe of the Greeks had Diomedes and Odysseus not treacherously slain him on his first night. Gold and silver were among the gifts that Maron, priest of Apollo in the land of the Thracian Kikones, on the north Aegean coast, presented to Odysseus. That these stories could reflect actual knowledge of the wealth of the Late Bronze Age Thracians is again suggested by the archaeological excavations of the oldest known gold mine in Europe, at Ada Tepe in the Rhodopes, barely sixty kilometers inland from the presumed location of Ismaros, the city of Maron.

Aside from the archaeological discoveries, little is known about this early Thrace, as there is no surviving testimony in the Thracian language, except for a small number of later inscriptions of uncertain meaning. Greek myths pictured Thrace as a harsh and often hostile place, home of the cold north wind, Boreas. Its people were often viewed as warlike and cruel, but the country was also renowned for its ecstatic religion and was considered the occasional dwelling place of the god Dionysos. Other myths, however, are more difficult to interpret. The Thracian singer Thamyris is briefly mentioned in the *Iliad* and provides early evidence for the belief in poets with uncanny powers, but the most famous singer of all, Orpheus, is not named until the early fifth century BC. He appears on many Greek vases from that period, typically in a Thracian setting, and among all the remarkable episodes in the singer's life, it is the story of his death at the hands of the Thracian women that is most often depicted. It is likely, however, that the Thracian locale was not integral to the myth and was an invention of Athenian story-tellers, mindful of the contemporary significance of Thrace in Athenian politics. Similarly, the story of King Lykourgos, whose disrespect for Dionysos brought about his downfall, was set in Thrace but need not have originated there, and the horrific tale of Tereus and Prokne was sometimes said to be Thracian (conflating the king's name with the Thracian Teres), evidently another Athenian invention, one that was

Hydria (detail, cat. 47h)

vehemently refuted by Thucydides. Greek writers display only a superficial knowledge of the Thracian gods, with the exception of Bendis, whose worship was introduced to Athens in the late fifth century BC by resident Thracians and Greeks returning from Thrace.

Far more must have been known to the Greeks about the Thracians than what survives today. Greeks had long been traveling to Thrace and by the late seventh century BC had established new settlements on the coasts of both the north Aegean Sea and the Black Sea. Among them were Thasos, an *apoikia* of Paros, and Abdera, founded twice by immigrants from Klazomenai and Teos, in Ionia, both on the north Aegean coast in present-day Greece. The island of Samothrace, home of the ancient mystery cult of the Great Gods, had a significant Thracian population at the time when Greeks from Samos settled there early in the sixth century BC. It seems that there and at Zone, on the opposite coast of Aegean Thrace, the Thracian language was used for a long time in rituals, as attested by inscriptions and dedications scratched on votive gifts. Immigrants from Miletos founded many cities on the coast of the Black Sea, including Istros and Tomis (in present-day Romania) and Apollonia Pontica and Odessos (in Bulgaria), and Mesembria was a colony of Megara on the Greek mainland. Although sometimes the new settlers came into conflict with the local populations, the cities that they founded typically prospered and served as gateways for goods, technologies, images, and ideas from the Greek world. Archaeological excavations provide a view of the culture of these Greek cities, including the remains of temples and private houses ornamented with decorative terracottas, marble sculpture, and imported Greek pottery. Trading posts were also established inland, and striking archaeological evidence for such settlements has been discovered at Pistiros, in Bulgaria, including an inscription that records a treaty with the local Thracian ruler.

Despite the proximity of Greece to Thrace and the presence of Greeks visiting and settling in Thracian territory, until the later fifth century BC Greek historians provide only meager evidence for the region's politics or culture. Herodotus took some notice of Thrace and its customs, primarily in regard to the country's role in the Greco-Persian Wars of around 492–479 BC, and filled the landscape with names of mountains, rivers, and tribes, among them the Dolonkoi, Edonoi, Bisaltai, Getai, Triballoi, Bessoi, and Odrysai. The Athenian writer Thucydides, himself apparently descended from the Thracian aristocracy

(his father had the Thracian royal name Oloros, and Thucydides owned concessions to work a gold mine in Thrace), was more familiar with the political situation there in the early stages of the Peloponnesian War. Another Athenian, Xenophon, who in 399 BC arrived in Thrace and briefly entered the service of the Thracian ruler Seuthes II, presents a vivid, although generally unflattering picture of his court.

Political relations between the Thracians and Athens can be traced as far back as the Athenian tyrant Peisistratos, who was exiled from Athens around 556 BC and sought allies in Macedonia and Thrace. A decade later, with the wealth derived from the mines around Mount Pangaion, he was able to hire mercenaries and return to claim power in Athens. Around the same time the Dolonkoi in the Thracian Chersonese, on the shores of the Hellespont, called in the Athenian aristocrat Miltiades the Elder to serve as despot in response to their conflict with the neighboring Apsinthioi. This Athenian fiefdom was inherited by his nephew, Miltiades the Younger, who arrived around 515 BC, married the daughter of the Thracian king Oloros, and kept a bodyguard of five hundred men. Soon after the Persian invasion of Thrace under Darius I in 513 BC, Miltiades returned to Athens and distinguished himself at the Battle of Marathon in 490 BC.

Persian control over Thrace was relatively brief, until 479 BC, when the defeated army of Xerxes retreated from Greece to the north, attacked by the local Thracians along the way. While under Persian rule, many Thracians had been sent to Persia as workers, as attested by the Persepolis Fortification Tablets, and are pictured bearing tribute for the Great King on the sculpted reliefs of the Apadana. The wealth and grandeur of Persian royalty surely made a lasting impression on the Thracian kings, who continued to use gold and silver drinking vessels at lavish banquets as a symbol of aristocratic status.

Following the Persian withdrawal, the Odrysian dynasty emerged as the dominant power in Thrace. According to Thucydides, it was King Teres who brought the dynasty to prominence. He was succeeded by his son Sitalkes, who forged an alliance with Athens at the time of the Peloponnesian War and was praised for his leadership by the Greek writer Diodorus Siculus. Also at this time, Thracian mercenaries, the lightly armed but highly mobile peltasts, fought for Athens and then for other Greek clients, bringing new military tactics that would become widespread in the Hellenistic period. Athenian entanglement with

Thrace continued into the fourth century BC, notably with the activities of the Athenian general Iphikrates, who married the daughter of the powerful Thracian king Kotys I (384/383–360 BC). Soon afterward, however, the Odrysian kingdom fell under the attacks of Philip II of Macedon in 342–340 BC, after which large areas of Thrace were put under Macedonian control. Thracian troops took part in Alexander the Great's campaigns, and later the Odrysai regained power under Seuthes III (ca. 330–ca. 300/295 BC), who built himself a royal capital, Seuthopolis, in the manner of the Diadochoi (successors of Alexander).

Archaeological discoveries provide a vivid illustration of the culture of the Odrysian aristocracy. Beginning in the mid-fifth century BC, hundreds of tombs located in the great central valley of present-day Bulgaria were constructed of ashlar masonry and covered with earth to create large and highly visible mounds (tumuli). Although most of these tombs were plundered in antiquity, the sophisticated architecture often remains, including decorated entrances with facades, passageways, antechambers, and beehive-shaped domes or coffered ceilings, sometimes painted. Murals like those in the tombs of Kazanlak and Alexandrovo focus on aristocratic pursuits—feasting, hunting, and military exploits. The few undisturbed tombs contained opulent objects reflecting the self-image of the Thracian elite. Male burials contained arms and armor, including bronze helmets, cuirasses, greaves, swords, spearheads, and arrowheads; luxurious drinking vessels, often in gold and silver or else in black- or red-figure pottery; and gold wreaths, pectorals, and funerary masks. The importance of horses is shown by the presence of bridles decorated with gold and silver ornaments, and the prized horses themselves were sometimes buried in the tombs. Elaborate sets of gold jewelry adorned the noblewomen.

A relatively recent discovery, the great tumulus at Golyama Kosmatka, near Kazanlak, revealed the one certain royal tomb, that of Seuthes III. The extraordinary bronze head of the king, evidently detached from a full-length statue, had been placed at the entrance, and the king's name appears on a fine bronze helmet and on silver vases. Greaves with the head of the goddess Athena, a richly decorated sword, a gold wreath, gold horse trappings, and other objects mark the king's high status.

Less is known of the northern Thracian tribes, although the Getai had a significant reputation for valor in antiquity. Several tombs of the late fourth

and early third centuries BC have been discovered in northern Bulgaria and both north and south of the Danube River in Romania. Although the tumuli were disturbed, many superb objects were recovered, including gold and silver helmets and other pieces of armor in a distinctive Thracian style, like the finds from Vratsa and Agighiol. This was the time of Syrmos, king of the Triballoi in the northwest, who fought Alexander the Great, and of Dromichaites, king of the Getai in the northeast, who—as related by Diodorus and others—captured the Diadochos Lysimachos with his entire army and married his daughter.

Conflict and turbulent times could explain a series of fortunate discoveries of gold and silver objects deliberately buried in antiquity but without archaeological context. The famous gold treasure from Panagyurishte in Bulgaria, found by chance in 1949, contained nine gold vessels—an amphora, a *phiale*, and seven *rhyta*—all richly decorated with mythological scenes in relief, very likely deriving from a Macedonian royal workshop of around 300 BC. In 1985–86 a huge trove of 165 silver vessels weighing more than twenty kilograms was found in Rogozen, Bulgaria. The vessels—including cups, *phialai*, and jugs—clearly were intended for aristocratic banqueting, and royal names inscribed on some of the objects indicate their association with the Odrysian court.

By the end of the third century BC, the practice of constructing tombs filled with riches ceased. The political situation had become very unstable, and the Odrysian kingdom had fragmented. Various local rulers emerged, but historical sources record little about them. A Celtic invasion established a short-lived kingdom in southeastern Thrace in the third century BC, and the arrival of the Romans in the mid-second century BC following their defeat of the Macedonian kingdom eventually led to the incorporation of Thrace, aside from those tribes north of the Danube, into the Roman Empire around AD 46. As in other parts of the empire, the local aristocracy was encouraged to assimilate and assume the responsibilities of local governance within the Roman state bureaucracy, as numerous honorific inscriptions throughout Thrace attest. Certainly the Thracian elite prospered, and it seems that some traditional indications of status continued, for even in the early Imperial period, teams of horses, along with carts decorated with silver ornament, were buried in the tumuli of their owners. Other aspects of Thracian culture, however, gradually vanished, absorbed into the fabric of the vast empire.

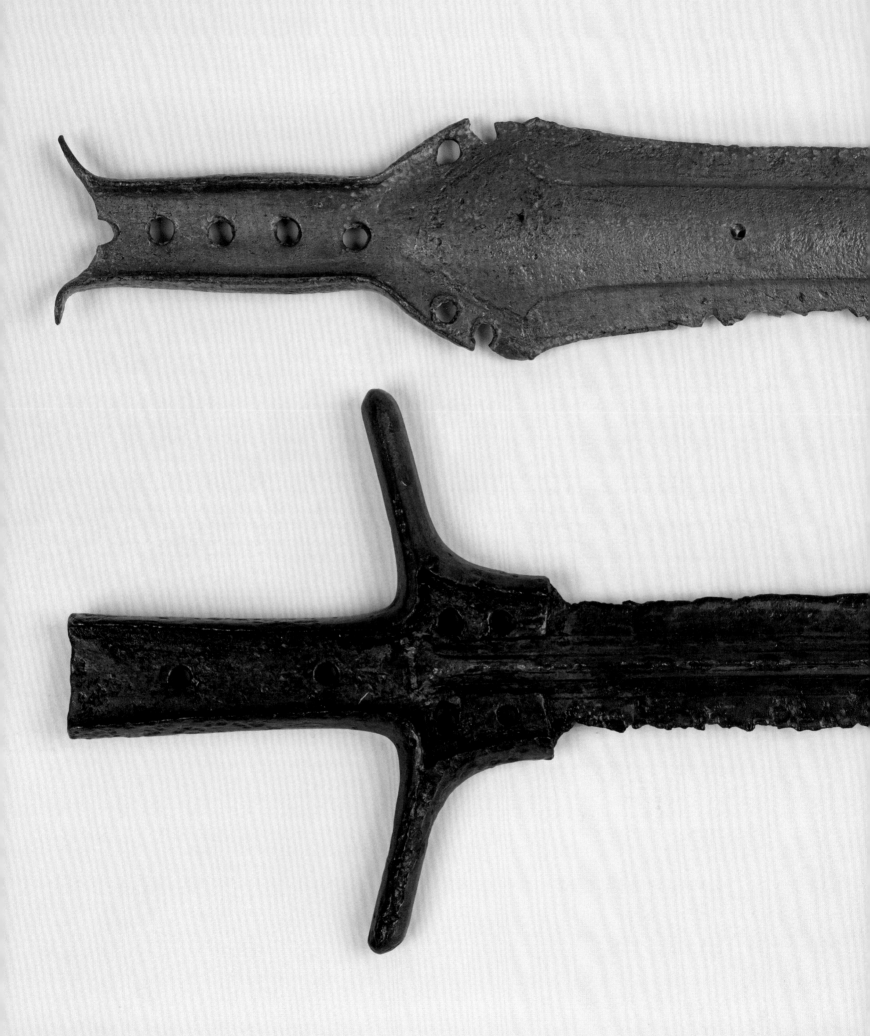

WHO WERE THE THRACIANS?

ZOSIA H. ARCHIBALD

GEOGRAPHY AND PEOPLES

The information that has been preserved in the works of ancient writers about Thracian geography and peoples is of highly variable quality. Much of the most interesting data comes from the period between the seventh and fifth centuries BC, which is not repeated or expanded on by later writers. The uneven character of this information is explained partly by the types of writings that have survived to modern times and partly by the interests and preoccupations of authors writing in Greek and Latin. Many more authors wrote in Greek than in Latin, but only a handful of writers were considered worth copying and preserving in medieval times. It is to some degree a matter of luck that the two great prose writers of the fifth century BC, Herodotus and Thucydides, shared an interest in Thrace, if for different reasons. Thrace was one of the regions that fell in the path of the Achaemenid Persian kings as they sought to expand their empire westward into southern Europe (520–479 BC). This explains why Herodotus has quite a lot to say about the communities along the north Aegean coast that experienced foreign occupation and coercion for close to three decades. Thucydides incorporated several key chapters on Thracian affairs into his *History of the Peloponnesian War*, particularly in book 2, in which

he describes events of 429/428 BC. These provide an extraordinarily suggestive, if tantalizingly brief, snapshot of a world that looks momentarily recognizable.

"Thrace" was long used by ancient Greek geographers as a topographic expression, with a rather imprecise definition. "Thracians" were identified in the eighth- or seventh-century BC Homeric *Iliad* and *Odyssey* at several points along the north Aegean coastline as far as the Hellespontine Straits into the Black Sea. The late sixth-century BC geographer Hekataios discussed locations and peoples in "Thrace." What he had in mind were the coastal regions of the north Aegean, that is, from the Thermaic Gulf and the Chalkidike Peninsula in the west to as far as the Hellespontine Straits and the Bosporus in the east, as well as along the western coast of the Black Sea. Like other writers on the physical and social geography of the Aegean area, Hekataios focused first and foremost on the coastal zone, which was familiar to ships' captains and merchants. Areas further inland required local knowledge and experience. Geographic knowledge among ancient writers was heavily influenced by the patterns of periodic maritime connections and the routes of coastal cabotage, that is, the many local journeys made by ships from one small harbor to another. Captains needed to know where they could take on water and supplies, sell commodities,

Sword (detail, cat. 5)
Rapier (detail, cat. 4)

and find out more about what kinds of goods and services might make future journeys of the same type worthwhile. This was where knowledge regarding local communities could prove useful, as well as interesting in its own right.

Some of the names of peoples and tribes that Hekataios apparently mentioned are not referred to by any other writer, save authors such as Stephanos of Byzantion, whose citations allow us to appreciate the nuances of Hekataios's extraordinary lists: Bantioi, Darsioi, Dasiloi, Datuleptoi, Disorai, Entribai, Xanthioi, Satrokentai, Skai, and Trisplai.[1] A modern reader gets the impression that the names of various "peoples" were very numerous, and only some of these have been preserved by Greek authors. The first German encyclopedia of ancient Thrace produced a list of more than fifty names of what are sometimes called tribes,[2] while Strabo, writing in the late first century BC, referred to twenty-two tribes.[3]

"Tribal" names are not unusual in the area of southern Europe and the Black Sea. If we look at the ways in which such names were used in the area of the Thermaic Gulf, for which there are more plentiful Greek sources, it becomes clear that such names correspond to local communities in regions where the population may have existed in scattered settlements or a combination of urban nuclei with various outlying rural locations. One of the most helpful authors in this respect is Herodotus, the great narrator of the Greco-Persian Wars. In book 4 of his *Histories*, in which the passage of the Persian armies into Europe and Scythia under King Darius I in 513 BC is described, Herodotus refers to the Getai, near the estuary of the Danube, as well as the Skyrmiadai and the Nipsaioi, in the vicinity of Apollonia and Mesembria, on the western Black Sea coast.[4] In book 5 we find an extensive digression on the customs of Thracian peoples, with an interesting distinction between most Thracians, on the one hand, and the Getai, Trausoi, and "those who live beyond Kreston," on the other.[5] The significance of the distinction that the historian makes here needs a bit more explanation. For Herodotus, most "Thracians" of his experience had similar customs, and he does not bother to specify what these are. The reader is left to infer that they are not very different from the customs of their neighbors, aside from the tendency of Thracians to sell their children, allow comparative freedom to young women (but keep wives under strict supervision), and display a preference for tattoos on the body.[6] The taste among Thracians for warfare, booty, and a life of noble

indolence (observations that are tacked on to the earlier comments relating to customs) will be discussed further below.

Herodotus goes on to describe the various communities pressed into service in the Persian armies of King Xerxes in 480 BC, as he moved across the north Aegean coast along the western edge of the Thermaic Gulf and down into mainland Greece. For the first time, the reader is treated to something more extensive and wide-ranging than the sketches gleaned from a conversation between a Greek-speaking captain and a local (usually Greek) tradesman. The historian lists all kinds of peoples. The Kikones, who are also mentioned by Homer, live near the city of Doriskos, which was located on the west bank of the Hebros River and above its lacustrine delta.[7] Moving westward, there were the Paitoi, Bistones, Sapaioi, Dersaioi, Edonoi, and Satrai.[8] In the area of Mount Pangaion, there were the Pieres and Odomantoi and the Doberes and Paioplai, the latter two called Paionians rather than Thracians.[9] Along the shores of the Chalkidike, Herodotus tends to refer to the principal harbor towns along each of the three fingers of land, but later in the same narrative, he returns to a description of peoples when talking about the mainland contingents drafted into the Persian army: Thracians, Paionians, Eordaians, Bottiaians, Chalkidians, Brygoi, Pierians, Macedonians, Perrhaibians, Enienes, Dolopes, Magnetes, Achaians, and the coastal settlements of Thrace.[10] It seems clear that the choice of terminology is related to various concerns in the historical narrative rather than to some difference of local nomenclature or to different types of settlements. When Herodotus wanted to refer to an urban center, he would do so, but more often than not he was concerned with larger collectives and only occasionally notes cities or other settlements. Herodotus's younger contemporary Thucydides also refers to tribes when discussing Macedonian peoples, such as the Lynkestai and Elymiotai, located in western Macedonia, as well as the people of Anthemous, Bisaltia, and Krestonia, who had been incorporated into the kingdom of the Macedonian Temenid monarchs in the decades immediately after the Greco-Persian Wars.[11] The reference to Krestonia connects Thucydides's narrative with that of Herodotus. We can begin to piece together an evolving picture of political and ethnic relatedness. Krestonia and the Krestonai form a collective that seems to represent the limits of Herodotus's personal knowledge. He alludes to "those who live beyond Kreston" without specifying in any detail who those communities were.[12] His knowledge of

the interior, west of the estuary of the Strymon River, seems to be exhausted at this point, and he was forced to triangulate what he knew of the "beyond" with what he knew of the Thracian peoples at the eastern extremities of the Balkan landmass, near the estuary of the Istros (Danube) River.

Thucydides, who had a good personal knowledge of Thrace since he inherited a mining concession in the Pangaion area from his father, Oloros,[13] and spent his exile in the region after 424 BC, appears far more knowledgeable than any other historian, moving confidently in his narrative between the better-known coastal districts around the Chalkidike and the estuary of the Strymon to inland areas at the northwesterly limits of the Odrysian realm, among the Laiaioi. Not only does he show an awareness of traveling distances by sea between Abdera, in the middle of the north Aegean coast, and the Danube estuary, but he is equally aware that his readers will be interested in knowing how long the overland route would take from Abdera due north to the Danube.[14] This implies that various people did travel along these routes and not just local officials but also foreigners. This is why Thucydides, notorious for being a writer who did not waste words, bothers to tell his readers that a fast traveler could get to the Danube from Abdera in eleven days and from Byzantion to the lands of the Laiaioi in thirteen days. We know a good deal about the maritime routes because of the containers for various foodstuffs (wine, oil, nuts, preserved foods) that have been discovered at port locations on the Black Sea and on the north Aegean coast; somewhat less is known about the many intermediate points across the interior of Thrace, where traces of such items have been found by archaeologists. These patterns reflect a dendritic set of commercial routes along rivers but also over land.[15] The existence of these roads is indirectly referenced by Thucydides himself, when he describes military roads created by the felling of forests in the time of the Odrysian king Sitalkes (ca. 450–424 BC).[16]

One of the more astonishing statements that Thucydides makes in his brief survey of the Odrysian kingdom and its resources pertains to the highest mountains of the interior. He refers to three peoples living outside the Odrysian realm of his day: the Triballoi, the Treres, and the Tilataioi.[17] They occupied land north of a high mountain, which he calls Mount Skombros, as far as the Oskios River (the present-day Iskar). The highest peak of the Balkan massif is Mount Botev, at 2,376 meters. It is difficult to know which

mountain corresponds to the Mount Skombros that Thucydides names, but his overall understanding of the geography of the Balkans seems remarkably well informed if not entirely accurate from a modern perspective. The Balkan (Haimos) Range is indeed a largely uninhabited chain of mountains that could be thought of as joining the Rhodope Mountains, as the historian claims, and it can be viewed as the origin of the Hebros River, but it is the Rhodopes from which the Nestos River rises. Thucydides elided this detail in his sketch. In the late 180s BC, Philip V of Macedon invaded Thrace and reached the Haimos Range. He too was trying to understand the geography of the Balkans.[18] The southeastern European landmass between the Axios River, the Bosporus, and the Danube offers great variety in terms of landscapes and resources. Temperate Continental and dry Mediterranean climates combine in this region, creating ample forest cover in the mountainous areas of the Rhodopes, and these forests extended well into lowland areas in antiquity, providing excellent timber for construction, heating, and manufacturing purposes. Good building stone was more limited in supply, but granite and crystalline rocks, including marble, were exploited selectively across the region for fortification, tomb building, decorative features, and inscriptions. Minerals are also found in abundance, particularly iron, copper, and precious metals. The silver and gold veins of Mount Pangaion formed a magnet for many interested parties—including Macedonian, Thracian, and Persian kings, as well as communities from across the Aegean—but the same metals were exploited in other parts of the region, particularly in the Rhodopes (silver) and the Thracian Plain (gold). Iron manufacture nevertheless represents one of the key products of Thracian metallurgical workshops.[19]

The best evidence of commercial networks in the Thracian interior comes from archaeology and inscriptions. The so-called Pistiros Inscription (also known as the Vetren Inscription)—found at the site of Asar Dere, which is likely identifiable as the Roman *mansio*, or road station, Bona Mansio (known earlier as Lissae), but moved from its original location at Adzhiyska Vodenitsa (ancient Pistiros), near Vetren, in central Bulgaria—contains a wealth of information about commercial relations between Thracians, the people of Pistiros (the Pistirenoi), and Greek merchants from Maroneia, Thasos, and Apollonia (cat. 27). The inscription is a decree of a Thracian prince from about 359 BC guaranteeing rights to merchants from the

named coastal Greek cities at Pistiros and at several other commercial sites.[20]

Later Greek and Roman writers found it harder to verify the kinds of information available to their two great predecessors, Herodotus and Thucydides. Strabo, writing in the early years of the Roman Principate, explored the same regions within the context of a much more ambitious work that covered the whole Roman Empire. Book 7 of his *Geography*, which is preserved only as a set of fragments, gives little idea of how he may have covered the inner parts of Thrace and Macedonia. The preserved passages suggest a more anecdotal approach, which drew on the work of his predecessors but did not deploy much new knowledge, at least not as far as Thrace was concerned; the same is true of Pliny the Elder, in his *Natural History*.

THE THRACIAN LANGUAGE(S)

Thracians spoke languages that were related to neighboring Indo-European languages: Greek, Illyrian,

and Phrygian. The huge landmass that is conceived by ancient writers as populated by Thracian speakers makes it unlikely that there was a single Thracian language. "Getic" is usually considered by linguists to have been a separate language, and there may have been dialects of "Thracian" that were to greater or lesser degrees mutually comprehensible. The difficulty that linguists face is that too few root words survive from these ancient languages, other than Greek, for a useful reconstruction of the linguistic relationships between Balkan languages. In places where a sufficiently large number of personal names has been preserved, it is becoming possible to identify regional variations: a "western Thracian" group, for example.[21] Public documents such as the Pistiros Inscription—issued by political authorities, including kings but also other kinds of officials and magistrates—were written in Greek, usually Ionian Greek.[22] The various other kinds of written texts, which are usually preserved on stone slabs or metal vessels, include personal names, occasionally phrases, and, very rarely, artists' signatures.

1 Hekataios of Miletos, frags. 174–83; Pownall 2013.
2 For a full review of the ancient evidence, see Lenk 1936, 404–7; see also Graninger 2015, 22–23.
3 Strabo, *Geography* 7.F47a.
4 Herodotus, *Histories* 4.93.
5 Herodotus, *Histories* 5.3–4.
6 Herodotus, *Histories* 5.5.1–2.
7 Herodotus, *Histories* 7.59.
8 Herodotus, *Histories* 7.110.
9 Herodotus, *Histories* 7.113.
10 Herodotus, *Histories* 7.185.
11 Thucydides, *History of the Peloponnesian War* 2.99.1–6. For a systematic presentation of sites in Macedonia and the Chalkidike, see Archibald, forthcoming.
12 Thucydides, *History of the Peloponnesian War* 5.3–4.
13 Thucydides, *History of the Peloponnesian War* 4.104.
14 Thucydides, *History of the Peloponnesian War* 2.97.1–2.
15 Archibald 2013, 193–248.
16 Thucydides, *History of the Peloponnesian War* 2.98.1.
17 Thucydides, *History of the Peloponnesian War* 2.96.4.
18 For discussion, see Archibald 2013, 172–73.
19 Archibald 2013, 171–81.
20 Demetriou 2012, 153–87; Archibald 2016.
21 D. Dana 2014; D. Dana 2018.
22 D. Dana 2015.

Fragmentary Stele with Greek and Thracian Inscriptions (detail, cat. 31)

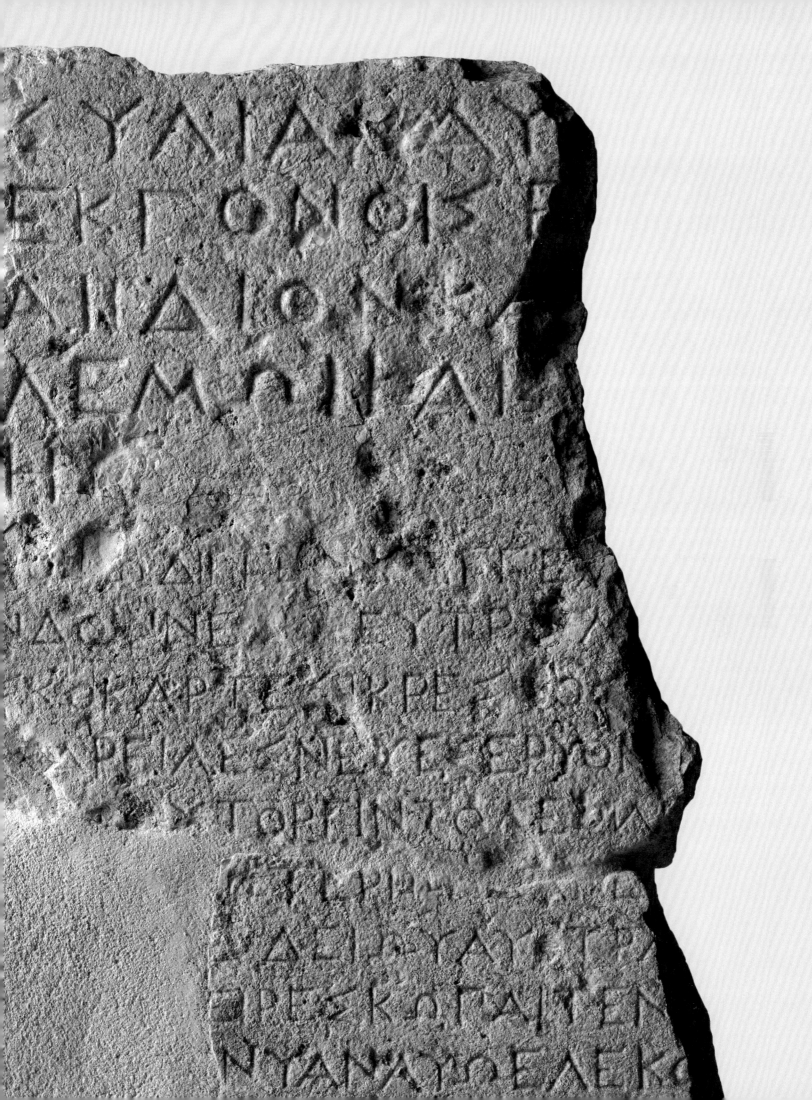

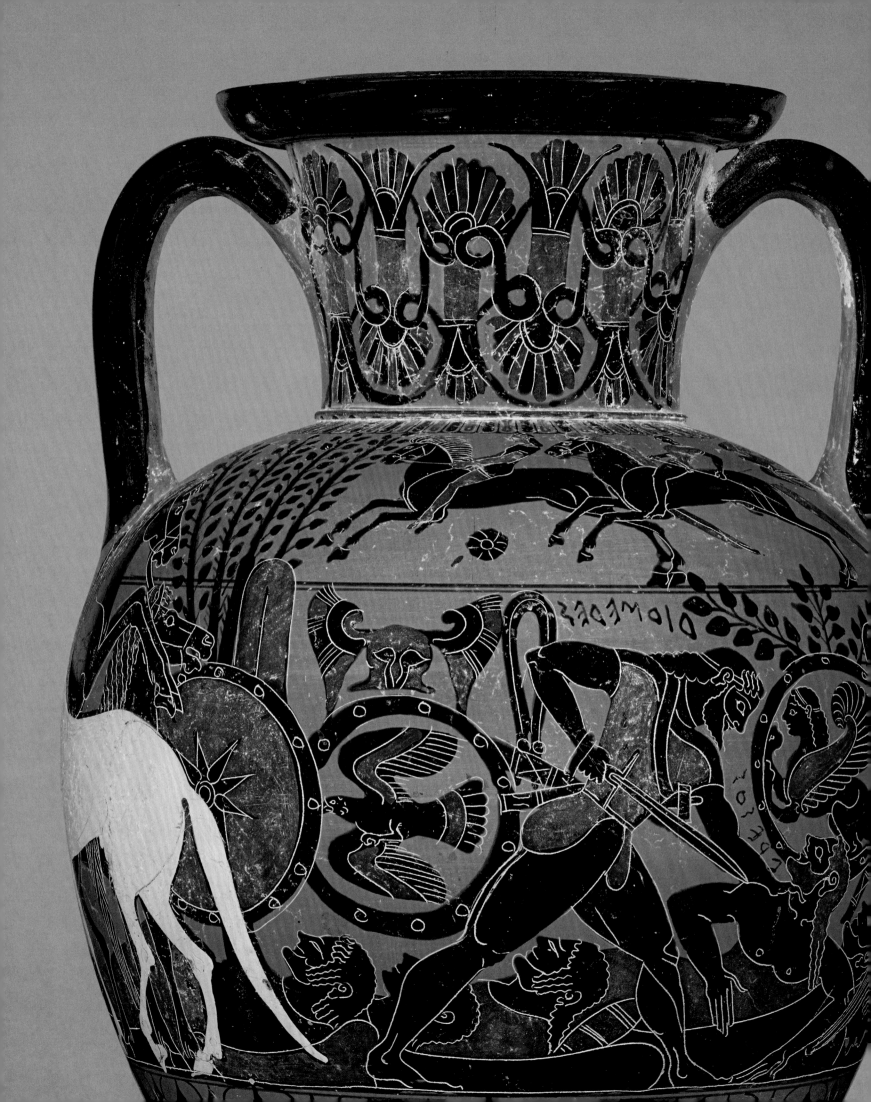

THRACIANS IN HOMER AND OTHER LITERARY SOURCES

ZOSIA H. ARCHIBALD

In book 14 of the Homeric *Iliad*, the scene moves from the din of battle to the gods on Mount Olympos. Hera, queen of the gods, prepares to intervene in her own distinctive way in order to support the Greeks fighting outside Troy. She is described as speeding down from the summit of Olympos, first into the Pierian Mountains and to "lovely Emathia," then swiftly over the snowy mountains of the horse-breeding Thracians; thence, from Mount Athos, the goddess travels over the foaming sea to the island of Lemnos, in the northeastern Aegean.[1] The topography that the poet of the *Iliad* was describing is sketchy but touches on elements that were important to his story. It is not what we might call, from a twenty-first-century perspective, a geographically accurate representation. The prominence of Mount Olympos throughout the Homeric poems is hardly surprising. It is visible along the horizon from many parts of Macedonia, Thessaly, and the Chalkidike Peninsula and, like Mount Athos, was a key topographic feature for sailors. The geography of the area over which Hera swooped is maritime with the mountains of Pieria, just to the north of Olympos, and the mysterious "Emathia," which corresponds to the low-lying coasts of the Thermaic Gulf. The location of the horse-breeding Thracians is less clear, somewhere behind Athos.

Thracians appear in the Homeric poems as allies of the Trojans. There were Akamas and Peiroos, who led troops from the European side of the Hellespont, while Euphemos led the Kikones, who were traditionally located in the area west of the Hellespontine Straits.[2] Pyraichmes led his men from Amydon, on the banks of the Axios River. In book 4 of the *Iliad*, we hear that Peiroos was the leader of men from Ainos, at the estuary of the Hebros River, who wear their hair in a topknot.[3] Akamas (or Iphidamas) was thought by later commentators on the poem to have come from Maroneia to match Peiroos. The most splendid Thracian leader was undoubtedly Rhesos, son of Eïoneus, whose magnificent snow-white horses, caparisoned with gold, fascinated the mischievous Dolon and led to his death, as well as that of Rhesos and his men, who had the misfortune of being Trojan allies.[4] They were all slaughtered by Diomedes and Odysseus.[5] In the *Odyssey*, we find Odysseus getting into a fight with the Kikones, because his men had sacked their city, Ismaros, but we later learn that he had received from Maron, the priest of Apollo at Ismaros, a goatskin of mellow, dark wine, as well as seven talents of gold, a solid silver mixing bowl, and twelve jars of wine.[6] Orpheus, the most evocative mythical figure of Thracian origin, is not mentioned by Homer but is referred to by the tragic poets of the fifth century BC and by the poet Pindar.[7] Homer mentions instead Thamyris, a Thracian singer, whom the Muses met as he was on his way from Oechalia.[8]

Black-Figure Neck Amphora with the Killing of Rhesos (detail, cat. 9)

Poets seem to have imagined places that were, to them, distant shores, imbued with a degree of exotic color.

It is not easy to distinguish between "Greeks" and "Thracians" in these early literary sources. What Thamyris was doing in Oechalia, an imaginary place in central Greece, is never explained. Some of the Trojan allies from Europe are called Thracians, and some are identified by their collective name only, without a linguistic identifier. In the same vein, Hera, in the *Iliad*, moves across the Thermaic Gulf from Mount Olympos, with few specific ethnic distinctions made in the text, and Bacchylides, the fifth-century BC poet, felt inspired to invoke Pythian Apollo, apparently conceived of as dwelling on the flower-filled banks of the Hebros River. When might Apollo have been found in Thrace? In order to make sense of the surviving verses, we have to tease out clues from the fragments of Bacchylides's poem with the help of other lyric poets. Alkaios wrote a hymn about Apollo's flight to the Hyperboreans and his return, prompted by the paeans, hymns composed by the people of Delphi. Bacchylides first hails a golden freighter, sent by the goddess Ourania, weighed down with songs, coming from Pieria, in Macedonia, the home of the Muses. The poet evidently seeks the Muses' inspiration.[9] Just as Hera, in book 2 of the *Iliad*, seems to be moving across physical and metaphysical space at the same time, so in Bacchylides's poem the singer imagines a ship, full of songs, sailing from the realm where the Muses dwell, in his direction, while Apollo's chariot, drawn by swans, will in due course be tempted to return to Delphi by the paeans of the Delphians. Since the text of this poem—which is a dithyramb, the lyric form that was considered most appropriate for honoring Dionysos—is rather fragmentary we do not know exactly what Bacchylides was saying, but it may well have been a song intended to recall Dionysos to his wintering quarters at Delphi.[10] For Homer, as for Bacchylides, the shores of Thrace were connected with sacred spaces. In winter, Apollo retired to the land of the mythical Hyperboreans (who were never geographically situated by our poets) and was replaced by Dionysos.

The Homeric poems and their successor epics were popular long after their creation in the eighth and seventh centuries BC, but the context of the stories they contain evolved as the commercial and political interests of different communities across the Aegean Sea grew in complexity. Rhesos, Orpheus, and other Thracian mythical heroes were reimagined in new settings, especially in the fifth century BC, when the great Athenian tragedians used a wide range of mythological components to satisfy the ambitious performance repertoire of the annual festivals of Dionysos. Sometimes these characters were used to create alterity—a sense of distance—from the Athenian audience and sometimes simply to make use of cultural settings distant from Athens. The historian Thucydides took issue with the way in which his contemporaries seemed to take such stories literally or chose to make ahistorical connections. He pointed out to them that Teres, who founded the Odrysian royal dynasty in Thrace around 480 BC, had nothing to do with Tereus, the legendary king of Daulis, also known as Phokis, which, the historian explained, used to be inhabited by Thracians.[11] The Athenians knew a story in which Tereus married the mythical Athenian princess Prokne, a ghastly tale of savagery and revenge, which was used in a tragedy by Sophocles, who made Tereus a Thracian and set the play in Thrace. Later poets, including Ovid, also employed this story to evoke scenes of particular savagery.[12] It is easy to see how contemporaries might be confused about the Thracians said to have lived in Daulis when in their own day there were no Thracians in central Greece. Mythology and history were not easy to disentangle.

Thucydides is the most factual of Greek writers on Thrace. Through his father, Oloros, and his great-great-grandfather of the same name, who is called a king of Thrace by Herodotus, Thucydides could claim to be well connected among the upper echelons of Thracian society.[13] He owned an important mining concession through the same familial connections, in the area of the most important gold and silver mines in northern Greece, Mount Pangaion.[14] Unlike most Greek geographers and historians, notably Xenophon and Strabo, Thucydides was interested in the interior of Thrace, not just the coastal regions that were familiar to Greek sailors and merchants. He describes the wealth and revenues of the Odrysian kings in the second half of the fifth century BC and outlines the basis of their social and economic capital, emphasizing their ability to make customs of hospitality and exchange work for their political interests as well.[15] The historian explained that it would take four days and nights to travel by ship from Abdera, the southern extremity of Odrysian territory, to the Danube estuary, which represented the northern limits of their power. A journey by land would take thirteen days, from Byzantion in the east to the lands of the Laiaioi in the far northwest.[16]

Whereas Thucydides gives readers a systematic account of the various peoples of the Odrysian kingdom and describes the military campaigns that took place during his period as general of the Athenians, Herodotus, in his account of the Greco-Persian Wars, takes a different approach to the ethnic makeup of the north Aegean area. Herodotus, who grew up in Halikarnassos, on the southwestern coast of Asia Minor, was interested in similarities, as well as differences, between the various peoples he included in his metanarrative of invasion, conquest, and military successes and reverses. He used a panoramic technique to represent the peoples drafted into the army of the Persian king Xerxes, in which Thracians in fox-skin caps, tunics, fawn-skin boots, and multicolored cloaks paraded with javelins, light shields, and daggers in the array of troops from as far afield as central Asia and Libya.[17] As the invading army proceeded westward across the north Aegean coastal strip, to the Chalkidike and to Macedonia, we see the ordering of Thracians from coastal and inland areas as far as the Rhodope Mountains aligned with others: Thracians, Paionians, Eordaians, Bottiaians, Chalkidians, Brygoi, Pierians, Macedonians, Perrhaibians, Enienes, Dolopes, Magnetes, and Achaians.[18] Here the historian wanted to draw attention to the way in which the different communities in the direct line of the Persian forces became a collective, a unity of peoples forced against their will into military service, an experience they were unlikely to forget.

Later writers have left only occasional references to Thracians. Thracian characters in Aristophanes's plays were selected for their comic value in front of a mainly Athenian audience, but these characters were used in very different ways by the playwright.[19] In *Acharnians* (425 BC), we find the poet making jokes about a recent political alliance with King Sitalkes.

In *Wasps* and in *Peace*, produced in quick succession in 422 and 421 BC, we find the poet referencing Thrace and Thracians because of recent events at Amphipolis, which brought the first decade of the Peloponnesian War to an end. In *Birds*, the faraway Triballian makes a useful target as an exotic, incomprehensible foreigner. The same play, however, uses the myth about Tereus, after his misdeeds, having been turned into a hoopoe to make him a principal character and an intermediary between humans and birds.[20] In 399 BC the historian Xenophon spent just over a month with a mercenary army in the area of southern Thrace around Byzantion. He tells readers of the *Anabasis* (devoted to the Persian expedition) of his reluctant leadership of the remaining "Cyreans" (Greek mercenaries who supported Cyrus the Younger). The mercenaries agreed to serve a local prince, Seuthes, to consolidate his territories. Xenophon offers readers anecdotal accounts that include some vivid scenes, including a banquet hosted by Seuthes.[21] The man depicted in the *Anabasis* is rather different from Seuthes, the ruler whose cooperation with Spartans and Athenians around 390/389 BC is described in the same author's *Hellenika*, despite the fact that this was likely the same individual.[22] Plato refers very briefly to Thracian drinking habits. They are listed among peoples who drank their wine neat.[23] Perhaps the most interesting thing about this comment is the inclusion of women, as well as men, in a drinking context.

For a fuller picture of Thracians in the period after 300 BC, we must turn to other kinds of texts, including papyri and inscriptions. Papyri, supplemented by some inscribed texts, give us a vivid picture of Thracian settlers in Ptolemaic Egypt (ca. 323–30 BC).[24] Inscriptions tell us about the lives and careers of Thracian officials, secular and religious, in civic contexts for the next five centuries.[25]

1 *Iliad* 14.225–30.
2 *Iliad* 2.819.
3 *Iliad* 4.446.
4 *Iliad* 10.434–525.
5 Gočeva et al. (1981) provide a wide array of texts from Homer to Thucydides, with the scholia added by scholars after around 300 BC.
6 *Odyssey* 9.39–66, 9.196–211.
7 Pindar, *Pythian Odes* 4.177. Orpheus: Garezou 1994; Fowler 2013, 211–13. Muses: Fowler 2013, 79–80.
8 *Iliad* 2.595.

9 Bacchylides, *Dithyrambs* 16, ll.1–5; Maehler 2004, 56, 165–68.
10 Maehler 2004, 169.
11 Thucydides, *History of the Peloponnesian War* 2.29.2–3.
12 Ovid, *Metamorphoses* 6.412.
13 Herodotus, *Histories* 6.39.1.
14 Thucydides, *History of the Peloponnesian War* 4.104.1.
15 Thucydides, *History of the Peloponnesian War* 2.97.
16 Thucydides, *History of the Peloponnesian War* 2.97.1.

17 Herodotus, *Histories* 7.75.
18 Herodotus, *Histories* 7.185.
19 Aristophanes, *Birds* 1337; Aristophanes, *Peace* 250; Aristophanes, *Wasps* 281.
20 Dobrov 1993.
21 Xenophon, *Anabasis* 7.3.21–23.
22 Xenophon, *Hellenika* 3.2.2–5; 4.8.26; see also Diodorus Siculus, *Bibliotheca historica* 14.94.2.
23 Plato, *Laws* I.637e.
24 Bingen 2007.
25 Levick 2000, 16–19, 37, 47, 113, 159, 167; see also Topalilov in this volume.

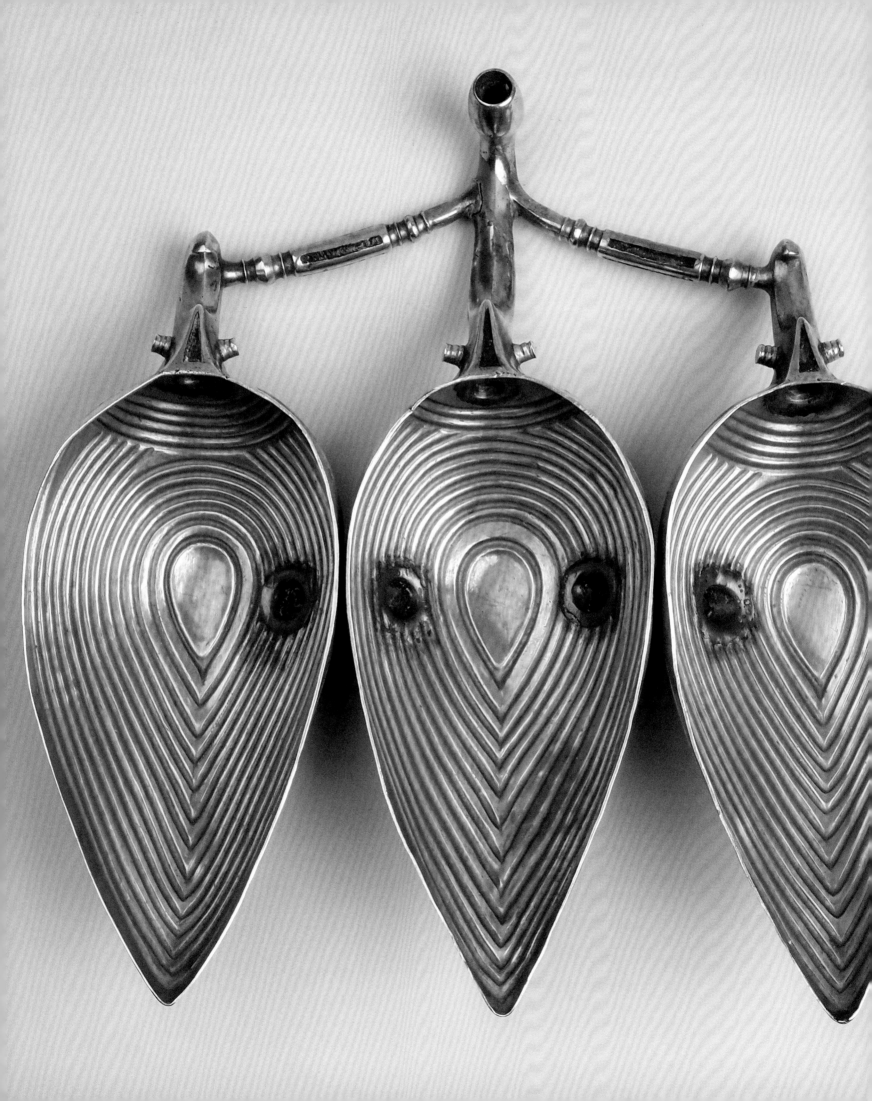

METALS IN THRACE FROM THE EARLY CHALCOLITHIC PERIOD TO THE END OF THE BRONZE AGE

HRISTO POPOV

Archaeology has a long history in southeastern Europe, one that reaches back to the nineteenth century. As with the earlier initial excavations of ancient sites in Egypt and Mesopotamia, European diplomats, travelers, cartographers, and military experts were the first to pay attention to the antiquities from this part of the Ottoman Empire, including through private or state-funded collecting and treasure hunting. After the restoration of statehood in the Balkan countries (1830–78), the study of their rich historical heritage was entrusted to the newly created national museums.

LAND OF GOLD AND SILVER

Among the first artifacts to enter the collection of the antiquities department of the Bulgarian National Library in 1880 were a gold wreath, a silver jug, and silver appliqués for a horse harness from a burial mound near present-day Rozovets, in southern Bulgaria, excavated the previous year, together with a nearby tumulus, on the orders of the Russian military governor of Plovdiv. Some finds were sent to Saint Petersburg, while the rest were presented to Alexander of Battenberg, the first Bulgarian prince, who donated them to the museum.[1] Russian army officers also excavated a rich late fifth-century BC burial at Dalboki, near Stara Zagora. The artifacts entered the collection of the Imperial Hermitage, and later some of them ended up in the Ashmolean Museum, Oxford.[2]

With the accumulation of evidence, it became clear that Classical, Hellenistic, and Early Imperial precious-metal artifacts were regularly discovered in the eastern, northern, and central Balkans, territories traditionally associated with ancient Thrace. The uncovering of these treasures not only enriched museum collections and contributed to our knowledge of the past but unfortunately also led to rampant looting. This problem has become particularly acute in modern times, when new technologies and the globalization of the illegal market for antiquities have resulted in the virtual destruction of entire archaeological sites, Bulgaria and Romania being among the countries in the region most affected.[3]

The list of the spectacular discoveries from the time of Classical and Hellenistic Thrace is a long one. Even a short selection of sites, some of them presented in this volume, would be sufficient to illustrate this extraordinary wealth: Alexandrovo (1900), Radyuvene (1911), Bukyovtsi (1925), Duvanlii (1925–31), Agighiol (1931), Panagyurishte (1949), Lukovit (1953), Letnitsa (1963), Vratsa and Peretu (1970–71), Borovo (1974), Kralevo (1979), Rogozen (1985–86), Golyama Kosmatka Tumulus (2004), Svetitsata Tumulus (2004), Zlatinitsa-Malomirovo (2005), Dalakova Tumulus (2007), Sboryanovo (2012), and others.

Tripartite Vessel (detail, cat. 1m)

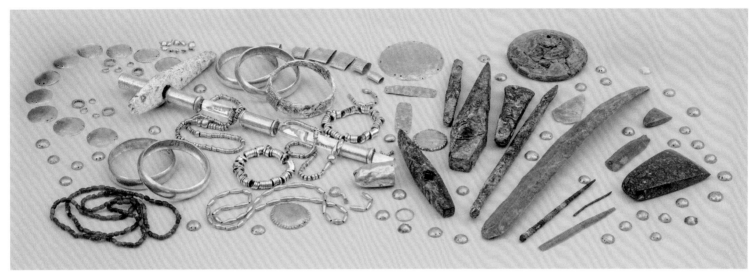

Figure 1. Burial assemblage, mid-5th millennium BC. Gold, copper, flint, stone, carnelian, and spondylus. Found in Grave 43, Varna Chalcolithic necropolis, Varna Province, Bulgaria. Varna, Regional Historical Museum

The social structure of ancient Thrace has been offered as an explanation for this abundance, together with the propensity for ostentation on the part of the Thracian aristocracy. Many precious-metal items were imported to Thrace, sent as diplomatic gifts from faraway lands (especially Achaemenid Persia and Athens) or as tribute from the Greek colonies,[4] and itinerant craftsmen were probably present at the courts of Thracian rulers.

A more exhaustive explanation, however, could be offered by reaching further back in time and considering the local natural resources. The Balkans have always been a major thoroughfare between Europe, on the one hand, and Asia and the eastern Mediterranean, on the other, carrying human migration but also new materials and technologies. Early farmers arrived in the region in the late seventh millennium BC, and the Neolithic culture spread from there to central and western Europe.[5] Because of favorable conditions and the availability of mineral resources, the region played a leading economic and technological role in Europe in the sixth and fifth millennia BC. In addition to resources that were vital for Neolithic populations, such as salt and high-quality flint, metals were also crucial for the development of new technologies. The eastern and central parts of the Balkan Peninsula and the Carpathians to the north offer numerous deposits of native copper and copper oxide and copper sulfide minerals. Precious metals, particularly gold, are also present in the region.[6]

METALS BEFORE ANCIENT THRACE

The eastern and central Balkans became the cradle of European metallurgy,[7] with the earliest evidence of deliberate mining of oxide and sulfide copper ores. In the 1970s the archaeological sites of Ay Bunar (central Bulgaria) and Rudna Glava (eastern Serbia) were discovered: ancient open-pit mines that indicate large demographic potential, complex social organization, and a high level of professional specialization.[8] In addition to these and other sites with direct evidence of copper extraction during the fifth and fourth millennia BC, chemical and lead isotope analyses indicate that other regions also supplied the Chalcolithic economy of the Balkans with metal: the mountains in the eastern parts of Serbia and north Macedonia, as well as Sredna Gora, Strandzha, and the Balkan Range in Bulgaria.[9] Evidence of early copper metallurgy has recently been discovered at Akladi Cheiri, on the Bulgarian Black Sea coast, and at Belovode, in Serbia,[10] the latter suggesting that copper metallurgy emerged as early as the turn of the fifth millennium BC.

In this context it is notable that only a few centuries after the development of copper-smelting technology, gold was also added to the metallurgy of the Balkans, significantly predating the processing of gold in other regions, such as Iran, Egypt, Anatolia, and the Caucasus. The currently accepted dates of the famous Chalcolithic necropolis near Varna, on the Bulgarian Black Sea coast, belong to the second and third quarters of the fifth millennium BC.[11] The numerous gold finds from the necropolis reveal a spectacular

diversity and a high technological level of gold processing (fig. 1).[12]

The presence of the earliest known gold artifacts at Varna testifies to a complex society with significant demographic, economic, and technological potential. The Chalcolithic cultures of the eastern and central Balkans were short-lived. Climate change seems to be the most plausible explanation for their collapse at the turn of the fourth millennium BC, leading to a prolonged period of uncertainty and economic and demographic decline.[13] A major negative consequence was the loss of professional knowledge and skills related to metallurgy, leading to an almost complete absence of massive copper tools and gold ornaments in the fourth millennium BC.

Despite its premature end, this first stage of the metal-related economy in the Balkans set a model for the cyclicity that can be observed in later periods. Mining and metallurgy became a traditional segment of the economy, with peaks and troughs depending on longer periods of prosperity and population growth that created conditions for professional specialization. The natural riches of the region and its strategic location led to the recurrent re-creation of this model in the Middle and Late Bronze Ages, in the Classical and Hellenistic periods, then under the Roman and Byzantine Empires, and, still later, in Ottoman times.

The next boom in metallurgy in the eastern and central Balkans came millennia after the collapse of the Chalcolithic cultures. The fourth and the third millennia BC were nevertheless a period of rapid development of extraction and processing of metals in other parts of the ancient world, reflected in the emergence of leading civilizations in Egypt and Mesopotamia and later the Hittite kingdom of Anatolia and the Aegean civilizations. Central Europe, especially the Alps and Transylvania, and the Iberian Peninsula were among the regions in Europe that replaced the Balkans as generators of new technologies.

THE BRONZE AGE

The eastern parts of the Balkans saw a gradual penetration of new populations from the north Pontic region (the so-called Pit-Grave Culture), central Europe, and the north Aegean region over the late fourth and the entire third millennium BC. Although the nomadic groups that arrived from the north owned adornments of gold and silver, the number and the quality of these finds argue against a high level of technological mastery. Changes in the occupation of the landscape indicate a different economic model and a more mobile population, which was considerably smaller compared to the previous period.[14] The development of and subsequent improvements in bronze technology and the emergence of long-distance trade networks to provide the necessary raw materials brought considerable changes that also affected the Balkans.

Despite scholarly discussions as to whether the Bronze Age started as early as the late fourth millennium BC or later, about the middle of the third millennium BC, when tin bronze became widespread,[15] it was during the Early Bronze Age that the metal riches of the eastern Balkans were rediscovered. It did not happen overnight. For a long time the region was peripheral, receiving people and technologies from central Europe and the Aegeo-Anatolian world, and served as a thoroughfare for the mineral riches, primarily tin, from Transylvania, the western Carpathians, and the eastern Alps.

Significant changes occurred from the middle of the third millennium BC onward, when the lands of future Thrace again became a major source of materials for the metal-hungry world of the Bronze Age.[16] The second half of the millennium saw an increase in the importation of artifacts. Trading posts may have emerged along the so-called Great Caravan Route, which crossed Anatolia, entered Europe following the Maritsa River, and branched to reach the Lower Danube region, Transylvania, and central Europe.[17] These new developments turned Thrace into a vital part of the Aegeo-Anatolian cultural and economic sphere.[18]

The eastern Balkans were rich in copper, but the metal had lost the strategic importance it had in the fifth millennium, as in the meantime new deposits were detected and developed in various parts of Europe. The copper deposits in the region were primarily of local significance,[19] but there is evidence of exchange during the third millennium BC between the northern and eastern Balkans and the more developed Aegean cultures. Analyses of bronze artifacts from Tell Ezero, on the Thracian plain, indicate they were made of copper from the island of Kythnos and, in some cases, from deposits at Roşia Montană, Romania.[20] This is surprising, considering the existence of local copper deposits, including at Ay Bunar. Metal was extracted from the deposits in Strandzha and the eastern Rhodopes and was exported to the north Aegean coast (Dikili Tash and Sitagroi) and Thessaly (Sesklo and Petromagoula).[21]

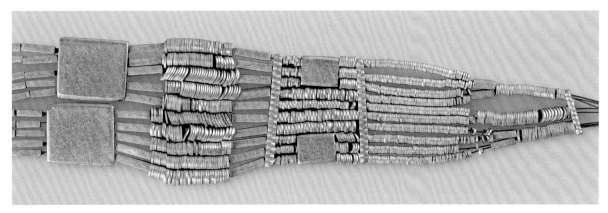

Figure 2. Gold necklace, late 3rd millennium BC (detail). Found in Feature 5 at Dabene, Plovdiv Province, Bulgaria. Sofia, National Historical Museum, 62481

In the later phases of the Early Bronze Age and during the Middle Bronze Age (ca. 2200/2100–1600/1500 BC), another metal gained priority over copper: gold. The Thracian plain was close to the rapidly developing cultures of western Anatolia (Troy) and the Aegean islands (Crete and the Cyclades). There is a high concentration of gold artifacts from this period from the valley of Maritsa,[22] some of them with exact parallels from Troy and Poliochni, on Lemnos.[23] The quantity and the diversity of finds indicate the existence of an Aegean gold-working koine that also included the lands to the south of the Balkan Range.[24] The eastern Rhodopes, Strandzha, and Sredna Gora were identified as sources of precious metals, and the region gradually emerged as a generator of innovation. The best example of this trend is a site near Dabene, in central Bulgaria (second half of the third millennium BC), that yielded complex gold adornments of unprecedented exquisiteness, testifying to the work of highly specialized workshops (fig. 2).[25] There have been similar finds from the western parts of Bulgaria.[26]

The eastern Balkans became a major source of metals for the Bronze Age economy, and a well-defined corridor emerged: from the Middle Danube and Transylvania, through the central and eastern parts of present-day northern Bulgaria, crossing the eastern portions of the Balkan Range and following the valleys of Maritsa and Tundzha on the Thracian plain, down to the north Aegean coast, where it joined the Mediterranean maritime network. During the second millennium BC, many regions along this route reveal a surge in the number of settlements with an increased demographic potential. There is evidence of human mobility in both directions, a good example being some of the gold adornments from Izvorovo

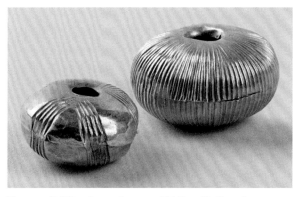

Figure 3. Gold beads, ca. 1600–1400 BC. Found in Tumulus 1 at Izvorovo, Haskovo Province, Bulgaria. Sofia, National Historical Museum, 55778, 55779

(ca. 1600–1400 BC), in southeastern Bulgaria (fig. 3), with good parallels from Minoan Crete, as well as imported ceramic vessels from Troy and the eastern Aegean islands.[27]

The sixteenth and fifteenth centuries BC added another element to the system of far-reaching economic contacts. The appearance of numerous weapons in Transylvania, the Carpathians, the Lower Danube region, and especially in the Thracian plain and the Rhodopes could be related to the rise of the Mycenaean civilization and its interest in the resources of the central and eastern Balkans.[28] It is revealing that the highest concentration of weapons identified as products of Mycenaean workshops or as influenced by them corresponds to the economic heyday of the Mycenaean kingdoms.[29] There are other, equally explicit testimonies to the inclusion of new partners from the southwest in the multicultural system of transregional contacts of the Balkans. Provenance studies have related the metal of some silver finds from the shaft graves in Mycenae to deposits near

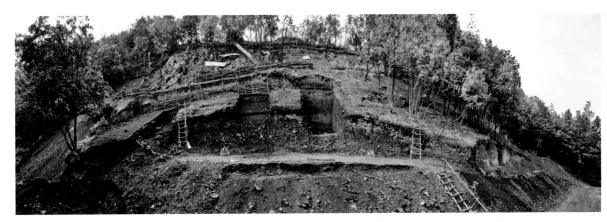

Figure 4. Late Bronze Age gold mine, ca. 1500–1400 BC. Ada Tepe, near Krumovgrad, Kardzhali Province, eastern Rhodopes, Bulgaria

Baia Mare and Roşia Montană, in Romania.[30] The clay analyses from the increasing number of finds of Mycenaean-type wheel-made pottery at archaeological sites in the Rhodopes point to Thessaly; the region of Volos, in western Greece; the Chalkidike; and the region of Troy and the nearby islands.[31]

The discovery of the gold mine at Ada Tepe, in the eastern Rhodopes, complements the picture (fig. 4).[32] Mining began around 1500 BC and continued for some two centuries, coinciding with the intensification of the exchange between Thrace and the Aegean. The imported goods from Ada Tepe (the marble pommel of a Mycenaean sword, fragments of wheel-made pottery) testify to the wide spectrum of contacts. Curiously, an indirect connection was traced between the area of Ada Tepe (from placer deposits, however) and one of the possible sources of gold used for the Valchitran Treasure, discovered in northern Bulgaria (cat. 1).[33]

Unlike in Anatolia and the Aegean, no early states formed in the Balkans, but there was a sustainable social model in which local communities controlled important communications and developed professional specialization, including in metalwork. These trends led to social and economic stratification and the emergence of Balkan elites. The appearance of symbolic weapons made of precious metal (like the gold daggers from Perşinari and Măcin, in Romania) and of precious-metal hoards (like Valchitran and many more) indicate the existence of elites that accumulated large quantities of precious metals and apparently controlled the resources and the technological means to produce them, from mining to finished products.[34] An indirect testimony to the large number and the diversity of the resources that were exploited is provided by the analyses of the composi-

tion of the Valchitran Treasure, indicating that gold from at least three different sources was used.[35]

Despite the decline in the number of Mycenaean imports after the fourteenth century BC,[36] the Balkan thoroughfare remained active. Present-day Bulgaria is the region in southeastern Europe with the highest concentration of oxhide copper ingots (cat. 2), emblematic of Late Bronze Age transregional trade (fig. 5).[37] Although they are all chance finds, their considerable number presents a paradox, given the

Figure 5. Oxhide copper ingots from southeastern and northeastern Bulgaria, ca. 1400–1200 BC. Kamenovo, Sliven Province, Bulgaria: Varna, Regional Historical Museum, 1.3772, 1.3773; Ruse, Ruse Province, Bulgaria: Ruse, Regional Historical Museum, IV 429; Cherkovo, Burgas Province, Bulgaria: Burgas, Regional Historical Museum, 2874; Chernozem, Yambol Province, Bulgaria: Elhovo, Ethnographical and Archaeological Museum, A–458

existence of copper deposits in the region. Some of them (Cherkovo, Elhovo, Yabalkovo) were found in the immediate hinterlands of the deposits in Strandzha and the eastern Rhodopes, providing grounds to hypothesize that they were made of local metal.[38] Archaeometric studies show unequivocally, however, that all oxhide ingots from Bulgaria are made of Cypriot copper.[39] They were hardly meant to meet local demand, but their presence along an important interregional corridor may suggest that they were symbolic gifts or tokens of prestige.

Communications in the eastern Mediterranean and the Aegean remained stable in the fourteenth and thirteenth centuries BC. A major archaeological discovery from that period, the Uluburun shipwreck, found near the coast of southwestern Turkey, yielded an interesting stone scepter that is typical of the eastern Balkans,[40] where it is interpreted as a symbol of high status.[41] More than ten are known from the Balkans, the only two exceptions coming from Uluburun and

Crete. In addition to the main cargo of copper and tin, the ship also carried gold and silver. In light of the new evidence from Ada Tepe and the archaeometric connections with various Balkan sources of precious metals, the question of the routes of distribution of these resources has become ever more timely.

Ada Tepe was not an exception but rather a model. Other ancient mines were identified in the eastern Rhodopes, some of them with materials from the Late Bronze and Early Iron Ages.[42] More evidence is available from the north Aegean region in present-day Greece, and early materials, preceding the Classical period, have been reported from Pangaion and the Chalkidike, other important centers of ancient mining.[43]

Contacts between the Lower Danube region and the western Carpathians and the eastern Alps remained active. Some of the highest concentrations of bronze objects in Late Bronze Age Thrace have been detected in areas without copper deposits, for example, in the central and eastern parts of present-

Figure 6. Hoard of molds for casting bronze weapons, tools, adornments, and status symbols, ca. 1400–1200 BC. Found in Pobit Kamak, Razgrad Province, Bulgaria. Sofia, National Archaeological Institute with Museum, and Razgrad, Regional History Museum

day northern Bulgaria and in southeastern Romania.[44] The former also yielded the largest hoard of molds in the Balkans, the one from Pobit Kamak (fig. 6), another spectacular testimony to highly developed metalworking.[45]

Despite the economic and demographic crisis of the so-called Dark Age (ca. 1200/1100–800 BC), which affected not only Greece and the eastern Mediterranean but also the Balkans, the specific social and professional model that had developed in local communities persisted during the period when the new iron technology was mastered.[46] Then contacts were resumed, and Greek colonists rediscovered Thrace as a major source of strategic raw materials. In the early written tradition, the eastern Balkans were again inhabited by people skilled in mining and metallurgy. In the *Iliad*, the Thracian king Rhesos is described as wearing extraordinary gold armor, and in the

Odyssey, Odysseus received gold and silver from the priest of Apollo in Ismaros, a city of the Kikones.[47]

Herodotus, Thucydides, and Xenophon also provide information about mining in Pangaion, the Thasian *peraia*, and the Rhodopes.[48] It is not accidental that the so-called tribal coinage emerged precisely in the region of Pangaion, in the lower Strymon, and in the northern parts of the Chalkidike (cats. 40, 41).[49] These relatively small communities controlled important resources and possessed the technological knowledge to exploit them. Ancient Thrace's sustainable model of having large portions of the population develop specialized professional skills was re-created with the formation of large states like the Odrysian and the Macedonian kingdoms and later in the Hellenistic kingdoms of the Diadochoi and the Epigonoi, in which control over metal resources became a mainstay of state policy.

1 Filov 1934b, 158–66.

2 Filov 1930–31, 45–46.

3 Boyadzhiev, Popov, and Chukalev 2018.

4 See Delev 2023, 15–27; Nikov 2023; H. Popov et al. 2023.

5 For an overview of the Neolithic and Chalcolithic periods in the eastern and central Balkans, see Krauss 2020.

6 On the metallogenic characteristics of the eastern portion of the Balkans and of the deposits of copper and precious metals, see Bogdanov 1987; G. Georgiev 1987; Pernicka et al. 1997; Milev et al. 2007; V. G. Georgiev 2012; K. L. Dimitrov and Stoychev 2018; K. L. Dimitrov 2020.

7 For an up-to-date overview of early mining and metallurgy in the Balkans in particular, see Ryndina 1971; Ryndina 1998; Chernykh 1992; Pernicka 2013; K. L. Dimitrov and Stoychev 2018; R. Kunze and Pernicka 2020.

8 Chernykh 1975; Chernykh 1978; Jovanović 1982; Jovanović 1995; Todorova 1999.

9 Pernicka et al. 1997; K. L. Dimitrov 2002; K. L. Dimitrov 2007.

10 Radivojević et al. 2010; P. Leshtakov 2013; Rehren, Leshtakov, and Penkova 2016; P. Leshtakov et al. 2020; Rehren, Penkova, and Pernicka 2020.

11 Higham et al. 2015; Krauss et al. 2017; Krauss 2020.

12 K. L. Dimitrov 2013; Leusch, Pernicka, and Armbruster 2014.

13 Todorova 1993; Suvandzhiev 2023.

14 K. Leshtakov 2006, 156.

15 See discussion in Alexandrov et al. 2018, 85–91; Nessel and Pernicka 2018, 133–39.

16 On the main raw materials and the long-distance contacts in the Bronze Age, see Harding 2013.

17 K. Leshtakov 2006, 207–8; K. Leshtakov 2007, 455–56; Alexandrov et al. 2018, 91; Vasileva and Minkov 2018, 98–99; Alexandrov 2020, 254–56.

18 Alexandrov 2020, 254.

19 Stos-Gale 2014, 205.

20 Stos-Gale and Băjenaru 2020, 271–73.

21 Krauss 2020, 55; Stos-Gale and Băjenaru 2020, 273.

22 Popescu and Oanţă-Marghitu 2018, 120–21, map 1; Vasileva and Minkov 2018, map 2; Alexandrov 2020, 259–60, maps 1–3.

23 Pavúk 2018, 271–78.

24 Laffineur 2008, 323; Vasileva and Minkov 2018, 100–101.

25 M. Hristov 2016; M. Hristov 2018.

26 Tsintsov 2005; Tsintsov 2018, 64–68, fig. 6.

27 Borislavov 2010; Borislavov 2018; Horejs and Jung 2018, 237–38.

28 For an overview, see Bonev 1988; K. Leshtakov 2009; Jung 2013; Jung 2018; Horejs and Jung 2018.

29 Jung 2018, 245–51, maps 1, 2.

30 Stos-Gale 2014, 199–205.

31 Bozhinova, Jung, and Mommsen 2013, 73–81; Jung et al. 2017, 282–92; H. Popov et al., forthcoming.

32 For an overview of the site, the mining technology, the long-distance contacts, and the possible routes of distribution, see H. Popov et al. 2015; H. Popov, Nikov, and Jockenhövel 2017; H. Popov 2018; H. Popov and Jockenhövel 2018; H. Popov et al., forthcoming.

33 Mehofer et al. 2024.

34 Horejs and Jung 2018, 237; Popescu and Oanţă-Marghitu 2018, 121; Stefanova 2018, 230–31; Vassileva 2018, 263; Popescu 2020, 232–41.

35 Pernicka 2018, 221–22, figs. 6, 7; Mehofer, Penkova, and Pernicka 2024.

36 Horejs and Jung 2018, 235; Jung 2018, 249–51.

37 K. Leshtakov 2007; Doncheva 2012; Athanassov et al. 2020.

38 K. Leshtakov 2007, 456.

39 Athanassov et al. 2020, 322–33, 342–43.

40 Pulak 1998, 219.

41 Vassileva 2018, 260–63, map 1.

42 H. Popov et al. 2011, 284–85; H. Popov and Jockenhövel 2018, 204–5, map 1; Iliev 2020, 1079.

43 Unger 1987; Vavelidis and Andreou 2008; Andreou and Vavelidis 2014.

44 Hristova 2018, 162, map 1.

45 For an overview, see Jockenhövel 2018; L. Leshtakov 2018a; L. Leshtakov 2018b; L. Leshtakov 2019.

46 For an overview, see Stoyanov and Borislavov 2018.

47 *Iliad* 10.434–40; *Odyssey* 9.201–4.

48 Herodotus, *Histories* 7.112; Thucydides, *History of the Peloponnesian War* 1.101, 4.105.1; Xenophon, *Hellenica* 5.2.17.

49 Delev 2014, 84–104.

ΚΑΙΑΛΛΑΙΩΣΡΑΣΥΝ
ΧΙΣΤΑΣΤΕΦΑΝΟΣΑΙΔΕΑΥΤΟΝΧΡΥ
ΦΑΝΟΙΙΕΥΕΙΕΤΑΝΕΟΡΤΑΤΑΣΠΟΛ
ΟΝΥΣΙΟΙΖΕΝΤΩΙΘΕΑΤΡΩΙΔΕΔΟΣΘΑΙΔΕΛ
ΤΟΙΚΑΙΕΚΓΟΝΟΙΣΠΟΛΙΤΕΙΑΝΚΑΙΠΡΟΞΕΝΙΑ
ΑΙΠΡΟΕΔΡΙΑΝΕΝΤΟΙΣΑΓΩΣΙΝΚΑΙΕΙΣΓ
ΑΙΕΚΠΛΟΥΝΑΣΥΛΕΙΚΑΙΑΣΠΟΝΔΕΙΣΤΕΦ
ΟΥΣΟΑΙΔΕΑΥΤΟΝΡΑΙΚΑΘΕΚΑΣΤΟΝΕΝΙΑ
ΟΝΣΤΕΦΑΝΩΙΣΤΑΤΗΡΩΝΠΕΝΤΗΚΟΝΤ
ΟΝΔΕΤΑΜΙΑΝΤΟΝΟΚΟΝΚΑΙΠΑΣΟΜΟΛΟ
ΡΑΨΑΝΤΑΕΙΣΣΤΑΛΑΝΛΙΘΙΝΑΝΚΑΙΑΓ
ΚΑΤΑΛΑΝΑΘΕΜΕΝΕΙΣΤΟΙΕΡΟΝΤΟΥΑΠΟΛ
ΝΟΣΠΑΡΑΤΑΣΣΕΤΑΛΑΣΤΩΜΠΡΟΓΟΝ
ΟΥΓΥΗΣΤΙΟΣΡΑΩΦΟΥΤΙΝΟΥΚΑΙΜΗΔΙ
ΑΙΚΟΤΥΟΣ

ΜΟΛΟΠΙΑΣΣΥΔΑΛΛΑΚΑΙΜΕΣΣΑΜΒΡΙΑΝ
ΙΤΙΝΕΣΕΚΛΑΚΕΠΙΕΝΤΙΜΕΣΑΜΒΡΙΑΝ
ΑΠΟΛΙΣΟΝΤΕΣΤΩΝΙ

GREEKS ON THRACIAN SHORES, WITH AN EMPHASIS ON THE BLACK SEA

MARGARIT DAMYANOV

Bordering the Aegean, Thrace had always been in contact with the ancient Mediterranean civilizations, but the process of interaction received a massive impetus from the foundation, from the early seventh century BC onward, of Greek settlements on its shores.[1] They served as active contact zones and entry points for goods, people, technology, skills, and ideas that found their way into the Thracian interior, gradually transforming its culture—to the extent that a few centuries later local rulers started issuing Greek-style decrees (in Greek), and one of them even commissioned a magnificent bronze statue of himself (cat. 53).

Our knowledge of Thrace during its heyday between the Late Archaic and the Hellenistic periods is also a direct result of so-called Greek colonization (the Greeks themselves termed their overseas settlements *apoikiai*). What little narrative evidence there is about pre-Roman Thrace comes from Greek authors. Some, like Thucydides and Xenophon, wrote from personal experience. The former possessed rights to gold mines on the north Aegean coast as well as an estate there, where he lived in exile,[2] while the latter served for a short period under the Thracian dynast Seuthes II in the hinterland of the Propontis (Sea of Marmara) and the Black Sea.[3] Others had to rely on local expertise, including Herodotus, who reported that he learned about Zalmoxis (a god of the Getai

and Thracians) from the "Greeks who lived beside the Hellespont and the Pontus."[4] This was probably true of his other Thracian stories as well, though not explicitly stated.

Although the literary sources tend to pay more attention to important individuals from mainland Greece who came to Thrace,[5] it was the rarely mentioned but undoubtedly far more numerous "colonial Greeks" who would have possessed the most intimate knowledge of the Thracians—people like Nymphodoros of Abdera, brother-in-law of the Odrysian king Sitalkes and clearly a man of influence,[6] or Herakleides of Maroneia, who was the right-hand man of Seuthes II.[7] These two were no exceptions, as Thasian and Maroneian traders regularly ventured into Thrace and even resided there, as we learn from the Pistiros (Vetren) Inscription (cat. 27), and the numerous graffiti with Greek names (and Thracian ones written in Greek) from that site as well as, at a later date, from Seuthopolis,[8] confirming the presence of Greeks deep in the Thracian interior.

Nymphodoros and Herakleides came from the north Aegean region, which is better illuminated by the literary tradition, starting with the Greek lyric poet Archilochos fighting the Thracians, as he describes in an elegy.[9] Other authors recount the difficulties of the Klazomenian founders of Abdera around 650 BC,[10] the Samians arriving as cohabitants (*synoikoi*) of

The Sadalas Decree (detail, cat. 26)

23

the Thracians on Samothrace,[11] the native Dolonkoi inviting Miltiades to the Thracian Chersonese in the mid-sixth century BC,[12] and the active involvement of the Edonoi in the Greek struggles for Amphipolis in 422 BC,[13] to mention just a few cases. These sources show that Greeks and a variety of Thracians were closely engaged in the region.[14] In some cases the written sources reveal the actual spatial proximity between the Greek cities and the seats of local power —the "tower" of Seuthes II was some ten kilometers from Perinthos, where he sold his booty,[15] as was the Edonian town of Myrkinos from Amphipolis.[16] These were distances easily covered that could also hold a variety of interactions between Greeks and Thracians— in fact, Myrkinos historically had a mixed population.[17]

Unlike this abundance of literary evidence (although it is more apparent than real), the history of the Thracian coast of the Black Sea suffers from the circumstance that few significant events in Greek history prior to the Hellenistic period reached beyond Byzantion, leaving the region in provincial obscurity. One can only mourn the loss of the work of Demetrios of Kallatis, another local Greek, who wrote *On Asia and Europe* in twenty books in the third century BC and was the source of the brief and sometimes ambiguous notes on the west Pontic cities in the geographer Pseudo-Skymnos's *Periodos to Nicomedes*.[18] Thus the question remains whether the situation in the north Aegean region was similar to that on Thrace's east coast.

Common sense and archaeology offer a positive answer, and the literary evidence seems to support it. For example, in the early fifth century BC, a woman from Istros married a native ruler; he was Scythian, not Thracian, but the practice of aristocratic intermarriage nonetheless existed.[19] The presence of presumably Thracian names, in combination with Greek ones, on tombstones from Apollonia Pontica suggests that intermarriage was not limited to the elite.[20]

Thucydides communicates that the Greek cities on the coast paid tribute to the Odrysians in the later fifth century BC.[21] I side with the view that the Apollonians named on the mid-fourth-century BC Pistiros Inscription came from Apollonia on the Black Sea,[22] as it was the only city on the Thracian coast that could compare in importance with Thasos and Maroneia, and it did maintain active relations with the interior.[23] The tombstone of an Apolloniates discovered at Vetren provides welcome archaeological support.[24] In the late fourth century BC, the Greek cities, led by Kallatis, joined forces with the local Thracians and Scythians against the Macedonian ruler Lysimachos.[25] Slightly earlier, the close relations of Kallatis with the Scythian king Ateas are illustrated by the coins the city struck for him.[26]

Several Hellenistic inscriptions from Istros reveal the complex coexistence of Greeks and Thracians. The honorary decree for the prominent citizen Agathokles relates how envoys were sent to Thracians (and others), ransoms and "protection money" were paid, and attacks were repelled.[27] Most significantly, there is a glimpse of the mechanisms that regulated the relationship between Greeks and Thracians, as "oaths and treaties" were sometimes breached by the latter. The same term for treaty (*homologia*) is used in the broadly contemporaneous inscription recording the dealings of Mesembria with a certain Sadalas, undoubtedly a Thracian, and the mention of the stelai of his ancestors in the city's archive suggests continuity with earlier times (cat. 26).[28]

Such interactions between Greeks and Thracians were not limited to the Hellenistic period and were not necessarily confined to the state level. Not on the Thracian coast but still on the Black Sea, private letters from Scythia reveal day-to-day dealings between Greeks and local populations already in the sixth century BC.[29] There is no need to think the situation was different in the west Pontic region. Agathokles's decree also notes the presence of "barbarians" in the city (where they sought refuge) willing to join forces with the Greeks in order to fight the encroaching Thracians. Presumably they were inhabitants of Istros's agricultural territory, which was under attack—and where Greeks and native people lived side by side. This evidence lends credibility to the idea that groups of mixed origin, most probably bilingual, could have existed in the contact zones around the Greek poleis—like the "mixed Greeks" in the vicinity of another west Pontic city, Dionysopolis.[30] This term finds good parallel in *mixhellenes*, the term used for people who inhabited the vicinity of Olbia, another Greek city on the Black Sea,[31] in the Hellenistic period, and suggests mixed ancestry, with a shade of "Hellenized barbarians."[32] Apparently, the "mixed Greeks" were significant enough to be listed among the populations in Pseudo-Skymnos's brief survey, which nonetheless was careful to put all Greek cities in a native context: Apollonia Pontica neighboring the Thracian Astika, Mesembria next to the Thracian Getika, the Krobyzoi around Odessos, Scythians to the north of Dionysopolis and as far north as Tomis (revealing the changes in the Hellenistic period).

One last touch could be added to the sketchy picture painted by the written evidence. Strabo explains that the original name of the city of Mesembria was Menebria, derived from the Thracian word for city, *bria*, and the name of its founder, Menas (fig. 7).[33] That this was a local tradition is confirmed by an epitaph from the Roman period (cat. 63).[34] Like other similar stories, it was most probably apocryphal,[35] but it well illustrates the acceptability of Thracian ancestry within a "colonial Greek" community.

Various factors pushed the first Ionian settlers to sail the dark waters of the Black Sea and seek their fortunes on its shores. One was the external pressure exerted by the Lydians on Ionia and in particular on Miletos, the main colonizer of the Pontic region.[36] The city lost its surrounding territories, and Herodotus is very specific about Lydian troops laying waste to the crops; the resulting hardships probably spurred the Milesian colonization. By the middle of the seventh century BC, sending away *apoikoi* was already an established practice in the Greek world, and the shores

of the Black Sea were among the few that remained vacant, possibly because of the waterway's reputation as the Inhospitable Sea (Pontos Axeinos) before the Ionians founded their settlements there and made it Hospitable (Euxeinos).[37] Although probably driven mostly by necessity, the settlers looked for more than land and took advantage of other opportunities as well.[38]

According to the written sources, the first Milesian settlements in the Black Sea were Istros, south of the Danube (657/656 BC), and Borysthenes, near the Dnieper-Bug estuary (647/646 BC).[39] A mid-seventh-century BC date for the first Greek artifacts in the region is confirmed by archaeological finds,[40] which also add to the picture the colony of Orgame, some twenty-five kilometers to the north of Istros, with material that actually predates the earliest finds from the latter (fig. 8).[41] A major discovery at Orgame is an early and very large burial mound, covering the remains of a funerary pyre, probably the grave of the settlement's *oikistes*, the leader of the first settlers.[42]

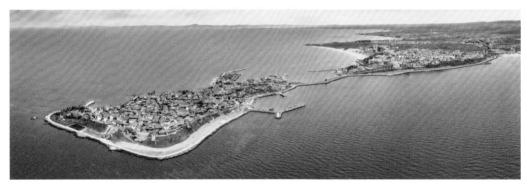

Figure 7. Aerial view of Nessebar (ancient Mesembria), Burgas Province, Bulgaria

Figure 8. Aerial view of Cape Doloşman in north Dobrudja, the site of the ancient Greek settlement Orgame, Tulcea County, Romania

Figure 9. View of the hills of Medni Rid (Copper Ridge), near Sozopol (ancient Apollonia Pontica), Burgas Province, Bulgaria

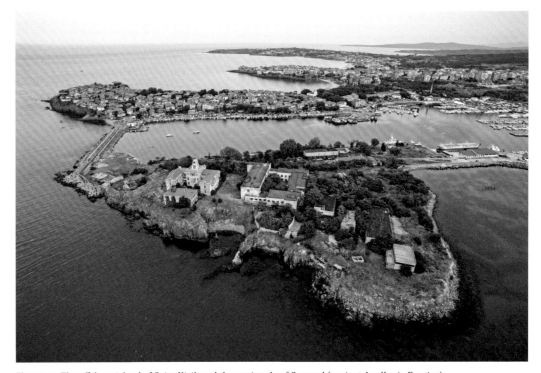

Figure 10. The offshore island of Saint Kirik and the peninsula of Sozopol (ancient Apollonia Pontica), Burgas Province, Bulgaria

The choice of these sites, hundreds of kilometers to the north of the Bosporus and past a number of places that would be occupied later, hints at the settlers' motivations. They sought flat areas suitable for agriculture near large rivers that offered an abundance of fish and other resources. Subsistence seems to have been a primary concern, while the absence of a settled native population at that time probably made it easier for the Greeks.[43] Early Greek imports deep in the forest steppe of present-day Ukraine indicate that the rivers could also serve as routes for communication and trade, but similar evidence is still lacking from the Thracian interior along the Istros (Danube) River.[44]

According to the traditional chronology, Apollonia Pontica was founded subsequently, in the late seventh century BC, providing a much-needed port of call on the way north, especially after the notoriously

dangerous coastal region of Salmydessos,[45] where local Thracians looted Greek ships as late as Xenophon's time.[46] Apollonia's important role as a safe harbor was probably reflected in the city's adoption of the anchor as the civic emblem for its coins. While the city did not command vast, fertile lands, it possessed other riches, above all the copper deposits in the nearby hills of Medni Rid (fig. 9). The evidence collected in recent years from various sites, including ancient mines and smelting facilities,[47] reveals that their exploitation probably started within the first generation of colonists and was an important factor for the city's prosperity in the Archaic period and beyond. This early access to metals suggests local knowledge, and imported goods in its hinterland confirm that Apollonia Pontica had already established close ties to the Thracians in the first decades of its existence.[48]

The first half of the sixth century BC witnessed the foundations of Odessos and Tomis, again by Milesians, and later in the century Dorian Mesembria was established. The foundation dates for other cities are less clear, including Kallatis, another Dorian city that may have been founded (or refounded) as late as the late fifth or early fourth century BC,[49] and Dionysopolis. It is very unfortunate that historical information is lacking, for these late foundations occurred under circumstances that differed significantly from those in the Archaic period, especially with regard to the changes in Thracian society.

Most Greek *apoikiai* were founded at sites that offered natural protection—peninsulas or promontories jutting into the sea, as at Istros, Orgame, Apollonia Pontica (where the city occupied a peninsula and the small offshore island of Saint Kirik; fig. 10), Tomis, and Mesembria. Such precautions were a typical practice of Greek colonization and do not necessarily imply a hostile situation. In fact, the earliest known city wall in the west Pontic region, discovered at Istros, dates only from the late sixth century BC, a century after its foundation.[50]

The initial contact with the native population is attested by fragments of handmade vessels of local shapes, which are invariably present in the earliest levels of all the Greek settlements in the region but best illustrated by Istros and Apollonia Pontica,[51] where they appear in modest numbers along with a profusion of East Greek fine ware and amphorae. While many scholars are reluctant to equate these finds with the actual presence of indigenous people,[52] the pottery does attest to interactions and exchange, and it is instructive that the share of local pottery appears to be larger in the peripheral settlements that emerged around the urban centers from an early date, shaping the agricultural territories of the poleis.

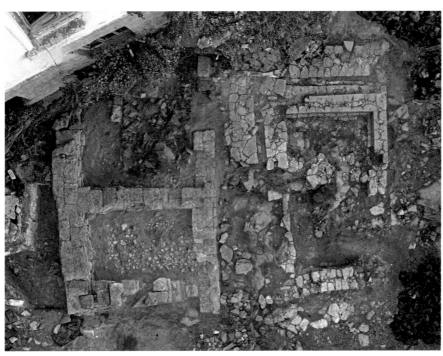

Figure 11. The remains of two temples, one Late Archaic and one Early Classical, on the island of Saint Kirik (ancient Apollonia Pontica), Burgas Province, Bulgaria

Around Istros, where the process is well studied,[53] the earliest such sites date from about 600 BC, and there the handmade fragments account for up to 10 to 15 percent of the assemblages.[54] While the formation of these economic zones could be related to the arrival of additional Greek settlers,[55] boosting the *apoikia*'s population, one cannot exclude the participation of local people, as suggested by later written sources (Agathokles's "barbarians").

The coarse handmade jars add to the overall impression of the humble beginnings of the west Pontic Greek settlements. The Archaic houses were small and primitive, with one or two rooms,[56] and some of the inhabitants of the countryside lived in dugout houses that were also typical of the earliest Greek settlements in the north Pontic region.[57] It took a few generations for the communities to gain strength. The first stone structures were built in the sacred precincts of the cities about a century after their foundation: three temples were erected in Istros just after the middle of the sixth century BC,[58] and another two in Apollonia Pontica in the late sixth and early fifth centuries BC (fig. 11).[59] These were modest structures— the temples themselves measuring up to fifteen by eight meters—but they followed closely Ionian architectural fashion and were an important step in the transformation of the early *apoikiai* into full-fledged cities. Early in the Classical period, a more extravagant display of civic pride in Apollonia Pontica took the form of a thirteen-meter-high bronze colossus of the eponymous deity Apollo by the sculptor Kalamis (fig. 12).[60] By the Classical and Hellenistic periods, the

Figure 12. Tetradrachm, Greek, 2nd century BC. Minted at Apollonia Pontica. Obverse: Laureate head of Apollo right. Reverse: Apollo standing on a low base, head left, holding in right hand a laurel branch on which a bird is perched, bow and two arrows in left hand; the inscriptions IATPOY to left, ΑΠΟΛΛΩΝΟΣ to right, ΑΘ-Η flanking Apollo's feet

appearance of the west Pontic colonies hardly differed from that of any other Greek city.

For the political situation in overseas Greek societies, one must rely on Aristotle's mentions of oligarchy in Istros and Apollonia Pontica,[61] presumably in the Archaic period (and later abolished), illustrated by the aristocratic image from Apollonia Pontica of a man named Deines, "the noblest of citizens" (cat. 21).[62] Considerably later, Hellenistic inscriptions provide evidence for ubiquitous and conventional democratic constitutions, although prominent individuals like Agathokles were declared "benefactors" and played an outsize role in society.

Cemeteries offer further evidence that requires careful interpretation. For example, at Istros, a group of Archaic tumuli built over funerary pyres has been the subject of decades-long controversy because of the presence of human and animal remains,[63] recognized as sacrifices. Initially considered Thracian and thought to reveal the mixed character of the necropolis,[64] the burials were later reinterpreted convincingly as illustrating an aristocratic Greek practice that emulated the Homeric epics.[65] The extensively excavated Classical-period necropolis of Apollonia Pontica revealed a cemetery of entirely Greek type,[66] however, while the Thracian surroundings remain almost undetectable.[67] Nonetheless, the funerary sphere could reflect changes in the cultural and historical setting of the Greek cities. A telling example is the appearance of Early Hellenistic barrel-vaulted (or "Macedonian") tombs around Odessos and Kallatis, where the written sources place most of the activity of Lysimachos after the west Pontic region was incorporated into his domain at some point shortly before 313 BC.[68]

It is worth noting that in 313 BC Lysimachos had to fight a coalition of Greeks and Thracians (as well as Scythians), reminding us again of the contact zone created by the Greek settlers and how it changed Thrace. This process, however, worked in both directions: the Greek cities became embedded in the fabric of local Thracian society, acting as connective tissue to the classical world. Striking visual testimonies to this intersection are the red-figure jugs decorated with Thracian warriors created in an Attic workshop, possibly as a special commission for local clientele, Greek and Thracian, in Apollonia Pontica and its hinterland (cats. 16, 17).[69]

1 This short essay does not aim to be an exhaustive overview of the Greek colonization in Thrace or along its Black Sea coast. The north Aegean region is discussed in detail in, among others, Isaac 1986, 1–214; Tiverios 2008; Vlassopoulos 2013, 119–28; Damyanov 2015b, 297–301, Tsiafaki 2020; see also the relevant chapters in Hansen and Nielsen 2004. For the Pontic region, see Isaac 1986, 237–80; Avram 1996; Avram, Hind, and Tsetskhladze 2004, 931–41; Oppermann 2004. On Greek-Thracian relations, see Damyanov 2015b, 301–4; Damyanov 2018.

2 Thucydides, *History of the Peloponnesian War* 4.105.1; Sears 2013, 87–89.

3 Xenophon, *Anabasis* 7.2–3.

4 Herodotus, *Histories* 4.93–96.

5 Delev 2002.

6 Thucydides, *History of the Peloponnesian War* 2.29.

7 Xenophon, *Anabasis* 7.3–6.

8 D. Dana 2015, 247–48.

9 Archilochos, frag. 5 *West*.

10 Herodotus, *Histories* 1.168.

11 Pseudo-Scymnos, *Periodos to Nicomedes* 690–95.

12 Herodotus, *Histories* 6.34–40.

13 Thucydides, *History of the Peloponnesian War* 4.107, 5.6.

14 Herodotus, *Histories* 7.110.

15 Xenophon, *Anabasis* 4.1, 7.2.17.

16 Thucydides, *History of the Peloponnesian War* 4.107.3, 5.6.4, 5.10.9.

17 Herodotus, *Histories* 5.23.2.

18 Pseudo-Scymnos, *Periodos to Nicomedes* 718–20; Boshnakov 2004, 79–91.

19 Herodotus, *Histories* 4.78.

20 *IGBulg*. I², 430, 438, 440, 441.

21 Thucydides, *History of the Peloponnesian War* 2.97.3.

22 Pro: Loukopoulou 1999, 371; O. Picard 1999, 340–41; Salviat 1999, 260–61. Contra: Velkov and Domaradzka 1994, 13; Bravo and Chankowski 1999, 286; Chankowski and Domaradzka 1999, 253; Demetriou 2012, 182.

23 Damyanov and Panayotova 2020, 273–74.

24 Velkov and Domaradzka 1994, 7.

25 Diodorus Siculus, *Bibliotheca historica* 19.73.1–10.

26 Stolyarik 2001, 22–27.

27 *ISM* I, 15.

28 *IGBulg*. I², 307.

29 M. Dana 2021.

30 Pseudo-Scymnos, *Periodos to Nicomedes* 756–57; Damyanov 2003, 258–60.

31 *Syll.*³, 495; Damyanov 2003, 256–58.

32 Casevitz 2001.

33 Strabo, *Geography* 7.6.1.

34 *IGBulg*. I², 345.

35 Nawotka 1994.

36 Herodotus, *Histories* 1.14–19.

37 Strabo, *Geography* 7.3.6.

38 Doonan 2006, 53–55.

39 Eusebius, *Chronological Canons* 95b.

40 Kerschner 2006; Buiskikh 2016.

41 Mănucu-Adameşteanu 2008, nos. 1, 2; Dupont and Lungu 2021.

42 Lungu 2000–2001.

43 Avram 2007, 487–89.

44 Vachtina 2007.

45 Isaac 1986, 239–40.

46 Xenophon, *Anabasis* 7.12–13.

47 Damyanov and Panayotova 2020, 254–59, figs. 12, 16.

48 Bozkova and Nikov 2009, 49; Tzochev 2011a; Nikov 2012, 151–52.

49 Bîrzescu and Ionescu 2016.

50 Avram 2003, 281–82.

51 Istros: Dimitriu 1966, 54–56, plates 65–67. Apollonia Pontica: Damyanov 2018, 251, fig. 3; Damyanov and Panayotova 2020, 272, fig. 33.

52 Bîrzescu 2012, 82.

53 Avram 1990; Avram 2007.

54 Avram 2007, 490.

55 Avram 2012, 198–207.

56 Dimitriu 1966, 32–37.

57 Bîrzescu 2012, 84–88.

58 Avram 2003, 319–22; Alexandrescu 2005, 70–85.

59 D. Stoyanova and Damyanov 2021.

60 Pliny, *Natural History* 4.92, 34.39; Strabo 7.6.1.

61 Aristotle, *Politics* 5.6, 1305b–1306a.

62 Petrova 2015, 166–68.

63 Alexandrescu 1966, tumuli XII, XVII, XIX.

64 Alexandrescu and Eftimie 1959; Boardman 1980, 248–49.

65 Alexandrescu 1994.

66 Venedikov 1963; Hermary et al. 2010.

67 Damyanov 2018, 257–58.

68 Damyanov, Nankov, and Stoyanova 2021, 113–17, figs. 1, 2.

69 Lezzi-Hafter 1997, 359–65.

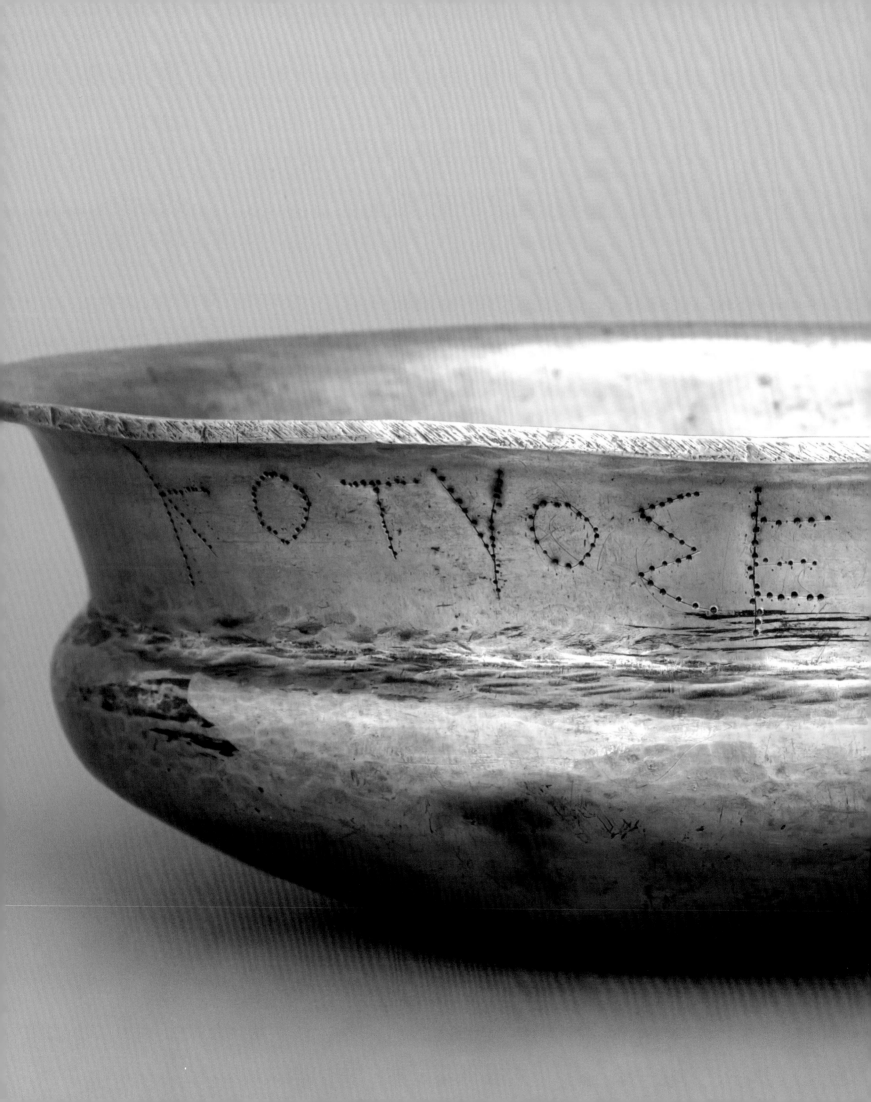

THE POLITICAL HISTORY OF THRACE FROM THE PERSIAN CONQUEST TO THE END OF THE ODRYSIAN KINGDOM
513–340 BC

JULIA TZVETKOVA

The later sixth century BC saw a new political situation in the eastern Mediterranean with the rise of the Achaemenid Persian Empire, its expansion beyond the Hellespont, and ultimately the Greco-Persian Wars. The Persian invasion played a key role in the major sociopolitical changes in the tribal communities of Thrace that led to the emergence of the Odrysian kingdom.[1] Unfortunately, these important times in the history of Thrace are very poorly illuminated in the accounts of the ancient authors. Since the Thracians did not produce their own narratives, Greek and Roman authors remain our main source of information for the reconstruction of past events in these lands. The narratives, however, are usually scarce and sometimes provide the biased and one-sided picture of a foreign observer. This is the reason Thracian studies also rely widely on data from various other media: epigraphic documents, numismatic evidence, and the archaeological record, the last being the most authentic record of the Thracians.

TRIBAL POLICIES

The political situation in the Thracian lands before the Persian expansion was quite varied and leaves an impression of instability. Ancient literary sources like Herodotus consistently pointed out the numerous-ness of the Thracians and the diversity of the Thracian *ethnē*, or tribes,[2] as usually translated in modern literature.[3] Ancient authors display some knowledge of the circumstances in inland Thrace after the establishment of Greek colonies on the shores of the Aegean and Black Seas in the Archaic period (eighth to sixth century BC), but the first overviews of Thracian society are not found until the Roman era, when Strabo and Pliny the Elder mention the number of tribes as twenty-two and fifty, respectively.[4] In fact, the number of Thracian ethnonyms (tribal names) attested in various narratives is larger. Modern studies count more than fifty tribal names in southwestern Thrace alone mentioned in various sources from the Classical period to Roman times.[5] Of course, not all of them coexisted, and some are unique attestations. This lack of reliable information presents problems for the study of the organization and social dynamics of the Thracian tribes. Social anthropology generally posits various stages of hierarchy within the Thracian tribes over time, however, with an evolution from a simple patriarchal structure to developed chiefdoms but few true hereditary kingdoms. This assessment is widely accepted by current scholars.[6]

The beginning of the Classical era finds the lands between the Istros (Danube) River to the north and the Aegean Sea to the south divided among several Thracian tribes. Most frequently referred to in literary

Phiale (detail, cat. 51c)

sources were those who came into contact—commercial, economic, or military—with the Greeks, and these were obviously the more active and organized communities. The accounts of the three great historians of the fifth century BC—Herodotus, Thucydides, and Xenophon—note the following major tribes: the Triballoi, occupying northwestern Thrace; the Getai to the northeast; the Edonoi to the southwest, east of the Strymon River; the Thynoi to the southeast; and the Odrysai in inner Thrace.

With the exception of the Thynoi, the tribes each had a king (*basileus*) at some point in their historical development. An explicit example of such a *basileus* was Getas, the king of the Edonoi, who is known only from his coins. He minted silver octadrachms bearing the inscription "Getas, King of the Edonoi" in the mid-460s BC (cat. 41). This remarkable formula, unknown elsewhere in ancient coinage prior to Early Hellenistic times, attests to the high esteem of his royal title.[7] Getas and his troops were likely responsible for the annihilation of the ten thousand Athenian colonists slaughtered at Drabeskos, in southwestern Thrace, in 465 BC.[8]

The coins of the Edonoi are just one manifestation of a widespread phenomenon in southwestern Thrace in the early fifth century BC of tribes issuing coinage, notably large-denomination octadrachms. Some bore the names of individual tribes—including the Derrones, Oreskioi, Edonoi, Bisaltai (cat. 40), Ichnai, Laiaioi, and Tyntenoi—while others were anonymous. Many examples were included in coin hoards uncovered in the territories of the Persian Empire, especially Egypt and Syria. Whatever the purpose of this coinage—either for paying taxes or for trade—most scholars regard the Persian presence in Europe as the trigger for these economic developments.[9] The issuance of such coinage also demonstrates the presence of local authorities. Nevertheless, it seems that neither the coinage nor the authorities lasted much later than the mid-fifth century BC.

While the ancient Greeks were somewhat acquainted with Aegean Thrace and the immediate neighboring regions, the northern areas remained largely unknown. It was Herodotus who first provided specific information on these lands in his account of the Scythian expedition of the Achaemenid king Darius I. In 513 BC this Great King undertook a campaign against the Scythians who lived north of the Istros River, crossing the straits at Byzantion and marching through eastern Thrace. This was the first time that a Persian army set foot on European soil.

Herodotus's account of the campaign is of considerable value because it provides the first description of the local tribes—the Thracians from Salmydessos, the Skyrmiadai, the Nipsaioi, and the Getai—who were subjugated by Darius.[10] None deserved more attention in the Herodotean text than the Getai, who resisted the Persian army, while the others surrendered without a fight.

Modern historians have attempted to reconstruct the chronology and history of events, as well as Darius's route through eastern Thrace and the location of the tribes mentioned by Herodotus with inadequate evidence.[11] It was the tribe of the Odrysai (or Odrysians) who come first in the report of Herodotus,[12] although very briefly, as a group who inhabited territories along the Arteskos River. This passing mention has been widely used to localize the original homelands of the Odrysians.[13] If we rely solely on Herodotus, however, we are facing two unknowns: the identification of the Arteskos River, which remains uncertain, and the location of the core Odrysian territory. By the time of the ancient historian, that was obviously not the situation, so Herodotus was most likely trying to explain to his public the location of the unknown river Arteskos by referencing something more recognizable in the mid-fifth century BC—the Odrysian lands.[14]

The archaeological discoveries over the last thirty years provide new information that helps place the Odrysian tribal territory inland in western Thrace, along the upper flow of the Hebros River.[15] This geographic isolation, far from the center of historical events, might be the reason the Odrysians came late into the light of the ancient sources.

Who were the Odrysians, and why are they so special? Except for one brief reference, Herodotus does not discuss them again, leaving the impression that they were an insignificant tribe, one of many mentioned. His summary of the political situation in Thrace highlights explicitly the lack of unity or a common ruling authority among the Thracians, expressing his doubts that they would be able to overcome this at all.[16] This view, however, contradicts the text of Thucydides, who provides just the opposite picture, stating that the Odrysians under their king Teres had established a great kingdom over a large portion of Thrace.[17] It must be that Herodotus's information about Thrace reflects different chronological periods and that his claims regarding the lack of any political power belong to an earlier stage, before the emergence of Teres and the great Odrysian kingdom.[18]

THE ODRYSIAN KINGDOM

The dynamics of political development among the Thracian tribes in the Late Archaic period provided the necessary prerequisites for the emergence of the Odrysian kingdom, although its early history is obscure. The most knowledgeable author is Thucydides, who, as an eyewitness to the Peloponnesian War, gathered valuable information on contemporaneous events in the Odrysian kingdom, as well as some recollections of the earlier periods. Further historical information is derived from testimonia scattered among other ancient authors, which has allowed scholars to reconstruct tentatively the chronology of the Odrysian kings. The history can be divided into two periods: the early kings, who ruled until the end of the Peloponnesian War, and the later ones down to the time of the Macedonian conquest. The periods correspond roughly to the fifth and fourth centuries BC, respectively.

According to the account of Thucydides, Teres was the first who extended the power of the Odrysians over most of the Thracian lands.[19] He is conceived as the founder of the great Odrysian realm as well as of the ruling royal house. The precise dating of his activity is controversial. Two main hypotheses have been proposed, both of which link his rise to power to the Persian campaigns in Europe: the traditionally accepted date is around 480 BC, after Xerxes's retreat, or an earlier date, at the end of the sixth century BC, after Darius's Scythian campaign of around 513 BC.[20] The latter sounds more plausible, considering the political turbulence Darius's invasion provoked, including the defeat of the Getai. There is also evidence of the political activities of Teres in the eastern parts of Thrace. Herodotus relates that a daughter of Teres was married to the Scythian king Ariapeithes,[21] obviously a royal marriage for settling the borders in northeastern Thrace, where the Odrysians overran the Getic territories. Xenophon tells of military campaigns by Teres against the Thynoi in southeastern Thrace.[22] It is highly likely that Teres took advantage of the political vacuum created by the Persian retreat and asserted his power over these lands.

Athens's attitude toward the Odrysian expansion is uncertain. The Greek poleis on the Aegean and Propontic coasts were members of the Delian League, probably from its very beginning in 478/477 BC, and an intersection of the political interests of Athens and the Odrysians is to be expected. Unfortunately, there is no clear evidence, but one can speculate that Teres

was known in Athens, though not with a good reputation. Indirect evidence for this is Thucydides, who attempts to clarify the difference between this Teres and the mythological Thracian king Tereus, known for his cruelty and apparently associated by some Athenians with the historical Odrysian king because of the similar-sounding names.[23]

The circumstances of the end of Teres's rule are also unclear. By 431 BC his son Sitalkes was already in power.[24] The old school in Thracology suggested that Teres also had an older son, Sparadokos, who ruled prior to Sitalkes. The assumed kinship is based on Thucydides's account, in which Sparadokos is introduced as the father of Seuthes, the nephew and successor of Sitalkes.[25] Unlike Teres and Sitalkes, Sparadokos minted coins in his own name and with images similar to those on the coins of Olynthos, in the Chalkidike, and the Macedonian kingdom (cat. 42).[26] This enigmatic figure raises many questions: How should we date his coinage? Where was the mint? What was his political status? If he was a king, why is he not mentioned by Thucydides as such? A reevaluation of the established view questions the kinship of Sparadokos and suggests he was the brother-in-law of Sitalkes, son-in-law of Teres, married to his daughter.[27] This assumption explains his exclusion from the Odrysian kings' list and suggests that he might have been a powerful dynast in southwestern Thrace in the 450s to 440s BC, someone important for Teres to have as a political ally.

The reign of Sitalkes, the son of Teres, was considered by the later Greek historian Diodorus Siculus to be the most successful period of Odrysian rule.[28] Diodorus does not spare superlatives in describing this Odrysian king as a courageous and wise man, a brave soldier, a skillful general, and an equitable governor of his lands. The contemporary historian Thucydides is more restrained in his characterization, although the general impression he conveys of Sitalkes's rule is the same. The combined picture from the literary sources provides clearer testimonies to trace his policy. Scholars tend to date his rise to power to the 450s BC.[29] The diplomatic resolution of political tensions with the Scythians to the north should be dated to the early years of his reign,[30] as should a reported military campaign to the west against the Paionians.[31] The extension of Odrysian power toward the Greek poleis on the Aegean coast also belongs to this period. We learn from Thucydides that Sitalkes was married to a woman from Abdera, the sister of Nymphodoros,[32] which was certainly

part of the political strategy of the Odrysian kings for cementing alliances and securing their borders.[33]

The first firmly dated political activity of the Odrysians is the alliance with the Athenians in 431 BC, at the beginning of the Peloponnesian War. With the help of Nymphodoros of Abdera, who was declared in Athens as *proxenos* (advocate for the Athenian interests), the polis made an alliance not only with Sitalkes but also with the Macedonian king Perdikkas II. The benefit for the Odrysians was Athenian citizenship for Sitalkes's son Sadokos. This was a highly esteemed position for a non-Greek person and allowed him, at least in theory, to take part in the political life of Athens with all resulting rights and duties. Sadokos probably took his duties too seriously: in the following year—430 BC—we see him involved in the diplomatic plot against the Spartan envoys who visited the Odrysian court on their way to Persia and tried to convince Sitalkes to abandon his alliance with Athens. Sadokos delivered them to the Athenians, who subsequently put them to death.[34] Herodotus's version of the story states that Sitalkes was the one who betrayed the Spartans.[35] He was probably perceived as the supreme royal power and ultimately responsible for the events in the territories under his control. That extreme pro-Athenian action, however, was perhaps not the envisaged policy of the Odrysian *basileus*, who was trying to be more diplomatic. In any case, after those events, Sadokos disappears from the literary sources.

In 429 BC Sitalkes, with an army of about 150,000 infantry and cavalry, invaded the Macedonian kingdom and the poleis in the Chalkidike.[36] The detailed description in Thucydides remains, however, imprecise when it comes to describing the reasons why Perdikkas II was the target. Sitalkes was clearly trying to intervene in the internal affairs of the Macedonian court, where dynastic struggles led a brother of Perdikkas II to flee to the Odrysians. Subsequently an agreement was reached between Sitalkes and Perdikkas, but the Macedonian was obviously reluctant to fulfill his part, which was the *casus belli* for the Odrysians. Thucydides's and Diodorus's accounts differ in some details when evaluating the impact of Sitalkes's campaign,[37] although they are unanimous as to the results—after thirty days of military action, Sitalkes was advised by his nephew Seuthes, who next to him had the greatest authority, to make a treaty with the Macedonians, which was cemented with the marriage of Seuthes to Perdikkas's sister. The effectiveness of the treaty was evident, as we do not learn about

any kind of complications in Macedonian-Odrysian relations again until the time of Philip II.

The last enterprise of Sitalkes was the unsuccessful military campaign against the Triballoi in northwestern Thrace in 424 BC, in which he was defeated.[38] In saying that Sitalkes died the same year, Thucydides leaves the impression that the king was killed in the battle, although this is not explicitly stated and may be only a contemporaneous event.

The son of Sparadokos, Seuthes I, became the new king of the Odrysians and the rest of the Thracians under their control (cat. 43). The year 424 BC is the only one in the entire history of the Odrysian kingdom in which a clearly dated transfer of power occurred. Very little is known, however, about Seuthes's policies. In the beginning he probably maintained the diplomatic course of Sitalkes, though in the last phase of the Peloponnesian War, he shifted to hostile actions against Athens in the Thracian Chersonese (the present-day Gallipoli Peninsula). During his reign, crises may already be observed: the tribes in southeastern Thrace revolted, and the Getai gained their autonomy as well.[39]

Seuthes I is the last certain descendant of the royal house of Teres, while for the later kings this is not explicitly stated. These three generations of the ruling dynasty made up the kingdom of the fifth century BC. In its heyday the Odrysian borders included the territories from Abdera to the Istros River and from Byzantion to the upper Strymon River.[40] Thucydides speaks about the existence of a well-established aristocratic elite, which was integrated into the power structure of the kingdom.[41] A specific taxation system was also present, distinguishing the Greek poleis from the "barbarian lands," that is, the Thracian tribes under Odrysian rule. This allowed the Odrysian kingdom to collect about four hundred talents of silver annually, thus becoming the most prosperous among all the polities in Europe.[42] Still uncertain is the location of the royal residence; although a number of important archaeological sites have been studied in recent years— including Adzhiyska Vodenitsa (identified as the *emporion* Pistiros), Vasil Levski, Kozi Gramadi, Krastevich, Karaevlialtı (ancient Heraion Teichos), among others[43]—none of them can unambiguously be identified as the capital of the realm.

The fourth century BC brought about significant political changes in the eastern Mediterranean world, marked by political instability and a lack of a central military power after the end of the Peloponnesian War.

The first half of the fourth century BC was a time of instability for the Odrysian kingdom as well. The isolated mentions in the ancient narratives do not allow us to establish a secure chronology of the named rulers or their dynastic relations to the house of Teres. Ancient written sources report the names of a number of rulers over the next fifty years: Medokos, Seuthes II, Amadokos I, Hebryzelmis, Kotys, and Kersebleptes, as well as Berisades, Ketriporis, Amadokos II, and Teres II, who emerged after Kotys's death as the rulers of regions of the divided kingdom until the Macedonian conquest. The chronology and interpretation of their political presence pose many historical problems. Similar-sounding names sometimes raise the question of whether we are dealing with one person or two different people. Multiple kings appear to have been ruling at the same time, suggesting that there were two parallel royal branches of the Odrysian kingdom.[44] The realm, confined to the territories south of the Haimos Mountains, was divided into two parts: the internal region along the upper Hebros River and the coastal area in southeastern Thrace. At least this is the impression conveyed by Xenophon, who had the chance to serve in the court of Seuthes II as a mercenary during the winter of 399 BC, helping the king regain his father's lands in the territories of the Thynoi in southeastern Thrace. Seuthes II, son of Maesades, was at that time subordinated to the then-king Medokos, called "king of the interior,"[45] in a region situated twelve days' journey from the sea.[46]

Odrysian political policy in the fourth century BC entailed a strategic shift toward southeastern Thrace. The importance of this region became clearer during the reign of the last powerful Odrysian king, Kotys I (384/383–360 BC). Ancient sources describe him as terrible, cruel, and arrogant, although behind these claims one should see the energetic actions of an ambitious ruler attempting to strengthen and unite his kingdom (cat. 45). With his centralizing policy he led the Odrysian realm to its last rise before the Macedonian conquest. The early years of his reign are poorly documented, probably because he was consolidating his power in the interior lands. Plots against Kotys mentioned by historians testify to the presence of internal opposition, which the king managed to overcome.[47] Kotys's military activities took place mostly east of the Hebros River, with a special focus on the Thracian Chersonese, where he threatened Athenian interests. This situation escalated to a violent conflict in 365–360 BC, the so-called War over the Chersonese in modern historiography.[48] In the beginning Kotys was probably acting not alone but as part of a joint operation by land and sea led by Autophradates, the Persian satrap of Lydia, in Asia Minor, and Mausolos of Caria against the rebellious Ariobarzanes, the Persian satrap of Phrygia, during the Great Satraps' Revolt against the Persian king Artaxerxes II.[49] In the second phase, 363/362–360 BC, targets of his raids were the Athenian strongholds on the peninsula, which surrendered one by one. This direct threat led some to assume that Athens may have organized the assassination of Kotys in 360 BC by two brothers from Ainos.[50]

Whatever the motives or whoever the beneficiaries were, the murder of Kotys deprived Thrace of its last chance to build a strong union. The turbulant events after his death led to serious changes and to the establishment of three independent rulers who arose in shattered parts of the great kingdom of Kotys: his son Kersebleptes, Berisades (who was succeeded by his son Ketriporis), and Amadokos II (who was succeeded by Teres II). Divided and weak, the kingdom was not able to resist the Macedonian army of Philip II and fell to him in 340 BC.

1 Zahrnt 2015, 37.

2 Herodotus, *Histories* 5.3.

3 See Delev 2014, 470; Graninger 2015.

4 Strabo, *Geography* 7 frag. 48; Pliny the Elder, *Natural History* 4.40–41.

5 Delev 2014.

6 Delev 2014, 470.

7 Tzamalis 2012, 521.

8 Delev 2014, 300, 483.

9 Price 1987; Tzamalis 2012; Delev 2014, 478.

10 Herodotus, *Histories* 4.93–94.

11 On the chronology of Darius's campaign, with extensive references to modern studies on the subject, see Boteva-Boyanova 2011, 738nn14–16; Zahrnt 2015; Boteva-Boyanova 2021.

12 Herodotus, *Histories* 4.92.1.

13 See the discussion in Boteva-Boyanova 2011, 740n29.

14 Boteva-Boyanova 2011, 740, 740n28.

15 Boteva-Boyanova 2011, 740.

16 Herodotus, *Histories* 5.3.

17 Thucydides, *History of the Peloponnesian War* 2.29.2.

18 Delev 2005.

19 Thucydides, *History of the Peloponnesian War* 2.29.2.

20 See the discussion in Boteva-Boyanova 2011, 749n74.

21 Herodotus, *Histories* 4.80.

22 Xenophon, *Anabasis* 7.2.22, 7.5.1.

23 Thucydides, *History of the Peloponnesian War* 2.29.3–4.

24 Thucydides, *History of the Peloponnesian War* 2.29.2.

25 Thucydides, *History of the Peloponnesian War* 2.101.5, 4.101.5.

26 On the coinage of Sparadokos, its dating, and its localization, see Tacheva 1992; Peter 1997, 62–75; Psoma 2002.

27 Kotova 2013a; Kotova 2023.

28 Diodorus Siculus, *Bibliotheca historica* 12.50.1.

29 See the arguments in Boteva-Boyanova 2011, 753n100.

30 Herodotus, *Histories* 4.80.

31 Thucydides, *History of the Peloponnesian War* 2.98.1.

32 Thucydides, *History of the Peloponnesian War* 2.29.1.

33 On this subject, see Kotova 2013b, 58, 255.

34 Thucydides, *History of the Peloponnesian War* 2.67.

35 Herodotus, *Histories* 7.137.

36 Thucydides, *History of the Peloponnesian War* 2.95–101.

37 Thucydides, *History of the Peloponnesian War* 2.95–101; Diodorus Siculus, *Bibliotheca historica* 12.50–51.

38 Thucydides, *History of the Peloponnesian War* 4.101.5.

39 Xenophon, *Anabasis* 7.2.32; Polyaenus, *Strategems* 7, 38.

40 Thucydides, *History of the Peloponnesian War* 2.97.

41 Thucydides (*History of the Peloponnesian War* 2.97.3) distinguishes three levels of aristocratic elite: the king, the corulers, usually described with the very contro-versial term "paradynasts" in modern historiography (see discussion in Tzvetkova 2016), and the noble Odrysians.

42 Thucydides, *History of the Peloponnesian War* 2.97.3.

43 An overview is offered in H. Popov 2017.

44 See in Tacheva 2006, 118n6.

45 Xenophon, *Anabasis* 7.7.3.

46 Xenophon, *Anabasis* 7.3.13. On the location of Medokos's residence, see Tzvetkova 2018a, 108–14, fig. 12.

47 Aristotle, *Politics* 5.12.

48 Heskel 1997, 15; Tzvetkova 2007.

49 Tzvetkova 2018b.

50 Demosthenes, *Orations 23: Against Aristocrates* 23.118.

Phiale with Inscription (detail, cat. 60b)

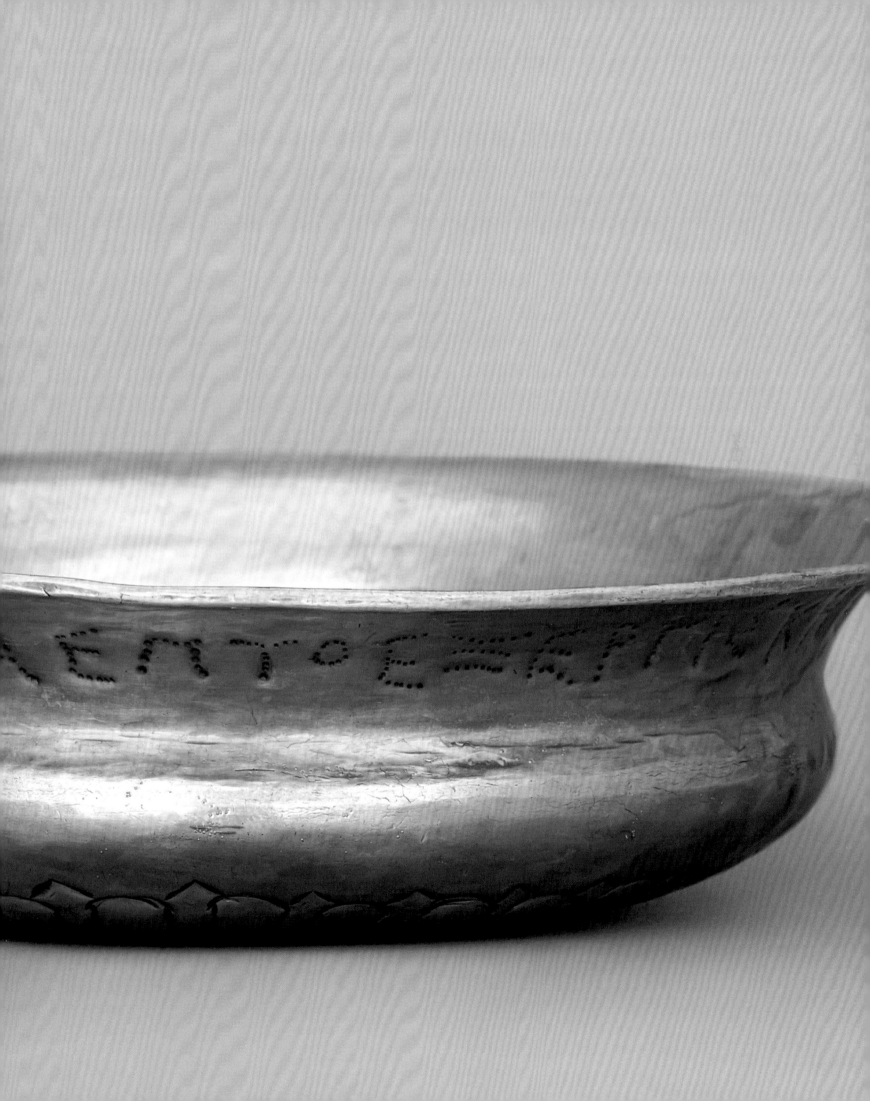

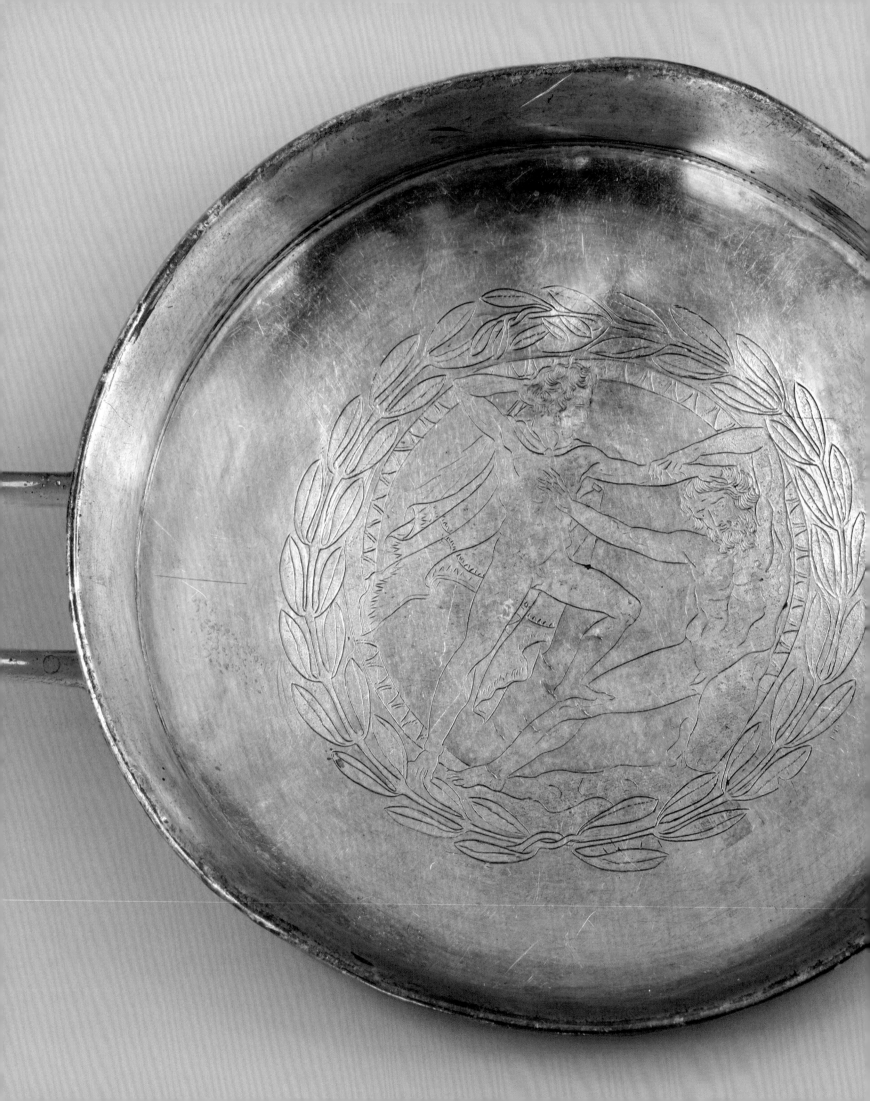

ATHENIAN "THRACE-HAUNTERS"

MATTHEW A. SEARS

GREECE'S WILD WEST

The indelible image of T. E. Lawrence, apart from Peter O'Toole's portrayal in the film *Lawrence of Arabia* (1962), is a 1919 portrait of the British officer in full Arab regalia (fig. 13). Lawrence was in Arabia to aid the Arab revolt from the Ottoman Empire, an ally of the Central Powers during World War I that the British hoped to weaken. As Lawrence himself recounts in *Seven Pillars of Wisdom*,[1] he was dispatched to Arabia for hard military purposes but grew enamored of the Arabs with whom he worked and fought and came to self-identify as one of them, complete with ostentatious displays of stereotypical dress. Lawrence's image and place in popular culture check many of the boxes of Edward Said's *Orientalism*, the groundbreaking work calling attention to the romantic and simplistic exoticism most in the "West" ascribe to the "East."[2] In ancient Greece the appeal of the exotic Other drew many, just as it drew Lawrence in the twentieth century. During the Archaic and Classical periods, the polis of Athens considered Thrace a vital source of raw materials, skilled mercenaries, and settlements to ensure maritime dominance of the Aegean. To advance Athenian aims in Thrace, the polis relied on a group of "Thrace experts" with ties to the region based on family estates, prior military campaigns, or simply personal affinities for Thrace and the Thracians. So

prevalent were these Thrace experts that the comic playwright Aristophanes coined the term "Thrace-haunters" (Θραικοφοῖται) to describe those who habitually haunted the lands to the north of the Aegean.[3]

Figure 13. T. E. Lawrence in Arab regalia, Arabia, 1919

Kylix with Theseus (detail, cat. 12)

39

We know most about the Thrace-haunters who were otherwise famous political and military leaders. Thrace seems to have offered such men opportunities for wealth, power, and military adventure that an increasingly egalitarian Athens did not—just as the "Wild West" did for certain Americans in the nineteenth century. As Lawrence found adventure and glory in Arabia, so too did these Athenians thrive in a region on the periphery of the world of the polis, and like Lawrence, these Athenians embraced and self-identified with a stereotypical image of Thracians. Apart from the elite, who tend to dominate the surviving sources, Thrace fascinated regular Athenians, too.

Thracians appeared in tragedies and comedies, which, while written by elites, were enjoyed by Athenians of diverse backgrounds. Art for public and private consumption depicted Thracians in recognizable costume, and some Athenians appeared in art wearing Thracian clothing. The Greco-Persian Wars of the early fifth century BC brought Persian characters and motifs into Athenian high and popular culture, and Athenian involvement in Thrace did the same for Thracian things.

Let us consider the importance of Thrace for Athens and a key group of Athenians while examining the cultural entanglement that was a consequence of interactions between Athenians and various Thracian peoples.[4]

SOURCES AND THEORIES

It is important to recognize that the region the Greeks called Thrace and that the Romans made a province of the same name—including present-day Bulgaria and parts of Romania, northeastern Greece, and northwestern Turkey—was home to dozens of peoples, none of whom called themselves Thracian. Orientalism in the modern world tends to encourage those in the "West" to think of the "East" as an unchanging and monolithic entity, and the Greeks likewise classed a diverse region under one label. Because we come to Athenian-Thracian ties mostly through Athenian sources, especially written sources, we must keep in mind that we typically have access only to what elite Athenians thought about the Thracians but not the Thracian point of view. Material evidence and archaeological excavation are invaluable for understanding the various peoples of Thrace on their own terms, including how they experienced and responded to contact

with Greeks. What is certain is that Greek interaction with the Thracians did not result in a monodirectional process of "Hellenization," whereby the Thracians became more Greek, but entailed influence flowing both ways and a variety of cultural entanglements.[5]

A good place to get a sense of how Greeks and Thracians dealt with one another is to look at Greek *emporia*, trading posts established by the Greeks as points of contact and exchange with Thracians. For decades, archaeologists have studied the site of Pistiros, a Greek *emporion* near present-day Vetren, Bulgaria, shedding light on a Greek presence in the heart of Thracian territory. A joint team from Princeton University and the Rhodope Ephorate of Antiquities in Greece has recently excavated at Molyvoti, identified as ancient Stryme, a Greek *emporion* on the north Aegean coast. A remarkable find at Pistiros is the so-called Pistiros Inscription (also known as the Vetren Inscription), which records the formal concessions granted by a Thracian king in the fourth century BC to the Greek merchants in the area (cat. 27).[6] Domestic spaces at the site have yielded distinctively Thracian loom weights and spindle whorls, possibly indicating intermarriage between Greek traders and Thracian women who worked in the home. A mixture of Greek and Thracian graffiti has also been found.[7] At Molyvoti, preliminary reports reveal that while Thracian pottery—a key sign of the presence and activities of Thracians—is rare in the town itself, it might be found in greater quantities outside of town in an area identified as a religious sanctuary.[8] While it is too early to tell whether Thracians and Greeks worshipped together but did not live together at Molyvoti, the ways in which they intermingled seem to have been different on the coast than inland at Pistiros.

Pistiros and Molyvoti (along with many other sites) afford us a glimpse into the everyday lives of regular Greeks and Thracians living together, trading with one another, and presenting offerings at the same shrines. Despite the nature of our literary sources, we need to remember that non-elite Greeks and non-elite Thracians came into contact with one another, learning from and being influenced by one another in the process, during the various missions to Thrace led by Athenian generals and politicians. That said, the nature of the evidence means we have a lot more information about elite Athenian Thrace-haunters than we do about other Greeks and Thracians, so those Thrace-haunters will be the focus of what follows. These elite sources and their elite subjects give us an idea of how appealing

and influential Thrace and the Thracians (at least as the Greeks understood those terms) were to certain Athenians, and that appeal and influence surely operated at non-elite levels, too.

POLITICS

Athens was among the most powerful Greek states in the fifth century BC because of its maritime empire spanning the Aegean. One of the linchpins of this empire was the group of colonies and subject states Athens had in the region of the north Aegean, particularly the city of Amphipolis, on the Strymon River, from which most of the timber for Athens's ships came. The importance Athens attached to Amphipolis and the Thraceward region is well demonstrated by the unsuccessful efforts Athens undertook to recapture the city from the Spartans in 422 BC, after losing it two years earlier, and the central place retaking Amphipolis held in Athenian foreign policy in the fourth century BC, including in the city's dealings with Philip II of Macedonia. Decades prior to the foundation of Amphipolis in 437 BC, the Athenians made several attempts to establish a presence in the area, most of which met with disaster at the hands of local Thracians. Even before the fifth-century BC efforts to build a permanent foothold in Thrace, several leading Athenians forged ties in Thrace and with the Thracians in ways that shaped their careers and altered Athenian history. For instance, Peisistratos, the Athenian tyrant who began the festivals at which the first tragedies were performed and who supervised an authoritative version of Homer's epics, rose to power in Athens in part because he was backed by Thracian mercenaries.[9] During one of the periods of exile from his home city, he spent many years in Thrace, where he built a base of military power and personal alliances. One of Peisistratos's chief rivals, Miltiades the Elder, abandoned an Athens governed by Peisistratos to found his own tyranny in another region of Thrace, which lasted for decades.[10] For Athens and many Athenians in the Late Archaic and Classical periods, Thrace was an area of vital strategic importance, analogous to resource-rich regions of Africa and the Middle East for modern European colonial powers.

To advance its interests in Thrace, Athens tended to rely on certain Thrace experts, by no means an official office but a readily identifiable status nonetheless. The most prominent of these Thrace specialists, at least for modern students of antiquity, is Thucydides, the great historian of the Peloponnesian War (431–404 BC). Thucydides's father was a man named Oloros, a name shared by a Thracian king. It is likely, therefore, that Thucydides was at least part Thracian and related to the Thracian nobility. Thucydides was not merely connected to Thrace by birth; he controlled lucrative gold mines on the mainland across from the island of Thasos. His Thracian connections were probably behind the Athenians' choice to appoint him the general in charge of the Thraceward region in the first half of the Peloponnesian War. He himself tells us that he was in command of a flotilla of ships at Thasos when the Spartan commander Brasidas attacked Amphipolis in 424 BC.[11] Thucydides arrived too late to save the city from falling under Spartan control, and he was exiled for his trouble, giving him ample leisure time to compose his history. Another commander during the Peloponnesian War, a man named Dieitrephes, seems to have had similar ties to Thrace. In 413 BC he was put in charge of a group of Thracian mercenaries being sent back to their homeland. On the way, as Dieitrephes looked on, these Thracians massacred the entire population of the small Boeotian town of Mykalessos.[12] Dieitrephes's father, Nikostratos, had been co-commander of a force that included one thousand Thracian mercenaries and a number of peltasts, which was sent to the Thraceward region in 423 BC, indicating that connections to Thrace had been passed from father to son and yielded important military posts.[13]

Thucydides's case provides a ready reason for why an Athenian would be interested in Thrace, namely the promise of great wealth. Thucydides, along with the family of Dieitrephes and several other notable Athenians, also reveals that Thracian contacts led to positions of power and influence within Athens, a lure that Thrace dangled before ambitious Greeks. Another attraction might be that Thrace furnished those stifled by Athens and its egalitarian political system an escape valve, an outlet where they could exercise their aristocratic prerogative with abandon. Thrace was a place where the sorts of dynastic marriages that take place in Homer's poems were still up for grabs—several Athenians obtained marriages with Thracian royalty—and where feasting, gift exchange, and the display of status objects continued to hold sway long after such practices fell out of fashion in Athens and much of Greece. Without his adventures in the Arabian desert, T. E. Lawrence would never have been famous as "Lawrence of Arabia" (even if his portrayal of Arabia is stereotyped

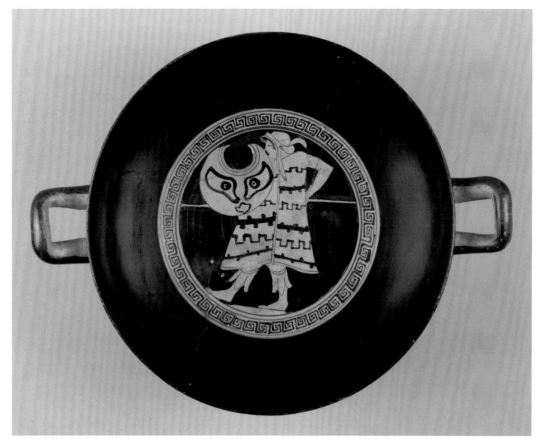

Figure 14. Red-Figure *Kylix*, Attic, Manner of Onesimos, 470–460 BC. Terracotta, H: 7.8 cm; W with handles: 26.4 cm. Cambridge, MA, The Harvard Art Museums, 1959.219 (BAPD 13447)

and inaccurate). The same can be said for the Athenian Thrace-haunters.

WAR

At least from the time Jan Best wrote his seminal book *Thracian Peltasts and Their Influence on Greek Warfare*, the importance of Thrace for the development of Greek military tactics has been widely known.[14] Peltasts, originating in Thrace and named after their crescent-shaped wicker shield, the *peltē*, were a type of medium-armed fighter equipped mainly with javelins (fig. 14). The Greeks, including the Athenians, made use of Thracian mercenary peltasts as a complement to the heavy-armed hoplites for which Greek armies were best known. In a few cases, peltasts on their own delivered crushing blows against hoplite formations, including against Spartan hoplites, supposedly the best soldiers in the Greek world, near Corinth in 390 BC.[15] In addition to hiring Thracians for the role,

the Greeks eventually trained their own peltasts, and peltasts were a key part of the combined-arms forces of Philip II and Alexander the Great of Macedonia.

The Thracian impact on Greek warfare went far deeper than the peltast. Many of Athens's most innovative and influential military leaders (and several leaders from other states too, notably Sparta) were the Thrace-haunters mocked by Aristophanes. The stamp of their Thracian experiences on the tactics of these commanders is evident. Xenophon, for example, the Athenian who wrote about his experiences as part of the mercenary expedition of the "Ten Thousand" to the heart of the Achaemenid Persian Empire in 401–399 BC, revealed his experience with diverse troop types, gained largely in Thrace. While returning to Greece, Xenophon fought as a mercenary alongside the Thracian ruler Seuthes II and deployed his forces in a staggered night march to prevent the slower-moving hoplites from being separated from the faster peltasts and cavalry of the Thracians.[16] Another Athenian commander, Iphikrates, who

rocketed to fame after leading a group of Thracian peltasts to victory over the Spartans in 390 BC, might have devised an entirely new hybrid soldier, something between a peltast and a hoplite, as a result of his experiences in Thrace at the command of Thracian troops.[17] For soldiers such as Iphikrates and Xenophon, campaigns in Thrace not only taught them how to use different types of troops, but they also allowed for more freedom to innovate and experiment with new tactics, far from the hoplite-dominated polis.

CULTURE

In the interior of an Attic red-figure cup from around 500 BC, now in Munich, a young man is depicted on horseback (fig. 15).[18] The rider wears a *chiton* and a broad-brimmed *petasos* hat, not unusual attire for a traveling Athenian horseman, but also distinctive

skin boots and a heavy patterned cloak called a *zeira*. These last two items are typically worn by Thracian horsemen and appear regularly in Attic representations of Thracians. This rider does not seem to be Thracian, however, since he lacks the other attributes, such as a pointy beard, that usually denote several types of foreigners, including Thracians.[19] There is also an inscription on the image, which reads, ΛΕΑΓΡΟ[Σ] ΚΑ[Λ]ΟΣ, "Leagros is beautiful"—a compliment for someone with a distinctly Greek name. It is very much a vexed question whether *kalos* vases depict the person declared to be beautiful. In some cases *kalos* vases betray no possible correlation between the inscription and the scene portrayed, while in others a connection appears likely. Leagros's name keeps popping up on vases with Thracian imagery.[20] On a vase now in Boston, Leagros is called *kalos* amid scenes of warriors in Thracian cloaks like the one worn by the rider in Munich, while Leagros is commemorated

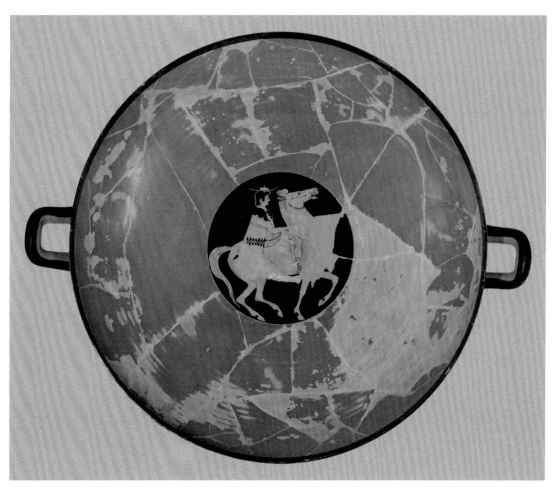

Figure 15. Red-Figure *Kylix*, Attic, signed by Euphronios as painter and Kachrylion as potter, 510–500 BC. Terracotta, H: 17 cm; Diam: 43 cm. From Vulci, Etruria. Munich, Staatliche Antikensammlungen und Glyptothek, 2620 (BAPD 200080)

Figure 16. Relief of an Athenian in Thracian dress, Attic, workshop of Pheidias, mid-fifth century BC. Marble, 101 × 140 × 64 cm. From the Parthenon, Athens (West Frieze, Block IV, figs. 7, 8). Athens, Acropolis Museum, Ακρ. 20018

on a vessel now in Paris showing an apparent Thracian leading a horse by the reins and wielding a javelin.[21] Whether or not all or any of these vases are meant to depict Leagros himself, he is associated with Thracian imagery to a marked degree. It may be far more than a coincidence that a particular Leagros, usually identified with the one honored as *kalos* in his youth, served as a general for an Athenian colonizing expedition to Thrace in 465 BC, a venture that ended in disaster when local Thracians drove the Athenians out and killed many, including Leagros himself.[22]

Leagros is not the only prominent Athenian with Thracian connections honored as *kalos* on Attic pottery with Thracian imagery. Miltiades the Younger, most famous as the hero of the Battle of Marathon in 490 BC, is proclaimed *kalos* on a red-figure plate now in Oxford that shows a rider clad in conventionally barbarian attire, typically Scythian or Thracian.[23] Before he returned to Athens to rise as the champion

of the young democracy against the Persian Empire, Miltiades had ruled for years as a tyrant in the Thracian Chersonese—today's Gallipoli Peninsula—having inherited this position from his family. His uncle Miltiades the Elder founded the settlement in the mid-sixth century BC and had himself ruled as a tyrant there. Miltiades the Younger and Leagros were in good company in terms of showing off various Thracian fashions. Many Athenian horsemen, the cream of Athenian society, are represented with Thracian cloaks and other accoutrements, including on the frieze of the Parthenon, the greatest work of Athenian art (fig. 16). Analogous to Margaret Miller's idea that elite Athenians adopted items of Persian dress to show off their wealth and status, Thracian clothing was a way for the Athenian wearer to stand out from the crowd, just as military and colonizing adventures in Thrace could enhance an individual's political influence.[24]

Athenian and Greek history would have been much different if not for the Thracians and the Athenian involvement in Thrace. This special relationship left its stamp on the careers of several prominent Athenian leaders, on Athenian foreign policy and warfare, and on Athenian art and elite self-representation. Athenian Thrace-haunters surely had a simplistic and romanticized view of Thrace and the Thracians, but there is no denying that Thrace held a profound appeal to the Athenians and furnished opportunities and the chance at a lifestyle not readily available in Athens. Comparatively, we know relatively little about what the various peoples in Thrace thought of those Athenians who haunted their land.

1 Lawrence (1935) 1991.

2 Said 1979. Hall (1989) argued that Aeschylus's *Persians*, produced in Athens in 472 BC, was among the first orientalist works. It would not be the last.

3 Aristophanes, frag. 156; Kassel and Austin 1984.

4 For an extensive treatment of this topic, including further bibliography, see Sears 2013; Sears 2015.

5 Zuchtriegel (2018, 164–96) provides a fascinating discussion of the entanglements between Greek colonists and indigenous populations (in a South Italian context).

6 See Chankowski and Domaradzka 1999.

7 Bouzek (2002) provides a useful summary of the site and its finds.

8 For the most recent work on Molyvoti, see Arrington et al. 2022; Arrington et al. 2023.

9 Herodotus, *Histories* 1.61–64; Best 1969, 1–15.

10 Herodotus, *Histories* 6.34–41.

11 Thucydides, *History of the Peloponnesian War* 4.104–6.

12 Thucydides, *History of the Peloponnesian War* 7.29–30.

13 Thucydides, *History of the Peloponnesian War* 4.129.2.

14 Best 1969.

15 Xenophon, *Hellenica* 4.5.

16 Xenophon, *Anabasis* 7.3.37–39.

17 Diodorus Siculus, *Bibliotheca historica* 15.44; Cornelius Nepos, *Iphicrates* 1; Sears 2013, 273–87.

18 Munich, Antikensammlungen, J337 (BAPD 200080).

19 For the Attic iconography of non-Greek warriors, see Lissarrague 1990.

20 For a discussion of Leagros, his place in Athens and Attic imagery, and the phenomenon of *kalos* vases as an ancient version of modern hashtags, see Shapiro 2021.

21 Boston, Museum of Fine Arts, 10.196 (BAPD 203234); Paris, Musée du Louvre, G26 (BAPD 203251).

22 Herodotus, *Histories* 9.75; Pausanias, *Description of Greece* 1.29.4–5.

23 Oxford, Ashmolean Museum, 310 (BAPD 201526).

24 M. Miller 1997.

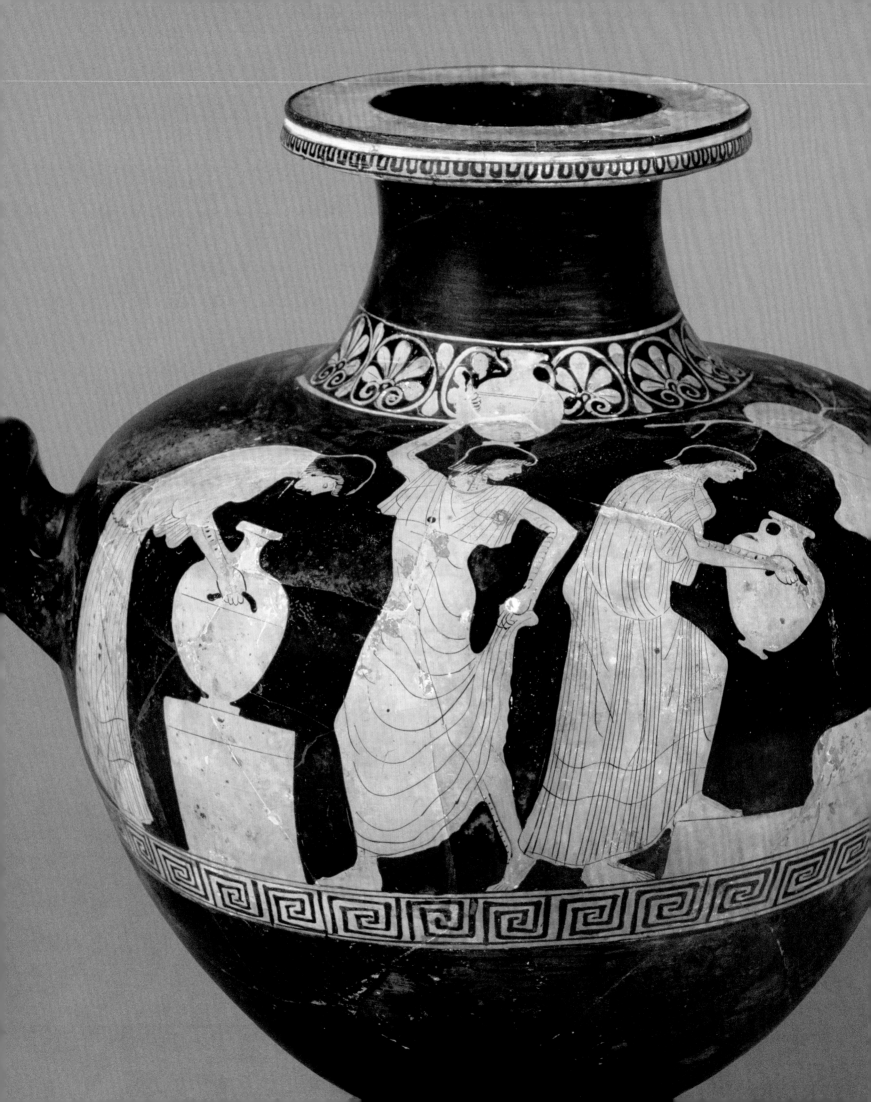

THRACIANS ON ATHENIAN VASES

DESPOINA TSIAFAKI

Thrace long captured the Greek imagination because of its abundant natural resources (such as metals and timber), its geography, its people, and their customs. As early as Homer and continuing with the poets, playwrights, and historians of the Classical era, Thracian legends and heroes served as a source of inspiration. From the mid-sixth century BC, with the establishment of an Athenian settlement in the Thracian Chersonese by Miltiades the Elder and then Peisistratos's stay in the areas of the Thermaic Gulf and Mount Pangaion during his exile, Athenians came into close contact with their Thracian neighbors and incorporated them into their iconography. Famed warriors,[1] Thracians likely traveled with Peisistratos to Athens as mercenaries when he returned from exile.[2] Their exotic (to the Greeks) and probably colorful costume[3]—with *zeira* (woolen cloak), *alopekis* (fox-skin cap), *embades* (fawn-skin boots), and the spear and characteristic *peltē* (crescent-shaped shield), as described by Herodotus[4]—certainly could not have gone unnoticed.

This image of Thracian warriors also attracted the interest of Athenian vase painters, who depicted them on black- and red-figure vases, just as they depicted other foreigners, including Scythians and Persians.[5] A number of figures on Attic vases wear the Thracian costume or parts of it. Some are certainly Thracians (cats. 9–11, 16, 17),[6] while others could be Athenians wearing garments or footwear of Thracian type, which

appear to have become fashionable in Athens at that time. Depictions on the vases accord with the description of Thracians by Xenophanes of Colophon:[7] they look fierce, with pointed beards and red hair, which was rendered in diluted clay.[8]

Thracian men and women were often enslaved, and many lived in Athens.[9] The Thracian women (*Thrassai*) were portrayed on Attic vases as household slaves and nurses (*trophoi*) or as wild women, as imagined by the Athenians (cats. 11, 37).[10] Their most distinctive feature is their tattoos, a symbol of their noble descent, according to Herodotus.[11] Vase painters, however, depict only Thracian women with tattoos, not the men, perhaps imposed on them as a mark of punishment for murdering Orpheus (as discussed below).[12] Those free Thracian women who killed Orpheus are often shown, decorated with tattoos, on Athenian vases. A characteristic example is found on a column krater by the Pan Painter, on which tattooed Thracian women appear on both sides (fig. 17). Their hair, rendered with diluted clay to denote red color, blows freely, suggesting their ferocity and vigor, as do their powerful and brisk movements. They wield swords and are poised to attack, indicating that they are taking part in the murder of Orpheus.

The Athenians viewed myth as a connection to the heroic past and a form of history. These stories did not have one standard version but were instead

Red-Figure *Hydria* with Thracian Women at a Well (detail, cat. 37)

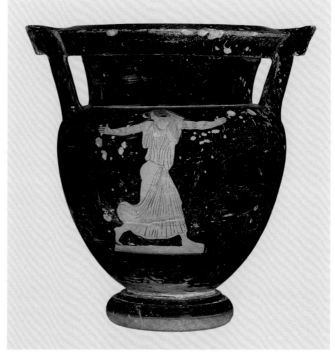

Figure 17. Red-Figure Column Krater, Attic, attributed to the Pan Painter, ca. 470 BC. Terracotta, H: 34.7 cm; Diam of rim: 28.3 cm. Found in Agrigento, Sicily. Munich, Staatliche Antikensammlungen und Glyptothek, 2378/J.777 (BAPD 206284)

changeable, and the poets created their own versions, including those by the tragedians who presented to the Athenian audience myths adapted to the beliefs and needs of the time.[13] Thracian myths attracted the interest not only of poets but also of painters, sculptors, and vase painters who might have been inspired by the former.[14] Thracian myths appear mostly but not exclusively on red-figure vases from the time of the Greco-Persian Wars (ca. 492–479 BC) onward.

Thrace was called the "homeland of music,"[15] and Thracians, "music lovers."[16] The most renowned musician of antiquity, the mythical Orpheus, was of Thracian descent, as were the mythical musicians Thamyris, Eumolpos, and Mousaios. Orpheus and secondly Thamyris were the most popular in Athenian literature and vase painting. According to various traditions, Orpheus was the son of the Muse Kalliope and the Thracian king Oiagros or, alternatively, probably because of his relation to music, the god Apollo.[17] Orpheus joined the expedition of the Argonauts, saving them from the Sirens by playing his music. Later he lost his wife, Eurydike, and ventured down to the Underworld to rescue her. His enchanting singing persuaded Persephone and Hades to give her back to him. Unfortunately, as a result of his impatience, which caused him to look at her before they reached the sunlight, he lost her forever.

Orpheus's grief led him to avoid the company of women and seek only the companionship of Thracian men, who were fascinated by his music. The women of Thrace, furious with Orpheus for keeping their men apart from them, killed him by tearing his body to pieces, which they threw into the Hebros River. Miraculously preserved, his head continued to sing, floating on the water until it reached the island of Lesbos, where it started to utter oracles.

Orpheus and his suffering drew the attention of Athenian vase painters in the fifth century BC. They chose specific episodes from the story, which varied over time. Around the time of the Greco-Persian Wars, the violent death of Orpheus was frequently shown, but by the middle of the fifth century Orpheus was more often depicted playing music and charming the belligerent Thracians. Later the oracular head appeared.[18]

The earliest representations of Orpheus's brutal murder by the Thracian women come from the workshop of the Brygos Painter (ca. 490–470 BC).[19] These are usually multifigure scenes that display a uniformity that suggests the existence of a common prototype, perhaps a wall painting. An indicative example is a red-figure *stamnos* by the Dokimasia Painter, on which the scene stretches around the vase in an intense and dramatic composition (fig. 18). Orpheus, already

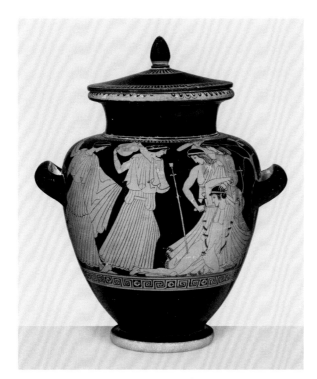 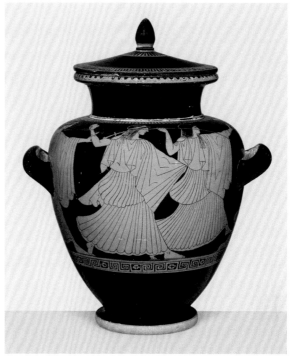

Figure 18. Red-Figure *Stamnos*, Attic, Dokimasia Painter, ca. 470 BC. Terracotta, H: 28.7 cm; Diam of rim: 16.6 cm. Basel, Antikenmuseum und Sammlung Ludwig, BS 1411 (BAPD 275231)

wounded in the thigh by a spear, is attacked by three Thracian women, one of whom holds her sword against the musician's bleeding throat. Nevertheless, Orpheus still holds his lyre in an attempt to keep it safe, an element found in other depictions.

On some vases the episode of the murder might be connected with the playing of music. In those cases, one side pictures Orpheus's murder at the hands of the Thracian women, while the other depicts the musician among Thracian warriors. On a calyx krater attributed to the Villa Giulia Painter, two Thracian women attack Orpheus with spear and axe while he attempts to push the spear away from his throat (cat. 11). He has dropped his lyre, which lies broken on the ground. The tattoos on the arms of the women denote their Thracian identity. Orpheus wears a short tunic and a *himation*, but the *embades* on his feet indicate his Thracian origin, while the laurel wreath and his long hair make him resemble Apollo. Three Thracian men stand calmly on the back of the vase, connecting the murder to the previous episode of the story, as if just before the attack of the women they were listening enchanted to the music of Orpheus but now do nothing to help him.

Orpheus as a musician who charms the Thracians is found more often on Attic vases from the middle and late fifth century BC. The krater by the Orpheus

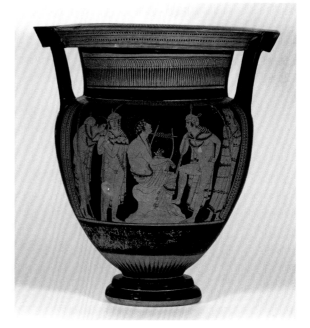

Figure 19. Red-Figure Column Krater, Attic, attributed to the Orpheus Painter, ca. 480–470 BC. Terracotta, H: 50.7 cm; Diam of rim: 40 cm. Found in Gela, Sicily. Berlin, Antikensammlung, 3172 (BAPD 216168)

Painter offers the most representative depiction (fig. 19).[20] The hero, seated on a rock and holding his lyre, is surrounded by four Thracian men who listen

to him attentively. One stands raptly, with eyes closed, charmed by Orpheus's music, which, according to Simonides and Conon,[21] could fascinate even beasts and stones. This would explain the absence of the renowned Thracian ferocity in those scenes. On another column krater, a turtle and a stone are shown before the musician, illustrating Simonides's claim.[22] In contrast to his compatriots, Orpheus is usually depicted in Greek garments, with only a few exceptions.[23]

Although it does not appear as frequently as the earlier episodes, the oracular head of Orpheus can be found on some Attic vases of the second half of the fifth century BC.[24] On one *hydria*, for instance, Orpheus's head is shown before a standing, bearded man—either one of the fishermen who found the head or the poet Terpander of Antissa on Lesbos, considered the successor of the Thracian musician (fig. 20). Around them are six Muses, who are believed to have gathered up Orpheus's dismembered limbs and buried him in Leibethra, in Macedonia.

The son of Argiope and the renowned musician Philammon, Thamyris is the only Thracian musician known to Homer.[25] He was considered to be the inventor of the Dorian mode (*harmonia*) and the winner of the musical contest at Delphi. His statue stood beside those of Hesiod and Orpheus in the Sanctuary of the Muses on Mount Helikon.[26] Thamyris was also famous for his physical beauty. He was said to have two different-colored eyes, one blue and one black, considered an especially attractive trait. His beauty and musical skill, along with his victory at Delphi, made him arrogant, and he challenged the Muses to a musical contest. The prize would be the Muses themselves, but if he lost, they would choose his punishment. Of course, the Muses won the contest and harshly deprived him of both his eyesight and his skill in playing the kithara.[27] In the lost drama *Thamyris*, Sophocles is believed to have described the struggles of the musician, taking the leading role for himself. The play must have had great resonance, for Sophocles was depicted as Thamyris in a painting in the Stoa Poikile (Painted Stoa) in Athens. The painter Polygnotos also included Thamyris in his *Nekyia* (a composition illustrating Odysseus's descent into the Underworld) in the Lesche of the Knidians (a building in the Sanctuary of Apollo at Delphi), placing him close to Orpheus.

Around this time the story of Thamyris drew the interest of the vase painters.[28] Shortly before the middle of the fifth century BC and continuing to the

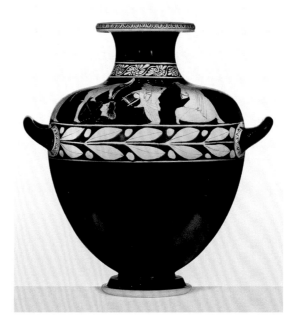

Figure 20. Red-Figure *Hydria* (with detail), Attic, attributed to the Polygnotos Group, ca. 475–425 BC. Terracotta, H: 37.7 cm; Diam of rim: 14.6 cm. Basel, Antikenmuseum und Sammlung Ludwig, S 481 (BAPD 3735)

end of the century, Attic vases narrate various episodes from the story. The earliest preserved ones, by the Niobid Painter, depict the preparations of Thamyris and the Muses for the musical contest.[29] The contest itself is shown on two *hydriai* by the Phiale Painter, on which Thamyris plays his lyre while two Muses watch him (fig. 21).[30] Also shown is his mother, Argiope, who is depicted as an elderly woman. Sure of his win and not anticipating his sad end, she ironically presents a laurel wreath to her son. Pausanias narrates the

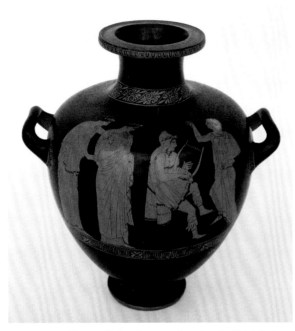

Figure 21. Red-Figure *Hydria*, Attic, attributed to the Phiale Painter, ca. 475–425 BC. Terracotta, H: 42.8 cm; Diam of rim: 15.2 cm. Found in Vulci, Etruria. Vatican City, Museo Gregoriano Etrusco Vaticano, 16549 (BAPD 214272)

story's next episode,[31] which appears on a *hydria* of the Polygnotos Group.[32] After his defeat and punishment by the Muses, Thamyris is now blind, as indicated by his closed eyes, and he throws away his kithara. His mother stands nearby, pulling her hair in despair (the tattoo on her right hand indicates her Thracian origin).

Vase painters of the Meidias Group placed Thamyris in an idyllic landscape, a setting they typically used for their compositions.[33] On a *hydria* now in New York, the musician is shown sitting among seven women and two winged Erotes.[34] One of the women is likely the goddess Aphrodite and the others, Muses. The erotic atmosphere of the composition dispels the tension and rivalry of the previous depictions.

In contrast to Orpheus, Thamyris typically appears on Attic vases wearing Thracian garments. His musical instrument is a form of kithara known as the Thracian kithara or the kithara of Thamyris,[35] and it is sometimes shown with the two other famous Thracian musicians, Orpheus and Mousaios.[36] Mousaios is occasionally considered the son of Orpheus or Thamyris, and he appears on Attic vases during the second half of the fifth century BC.[37] According to Herodotus,[38] his oracles were collected by Onomacritus, the famous Greek chresmologue, or compiler of oracles, in the sixth century BC. Of particular interest is a *pyxis* depicting for the first time together

the two Thracian musicians, Thamyris and Mousaios, with the Muses and Apollo.[39]

The last of the quartet of renowned musicians of antiquity connected with Thrace is Eumolpos, the son of Mousaios, according to some literary sources. Eumolpos is usually associated with the Eleusinian Mysteries, and in fact the few preserved depictions of him in Attic vase painting do not focus on his musical skills.[40] He appears as an infant in the company of his father, Mousaios, and his mother, Deiope, on a red-figure *pelike*.[41] Mousaios is the central figure, wearing Thracian garments and holding the Thracian kithara. He is surrounded by a number of female figures, including the Muses and Aphrodite. Two small, winged figures, Eros and Pothos, complete the idyllic atmosphere typical of the Meidian Group. The image of Mousaios resembles those of Thamyris, and without the inscription he would not be identifiable.

Although Thrace had not been organized into a single kingdom before the establishment of the Odrysian state in the fifth century BC,[42] Greek mythology tells of some mythical Thracian kings. Homer names Rhesos, a Trojan ally slain by Diomedes,[43] but the episode is not preserved in Attic vase painting. There is, however, an outstanding depiction of the death of Rhesos on a Chalkidian amphora (cat. 9).[44]

Other kings of Thrace do appear on Attic vases, notably Phineus, who was both a king and a prophet. Sophocles refers to him as king of Salmydessos in Thrace and husband of Kleopatra, the daughter of Boreas (the north wind, who was viewed as a Thracian) and the Athenian Oreithyia.[45] Phineus had two sons, whom he blinded at the instigation of his second wife. For that sacrilegious act, the gods punished him with blindness and sent the abominable Harpies to torment him; they stole and soiled his food, preventing him from eating. The winged Boreads, members of the visiting expedition of the Argonauts, rescued Phineus by driving away the Harpies. In return, Phineus instructed them on how to pass safely through the Symplegades.[46]

The punishment of a Thracian king by supernatural winged creatures drew the attention of Greek vase painters, who initially focused on the episode of the Boreads pursuing the Harpies. Later, in the fifth century BC, however, Phineus becomes the focus of the composition, usually depicted seated and holding a royal scepter and either being assaulted by the Harpies or victorious after their expulsion. The stealing of food by the Harpies is depicted in a dramatic manner on a *hydria* by

the Kleophrades Painter (fig. 22).⁴⁷ Phineus, blind and elderly, is seated, raising his hands in despair as the Harpies swoop down to snatch his food, which lies in abundance on a table. The end of Phineus's torment is presented on a *pelike* by the Nausicaa Painter.⁴⁸ The king sits frontally, scepter in hand, flanked by his liberators, who stand like royal guardians. Their Thracian dress both suggests their Thracian descent and indicates the place where the event occurs.

Violence characterizes the stories of other Thracian kings as well. Lykourgos, king of the Edonoi and son of Ares, god of war, was hostile to the intro- duction of the worship of Dionysos in his country and would not allow the god to pass through his king- dom.⁴⁹ The god then punished him by depriving him of his sanity and causing him in a manic frenzy to murder with an axe his own son, Dryas, believing him to be a grapevine. Although the story was already known to Homer,⁵⁰ the subject is rare in Attic vase painting.⁵¹ On a *hydria* by the Nausicaa Painter, Lykourgos, wearing Thracian *zeira* and *embades*, attacks his son with an axe (fig. 23). Dryas, seated on an altar, plead- ingly raises his hands to his father, but Lykourgos's frenzy is unstoppable. Nearby, Dryas's mother shows her despair by pulling her hair, just as Argiope did. Dionysos is also present in the scene, pushing a grape- vine toward Lykourgos.

Another son of Ares, Diomedes, was king of the Thracian Bistones tribe, who inhabited the area around Abdera and Lake Bistonis (Vistonida).⁵² He was famous for his flesh-eating horses that devoured strangers upon arrival in his country. As his eighth Labor, Herakles put an end to this practice, killing Diomedes and bringing his mares to King Eurystheus. One of the few known depictions of the myth on Attic vases, the oldest and most renowned, is on a *kylix* by Psiax dated around 520 BC, the time of the Athenian presence in Aegean Thrace.⁵³ The vase painter placed Herakles freely in the center of the cup, depicting him taming one of Diomedes's horses, which is devouring a human figure.

Violence and cannibalism appear in the story of another Thracian king, Tereus, who married the daughter of the Athenian king, Prokne, with whom he had a son named Itys.⁵⁴ Tereus raped Prokne's sister Philomela and cut out her tongue to hide his impious deed. But Philomela found a way to inform her sister, and together they sought revenge. They slaughtered Itys and served his flesh to Tereus. When the king discovered that he had eaten his own son, he attempted to kill the two sisters, but the gods changed all three of them into birds. Prokne became a nightingale, Philomela a swallow, and Tereus a hoopoe. Sophocles staged the myth in his drama *Tereus*. Thucydides notes that the mythical Tereus

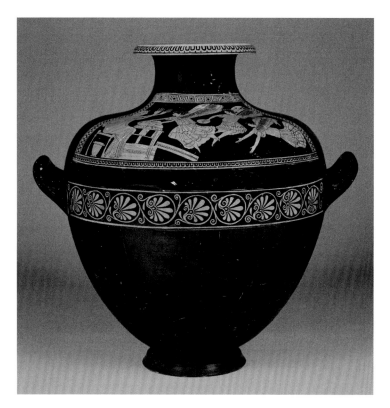

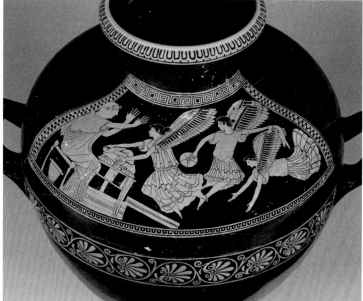

Figure 22. Red-Figure *Hydria* (with detail), Attic, Kleophrades Painter, ca. 480 BC. Terracotta, H: 39 cm; Diam: 15 cm. Naples, Museo Archeologico Nazionale di Napoli, 248779 (BAPD 30369)

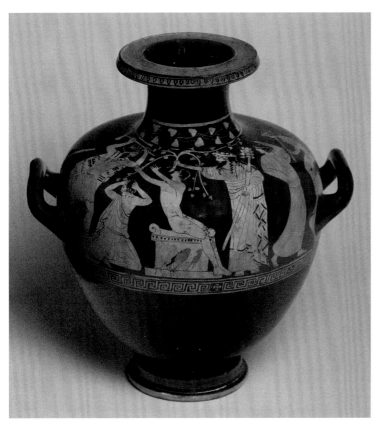

Figure 23. Red-Figure *Hydria*, Attic, Nausicaa Painter, ca. 460–450 BC. Terracotta, H: 36 cm; Diam of rim: 14 cm. Krakow, National Museum, MNK IX-1225 (BAPD 214835)

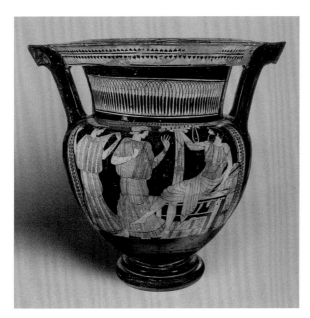

Figure 24. Red-Figure Column Krater, Attic, Group of Naples 3169, ca. 500–450 BC. Terracotta, H: 42 cm; Diam of rim: 27 cm. Found in Falerii, Italy. Rome, Museo Nazionale Etrusco di Villa Giulia, 3579 (BAPD 205766)

was not related to the actual Teres I, father of the fifth-century BC Thracian king Sitalkes.[55] There are few depictions of Tereus in Attic vase painting.[56] On a column krater attributed to the Group of Naples 3169, Tereus is shown as a symposiast, with a box containing Itys's dismembered body under the table (fig. 24). He has just discovered what he was served and grabs his sword to kill the two sisters, who flee.

Another mythical Thracian with ties to Athens was Boreas, the personification of the north wind.[57] As early as the time of Homer, Thrace was thought to be a suitable homeland for him—a cold region to the north.[58] Myth relates that Boreas asked the king of Athens, Erechtheus, for his daughter Oreithyia but was refused. Boreas then abducted her and took her to Thrace, where they had two sons, Zetes and Kalais, and two daughters, Kleopatra, who married the Thracian king Phineus, and Chione, who gave birth to Eumolpos by Poseidon. Herodotus states that the Athenians received assistance from their king's son-in-law, Boreas, on two significant occasions during the Greco-Persian Wars, and as an expression of their gratitude, they dedicated a sanctuary to him near the Ilisos River.[59] The presence of Athena in scenes with Boreas on some Attic vases is notable.

The abduction of Oreithyia by Boreas was a popular theme in Attic vase painting from the time of the Greco-Persian Wars onward and was in fact the most frequently depicted myth relating to Thrace.[60] The Greek imagination personified the Thracian wind, as it did other natural occurrences or abstract concepts, and gave him traits that illustrated distinctive characteristics.[61] He was usually depicted as a fierce figure, winged and with wild hair and beard, as on one of the earliest depictions of his abduction of Oreithyia on a pointed amphora by the Oreithyia Painter, now in Munich (fig. 25). In contrast, Oreithyia is shown as a young Athenian woman, wearing jewelry that denotes her noble descent, who reaches out to her friends for help. Boreas's ferocity, however, moderates over time, and eventually he appears as a young, unbearded man, as on a *hydria* found in Zone, an ancient colony in Aegean Thrace (fig. 26).[62] Although he was believed to reside in Thrace, Boreas was usually shown wearing Greek garments and only rarely Thracian or Eastern costume.[63]

Another personification depicted on Athenian vases is the Strymon River, which was located in one of the wealthiest regions of Aegean Thrace, a place of special importance to the Athenians, for it was there that the Athenian colonists founded the city of

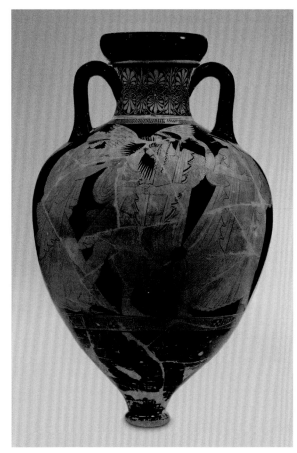

Figure 25. Red-Figure Amphora, Attic, Oreithyia Painter, ca. 500–450 BC. Terracotta, H: 58 cm. Found in Vulci, Etruria. Munich, Staatliche Antikensammlungen und Glyptothek, 2345 (BAPD 206422)

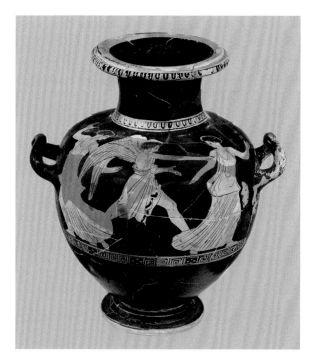

Figure 26. Red-Figure *Hydria*, Attic, ca. 440–430 BC. Terracotta, H: 23.8 cm; Diam of rim: 11.9 cm. Found in the cemetery of Zone, Greece. Archaeological Museum of Alexandroupolis, ΑΓΚ 6510 (BAPD 9052700)

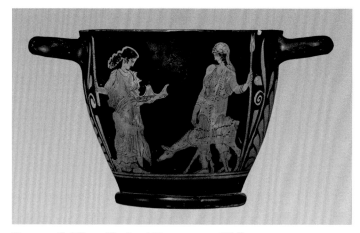

Figure 27. Red-Figure *Skyphos*, Attic, ca. 475–425 BC. Terracotta, H: 17.5 cm; Diam of rim: 21.3 cm. Found in Boeotia, Greece. Tübingen, Eberhard-Karls-Universität, Archäologisches Institut, 1347 (BAPD 214330)

Amphipolis after many fraught attempts. On a pointed amphora with the image of Herakles in the Garden of the Hesperides, three figures surround the main protagonists: Okeanos and the Strymon and Neilos (Nile) Rivers.[64] Both the Strymon and the Nile reflect Athenian political and commercial interests.[65]

Finally, the Thracian goddess Bendis had a significant presence in Athens (see cat. 38).[66] Her cult was officially introduced to the city in 430–429 BC and spread widely among Athenians and Thracians alike. Despite this, her presence in Attic vase painting is not particularly common.[67] The earliest known representation of Bendis on an Attic vase is close in date to the official introduction of her cult; she is pictured on the inside of a *kylix* showing a running woman holding two spears and wearing the Thracian *alopekis* and *embades*.[68] She must be Bendis, for she matches the literary description provided by the playwright Cratinus,[69] and her identity is confirmed by an inscription accompanying a depiction on a somewhat

later *skyphos* (fig. 27). Here the Thracian goddess is shown with Themis, who welcomes her to the city. The presence of Themis, representing divine law and custom, legitimizes the arrival of Bendis in Athens. The similarities in appearance of Bendis to Artemis are emphasized by the placement of Artemis on the other side of the vase; perhaps in this way the vase painter also intended to connect Athens to Thrace.

Although both mythical and actual Thracians continued to be shown on Athenian vases until the fourth century BC, they became less frequent, and some Thracians appear subsequently in South Italian vase painting.[70] Unfortunately, self-portrayals are not preserved in Thracian art, at least not prior to Roman times.[71] Furthermore, it is unknown whether the myths preserved in Greek tradition were derived from Thracian traditions or even known in Thrace.[72] Some Greek works imported to Thrace portray Orpheus or Boreas's abduction of Oreithyia (cat. 13), but these works may reflect only the Athenian imagination.[73]

Perhaps in some cases (the specific ones are unknown), a core of oral tradition emerged in Thrace and was transformed over time by poets and writers. Some stories, such as that of the north wind (Boreas), could be the creation of the poets. The modular configuration, with the addition of elements observed in several of the Thracian myths, might be the result of social needs and conditions that were often reinforced by political considerations (as in the case of Tereus). Regardless of the reasons for their creation and presence, Thracians, mortal and mythical, became an important part of the iconography of Attic vases.

1 Thucydides, *History of the Peloponnesian War* 7.29.

2 Aristotle, *Athenaion politeia* 15.2; Best 1969, 6–7; Bäbler 1998, 189; Sears 2015, 309–10.

3 Tsiafaki 1998, 31–40; Tsiafaki 2000, 366–67.

4 Herodotus, *Histories* 7.75.

5 Vos 1963; Drougou 1975, 96–97; Zimmermann 1980b; Raeck 1981, 67–100, 323–25; M. Miller 1997; Tsiafaki 1998, 31–37; Ivantchik 2006, 197–271; Tsiafaki 2021.

6 Tsiafaki 2021, 249–50.

7 Xenophanes, frag. 16.

8 Georgieva 2005; Georgieva 2009. See also a bell krater by the London E 497 Painter: New York, The Metropolitan Museum of Art, 24.97.30 (BAPD 214496); Tsiafaki 2021, 252–53.

9 Hall 1989, 110; Tsiafaki 2021, 253.

10 Bäbler 1998; Tsiafaki 2015, 96–107.

11 Herodotus, *Histories* 5.6.

12 Tsiafaki 1998, 37–38.

13 Hall 1989, 48, 160; Green 1994, 27; Sourvinou-Inwood 2003, 45.

14 For the poets, see Hall 1989, 47–50, 103–10, 122–59; Tsiafaki 1998; Avramidou and Tsiafaki 2015, 56–58.

15 Strabo, *Geography* 1.3.17, 1.471.17.

16 Conon, *Narratives* frag. 45.

17 Tsiafaki 1998, 41–45.

18 For the depictions of Orpheus, see Schoeller 1969; Garezou 1994; Tsiafaki 1998, 44–93; Tsiafaki 2000, 376–78; Tsiafaki 2016a, 269–72.

19 Tsiafaki 1998, 48–52, 214.

20 Column krater attributed to the Orpheus Painter: Berlin, Antikensammlung, 3172 (BAPD 216168).

21 Simonides, frag. 40; Conon, *Narratives* frag. 45.

22 Column krater attributed to the Naples Painter: Hamburg, Museum für Kunst und Gewerbe, 1968.79 (BAPD 275004).

23 On these vases Orpheus wears *embades* or the *alopekis*: Tsiafaki 1998, 86–88.

24 Tsiafaki 1998, 62–68.

25 *Iliad* 2.594–600; Tsiafaki 1998, 94–96.

26 Pausanias, *Description of Greece* 10.7.2, 9.30.2–4.

27 *Iliad* 2.594–600; Apollodorus, *Library* 1.3.3.

28 Tsiafaki 1998, 94–106; Tsiafaki 2000, 377–80; Bundrick 2005, 126–31; Heinemann 2013, 298–300.

29 *Hydria* attributed to the Niobid Painter: Bordeaux, private collection; Prange 1989, 122; Tsiafaki 1998, 97–98; Digital *LIMC* (2020): DaSCH, http://ark.dasch.swiss /ark:/72163/080e-742d383a15c3f-7.

30 *Hydria* attributed to the Phiale Painter: Naples, Museo Archeologico Nazionale, M1342 (BAPD 214273).

31 Pausanias, *Description of Greece* 4.33.3.

32 *Hydria* attributed to the Polygnotos Group: Oxford, Ashmolean Museum, G. 291 (BAPD 213783).

33 For the Meidias Painter, see Burn 1987.

34 *Hydria* attributed to the Meidias Group: New York, The Metropolitan Museum of Art, 16.52 (BAPD 220550).

35 Maas and Snyder 1989, 145–47.

36 Tsiafaki 1998, 107–22.

37 Tsiafaki 1998, 107–22.

38 Herodotus, *Histories* 7.6, 8.96, 9.43.

39 *Pyxis* attributed to the manner of the Meidias Painter: Athens, National Archaeological Museum, 19636 (BAPD 202344); Vivliodetis 2019, plate 40.

40 Tsiafaki 1998, 123–34.

41 *Pelike* attributed to the Meidias Painter: New York, The Metropolitan Museum of Art, 37.11.23 (BAPD 220499).

42 Archibald 1998.

43 *Iliad* 10.433–511.

44 Chalkidian black-figure neck amphora attributed to the Inscription Painter: Malibu, The J. Paul Getty Museum, Villa Collection, 96.AE.1; True 1995.

45 Sophocles, *Antigone* 970.

46 Tsiafaki 2016b.

47 Tsiafaki 1998, 169, plate 53.

48 Boston, Museum of Fine Arts, 1979.40 (BAPD 9979).

49 Aeschylus was probably the first to present Lykourgos as a Thracian: Hall 1989, 107.

50 *Iliad* 6.130–36.

51 Tsiafaki 1998, 182–87; Kefalidou 2009, 92–96; Topper 2015.

52 Tsiafaki 1998, 198–200.

53 Black-figure *kylix* on coral-red ground by Psiax: Saint Petersburg, State Hermitage Museum, ГР-28190 (BAPD 320368).

54 Tsiafaki 1998, 189–97; Zacharia 2001; Finglass 2016.

55 Thucydides, *History of the Peloponnesian War* 2.29.

56 Tsiafaki 1998, 189–97.

57 Tsiafaki 1998, 135–64.

58 *Iliad* 9.5, 23.230.

59 Herodotus, *Histories* 6.44, 7.189.

60 Kaempf-Dimitriadou 1979, 36–41; Neuser 1982, 27–89; Tsiafaki 1998, 135–64; Tsiafaki 2000, 383–86.

61 Shapiro 1993.

62 Iliopoulou 2015, 153–54, figs. 274–75; Iliopoulou and Pardalidou 2022, 236–37, fig. 5. For Boreas representations, see Tsiafaki 1998, 135–64.

63 Ibycus (PMG, frag. 286.9) speaks about the *Thracian Boreas*; Tsiafaki 1998, 152–53. See also Vivliodetis 2019, plate 29.

64 Pointed amphora: Germany, private collection (BAPD 30676).

65 Cahn 1988, 107–15; Tiverios 1991; Tiverios 2023, 173–82.

66 See Rabadjiev in this volume.

67 Tsiafaki 1998, 205–12; Rabadjiev 2015; Deoudi 2019.

68 *Kylix* attributed to the Phiale Painter: Verona, Museo Civico, 52 (BAPD 214329).

69 Cratinus, frag. 85.

70 Tsiafaki 1998, 221–40.

71 Rabadjiev 2005a, 79.

72 Tsiafaki 2022.

73 See Sideris in this volume.

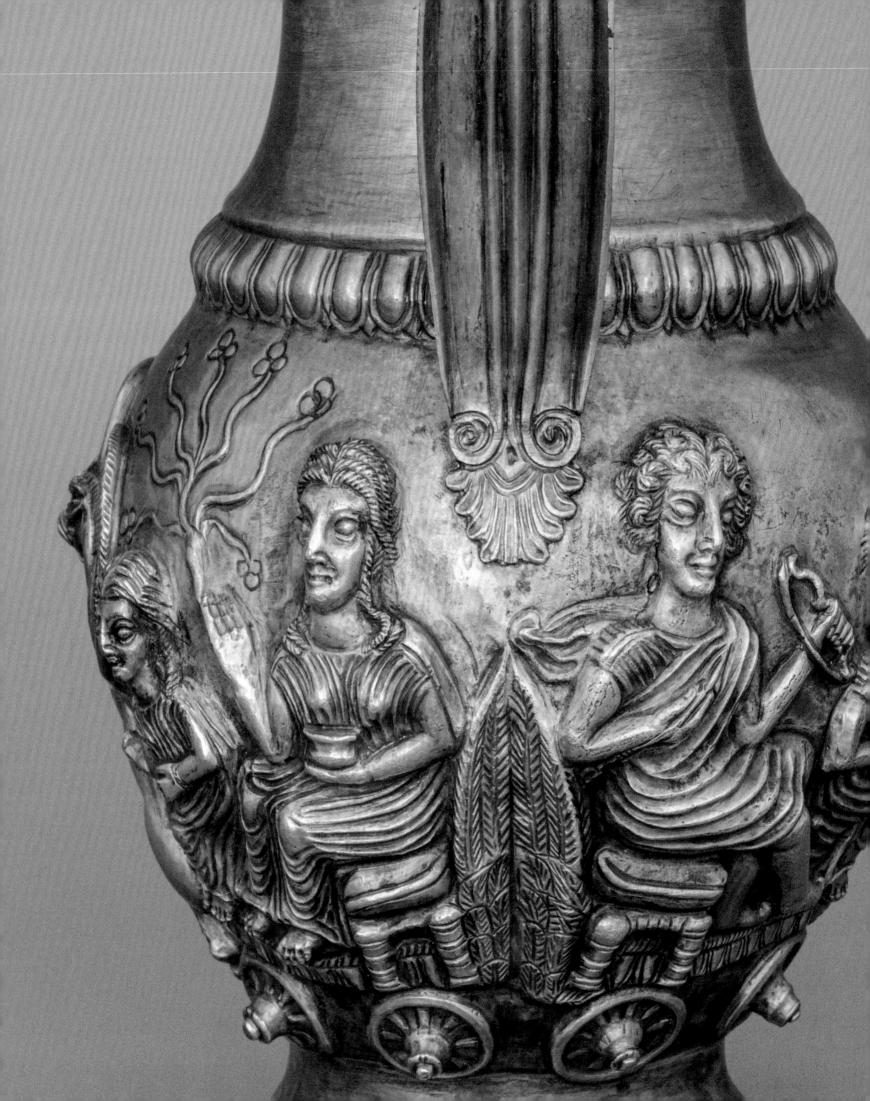

THE THRACIANS
AND THEIR RELIGION

KOSTADIN RABADJIEV

Our scant knowledge of the Thracians makes any reconstruction of their religious life uncertain and problematic. Only the names of some gods and little about their rituals and calendar are preserved. While Greek literary sources do identify some deities, they provide merely fragmentary information. Epigraphic texts constitute the sole Thracian written evidence. These were inscriptions in Greek, relating to Thracian religion, but they are very rare even in the Hellenistic period. Pictorial evidence can also be valuable. Coins serve as official royal propaganda. Images on imported luxuries—mostly tableware, jewelry, and weapons—may have been selected to convey specific messages. Some knowledge can be gained from the archaeological exploration of cult, and the evidence from Roman times also sheds light on earlier Thracian religious ideas and practices.

The geographic focus of this essay is mainly European Thrace south of the Istros (Danube) River. Unfortunately, little is known of the lands inhabited by Thracians in Asia Minor. While the first manifestations of Thracian religion belong to the Late Bronze Age and the Early Iron Age, only in the fifth century BC did names of deities begin to be attested by Greek observers in Thrace and did personifications of deities begin to appear in Thrace on imported Greek goods. This date is later than the foundation of the first Greek settlements on the Thracian coasts in the seventh century BC, but it coincides with the emergence of the Odrysian kingdom in the early fifth century BC, when Greek *emporia* also appeared in the Thracian interior. The gods we know of appear mainly with Greek names, and they were venerated by the Thracian elite, thus indicating its Hellenization and signaling the political function of religious cults, which become clearly recognizable after the campaign of the Macedonian king Philip II in Thrace in 342–340 BC. Hence the real and imaginary Thracian worlds were crowded with Greek notions, reflecting the Greek interest in Thrace.[1]

THE PANTHEON

There is no evidence of personified divinities in Bronze Age Thrace, although painted and engraved circles on Late Bronze Age pottery have been interpreted as solar symbols.[2] Human images are, however, found in sacred contexts as burial gifts and votive offerings in sanctuaries, including clay figurines, which remained popular in Thrace throughout the entire Iron Age. Stylized terracotta figurines with central European influence in the Inlaid Pottery Culture style have been found on the Lower Danube, and schematic carved stone images of warriors were used as markers on burial mounds of members of the nobility, an influence from the steppes brought by the Pit-Grave Culture in

Jug with Deities in Chariots (detail, cat. 60c)

Figure 28. Engraved stele, Late Bronze Age. Marble, 160 × 170 × 18 cm. From the vicinity of Razlog, Blagoevgrad Province, Bulgaria. Razlog, Historical Museum

the Early Bronze Age. There is a distinctive Mycenaean connection in the unique scene of an ithyphallic warrior fighting a serpent-like monster that has swallowed the sun(?) on a stele from a sanctuary (or a tombstone over a grave?) near present-day Razlog, Bulgaria (fig. 28).[3] These images appear to represent not deities but rather heroes or substitutes for men in mythological settings. All seem to reflect foreign influences.

The earliest specific attestation of gods associated with Thrace comes from the Homeric epics. Apollo protected Ismaros, the city of the Thracian Kikones,[4] and Ares was said to have come from Thrace and to have returned there after his affair with Aphrodite was exposed,[5] perhaps a reflection of the Greek colonization of the Thracian coast. Euripides names a Muse as the mother of Rhesos, the Thracian king.[6] Kotyto was an Edonian goddess, according to Aeschylus, and Dionysos was widely believed to be from Thrace.

According to Herodotus in the early fifth century BC, Ares, Dionysos, and Artemis were worshipped by the Thracians, and the kings prayed to Hermes, claiming him as their ancestor.[7] But to what extent can the historian be trusted? Herodotus does not provide the Thracian names of the gods, as he usually does when he identifies the Greek counterparts of deities of foreign lands for his readers. Perhaps the names were unknown to him, but it is unlikely that Greek gods pervaded the Thracian world at this date. In his typical manner, Herodotus translates perceived religious activities as part of his ethnopsychological portrait of the Thracians. Those who lived by war and pillage are said to have held the highest honor, as did those who idled, while the tiller of the soil was deemed most contemptible.[8] Thus Ares personified war, Artemis hunting, and Dionysos idleness in an artificially constructed pantheon. Herodotus misleads us, however, since these were not the only gods. Elsewhere, he mentions the goddess Artemis Basileia, to whom the Thracian and Paionian women sacrificed;[9] Zalmoxis of the Getai (whom he calls Salmoxis), although he is not sure whether Zalmoxis was a deity (*daimon*), a man, or even a slave of Pythagoras, as he was told by the Greeks who dwelled beside the Hellespont and Pontus;[10] and Pleistoros, a god of war worshipped by the Apsinthioi tribe on the Thracian Chersonese, who practiced human sacrifice.[11]

Another goddess was Bendis, whose public cult was introduced to Athens in 430/429 BC. The Thracians were the only foreign people granted the right to acquire land and found a sanctuary, the Bendideion in Piraeus (fig. 29; cat. 38).[12] But surprisingly, the goddess was unknown in Thrace except to the Bithynian Thracians in Asia Minor. Kandaon—a god of war, like Ares—is curiously mentioned by the Hellenistic poet Lykophron as the god of Krestonia.[13] Hera was the goddess of the Kebrenoi and Sykaiboai tribes, as attested by Polyaenus (see below). According to some scholars, all these deities were local variants of a Thracian mother goddess and a supreme god.[14] But this religious plurality rather suggests various tribal cults and the absence of a common Thracian pantheon, perhaps due to the lack of a central state structure, even if the Thracians constituted the second-largest nation on earth, exceeded only by the Indians.[15] It should also be noted that the abovementioned tribes are only those known to the Greeks on the Thracian littoral, in the contact zone where goods and ideas were exchanged with the political centers of the Odrysian kingdom.

The Odrysian royal coinage might be expected to provide images of patron deities, but the identifications are uncertain.[16] The images of a horseman on silver coins of Sparadokos in the fifth century BC and on those of Seuthes II in the early fourth century BC appear on the obverse, where the gods

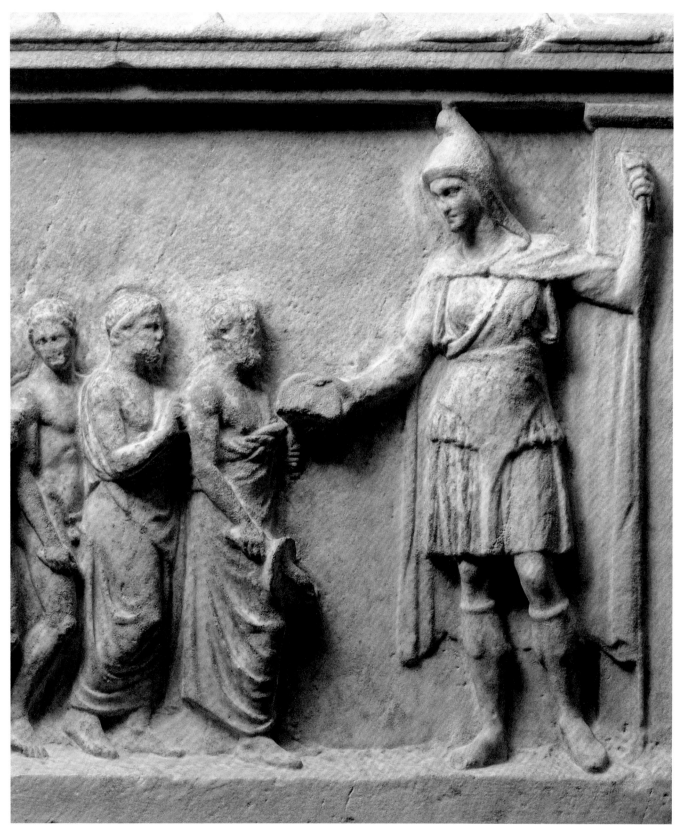

Figure 29. Votive Relief for Bendis (detail, cat. 38)

Figure 30. Jug with inscription (with detail), first half of the 4th century BC. Silver, H: 17.9 cm; Diam of body: 12.6 cm. Found with the Rogozen Treasure, Vratsa, Vratsa Province, Bulgaria. Vratsa, Regional Historical Museum, B 540

were usually shown, and may depict a royal ancestor (cat. 42).[17] Later the figure appears reduced in status on the reverses of bronze coins of Kotys I (384/383–360 BC) and kings of the Hellenistic period (Seuthes III, Skostokos, and Rhoigos; cat. 46). Certainly identifiable deities include Kybele wearing a city crown and Apollo on the bronze coins of King Hebryzelmis in the early fourth century BC; Dionysos wearing an ivy wreath appears on coins of Ketriporis, and Demeter, on coins of Kersebleptes. All these coins were minted in the Greek *apoikiai* in Thrace, the dies made by Greek engravers, and were intended mainly for exchange with Greek merchants, which would explain the

appearance of Greek deities in the fourth century BC but not necessarily the absence of Thracian ones.

Fourth-century BC epigraphic evidence also suggests the presence of Greek gods in Thracian royal contexts. Dionysos is mentioned as a guarantor of an oath in a decree issued by a successor of Kotys about the rights of the *emporitai* in Pistiros (cat. 27).[18] An inscription on a jug from the Rogozen Treasure uses a sacred formula, naming a certain Kotys (I?) as a child (or slave?) of Apollo: ΚΟΤΥΣ ΑΠΟΛΛΟΝΟΣ ΠΑΙΣ (fig. 30).[19]

The Greek gods in Hellenistic Thrace are better attested, probably as a result of the Macedonian

conquest.[20] Zeus appears on the obverse of several types of the bronze coins of Seuthes III in a manner quite similar to that on the coinage of Philip II.[21] Artemis Phosphoros and Herakles are shown on the coins of Spartokos; Apollo, Artemis, Athena, and Herakles can be seen on the municipal coinage from the city of Kabyle; Zeus is on the coins of Mostis; Athena is on the coins of Adaios; Artemis appears on those of Kotys II; and Apollo is found on coins of Skostokos, Adaeus, and Mostis. A temple of Apollo is mentioned in an honorary decree enacted by the *politai*, probably from Philippopolis,[22] while another dedication to Phosphoros was made by a worshipper with a Greek name in the capital of the Getai tribe, Helis.[23] A treaty between two ruling families mentions a Phosphorion (a sanctuary to Phosphoros), an altar of Apollo on the agora of Kabyle, and both a temple of the Samothracian gods and an altar of Dionysos on the agora in Seuthopolis (cat. 55).[24] The cult of the Samothracian gods in Seuthopolis could be the result of a political agreement between Lysimachos and Seuthes III in 320 BC, after the war between the two rulers following the death of Alexander the Great, which ended without a victor, and at the time construction of the city was beginning.[25]

Greek gods are also seen in the decoration of imported objects, products of Greek craftsmen but commissioned by Thracians, as well as in imitations by local artisans.[26] There does appear to be considerable Hellenization of Thracian society and little evidence of actual Thracian religious practice. The phenomenon of imported images could be compared to the songs about Lakedaimon and Thebes, sung by Greek singers at the wedding of King Kotys's daughter to the Greek general Iphikrates.[27] Beyond doubt the interpretation of these religious images is difficult. There are two categories of evidence, conventionally defined as Thracian and Hellenizing tendencies. Non-Greek (Thracian) names of deities and images that cannot be recognized as Greek are clearly local, but the second category of gods bearing Greek names or looking Greek is challenging. Were they Greek gods worshiped by the Thracians or just a functional translation by the Greeks that was then adopted by the Thracians themselves and discussed by some modern researchers as *interpretatio Thracica* of the Greek religious concepts? The popular belief of the Greeks that Dionysos was a Thracian deity is currently shared by scholars, but I find it insupportable. The god was not a newcomer to the Greek pantheon but was well known to the Mycenaean

Greeks. And his significant presence in Thrace in Greek myth and drama can be explained as an attempt to situate him as a deity of the wild, whose *thiasos* is a collection of marginal characters situated between beasts and humans. Their orgiastic behavior outside civilized space hints at an ideological message about Thrace and the Thracians.[28]

A particular case is the aristocratic cult of Dionysos that was practiced in Thrace, traced through his association with kings and royal families, his images on imported precious artifacts, and even his solar aspect. This Thracian Dionysos has been interpreted as being related to Orphic ideas or to the mystery cult of the Kabeiroi in the north Aegean.[29] Even though a Thracian Orphic/Dionysian doctrine has been reconstructed by modern scholars as a royal propaganda of the chosen, whose aim was spiritual perfection and immortality, it would appear incongruent with a non-literary and unconsolidated society; moreover, our knowledge is insufficient.[30]

The little that is known of the actual local beliefs about the Thracian gods, if the author Xenophanes of Colophon and his philosophical speculation are to be trusted, suggests they were anthropomorphic in appearance, blue-eyed and red-haired like the Thracians themselves. It is notable, however, that this claim was part of his general refutation of the anthropomorphism of the gods.[31] These gods inhabited the heaven above, which we learn in a curious anecdote about Kosingas, chieftain of the Kebrenoi and Sykaiboai and priest of Hera, who joined several long ladders to climb up to the sky to complain to the goddess of the tribes' disobedience.[32] The gods were also omnipresent, as Athenaeus reports that Kotys I celebrated sacrifices to the gods in symposia at places of his choice that were shaded with trees and watered with springs.[33]

PRIESTS AND RITUALS

Some legendary Thracian kings were also priests, such as the abovementioned Kosingas, who served as the priest of Hera. This practice of kings serving a priestly function seems to have continued into historical times, since Kotys is said to have offered sacrifices to the gods at his feasts and King Diegylis made human sacrifices in 145 BC (see below). The aforementioned sacred formula on the Rogozen jug suggests a priestly role for the king but not the survival of the "king-priest" of legend, who exists to the exclusion of other

priests. The *Odyssey* names Maron, a grandson of Dionysos, as a priest of Apollo at Ismaros, a city of the Kikones,[34] who dwelled in a grove dedicated to the god and was spared by Odysseus after his invasion of the city. Jordanes relates a confusing story about the holy men of the Getai—the priests who opened the gates of Odessos when Philip II besieged the town and, clad in white robes and with harps in hand, marched against the armed men and chanted pleas for help to the gods of their fathers.[35] Zalmoxis was said to have first been appointed a priest of the god of the Getai and later was called a god himself. In the time of Byrebistas, this priestly position was held by Dekaineos.[36]

The high social status of priests may be explained as tribal monotheism, hence their unique position, ranking just below the king in the hierarchy. Vologases, the Dionysian priest of the Bessoi, was known as the leader of an uprising against the Romans in 15 BC.[37] In Seuthopolis, Amaistas—son of Medistas, whose name suggests that he was a member of the Odrysian dynasty—made a dedication to Dionysos at his altar in the agora "after having been a priest," which means that he held the office of priest for a fixed period and was then replaced, just as in the Greek practice.[38]

Temples and altars of Greek gods were inaugurated in newly built Hellenistic towns, such as those for Artemis Phosphoros and Apollo in Kabyle and for the Great Gods and Dionysos in Seuthopolis. There were local priests (as attested in Seuthopolis), and the temples functioned as repositories of the city's archives. With the municipal transformation of Kabyle, Artemis became the city goddess, and her cult statue became the city's emblem, replacing the ruler's image. There were no cult statues in the Thracian sacred spaces (an aniconic cult), however, except for those related to Greek cults in towns.[39]

The offering of burnt sacrifices is evidenced by the altars in the agoras in Kabyle and Seuthopolis, while other ritual activity was associated with the table, where portions of food and drink were set aside for the gods and burned or offered with libation at the banquet, as performed by Kotys (mentioned above). The libation using a *rhyton* and *phiale* is a recognizable Thracian practice—a seated goddess holding a *rhyton* is accompanied by a priestess on an actual silver *rhyton* found in the present-day village of Poroina Mare, in Romania (fig. 31),[40] and numerous *phialai*, *rhyta*, and jugs have been found in

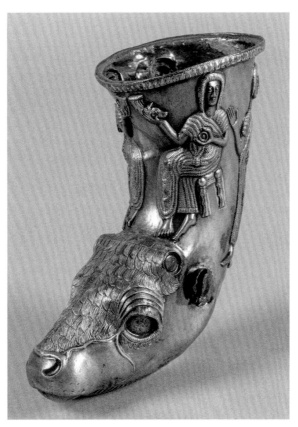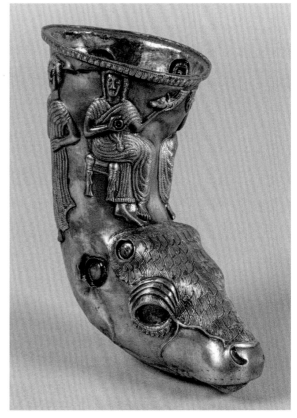

Figure 31. *Rhyton,* ca. 300 BC. Silver. Found in Poroina Mare, Romania. Bucharest, National History Museum of Romania, 50457

Figure 32. Ornamented hearth-altar (*eschara*), Hellenistic period. Clay. Found in Seuthopolis, near Kazanlak, Stara Zagora Province, Bulgaria. Drawing: K. Chervenrakov, archive D. Dimitrov and M. Chichikova

Thrace, also mostly of silver. Sacrifices are suggested by ornamented clay hearths (*eschara*) of Hellenistic date, discovered in urban centers—including Seuthopolis, Philippopolis, Kabyle, Pistiros, and Helis—but also in funerary contexts (fig. 32).[41] They cannot be interpreted as domestic hearths,[42] and their decorated surfaces suggest they were used in purification rituals for burning aromatic substances or hallucinogens as reported of some Thracians, who threw seeds onto the fire as they sat around them at banquets. The smoke would induce a state akin to drunkenness and allow communication with the gods through enthusiasm or ecstasy.[43]

The use of fire was prominent in the all-night festival of Bendis in Piraeus as well. Socrates was amazed by a nighttime cavalcade of riders who passed torches to one another as they raced their horses. The procession from Athens to the sanctuary of the goddess on Munychia Hill was divided into two groups, one of local people and the other, no less impressive, of Thracians in accordance with their ancestral traditions and the laws of the city, as written on a mid-third-century decree of the Athenian people.[44] Fire was also used in divinations. Suetonius mentions a sanctuary in the grove of Liber in Thrace,

where the father of Octavian, the future emperor Augustus, consulted the priests about his son. Using barbarian rites, they predicted his world domination in the pillar of flame from the wine poured over the altar, which had happened before on this same altar only for Alexander the Great.[45] A different sort of divination was practiced at the shrine of Dionysos located high on a mountain, where the Bessoi were prophets and a priestess uttered oracles in the manner of Delphi, according to Herodotus.[46] Macrobius relates a story that the sun was identified with Liber in Thrace and worshipped under the name Sebazius in a round temple on the hill of Zilmissos, which had an opening in the middle of the roof,[47] all of which seems fanciful. But could the tale hint at a local deity behind this unusual solar cult of Dionysos?

Another form of sacrifice is the deposition of gifts for the gods—clothes, jewelry, and vessels—that are found in extramural sanctuaries, some on mountaintops, possibly sites for Thracian solar cult practices. Many hoards of precious-metal objects were buried in rural areas,[48] where so-called pit-sanctuaries were situated. Complexes of numerous pits were filled with objects that can be recognized as for both ritual (models, clay figurines, amulets) and household (vessels, tools, weapons) use. There are also fragments of hearths, along with portions of food or even entire animals and, rarely, human sacrifices. Some were located in necropoleis, suggesting an exchange with the chthonic world.

Herodotus describes the Getai employing a special method of communication with their god Zalmoxis by sending a messenger to him once every five years. They chose the messenger by lot and killed him by hurling him aloft and letting him fall over three spears. While he was still alive, they entrusted him with the message.[49] Herodotus goes on to say that human sacrifices were offered to the god Pleistoros by the Thracian Apsinthioi after their fashion,[50] and according to Diodorus Siculus, when the Thracian king Diegylis sacrificed two Greek youths, he justified it by stating that kings and commoners ought not to offer the same sacrifices.[51]

DEIFICATION

The Thracian kings were believed to be of divine origin, descended from Hermes, according to Herodotus. Their special status is illustrated by their portraits on the obverse of coins, where the protective deities

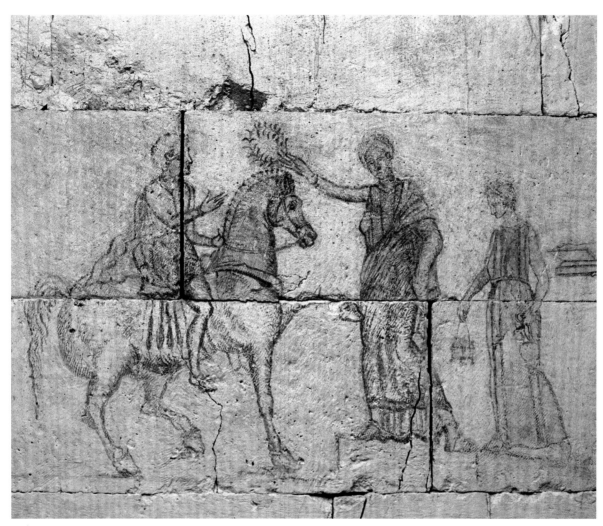

Figure 33. Wall painting depicting a goddess crowning a horseman with a wreath, ca. 275 BC. From the Tomb of Sveshtari, near Sveshtari, Razgrad Province, Bulgaria

usually appear, like the images of Amatokos I and Saratokos at the end of the fifth century BC and later those of Hebryzelmis and Kotys I. This practice could be a propagandistic expression of power, similar to the coins of the Persian satraps,[52] or a reference to a ruler's cult, a common practice after Alexander. Thus, the meaning of "king-god"[53]—that is, a king who is comparable to the gods with honors that exceed the royal dignity—proves to be uncertain. Athenaeus's story about Kotys, who prepared a bedchamber as if he had married the goddess Athena,[54] is a satirical anecdote for an Athenian audience, alluding to the sexual ambitions of the barbarian king but not true ritual.

There is clear evidence for posthumous heroization in Thracian culture.[55] The wall painting in the Tomb of Sveshtari depicts a goddess(?) crowning a horseman with a wreath (fig. 33). He is horned, a sign of

divine rank in Hellenistic iconography.[56] Immortality is a recurring theme in Thracian kingship. Zalmoxis, according to Herodotus, feasted in his *andreon* and taught the chiefs among his countrymen that neither he nor his guests nor any of their descendants should ever die but that they should go to a place where they would live forever and have all good things. The proof was that he himself had returned alive from a three-year stay in the beyond.[57] Similar is the destiny of Rhesos, who, in the words of his mother (a Muse, according to Euripides), will not go "into earth's dark lap down," meaning not enter the kingdom of Hades, but remain "in the caverns of the silver-veined land," as was told in Euripides, referencing Mount Pangaion, where he would become an *anthropodaimon*.[58] This invented word suggests a concept different from Greek heroization, in which human nature is preserved and reinforced with divinity, implying that the transi-

tion would not require passing through death, as promised by the god Zalmoxis. Such an idea of psycho-somatic immortality is attested in Plato's account of a Thracian physician, a follower of Zalmoxis, who said that soul and body must be treated as one, as they were an inseparable whole.[59] The stories of Rhesos and Zalmoxis—the *anthropodaimon* characterized by the unity of body and soul—can in no way be inter-preted as related to the cult of the mythical Thracian singer Orpheus, for the immortal soul in Orphic doctrine was imprisoned in the body and liberated after death.[60] Corporeal immortality can be found in earlier Greek belief, as in the Homeric epics, in which the gods promised Menelaus he would be taken alive to Elysium,[61] or stories of other heroes being brought to the Islands of the Blessed,[62] places at the periphery of the inhabited world. But this notion of corporeal immortality, unlike Thracian beliefs and practice, had become obsolete in the world of the Greek polis, and in Pindar's poems it was replaced by the notion of the immortal soul and its reincarna-tions.[63] These concepts were current in the Thracian royal ideology, mainly among the Getai in the far-away north and up to the time of the Roman invasion, thus presenting a society firmly bound to tradition. As far as the Thracian pantheon is concerned, particularly to the south, in the contact zone with the Greeks, religious ideas were dependent on the society's political fortunes, and we see this in the strong Hellenic influence brought by Greek coloniza-tion and, later, Macedonian conquest.

1 Rabadjiev 2001.
2 Bonev 2003, 77.
3 Bonev 2003, 42–43
4 *Odyssey* 9.197.
5 *Iliad* 13.298–301; *Odyssey* 8.361.
6 Euripides, *Rhesus*.
7 Herodotus, *Histories* 5.7.
8 Herodotus, *Histories* 5.6–7.
9 Herodotus, *Histories* 4.33.
10 Herodotus, *Histories* 4.96.
11 Herodotus, *Histories* 9.119.
12 Parker 1996, 170–74; D. Popov 2010, 66–90.
13 Lykophron, *Alexandra* 938.
14 D. Popov 2010, 55–212.
15 Herodotus, *Histories* 5.3.
16 After Yurukova 1976.
17 D. Popov 2010, 252–54; Rabadjiev 2014, 403–9.
18 Archibald 1999, 437.
19 Mihailov 1989, 56.
20 K. Dimitrov 1989.
21 On coin types, see K. Dimitrov 1989.
22 *IGBulg.* III.1, 1114.
23 Delev 2000, 399.
24 *IGBulg.* III.2, 1731.

25 Rabadjiev 2017.
26 See Marazov 1992.
27 Athenaeus, *Deipnosophistae* 4.7.
28 Marazov 1994. This could explain the "Thracian origin" of Orpheus or Eumolpos as alien to the polis religion; see Rabadjiev 2002.
29 On Orphic ideas, see Fol 1986; on the cult of the Kabeiroi, see Marazov 2011a.
30 For discussion, see Rabadjiev 2002.
31 Xenophanes, frag. 21 B16.
32 Polyaenus, *Stratagems* 7.22.
33 Athenaeus, *Deipnosophistae* 12.531e.
34 *Odyssey* 9.197.
35 Jordanes, *Getica* 10.65.
36 Strabo, *Geography* 7.3.5.
37 Cassius Dio, *Roman History* 54.34.
38 *IGBulg.* III.2, 1732; D. Dimitrov 1957a.
39 Rabadjiev 2018. For the sacred sites of the Thracians, see Domaradzki 1994.
40 Marazov 1978, 60–62, figs. 54–57.
41 Krasteva 2021.
42 An idea of Makiewicz 1987.
43 Pomponius Mela, *De situ orbis* 2.2.21; Solinus, *Polyhistor* 10.5.
44 Plato, *Republic* 327a–328a; *IG* II², 1283.

45 Suetonius, *Life of Augustus* 94.
46 Herodotus, *Histories* 7.111.
47 Macrobius, *Saturnalia* 1.18.11.
48 Marazov 1996b, 265–94.
49 Herodotus, *Histories* 4.94.
50 Herodotus, *Histories* 9.119.
51 Diodorus Siculus, *Bibliotheca historica* 33.14.
52 K. Dimitrov 1987; K. Dimitrov 1988a.
53 D. Popov 2010, 258.
54 Athenaeus, *Deipnosophistae* 12.531e.
55 Here used as a "technical" term since the structure of the Thracian pantheon remains unknown.
56 K. Dimitrov 1988b.
57 Herodotus, *Histories* 4.95.
58 Euripides, *Rhesus* 962–75.
59 Plato, *Charmides* 156e.
60 Rabadjiev 2016.
61 *Odyssey* 4.561–69.
62 Hesiod, *Works and Days* 166–73.
63 Rabadjiev 2016.

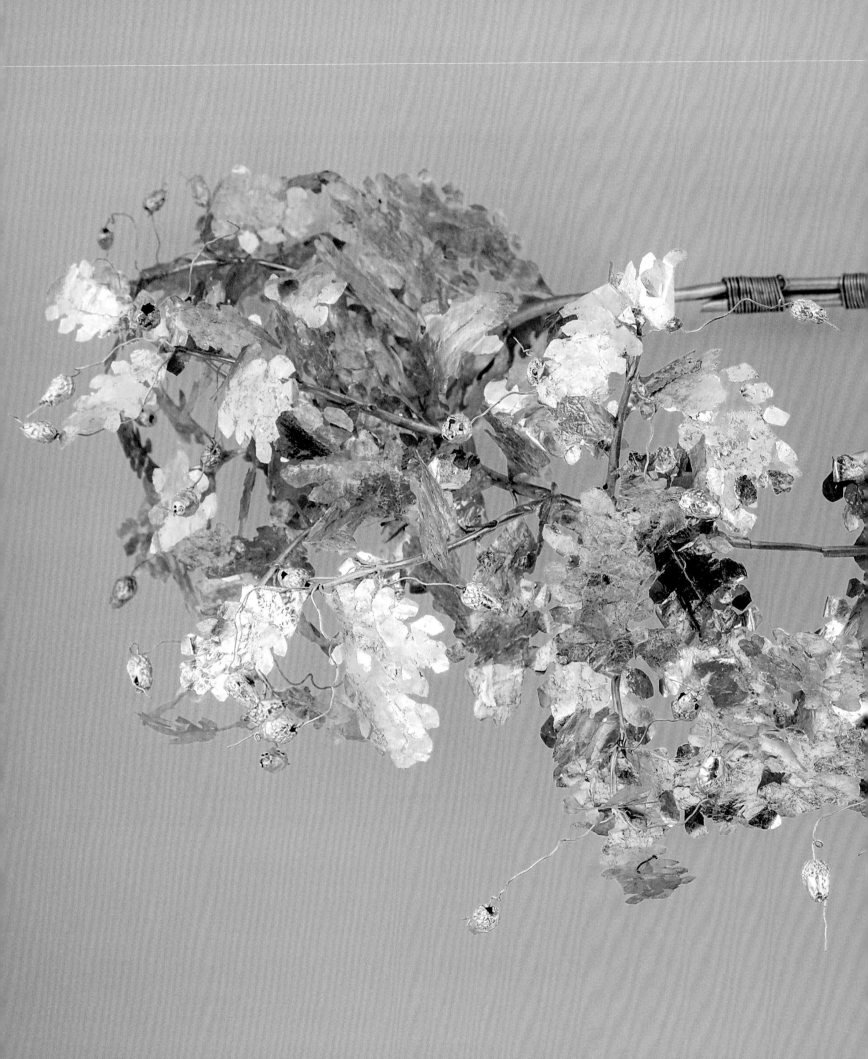

THE GEOGRAPHY OF POWER: PRINCELY TOMBS IN THRACE

TOTKO STOYANOV

Archaeological investigations undertaken between the late nineteenth century and the 1970s have revealed a great deal about Thracian burial structures, their contents, and the ritual practices associated with them. The large (and growing) number of burials containing rich goods among the approximately two hundred monumental tombs discovered thus far necessitated comparisons with tombs in other parts of the Balkans and Europe, conventionally known as "rich" or "princely" tombs or burials. Three phases in burial traditions have been identified that are representative of elite Thracian culture.[1]

In the first period (late sixth to early fourth century BC), the most significant category of grave good is metal (gold, silver, and bronze) and ceramic vases. Kraters, *hydriai*, *situlae*, jugs, *kantharoi*, *kylikes*, *phialai*, *rhyta*, and other shapes constitute the sets used for wine consumption and are similar to examples used in Greece, Macedonia, and within the Achaemenid Persian Empire. The metal vessels are mostly products of major centers in mainland and East Greece, the Propontis region, and Anatolia,[2] and the pottery was imported mainly from Attic workshops.[3] The other major category of grave good is weapons and armor. These were the essential symbols of the heroization of the deceased aristocrat by his community. In addition, personal insignia, such as rings and breast plaques of gold foil, were placed in some burials.[4]

The second phase (second quarter to late fourth century BC) is marked by changes in the burial structures, notably the development of monumental tombs with beehive burial chambers or rectangular burial chambers utilizing various types of coverings, with an entrance, further rooms, and a *dromos* for repeated visits and rituals.[5] Products of local workshops now appear among the metal vases for banquets. There are parallels with the principal silver shapes in the contemporaneous princely tombs in Macedonia (calyx *phialai* and cups, jugs, bolster-kraters, and so on), attesting to the connections between the workshops of the two regions.[6] Local workshops produced luxury horse trappings of distinctive Thracian style, symbolizing the deceased as a horseman-warrior. The tradition of sacrificial burials of one or more horses in the tomb is attested in some burials already in the earlier period. In the second half of the fourth century BC, gold wreaths were adopted as status symbols in both Thracian political life and funerary practice (see cat. 54a). Storing wine in transport amphorae in the princely and aristocratic tombs also became a norm.

During the third period (late fourth to the middle of the third century BC), most of the elements of the previous phase persisted, but new features derived from the Hellenistic lifestyle penetrated local traditions. The building of monumental tombs reached its apogee in this period. These rich burials displaying all

Oak Wreath (detail, cat. 54a)

the elements of elite pomp can justifiably be considered "princely tombs."[7]

The earliest necropolis with male and female princely burials of the first period was a very large one excavated in 1925–31 in the villages of Duvanlii and Zhitnitsa, in the Plovdiv region of Bulgaria, where twenty-five of fifty identified mounds were excavated. In 2000–2003 a survey of the lands around the nearby villages of Chernozemen,[8] Begovo, Pesnopoj, Chernichevo, and Miromir documented numerous plundered tombs. Three tumuli were investigated near Chernozemen, and Tumulus 1 was found intact.[9] Seven groups of tumuli made up a necropolis of the fifth century BC in this vast territory of about one hundred square kilometers. Usually several mounds form a group, with a dominant, larger one containing an elite burial, most often in a sarcophagus-like stone tomb. In some cases the tombs had polychrome decoration. Some, like the Golyamata and Kukova Tumuli, near Duvanlii, are single, without smaller mounds nearby.

This complex is likely an important necropolis of the early Odrysian state, possibly related to the royal family.[10] Three male burials are princely tombs—those in the Golyamata and Bashova Tumuli, at Duvanlii, and Tumulus 1 near Chernozemen. Golyamata is the earliest one (ca. mid-fifth century BC), with the most elaborate and largest tomb chamber (3.9 by 2.1 meters), built of ashlar masonry. The dead warrior's panoply consists of a composite bronze and leather helmet, eight gilded-silver plaques (presumably from a leather corselet), a large sword, and two spearheads. The deceased could feast in the beyond with two silver *kantharoi*, one of them with engraved and gilded figures of Dionysos and his *thiasos*, and a bronze *hydria*. A gold ring with a horseman and two gold pectorals placed on top of the cremated remains suggest their function as insignia of high status.[11]

Of somewhat later date, the tomb at Chernozemen displays even more riches. It contained a well-preserved cuirass with a gilded-silver appliqué of a Medusa head at the center, nine other appliqués,[12] a spearhead, and 211 bronze arrowheads. The banquet set consists of a silver *kylix* with an engraved and gilded composition of Bellerophon killing Chimera, a silver patera-strainer, a rare strainer-*kyathos*, two silver spoons, a bronze *lekane* and a bronze *hydria*, and an Athenian black-figure *hydria*. A large gold pectoral with an embossed scene of five animals around a Medusa head was placed on the chest, along with a gold ring set with a gem and two East Greek *lekythoi*.[13]

The tomb in the Bashova Tumulus surpasses the earlier two in its wealth (cat. 47). Among the finds of armor, imported Attic pottery, and silver and bronze vessels was an elegant silver *rhyton*, the only one in the entire necropolis. It is worth emphasizing that the silver drinking vessels in these three tombs are of exceptionally fine craftsmanship and were likely produced in Attic workshops.

In the fourth century BC a series of necropoleis were built about twenty kilometers to the northwest, in the vicinity of Starosel. Several monumental tombs were investigated, most of them now plundered. They probably belong to individuals from the same branch of the Odrysian dynasty that created the Duvanlii-Chernozemen necropoleis. Most impressive are the two mounds built on a hill dominating the valley. One of the most striking Thracian sepulchral monuments was excavated in the larger Chetinyova Tumulus, which measures 79 by 25 meters and is enclosed with a monumental *crepis*. A monumental *propylon* with a stairway leads to a broad, open vestibule and a rectangular antechamber covered by a truncated corbeled vault. The burial chamber is a *tholos* (5.39 meters in diameter) with vertical walls and ten half-engaged Doric columns that support a complete Doric entablature with an architrave, frieze, and cornice crowned by a dome (with a total height of 7.83 meters) (fig. 34).[14] The tomb is likely that

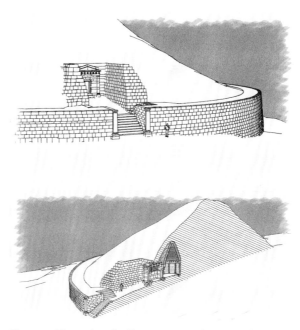

Figure 34. The tomb in the Chetinyova Tumulus, Starosel, Plovdiv Province, Bulgaria. Cross-section and reconstruction of the retaining wall after Ch. Tzochev 2022, fig. 19

of a person of royal status, but the excavator's suggestion of Sitalkes cannot be proven;[15] nor can the alternatives of Kotys I (or his heir).[16] The tomb's architectural details point to the last decades of the fourth century BC.[17]

The man buried in the sarcophagus-type tomb in the nearby Peychova Tumulus of the third quarter of the fourth century BC was perhaps a generation older. His elevated social status is indicated by the rich panoply (bronze helmet, greaves, shield, and scaled leather corselet with a gorget of gilded scales), a set of weapons, banqueting silver (two *phialai*, a jug, and a *psykter*), two bronze *situlae*, a black-glazed *kylix* and a cup-*kantharos*, a red-figure *skyphos* and *pelike*, and three amphorae. Three sets of silver harness appliqués, a gilded-bronze wreath, and a gold signet ring confirm the high rank of the deceased.[18]

The excavations of necropoleis in Bulgaria's Kazanlak Valley in the last few decades have revealed hundreds of burial mounds organized in both larger and smaller groups. A concentration of such groups is evident in the central part of the valley, between the town of Shipka and Koprinka Dam, where Seuthopolis was located.[19] The mapping of the rich burials in the area distinguishes four groups, providing grounds for the hypothesis of the existence of lands belonging to specific families or clans where funerary complexes were established between the second half of the

fifth century and the third century BC. The evidence indicates reuse, secondary burials, and an evolution of usage of the complexes, strongly suggesting that these were family tombs on family plots. Since Seuthopolis was founded after the Peace of the Dynasts in about 313–311 BC,[20] it is probable that the residential seat would have been close to the earlier burials near Shipka.[21]

Four mounds in the necropolis to the north of the village of Kran cover monumental tombs. The earliest is the sarcophagus-like structure in the Svetitsata Tumulus. A massive gold mask and a gold ring with a depiction of an athlete stand out among the rich grave goods. The banquet set consists of a two-handled silver mug, a bronze *hydria*, two Attic red-figure *oinochoai*, and three amphorae. There are two swords, several spearheads, 144 arrowheads, and a bimetallic (bronze and iron) cuirass. The burial belongs to the last quarter of the fifth century BC and is comparable to the warrior's tomb in Tumulus 1 at Chernozemen.[22]

The Ostrusha Tumulus is among the largest in the vicinity (some 20 meters high) and dominates the others around it (fig. 35a–b). An architectural complex without analogue in Thrace so far was discovered in its southern periphery. Two or three construction phases can be distinguished. Initially a monolithic sarcophagus-like chamber with a gable roof was placed on a three-step platform. A stone bed was carved

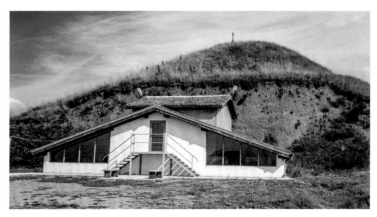
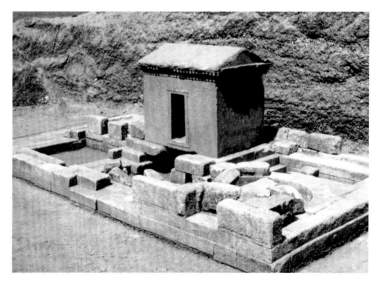

Figure 35a–b. The Ostrusha Tumulus, near Shipka, Stara Zagora Province, Bulgaria

Figure 36a–b. Coffered ceiling and painted detail from the sarcophagus-like chamber of the Ostrusha Tumulus, near Shipka, Stara Zagora Province, Bulgaria

from the northern wall of the chamber. The coffered ceiling, which imitates those of Greek temples and public buildings, preserves painted decoration— portraits, scenes with humans and animals, and floral and geometric ornaments (fig. 36a–b). At a later stage four more burial chambers were added around the sarcophagus, and a rectangular room was built in front of it connecting it to the entrance of the complex. The entire structure was plundered, except for the southwestern chamber, where the original context was partially preserved. No human remains have been reported. A horse skeleton with silver decorations for the bridle, a silver jug, a calyx cup, and fragments of a gorget-pectoral of Mezek type were found. Based on the preserved architectural details and some amphora stamps, the construction phases of the monument

should date to the last quarter of the fourth century BC. Further burials and rituals were probably carried out for at least two or three decades after the first stage of construction and the burial in the sarcophagus, resulting in the transformation of the complex into a *heroon* of Hellenistic type.[23] There are also two other tombs in the group that are later and of more modest design.[24]

The necropolis at Shushmanets, in the northeastern part of the region, comprises six mounds, including a huge one 21 meters high. This impressive monument has a unique design. The access is through a large vestibule with walls of rough-hewn stone leading to an entrance porch with corbeled vault supported by a single Ionic column and crowned with a pediment. An Ionic doorframe surmounted by a pediment

decorated with palmettes leads to the main chamber, a *tholos* with vertical walls and seven engaged Doric semicolumns, carrying an architrave crowned by a dome, supported by a monumental Doric column in the center of the chamber (fig. 37). The columns, the walls and floors of the chamber, and the porch are plastered with lime. The excavator distinguished three layers, suggesting at least three phases in the use of the complex. The remains of four horses and two dogs were discovered, sacrificed on the antechamber floor but without datable material. Remains of arms and armor include a spearhead and pieces of a gorget with gilded-silver scales. A date in the last third of the fourth century BC has been suggested.[25] Undoubtedly this extraordinary tomb was the last abode of a member of the local branch of the Odrysian kings.

Another noteworthy princely burial in this necropolis was the so-called Griffins Tomb, which was added to the southern periphery of an already existing mound (fig. 38). It consists of an unusually large vestibule leading to a monumental facade, a rectangular antechamber with triangular roof, and a beehive chamber (fig. 39). The entrance to the antechamber was given the shape of an *aedicula*, including an Ionic doorframe and pediment with two side *acroteria* and a crowning palmette. There were at least two stages in the construction of the tomb, which may be dated to the Early Hellenistic period.[26]

In the third grouping of tumuli, four mounds were raised close to the Golyama Kosmatka Tumulus, three of which have been excavated completely (Tsvyatkova, Halachova, and Aldinova) and one only partially (Malka Kosmatka). Only Tsvyatkova covered a stone structure with relatively rich furnishings, but a horse skeleton was all that was discovered. Deposits of pottery and gold adornments dating to the middle and the second half of the fourth century BC were unearthed in Halachova and Malka Kosmatka, and Aldinova is empty. These mounds are probably directly related to the Golyama Kosmatka Tumulus and the extraordinary tomb there.[27]

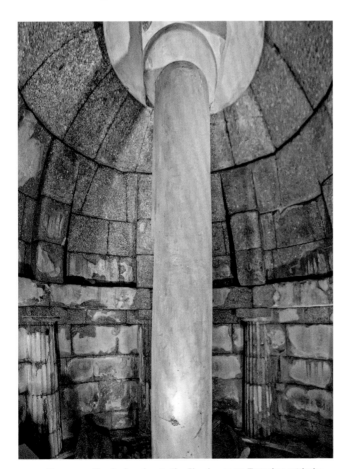

Figure 37. Tomb chamber in the Shushmanets Tumulus, with the central column supporting the dome, near Shipka, Stara Zagora Province, Bulgaria

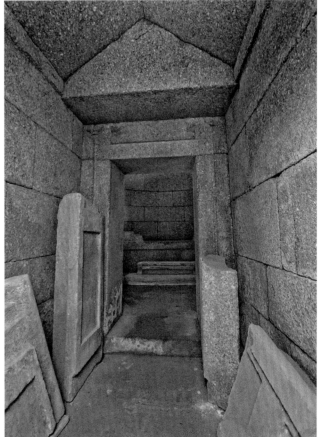

Figure 38. Interior of the Griffins Tomb, near Shipka, Stara Zagora Province, Bulgaria

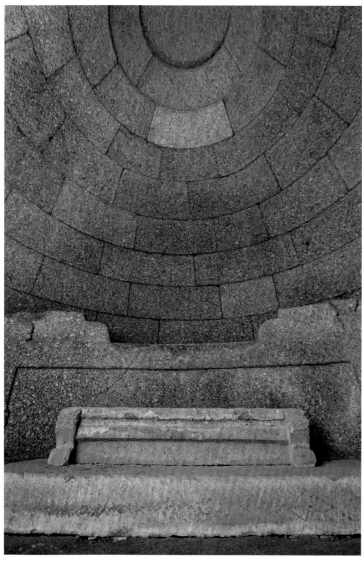

Figure 39. Burial chamber in the Griffins Tomb, near Shipka, Stara Zagora Province, Bulgaria

The important Golyama Kosmatka burial presents special problems of interpretation. The large tomb of unusual design was built in a trench within a huge, already existing tumulus (120 to 130 meters in diameter and 19 to 23 meters high)—the largest in the valley.[28] This fact and the presence of the richest grave goods found thus far in any tomb in Thrace, comprising the key elements of princely pomp, testifies to royal status (cats. 53, 54). The massive gold wreath is the only example with oak leaves found in Thrace and recalls similar wreaths from Tombs II and III in the Great Tumulus at Vergina, in Macedonia. The helmet and the silver calyx cup and jug inscribed with the name Seuthes (in the genitive), as well as the portrait head from a bronze statue with the features of Seuthes III

found at the edge of the mound, prove a clear relationship to the king, who is believed to have died between 300 and 295 BC.[29] There were no physical remains of an old man, suggesting that the burial of the king was only symbolic and that the monument is in fact a cenotaph. Two different dates have been proposed for the complex: the abovementioned period, at the time of the king's death,[30] or later, about 275 BC, suggesting that the cenotaph is a later reburial.[31]

In terms of design and dimensions (25 meters long), Seuthes's tomb resembles the well-known tomb in the Mal-tepe Tumulus, near the village of Mezek, also among the largest in Thrace (14 meters high and 90 meters in diameter). The tomb is 29.95 meters long and consists of a corridor, two rectangular antechambers, and a beehive *tholos* chamber. At least three construction phases were identified, related to some of the burials in the chamber, the antechambers, and the *dromos*. During the second phase, the *dromos* was elongated to 21 meters, a monumental entrance was built, and the mound was enclosed in a massive *crepis* wall some five meters thick. During the last phase, two rooms were built next to the entrance, a bronze statuary group depicting a boar hunt was erected, and the complex was turned into a *heroon*. The tomb was discovered partially plundered, but the inventory attests to the high status of the buried men and women. Various dates have been proposed for the beginning and the end of its construction, from the mid-fourth to mid-third century BC, and the first burial has been tentatively related to a member of the Odrysian dynasty.[32]

In the final grouping of mounds near Shipka, only the Golyama Arsenalka Tumulus, datable probably to the last quarter of the fourth or early third century BC, is a potential candidate for a princely burial. It is a beehive tomb, but the finds are too scanty to allow for further interpretation.[33] The objects in the latest burial of a noble warrior in the Sashova Tumulus date it to about 200 BC, illustrating the continuity of burial traditions in this microregion.[34]

Further to the east, in the Sliven region, two rich tumulus burials in the necropoleis near the villages of Topolchane and Krushare, excavated in 2007 and 2008, along with evidence from the tomb investigated in a tumulus at nearby Kaloyanovo in 1963,[35] present a coherent group of burials of a local paradynasty that lived in the fifth and fourth centuries BC on the eastern periphery of the Odrysian territory.[36] In the Yakimova Tumulus a large stone cairn concealed

a pit (3.6 by 4.9 meters) covered with wooden planks or beams and with a floor of stone slabs. A Thracian aristocrat was buried here with rich grave goods: a golden pectoral intentionally folded in two, vessels of both silver (*phiale*, *kylix*, and *chytra*) and bronze (*oinochoe* and *hydria*), some of them ritually destroyed, an intentionally bent bimetallic (bronze-and-iron) cuirass, weapons (sword, spearheads, and bronze arrowheads), an iron bit, and a bronze front piece from horse trappings. These items and three Attic black-figure *lekythoi* date the burial to the mid-fifth century BC.[37]

The Dalakova Tumulus, where a sumptuous inhumation burial was uncovered in a pit in which a square wooden structure (2.4 by 2.45 meters) was built, contained a rich assortment of grave goods. There were two swords, ten spearheads, several dozen bronze arrowheads in a quiver, an iron scale cuirass with edgings of bronze and silver appliqués, and a unique silver helmet of Chalkidian type. The banqueting vessels comprise two identical fine gold *phialai* of Achaemenid type; a gilded-silver *rhyton* of a type common in Thrace, with the head of a ram and bearing a mythological scene; another silver *rhyton* with a long fluted horn and a protome in the form of a centaur (fig. 40a–b); a silver beaker with fluted body and a palmette at the mouth, partially gilded; and a bronze *oinochoe* and *hydria*. There are two horse bits (silver and iron) and two sets of gold and silver horse trappings. Five red-figure *lekanides* and a red-figure *lekythos* were discovered as well.[38] The stamps on five Thasian amphorae date the burial to about 380 BC or soon after.[39] A gold signet ring with a portrait of a man and the inscription ΣΗΥΣΑ ΤΗΡΗΤΟΣ (its reading is a matter of controversy) led the excavator to identify the deceased aristocrat as the little-known Odrysian king Teres II; later he changed his opinion in favor of an as-yet unknown paradynast (coruler) or Odrysian king.[40] It should be noted that despite the extraordinarily rich inventory, the burial is unlikely to be of a person of Odrysian descent, as the structure displays none of the characteristics of the known Odrysian royal graves and tombs.

Further south, near the village of Zlatinitsa, in the Yambol region, another similar princely burial was found in the Golyamata Tumulus (102 by 82 meters in diameter and 12.4 to 15.5 meters high), which contained a pit in which a rectangular wooden structure (2.7 by 1.55 by 1.5 meters) was built. An opulent selection of objects was arranged around the body of a young man. The armor includes a bronze helmet,

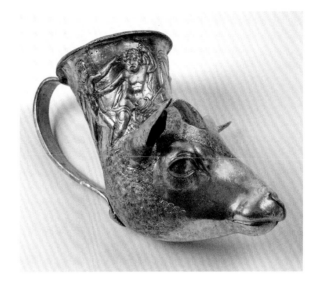

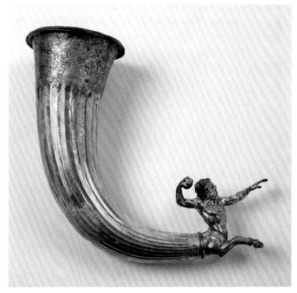

Figure 40a–b. *Rhyta* from the Dalakova Tumulus near Topolchane, Kardzhali Province, Bulgaria. (a) *Rhyton* with a ram's head, late 5th–early 4th century BC. Silver with gilding, H: 16 cm; Diam of rim: 10.1 cm. (b) *Rhyton* with a centaur protome, late 5th–early 4th century BC. Silver with gilding, H: 21 cm; Diam of rim: 9.5 cm. Sliven, Regional Historical Museum, Сл 3369 A, Сл 3372 A

an iron scale corselet with a collar, a lavishly decorated silver greave (fig. 41), and weapons (a *machaira*, seven spearheads, and 177 arrowheads). A banquet set is composed of four silver *phialai*, two silver *rhyta* with hind heads, a bronze *situla*, a *psykter*, a jug, a strainer, and a basin, as well as a black-glaze *kylix*, a red-figure *skyphos* and *pelike*, and four amphorae. There were also seven locally made vessels and an *alabastron*. A gold laurel wreath, a diadem with gold appliqués, and a fine gold signet ring demonstrate the high status of the young warrior. Two sets of silver horse trappings with iron bridle bits in the burial belong to two saddle horses laid just outside the southwestern edge of the tomb. The objects date the burial to the mid-fourth century BC.[41]

Undoubtedly belonging to a person of royal descent on the eve of the Hellenistic period is Tomb II in the Mogilanskata Tumulus, which was excavated in the 1960s in the center of the town of Vratsa. The tumulus contains three distinct tombs built successively over the second and third quarters of the fourth century BC. They all differ in terms of construction from the majority of the tombs in Thrace, which were built of dressed stone blocks.[42] Only Tomb II, dating from the third quarter of the fourth century BC, contained rich offerings (cat. 51). The remains discovered were of a young woman, who was buried with sumptuous gold earrings and other adornments, but the tomb also contained weapons—fourteen iron spearheads and eighty-eight bronze arrowheads— as well as armor, including a bronze helmet and a ceremonial gilded-silver greave, the most finely crafted among those discovered in Thrace, as well as a banqueting set of four silver *phialai*, a gilded-silver jug-*rhyton*, a silver *rhyton* with a pinecone body, two bronze *situlae*, a jug, a bronze *hydria*, a *podanypter*, and a black-glaze *kylix*. Such an assortment of finds suggests that they represent a symbolic burial, or cenotaph, of a high-ranking male, whose remains are missing. The massive gold laurel wreath confirms his princely status.[43] The date of the burial corresponds to the time of the only Triballian king known by name, Syrmos, who fought Alexander the Great in 335 BC. The tomb may have been made for Syrmos himself, or perhaps it served as a cenotaph and a burial place for a member of his family. The inscriptions mentioning Kotys on three of the *phialai* attest to the political relations between the Triballian royal court and the Odrysian king.[44]

At about the same date but located far to the northeast is the princely burial at Agighiol, in the

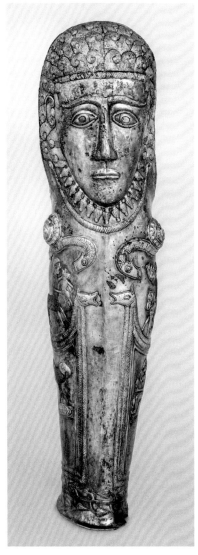

Figure 41. Greave, ca. 375–350 BC. Silver with gilding, H: 21 cm; W: 10.7 cm. From the Golyamata Tumulus, near Zlatinitsa, Yambol Province, Bulgaria. Sofia, National Historical Museum, 50457

northern Dobruja region of Romania (cat. 52). The tomb is thought to be that of the enigmatic *Histrianorum rex*, presumably a Getic ruler who waged war against the Scythian king Ateas, prompting him to seek the help of Philip II, while the latter besieged Byzantion in 340–339 BC.[45] It contained a remarkable set of silver ceremonial armor and a feasting set that brings together two traditions—large beakers of purely local design and four silver *phialai* and one of bronze that combine Achaemenid and Hellenic stylistic features.[46]

Also in the northeast of Thrace, in Bulgaria's Sboryanovo Historical and Archaeological Reserve, is the city believed to be Helis, the capital of the

Early Hellenistic Getic kingdom.[47] Here an extraordinary tomb (the Tomb of Sveshtari) was discovered, built of ashlar masonry in a pseudo-isodomic system with a *dromos*, an antechamber, a main chamber, and a side chamber, each covered by a separate barrel vault, which, in contrast to the practice with Macedonian tombs, was meant to be visible. The tomb has rich architectonic, sculptural, and painted decoration integral to the design of the burial chamber. On the walls, elements of the Doric order were added in relief: four half-columns, entablature, and a Corinthian column engaged in the center of a frieze of ten caryatids, carved in high relief between the columns, stepping on a podium and supporting the entablature (fig. 42a–b). On the lunette above, the centerpiece of the decorative program is painted. A horseman rides to the right to receive a wreath from a woman on a ramp (see fig. 33). He has a ram's(?) horn above his ear,[48] which provides the key to the identity of the ruler for whom this tomb was built. The only Getic king who would dare to be represented as the deified Alexander the Great with Ammon's horn was Dromichaites, who defeated Lysimachos and took him with his entire army to Helis.[49] Unfortunately, the tomb was plundered in ancient times, depriving us of the chance to witness the rich royal possessions of the king and his wife, daughter of Lysimachos.[50]

The composition on the lunette was only drawn with charcoal and was not finished with polychromy, probably because of the ruler's premature death.

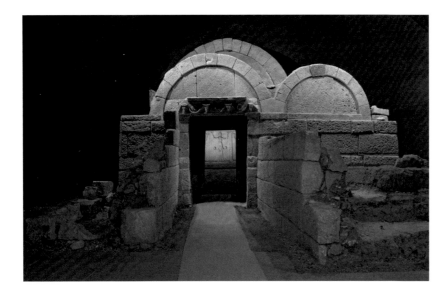

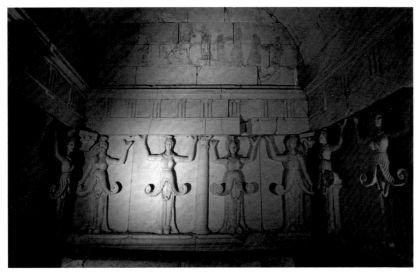

Figure 42a–b. The Tomb of Sveshtari, exterior view and central chamber, ca. 275 BC. Near Sveshtari, Razgrad Province, Bulgaria

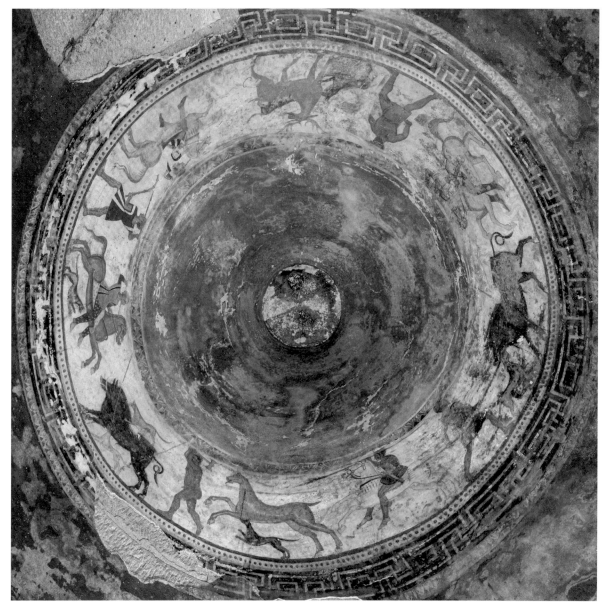

Figure 43. Painted *tholos* ceiling from the Tomb of Alexandrovo, 4th century BC. Near Alexandrovo, Haskovo Province, Bulgaria

Later, next to his funerary couch, the one of his wife was added. The elongated silhouettes, the garments, and the attributes of the women in the scene on the lunette recall some of the painted figures from the ceiling of the *tholos* in the Tomb of Kazanlak (see fig. 50), also dated to about 275 BC, where the entire walls of the chamber and the antechamber are covered with polychrome murals. The main frieze in the *thalamos* depicts a heroic banquet centered on the deceased and his wife, seated according to the Thracian custom,[51] respectively on a *diphros* stool and a throne. The presence of a quadriga and two saddle horses at the end of the procession toward

the aristocratic couple has fueled discussions about the semantics of the scene. The second frieze depicts racing chariots, and the friezes in the antechamber present the encounter of two armies. In both cases, infantrymen meet or fight in the middle, followed by horsemen and foot soldiers.[52] It has been suggested that one of the sons of Seuthes III and his wife could have been buried in the tomb.

Banqueting and military exploits were among the main themes of the painted program of the *tholos* tomb at Alexandrovo, from the late fourth to the early third century BC.[53] The poorly preserved lower frieze in the chamber depicts a feast. The banqueteers are

seated according to the Thracian custom—three men in front of a table, the two at the ends on chairs with backrests, and the one in the middle on a throne with decorated legs and backrest; three standing cupbearers complete the composition, one to the left and two to the right. The first one carries a large silver horn, and the other two, a silver *phiale* and a gold(?) horn. After a missing part, a smaller fragment of the frieze depicts a table (*kylikeion*?) with several metal vases (painted in yellow) on top and under it, and the vague outline of a human figure.[54] The upper frieze in the chamber depicts another popular subject of the funerary art of the eastern Mediterranean, hunting. There are four groups of figures: two boars and two stags, attacked by symmetrically arranged hunters, one on horseback and one on foot, and dogs (fig. 43).[55] The absence of lions suggests an aristocratic but not royal status of the person buried in the tomb. The

fights between cavalrymen and foot soldiers depicted in the *dromos* and the antechamber hint at the military prowess of the deceased nobleman.[56]

The tombs at Alexandrovo, Kazanlak, and Sveshtari exemplify the implementation of established local traditions in the design and decoration of the funerary monuments in Early Hellenistic Thrace and of readily combining them with fashionable architectural and artistic models spread by the Hellenistic koine. The unique designs indicate that the builders and the painters incorporated specific ideas in the construction of the "final abodes" of the members of the Thracian elite. After a heyday of rich burials in monumental tombs in the wake of Alexander the Great's campaigns, the general political and economic trends in the eastern Mediterranean by the middle of the third century BC led to the gradual decline of this phenomenon.

1 Domaradzki 1988; Domaradzki 1997; Archibald 1998, 168–70; Domaradzki 1998a.
2 Valeva 2015; Vassileva 2015, 326–33.
3 Bozkova 2017, esp. 134–37.
4 Marazov 2019.
5 D. Stoyanova 2015.
6 Stoyanov 2007; Stoyanov 2015b; Valeva 2015.
7 Domaradzki 1988, 84–85.
8 In earlier publications, the name of the village of Chernozemen was inadvertently given as Chernozem: for example, Kisyov 2005; K. Kisyov in Martinez et al. 2015, 76–87.
9 Kisyov 2005, 12–15, map II.
10 Tacheva 1994; Archibald 1998, 158; Delev 2014, 181; H. Popov 2017, 473.
11 Filov 1934a, 98–118, figs. 123–41, plates VII–IX.
12 Kisyov 2005, 54–56, plates XIII, XIV.
13 Kisyov 2005, 16–59, plates I–XX; Kisyov 2015.
14 Kitov 2003a, 505–11, figs. 1, 3–8; Kitov 2008, 142–51, figs. 182–97; Tzochev 2021a with an exhaustive study.
15 Kitov 2003a, 511; Kitov 2008, 150–51.
16 Tzochev 2011b, 18; Tzochev 2021a, 159–60.
17 Stoyanov and Stoyanova 2016, 324. The Chian amphora (Tzochev 2021a, 147, 149, fig. 108) is to be dated to the last quarter of the fourth century BC.

18 Kitov 2003a, 511–17, figs. 10–14; Kitov 2008, 161–65, figs. 234–46.
19 Kitov 2005d, 3–5, fig. 1; Stoyanov and Tonkova 2015b, fig. 1, with the list of tumuli.
20 Nankov 2008.
21 At Gradovete locality; see Stoyanov and Tonkova 2015a, 913–19, figs. 2, 3.
22 Kitov 2005c; Stoyanov and Tonkova 2015a, 921–23.
23 Stoyanov and Tonkova 2015a, 923–26; Manetta, Stoyanova, and Luglio 2016; D. Stoyanova and Manetta 2019; Parvin 2022.
24 Stoyanov and Tonkova 2015a, 927–28.
25 Stoyanov and Tonkova 2015a, 929–30.
26 Stoyanov and Tonkova 2015a, 930–31.
27 D. Dimitrova 2019, 66–70, nos. 1–35, figs. 1–18, 23–38.
28 D. Dimitrova 2019, 70–71.
29 For a discussion of the head, see Rabadjiev 2016, 300–301.
30 D. Dimitrova 2015, 220–21.
31 Stoyanov and Stoyanova 2016, 319–22.
32 Stoyanov and Stoyanova 2016, 317–18.
33 Stoyanov and Tonkova 2015a, 940–42.
34 Stoyanov and Tonkova 2015a, 940–42.
35 Chichikova 1969.
36 Map in Archibald 2015, 57.
37 D. Dimitrova 2008b.
38 Kitov 2008, 262–78, figs. 451, 458–62, 467–89; D. Dimitrova 2017.

39 Tzochev 2009, 56, fig. 1, table 1; Tzochev 2016b, table 2, Gr. B.
40 Kitov and Dimitrov 2008.
41 Agre 2011; Agre 2015.
42 Wooden frame combined with walls of rough stones; Torbov 2005, 28–38, figs. 1–3, 5, 6, 11–13.
43 Torbov 2005, chaps. 3–5, catalogue for Tomb II, 96–105, plates IV–XXIII; Torbov 2015.
44 Stoyanov 2017, 19–23.
45 Justin, *Philippic Histories* 9.2.2.
46 Berciu 1969; Trohani 2013.
47 Stoyanov 2022.
48 Chichikova 2012; Palagia 2021, 668–69.
49 Diodorus, *Bibliotheca historica*, 21.12.2–5.
50 Pausanias, *Description of Greece*, 1.9.5–6; Stoyanov 1998.
51 Known from the description of the banquet given by Seuthes II in Xenophon, *Anabasis* 7.3.
52 Zhivkova 1975; S. Miller 2014, 184–85, 197– 98.
53 Stoyanov 2008b, 59–60.
54 Kitov 2009, 38–46, figs. 36–38, 40, 41, 44–46; Valeva 2023.
55 Kitov 2009, 54–79, figs. 55–81, 83.
56 Kitov 2009, 27–35, figs. 31–35, 91, 92.

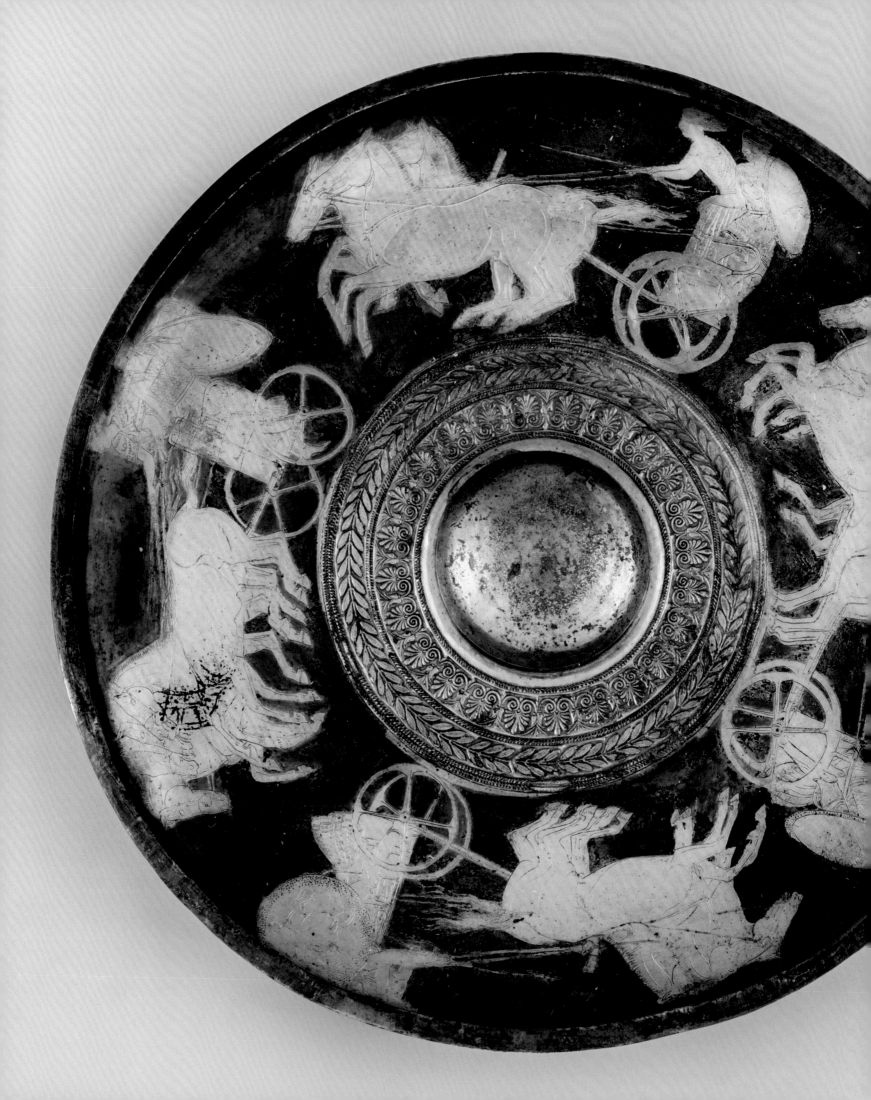

ATHENIAN SILVER VESSELS IN THRACIAN TOMBS

ATHANASIOS SIDERIS

There have been numerous finds of high-quality Greek silverware in Thrace, most examples of which are not only very well preserved but also of exceptional workmanship, with chiseled and gilded figural decoration and Greek inscriptions. This corpus has increased considerably over the past two decades, and now, along with the similar but significantly less numerous examples from Scythian tumuli, constitutes the primary source for surviving Athenian silver. Although such items are often mentioned in ancient Greek literary sources,[1] they rarely appear in temple inventories, aside from those objects that served ritual and ceremonial purposes, such as *phialai* and incense burners.[2] They are conspicuously absent from the archaeological record in Attica itself or anywhere else in Greece, which led some scholars to doubt the existence of the production of such silver objects in Athens during the fifth century BC.[3] The production of luxury silver in Athens is now amply documented, at least from the end of the Greco-Persian Wars (ca. 492–479 BC) onward, by the exquisite pieces preserved in the monumental tombs and burial mounds of the Thracians and the Scythians.

The earliest examples come from the northern and eastern coasts of the Black Sea. A stemmed silver cup from Semibratny (Seven Brothers') Tumulus IV on the Bosporan Taman Peninsula, decorated with a gilded tondo showing a seated Nike pouring a libation from a *phiale*, dates from about 470 BC (fig. 44). The subject and style of the figure recall Attic red-figure pottery immediately after the Greek victories over the Persians. To the same period are ascribed three undecorated silver stemmed cups from Vani and Sairkhe, in present-day Georgia.[4] They are considered Athenian works as well because of their shape, although related types are attested in Ionia during the Archaic period.

Twice as many silver vases of Athenian origin have been found in Thrace as in Scythia and Georgia combined, although the Thracian finds are slightly later in date, first appearing around the middle of the fifth century BC. Unfortunately, the majority of the silver vessels that have come to light in Thrace have no archaeological context, being products of the illegal excavations and looting that took place on an unprecedented scale in Bulgaria during the last three decades.[5] One of the best-known pieces with a documented origin is a silver *kantharos* with figures of Dionysos and a bacchante holding a doe on one side and a satyr and maenad on the other side, found in the Golyamata Tumulus of the Duvanlii necropolis, dated to the middle of the fifth century BC (fig. 45).[6] Relief masks of *silenoi* in a Late Archaic style are placed on the junctions of the handles with the rim of the cup. Their grimacing faces recall those of centaurs from the metopes of the Parthenon. A rare silver

Phiale Mesomphalos with Chariots (detail, cat. 47c)

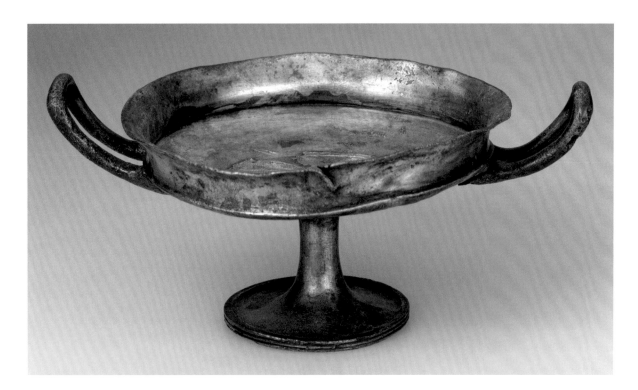

Figure 44. *Kylix* (with detail), Attic, ca. 470 BC. Silver with gilding, H: 6.7 cm; Diam with handles: 16 cm. Found in the Semibratny (Seven Brothers') Tumulus IV, Taman Peninsula, Russia. Saint Petersburg, State Hermitage Museum, SBr.IV.15

amphora of approximately the same period, fitted with a third, swiveling handle and a lid, has stylistically similar masks of Pan on the vertical handle attachments with chiseled and gilded ivy wreaths around the neck.[7] A *kylix* created immediately after the middle of the fifth century shows in its tondo Theseus, labeled by an inscription, holding a club and subduing the Marathon bull.[8] The subject, long popular in Athenian art, received a significant boost with the politics of the Athenian military hero Kimon, who repatriated the

"bones of the hero" from the island of Skyros, erected a temple in his honor, and reinvigorated a preexisting cult.[9] Iconographically this *kylix* may be related to a sculptural group dedicated by the people of Marathon on the Athenian Acropolis, fragments of which have been identified.[10] The episode of Theseus and the Marathon bull is also represented on one of the metopes of the Temple of Hephaistos, dating from the early 440s BC, and it occurs frequently on red-figure pottery of this time, especially on vases by the Polygnotos Group and the Penthesileia, Codrus, and Eretria Painters.[11]

A silver *kantharos* of slightly later date, around the mid-430s BC, displays Theseus, Athena, and Minos on one side and Ariadne, Aphrodite, and the personification of the city of Knossos on the other. All the figures are labeled in Greek, along with Silenos masks on the upper handle attachments,[12] which are nearly identical to those on the Duvanlii *kantharos*.[13] Theseus in particular, with his Polykleitan *contrapposto* pose, and Athena, with her Parthenonian *adlocutio* gesture and collar-aegis,[14] must allude to a famous sculptural prototype, as well as to the pedimental sculpture of the temple of Athena Pallenis, in the Attic countryside.[15] The figure of Knossos is the earliest known personification of a city in Greek art,[16] a concept that may have entered the visual arts in Periclean Athens from the theatrical world, where the chorus expresses its collective voice through the *koryphaios* (chorus leader).[17]

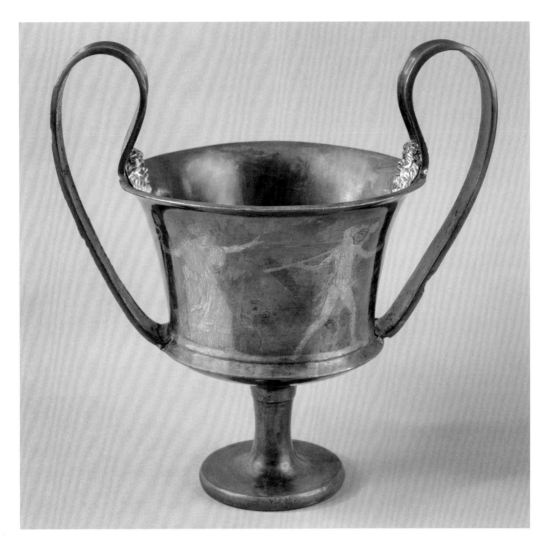

Figure 45. Stemmed *Kantharos* (with details), Attic, ca. 450–440 BC. Silver, H with handles: 25.5 cm. Found in the Golyamata Tumulus, Duvanlii, Plovdiv Province, Bulgaria. Plovdiv, Regional Archaeological Museum, 1634

The episode of Theseus fighting the bandit Skiron appears on a silver *kylix* from a rich grave near Kapinovo, in northeastern Bulgaria, dated to around 430 BC (cat. 12).[18] Using simple chiseled lines, the artist achieved a degree of expressiveness and drama at least the equal of the best red-figure and white-ground Attic vases of the period. The scene is regularly depicted on Attic cups showing the cycle of the Labors of Theseus. It has been suggested that these myths reflect Athenian ambitions to rule

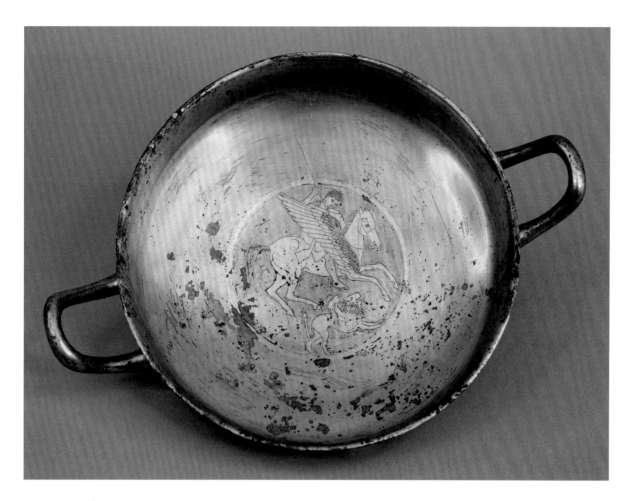

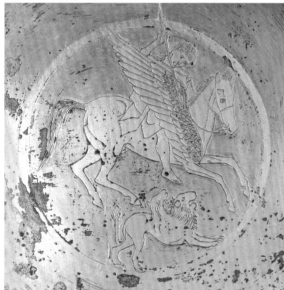

Figure 46. *Kylix* (with detail), ca. 440–430 BC. Silver, Diam of rim: 13.5 cm. Found in a grave in Chernozemen, Plovdiv Province, Bulgaria. Plovdiv, Regional Archaeological Museum, IV–4

the Corinthian Isthmus,[19] but an effort to establish Theseus as a Panhellenic hero seems an equally plausible possibility.

Two nearly identical silver cups with Bellerophon on Pegasos fighting the Chimera, one from a grave of a Thracian nobleman in Chernozemen, near Plovdiv (fig. 46), and the other of unknown provenance, can be dated to about 440 BC.[20] A third cup of slightly earlier date, from Scythian Semibratny Tumulus II, shows the central figure of Bellerophon and the Chimera surrounded by six figures of warriors, meant either as the hero's companions or as the Solymoi of Lycia.[21] The latter were an Anatolian people whom the Greek hero fought, as he did the Amazons, thus providing a powerful anti-Persian symbol to the Athenian iconographic repertoire.[22] The theme survives in late fourth-century BC Thracian metalwork and even later in Hellenistic versions. Epinicus, a third-century BC Athenian poet of the New Comedy, describes a *rhyton* with "Bellerophon on Pegasos spearing the fire-breathing Chimera."[23]

From the Bashova Tumulus in Duvanlii come two more silver vases with chiseled and gilded figures.

The first, a *phiale* dating to about 430 BC, illustrates the athletic competition known as the apobatic race, an equestrian contest specific to Athens, during which a fully armored warrior jumped from a chariot running at full speed (cat. 47c).[24] Around the interior, four quadrigae, each with a charioteer and a hoplite-*apobates*, run counterclockwise, representing various moments of the contest (fig. 47). The hoplites wear a variety of helmets (*pilos*, Chalkidian, and Illyrian) and have shields decorated with emblems, including a centaur, a lion, and a horse (or perhaps Pegasos). A number of parallels for the horses appear on Attic vases, the finest of which are by the Meidias Painter,[25] but no doubt the horses of the Parthenon frieze and its *apobatai* would have been the most influential visual reference for the *phiale*.[26] The second vase from the Bashova Tumulus is a *kylix* with a female figure

on horseback, who is most likely Selene, the moon goddess, although other identifications have been suggested (cat. 47d).[27] It dates slightly later than the *phiale*, and again the figure has close parallels, especially for her billowing mantle and richly ornamented peplos, among the figures painted by Aison and the Eretria and Meidias Painters.[28]

More silver *kylikes* and *kantharoi* of uncertain provenance but allegedly from Thrace, in both museum and private collections, also date to this time and later, the period of the Peloponnesian War (431–404 BC). On one, Peleus is hunting a deer on Mount Pelion,[29] a story known from literary sources,[30] as well as from representations on vases, notably one by the Codrus Painter, which identifies the hero in an inscription.[31] On another *kylix* Hermes visits Helen, presumably to inform her about her "dual"

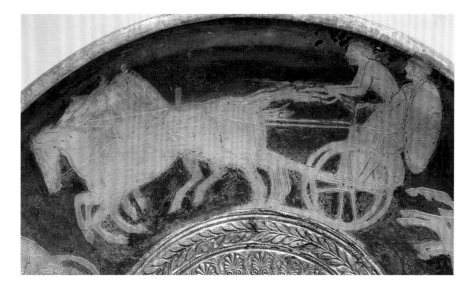

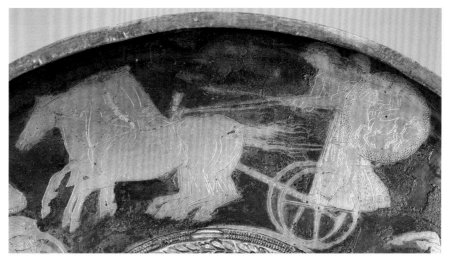

Figure 47. *Phiale Mesomphalos* with Chariots (details, cat. 47c)

fate: only her phantom will follow Paris to Troy, while the true Helen will be sent to Egypt. The theme first appears in the Greek poet Steisichorus, but the myth enjoyed a revival in Athens during the Peloponnesian War, perhaps in connection with the play *Helen* by Euripides, staged in 412/411 BC. A *kalos* inscription praising a certain Athanaion is seen on the small pillar on which Hermes leans.[32] It is notable that Aristophanes, whether reporting a historical fact or making a comical exaggeration, says that the Thracian king Sitalkes had *Athenaioi kaloi* ("the Athenians are handsome") written on the walls of his palace, as proof of his commitment to their cause.[33]

A scene of two men in what appears to be a symposium adorns another cup. Both, however, wear female clothing and the *alopekis*, the typical Thracian cap made of fox skin. One man is seated and holds a kithara, while the other reclines on a couch.[34] Similar compositions in outdoor settings are identified as Orpheus singing to his Thracian companions.[35] The garments and the interior setting are a novelty for such a scene and difficult to interpret. Although the theory is highly speculative, the image may derive from a fragmentarily preserved play, the fifth-century BC comedy *Baptai* by Eupolis, and the men may be priests of the Thracian goddess Kotyto.[36] Alternatively, it has been suggested that the garments, especially the *alopekides*, worn by these figures represent a deliberate attempt by the Athenian artist to "Thracian-ize" Orpheus in the context of Athenian diplomatic policy. Such a supposition implies that the *kylix* was from its conception intended for a Thracian audience, a possibility that is far from certain.[37]

Another episode from the life of Theseus that appears on Athenian silver is his abduction of the young Helen from Sparta, a scene that decorates one side of a stemmed *kantharos*.[38] Theseus left the Spartan princess, who was still too young for marriage, at Aphidnai, in the north of Attica, under the protection of his mother.[39] The theme was well suited to the anti-Spartan feelings in Athens during the Peloponnesian War, of which the last and most dramatic phase, ironically, took place in Dekeleia, an Athenian fort very close to Aphidnai. According to Herodotus, the inhabitants of Dekeleia were treated well by the Spartans in honor of a local man who led the Dioskouroi to Aphidnai when they were searching for their sister Helen.[40] The other side of the *kantharos* shows the Thracian women killing Orpheus, who is named in an inscription.[41]

On another *kantharos*, Helen meets Paris, guided by winged Himeros and Aphrodite. This scene is paired with Hermes's "annunciation" to Helen, although in a different composition from that on the cup with the *kalos* inscription.[42] Both vases, however, were created in the same workshop, probably by the same artisan, as suggested by some identical details, such as the distinctive shoes with a rosette above the ankle worn by both Helen and Aphrodite. This *kantharos*, like the previous one, must date to the middle years of the Peloponnesian War and represents not only one of the most beautiful achievements of Athenian metalwork but also one of the more accomplished expressions of the Classical aesthetic ideal. A third *kantharos* of the same class shows a sacrifice on both sides.[43] In a typical procession to the altar, six people lead a sacrificial ram.[44] Behind the altar, Hermes in epiphany assists the sacrifice offered to him. There is abundant testimony regarding the cult of Hermes in Athens, including references to the bronze statue in the Agora (*Hermes Agoraios*), the famous herm by the sculptor Alkamenes at the entrance to the Acropolis (*Hermes Propylaios*), and the gymnasium in Kerameikos, which bore his name.[45] The composition on this *kantharos*, which departs from all other images seen thus far, may refer to some kind of atonement in the aftermath of the major political scandal of the Hermokopidai affair (the vandalizing of herms in the streets of Athens) in 415 BC, which cast its shadow over aristocratic and wealthy Athenians, the very families who would use this kind of luxury silver.[46] Another *kylix* shows in its tondo a bearded, barefoot rider wearing a short *chiton* and an *alopekis*.[47] Since he does not resemble the figures of Thracians known on the Athenian red-figure pottery of that time,[48] he is probably a Thrakophoites, a Greek who spent a long time in or traveled often to Thrace.[49]

Finally, some vases dating from the end of the fifth century BC, found in Thrace (and at least one in Scythia) and bearing chiseled figurative scenes, show some deviation from the Athenian norms either in shape (notably *rhyta*) or in style and subsidiary iconographic details.[50] One of them is a tall *rhyton* terminating in a goat protome and bearing on the neck a frieze with three Thracian women attacking Orpheus.[51] A comparison with the same scene on the *kantharos* discussed above makes evident that the *rhyton* belongs to the distinctive output of a workshop probably run by Athenian immigrants in a Greek colony, with Abdera the most likely location.[52] Another vase from this workshop, clearly inspired by an Athenian model,

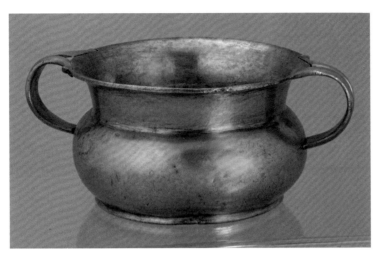

Figure 48. Mug with two handles, probably Attic, ca. 430 BC. Silver, H: 5.5 cm; Diam of rim: 10 cm. Found in the Svetitsata Tumulus, near Shipka, Stara Zagora Province, Bulgaria. Sofia, National Archaeological Institute with Museum, 8956

is a *phiale* with a chiseled and gilded Amazonomachy, some figures of which are derived directly from the Amazonomachy on the shield of the gold and ivory statue of Athena Parthenos by the sculptor Phidias.[53] This Theseus-related subject may have been inspired by other Parthenonian models as well, which are reflected in contemporaneous vase painting.[54] Some undecorated silver vases have also been found in Thrace; their Athenian origin is suggested by the similarities in shape to Attic black-glaze ceramics. These include a ribbed one-handled mug from the Bashova Tumulus in Duvanlii (cat. 47e);[55] two plain-surface mugs, one from the village of Dalboki, in southern Bulgaria, and the other of unknown provenance, both bearing the same graffito, ΣΚΥ, on the bottom;[56] a *kylix* from the Yakimova Tumulus;[57] a *kantharos* from the Golyamata Tumulus in Duvanlii;[58] and several cup handles and a two-handled mug with bilobed handles from the Svetitsata Tumulus (fig. 48), which has close parallels in clay from the agora of Athens.[59]

The figurative scenes on the main group of silver vessels found in Thrace leave no doubt as to their Athenian origin. The presence of a *kalos* inscription and the apobatic race and especially the recurrent presence of Theseus also confirm Athens as a source. The works date to the second half of the fifth century BC, and their subjects, though varying, reflect Athenian state ideology and the political propaganda of Athenian hegemony. A second group, which I attribute to a colonial workshop run by Athenian craftsmen or under strong Athenian influence, shows many similarities in iconography and style, but one

can discern a slight shift in spirit reflected in the details of execution.[60] The workshop is difficult to locate precisely. The vases, all dating to the end of the fifth or the beginning of the fourth century BC, could have been created in any city with favorable conditions for Athenian immigrant artists. Amphipolis would have been ideal had it not been captured by the Spartan general Brasidas in 424/423 BC, that is, before any of the colonial vases can be dated. Abdera is a more likely alternative. Nymphodoros of Abdera was an Athenian *proxenos* to the Odrysian king Sitalkes, who was also his brother-in-law, and Abdera probably remained on good terms with Sitalkes's successor, Seuthes I. The city, twice colonized from Ionia and open to trade with the Thracians, presents the ideal conditions for being the production center of this group of vases, which are characterized both by their distinctive Ionian elements and the *realia* of Thracian life incorporated into their imagery (such as women with short hair, the use of *rhyta*, and deer hunting on horseback). Such features go beyond the typical and rather superficial Thracian elements (such as the *alopekis*) found on the vases of the main group made in Athens.

All the vases discussed here were intended for use in the symposium. Those imported from Athens include *kylikes*, *kantharoi*, *phialai*, and some undecorated mugs, while vessels made in the colonial workshop comprise some of the same shapes, as well as *rhyta*. Until the recent discoveries, such precious-metal vessels of fifth-century BC date were very rare. Of the twenty-seven silver examples now known, decorated or not, that have been found in Thrace,

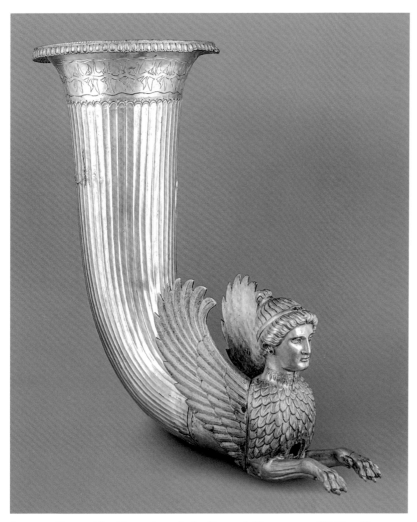

Figure 49. *Rhyton* with sphinx protome, Ionian/Propontic(?), ca. 400–350 BC. Silver, H: 21.5 cm; Diam: 10.7 cm. From the Borovo Treasure, Ruse Province, Bulgaria. Ruse, Regional Museum of History, II 358

only twelve come from documented excavations. All of these are from monumental tumuli and none from hoards, like the well-known examples of fourth-century BC date from Borovo (fig. 49), Rogozen (cat. 60), and Panagyurishte (cat. 59). Sometimes the works are older than the burials in which they were found, even decades older. This phenomenon is not uncommon and is attested in many finds from Greece and elsewhere, with burials one or two generations later than the time of production and in exceptional cases up to two or more centuries later.[61]

Were the Athenian silver vases found in Thrace made specifically for the Thracians? There is little evidence to support such a hypothesis, nor is there any reason to suggest such an intention, at least not for the majority of them. Their shapes are Attic—the *rhyton* entered the repertoire only with

the colonial group. Their style and imagery are also Athenian, often inspired by the monumental arts, judging from comparisons with sculpture, although they might have been even closer to large-scale paintings, which do not survive. There are also clear stylistic and thematic connections with specific vase painters, such as the Codrus, Shuvalov, Eretria, and Meleager Painters, Aison, and the Meidias Painter and his circle.[62]

The themes are also typically Athenian: the national hero Theseus; Bellerophon, perhaps with anti-Persian connotations; the *apobates* competition; Helen as an elusive cause of war; and a sacrifice to Hermes, possibly inspired by a contemporary political scandal. None of these scenes are relevant to the Thracians. In addition, a certain Athanaion is named *kalos* in a carefully executed inscription,

certainly from the maker's hand. Although Orpheus is the Thracian hero cherished by Athenian culture, he was not necessarily viewed as such by the Thracians and is noticeably absent in native Thracian art.

In the finds from Thrace, the Theseus and Helen legends are the most popular, following a trend apparent throughout the Athenian artistic output of the second half of the fifth century BC, including monumental sculpture and pottery. A gradually increasing taste for "Thracian" themes is observed only toward the end of the fifth century BC, after the establishment of a new production center for silverware somewhere in the northern Aegean. Only four of the thirty-three Athenian silver vases with figural scenes have what might be considered "Thracian" themes, however. These include the three depictions of Orpheus and two with men wearing the *alopekis* (the five depictions represent only four vases—one contains both subjects). Yet these examples reflect only the way the Greeks themselves labeled stories rather than how they were perceived by the Thracians.[63] The majority of the silver vessels with figural decoration of this class were in all probability commissioned by Athenian citizens from Athenian workshops for private use. They were not intended for public display and use, as we may surmise from their total absence in the otherwise extensive and detailed inventories of the Hekatompedon, the Opisthodomos, and the Erechtheion on the Acropolis.[64]

These vases do not survive in large numbers because the funerary customs of the Athenians and of most southern Greeks did not permit the burial of valuable objects, unlike the practices of the Macedonians, Thracians, and Scythians. Virtually all Athenian silver was at some point melted down to produce new luxury items or simply to mint coins, and the few items that survive did so because of the northern neighbors who placed the vessels in tombs. Some of them, especially those decorated with Theseus legends, may have been state commissions because they most clearly expressed the Athenian state's propaganda and served its geopolitical ambitions. Drinking vessels originally made for private Athenian symposia could also have passed to state ownership by means of purchase, confiscation, or even private initiative and donation and then become diplomatic gifts, accompanying the many embassies to the north. In this way, Athenian silver traveled to the Odrysian kings and Thracian and Scythian nobles. One cannot exclude the possibility that gifts were presented by private individuals as well, in view of the favorable trade agreements with the Thracians for the exploitation of mines, forests, and cultivable lands.

The conspicuous absence of Athenian silver objects from the Macedonian graves of the fifth century BC came to an end with the recent identification of two fragmentary examples from Aigai.[65] Their rarity in Macedonia compared to their relative abundance in Thrace may be imputed to some sort of latent hostility between Athens and the expanding Macedonian kingdom, however, rather than to a difference in taste or funerary practices.[66]

It is more difficult to understand the reception of such objects by the Thracians. Did they value them primarily for their precious metal? Certainly not, since there is enough evidence that the Thracian kings and nobility possessed considerable wealth, at times comparable to that of the Athenian state.[67] Did they understand or interpret the images on their own terms? Possibly, but the absence until the late fourth century BC of local versions of Greek mythological imagery, which even then appears only rarely, may indicate that the Thracians did not care much for interpreting these images from their own mythological perspective. These sumptuous and "exotic" artifacts were valued for their unparalleled craftsmanship, for their fine design and intriguing subject matter, and ultimately for their capacity to render the Thracian aristocracy conversant with the cultivated Greek world through the adoption of its high-end products.

The study of Athenian luxury metalwork has long been neglected both because of the scant evidence and the belief that *tryphē* (luxury) and *thambos* (astonishment) had no place in the idealized construct of Athenian democracy. Also, Athenian funerary practice did not help preserve these exceptional artistic products for the archaeological record, despite the literary references. Expansionist Athenian policy in the years after the Greco-Persian Wars, followed by the increasing insecurity before and during the Peloponnesian War, led Athens to seek allies in the north to secure access to the resources they controlled, primarily timber for shipbuilding. In the process, Athenian silver vases offered as diplomatic gifts became fashionable among the Thracian nobility and played an instrumental role in establishing friendly relations and concluding profitable agreements. Thanks to the Thracians we gain a glimpse of an exceptional and otherwise vanished body of art, which translates the philosophical and aesthetic aims that characterize Classical art into small-scale luxury works.

1 A wide collection of sources can be found in Vickers and Gill 1994, esp. 35–43, 55–70.

2 Harris 1995.

3 Boardman 1987, 287; Williams 1991, 106.

4 Gorbunova 1971, 20, fig. 1.5; Brijder and Stibbe 1997, 26, figs. 6, 7; Trofimova 2007, 219, no. 119; Kacharava and Kvirkvelia 2009, 134, 150, plate 15.

5 Similarly in Greece, Italy, and Turkey: Adam-Veleni 2012; Boyadzhiev, Popov, and Chukalev 2018.

6 Filov 1934a, 106–11, no. 4, fig. 132; Marazov 1998a, 149, no. 78.

7 Marazov 2011b, 134–35, no. 98 (misdated); Sideris 2016, 118–20, no. 151.

8 Sideris 2015, 17–20, figs. 8–12; Sideris 2016, 130–33, no. 57.

9 Pausanias, *Description of Greece* 1.17.2; Philochorus in *FGrH* 328 F18a; Plutarch, *Kimon* 8; Den Boer 1969, 11–12; Davie 1982; Shapiro 1992, 47; Walker 1995, 20–24, 55–61; Gouschin 1999, 173.

10 Pausanias, *Description of Greece* 1.27.9; Shapiro 1988.

11 Metopes: Boardman 1985, fig. 111, South 3; Rolley 1999, 104–5. Red-figure vases: Moon and Berge 1979, 194–96; Brommer 1982, plate 14.1; Lezzi-Hafter 1988, plate 36c; Boardman 1989, figs. 164, 240, 292.3.

12 Sideris 2015, 20–30, figs. 13, 14, 17–23; Sideris 2016, 134–41, no. 58.

13 Sideris 2021, 366, fig. 58.12 (only one mask preserved).

14 *Adlocutio* is a pose named after the representations of Roman emperors and generals addressing the army, which consists of a *contrapposto* position of the legs and a raised right arm. The pose, however, first appears on the Parthenon frieze.

15 Stewart et al. 2021, 541–50, figs. 8, 9, 11–13.

16 Shapiro 1993; Stafford 2000; Borg 2002; Messerschmidt 2003; Stafford and Herrin 2005; A. C. Smith 2011.

17 Paxson 1994, 8–15, 82–88; Sideris 2016, 40.

18 Marazov 1998a, 174–75, no. 104; Sideris 2015, 31–32, figs. 25, 26. In his entry in this volume (cat. 12), R. Stoychev identifies Theseus's opponent as the bandit Periphetes. On the problematic identification of scenes with Sinis, Periphetes, and Skiron, see Iozzo 2014 and the testimony of Plutarch, *Theseus* 8.

19 Walker 1995, 42.

20 Kisyov 2005, 45–48, plates 10, 11; Sideris 2016, 152, fig. 62.b (unknown provenance).

21 Gorbunova 1971, 23–26, 30, figs. 2, 6, 7; Sideris 2015, 61, no. 3, fig. 68.

22 *Iliad* 6.184–86; Pseudo-Apollodorus, *Bibliotheca* II.3; Ovid, *Metamorphoses* IX.646.

23 Epinicus, *Hypoballomenai*, after Athenaeus, *Deipnosophistae* XI 497 b: "περί δὲ τοῦ τρίτου λέγων φησίν· ὁ Βελλεροφόντης ἐστίν ἀπό τοῦ Πηγάσου τὴν πύρπνοον Χίμαιραν εἰσηκοντικώς." Fol 1989b, 192–95, no. 162.

24 Filov 1934a, 63–65, plate 4; Marazov 1998a, 138, no. 64. On the apobatic race, see Theophrastus, after Harpocration s.v. ἀποβάτης.

25 Boardman 1989, figs. 202, 243, 287 (Meidias Painter), 329.

26 Boardman 1985, figs. 96.7, 96.11; Rolley 1999, figs. 78, 79, 84; Sideris 2015, 63.

27 Filov 1934a, 65–66, plate 5; Marazov 1998a, 181, no. 116.

28 Boardman 1989, figs. 233, 285–87, 292.1, 300.

29 Marazov 2011b, 72–73, no. 51; Sideris 2015, 14–16, figs. 1–5; Sideris 2016, 144–45, no. 60.

30 Pindar, *Nemean* 4.29, 5.26; Pseudo-Apollodorus, *Bibliotheca* 3.12.7; Zenobius, *Proverbs* 5.20.

31 Shapiro 1994, 101, fig. 67; Avramidou 2011, 39–40, 108–9, plate 8b.

32 Marazov 2011b, 68–69, no. 49; Sideris 2016, 146–48, no. 61. For the literary sources, see Steisichorus, frag. 32 Bergk; Euripides, *Helen* 605–16, 670–85. On *kalos* inscriptions, see Lissarrague 1999. On the survival of the name Athanaion in Thrace, see the stele from Mesembria (cat. 24).

33 Aristophanes, *Acharnians* 144; Slater 1999, 144, 151–52. See, however, an alternative explanation by Lear 2008, 164–66; Sideris 2016, 148n19.

34 Marazov 2011b, 70–71, no. 50; Sideris 2016, 149–51, no. 62.

35 *LIMC VII* (1994), s.v. "Orpheus," 84–85, nos. 7–16, 22–26 (M.-X. Garezou); Desbals 1997, 179–92; Tsiafaki 1998, 77–93.

36 Avramidou 2019, 130–31.

37 Marazov 2013, 221–22; Sideris 2015, 78–79. Orpheus was represented predominantly in Greek attire at least until the mid-fifth century BC: Pausanias, *Description of Greece* 10.30.6; Tsiafaki 1998, 90.

38 Marazov 2011b, 79–82, no. 53 (misidentified); Sideris 2015, 39–40; Sideris 2016, 154–59, no. 63. For a bronze plate with a relief plaque on the handle attachment showing Theseus and the bandit Sinis, see Agre 2011, 163–67, figs. V-32, V-33; Sideris 2022, 325, fig. 4.

39 Diodorus Siculus, *Bibliotheca historica* 4.63; Pausanias, *Description of Greece* 1.18.5, 1.41.5; Plutarch, *Life of Theseus* 31; Pseudo-Hyginus, *Fabulae* 79; Pseudo-Apollodorus, *Epitome* 1.24.

40 Herodotus, *Histories* 9.73. For a slightly different account that places the events in the Academy neighborhood of Athens, see Plutarch, *Life of Theseus* 32.2–3.

41 Schoeller 1969, 55–59; Matheson 1995, 231; Mannack 2001, 90. According to Schoeller's classification, the composition belongs to his second class, in which Orpheus holds the *chelys* lyre above his head in an attempt to protect himself from the attacking women.

42 Marazov 2011b, 74–78, no. 52; Sideris 2016, 160–65, no. 64.

43 Sideris 2021, 198–204, no. 240.

44 Van Straten 1995, 13–45; Bundrick 2014, 656–60. Gebauer (2002, nos. P 1–148, A 1–23) differentiates between the procession scenes and those showing the preparatory rituals, but here we have a combination of both.

45 More statues of Hermes are mentioned in the temples of Eumenids and of Athena Polias. Pausanias, *Description of Greece* 1.2.5, 1.15.1, 1.22.8, 1.27.1, 1.28.6; Rolley 1999, 144–45, 181–82, figs. 130–32; Stewart 2003; Palagia 2009, 26–33.

46 Osborne 1985; Winkler 1990; Wohl 1999; Hamel 2012; Rubel 2014, 74–98.

47 Sideris 2016, 151, fig. 62.a; Tiverios 2019, 198, fig. 8.

48 Tsiafaki 1998, figs. 1a, 2–3a, 21–23, 25, 27, 60–61a; S. Padel-Imbaud in Martinez et al. 2015, 48–49, no. 13, and 51, no. 15; R. Georgieva in Martinez et al. 2015, 50, no. 14.

49 Sears 2013, 1–4. See also Sears in this volume.

50 Marazov 2011b, 57–58, 62–67, nos. 45, 47, 48; Sideris 2015, 71–74; Sideris 2016, 172–82, nos. 67–69. For a silver *karchesion-kantharos* from the Solokha Tumulus in Ukraine with prenuptial scenes of the female quarter reminiscent of those on the *epinetron* of Eretria, see Mantsevich 1987, 86–88, no. 60.

51 Marazov 2011b, 65–67, no. 48; Sideris 2016, 177–79, no. 68.

52 Sideris 2015, 78; Sideris 2022, 329, 332, 335.

53 Marazov 2011b, 57–58, no. 45; Sideris 2015, 40–43, figs. 37–42 (especially fig. 40); Sideris 2016, 181–82, no. 69.

54 Such as one of the western metopes: Dörig 1982, 193–95, figs. 4–6.

55 Filov 1934a, 67–68, fig. 84; K. Kisyov in Martinez et al. 2015, 239, no. 196.

56 Filov 1930–31, 50, 54, no. 3, fig. 36.10; Vickers, Impey, and Allan 1986, plate 1; Sideris 2016, 142–43, no. 59. The same graffito, obviously from the same hand, appears again underneath the bottom of the Bellerophon *kylix* from Chernozemen (see fig. 46). The shape is also attested in bronze from the Bashova Tumulus: Filov 1934a, 70–71, no. 8, fig. 88.

57 D. Dimitrova 2008b, 224, fig. 7; Sideris 2015, 74, no. 2, fig. 97.

58 Filov 1934a, 110–11, 209, fig. 135, plates 8.7, 8.8; Sideris 2015, 74, no. 6, fig. 98.

59 Sparkes and Talcott 1970, 252, nos. 228–30, fig. 3, plate 11; Kitov 2005d, figs. 83, 86; Sideris 2022, 330, fig. 10.

60 Sideris 2015, 60, 71–73.

61 Sideris 2000, 28–29; Reiterman 2016, 59–61, 65, 86–87; Sideris 2020, 111.

62 Sideris 2016, 132, 139–40, 145, 164; Avramidou 2019, 131–32; Tiverios 2019, 196–202.

63 The numerous representations of Thracian heroes on Attic red-figure vases are conveniently assembled by Tsiafaki 1998, but neither those vessels nor the vases with representations of Greek heroes were popular in Thrace itself: Sideris 2015, 13–14, 78–79, 85 table 1; Sideris 2022, 337–38. See also Tsiafaki in this volume.

64 The inventories document various silver and gold shapes, including mainly *hydriai*, *thymiateria*, *oinochoai*, and *phialai*. There are as well a few drinking cups, but all of them are undecorated. For comparison, even the feather-shaped ornamental motifs on a *phiale* are noted in the inventories: Harris 1995, 44–49, 58–61, 66–76, 99–101, 151–79.

65 A *kylix* handle and a Silenos mask from a *kantharos* come, respectively, from graves K1/1989 and 2/2013, and they are under publication by the author. Silver vases were already known in Late Archaic Macedonian graves, but they are all of Ionian and local manufacture: Despoini et al. 2016, 249–63, nos. 308–13, with further references to similar finds from Aigai, Archontiko, and Trebenishte.

66 On Athenian-Macedonian hostility in the fifth century, see Zahrnt 2015, 37–43; Karathanasis 2019, 720–26.

67 Porozhanov 2021, 296–97.

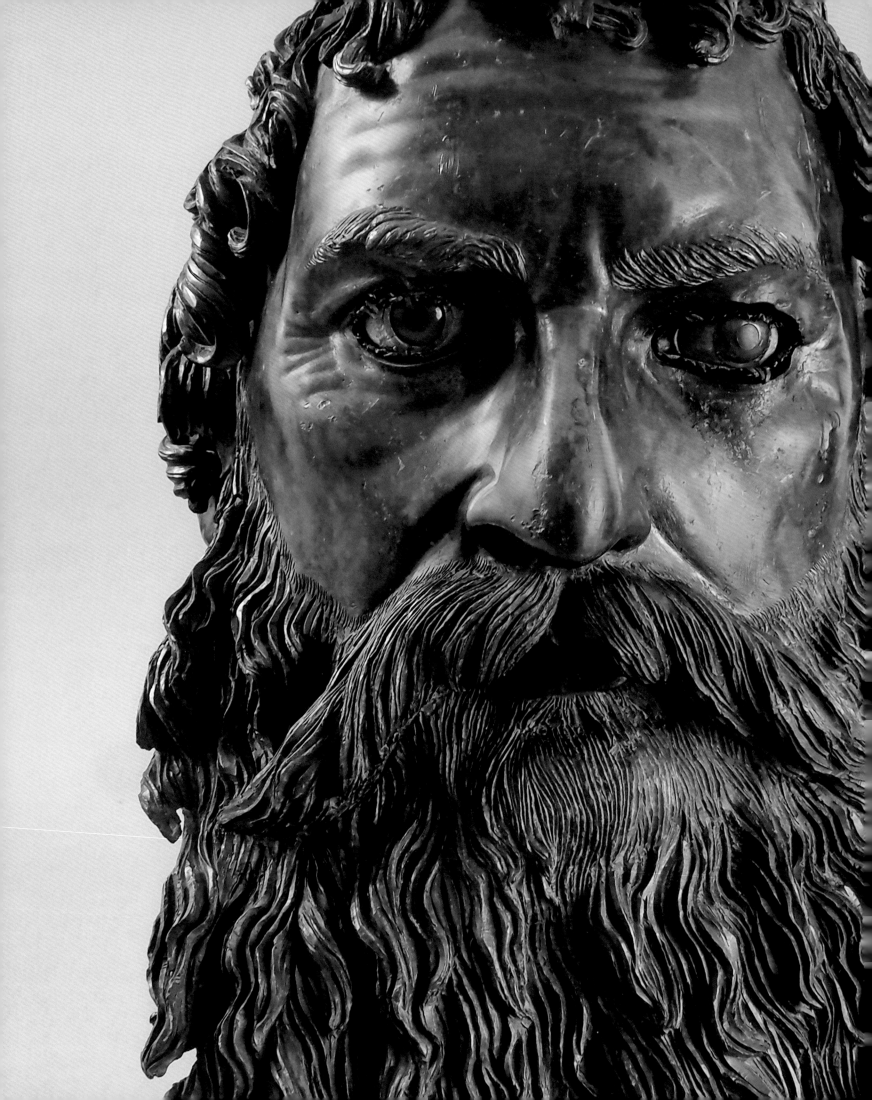

THE POLITICAL HISTORY OF THRACE IN THE HELLENISTIC PERIOD
340 BC–ca. AD 46

PETER DELEV

The political history of Hellenistic Thrace after the Macedonian invasion is poorly preserved in the literary tradition, and the archaeological, numismatic, and epigraphic data cannot remedy this unhappy situation or provide a continuous historical reconstruction. The period has not been a favorite of modern scholars either; the only two attempts at more substantial overviews belong to Christo Danov and Margarita Tacheva.[1]

The Macedonians seized some lands inhabited by Thracians as early as the seventh century BC, when they descended from Upper Macedonia into the area east of the lower Haliakmon River, where their first capital, Aigai, was established in the northern foothills of Mount Olympos. One of their early acquisitions was the adjoining coastal plain of Pieria, a region inhabited until then by Thracians, among whom the legendary Orpheus was believed to have lived in much earlier times.[2] In the second quarter of the fifth century BC, after the departure of the occupying Persians, Alexander I of Macedon secured further Thracian territory in Mygdonia, Krestonia, and the Chalkidike Peninsula across the Axios (Vardar) River.[3] It was not until more than a century later, in the turbulent years of the reign of Philip II (359–336 BC), that the appropriation of Thracian lands gained momentum. Soon after his accession to the Macedonian throne, Philip seized Amphipolis, on the Strymon River, and established Philippoi (Philippi) further east,

in effect conquering much of the territory between the lower Strymon and Nestos Rivers. It took another fifteen years, several resolute military campaigns, and a protracted final war (342–340 BC) before Philip could claim full victory over the Odrysian kingdom.[4]

The results of Philip's invasion in Thrace are often overestimated by modern historians. Even south of the Haimos Mountains, large areas remained outside the sphere of direct Macedonian domination. Two good examples are offered by the "independent Thracians" of the Rhodope Mountains and the Agrianes on the upper Strymon River, who were Macedonian allies, not subjects, and were ruled by their own king.[5] No effective Macedonian control was established over the lands in the north. A part of the Getic tribes in the northeast under King Kothelas became Philip's allies,[6] while the tribe of the Triballoi defeated the Macedonian army in 339 BC, appropriating the booty from the campaign of Philip against the Scythian king Ateas.[7] Later, in the first major military campaign of his reign, Alexander the Great (336–323 BC) failed in his attempt to conquer the Triballoi and finally concluded a treaty with their king, Syrmos, and his neighbors, forming a set of alliances in the Thracian northwest in 335 BC.[8]

Direct Macedonian rule was, however, imposed over the former territory of the Odrysian kingdom in southern Thrace. Diodorus Siculus mentions the

Portrait of Seuthes III (detail, cat. 53)

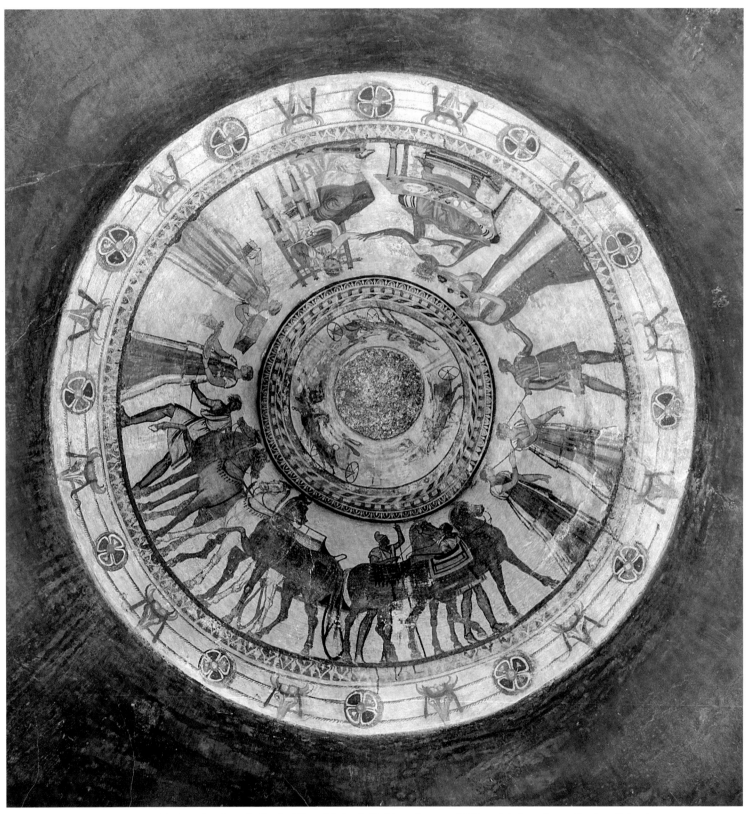

Figure 50. Painted *tholos* ceiling from the Tomb of Kazanlak, first half of the 3rd century BC. Kazanlak, Stara Zagora Province, Bulgaria

The Political History of Thrace, 340 BC–ca. AD 46

93

imposition of a tithe and the establishment of fortified cities in the interior as a result of the war of 342–340 BC.[9] The best-known examples of such Macedonian foundations are Philippopolis, on the Hebros River, and Kabyle, on the Tonzos River, the two key waterways of the central Thracian plain.

During the reign of Alexander the Great, the former Odrysian lands were placed under the authority of a special Macedonian "*strategos* of Thrace."[10] The office might have been created by Philip II in his last years, but its first known holder, Alexander of Lynkestis, the son of Aeropos, was appointed by Alexander the Great shortly after he assumed power in 336 BC and remained in office until 334 BC, when he joined the king with Thracian recruits at the start of the eastern expedition.[11] His place as governor of Thrace may have been taken then by a certain Ptolemy, who seems to have brought Alexander considerable Thracian reinforcements in the autumn of 331 BC.[12] The *strategos* Memnon, who revolted against the regent Antipater in 331 BC, would have succeeded Ptolemy; in 326 BC Memnon joined the king in India with a new levy of Thracian recruits.[13] The evidence for another *strategos* of Thrace, Zopyrion, is conflicting and questionable.[14] He died during a reckless expedition somewhere in the north, and his whole army was annihilated. According to Curtius Rufus, this disaster provoked a revolt by the Odrysai under a Seuthes, who later proclaimed himself king.[15]

After the death of Alexander the Great in the summer of 323 BC, rule over what remained of the Macedonian possessions in Thrace was entrusted to Lysimachos, a former royal bodyguard.[16] The events in Thrace in the ensuing period are poorly known. Lysimachos secured the important southern coast, along which ran the only land route between Macedonia and the east, and advanced along the western Black Sea littoral as far as the Istros (Danube) River in the north, taking control of the coastal Greek cities. In 309 BC he inaugurated his new capital, Lysimachia, on the neck of the Thracian Chersonese (Gallipoli Peninsula), and in 305 BC he proclaimed himself king. Yet neither at that time nor later, when much of Asia Minor and the whole of Macedonia fell under his power, could Lysimachos establish his rule over the interior regions of Thrace. Most of the central Thracian plain remained under the control of Seuthes III, who built his own royal city on the Tonzos River, near present-day Kazanlak, and gave it his name— Seuthopolis.[17] The relations between Lysimachos and Seuthes took different turns; we know from an inscription found in Seuthopolis that Seuthes had a Macedonian wife, Berenike, but nothing is known of the circumstances of their marriage (cat. 55).[18] One of the most spectacular archaeological finds from Thrace—the famous gold treasure from Panagyurishte—dates from this period and may have been a royal gift to Seuthes from either Lysimachos or Antigonos I Monophthalmos (the One-Eyed), founder of the Antigonid dynasty (cat. 59).

A recently excavated tomb near Shipka has been tentatively identified as the burial place of Seuthes III (cats. 53, 54).[19] A number of other impressive tumulus burials in the same area are also datable to the Early Hellenistic period and represent an imposing sign of the opulence of the elite class of Seuthopolis.[20] The so-called Thracian Tomb of Kazanlak, although by no means the most impressive in size or architecture is, however, noteworthy for its excellent wall paintings (fig. 50).[21]

In the extensive area between the Haimos Mountains and the Istros River in the northeast, the tribes of the Getai, stirred by a succession of foreign invasions over a short period of time (the Scythians of Ateas, Philip II in 339 BC, Alexander the Great in 335 BC, Zopyrion, and then Lysimachos), united to form a grand tribal alliance under one common king. A new fortified city was established in the final decades of the fourth century BC as the capital of the Getic kingdom near present-day Sveshtari; it may have been called Helis. In the early third century BC, the Getic kingdom was ruled by a king called Dromichaites; Diodorus Siculus describes how he captured Lysimachos and his entire army and then graciously set them free.[22] An impressive tomb excavated in 1982 near Sveshtari might have been the burial place of Dromichaites (see figs. 33, 42).[23]

Lysimachos was killed in the Battle of Koroupedion in 281 BC, and his death was soon followed by the murder of the victor, Seleukos I Nikator. With the deaths of these two last survivors of the top commanders of Alexander the Great, the turbulent Age of the Successors came to an end. Soon afterward the Balkan Peninsula suffered a disastrous invasion by the Celts, which spilled over into Asia Minor (fig. 51). A Celtic kingdom was established somewhere in southeastern Thrace and lasted for much of the third century BC, until it was eradicated by the Thracians. Little is known about the Celts in Thrace; their first king was called Komontorios, and the last one, Kavaros. The geographically elusive Tylis was the main center of their power.[24]

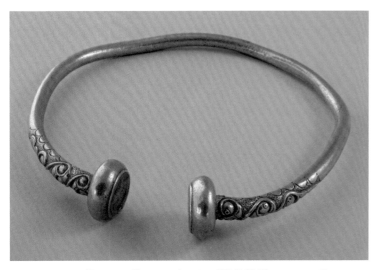

Figure 51. Torque, 3rd century BC. Gold, Diam: 15.5 cm. From Cibar Varosh (now Gorni Tsibar, near Lom), Montana Province, Bulgaria. Sofia, National Archaeological Institute with Museum, 3242. This torque is the most representative artifact of Celtic origin found in the Thracian lands.

Besides the Celtic kingdom of Tylis, it seems that a number of other political entities existed in southern Thrace in the third century BC, suggesting political fragmentation and instability.[25] The names of some kings or local dynasts have survived in epigraphic texts and on their coinage: Spartokos; Kotys, son of Rhaizdos; another Kotys and his son Rhaskouporis; Sadalas; Adaios, who was probably a Macedonian; and Skostokos, who may have been either Thracian or Celtic. Seuthopolis continued as a royal city after the death of Seuthes III under his widow, Berenike, who had four young sons; it is disputed whether the violent end of the city came at the hands of the Celts in the 270s BC or only later, around the middle of the century. In the north the Getic city at present-day Sveshtari survived the Celtic invasion only to be destroyed later by an earthquake.

The southern coasts of Thrace were contested in the third century BC by the powerful Hellenistic kings, with the Ptolemies of Egypt at first gaining the upper hand thanks to their powerful fleet. By the end of the century this coastal area fell for a brief time into the hands of Philip V of Macedon, but he was forced by the Romans to relinquish his gains after their victory at Kynoskephalai in 197 BC. New political entities started to appear in southern Thrace in the second century BC: the Astai and the Kainoi in the southeast (who successfully attacked the Roman army returning from war in Asia in 188 BC); the Sapaioi in the southern Rhodope Mountains (whose king,

Abrupolis, invaded Macedonian territory around Mount Pangaion after the death of Philip V but was repelled by his son Perseus); and the Maidoi, Dentheletai, and Bessoi on the Strymon River. Contrary to a popular view among modern scholars, it seems that no important Odrysian kingdom existed at all in the Hellenistic period. The one explicit piece of evidence—the assertion of Polybius (followed also by Livy) that Kotys, an ally of Perseus, was a king of the Odrysai is implausible, since he would instead have been king of the Sapaioi; Polybius likely used the ethnonym Odrysai mistakenly or as a general synonym for Thracians.[26] After the defeat of Perseus at Pydna in 168 BC, Kotys concluded an agreement with the Romans, who graciously freed his captive son.

Several Thracian princes are mentioned in connection with the short career of Pseudo-Philip (Andriskos, a pretender to the Macedonian throne who claimed to be a son of Perseus) and the Fourth Macedonian War (150–148 BC). These include Teres and Barsabas, both called "kings of the Thracians" by Diodorus Siculus, and an uncertain number of other Thracian "dynasts" who helped the usurper in his invasion of Macedonia.[27] Yet another dynast, Byzes, to whom Andriskos fled after being defeated by Caecilius Metellus, handed him over to the Romans.[28] Teres was married to a daughter of Philip V and might have been a king of the Astai rather than of the Odrysai, as has been assumed in the past; Barsabas was probably king of the Sapaioi. The tribal kingdom of the Kainoi must have been ruled at that time by Diegylis; both he and his successor, Zibelmios, fought against the Attalids of Pergamon, who were trying to enlarge their Thracian possessions beyond the Chersonese (allotted to them by the Romans in 167 BC) at the expense of Kainoi territory.

The establishment of the Roman province of Macedonia in 148 BC brought about a dramatic change in the general political situation in the Balkans, greatly affecting the Thracians in the eastern portion of the peninsula. Some Thracian lands were incorporated into the new province—not only those between the Axios and Strymon Rivers, which had long been a part of the Macedonian kingdom, but also the Aegean coast between the Nestos and Hebros Rivers. It was along this littoral that the eastern section of the strategic Roman road across the Balkans, called the Via Egnatia, was built in the last third of the second century BC; this was the only land route to the new province of Asia, established on the former territory of the Attalid Kingdom in Asia Minor, which Rome inherited from

The Political History of Thrace, 340 BC–ca. AD 46

95

the last Pergamene king, Attalos III. For reasons that remain unknown, the Via Egnatia originally ended at the Hebros near Kypsela; it was only around 100 BC that the Romans finally appropriated the former Attalid possessions in Thrace, including the Thracian Chersonese, adding them to the province of Macedonia.[29] It is uncertain who ruled over these territories in the meantime; one possible candidate is the Thracian king Mostis, known only from his coins and two inscriptions (fig. 52).[30] Mostis likely ruled over a large territory between the northern coast of the Propontis and the Bay of Burgas in the north, possibly uniting the tribal kingdoms of the Astai and the Kainoi, and his long reign (some of his coins are marked with the regnal "year 38") suggests that he must have been a trusted Roman ally. The Romans did not have an appetite for expansion further north. For a long time their relations with the unruly Thracians, who would often assail the territories of the province of Macedonia for plunder, were restricted to preventive or punitive raids. Gradually the Romans adopted a policy of supporting strong local allies to keep the marauding tribes at bay.[31]

The history of Thrace in the period from the Mithridatic Wars (89–63 BC) to the establishment of the Roman provinces of Moesia, Thracia, and Dacia is dominated by the tribal dynasties of the Astai and the Sapaioi, while other political entities—such as the tribes of the Maidoi, Dentheletai, and Bessoi in the west; the Getai in the northeast; and the Dacians in the far north—make only episodic appearances in the literary sources.

The Astai were based in the southeast, around the Strandzha Mountains, with Bizye (present-day Vize, in European Turkey) as their capital city. The ruler Sadalas, mentioned with four of his predecessors in a Mesembrian decree dated imprecisely to the third century BC, could have been one of their early kings (cat. 26).[32] Three successive kings of the Astai are known in the first century BC; the first was another Sadalas, who ruled at the time of the First Mithridatic War (89–85 BC) and sent a military unit to Greece to aid Sulla.[33] We do not know when this Sadalas was replaced by his son Kotys, who honored his father and mother, Sadalas and Polemokratia, in an inscription found at Bizye.[34] It was either Sadalas or Kotys who supplied a Thracian mounted unit to the Roman general Lucius Licinius Lucullus during the Third Mithridatic War (73–63 BC).[35] In 72 or 71 BC the brother of Licinius, Marcus Terentius Varro Lucullus, while serving as provincial governor of Macedonia,

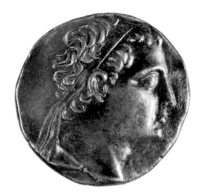

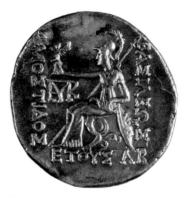

Figure 52. Tetradrachm of King Mostis marked "year 32," late 2nd–early 1st century BC. Silver. From a hoard discovered at Sinemorets, Burgas Province, Bulgaria, in 2012. Tsarevo, Municipal History Museum, 185

undertook a major retaliatory campaign against the supporters of Mithridates VI in Thrace; his targets included the tribe of the Bessoi; the inland cities of Pulpudeva, Uskudama, and Kabyle; and the colonies on the Pontic coast from Apollonia to Istros.[36] It is likely that this was the moment when the kings of the Astai were remunerated for their staunch pro-Roman position, enlarging their kingdom with vast territories both in the interior of Thrace and along the west Pontic coast, but the evidence remains scanty.

The advance of the Astai to the north was checked temporarily by the establishment of a massive new Getic kingdom under Byrebistas.[37] The information on this powerful king of the Getai is poor; the historical tradition and the few inscriptions that name him leave many questions regarding the chronology, territorial scope, and organization of his state.[38] Sometime in the 40s BC, Byrebistas lost his life in an internal disturbance, and the unified Getic state was split by his successors into several smaller (probably tribal) kingdoms.

The Roman civil wars in the third quarter of the first century BC profoundly affected the Balkans, where three major battles were fought successively.

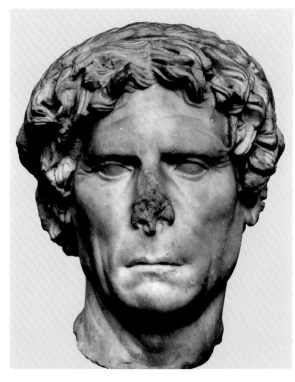

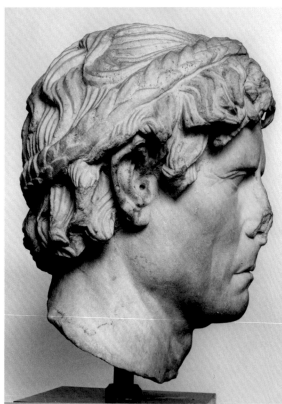

Figure 53. Head, possibly from a statue of Kotys, son of Rhaskouporis, king of the Sapaioi, third quarter of the 1st century BC. Pentelic marble, H: 31 cm. Found in Athens in 1837. Athens, National Archaeological Museum, 351

In 48 BC Kotys, king of the Astai, sent his son Sadalas with five hundred horsemen to the camp of Pompey, while Rhaskouporis of the Sapaioi, "a man of excellent valor," brought another two hundred; after the Battle of Pharsalus (48 BC), both Sadalas and Rhaskouporis were pardoned by Caesar.[39] In 42 BC Rhaskouporis and his brother Rhaskos divided their forces between the armies of the Republicans and the Second Triumvirate, each leading three thousand horsemen; after the victory of Octavian and Marc Antony at Philippi, Rhaskos successfully pleaded for his brother to be pardoned.[40] It is unknown when the younger Sadalas succeeded his father, Kotys, as king of the Astai; it has long been maintained that Sadalas died in 43 BC,[41] but it seems more probable now that he lived and ruled until 31 BC, when, according to Plutarch, he was in the camp of Marc Antony at Actium and presumably soon afterward removed by Octavian.[42] Bizye, the capital of the Astai, then passed into the hands of King Kotys of the Sapaioi, a son of Rhaskouporis (fig. 53),[43] and for the next seventy-five years much of Thrace was united, with Roman support, under this last dynasty.[44]

This was the final chapter in the story of declining Thracian independence; already in 29–28 BC, the governor of Macedonia, Marcus Licinius Crassus, was preparing by means of his military campaigns the establishment of direct Roman rule on the Lower Danube.[45] The long and successful reign of King Rhoemetalkes I (probably a son of Kotys) under Augustus was followed by an unfortunate division of power between his son Kotys and his brother Rhaskouporis; the uncle killed his nephew, was sentenced to exile by the Roman Senate, and soon afterward perished in an attempted escape, probably in AD 19.[46] In the meantime the Roman province of Moesia had been officially established over most of the lands along the right bank of the Lower Danube, surrounding the Thracian kingdom from the west and north. Two more kings of the Sapaioi, Rhoemetalkes II and III, reigned for more than twenty-five years, but around AD 46 the emperor Claudius finally abolished the Thracian client kingdom and established the province of Thracia in its stead. The Thracian lands beyond the Danube remained free from Roman rule in the second half of the first century AD. United under a valiant king, Dekabalos, the Dacians of the southern Carpathians and Transylvania offered the Romans staunch resistance until they were finally conquered by the emperor Trajan early in his reign.

The Political History of Thrace, 340 BC–ca. AD 46

97

1 Danov 1979, 21–145; Tacheva 1997, 13–149. For an overview in English, see Delev 2015a; Delev 2015b.

2 Thucydides, *History of the Peloponnesian War* 2.99.3; Strabo, *Geography* 7 frag. 11.

3 Thucydides, *History of the Peloponnesian War* 2.99.4, 2.99.6.

4 See Delev 2015b, 48–51.

5 On "Independent Thracians," see Arrian, *Anabasis* 1.1.5; on Agrianes, see Arrian, *Anabasis* 1.5.2–4. The ethnic attribution of the Agrianes as a Thracian or Paionian tribe remains controversial.

6 Athenaeus, *Deipnosophistae* 13.5; Jordan, *Getica* 10.65.

7 Justin, *Epitome* 9.3.1–3.

8 Arrian, *Anabasis* 1.1.4–5.5.

9 Diodorus Siculus, *Bibliotheca historica* 16.71.2.

10 On the office, see Berve 1926, 1:227–28; Bengtson 1937, 39–40; Bengtson 1944, 336–39.

11 On Alexander, the son of Aeropos, see Arrian, *Anabasis* 1.25.1–2; Curtius Rufus, *Histories of Alexander the Great* 7.1.6–7; Justin, *Epitome* 11.2.2; see also Berve 1926, 2:17–19; Heckel 2006, 19, no. 4.

12 On Ptolemy "the *strategos* of the Thracians," a shadowy figure, see Arrian, *Anabasis* 4.7.2; Berve 1926, 2:337, no. 637; Heckel 2006, 235, no. 4. The conjecture that he could have been a *strategos* of Thrace between 334 and 331 BC was proposed by the present author in a recent paper still awaiting publication.

13 Diodorus Siculus, *Bibliotheca historica* 17.62.1–63.1; Curtius Rufus, *Histories of Alexander the Great* 9.3.21. On Memnon, see Berve 1926, 2:254, no. 499; Badian 1967, 179–80, 191–92; Heckel 2006, 162, no. 3.

14 Curtius Rufus, *Histories of Alexander the Great* 10.1.43–45; Justin, *Epitome* 12.2.16–17; Macrobius, *Saturnalia* 1.11.33. On Zopyrion, see Berve 1926, 2:164, no. 340; Heckel 2006, 273.

15 Curtius Rufus, *Histories of Alexander the Great* 10.1.45. On Seuthes III, see Höck 1891, 115–16; Berve 1926, 2:353, no. 702; Y. Todorov 1933, 62–66; Peter 1997, 173–202; Tacheva 2006, 184–210.

16 On Lysimachos and his career, see Landucci Gattinoni 1992; Lund 1992; Delev 2004.

17 On Seuthopolis, see D. Dimitrov and Chichikova 1978; Chichikova and Dimitrov 2016.

18 The so-called Seuthopolis Inscription, *IGBulg.* III.2, 1731 = *IGBulg.* V, 5614. The full Greek text was published by Velkov 1991, 7–11, no. 1; see also Elvers 1994.

19 D. Dimitrova 2015; Tzochev 2016a.

20 Kitov 2003b; Stoyanov and Tonkova 2015a.

21 V. Mikov 1954.

22 Diodorus Siculus, *Bibliotheca historica* 21.12.

23 This is variously known as the Thracian Tomb of Sveshtari, the Sveshtari Tomb, the Caryatids' Tomb, or the tomb in Ghinina Mogila; see Fol et al. 1986; Chichikova 2012. See also Stoyanov in this volume.

24 On the Celts in Thrace, see Domaradzki 1984; Vagalinski 2010.

25 For a brief discussion of Thrace in the third century BC, see Delev 2003; Delev 2015a, 59–63.

26 Polybius, *Histories* 30.17.1; see Delev 2018.

27 Diodorus Siculus, *Bibliotheca historica* 32.15.5–7.

28 Zonaras, *Epitome historiarum* 9.28; Florus, *Epitome of Roman History* 2.14.

29 Loukopoulou 1987, 73–81.

30 On Mostis, see Sayar 1992; Paunov 2014.

31 For these relations, see Walbank 1981; Delev 2018.

32 *IGBulg.* I², 307 = *IGBulg.* V, 5086.

33 Holleaux 1919.

34 Dumont 1892, 365, no. 62ᵃ = *IGRom.* 1901, no. 775.

35 Plutarch, *Lucullus* 28.2.

36 Livy, *Periochae* 97; Eutropius, *Summary of Roman History* 6.10; Ammianus Marcellinus, *Res gestae* 27.4.11; Festus, *Summary of the History of Rome* 9; Jordan, *Romana* 221; Florus, *Epitome of Roman History* 1.39; Orosius, *History against the Pagans* 6.3.4.

37 Strabo, *Geography* 7.3.5, 7.3.11–13, 7.5.2; Jordan, *Getica* 68; Dio Chrysostom, *Orations* 36.1–4. See also Crişan 1978.

38 *IGBulg.* I², 323.

39 Caesar, *Civil War* 3.4.3; Lucan, *Civil War* 5.54.

40 Appian, *Civil War* 4.11.87, 13.103–5, 16.129, 17.136.

41 Perrot 1868, 75–82; Mommsen 1875, 251–53; Perrot 1875, 214–25; Dessau 1913, 697–99.

42 Plutarch, *Antony* 61. See Delev 2014, 423–24; Delev 2016a, 122–26.

43 For the identification of the marble head from Athens (see fig. 53) as possibly belonging to a statue of Kotys, son of Rhaskouporis, king of the Sapaioi, see Crowfoot 1897.

44 Delev 2016b.

45 Cassius Dio, *Roman History* 51.23–27.

46 Tacitus, *Annals* 2.64–67.

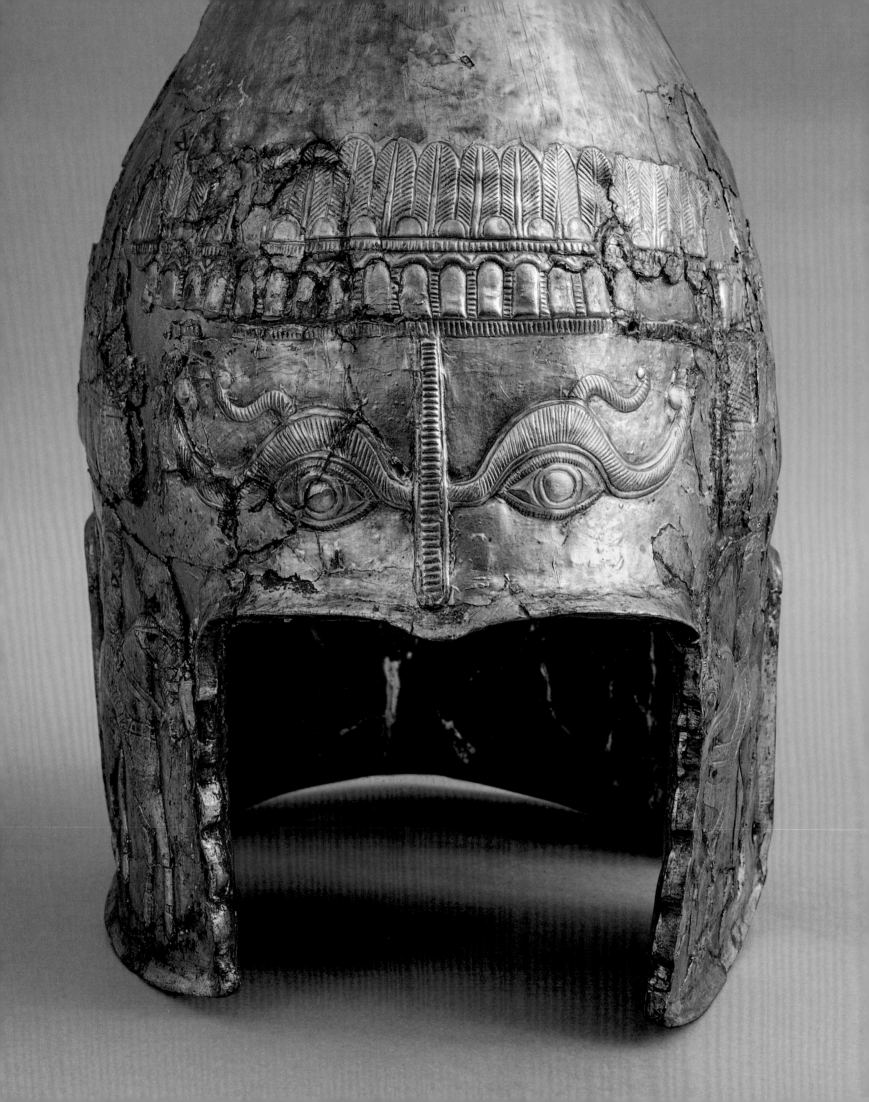

THRACIAN WARRIORS AND MERCENARIES

EMIL NANKOV

Thracians were often viewed by the Greeks as warlike and held in high esteem as soldiers for hire. With the exception of Herodotus, however, no ancient author made it their task to investigate the culture of Thrace in depth. For this reason the historical record is fragmentary and often generalized and full of stereotypes. Thracians were described by Greek historians as being divided into various *ethnē* (traditionally translated as "tribes"), and the Greek polis system never took root on Thracian soil, which contributed to the Greek misunderstanding of Thracian society.

Thracian warfare has been a subject of interest for several branches of scholarship studying classical antiquity, which employ various methodologies in an attempt to produce coherent narratives.[1] Historians and philologists have constructed perhaps the most compelling picture, thanks to the plethora of Greek and Roman sources,[2] and continue to bring fresh insights to Thracian military organization and tactics.[3]

Iconographic studies have also become important for the study of Thracian warfare. Art historians and archaeologists deal with a wide variety of architectural, sculptural, and visual monuments, which are mostly of Classical and Hellenistic date. Among the most significant are the iconographic studies of Thracian warriors depicted on Athenian red-figure pottery (cats. 16, 17),[4] Thracian metalwork,[5] and the figural compositions painted in Thracian tombs of the Early Hellenistic period, such as those at Kazanlak (see fig. 50), Alexandrovo (see fig. 43), Sveshtari (see fig. 33), and Ostrusha (see fig. 35b).[6]

Archaeology provides the most diverse evidence for Thracian warfare, although conceptualizing the finds remains a challenge. The first obstacle comes from the unequal distribution of artifacts within vastly different archaeological contexts.[7] For example, weapons and armor from burials spanning the entire first millennium BC have provided the foundation for the establishment of typologies,[8] notably for "rich burials."[9] This class of artifact is sometimes taken to indicate the existence of trade connections, as some have been labeled as Greek imports.[10] The construct, however, primarily concerns objects found in wealthy graves or tombs associated with the aristocracy, whereas the panoplies of common soldiers possess almost no archaeological visibility.[11]

Mapping artifact distribution at urban sites provides new ways of understanding ancient warfare, especially siege operations.[12] Conceptual treatments of excavation data derived from Thracian settlements are likely to increase in the future, even though at the moment they constitute few examples.[13] The same is true of battlefield studies, as the fortified residences or mountain estates of the Odrysian aristocracy recently discovered in Kozi Gramadi and Sotirya have

shown convincingly that inland Thrace has much to offer in understanding the impact of Macedonian expansion in Thrace during the reigns of Philip II (359–336 BC) and Alexander III (336–323 BC).[14]

THE GREEK HISTORICAL TRADITION: HEROES, WARRIORS, AND MERCENARIES

Greek and Roman literary sources provide considerable information about Thracian warriors and their tactics. The *Iliad* tells of the Kikones and Abantes fighting in close quarters using spears and swords. The Paionians, in contrast, are described as fighting with spears and "crooked-bows" as well.[15] According to the Homeric account, the Thracian nobility also practiced chariot fighting.[16]

From later sources—most notably Herodotus, Thucydides, and Xenophon—one learns of different troop types and Thracian military tactics. Best known are the light-armed peltasts, who carried two javelins, a crescent-shaped *peltē* (shield), and an *encheiridion* (short sword). They wore *alopekides* (fox-skin caps), *chitons* covered with long cloaks called *zeirai*, and *embades* (tall fawn-skin boots).[17] This image of the Thracian warrior is the one found on Athenian red-figure pottery in the Classical period. Heavy infantry like the Greek hoplites always remained a foreign concept, however, and one that Thracians never embraced. The most significant role, reserved traditionally for the Thracian nobility, was played by the cavalry, armed with spears, javelins, swords, and bows. Horse breeding had long been significant in Thrace, most notably among the Odrysai and the Getai. During his march against the Macedonians in 429 BC, Sitalkes mustered fifty thousand horsemen (if we are to believe Thucydides),[18] a staggeringly high number that testifies to the vast potential of an economy based on horse breeding.

Several military qualities traditionally ascribed to the varied Thracian *ethnē* immediately stand out. Thracians had the reputation of being skilled and courageous fighters, often depicted as fierce and warlike.[19] They preferred marching and fighting under the cover of night.[20] When the battle commenced, they issued vociferous war cries, singing songs and performing war dances while loudly clashing their weapons.[21] The lack of heavy infantry allowed for greater flexibility and mobility; very often an element of surprise assumed priority. Their use of the wedge

formation, which the northern Thracians allegedly learned from the Scythians,[22] has been questioned,[23] but Arrian recounts that the Triballoi positioned themselves against Alexander in 335 BC divided into a center and two flanks.[24]

Thracian peltasts frequently served as mercenaries, beginning with the Persian king Xerxes's invasion of Greece in 480 BC.[25] They served, notably, in the Peloponnesian War (431–404 BC),[26] as well as in the war between the Persian prince Cyrus the Younger and his brother Artaxerxes in 401 BC.[27] The Greek perception of mercenaries emphasizes that unlike hoplites, who fought for their homeland, mercenaries engaged in war for money and booty. According to Xenophon, for example, the peltasts were simply pillagers. For this reason Greek comedies of the fourth century BC portray mercenary soldiers as drunken, greedy, ill-mannered, and with no sense of propriety. Because of their well-known role as mercenaries, the Thracian people as a whole were often associated by the Greeks with many of these negative qualities.

Greek commanders in the service of Thracian rulers came to appreciate the tactical advantages of light-armed troops against heavy infantry, and this came to have a profound impact on the development of Greek warfare. The Athenian general Iphikrates, who married a daughter of the Odrysian king Kotys I (384/383–360 BC), both introduced reforms to the cumbersome panoply of Greek hoplites and utilized the effective Thracian peltasts during the Corinthian War (395–387 BC).[28] After the Macedonian conquest of Thrace by Philip II and Alexander the Great, Thracian cavalry and light-armed troops (*psiloi*) began to appear under the supervision of Macedonian and Thracian commanders.[29] During the turbulent years of the successors of Alexander (Diadochoi), Thracian regiments were frequently used by Hellenistic rulers. The practice continued during the Macedonian Wars, when Thracians fought for the armies of the Macedonian king Philip V and his son Perseus against the Romans at the Battles of Kynoskephalai in 197 BC, Kallinikos in 171 BC, and Pydna in 168 BC.[30] Thracians even served as mercenaries in the armies of the Ptolemaic rulers of Egypt and eventually were settled in Egypt as military colonists.[31]

THE ARCHAEOLOGY OF WEAPONS

Archaeology always complicates the picture by bringing new material to light, but it also provides

validation or refutation of what ancient historians chose to tell us. Archaeological discoveries have contributed to our understanding of Thracian warfare. The discussion that follows focuses specifically on several types of arms and armor. The selection offered here is by no means exhaustive.

Fortunately the Thracian military elite buried the deceased with armor and weapons for their journey to the next life.[32] Thanks to this practice, our knowledge of the Thracian panoply is considerable. Military paraphernalia displayed wealth, social standing, and perhaps also individual choice, even within the context of cultural tradition and religious concerns, and there is always a possibility that only a fraction of the weapons and armor owned may end up in one's grave. In times of war a greater number of people, including aristocrats, would die during sieges or perish on battlefields. If mortuary data is approached systematically, linking grave assemblages with particular historical events can become quite revealing.

Mieczysław Domaradzki was the first to realize the sociopolitical potential of what he called "Thracian rich burials," thus advancing the discipline beyond arranging weaponry into neat typologies.[33] He saw an opportunity to chart the turbulent trajectory of the Odrysian kingdom from its heyday until the arrival of the Romans through the lens of how the military aristocracy chose to portray themselves in death.[34] This in turn made it possible to acknowledge the changing nature of Thracian warfare, which quickly adapted itself to the emergence of new weapons and fighting techniques, especially during times of crisis and military turmoil. The Thracian elite often appropriated pieces of equipment that suited their needs best.

Bronze cuirasses of the "bell-shaped" type are a case in point (cat. 47b).[35] Archaeological finds have shown their limited use in Thrace, not as hoplite armor but instead adapted for horsemen, during the late fifth century BC, long after they had been discontinued in Greece. During the next century, up until the arrival of the armies of Philip II and Alexander the Great, such cuirasses seem to have been replaced entirely by scale-leather corselets, supplemented with gorget-pectorals, called *peritrachelia*, to protect the neck (cat. 50).[36] The Macedonian invasion forced many Odrysian dynasts to stand their ground in the upper Thrace Valley, along the courses of the Tonzos and Hebros Rivers. One result of these encounters was the emergence of "rich equestrian burials" containing sets of military equipment, which included helmets, greaves, swords, and appliqués for horse trappings,

as well as scale-leather corselets and *peritrachelia*. Such burials include those in the Peychova Tumulus, near the village of Starosel; the Dalakova Tumulus, near Sliven; and others in Zlatinitsa (see fig. 41), Kyolmen, and Branichevo.[37]

The arrival of spurs presents another interesting case. It was long thought that they were brought into Thrace by the Celts during the second or first century BC,[38] in view of the high concentration deposited in graves or chance finds situated exclusively in northwestern Bulgaria.[39] Recent discoveries have shown, however, that they were introduced to northeastern Bulgaria (the territory occupied by the Getai) and the upper Thrace Valley much earlier, with the arrival of the Macedonians.[40] Two different contexts testify to this phenomenon. In the fortress of Dragoevo, in the Shumen district, seventy-one examples were singled out as "Macedonian,"[41] possibly associated with the operations of Macedonian troops, including cavalry, in northeastern Thrace during the reigns of Philip II and Alexander III.[42] A few decades later, spurs are part of the assemblages in rich equestrian burials in the Golyama Kosmatka Tumulus (cats. 53, 54), near Shipka, and near Dolna Koznitsa, in Kyustendil Province.[43]

Swords are not readily identified with Thracians, despite the "great Thracian swords" mentioned in the *Iliad*.[44] They appear to have been considered a weapon of last resort, while the supremacy of the spear and shorter javelins was never challenged,[45] as can be seen on Athenian red-figure pottery and in painted Thracian tombs (fig. 54).[46] The Greek *kopis* (a knife with a curved blade), often described generically as a *machaira*, was recommended by Xenophon for use by cavalrymen because curved one-edged weapons performed better when used from an elevated position.[47] The curved shape and off-center gravity point allowed the user to strike with greater force, offering some of the advantages of the battle-axe. Evidently, Thracian cavalrymen were in agreement with Xenophon, for the *kopis* accompanied them to their graves during the Classical and Hellenistic periods, including in burials at Duvanlii, Zlatinitsa, Kabyle, and the Golyama Kosmatka Tumulus (cat. 54g).[48]

The iron *rhomphaia* may be a Thracian invention.[49] A peculiar cross between a spear and a sickle thought to have evolved from an agricultural implement into a fierce slashing weapon (identified by Nicholas Sekunda as the Greek *dorydrepanon*, a sickle-spear), it was utilized by foot soldiers during the First and Second

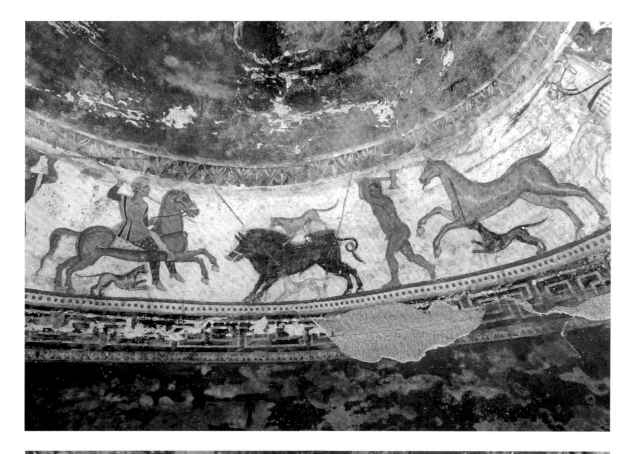

Figure 54. Details from the hunting frieze of the Tomb of Alexandrovo, near Alexandrovo, Haskovo Province, Bulgaria, 4th century BC

Macedonian Wars (214–205 BC, 200–196 BC).[50] With a few exceptions, however, its use seems to have been restricted to the mountainous terrain of the west and central Rhodopes, as confirmed by the numerous graves with *rhomphaiai* found there (fig. 55).[51] Thracian units equipped with *rhomphaiai* and small shields (*thureoi*) were recruited by Macedonian kings and used mainly as a cavalry-fighting force, since the slashing quality of the weapon was very effective against horses.[52] Attempts to identify the weapon on wall paintings in tombs at Alexandrovo and Sveshtari have been discounted.[53] Sekunda's intriguing suggestion that Thucydides's description of the Dioi in the Rhodopes as *machairophoroi* (sword-bearers) during the Peloponnesian War in fact meant *rhomphaiophoroi* (soldiers with sickle-spears and shields) has gone largely unnoticed.[54] It is still unclear why Thracians began to deposit *rhomphaiai* in graves during and after the First and Second Macedonian Wars but not earlier.

Deposits of sling ammunition in graves are rare and difficult to explain. Slingshots in the form of round stones or pebbles, put in leather pouches, were placed conspicuously alongside other weapons in the aristocratic equestrian burials at Golemanite, in Veliko Tarnovo Province, and at Agighiol.[55] Although this practice is better attested in Scythia, the interpretation of the finds as sling projectiles has not been accepted uncritically.[56] That these stone projectiles were more likely thrown by hand rather than a sling is borne out by the written sources.[57] For example, the Odrysai are mentioned as skillful *petroboloi* (stone throwers) by the early fourth century BC.[58] Lead sling bullets cast in molds arrived in Thrace with the Macedonians. Evidence for this can be found not only inside besieged settlements and battlefields but also in burials. One of the sling bullets published by Ivan Venedikov, inscribed with a personal name in Greek,[59] was found in the grave of a ten-year-old child in Apollonia Pontica.[60] The fact that no weapons accompany the deceased in the excavated necropoleis rules out the possibility that the bullet was deliberately deposited as a grave gift.[61] It is more likely that the child was a casualty of an unrecorded siege of the town by the Macedonians, as were at least a hundred individuals, whose cremated remains were buried in a *polyandreion* (mass grave).[62] A recent publication of other sling bullets from Apollonia Pontica carrying the names of Macedonian commanders—for example, Diagoras—has made the case even stronger (fig. 56).[63]

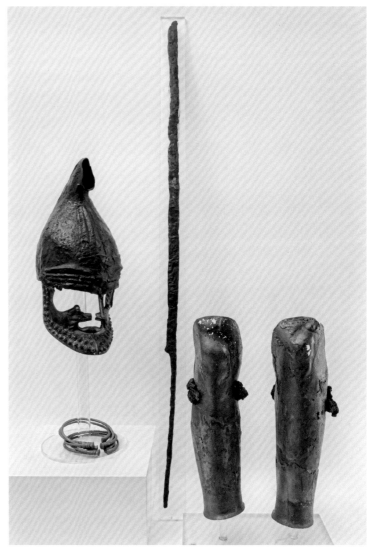

Figure 55. Burial assemblage, including a *rhomphaia* and a Thracian-type helmet, ca. 250–200 BC. From a warrior's grave in Pletena, Blagoevgrad Province, Bulgaria. Blagoevgrad, Regional History Museum, 1.1.-212 (helmet), 1.1.-213 (torques), 1.1.-214 (greaves), 1.1.-215 (*rhomphaia*)

Figure 56. Sling bullet inscribed with the name Diagoras, 340–300 BC. Lead, 2.9 × 1.6 × 1.2 cm. Found at Apollonia Pontica (present-day Sozopol), Burgas Province, Bulgaria. Sozopol, Archaeological Museum, 3700

Figure 57. A quiver depicted in a painting from the Maglizh Tomb, Maglizh, Stara Zagora Province, Bulgaria, ca. 225 BC. Mortar, clay, lime, pigment, 93.7 × 96 cm. Found in situ on the pediment above the doorway to the burial chamber. Kazanlak, Iskra Historical Museum, MIK A II 1213

That the Thracians, like the Scythians, were famed for their skillful use of the composite bow is evident from grave assemblages and artistic representations (fig. 57).[64] Many aristocratic graves of the late fifth and early fourth centuries BC have produced large numbers of bronze arrowheads of so-called Scythian type. Variation in projectile size and deposition in separate quivers perhaps account for different uses (for example, at Golemanite, the Svetitsata Tumulus,

Duvanlii, Chernozemen, and Zlatinitsa)—hunting and combat.[65] The possible identification of an archer's thumb ring, comprising a gold bezel and an iron hoop, from the Racheva Tumulus, near Maglizh, remains an exceptional case needing further substantive evidence.[66] The use of "Scythian" arrowheads continued during the Hellenistic period, and they remain archaeologically visible in excavations of settlements (Pistiros, Kabyle, Dragoevo, and Seuthopolis) but

not in graves. Their ballistic properties proved inferior to those of Cretan arrowheads and tanged catapult bolts made of iron,[67] which arrived in Thrace with the Macedonian troops of Philip II, Alexander the Great, and his successors.

The diverse nature of Thracian warfare as a subject of investigation requires a multifaceted approach, drawing on several disciplines within the scope of

studies of classical antiquity, since no single source of data has the capacity to address this complexity on its own. Although literary testimonia remain deeply ingrained in our perceptions of the Thracians, iconography and especially archaeology provide a counterbalance. The present overview has high-lighted the main challenges with which modern scholarship is confronted when attempting to cap-ture the ever-changing face of the Thracian Ares.

1 Katsarov 1913, 31–36; Fol 1969, 103–26; Tacheva 1971; P. Kolev 1975; Launey 1987, 366–98, 404–6; Webber 2011, xx–xxiii.
2 Best 1969; Mihailov 2015, 267–305.
3 Webber 2011, 136–42; Sears 2013, 234–89; Stoyanov 2015a, 436–37.
4 Lezzi-Hafter 1997, 359–66; Hermary 2010, 485–86; for Persian reliefs, see Vassileva 2015, 322, and cat. 32. See also Tsiafaki in this volume.
5 Marazov 2005; Webber 2011.
6 Valeva 1992; Valeva 2005, 83–84, 93–96, 97–102, 103–4; Nankov 2007, 41, 43; Stoyanov 2008a; Nankov 2010, 44n14, 50.
7 Stoyanov 2015a, 426–35.
8 Teleaga 2008.
9 Domaradzki 1998b, 44–64; see G. Stoyanova 2015; Stoyanov in this volume.
10 Teleaga 2008, 323–27.
11 Archibald 1998, 197–208; Georgieva 2016.
12 For artifact distribution at Olynthos, see Lee 2001; for Stymphalos, see Hagerman 2014.
13 For excavation data from the Thracian settlement at Helis, see Stoyanov 2008c; for Seuthopolis, see Nankov 2008.
14 Nankov 2015.
15 Iliad 2.536–544, 2.848, 21.155.
16 Iliad 14.287, 20.48–487, 21.205.
17 Herodotus, Histories 7.75.1.
18 Thucydides, History of the Peloponnesian War 2.98.3–4.
19 Herodotus, Histories 7.111.1.
20 Herodotus, Histories 6.45.1; Xenophon, Anabasis 7.3.37–41.
21 Tacitus, Annals 4.47.
22 Arrian, Techne Taktike 16.6.
23 Stoyanov 2015a, 436, with further references; Mihailov 2015, 279–80.
24 Arrian, Anabasis 1.2.5–6.
25 Herodotus, Histories 7.75.1.
26 Thucydides, History of the Peloponnesian War 4.129.2, 5.6.2, 7.27.1.
27 Xenophon, Anabasis 1.2.9, 2.2.7.
28 Best 1969, 102–10; see Mihailov 2015, 293–95.
29 Heckel 1992, 332–34.
30 Livy, History of Rome 33.3–10, 31.39.10–11; Plutarch, Life of Flaminius 7–8; Plutarch, Life of Aemelius 18.3.
31 Velkov and Fol 1977, 22–96; Bingen 2007.
32 Georgieva 2016.
33 Domaradzki 1998b, 44–64.
34 Archibald 1998, 198–207; Georgieva 2016.
35 Ognenova-Marinova 1961, 504–26; S. Dimitrov 2010, 219–20; Parvin 2010, 227.
36 Parvin 2008. See also Ognenova-Marinova 1961, 527–38; Tacheva 1971, 55.
37 Atanasov 1995, nos. 87–88; Parvin 2008; Agre 2011, 72–83.
38 Stoyanov 2003, 198.
39 Torbov 1998.
40 Stoyanov 2003, 200.
41 Type II after Atanasov 2006, 27; list of other examples in Baitinger 2004, 368–69.
42 Nankov 2016b, 286–87; see also Baitinger 2004, 371.
43 D. Dimitrova 2015, 164, 305, no. 56, and 330, no. 91.
44 Iliad 13.576.
45 Marazov 2005, 35–40.
46 Hermary 2010, 484–86; Nankov 2010, 44n14, 50.
47 Xenophon, On Horsemanship 12.11–12.
48 Agre 2011, 91; Stoyanov, Mikov, and Dzanfezova 2013, 265, 267, fig. 23; D. Dimitrova 2015, 325–28, no. 84; Torbov
2016, IX–XI; I. Marazov in Marazov et al. 2013, 92–93, no. 18.
49 P. Kolev 1975, 20–21; Buyukliev 1994, 159; Webber 2011, 61–67; Torbov 2016, XII–XIV.
50 Sekunda 1983, 275–76.
51 R. Mikov 2010, 209, table 2.
52 Sekunda 1983, 284–85.
53 S. Dimitrov 2005, 290, fig. 7; Paunov 2005, 369; see Stoyanov 2008c, 62; R. Mikov 2010, 224; Nankov 2010, 36–37.
54 Sekunda 1983, 283–84. See S. Dimitrov 2005; Paunov 2005; R. Mikov 2010; see Marazov 2005, 48; Webber 2011, 61–67.
55 Stoyanov 2015a, 427.
56 Dedyulkin 2015b.
57 Dedyulkin 2015b, 51; see Pritchett 1991, 65–67.
58 Xenophon, Hellenica 2.4.12; Polyaenus, Strategems 3.9.62; see also Xenophon, Anabasis 5.2.12.
59 See Avram 2011, 198.
60 Venedikov 1948, 18, fig. 21.
61 Damyanov 2015a, 32.
62 Damyanov, Reho, and Panayotova 2021.
63 Nankov 2016b, 286–87; Y. Ivanov 2019, 199, fig. 2; Baralis, Gyuzelev, and Panayotova 2021, 105–7; Damyanov, Nankov, and Stoyanova 2021, 118–19; Nankov 2023, 77–78, 139, no. L156.
64 Buyukliev 1991; Marazov 2005, 40–45; Y. Valeva in Martinez et al. 2015, 154–55, no. 113; Georgieva 2016, 271.
65 Agre 2011, 100; Stoyanov 2015a, 427.
66 I. Todorov 2008, fig. 1. See D. Dimitrova 2012, 182–84, 187n5, fig. 10.
67 Hagerman 2014, 80–85.

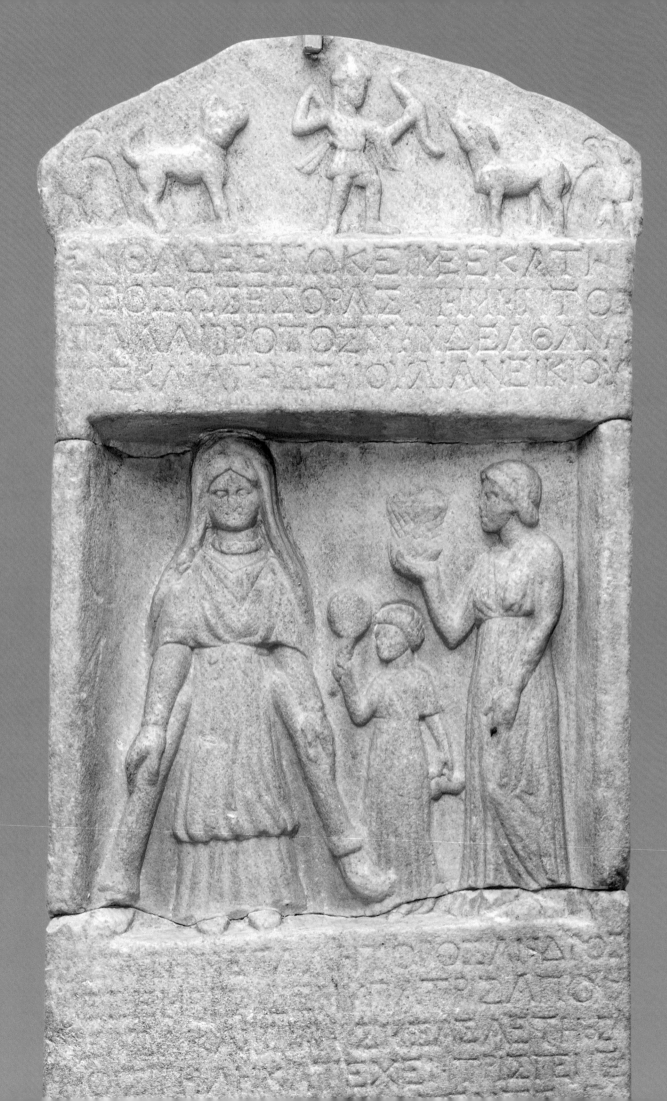

THE THRACIAN ELITE UNDER ROMAN RULE
FIRST TO EARLY FOURTH CENTURY AD

IVO TOPALILOV

To consolidate their increasing military and political influence in the Balkan Peninsula, the Romans knew it was necessary to attract the local Thracian elites. The elites in turn could respond to the Roman involvement in their affairs either with obedience, agreement, and adaptation or with fierce resistance. The chronologically and geographically uneven expansion of the Roman presence in Thrace allowed the Thracian aristocracy to gradually understand the changing political situation that culminated in the Roman-led creation of the Thracian client kingdom in the first century BC and the inclusion of the royal family in the Pax Romana. Those who participated in the maintenance of the client kingdom obtained a Roman name in the form of the addition of the imperial praenomen and nomen (such as Caius Iulius or Tiberius Claudius) to their Thracian personal name. This name change also indicated the acquisition of Roman citizenship in most cases. Many members of the Thracian nobility were incorporated into the Roman Imperial bureaucracy under the Julio-Claudians.

Guided by the praetor Trebellienus Rufus, the Thracian king Rhoemetalkes II pursued a strategic policy that significantly furthered the region's incorporation into the Pax Romana. In honor of his benefactor, the Thracian king founded Tiberias, which was a Roman city in Thrace. Representatives of the royal family were further given the opportunity to receive their education in Rome under the patronage of the imperial court, and Rhoemetalkes III, the successor of Rhoemetalkes II, although sent to Rome as a hostage, became a boyhood friend of the future emperor Caligula (Gaius).

Most of the Thracian elites who were allied with Rome served as *strategoi*, district governors who were entrusted with economic, military, and possibly religious functions in their respective territories. It is also likely that some of these *strategoi*, such as the individual buried in the eastern necropolis of Philippopolis (the tumulus known as Kamenitsa), joined the Roman army. This rich burial included his silver helmet-mask with the face of the Roman emperor (figs. 58, 59).[1]

After the incorporation of the Thracian client kingdom into the Roman Empire and the creation of the province of Thracia around AD 46, the Thracian aristocracy retained its high status. The Romans did not change the existing administrative structure, particularly the system of *strategoi*. Roman rule slowly established an urban presence across Thracia centered on Perinthos, which became the seat of the provincial procurator, but also included other strategic regions, such as the colony at Apri, in southeastern Thrace, and the colony of Deultum, near the Bay of Burgas. With the exception of the Greek cities on the coast; the old Odrysian capital, Bizye; and

Funerary Stele of Iulia (detail, cat. 63)

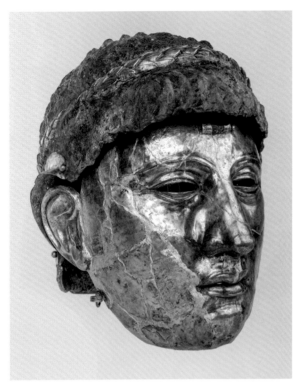

Figure 58. Helmet-Mask, 1st century AD. Silver and iron, H: 25.5 cm. Found in the Kamenitsa Tumulus, eastern necropolis of Philippopolis (Plovdiv), Plovdiv Province, Bulgaria. Plovdiv, Archaeological Museum, 19

Figure 59. Burial Assemblage, 1st century AD. Found in the Kamenitsa Tumulus, eastern necropolis of Philippopolis (Plovdiv), Plovdiv Province, Bulgaria. Plovdiv, Archaeological Museum, 1, 2, 3, 4, 7, 9, 10, 11

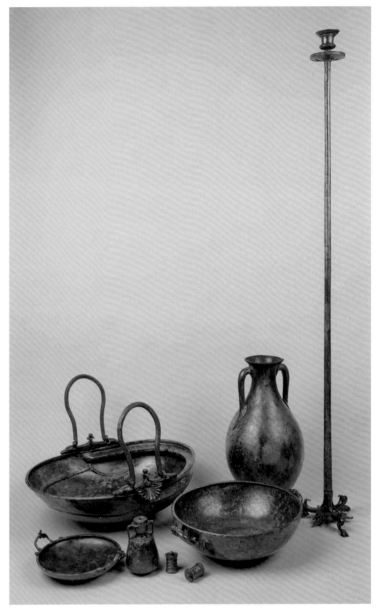

the urban centers Philippopolis and Uskudama (later Hadrianopolis), Thracia remained a sparsely urbanized province, and its control was still largely entrusted to the *strategoi*, whose numbers the Flavian emperors increased.

Imperial strategic planning led to the inclusion of other members of the Thracian aristocracy in Thracia's provincial administration. Unlike their counterparts in the Thracian client kingdom, however, not all of the new *strategoi* received Roman names or citizenship, and some of them retained their Thracian names in full. Evidence for this development is provided by a famous inscription from Topeiros, which is dedicated to the procurator of Thracia, Marcus Vettius Marcellus,

and lists thirty-three *strategoi* from the period AD 46–54.[2] Certainly the representatives of the royal family, who were included in the municipal elite (more precisely the *decurion* class) of the nearby Roman colony of Philippi, received special treatment that allowed them to integrate more closely into Roman society not only in the colony but also in the wider empire. A certain Caius Iulius Teres, who is mentioned in an inscription dating from AD 161–80 as *pater senatorum* (the father of senators), was likely a direct descendant of the last Thracian king.[3]

Some members of the Romanized Thracian elite achieved high rank in the Roman army during Julio-Claudian and Flavian times. The tomb relief of

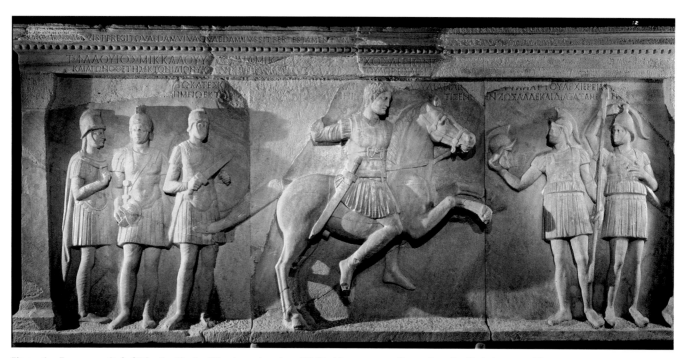

Figure 60. Funerary relief of Tiberius Flavius Miccalus, 1st century AD. Marble, 252 × 545 × 82 cm. Found at Perinthos, near Marmara Ereğlisi, Turkey. Istanbul, Archaeology Museums, 73.7 T

Tiberius Flavius Miccalus at Perinthos, for example, shows the deceased with a military escort (fig. 60).[4] This high-quality Roman Imperial–style relief is rare for Thracia, and it may suggest that the deceased reached the position of military tribune and entered the equestrian order (*ordo equester*).

Similarly, an elite burial in a necropolis of tumuli south of Philippopolis, which contained rich offerings and weapons, preserved a cavalry helmet of a type that suggests the deceased was an officer (fig. 61a–b).[5] Similarly, the owner of the so-called Villa Chatalka, outside Augusta Traiana, might have served in the higher ranks of the Roman army. One of the graves there contained a Roman parade helmet-mask as well as Sarmatian weapons that may have been acquired as war trophies in a successful military campaign in the steppes. Also in the villa was a portrait of a young woman who was most probably the wife of the villa's owner (fig. 62).[6] Like Tiberius Flavius Miccalus, the villa's owner probably belonged to the equestrian order.

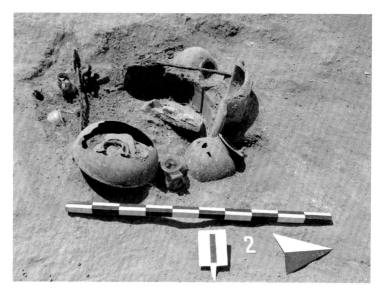

Figure 61a–b. Tumulus (61a) and burial assemblage (61b), 1st century AD. Located in a necropolis south of Philippopolis (Plovdiv), Plovdiv Province, Bulgaria. Pictured in figure 61b: Plovdiv, Archaeological Museum, II-3156, II-3157, II-3158, II-3159, II-3170, II-3171, II-3172, II-3173, II-3174, II-3176, II-3177, II-3179, II-3183, II-3184, II-3188, II-3189, II-3190

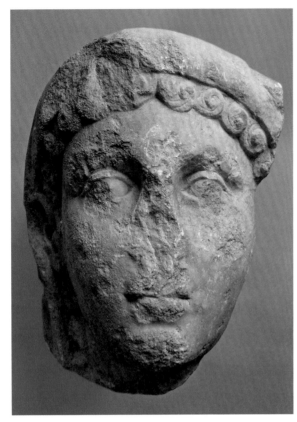

Figure 62. Portrait of a Young Woman, ca. AD 25–50. Marble. Found in the Villa Chatalka, near Stara Zagora, Stara Zagora Province, Bulgaria. Stara Zagora, Regional Historical Museum

Aside from those in the military, many other members of the Thracian aristocracy were involved in civic activities in urban centers such as Mesembria Pontica, Anchialos, Bizye, and Philippopolis. There is considerable evidence for their participation in the municipal and provincial administration, especially from the end of the first century AD, after the further integration of the region into the empire's wider network of political, economic, and cultural connections. From Domitian's principate through the later years of Hadrian, the Thracian elite were involved in city institutions both in Perinthos and Philippopolis, at the heart of Thracia's Roman administration, and in the new cities founded during the reign of Trajan, including Pautalia, Serdica, and Augusta Traiana.

Thracians joined city councils and were often elected as their leaders (such as first archon), but they also held other civic positions, including phylarch and priest. Thracian aristocrats were also members of local Sacred Gerusiae (councils of elders), such as that at Philippopolis. The names of these local Thracian leaders appear in inscriptions, most of which

accompanied honorific statues erected in public places to commemorate acts of patronage. These inscriptions follow Roman practice—listing the sequence of offices the leader held (the *cursus honorum*), beginning with the most prestigious position—as well as Roman epigraphic conventions, but they are nearly always in Greek. It is also noteworthy that the tribal affiliation was added to the nomenclature in the form of the designation Quirina, which conveys the dignity of being enrolled in the Flavian emperor's tribe. This also indicates the increased familiarity of the Thracian elite with the Romans' "epigraphic habit."[7] Because the province's Romanization took place at a time when Rome was embracing Greek and Hellenistic art under the Julio-Claudian dynasty, a wave of Hellenization and *paideia* also greatly impacted Thracia, including religious-mythological beliefs, temples, cults, and the pictorial arts.

The inclusion of members of the Thracian aristocracy in municipal administrative positions allowed them to play a leading role in the public life of Thracia's cities. This development is demonstrated by the association of their names with a number of important civic events—such as the sacred Pythian Games, for which they served as *agonothetēs* (supervising officers)—and the construction of new monumental public spaces. These construction projects, which completely transformed the appearance of the cities, were often commemorated on issues of local coinage, which then became an important source of civic pride. Building initiatives included structures that became iconic for particular cities and for the province of Thracia as a whole.

A certain Titus Flavius Kotys, from the Quirina tribe, made significant contributions to the building program in Philippopolis and was also superintendent of building works. An honorary inscription placed in the theater there lists his *cursus honorum* and proclaims that he "had adorned magnificently the place, and…the sanctuaries of…"[8] This detail suggests that among Kotys's benefactions was the theater itself, a place of great importance to the province, since it was the meeting place for representatives of the Thracian *koinon* (provincial council). Kotys's gifts are indicative of the great economic power held by some members of the Thracian elite. In AD 116–17 the restoration of the same theater was financed by another city magistrate of Philippopolis with a Thracian name, Tarsas, son of Basos.[9] The examples of Kotys and Tarsas clearly demonstrate the considerable patronage of local magistrates

descended from Thracian nobility. Such patronage also extended to the old Greek cities, as is shown by the construction of a richly decorated temple adorned with statues in Perinthos, which was dedicated to Hadrian and Sabina in AD 129–37 by the Thracian woman Larcia Gepaipyris in honor of her father, Larcius Asiaticus. The construction of the temple is probably related to the visit of the emperor himself to the city in AD 131, when Hadrian seems to have decided to include Perinthos in the league known as the Panhellenion, which he founded the following year.[10]

Members of the Thracian hereditary elite also retained their place in the religious life in the lands that were incorporated into the province of Thracia in the mid-first century AD. The Romans in fact encouraged their continued involvement. Inscriptions reveal that these individuals were typically hereditary priests, who not only worshipped their ancestral deities but also were priests of specific cults. For example, Reginus, son of Sudios, was a μαγαρεύς, a priest of Dionysos in the *megaron* (sacred meeting space) at Augusta Traiana.[11]

The Romans held a liberal attitude toward local cults and funerary practices as long as official Roman cults were observed as well, and this policy allowed the continuation and renewal of earlier sanctuaries and religious monuments. For example, images of the Thracian horseman continued to appear on votive sculpture (see cat. 64), and there were even chariot interments in tumuli, as in previous centuries under the Thracian kings. In fact, it was the sanctuaries of local deities that allowed the Thracian aristocracy a public appearance and manifestation of euergetism (benefaction) and therefore the reception of tribute in still underurbanized inner Roman Thrace. Unsurprisingly, the social and political importance of these sites in the Roman period was higher than previously, which impacted the honoring of deities as well. One such sanctuary that acquired provincial significance was that of Asklepios, near Batkun, which was built by the *strategos* Dizalus, son of Kotys. The patronage by aristocratic families of certain sanctuaries appears in areas where it was formerly not widespread. Evidently priestly offices gave many elites, some of whom were former *strategoi*, a prestigious role in a changing Thracian provincial society.[12]

New priestly positions, which emerged as a result of the reforms undertaken in the province, were often entrusted to local Romanized aristocracy from the very beginning of Thrace's provincialization. This is especially evident in the case of the provincial council

(*koinon*) of the Thracians, which was most probably founded during the reign of Domitian. Philippopolis was chosen as its host, thus garnering the title "metropolis." Since the *koinon*'s main functions included solving disputes between its member cities and instituting the worship of the imperial cult, its activities were under the strict control of imperial authorities. The establishment of the provincial council allowed hereditary Thracian aristocrats to be actively involved in provincial life. The first leader of the *koinon* was probably Titus Flavius Dinis, who was elected the province's archpriest. Titus Flavius Kotys then held the office three times and was granted the title "first and worthiest man of the province" by the provincial council.[13] Another probable Thracian aristocrat was the owner of the so-called Villa Armira in southeastern Thrace, the most lavishly decorated villa yet found in the region, which is noteworthy for its architecture and ornate decoration, including mosaics and wall painting.[14] One of the mosaic pavements presents a portrait of the owner and possibly his children (fig. 63).[15]

With the end of the *strategoi* system late in Trajan's rule, the governance of Thracia's subregions was placed in the hands of the municipal elite. In the second half of the second century AD, the leader of the *koinon* was called the *thracarch*. The holder of this office was an individual typically of high status, such as a senator, with clear allegiance to Rome.[16] At this time the integration of the Thracian elite into the provincial administration, as well as into the upper echelons of Roman society, was significantly curtailed. Only descendants of the former royal family could join the senatorial class. For example, during the reign of Emperor Antoninus Pius, Caius Iulius Maximus Micianus, brother of the aforementioned Caius Iulius Teres (who was *pater senatorum*), held the titles *vir clarissimus* and *decurio* in "Philippi and the province of Thracia" and was granted entry to the senatorial class. This distinction in turn allowed both figures to be elected to positions outside Thracia, the latter becoming not only *quaestor pro praetore* of the province of Bithynia and Pontus but also *aedilis cerialis* and *praetor designatus*. Another Caius Iulius Teres, possibly the grandson of the above *pater senatorum*, was appointed λαμπρότατος ὑπατικός (*clarissimus consularis*) in the third century.[17]

While the senatorial class was, for the most part, open only to descendants of the royal family, some upper-class Thracians achieved the equestrian order. They received the honorific title διασημότατος

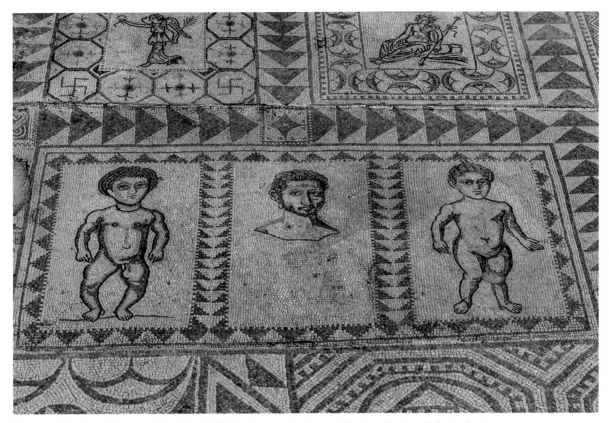

Figure 63. Mosaic, ca. AD 50–100. Found in the Villa Armira, near Ivaylovgrad, Haskovo Province, Bulgaria. In situ

(*vir perfectissimus*) and held various positions both in the province of Thracia and elsewhere in the empire, particularly in the Roman army. For example, Marcus Virdius Taurus, the earliest member (and perhaps founder) of the *gens Virdia*, who is known from inscriptions from Philippopolis dating to the second half of the second century and first decades of the third century AD, passed through a short military career on his way to attaining high status through his public service in his hometown. While his relative Publius Virdius Iulianus does not seem to have reached a senior military position, his sons became military tribunes. Other members of the family include the *thracarch* and the *agonothetēs* of the Pythian Games organized by the Thracian *koinon* at Philippopolis. The son of Publius Virdius Iulianus, with the same name, was also a rhetor (ῥήτωρ), a title that indicates his active participation in politics in his hometown. Another family member served as a *neokoros* (official of the imperial cult) when Philippopolis was granted the neokorate during the reign of Elagabalus or Severus Alexander. It seems that one member of the *gens Virdia* had reached the highest possible post in the province—that of *thracarch*.[18] Similarly, the *gens Antia*

from Pautalia entered the equestrian order, and family members were appointed *thracarch* as well.[19] Members of the Thracian aristocracy even became provincial governors; for example, a certain Teres became *vir perfectissimus* and was appointed governor of Thracia around AD 305–11. After his death he received a burial typical for a nobleman of Thracian origin, with a large mound over his grave that was described in the literary sources being "as high as a mountain" (εἰς ὄρους μέγεθος τὸ χῶμα ἀπεκορύφωσαν).[20]

Inscriptions provide evidence not only of high standards of education and literacy among members of the Thracian elite but also of a sense of belonging to a particular cultural community, the world of Hellenic literature.[21] The metrical inscription of a certain Teres at Augusta Traiana, for example, dated to the first decades of the third century AD, dedicates to Apollo "an exquisitely made statue of Apollo's friend Orpheus, who calmed the beasts, trees, reptiles, and birds with his voice and the harmony under his arms."[22] There clearly was a demand among educated Thracians for Greek literary culture, as demonstrated by the visits of traveling orators, such as Lucian of Samosata and Aelius Aristides. Lucian spent the

winter of AD 165–66 in Philippopolis, where he wrote his dialogue *Runaways*.[23] The visit of such a distinguished intellectual speaks to the wealthy Philippopolitans' interest in literature and philosophy at that time. The inclusion of poetry competitions in Thracia's sacred games suggests that intellectual pursuits were not valued by the elites at Philippopolis alone.

The presence of semiliterate Thracians among municipal elites is also detectable in some cases, such as the Hellenized Aurelius Sostratos, son of Doles, a member of the Sacred Gerousia of Philippopolis. The inscription on the lid of his large sarcophagus found in the necropolis of the city, while elegant, contains no fewer than sixteen errors. Dating to the second decade of the third century AD, the sarcophagus reveals the process of the Hellenization of the Thracian elite, which now also included a newly rich member.[24]

Although the Thracian elite became increasingly integrated into an empire-wide Roman society, they still preserved the memory of their ethnic origins. Aside from often keeping their Thracian names, some also continued to observe the traditional Thracian burial practice of interring bodies with rich offerings— even chariots with horses—under grave mounds

Figure 64. Philippopolitan coin with the image of Eumolpus, AD 209–10. Bronze, Diam: 2.9 cm; Wt: 16.6 grams. Gorny & Mosch, Munich, Auction 113, October 18, 2001, lot 5431

(see cat. 65). The Thracian elite not only kept but also propagandized and even invented a glorious past linked to Classical Greece, which became the basis for the identity of the municipal community itself. The people of Philippopolis, for example, proclaimed the Eleusinian priest Eumolpos as the mythical founder of the city on their coins and invented the story that the city was originally called Eumolpiada (fig. 64).[25] Although subjected to Romanization and Hellenization, the Thracian elite retained the memory of their origins without compromising their sense of loyalty to Rome and the traditions and achievements of its empire.

This essay was written during my stay at the Getty Villa in 2020. I am indebted to Dr. Matthew Schueller, who participated with me in the 2019–20 Getty Research Institute's Scholars Program, for his editing help.

1 Dyakovich 1906–7.
2 *IThr.Aeg.* E 84.
3 Pilhofer 2009, 73–75, no. 61.
4 Sayar 1998, 257–58, no. 72, plate 20, fig. 75.
5 The helmet is of the Weiler/ Koblenz-Bubenheim type; see Kisyov and Davidova 2014.
6 Popova-Moroz 2022, 258–60, fig.1.

7 On this phenomenon in Thrace, see Sharankov 2011; on the sculpture in Roman Thrace, see Koleva 2017.
8 Sharankov 2007, 518–19; Sharankov 2017, 780.
9 Sharankov 2014, 276–77.
10 Topalilov 2020.
11 Sharankov 2013, 397.
12 Sharankov 2015, 71–73.
13 Sharankov 2007, 518–19; Sharankov 2017, 779–80.
14 Mladenova 1991.
15 On the image, see Popova-Moroz 1987, 47.
16 On the *thracarchs*, see Sharankov 2007.

17 Pilhofer 2009, 73–75, no. 61, 303–6, no. 240, and 428–29, no. 357.
18 Sharankov 2005c, 69.
19 Sharankov 2006, 179–94, 196–98.
20 Sharankov 2018, 105–6.
21 Sharankov 2005a, 48–49.
22 *IGBulg.* III.2, 1595.
23 Sharankov 2002, 233–34.
24 Sharankov 2005b, 278–89.
25 On this, see most recently Topalilov 2018. On the presentation of Eumolpos on Philippopolitan coin issues in Thracian manner, which became one of the key elements in the identity of the Philippopolitan community, see Peter 2005, 108–9.

CATALOGUE

BRONZE AGE AND EARLY IRON AGE THRACE

I.

It was in the last days of the mythical Heroic Age that the Thracians appeared for the first time in the world of ancient Greek literature, helping the Trojans fight off the Achaeans in the *Iliad*. There were several peoples inhabiting the north Aegean region: the Thracians living by the Hellespont, next-door neighbors of the Trojans; then the Kikones further west; and the Thracians, led by King Rhesos, presumably from the region of the Strymon River. While Hesiod inserted the Heroic Age between his Bronze and Iron Ages (*Works and Days* 109–201), the conventional date of the Trojan War, in the early twelfth century BC, as calculated by Eratosthenes—and possibly confirmed by archaeology—would place the conflict near the end of the Late Bronze Age, as conceived by modern-day scholars.

Homer's Thracians were fearsome warriors, and their land was famous for its horses and other riches, including gold and silver. Certainly there is always the question of whether this image in the epics reflected the Mycenaean Greeks' actual knowledge of the northern periphery of the Aegean world or was derived from later encounters. Archaeology cannot provide a definitive answer, but an ever-growing number of discoveries clearly demonstrates that goods and probably ideas from the Mediterranean found their way to what would become known as Thrace in the second half of the second millennium BC.

Occasional sherds of Mycenaean vases have been found at archaeological sites in present-day southern Bulgaria, but other types of artifacts offer weightier evidence of contacts and trade, among them several oxhide copper ingots. Archaeometric analyses reveal their Cypriot origin, and Troy must have played a role in their redistribution northward. That Thracian warriors may have met, if not necessarily fought, their Aegean counterparts is also suggested by the adoption in Thrace of one of the iconic weapons of the Mycenaean world: the long rapier, which was re-created locally in an improved version. Rapiers were used longer in Thrace than in Greece, to be replaced later by swords from central Europe.

Numerous other finds indicate that Bronze Age Thracians were skilled metalworkers, and there is another aspect of Thrace's depiction in the *Iliad* and the *Odyssey* that finds support in artifacts from Bulgaria and elsewhere: its wealth. The Valchitran Treasure, with its masterful artisanship and its almost 12.5 kilograms of pure gold, would be fit for a mythical king like Rhesos, and it is probably not a coincidence that recent excavations in the eastern Rhodopes, in Bulgaria, uncovered an actual gold mine that operated for several centuries, from about 1500 BC onward.

The transformations that marked the end of the Mycenaean world also affected its contacts with Thrace. The memory of Thracian riches may have persisted in myths, however, and lured the Greeks of the Archaic period to set sail for the northern shores of the Aegean, above which loomed the gold-rich Mount Pangaion. •MD

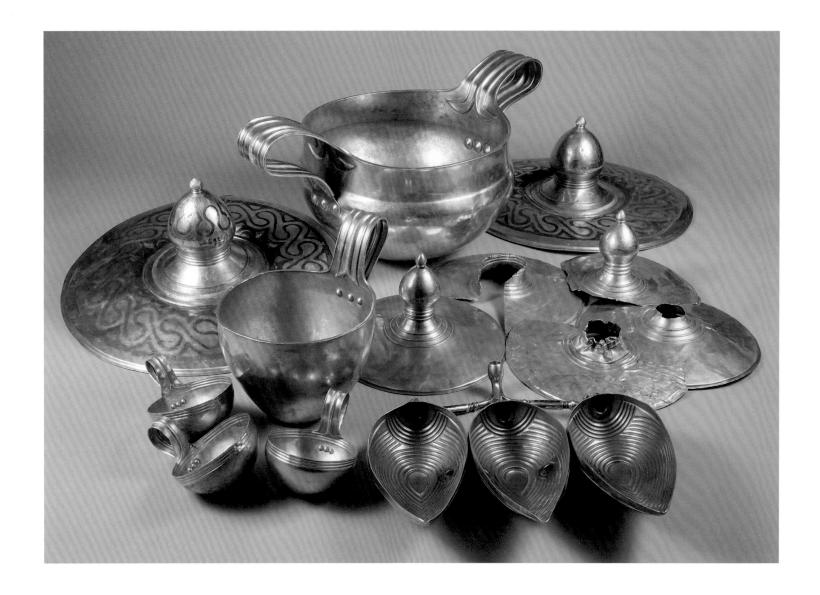

1

THE VALCHITRAN TREASURE

ca. 1500–1000 BC
Found near Valchitran, Pleven Province,
Bulgaria, in 1924

One of the most significant Late Bronze Age finds from the Balkans, the Valchitran Treasure was discovered in 1924 during land cultivation near the village of Valchitran, in northern Bulgaria.[1] Archaeologists from the National Archaeological Institute with Museum in Sofia established that the thirteen gold artifacts with a total weight of 12.5 kilograms were found together, without associated materials, at approximately thirty centimeters below the modern surface.[2] The large two-handled vessel (conventionally identified by the Greek term *kantharos*) was found tilted to the side, with the smaller ones placed in it and the lids propped on their sides in front of its mouth. A short field survey detected traces of human habitation from the Late Bronze Age (second half of the second millennium BC) at several locations in the area.

The treasure has attracted considerable scholarly interest ever since, generating numerous hypotheses and interpretations regarding its cultural affiliation, function, and date.[3] The most widely accepted opinion is that the treasure was used in rituals, especially for libations,[4] or for ritual feasts, as part of a larger set that also included vessels made from other materials.[5] The disks are usually interpreted as lids for vessels, some of which were probably not made of gold,[6] although some scholars suggest that the absence of such vessels indicates that the disks did not serve any practical function.[7] Opinions on the tripartite vessel also vary widely because of its uniqueness, both typologically and technologically: the oval chased containers are connected by soldered arched electrum tubes. Other tubes extend from the rounded ends of the containers, the two outer ones joining the one in the middle. Thus it may have been used for libations,[8] storage, ritual mixing of liquids,[9] or even as a burner for narcotic

substances.[10] Less controversially, the *kantharos*, the large one-handled vessel, and the smaller cups (*kyathoi*) are regarded as a set for ritual communal drinking.[11]

All the artifacts are made of placer gold (gold separated from its original deposit through erosion or alluvial flow). The composition varies, and thus the objects appear not to have been produced from the same batch of metal.[12] Various techniques were utilized for their production and decoration: casting, hammering, chasing, soldering, and damascening (silver strips inlaid into the gold alloy).[13] Most probably, the first step was the casting of a blank (positively established for the *kantharos* and the large one-handled vessel). The next step for all artifacts was hammering, that is, mechanically shaping the metal into the intended form. The construction of the disks includes an inner cast-bronze armature with ball-shaped upper part and disk-shaped base. The gold was forged onto the bronze base.[14]

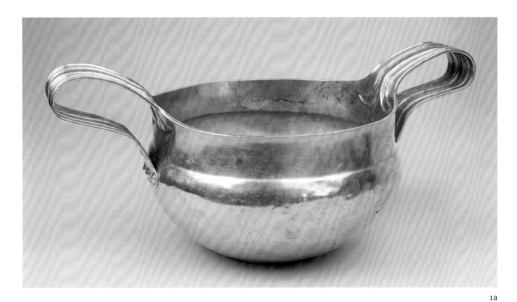

1a

a. **Vessel with Two Handles (*Kantharos*)**
Gold
H with handles: 21.5 cm; W with handles:
50 cm; H of vessel: 16.5 cm;
Diam of rim: 28 cm; Wt: 4395 grams
Sofia, National Archaeological Institute
with Museum, 3192

b. Cup with One Handle (*Kyathos*)
Gold
H with handle: 17.8 cm; W with handle:
20 cm; H of vessel: 12 cm;
Diam of rim: 15.7 cm; Wt: 919 grams
Sofia, National Archaeological Institute
with Museum, 3193

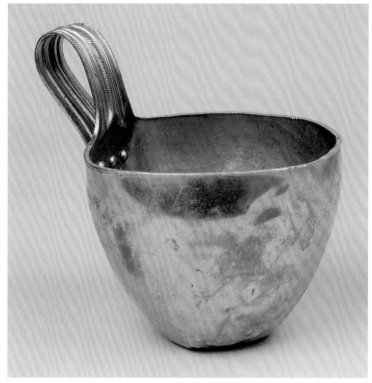

1b

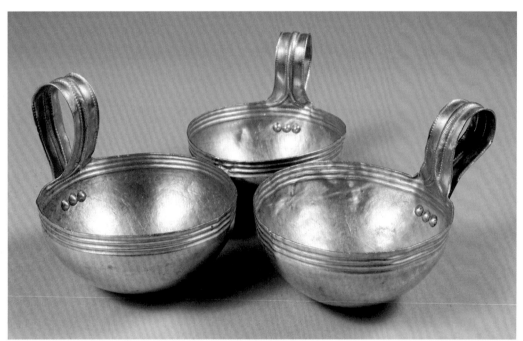

1c–e

c. Cup with One Handle (*Kyathos*)
Gold
H with handle: 8.2 cm; W with handle:
11.5 cm; H of vessel: 4.5 cm;
Diam of rim: 8.5 cm; Wt: 130 grams
Sofia, National Archaeological Institute
with Museum, 3194

d. Cup with One Handle (*Kyathos*)
Gold
H with handle: 8.2 cm; W with handle:
11 cm; H of vessel: 4.5 cm; Diam of rim:
8.5 cm; Wt: 132 grams
Sofia, National Archaeological Institute
with Museum, 3195

e. Cup with One Handle (*Kyathos*)
Gold
H with handle: 8.5 cm; W with handle:
10 cm; H of vessel: 4.7 cm; Diam of rim:
8.7 cm; Wt: 123 grams
Sofia, National Archaeological Institute
with Museum, 3204

f. Lid with Bulbous Knob
Gold, bronze
H: 12.6 cm; Diam: 36.8 cm; Wt: 1850 grams
Sofia, National Archaeological Institute
with Museum, 3196

g. Lid with Bulbous Knob
Gold, bronze
H: 12.6 cm; Diam: 37 cm; Wt: 1755 grams
Sofia, National Archaeological Institute
with Museum, 3197

The final appearance of the items was accomplished by chased decoration.

Based on technical analyses, three groups can be distinguished.[15] The first one comprises the *kantharos* (cat. 1a), the large one-handled vessel (cat. 1b), and the three cups (cats. 1c–1e), united by the fine chased decoration and the riveting of the handle to the body. The disks belong to the second group in view of the bronze armature and the decoration by damascening (cats. 1f–1l). The use of soldering places the tripartite vessel in a separate, third group (cat. 1m). All objects show traces of chasing and chiseling, indicating that they belong to the same technological circle. The casting of precious metals and bronze, as well as the use of elaborate decorative techniques such as damascening, demonstrate the very high expertise of the ancient craftsmen, who were capable of melting large amounts of gold and also of casting large objects with very thin walls.[16]

It has been suggested that the three groups were made either in different workshops or at different times and that the composition of the gold of the tripartite vessel may indicate a different origin.[17] The first group is considered the earliest, from the sixteenth to fifteenth century BC,[18] while a date in the ninth century BC has been offered for the second.[19] Other scholars regard the treasure as a single, cohesive set and date it to the fourteenth to thirteenth century BC,[20] to the transition between the Late Bronze and the Early Iron Age,[21] or as late as the ninth century BC.[22]

These discordant opinions reflect the uniqueness of the Valchitran Treasure. Still, most of the vessels find good analogies in neighboring areas. Vessels similar to the large *kantharos* were discovered at Krizhovlin (Ukraine) and Rădeni (Romania),[23] and both the *kantharos* and the cups

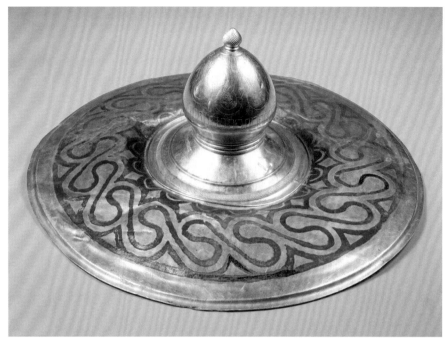

1f

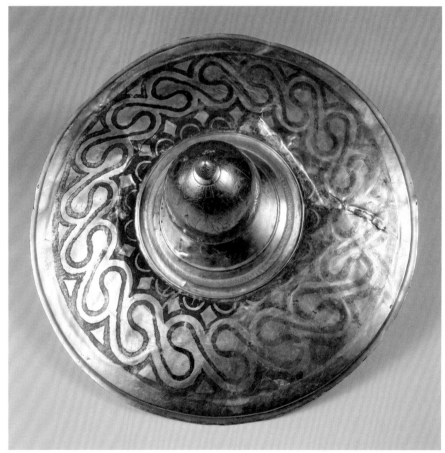

1g

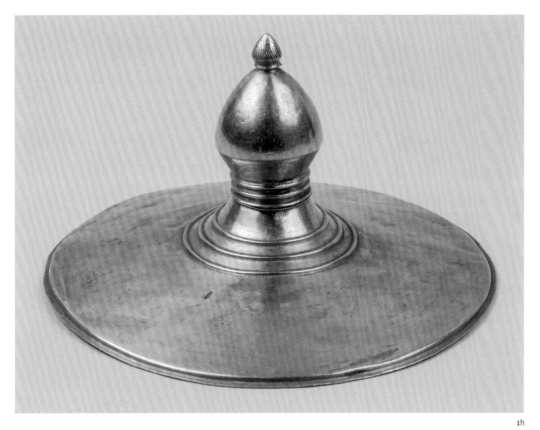

1h

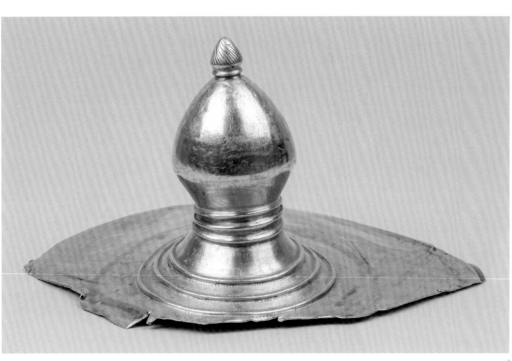

1i

h. Lid with Bulbous Knob
Gold, bronze
H: 11.5 cm; Diam: 21.6 cm; Wt: 588 grams
Sofia, National Archaeological Institute
with Museum, 3198

i. Lid with Bulbous Knob
Gold, bronze
10.5 × 19.7 × 15.5 cm; Wt: 462 grams
Sofia, National Archaeological Institute
with Museum, 3199

j. Lid
Gold, bronze
H: 3.1 cm; Diam: 21.6 cm; Wt: 369 grams
Sofia, National Archaeological Institute
with Museum, 3200

k. Lid
Gold, bronze
H: 4 cm; Diam: 21.2 cm; Wt: 300 grams
Sofia, National Archaeological Institute
with Museum, 3201

1j

1k

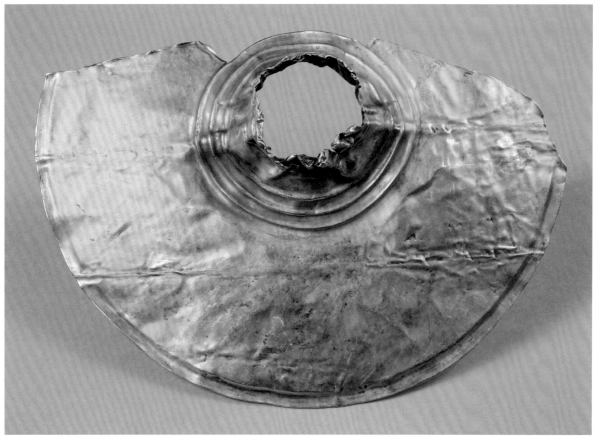

1|

l. Lid

Gold, bronze
4 × 22 × 14.7 cm; Wt: 207 grams
Sofia, National Archaeological Institute
with Museum, 3202

resemble ceramic vessels from the Late
Bronze Age and the beginning of the Early
Iron Age in southeastern Europe.[24] Disks
identical to those from the Valchitran group
but made of electrum are in the National
Historical Museum in Sofia,[25] and there are
two others in a private collection.[26] Another
disk made of silver, gold, and bronze is
known from Călăraşi, Romania.[27] Particularly
interesting is the parallel with one of the
molds in the Pobit Kamak hoard (from north-
eastern Bulgaria), made for casting the
bronze core of a bulbous handle, probably
of a disk.[28]

Taking all parallels into account, the
Valchitran Treasure is considered the
product of a local toreutic workshop,[29]
related to the Carpatho-Danubian cultural
zone, with prototypes, or at least influences,
from the Aegean world and the west coast

of the Black Sea.[30] The concentration
of treasures and finds of Valchitran type
distinguishes the region of the Lower
Danube as a unique area in the Late Bronze
Age North Balkan cultural zone.[31] •YD KC

1 Marazov 1998a, 228–32, nos. 184–96; K. Chukalev
 in Alexandrov et al. 2018, 504–7, nos. 299–311.
2 V. Mikov 1958, 5–7.
3 Chukalev and Dimitrova 2018, 379–82.
4 Bonev 1988, 37–38; Gergova 1994, 70; Varbanova
 1994, 28; Bonev 2003, 28.
5 Shalganova 2003, 78.
6 Venedikov and Gerasimov 1973, 33; Venedikov
 1987, 27–29; Sherratt and Taylor 1989, 119.
7 Andrieşescu 1925; V. Mikov 1958, 47–49;
 Ognenova-Marinova 1978b, 240; Gergova 1987,
 63–64; Gergova 1994, 70.
8 Ognenova-Marinova 1978b, 243.
9 Venedikov 1987, 51–52, 97–98; Varbanova
 1994, 26.
10 Gergova 2000, 142–43; Shalganova 2003, 89.
11 Sherratt and Taylor 1989, 119–23, 126; Gergova
 1994, 69.
12 Pernicka 2018, 220–21.
13 P. Penkova and Mehofer 2018.
14 P. Penkova and Mehofer 2018, 211.
15 P. Penkova and Mehofer 2018, 213.
16 P. Penkova and Mehofer 2018, 213.

17 Pernicka 2018, 222.
18 Venedikov and Gerasimov 1973, 33; Venedikov
 1987, 27–29, 79–80; Sherratt and Taylor 1989, 127.
19 Sherratt and Taylor 1989, 119.
20 Bonev 1984; Bonev 1988, 17, 36; Bonev 2003, 27.
21 Shalganova 2003, 92–93.
22 Gergova 1994, 72–78.
23 Dzis-Raiko and Chernyakov 1981; Vulpe and
 Mihăilesku-Bîrliba 1985.
24 Hänsel 1976, plates 7:5, 8:8, 16:1, 16:3, 21:1;
 Y. Dimitrova, forthcoming.
25 Shalganova 2003, 79.
26 Marazov 2011c, 20; Stefanova 2018.
27 Bondoc 2006.
28 Bonev 1988, 28, 30.
29 V. Mikov 1958; Garašanin 1978, 284–87; Venedikov
 1987, 79, 85, 98–101; Sherratt and Taylor 1989;
 Bonev 2003, 29.
30 On Aegean influences, see Garašanin 1978;
 Bonev 2003, 27–29; on Black Sea connections,
 see Dzis-Raiko and Chernyakov 1981, 160–61;
 Sherratt and Taylor 1989, 129.
31 Shalganova 2003, 79; Chukalev and Dimitrova
 2018.

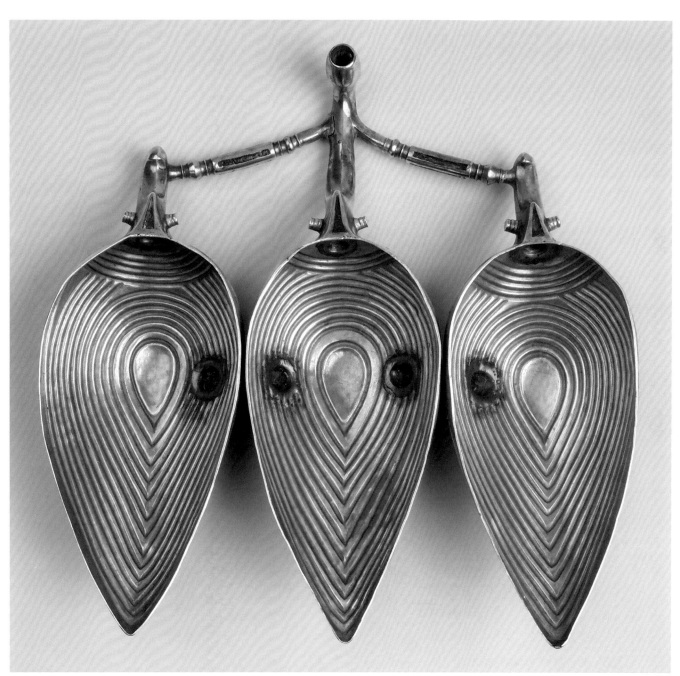

1m

m. Tripartite Vessel
Gold
28 × 27.9 × 6.2 cm; Wt: 1190 grams
Sofia, National Archaeological Institute
with Museum, 3203

2

2

Oxhide Ingot

14th–13th century BC
Copper
34 × 58 × 4 cm; Wt: 26 kg
Found near the village of Cherkovo,
Burgas Province, Bulgaria
Burgas, Regional Historical Museum,
B-2874

The ingot is rectangular, with concave sides, and originally had four handles at the corners, now broken off.[1] There is a mark on the surface that may be a trademark. The shape of the ingot is characteristic of the type known as oxhide ingots, which are emblematic of the long-distance trade in the Mediterranean in the Late Bronze Age (sixteenth to twelfth century BC). Such ingots have been discovered in the Levant, Anatolia, and Egypt in the east and in Greece, Sicily, Sardinia, and the southern coast of France in the west.[2]

The Cherkovo ingot is among the first discovered in the eastern parts of the Balkan Peninsula.[3] It belongs to a relatively large group that reached the hinterland of the Propontis (Sea of Marmara) and the west Pontic coast, in present-day Bulgaria and

Turkey. Intact or fragmentary ingots have been found in Kozman Dere, Chernozem, Kirilovo, Kamenovo, Ruse, and other locations,[4] indicating the development of trade and transregional contacts between the Mediterranean civilizations and the Lower Danube.[5] Cyprus was one of the main producers of copper in this period, and the latest technical studies clearly demonstrate that all oxhide ingots from the eastern Balkans are made of Cypriot copper.[6]

A question remains, however: what necessitated the long-distance importation of copper to a region that already possessed rich copper deposits?[7] The copper sources in the area of the Strandzha and Sredna Gora Mountains were already being exploited in the Chalcolithic period (fifth and early fourth millennium BC). The oxhide ingots may have served as high-status gifts within a developed exchange system in which the actual use of the metal itself was not the primary function.[8] The ingots may also have served as a premonetary means of exchange.[9] Discovered near major thoroughfares connecting the Aegean and the Mediterranean with the Lower Danube, the ingots are indicators of the demand for other important goods the Balkans could offer, such as precious metals and salt.

In recent years interest in the provenance and distribution of metals in the Bronze Age has increased, aided by the continuing progress of archaeometric analyses that offer unprecedented new data.[10] The picture of the main sources of copper used in the Bronze Age East Balkans remains incomplete and requires a detailed comparison between the characteristics of the copper used for mass-produced metal items and those of the copper used for the oxhide ingots discovered in these parts of southeastern Europe. •HP

1 M. Klasnakov in Alexandrov et al. 2018, 521, no. 368.
2 Buchholz 1988; Yalçın, Pulak, and Slotta 2005; Lo Schiavo et al. 2009; Jockenhövel 2018.
3 Karayotov 1978.
4 Athanassov et al. 2020, 300–314, figs. 1, 10, map 1.
5 Doncheva 2012; Jockenhövel 2018.
6 Athanassov et al. 2020, 322–32, figs. 13–18.
7 K. Leshtakov 2007, 456.
8 Jockenhövel 2018, 179; Athanassov et al. 2020, 333–41.
9 Karayotov 1978, 16.
10 Radivojević et al. 2019.

3–5
THRACIAN WEAPONS IN THE LATE BRONZE AGE

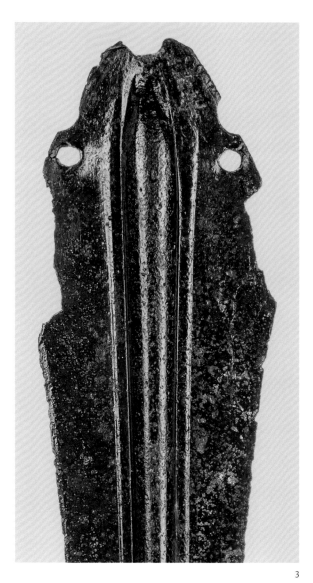

3

3
Rapier

1700–1500 BC
Bronze
88.2 × 6.2 × 1.6 cm; Wt: 735 grams
Sofia, National Historical Museum,
52530

Rapiers were cut-and-thrust swords that appeared in the Early Bronze Age but were most popular in both ancient Greece and the Balkans during the Late Bronze Age (1600–1100/1050 BC).[1] They had long triangular blades, in some cases almost one meter long, with a pronounced midrib to prevent bending. The long blade provided an advantage in close-quarter combat against other weapons. Preserved depictions from the Aegean world and anthropological analyses of bones from warrior graves on Crete indicate that rapiers were used to inflict wounds on the neck and right arm.[2]

Initially the grip was made of wood and riveted to the base of the blade. This joint proved to be a weak spot on the early Type A rapiers, as the blade often broke at the base. In order to improve the strength of the weapon, an entirely metal hilt was created, and a guard was added to protect the hand of the fighter.[3] These new weapons are termed "horned," or Type C, rapiers,[4] and include the weapon from the National Historical Museum in Sofia (cat. 3) and the example from the village of Levski (cat. 4).[5]

Late Bronze Age rapiers found in Bulgaria have long been regarded as evidence of direct contacts—both through trade and the exchange of technology—between ancient Thrace and the Mycenaean world.[6] Twelve such weapons are known from various regions of the country. While influenced by the Mycenaean horned rapiers, however, those from Thrace demonstrate local characteristics. Differences can be seen mainly in the construction of the hilt, with longer horns that protrude to the sides at almost right angles; also, the midrib and the flange are sturdier. Bernhard Hänsel

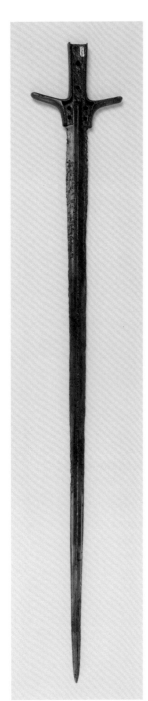

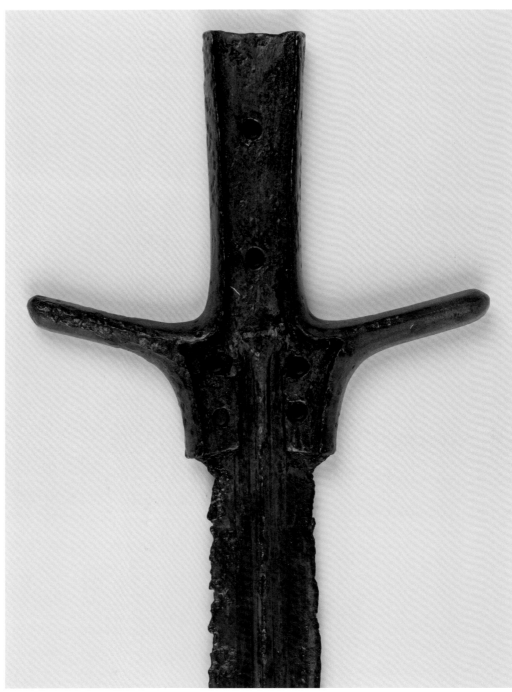

4

4
Rapier

1500–1000 BC
Bronze
78 × 11.5 (at hilt guard) × 1.5 cm;
Wt: 500 grams
Probably from a burial near Levski,
Pleven Province, Bulgaria
Sofia, National Archaeological Institute
with Museum, 616

considered them superior to the Greek prototypes and evidence of the existence of a high-ranking warrior class like the one in Mycenae.[7]

In the Aegean, horned rapiers were used mainly in the first half of the Late Bronze Age (1450–1350 BC). They were probably symbols of prestige and served ceremonial functions in addition to being used in combat, considerably extending the lifespan of certain weapons.[8] After 1350 BC there were changes in Mycenaean warfare, and rapiers were replaced by new types of short swords that do not occur in the Balkans.[9] It could therefore be presumed that Type C rapiers were used longer in the Balkans—until the appearance of bronze swords of the Naue II / Nenzingen type, which arrived from central Europe around 1250 BC.[10]

A typical example of this later type is the sword from Oryahovo, which has a broad blade with straight edges (cat. 5).[11] The midrib is lower and broader, adding to the strength of the construction together with the reinforced hilt. This new type of weapon was meant for slashing or stabbing. Damage at the base of the blade of the Oryahovo sword indicates that this part served to block slashing blows. These innovations made swords superior to rapiers. Their introduction brought fundamental changes to warfare in both Thrace and the Mycenaean world, and their use continued after the end of the Late Bronze Age, when iron became the main material for their production.[12] •LL

1 Kilian-Dirlmeier 1993; Abramišvili 2001, 7, plate 1; Kilian-Dirlmeier 2005, plates 10, 26.
2 Peatfield 1999, 70–71.
3 Peatfield 1999, 70.
4 Sandars 1963, 119.
5 M. Hristov in Alexandrov et al. 2018, 514, no. 344, and S. Taneva in Alexandrov et al. 2018, 517, no. 352, respectively.
6 Hänsel 1970, 26, 29.
7 Hänsel 1970, 29; see Jung 2018, 249.
8 Kilian-Dirlmeier 1993, 32.
9 Sandars 1963, 123, 142.
10 Panayotov 1980, 175.
11 S. Taneva in Alexandrov et al. 2018, 518, no. 358.
12 Kilian-Dirlmeier 1993, 106–15.

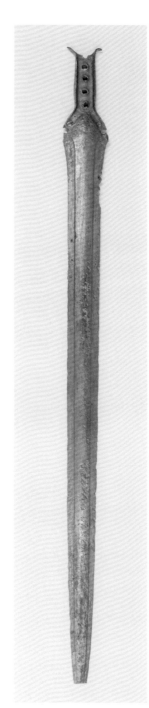

5

5
Sword

1250–1000 BC
Bronze
70 × 5.3 × 1.1 cm
Chance find near Oryahovo,
Vratsa Province, Bulgaria
Sofia, National Archaeological Institute
with Museum, 3020

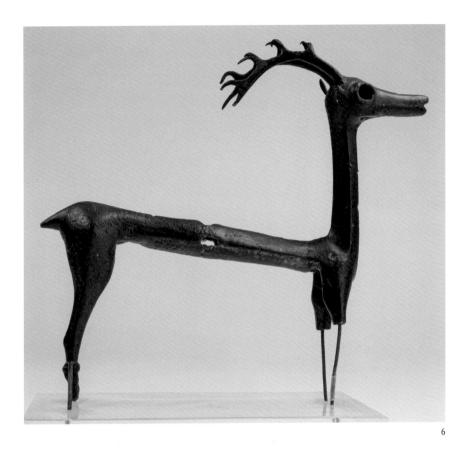

6

6

Stag Figurine

ca. 650–600 BC
Bronze
16.5 × 2.7 × 19 cm
Chance find near Sevlievo,
Gabrovo Province, Bulgaria
Sofia, National Archaeological Institute
with Museum, 747

This figurine of a red deer was made by hollow-core casting and forging.[1] The animal's body and neck are elongated and of prismatic shape, with pronounced edges. The head is also elongated and bent slightly back. The large eyes are round and hollow, the mouth slightly open, and the nostrils wide. The antlers were cast separately and soldered to the head. They are symmetrical, each one with five pointed tines, and arched backward. The tail is short, typical of this species. In the middle of the body are three holes that intersect at right angles, one of irregular shape on the back and two rectangular ones at the sides. The location and the symmetrical arrangement of the holes suggest the stag was part of a sculptural

group, as indicated by riveted pieces of bronze that may have served for attaching another statuette. The large size of the stag excludes the possibility that the holes were used to attach rings for hanging.[2] The stag's legs are partially preserved, with only the left hind leg intact. It is also missing its right ear. The hoof of the left hind leg is not finished; its lower part was made separately and added. It is unclear why it was left poorly shaped. Possibly the figurine was mounted on a metal base by means of holes.

The stag figurine is among the earliest depictions of a deer from ancient Thrace. While it testifies to the great technological and artistic skill of the artisan, it still lacks close parallels, leading to a variety of hypotheses as to possible influences. Some scholars have suggested a transfer of Near Eastern influence by means of Scythian or Iranian intermediaries,[3] but the similarities with the bronze miniatures of deer and horses from sanctuaries in Arcadia, Olympia, Thebes, and Philippi, in Greece, provide grounds to consider the figurine a Thracian work influenced by Greek Geometric art.[4] Among the local features are the prismatic

body and neck, which reflect stylized animal depictions on bronze votive axes from Thrace,[5] while the overall silhouette and the technology reflect Archaic trends in Greek art.[6]

The figurine was acquired by the National Archaeological Institute with Museum in Sofia without information about its context. Presumably it was part of a disturbed burial or a hoard. It was probably made near the area where it was found. •MS

1 Marazov 1998a, 216–17, no. 164; P. Delev in Martinez et al. 2015, 24–25, fig. 5; Y. Dimitrova in Boyadzhiev, Stamberova, and Vasileva 2022, 72. Evidence of the manufacturing process can be seen at the lower part of the head, where a triangular hole was used for scraping out the core: V. Vasilev 1989, 20.
2 Ognenova-Marinova 1976, 134.
3 Milchev 1955, 364–65; Venedikov and Gerasimov 1973, 31–32.
4 Bouzek 1997, 246; Karadzhinov 2013.
5 Milchev 1955, 364.
6 Ognenova-Marinova 1976, 132–33.

THRACIAN INSCRIPTIONS

II.

Although they did not develop their own writing system, the ancient Thracians appreciated the usefulness of writing and did not shun using Greek script for everyday needs. Numerous fifth- and fourth-century BC objects are inscribed with the names of their Thracian owners—for example, the silver vases from the Bashova Tumulus at Duvanlii bearing the inscription *Dadaleme* or the helmet and two vessels from the Golyama Kosmatka Tumulus, dated a century later, which are inscribed *Seuthou*. The short formulae on *phialai* from the Rogozen Treasure and elsewhere may have had fiscal functions, and a handful of official documents recording dealings between Greeks and Thracians, such as the Pistiros and Seuthopolis Inscriptions or the Mesembrian decrees for Sadalas and his ancestors, suggest an even higher decree of literacy among the elite. Another testimony to this is the facade of an early Hellenistic tomb near Smyadovo, in northeast Bulgaria, which bears a carefully engraved inscription that is completely Greek in its manner: ΓΟΝΙΜΑΣΗΖΗ ΣΕΥΘΟΥ ΓΥΝΗ (Gonimasedze, wife of Seuthes).

Against this backdrop of a wide use of the Greek alphabet in Classical and Hellenistic Thrace, the instances in which it served to record something in the Thracian language are preciously rare. The numerous non-Greek graffiti from the sanctuaries at Zone and Samothrace have a clear context related to cult, and Diodorus's note on the use of the native language in sacrificial rituals (*Bibliotheca historica* 5.47.3) has contributed to our understanding of them. In contrast, only two presumably Thracian inscriptions are known from the interior of the country: those on a gold finger ring from a disturbed rich burial near Ezerovo, contemporaneous with the Duvanlii necropolis, and a stone stele from Kyolmen, in the northeast, associated with an early Hellenistic warrior's grave but most probably reused. The funerary context of both finds has influenced the efforts to translate them, but the results are hardly convincing. And while the finger ring belongs to the lavish material culture of the Odrysian nobility in a period of active exchange with Greece, the Archaic appearance of the Kyolmen inscription and its alphabet, with no exact parallel in the Greek world, only adds to its enigma. •MD

7

Thracian Inscription

Possibly 6th or 5th century BC
Sandstone
148 × 72 × 15.5 cm
Chance find near the village of Kyolmen,
Shumen Province, Bulgaria, in 1965
Sofia, National Archaeological Institute
with Museum, 8412

This inscribed stone, found during agricultural work, had been used as a covering slab for a grave under a low tumulus. The ensuing archaeological excavations revealed that the grave dates to the late fourth century BC, based on the finds, which include fragments of scale armor, spearheads, an amphora, and a *lekythos*.[1] Since the presumed date of the inscription is much earlier and the slab is said to have been found with its inscribed face turned down, it was apparently reused.

The Kyolmen inscription is regarded as one of the very few Thracian inscriptions on stone and the only one found in the interior of Thrace. All other examples were discovered on Samothrace or on the Aegean coast across from the island. None of the interpretations thus far proposed by different scholars can be considered successful. Despite the uncertainty about its original use, most editors are inclined to regard it as a funerary inscription,[2] and only a few, considering the secondary use of the stone, propose other possibilities, like a pedestal for a movable object with a dedicatory inscription.[3]

Almost all editors accept that the text starts on the right part of the slab and crosses to the opposite edge, written from right to left. It then continues—written from left to right—along the edge, turns obliquely near the corner, and then turns again along the other edge. Most scholars divide this long line before the letters EBA (the beginning of the text, according to Vladimir Georgiev),[4] but these three letters are a continuation of the first part of the line written from right to left. A separate line is engraved in the middle part of the slab, also from right to left.

1: [.?]II<AΣII>ETEΔII<EΔIIEIIIΔAKATD
 •Σ•[.?]EBA ←
 Ɔ•ZEΣAΣII →
 HIIETEΣAIƆEK•A →
2: IIB>ABAHƆII ←

The alphabet partially resembles some early Greek alphabets but has no exact parallels; it is different from both the Milesian and the Megarian alphabets used in the west Pontic Greek colonies. Moreover, the values of some letters remain uncertain. Two angular letters, < and >, are seen as one and the same letter carelessly written with different orientation, as lambda and upsilon, or as an angular variant of gamma, which is otherwise rounded, Ɔ. The letter D is interpreted differently as either rho or a rounded variant of delta, twice written as Δ. There are two types of "sigma," four- and six-bar, which some scholars interpret as different sibilants, similar to those in some early Greek alphabets; others think that one of the two letters could be M written sideways. The interpretation of the three-bar letter, usually considered to be Z (but zeta has a different shape in early Greek alphabets), is also uncertain. The sign consisting of two vertical strokes and appearing no less than nine times throughout the text was initially considered a separation mark,[5] but Georgiev, after noticing the absence of N among the other letters, proposed interpreting it as a variant of N. If it is interpreted as N or as a word divider, however, the text would contain consonant clusters or words ending in consonants, which is not compatible with other early examples of Thracian or with the imitation of Thracian in Aristophanes's comedic play *Birds* (first performed 414 BC), in which one sees only open syllables.

The language is generally thought to be Thracian or, more specifically, Getic/Daco-Moesian. Veselin Beševliev mentioned another possibility, however—that it could be an unknown language belonging to foreign warriors (because of the weapons in the grave), one of whom died during a campaign in Thrace. Other suggestions include a mixed language or a verse inscription in a language closely related to Phrygian.[6]

The letter sequence ETEΣA is usually explained as the plural of an es-stem noun related to Greek ἔτεα/ἔτη, "years," in an indication of the age of the deceased, while his name is read by many editors in the sequence as EBAPO and related to the name of the Hebros River or the first element in Thracian anthroponyms such as Ebry-zelmis. As Beševliev noted, however, the fourth letter of the presumed EBAPO is certainly not P, but rather Ɔ = Γ. The sequence BΛABA in the second line is commonly interpreted as corresponding to the Greek βλάβη/βλάβα, "harm"—a warning to grave violators. Fred Woudhuizen read this line from left to right, however, and thinks of a writing exercise containing the first three letters of the alphabet (A, B, Γ).[7] •NS

1 Dremsizova-Nelchinova 1970.
2 Beševliev 1965; V. Georgiev 1966; Schmitt-Brandt
 1967; Ancillotti 1986; Schmid 1987; P. Dimitrov
 2003.
3 Woudhuizen 2000–2001, 291–92.
4 V. Georgiev 1966, 13.
5 Beševliev 1965, followed by Ancillotti 1986;
 Woudhuizen 2000–2001.
6 Mixed language: Woudhuizen 2000–2001; verse
 inscription: Orel 1997.
7 Woudhuizen 2000–2001.

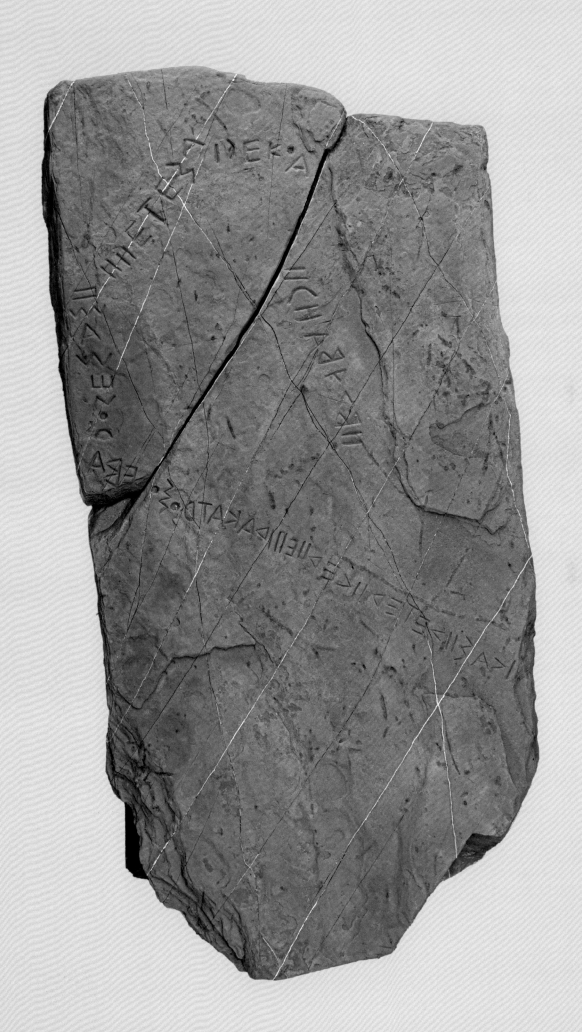

8

Finger Ring with Thracian Inscription

Late 5th–early 4th century BC
Gold
H: 2.5 cm; Diam of inner band: 2.3 cm;
scaraboid: 1.7 × 2 × 0.6 cm; Wt: 31.3 grams
Found near the village of Ezerovo,
Plovdiv Province, Bulgaria, in 1912
Sofia, National Archaeological Institute
with Museum, 5217

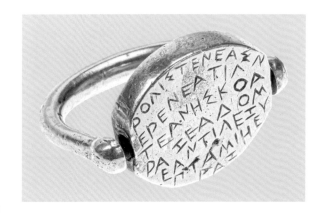

This solid gold ring has a hoop that thickens
in the middle and holds an oval scaraboid
that swivels; it was made by casting, forging,
polishing, and engraving. The scaraboid
is pierced longitudinally and attached to
the hoop by means of a gold pin ending in
hemispheric elements. It has a slightly
convex upper side with an unpolished spot
of what appears to be another metal of
whitish color. The lower surface is flat, with
an engraved inscription in Greek letters,
four of them engraved on the scaraboid's
side.

The inscription of sixty-one letters
in eight lines is continuous, without spaces
between words, and presumably in the
Thracian language:[1]

8

ΡΟΛΙΣΤΕΝΕΑΣ Ν-
ΕΡΕΝΕΑ ΤΙΛ-
ΤΕΑΝ ΗΣΚΟ Α-
4 ΡΑ<Σ> ΖΕΑ ΔΟΜ-
ΕΑΝ ΤΙΛΕΖΥ-
Π ΤΑ ΜΙΗ Ε-
ΡΑ Ζ-
8 ΗΛΤΑ

This is one of the few preserved examples
of the ancient Thracian language and has
provoked a century-long discussion and
numerous interpretations, most suggest-
ing a sacred formula but none completely
convincing.[2] Most often the translation of
Vladimir Georgiev is referred to: "Roliste-
neas, I, your young wife, the chosen one
(or Nerenea Tiltea?), die beside (you),
my blessed one, (I) who nourished (raised)
the children."[3]

The ring is unique for Thrace not only for
the inscription but also as a piece of jewelry.
The shape is typical of fifth-century BC

Greek jewelry: a gold hoop usually set with
a scaraboid of semiprecious gemstone
with engraved figural images but sometimes
with inscriptions.[4] There are few such finds
from Thrace, but these include gold finger
rings with agate and chalcedony scara-
boids of Greek workmanship discovered in
Odrysian aristocratic burials from the middle
and the second half of the fifth century BC
in burial mounds at Krushare, Brezovo,
and Chernozemen-Kaloyanovo.[5] The ring
from Ezerovo is of this general type, but
the scaraboid was cast in gold in order
to be engraved with an inscription that was
apparently important to the owner. It is
a work of a local Thracian goldsmith and
was discovered with other gold items,
including a pectoral, a spoon, and three
triangular plates. The archaeological
context—a cremation grave in a burial
mound—was disturbed when it was discov-
ered, and some items were recovered
later, but it seems that the burial's inven-
tory also comprised a bronze *lekane*,

a mirror, a bracelet, and fragments of a
black-glaze bowl. The burial is dated
to the later fifth century BC or the begin-
ning of the fourth century BC.[6] •MT

1 Filov 1913, 205–6, 214–20, table III-3, 4; Venedikov
 and Gerasimov 1975, 374, no. 206; Marazov 1998a,
 188, no. 125; L. Domaradzka and M. Tonkova in
 Martinez et al. 2015, 160, no. 114. The text is
 reproduced after *SEG* 38, 733.

2 Most of them are brought together in Detschew
 1976, 566–82; Polomé 1982, 878–79; Rządkiewicz
 2006; see also L. Domaradzka in Martinez et al.
 2015, 158–59.

3 V. Georgiev 1977, 108.

4 Filov 1913, 215–16; Boardman 1970, 191–92, 230.

5 Tonkova 2015, 216.

6 Filov 1913, 207–9; Venedikov and Gerasimov 1975,
 no. 206.

THRACE IN
GREEK MYTH

III.

Though geographically close to Greece, Thrace remained remote in the Greek imagination. The land was the home of the cold north wind, Boreas. Its people were often viewed as warlike and cruel. But the country was also believed to be a place of ecstatic religion, the occasional dwelling place of the god Dionysos. Already in the Homeric epics, Thracians were regarded as formidable warriors and famed for their fine horses. The Thracian king Rhesos would have been a devastating foe of the Greeks had he not been treacherously slain on his first night in Troy by Diomedes and Odysseus. After leaving Troy, Odysseus encountered the Thracian Kikones tribe and sacked their city, Ismaros, before being driven away (*Odyssey* 9.39–61). These stories must reflect actual knowledge of the wealth and prowess of the Thracian tribes.

Other myths, however, are more difficult to interpret. The Thracian singer Thamyris is briefly mentioned in the *Iliad* and provides evidence for an early belief in such uncanny figures, but the most famous singer of all, Orpheus, became widely known only in the fifth century BC. At that time he appeared often on Greek vases, usually in a Thracian setting, and his death at the hands of Thracian women is the aspect of his story most often depicted. It is likely, however, that the Thracian locale is not integral to the myth and was an invention of Athenian storytellers, who had some awareness of the significance of Thrace in Athenian politics. Similarly, the story of King Lykourgos, whose disrespect for Dionysos brought about his downfall, was set in Thrace but need not have originated there, and the horrific tale of Tereus and Prokne was sometimes said to be Thracian (conflating the king's name with that of the Thracian Teres), evidently another Athenian invention, one that was vehemently refuted by Thucydides (*History* 2.29). Greek writers display only a superficial knowledge of the Thracian gods, with the exception of Bendis, whose worship was introduced to Greece in the fifth century BC by visiting Thracians and Greek settlers and merchants returning from Thrace. •JS

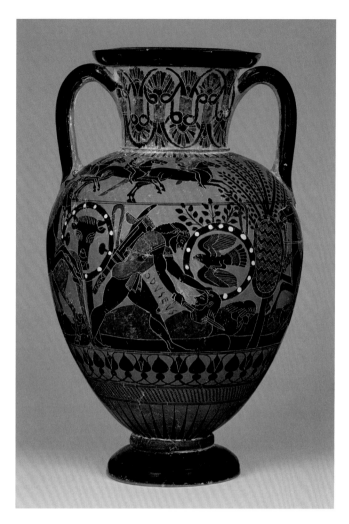 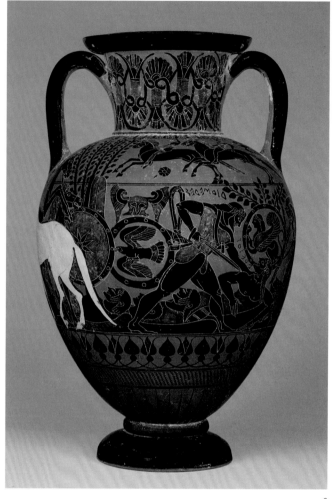

9

9

Black-Figure Neck Amphora with the Killing of Rhesos

Greek, Chalkidian, attributed to the
Inscription Painter, ca. 540 BC
Terracotta
H: 39.6 cm; Diam: 24.9 cm
Los Angeles, The J. Paul Getty Museum,
Villa Collection, 96.AE.1

As related in the *Iliad*, the Thracian king
Rhesos and his men, allies of the Trojans,
arrived at Troy and camped outside the walls
of the city.[1] The king brought magnificent
horses, a chariot worked with gold and silver,
and gold armor, "a wonder to look at." This
information is told to the Greek heroes
Diomedes and Odysseus by the captured
Trojan spy Dolon. As soon as they learn this,
the two Greeks steal into the enemy camp,
slaughter King Rhesos and twelve other

sleeping Thracians, and capture the horses.
Although Homer does not mention it, there
was urgency in killing the Thracians, for an
oracle told that if the Thracians and their
horses slept even one night in Troy and drank
the water, the city could not be captured.[2]

The scene rarely appears in Greek art but
is vividly portrayed on this black-figure neck
amphora produced in the Chalkidian colony
of Rhegion, in present-day southern Italy,
around 540 BC.[3] Odysseus and Diomedes,
both labeled in Greek, slit the throats of
twelve Thracians (as specified in the epic),
who lie asleep on the ground. Diomedes
grasps the neck of the rising Rhesos and
prepares to slay him with his sword. Black,
white, and red horses tethered to posts and
trees rear in fright. One horse is a brilliant
white, recalling the Homeric description
of Rhesos's horses, "the fairest horses that
ever I saw, and the greatest, whiter than
snow, and in speed like the winds."[4]

The presence of a powerful Thracian
king in the Trojan War was significant to a
Greek audience in the sixth century BC,
when there were increasing political and
economic connections to the region. Horses
were also important as an indicator of
wealth and status, and those from Thrace
were renowned.[5] An awareness among the
Greeks of the appearance of the Thracians
may be reflected in the depiction of Rhesos
with red hair and beard, believed by the
Greeks to be characteristic of the people.[6]
•JS

1 *Iliad*, 10.433–41, 10.469–502.
2 The variant versions of the myth are preserved in
 the scholia to the passage in the *Iliad*, which also
 cites a lost poem by Pindar; see Fenik 1964.
3 True 1995; True 1997, no. 2, plate 694.
4 *Iliad*, 10.436–37, translation by A. T. Murray in
 Iliad 1924.
5 Tsiafaki 2021, 250–51, fig. 2.
6 Xenophanes of Kolophon, frag. 16.

10, 11

ORPHEUS IN THRACE

In the Greek mythological tradition, Orpheus was a singer with extraordinary powers.[1] His songs entranced not only men and women but also birds and savage beasts. Even trees and rocks would follow him. When he accompanied the Argonauts on their mission to retrieve the Golden Fleece, his music succeeded in overcoming the destructive song of the Sirens and saving the crew. Most remarkable of all, he was able to descend to the Underworld and charm Hades and Persephone, persuading them to release his dead wife, Eurydike, although in the end her rescue failed.

Orpheus nevertheless was always considered a Thracian in Greek myth and literature, although the source of this belief is uncertain and relatively late. He is not, for example, mentioned in the Homeric epics or in Hesiod. The singer is said to be the son of the Thracian king Oiagros and the Muse Kalliope. Athenian vases typically place him in Thrace, often in local garb and in the company of Thracians.[2] Various mystery cults and poems were ascribed to Orpheus, who was associated with Dionysos as a guide for initiates to reach a blissful afterlife. Such cults were widespread in Greece, however, and appear not to display any actual Thracian influence.[3]

It is his death at the hands of wild Thracian women, rather than other episodes of his story, that most often appears on Athenian vases of the fifth century BC, as well as on engraved and gilded-silver vessels, including a *kantharos* and a *rhyton*.[4] The reason for the Thracian women's anger is never entirely clear. Orpheus is shown in the company of Thracian men, who are entranced by his singing, and according to literary sources, he shuns the women, who become resentful. Some sources speak of a slight to Dionysos, and it is the god who drives the women to frenzy, in the manner of maenads. The women attack Orpheus and tear him apart. Some traditions say that his severed head continued to sing and utter oracles, and this scene, too, appears on vases of later date.

10

Red-Figure Bell Krater with Orpheus among the Thracians

Greek, made in Athens, attributed to the Painter of London E 497, ca. 440 BC
Terracotta
H: 29.5 cm; Diam: 32.6 cm
New York, The Metropolitan Museum of Art, Fletcher Fund, 1924, 24.97.30

Orpheus, wreathed with laurel, sits holding a lyre in his lap.[5] Before him stands a Thracian man, who turns his head to address a woman at right. He wears typically Thracian garb, a long patterned woolen cloak (*zeira*), a pointed fox-skin cap (*alopekis*), and the soft boots known as *embades*. He also holds a pair of spears, as is customary. He has a short, pointed beard of light color, rendered in dilute glaze to convey that it is blond or red. The woman holds a sickle (*harpē*), an indication of the coming murder of Orpheus at the hands of the Thracian women.

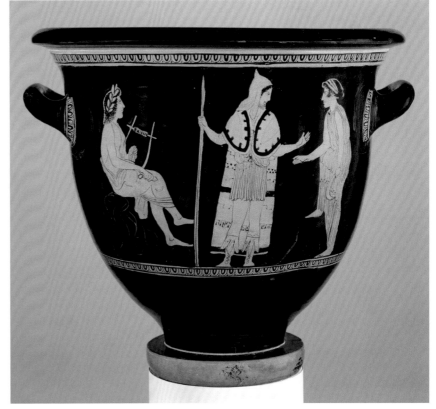

10

11

Red-Figure Calyx Krater with the Killing of Orpheus

Greek, made in Athens, attributed to
the Villa Giulia Painter, 460–450 BC
Terracotta
H: 42.7 cm; Diam: 43.3 cm
Los Angeles, The J. Paul Getty Museum,
Villa Collection, Gift of Dr. Paul Flanagan,
80.AE.71

This Athenian calyx krater shows two
Thracian women attacking Orpheus.[6]
One woman drives a spear into the neck
of the singer, while the other approaches
from behind, raising a pickaxe to strike.
Both women have tattoos on their arms.
Orpheus, wreathed with laurel, wears a
short *chiton* but also the boots known
as *embades* to signify his Thracian origins.
On the other side of the vase stand
three men in Thracian dress, armed with
spears, representing the audience of
Thracian men who had been listening
raptly to Orpheus. •JS

1 Graf 1987; Edmonds 2013; for the literary and
 artistic sources, see Gantz 1993, 721–25. See also
 Tsiafaki in this volume.
2 Archibald 1998, 208–9.
3 Burkert 1985, 296–304; Edmonds 2013. West
 (1983, 1–7) accepts shamanistic influence, perhaps
 via Thrace.
4 Garezou 1994; for the silver vessels, see Sideris
 2016, 154–59, no. 63, and 176–79, no. 68. See also
 Sideris in this volume.
5 Richter 1936, 1:165–66, no. 131, 2: plates 130, 171;
 Beazley 1963, 2:1079, no. 2; Garezou 1994, 85, 99,
 no. 26, plate 60; Huf 2018, 105–6, fig. 40.
6 Tsiafaki 1998, 75–76, 87, plates 20–22 and cover
 illustration; Tsiafaki 2015, 102–3, figs. 6a–c.

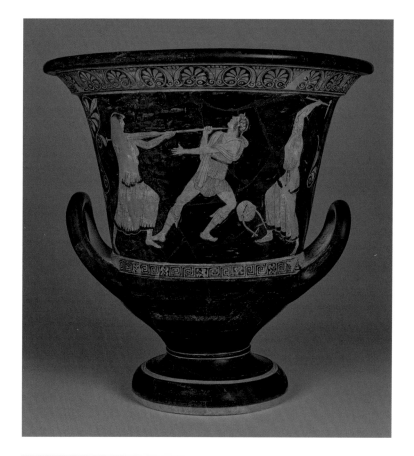

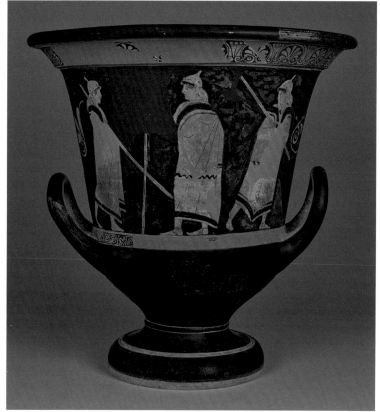

11

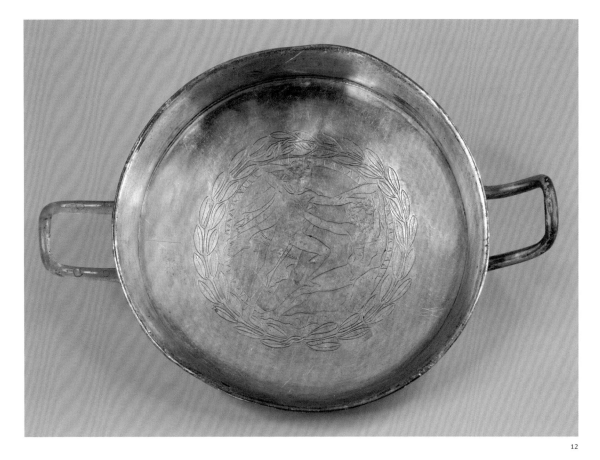

12

12

Kylix with Theseus

440–410 BC
Silver with gilding
H: 3 cm; W with handles: 18 cm;
Diam of rim: 13 cm; Wt: 187.5 grams
Found in a burial mound near Kapinovo,
Veliko Tarnovo Province, Bulgaria, in 1987
Veliko Tarnovo, Regional Historical
Museum, 1728П/TOM

The body of this cup is hammered from
thick silver plate; the handles (one missing
and reconstructed) and the low foot were
cast separately and attached by soldering.[1]
The shape, known as a Rheneia cup, was
popular in Attic pottery between the second
quarter and the last decade of the fifth
century BC.[2] The decoration in the interior
is executed by chiseling; gilding is partially
preserved on the figures and the vegetal
ornament.

The image in the tondo depicts two
naked men fighting, encircled by a band
of Ionic cymatium and a wreath of two laurel
sprigs with entwined ends. The scene por-
trays one of the Labors of Theseus during his
journey from Troezen to Athens: the defeat
of the bandit Periphetes.[3] The young hero
is beardless and nude, except for a *chlamys*
fastened around his neck, which billows
behind him. With his left hand he grasps the
hair of an older but muscular bearded man,
who appears to be exhausted and raises
his arms in defense. His helplessness and
humiliation are emphasized by the way the
young hero steps on his right knee. Although
he carries his father's sword, Theseus is
about to deliver a final blow with a club,
raised in his right hand, which he has taken
from his adversary.

The *kylix* is surely of Athenian manufac-
ture, and the myth of Theseus was highly
significant in Athens in the late fifth
century BC. Although the scene could be
interpreted as a metaphor for the eternal
struggle between good and evil, Theseus
was the national hero of Athens, and his
image carried a special meaning that glori-
fied the city's greatness after the Greco-
Persian Wars. In this context Periphetes was
an appropriate allegory of the waning
Persian Empire.

Although such silver objects have not
been discovered in Athens, their place
of origin, a number of them have been dis-
covered in Thrace and farther north along
the Black Sea, in the Bosporan Kingdom.[4]
The exquisite vessels were produced
during the Pentecontaetia, the five decades
between the victory against the Persians
and the Peloponnesian War, when Athens
was at the peak of its power. They were
probably among the lavish diplomatic gifts
sent by the Athenians to their northern
neighbors (Thracians and Scythians)
on the eve of the conflict with Sparta. •RS

1 Marazov 1998a, 174–75, no. 104
2 Sparkes and Talcott 1970, 100.
3 Sideris (2015, 32, and in this volume) offers
 arguments for the identification of the bearded
 man as the bandit Skiron.
4 Filov 1934b, 65, figs. 81, 82; Kisyov 2005, 143,
 plates X, XI; Sideris 2015, 60–79. See also Sideris
 in this volume.

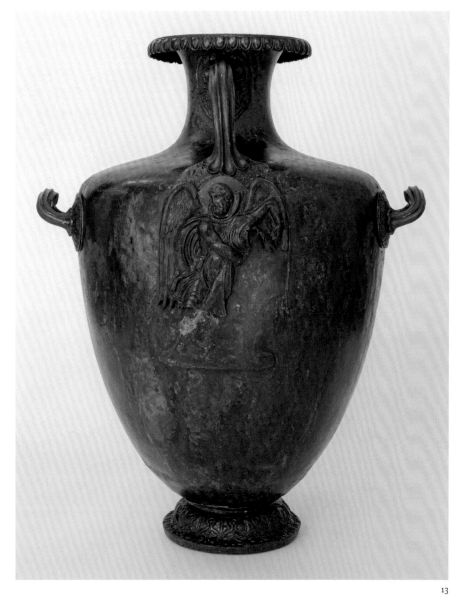

13

13

Hydria with Boreas and Oreithyia

330–300 BC
Bronze
H: 50 cm; W with handles: 39 cm;
Diam: 32.5 cm
Found in the necropolis of Mesembria
(Nessebar), Burgas Province,
Bulgaria, in 1911
Sofia, National Archaeological Institute
with Museum, 5039

This *hydria* from the necropolis of Mesembria has an ovoid body, sloping shoulders, and concave neck.[1] The mouth has a vertical lip decorated with egg-and-dart ornament and a row of beads above. The horizontal handles are fluted, and the attachments are decorated with elaborate rosettes. The upper attachment of the vertical handle is decorated with acanthus leaves, half-palmettes, and rosettes, and the lower takes the form of a pair of acanthus leaves with two rosettes. The relief appliqué beneath it depicts the north wind, Boreas, abducting Oreithyia. The god has wings rendered in meticulous detail and wears a long garment fastened at the chest with a round clasp. He stands behind Oreithyia, whom he grabs by the waist. She wears a long draped *chiton* and is depicted in a helpless pose, with her right hand bent at the elbow and touching her hair.

The scene is well known in the Greek world, and the *hydria* from Mesembria has good parallels, notably another bronze vessel from the same necropolis and a third from Kyzikos.[2] The same subject appears on *hydriai* from Kalymnos,[3] Chalke,[4] and Pharsala.[5] One vessel from the necropolis of Mesembria is decorated with Dionysos and a satyr,[6] and another features Eros and Psyche.[7] An example from the necropolis of Kallatis adds Dionysos and Ariadne to the repertoire.[8] It is perhaps significant that an Athenian red-figure *hydria* with Boreas and Oreithyia was discovered at Zone, in Thrace,[9] which may reflect a Greek interest in Thrace as the setting for the myth.

Iconographic evidence illustrates the important role *hydriai* played in ancient Greek rituals, both in life and in death. Their use as funerary urns and the iconographic interpretation of the figural appliqués as eschatological symbols suggest a mainly funerary function.[10] The abduction of Oreithyia by Boreas could be regarded as "an allusion to celestial immortalization through abduction,"[11] as Charles Picard proposed, or as representing the violence perpetrated by death against the soul of the deceased, taken to the Underworld to enter into a new state.[12] Other scholars regard the *hydriai* as utilitarian and their use as cinerary urns as only secondary.[13]

The large number of bronze *hydriai* used as urns on the Black Sea coast reflect purely Greek practice. No such vases have been discovered in the Thracian interior, and the native aristocracy did not adopt their iconography. •YM

1 Katsarov 1911, 265, fig. 7.
2 For the bronze vessel from Mesembria, see Chimbuleva 1962, 38–39, figs. 1–3; for the one from Kyzikos, see Sieveking 1913, 78–79, plates 36, 37.
3 Richter 1946, 365–67, no. 19, fig. 23.
4 Richter 1946, 365–67, no. 18, fig. 22.
5 Verdelis 1951, 82–83, figs. 1, 2.
6 Chimbuleva 1962, 39–41, fig. 5.
7 Bozkova and Kiyashkina 2013, 25, figs. 4, 5, 26, fig. 6.
8 Zavatin-Coman 1972, 272, fig. 1, 276–77, figs. 4a–c.
9 See Tsiafaki in this volume (fig. 26).
10 C. Picard 1940, 89–93.
11 C. Picard 1940, 99.
12 Touloumdzidou 2011, 654.
13 Richter 1946, 366–67.

GREEK COLONIES IN THRACE

IV.

Over the course of the seventh and sixth centuries BC, Greek settlements emerged on the north Aegean, Propontic, and Pontic shores of Thrace, "like frogs around the pond," as famously described by Plato (*Phaedo* 109b), transforming the legendary warlike and gold-clad barbarians of the Homeric epics into next-door neighbors. Ancient sources have preserved records of early clashes, and Hellenistic inscriptions capture a vivid picture of native chieftains harassing the Greek poleis. Nonetheless, Greeks and Thracians found ways to coexist for many centuries: there was trade and intermarriage, oaths were exchanged, and treaties were concluded.

Some Greek cities in Thrace achieved prominence and fame far beyond the region, sometimes drawing from the riches of the land. Thasos, in the northern Aegean Sea, gained huge wealth from gold and silver mines, invested in city walls of marble and a large fleet of warships, and felt powerful enough to challenge Athens at the height of its influence in the so-called Thasian Rebellion of 465 BC. As if embodying this power, in the early decades of the fifth century BC, the immensely strong Thasian Theogenes won Olympic crowns in boxing and pankration (a combination of boxing and wrestling), along with hundreds of other prizes; the painter Polygnotos, a "fine portrayer of character" according to Aristotle (*Poetics* 6.15), was his compatriot and contemporary. Neighboring Abdera, on Thrace's north Aegean coast, was the motherland of great minds like Democritus, who imagined a universe built of atoms, and of the sophist Protagoras. Also in the fifth century BC, Pontic Apollonians amazed the Greek world by erecting a thirteen-meter-high bronze colossus of Apollo that certainly dwarfed the modest temples excavated in his sacred precinct on the island of Saint Kirik in present-day Sozopol, on the Black Sea.

Apollo was the principal deity of Miletos, the metropolis of a great many of the Black Sea *apoikiai*, and his cult was transferred to the early settlements. Curiously, the god was worshipped here not as Delphinios, as in Miletos, but as Ietros, "the Healer"—an epithet that is not attested in the mother city, possibly an act of establishing a separate identity for the colonies. Otherwise the pantheon was and remained thoroughly Greek, and only in the later Hellenistic period might native influences be detected in the appearance of local deities depicted as riders, heralding the omnipresent image of the Thracian Rider in the Roman period. A regional touch could be seen in the cult of the Meter Pontia, the Pontic Mother of Gods, venerated in a recently discovered temple in the small town of Dionysopolis, on the Black Sea coast.

The Greeks in Thrace tended to retain Greek customs. While a few Archaic tumuli near Istros, possibly containing animal and human sacrifices, have long puzzled archaeologists, a Homeric interpretation sees them as an emulation of the heroic burials in the epics. The graves in the Classical necropolis of Apollonia Pontica, with their exquisite *lekythoi* bearing Erotes with gilded wings, could have been excavated anywhere else in the Greek world. The Pontic Greeks imported amphorae with wine and olive oil and other goods that were essential for the Greek way of life. Inevitably they spilled beyond their borders, toward the hinterland, together with people, images, and ideas that transformed Late Iron Age Thrace.
•MD

14

14, 15
ARCHAIC POTTERY FROM APOLLONIA PONTICA

14
Fikellura-Style *Amphoriskos*

Milesian, ca. 550–500 BC
Terracotta
H: 31.5 cm; Diam: 11.3 cm
Found in the harbor of Apollonia Pontica
(Sozopol), Burgas Province, Bulgaria,
in 1927
Sofia, National Archaeological Institute
with Museum, 6286

In the second half of the seventh century BC,
settlers from Ionia in Asia Minor created
the first Greek settlements on the shores of
the Black Sea. Literary sources invariably
point to Miletos as the leading metropolis
that founded Apollonia Pontica (present-
day Sozopol) "fifty years before Cyrus,"[1] or
about 610 BC. Therefore it is natural that the
production of East Greek artisans, among
them Milesian workshops, dominates among
the finds from the Archaic period from all
early *apoikiai*, including Apollonia. Miletos
exported both painted tableware and trans-
port amphorae filled with olive oil and wine,
essential for maintaining the Greek way of
life overseas.

The *amphoriskos* from Sozopol's harbor,[2]
which is of the so-called Fikellura style
(cat. 14),[3] is a typical product of the Milesian
potters of the second half of the sixth cen-
tury BC, when East Greek pottery began to
make way for increasing imports of black-
figure vases from Athens.

The shape is elongated, with thickened
rim, short and narrow neck, and tall, slightly
rounded body that narrows down toward
the conical foot.[4] The painted decoration
is applied with diluted brownish glaze on top
of a cream slip and consists of a series of
zones of geometric ornaments. Immediately
beneath the rim, there are vertical lines,
a meander on the neck, and heart-shaped
leaves on the shoulders. Most of the body
is covered with a netlike motif of diamonds
shaped by intersecting dotted lines,[5] with
a rosette of four dots in the middle of

15

15

Kylix Dedicated to Apollo Ietros

Ionian Greek, ca. 600–550 BC
Terracotta
H: 13.9 cm; W with handles: 30.9 cm;
Diam of rim: 24 cm
Found on the island of Saint Kirik, Sozopol,
Burgas Province, Bulgaria, in 2013
Sozopol, Archaeological Museum, 3607

with dull black glaze on the inside and with grayish-brown glaze on the outside, with the upper body left reserved. It is notable, however, for its size and volume (about three liters). It was discovered together with other ceramic vases and artifacts in a pit within the sacred precinct on the island of Saint Kirik,[7] probably a *bothros* for discarding the votives that accumulated in the sanctuary.[8] The accompanying materials date broadly from the second

quarter of the sixth century BC, while the cup itself could be earlier.

Of utmost importance is the dedicatory inscription scratched on the outside while the cup was placed upside down:

[Αἰσχί]νας (or [Κρί]νας?) μ' ἀνέθηκε
τἀπόλλωνι τῶι Ἰατρῶι ho Κνίδιος

Aischi]nas (or [Kri]nas), the Knidian,
dedicated me to Apollo the Healer.[9]

each diamond. A narrow band of oblique lines follows below, then crescents and another band of vertical lines. The execution of the decoration is relatively careless.

The second vase is a cup with an everted rim, called an Ionian cup (cat. 15).[6] It is fragmentary, with about half the body and one of the handles missing. The vessel has a short rim, narrow shoulders with an angular transition to the deep hemispherical body, and a narrow conical foot. Two small horseshoe-shaped handles are attached immediately beneath the shoulders. The decoration is simple. The cup is covered

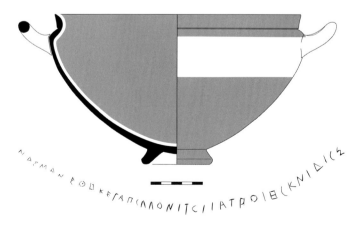

At present this is the earliest known dedication to the eponymous deity Apollo Ietros from Apollonia and one of the earliest from the Black Sea, where the god was worshipped with this specific Pontic epiclesis in all the early Milesian colonies.[10] A century later, in the second quarter of the fifth century BC, Apollonians invited the famous sculptor Kalamis to erect in the sanctuary a thirteen-meter-high bronze colossus of Apollo Ietros.[11] The inscription also sheds light on Apollonia's overseas contacts and the mobility of people in this early period. The dedicant was from the Dorian city of Knidos, on the Datcha Peninsula, in present-day Turkey, some one thousand kilometers to the south of Apollonia, and probably dedicated the cup to celebrate his successful journey. This is also one of the few surviving examples of the Archaic Knidian alphabet.

•MD

1 Pseudo-Scymnos, *Periodos to Nicomedes* 728–31.
2 R. Cook 1933–34, 49, no. 22a; Lazarov 1990, no. 2; S. Vasileva in Baralis, Panayotova, and Nedev 2019, 347, no. 384.
3 R. Cook 1933–34; R. Cook and Dupont 1998, 77–89.
4 Shape *b* after R. Cook 1933–34, 58–59.
5 *Group 3: Reticulation* after R. Cook 1933–34, 59, Y13–41b.
6 K. Panayotova in Martinez et al. 2015, 298, no. 254; N. Sharankov in Baralis, Panayotova, and Nedev 2019, 76–77, no. 67.
7 Panayotova et al. 2014; Baralis, Panayotova, and Nedev 2019, 22–78.
8 K. Panayotova in Baralis, Panayotova, and Nedev 2019, 45, 46–47, nos. 21–24.
9 Reconstruction by Nicolay Sharankov.
10 Overview in Ehrhardt 1983, 130–47; Ustinova 2001, 246–54.
11 Pliny, *Natural History* 4.92, 34.39.

16–20

ATHENIAN POTTERY FROM APOLLONIA PONTICA

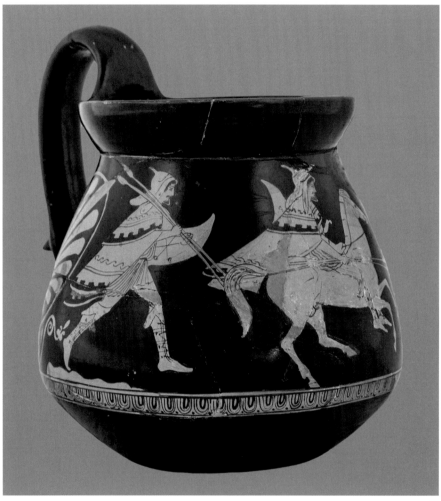

16

16

Red-Figure Jug

Greek, made in Athens, attributed to the Eretria Painter, ca. 425 BC
Terracotta
H with handle: 14 cm;
W with handle: 14.4 cm
Found in the necropolis of Apollonia Pontica (Sozopol), Burgas Province, Bulgaria, in 1965
Sozopol, Archaeological Museum, 261

Among the finds of fifth-century BC Greek painted pottery in Thrace, two vases—discovered, respectively, in the necropolis

of Apollonia Pontica (cat. 16) and in a burial mound near Karnobat (cat. 17), in the interior nearly one hundred kilometers from the coast[1]—are especially notable for their depictions of Thracian warriors, one on horseback and two running. The fox-skin caps (*alopekides*), heavy patterned cloaks (*zeirai*), and deer-skin boots (*embades*), together with the crescent-shaped shields (*peltai*) and the javelins, present an image that was readily recognizable to the Athenians. Such figures appear often in Attic vase painting of the Late Archaic and Classical periods and correspond to the description provided by Herodotus.[2]

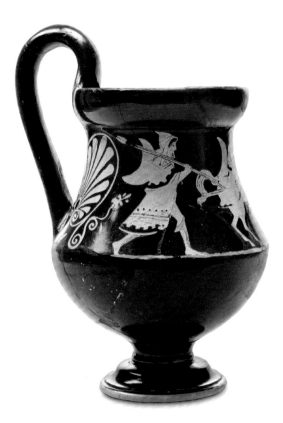
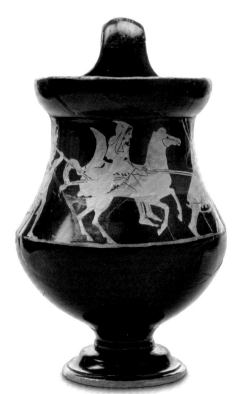
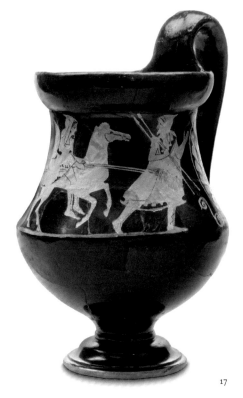

17

17

Red-Figure Jug

Greek, made in Athens, ca. 425 BC
Terracotta
H: 18 cm; W with handle: 13 cm
Found in Gyaurskata Tumulus
near Karnobat, Burgas Province,
Bulgaria, in 2005
Karnobat, Historical Museum, 447

18

Grayware Jug

Apollonian(?), 500–400 BC
Terracotta
H: 16.9 cm; W with handle: 15.2 cm
Found in a cistern in Sozopol,
Burgas Province, Bulgaria
Sozopol, Archaeological Museum, 2248

It is the choice of shape, however, that
makes the vessels from Apollonia and
Karnobat particular to Thrace. This type of
jug, with biconical body and everted rim, is
typical of local grayware pottery in the fifth
and the first half of the fourth century BC, such
as the example made in Apollonia (cat. 18), but
aside from the two red-figure examples noted
here, the shape is not otherwise attested in
the Athenian potters' repertoire. Because of

18

19

Red-Figure *Lekythos*

Greek, made in Athens, 360–350 BC
Terracotta with polychrome decoration
and gilding
H: 15.1 cm; Diam of body: 6.9 cm
Found in the necropolis of Apollonia
Pontica (Sozopol), Burgas Province,
Bulgaria
Sofia, National Historical Museum, 58189

this interaction between Attic vase painting
and the local ceramic traditions, the jugs
with Thracian warriors are regarded as prod-
ucts created specifically for the Thracian
market, possibly as a special commission
for a customer in Thrace or as a gift for an
ally in the context of the Peloponnesian
War.[3] Important for their interpretation are
the differences in shape and decoration,
suggesting that the two vases were not
made together and probably arrived in
Thrace at different times, thus indicating a
more enduring trend. These exceptional
objects occupy a central place in the study
of the interrelations between the Greek
world and the Thracian elites, as well of
Apollonia's role in these processes.

The fourth-century BC Athenian poly-
chrome *lekythoi* illustrate another local
peculiarity. Decades of investigations in the
necropolis of Apollonia have yielded a large
collection of these spectacular vases from
the final phase of red-figure vase painting.
The technique of added colors and details in
relief is attested on various types of vessels,
among them exceptional works with com-
plex multifigure compositions. Polychrome
decoration was not resilient, however,
and the vases could not be used actively in
everyday life. Most finds from the Black
Sea, Macedonia, and the eastern Mediter-
ranean come from burials. The necropolis of
Apollonia displays a pronounced prefer-
ence for the squat *lekythos*, an elegant vase

19

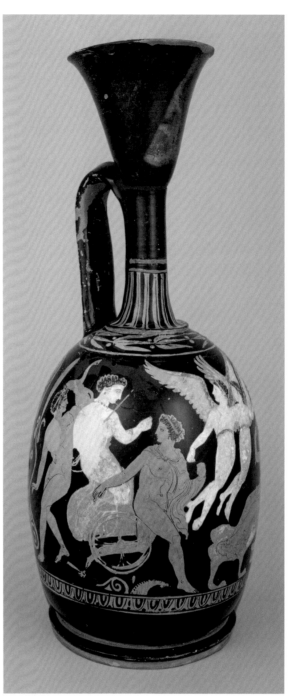

20

20

Red-Figure *Lekythos*

Greek, made in Athens, 360–350 BC
Terracotta with polychrome decoration
and gilding
H: 31.2 cm; Diam of body: 13.6 cm
Found in the necropolis of Apollonia
Pontica (Sozopol), Burgas Province,
Bulgaria, in 2005
Sozopol, Archaeological Museum, 3186

for oils and perfumes with rounded body,
tall neck, and flaring trumpet mouth. Scenes
from the circle of Aphrodite and Eros are
best attested[4]—simplified versions of the
idyllic compositions set in the "garden
of Aphrodite" popular during the Pelopon-
nesian War.[5] They variously depict the
goddess and her son, nymphs, and personi-
fications from their circle, as well as wor-
shippers. These scenes often create an

impression of the merging of the worlds of
gods and mortals. They illustrate offerings
or nuptial rituals but more often lack a
clear narrative.

One of the vases here depicts Eros seated
between two female figures who cannot
be identified with any certainty (cat. 19).[6]
The posture and the gesture of the one to
the right suggest that she could be Aphro-
dite. Eros reaches toward her, probably

offering an item that is not preserved, perhaps a garland or a piece of jewelry. The colors of the god's wings and the women's garments are mostly gone, but the erosion of the pigment reveals a technical detail: the painter used additional white strips for the contours of the polychrome details.

The large *lekythos* is a good example of a rich composition with well-preserved colors (cat. 20).[7] The scene unites the thematic circles of Aphrodite and Dionysos. The goddess flies in a chariot drawn by Erotes, arriving before Dionysos, who reclines on a couch. A maenad with a *tympanon* and dancing satyrs indicate the god's realm. The blue, white, and gold on the Erotes' wings, the pink *chitons* of Aphrodite and the maenad, and the red, white, and gold on the *tympanon* provide a glimpse of the vessels' original appearance.

The impressive number of polychrome *lekythoi* in Apollonia is related to the ever more pronounced specialization of the markets for painted pottery in the Late Classical period. These luxury goods of ritual function form a homogeneous group dated between 375 and 325 BC. They were specific to the Greek way of life and beliefs, and they were not exported to the Thracian interior. Taking into account the evidence of artisans' mobility in the Late Classical period and the emergence of local workshops, as well as some preliminary analyses, at least some of the smaller *lekythoi* could be of non-Attic or even local manufacture.[8] •SV

1 For the example from Apollonia Pontica, see Reho 1990, 31, no. 190; Lezzi-Hafter 1997, 359–64; L. Konova in E. Penkova, Konova, and Kisyov 2017, 158, no. 154; D. Nedev in Baralis, Panayotova, and Nedev 2019, 450–51, no. 538. For the example from Karnobat, see Georgieva 2005.

2 Tsiafaki 2021, 249–50, 252.

3 Lezzi-Hafter 1997, 365–66; Georgieva 2005, 36–37; Tsiafaki 2021, 253–54.

4 On the iconographic variations and the relationship of Aphrodite to the afterlife, see Metzger 1951, 41–99, 371–72, 406.

5 Burn 1987, 26–33.

6 E. Penkova and L. Konova in E. Penkova, Konova, and Kisyov 2017, 171–72, no. 173.

7 K. Panayotova in Martinez et al. 2015, 317, no. 264; D. Nedev in E. Penkova, Konova, and Kisyov 2017, 172–73, no. 174.

8 Damyanov 2022, 301–2.

21

Funerary Stele of Deines

500–475 BC
Marble
248 × 52 × 18 cm
Found in Apollonia Pontica (Sozopol),
Burgas Province, Bulgaria, in 1895
and 1930 (in two pieces)
Sofia, National Archaeological Institute
with Museum, 727

The stele of Deines is among the best examples of Late Archaic Greek relief sculpture from the entire Black Sea region.[1] Most probably, it had a separately carved anthemion at the top, as indicated by the preserved holes for dowels. The composition is the "man and dog" motif that is well known from the period.[2] An elderly man stands facing to the right, stepping forward with his left foot. He occupies almost the entire field, partially overlapping the relief frame on both sides. His arms are bent at the elbows, and with his right hand he offers a piece of meat to the dog that stands at his feet. With his left hand he leans on the end of a staff that descends diagonally to the lower right corner of the field. His bearded head bends downward, looking at the dog. The man wears sandals and a *himation*, which covers his left shoulder, leaving the right one bare. The garment falls in flat diagonal folds across his torso and down his right leg, is pulled tight around the back of his body, and the loose end is wrapped around his left elbow, falling vertically to below the knees. The short-haired dog occupies the lower part of the field and overlaps the man's lower left leg. It is turned to the right, rearing with its front legs stretched upward and its pointed muzzle reaching for the piece of meat. Above the man's head, there is a metrical epitaph:[3]

[ἐνθάδ' Ἀ]ναξάνδρο Δεινῆ[ς δ]
 οκιμώτατος ἀστῶγ
κε[ῖμ]αι ἀμώμητο[ς τ]έρμα λα[χ]ὼν
 θανάτο

Here I lie blameless, Deines, son of
 Anaxander,
The noblest of citizens, allotted the limit
 of death.

The reverse side bears the traces of another scene, which was carefully chiseled off. Only the outline of a standing male figure to the right, dressed in a *himation*, can be discerned. One foot steps forward, and both arms are bent at the elbows and held forward, one slightly above the other, probably holding an object.

In style, the stele of Deines is Ionian of the Late Archaic period.[4] Most scholars consider it an amphiglyph (sculpted on both sides), with one of the figures erased. Another view is that it was reused, with the old relief effaced, suggesting that it may have been created in Apollonia Pontica,[5] possibly by an itinerant sculptor.[6] The scene, as well the garment of the elderly man and his staff,[7] point to the elevated status of Deines, which is also supported by the epitaph, which praises him as "the noblest of citizens." He was probably a member of the oligarchic regime in Apollonia that was later replaced by a democracy, as mentioned by Aristotle.[8] These political developments occurred at some point during the fifth century BC, probably under Athenian influence, and also affected the funerary sphere. Reliefs disappeared, and much more modest tombstones were typical of Classical Apollonia.[9] •MD

1 Most recently in Petrova 2015, 14–18, 166–68,
 A-2, with further references.
2 Ridgway 1971; Zlotogorska 1997; Schneider 2000.
3 *IGBulg.* I², 405.
4 Hiller 1975, 40–43; Pfuhl and Möbius 1977, no. 10.
5 D. Dimitrov 1942–43, 12.
6 Manzova 1970, 268.
7 Posamentir 2022.
8 Aristotle, *Politics* 5, 6, 1306a.
9 Petrova 2015, 138.

21

22

Relief Plaque with Warriors

Late 6th century BC
Terracotta
15 × 14 × 2.5 cm
Found on the island of Saint Kirik,
Sozopol, Burgas Province, Bulgaria,
in 1904
Paris, Musée du Louvre, Département
des Antiquités grecques, étrusques et
romaines, CA 1748

22

This fragment is from the right side of a plaque depicting two hoplites marching to the right.[1] They wear short *chitons* and composite corselets with shoulder flaps and metal(?) plates sewn on a linen or leather base. The one in front has a Corinthian helmet worn raised on his head, a spear in his left hand, and an uncertain object (a sling?) in his right. The second hoplite carries a round shield held by a strap across his right shoulder. He holds a spear in his right hand and blows the horn held in his left hand. Although rigid and Archaic in terms of style, the depictions are executed in meticulous detail. The plaque was part of the architectural decoration, possibly a frieze, of a Late Archaic building in the *temenos* of Apollo on the island of Saint Kirik.[2]

Renewed archaeological investigations there brought to light more such fragments,[3] and at least four identical mold-made plaques have been identified, allowing for a partial reconstruction of their original appearance.[4] Above the figural field, there were bands of egg-and-dart and bead-and-reel ornaments, bringing the height to about thiry-two centimeters. Behind the marching warriors are a horseman galloping to the left and a slain hoplite with his Corinthian helmet fallen beneath the horse. The fallen warrior has the same type of corselet as the marching hoplites, while the horseman wears a *chlamys*(?), holds a *peltē* shield in his left hand, and brandishes a spear in his right. More fragments belong to the same frieze but cannot be related to this particular scene: a hoplite charging to the left; a hoplite kneeling and leaning on a spear in front of a horseman; and horsemen with *peltai* pacing to the left.[5]

This exceptional monument depicted a multifigure battle between hoplites and cavalry. The entire composition resembles painted scenes on the so-called Klazomenian sarcophagi, especially one now in London.[6] Greek warriors fight against non-Greeks, as revealed by the differences in costume and arms. While the "barbarians" on sarcophagi are usually identified with peoples from the East—Scythians, Kimmerians, Lydians, or Persians[7]—in this case the *peltē* is significant, as it is traditionally related to the Thracians, who were considered the inventors of fighting with a shield on horseback.[8] The reliefs may document a clash between Greeks (from Apollonia Pontica?) and Thracians, but their fragmentary condition precludes any certainty. An Amazonomachy would be another possibility, as scenes from the same period depict Amazons with *peltai*.[9] •MD

1 There is an extensive bibliography: see
 A. Hermary in Martinez et al. 2015, 299, no. 256;
 A. Hermary in Baralis, Panayotova, and Nedev
 2019, 65, no. 51; Panayotova, Stoyanova, and
 Damyanov 2021, 598nn1–3.
2 Panayotova, Stoyanova, and Damyanov 2021,
 606–7; D. Stoyanova and Damyanov 2021, 14–17.
3 Damyanov and Stoyanova 2019; Panayotova,
 Stoyanova, and Damyanov 2021.
4 Most up-to-date in D. Stoyanova and Damyanov
 2021, 15–17, figs. 4a–b.
5 Damyanov and Stoyanova 2019, 64–72, nos. 55,
 59, 63.
6 London, British Museum, 1896,0615.1: R. Cook
 1981, 31–34, no. G.1, fig. 20, plates 39–46.
7 Greenhalgh 1973, 143–44; R. Cook 1981, 117.
8 Nefedkin 2009, 356.
9 Shapiro 1983.

23

Sima with Relief Decoration

ca. 375–350 BC
Terracotta and pigment
19 × 55.5 × 20 cm
Found in Mesembria (Nessebar),
Burgas Province, Bulgaria, in 2010
Ancient Nessebar Museum, 4135

During investigations of an ancient house in the Dorian colony of Mesembria (present-day Nessebar), three identical raking simas were discovered.[1] These architectural moldings were placed above the building's pediment and followed the slope of the roof. The decoration of this sima consists, from left to right, of a half-palmette, a satyr's head, a palmette, a nymph's head, and another half-palmette. The heads face frontally, the leaves of the central eleven-leaf palmette curve outward, and the half-palmette's leaves curve inward. Spiral volutes form the base of the palmettes. The satyr has round eyes, wide nostrils, full lips, thick eyebrows, animal ears, and neatly combed hair. The nymph has an oval face, delicate nose, prominent eyebrows, full lips, and almond-shaped eyes. Her hair covers her ears, but pyramidal earrings are visible. A meander pattern of swastikas and inscribed rectangles runs beneath the frieze. The figures' hair and faces, as well as the meander fields, are painted in gold, red, and blue.

These are the earliest simas made in Mesembria.[2] Such architectural terracottas were used for both temples and private houses.[3] The production of these objects surged with the construction activities of the second quarter of the fourth century BC, when large two-story houses were built. They had basements dug into the ground and were faced with stone masonry, with a ground floor of mud-brick walls and terracotta roof tiles and other architectural elements.[4]

This local production lasted from the second quarter of the fourth to the middle of the third century BC. After the mid-fourth century BC, a second series of satyr and nymph simas appeared, without the meander and with a stamp naming Moscho, either the maker or a responsible magistrate. In addition, eave tiles decorated with an Ionic cymation design or meander pattern in relief were produced, along with simas with nymphs and floral elements, palmette antefixes, and antefixes depicting the deities Athena and Herakles.[5] Heads of satyrs shown in a three-quarter profile on the simas and the head of Herakles testify to the considerable artistic abilities of the artisans who created the molds.

Tiles bearing other stamps provide the names of various makers or the individuals responsible for the manufacture of roof tiles and architectural terracottas. Mesembria, along with Sinope, was a major producer of such goods in the Black Sea region, exporting to other cities, including Olbia,[6] Odessos,[7] and Apollonia Pontica.[8] •DS

1 Marvakov 2011, 251, fig. 1, room 4, fig. 2.1;
 P. Kiyashkina and D. Stoyanova in Martinez et al.
 2015, 304–5, no. 259.
2 Kovachev et al. 2011, 218–19, 221, 227, figs. 5, 10,
 app. 1.
3 Ognenova-Marinova 1980, 130–38, figs. 37–53.
4 Ognenova-Marinova 2005.
5 Ognenova-Marinova 1980, 113–46, figs. 7–74.
6 Kryzhitskii, Rusyaeva, and Nazarchuk 2006, 115,
 fig. 122, 2.
7 D. Stoyanova 2008, 225–29, figs. 5–9, plates 22,
 23, 24.1–2.
8 D. Stoyanova 2022, 85–90, 105–8, 147–49,
 figs. 60–65, 80, 81, 137–40.

23

24

24

Dedication to Mother Kybeleia

4th century BC
Marble
29 × 51.3 × 7 cm
Found in Mesembria (Nessebar),
Burgas Province, Bulgaria, in 1971
Ancient Nessebar Museum, 1354

This slab is missing its upper and lower left corners, but the text is entirely preserved.[1] The shape and dimensions of the slab suggest that it was not a freestanding object but was part of a larger dedication, possibly mounted within a structure such as an altar or a statue base. Initially published as a funerary inscription,[2] the text was only later recognized as a dedication to the goddess Kybele:[3]

Κλεῦσις
Ἀθαναίωνος
Ματρὶ
Κυβελείαι

Kleusis, son(?) of Athanaion, (dedicated this) to Mother Kybeleia

The earliest monuments connected with Kybele in the western Black Sea region—for example, several Archaic reliefs from Apollonia Pontica depicting the goddess in a *naiskos*—are dated to the sixth and early fifth centuries BC. By the end of the Classical period, her cult is already attested throughout the region, and it remained popular until the late Roman Imperial period. The goddess is usually named Mother of Gods (Μήτηρ θεῶν or, in Doric, Μάτηρ θεῶν), and in Dionysopolis she also received the epithet Pontic (Ποντία). Only this dedication from Doric Mesembria refers to her as Kybelean Mother (Μάτηρ Κυβέλεια), which probably indicates a different origin of the cult there, that is, not from Miletos, as supposed for the Ionian colonies. The only other Greek inscription using this divine name—albeit in its Ionic form—is from Chios and also dated to the fourth century BC: Εὐήνωρ Ἡραγόρεω Μητρὶ Κυβελείη τὰ πρὸ τὸ νάου ἀνέθηκεν, "Evenor, son of Heragores, dedicated to the Kybelean Mother the (objects or structures) in front of the temple."[4] It is worth noting that this appellation corresponds exactly to the Phrygian name of the goddess, Matar

Kubeleya or Kubileya, as attested in several inscriptions,[5] which could possibly point to a direct transfer of the cult from Phrygia to Mesembria (or to another Greek [Dorian] center, whence it came to Mesembria). This is so far the only dedicatory inscription for Kybele from the city, but evidence for the cult is to be found in other objects, such as terracottas of Early Hellenistic date.[6]

The name of the dedicant, Kleusis, is attested only in this inscription, and while its origin is clear (from κλέος/κλείω, "fame" or "to make famous," and seemingly an abbreviation of a compound name with the first element Κλευσι-), it is uncertain whether the dedicant was a man or a woman. The patronymic is the theophoric name Athanaion, common in Mesembria and widespread throughout the western Black Sea region. •NS

1 M. Gyuzelev in Martinez et al. 2015, 300, no. 258.
2 Velkov 2005, 176–77, no. 28.
3 Avram 2006, 686, no. 283; Sharankov 2009, 49; SEG 59, 742.
4 Robert 1933, 483–84, no. 4, fig. 3.
5 Obrador-Cursach 2020, 280–81.
6 Oppermann 2017.

25

Funerary Stele of Menis

175–150 BC
Marble
60 × 27 × 7.5 cm
Found in the necropolis of Mesembria
(Nessebar), Burgas Province, Bulgaria,
in 1949
Burgas, Regional Historical Museum,
B-s 977

Within a recessed area on this stele crowned
with a pediment, a relief shows a seated
man facing a boy, probably a servant, who
stands before him. The man wears only a
mantle thrown over his back and left
shoulder, leaving his chest uncovered. He
holds a scroll and is seated on a chair with
lion's feet, resting his bare feet on a low
footstool. The servant, dressed in a *chiton*,
stands with his arms crossed in front.[1] A
Greek inscription above the scene, ΜΗΝΙΣ
ΑΘΑΝΑΙΩΝΟΣ, identifies the deceased as
Menis, son of Athanaion.

The shape and the composition of the
stele are typical of Mesembria and often
seen in cities on the west Pontic coast
in the second half of the third and the first
half of the second centuries BC, as well
as in Byzantion, Chalkedon, Kyzikos, and
Smyrna, where such monuments became
popular after the middle of the second
century BC. The Mesembrian stelai form a
compact group created by a workshop
with distinctive details and traditions. The
image representing the deceased as an
educated man appears often in funerary
reliefs in the Hellenistic period, notably
in Dorian Mesembria and Kallatis, as well
as in Byzantion, but it was rarely used
outside the west Pontic region. The work-
manship of the relief resembles that of
some Cycladic monuments from the second
quarter of the second century BC.[2] •AP

1 *IGBulg.* I², 335, plate 175; *IGBulg.* V, 5107;
 Chimbuleva 1988, 11–12, 17–20, no. 5; Oppermann
 2004, 271, plate 40.4.
2 Petrova 2015, 40, 190–92, M-10, plate 8.1.

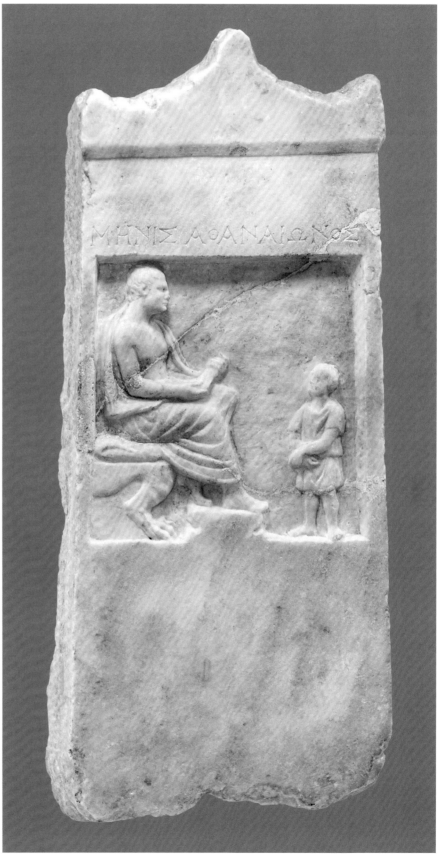

26

The Sadalas Decree

3rd century BC
Marble
36.5 × 35.5 × 9 cm
From Mesembria (Nessebar), Burgas
Province, Bulgaria
Burgas, Regional Historical Museum,
B-s 972

This fragmentary stele preserves a decree in honor of the Thracian ruler Sadalas on behalf of the Greek city of Mesembria, followed by an agreement between the city and the ruler.[1] The beginning of the text is lost, as is the lower section. A blank line divides the inscription into two parts, and the second part has its own title occupying an entire line. Since the text mentions "agreements" in the plural, the inscription could have originally contained more than the two documents preserved. The letterforms indicate a date in the third century BC.

> [- -]
> [- - - - - - - - - - - - - - - -]+A++ΑΝΣΑ[- - -]
> [- - - - - - - - - -]++οις Σαδαλαι ὥς κα δυνα-
> [τὸν τ]άχιστα· στεφανῶσαι δὲ αὐτὸν χρυσ[έ]-
> [ωι] στεφάνωι εὐε[ρ]γέταν ἐόντα τᾶς πόλιος
> 5 Διονυσίοις ἐν τῶι θεάτρωι· δεδόσθαι δὲ αὐ-
> τῶι καὶ ἐκγόνοις πολιτείαν καὶ προξενίαν
> καὶ προεδρίαν ἐν τοῖς ἀγῶσιν καὶ εἴσπλουν
> καὶ ἔκπλουν ἀσυλεὶ καὶ ἀσπονδεί· στεφα-
> νοῦσθαι δὲ αὐτὸν καθ' ἕκαστον ἐνιαυ-
> 10 τὸν στεφάνωι στατήρων πεντήκοντα·
> τὸν δὲ ταμίαν τὸν ὅρκον καὶ τὰς ὁμολογία[ς]
> γράψαντα εἰς στάλαν λιθίναν κοῖλα γράμ-
> ματα ἀναθέμεν εἰς τὸ ἱερὸν τοῦ Ἀπόλ-
> λωνος παρὰ τὰς στάλας τῶμ προγόνων
> 15 Μοψυηστιος καὶ Ταρουτινου καὶ Μηδιστα
> καὶ Κοτυος.
> Ὁμολογία Σαδαλα καὶ Μεσσαμβριανῶν·
> Αἴ τινές κα ἐκπίπτωντι Μεσσαμβριανῶν
> [εἰς τ]ὰν Σαδαλα, ἀποδιδόντες τῶν ναύλ-
> 20 [λων - - - - - - στα]τῆρας καὶ ἡμιστάτηρον
> [- -]

…to Sadalas as soon as possible. (They also decided) to crown him with a gold wreath in the theater during the Dionysia because he is a benefactor of the city. (They also decided) to give to him as well as to his descendants citizenship, status of a *proxenos*, and the privilege of sitting in the front row at contests, as well as the right of import and export by sea without any violation or requirement for a formal treaty. They should crown him every year with a wreath worth fifty staters. And the treasurer, after having inscribed the oath and the agreements in hollow letters on a stone stele, should dedicate it in the sanctuary of Apollo next to the stelai of (Sadalas's) ancestors Mopsyestis, Taroutinas, Medistas, and Kotys.

Agreement between Sadalas and the Mesembrians. If any persons from Mesembria are cast ashore on the land of Sadalas, they should, after having paid a sailing tax amounting to…staters and half a stater…

The missing beginning of the first document could be reconstructed as follows: "Decree of the city council and the people's assembly. So-and-so (the archons?) proposed: Since Sadalas…, let the city council and the people make the following decision about him…"

The preserved text does not provide any information about Sadalas, who is not otherwise known in historical sources, but he was clearly a ruler of a territory neighboring that of Mesembria. His name—and those of his ancestors—indicates that he was a Thracian. There has been much discussion regarding the date of his rule—whether it should be placed at the end of the fourth century BC,[2] about 280 BC,[3] or in the second half of the third century BC[4]—and his origins. Was he a member of the Odrysian nobility,[5] or did he belong to another dynasty that ruled in the southeastern parts of Thrace, in the region of the Astai?[6] His domain certainly included parts of a coast, apparently of the Black Sea. The agreement, along with the literary evidence that the shore near Salmydessos was a most dangerous place for shipwrecked sailors,[7] suggests that the latter territory belonged to Sadalas, but this is uncertain.

The mention of stelai with similar inscriptions concerning four ancestors of Sadalas attests to long-term relations between Mesembria and this dynasty. Unfortunately, none of these predecessors can be securely identified with members of Thracian royalty attested in other sources. Kotys has been identified as the fourth-century BC Odrysian king Kotys (I), or as a certain Kotys, son of Taroulas, known from a fragmentary building contract(?) between him and the city of Apollonia.[8] Medistas was the name of one of the sons of King Kersebleptes,[9] and the name also appears as a patronymic of the priest of Dionysos Maistas in Seuthopolis.[10] Sadalas himself could have been one of the sons of Seuthes III attested in the Seuthopolis oath.[11] •NS

1 *IGBulg.* I², 307 = *IGBulg.* V, 5086.
2 Galabov 1950.
3 Mihailov 1955.
4 Danov 1952.
5 Mihailov 1955, 161–62; Schmitt 1969, 333–34, no. 556; Venedikov 1980.
6 Danov 1952, 125–29; see Delev in this volume.
7 M. Vasilev 2021.
8 *IGBulg.* I², 469 bis.
9 Bouguet 1929, 392.
10 *IGBulg.* III.2, 1732.
11 As proposed by Georgi Mihailov (1955); *IGBulg.* III.2, 1731 = *SEG* 42, 661.

ΚΑΙ ΑΛΛΑΙΣ ΚΑΙ ΣΥΝ..
ΧΙΣΤΑ ΣΤΕΦΑΝΟΣ ΑΙΔΕ ΑΥΤΩΙ ΧΡΥΣ..
ΤΕΦΑΝΟΙ ΕΥΕΣ ΕΤΑΝ ΕΟΝΤΑ ΤΑΣ ΠΟΛΙΟ..
ΙΟΝΥΣΙΟΙΣ ΕΝ ΤΩΙ ΘΕΑΤΡΩΙ ΔΕΔΟΣΘΑΙ ΔΕ ΑΥ
ΤΩΙ ΚΑΙ ΕΚΓΟΝΟΙΣ ΠΟΛΙΤΕΙΑΝ ΚΑΙ ΠΡΟΞΕΝΙΑΝ
ΚΑΙ ΠΡΟΕΔΡΙΑΝ ΕΝ ΤΟΙΣ ΑΓΩΣΙΝ ΚΑΙ ΕΙΣΠΛ ΟΥΝ
ΚΑΙ ΕΚΠΛΟΥΝ ΑΣΥΛΕΙ ΚΑΙ ΑΣΠΟΝΔΕΙ ΣΤΕΦΑ
ΝΩΣΘΑΙ ΔΕ ΑΥΤΟΝ ΚΑΙ ΚΑΘ ΕΚΑΣΤΟΝ ΕΝΙΑΥ
ΤΟΝ ΣΤΕΦΑΝΩΙΣ ΤΑΤΗΡΩΝ ΠΕΝΤΗΚΟΝΤΑ
ΤΟΝ ΔΕ ΤΑΜΙΑΝ ΤΟΝ..ΚΟΝ ΚΑΙ ΠΑΖΟΜΟΛΟΓΙΑ
ΓΡΑΨΑΝΤΑ ΕΙΣ ΣΤΑΛΑΝ ΛΙΓΙΝΑΝ ΚΑΙ ΑΓΡΑΜ
ΜΑΤΑ ΑΝΛΑΘΕΜΕΝ ΕΙΣ ΤΟ ΙΕΡΟΝ ΤΟΥ ΑΠΟΛ
ΛΩΝΟΣ ΠΑΡΑ ΤΑΣ ΣΤΑΛΛΑΣ ΤΩΜ ΠΡΟΓΟΝΩ..
ΜΟΥ ΥΗΕΤΙΟΣ ΡΑΠΤΑΓΟΥ ΤΙΝΟΥ ΚΑΙ ΜΗΔΙΣ..
ΨΑΙ ΚΟΤΥΟΣ

ΟΜΟΛΟΓΙΑ ΣΑΔΑΛΛΑ ΚΑΙ ΜΕΣΣΑΜΒΡΙΑΝΩ..
ΥΙΤΙΝΕΣ ΚΑΙ ΕΚ ΥΙΕ ΤΩΝ ΤΙΜΕΣΣΑΜΒΡΙΑΝ..
ΑΛΛΑ ΑΠΟΔΙΔΟΝΤΕΣ ΤΟΝ ΝΙΑΥ..
....ΑΙ ΩΙΣ ΤΑΤΗΡ..

27

The Pistiros Inscription

Soon after 360 BC
Granite
164 × 63 × 27 cm
Found in Asar Dere, Municipality of
Septemvri, Pazardzhik Province,
Bulgaria, in 1990
Septemvri, Archaeological Museum,
AMC 1.169

The Pistiros Inscription was found in a
secondary context near a late Roman road
station (probably Bona Mansio, known
earlier as Lissae) roughly halfway between
Philippopolis (present-day Plovdiv) and
Serdica (present-day Sofia), on the so-called
Via Diagonalis, or "Diagonal Road"; this
major artery connected Byzantion (later
Constantinople, present-day Istanbul) to
Singidunum (present-day Belgrade), and the
portion in inland Thrace was likely built on
an earlier road network. This large fragment
of a granite stele, broken at the top and
damaged on the left side, partially preserves
forty-six lines of an inscription in Greek that
mentions at several points a place called
Pistiros.[1] The letterforms suggest a date in
the fourth century BC for the inscription,
and an apparent reference to the concluded
reign of the Odrysian king Kotys I may allow
for a more precise date soon after 360 BC.

[——— ca 14-16 ——— · ὅσα ἐπ]ικα[λῆι]
[τις ἐμπορίτης ?], ΔΕΝΝΥ . . Η, εἰ δὲ [μὴ]
[εἴδηι, ὀμνύτ?]ω τὸν Διόνυσογ καὶ [τα-]
4 [ὅτα μὴ ?] ὀφειλέτω · ὅ τι ἂν δέ τις τῶν
[ἐμπ]οριτέων ἐπικαλῆι ὁ ἕτερος τ-
[ῶι ἑ]τέρωι, κρίνεσθαι αὐτοὺς ἐπὶ τ-
[οῖς] συγγενέσι καὶ ὅσα ὀφείλετα[ι]
8 τοῖς ἐμπορίταις παρὰ τοῖς Θραιξ-
[ί]ν, τούτωγ χρεῶν ἀποκοπὰς μὴ
ποιεῖγ · γῆγ καὶ βοσκὴν ὅσην ἔχουσ-
ιν ἐμπορῖται, ταῦτα μὴ ἀφαιρεῖ-
12 [σθ]αι · ἐπαυλιστὰς μὴ πέμπειν το-
[ῖς] ἐμπορίταις · φρουρὴμ μηδεμίαν
εἰς Πίστιρον καταστῆσαι μήτε α-
[ὐτ]ὸμ μήτε ἄλλωι ἐπιτρέπειν ·
16 [ὁμ]ήρους Πιστιρηνῶμ μὴ λαμ-
[βάν]ειμ μηδὲ ἄλλωι ἐπιτρέπειν ·
[τὰ vel γῆν] τῶν ἐμποριτέωμ μὴ [ἀ]
φαιρεῖ-
[σθ]αι μήτε αὀτὸμ μήτ[ε το]ὺς ἐ-

27

20 [αυτ]οῦ · τέλεα κατὰ τὰς ὁδούς
μὴ πρήσσειν, ὅσα εἰς Μαρώνεια[ν]
[εἰσ]άγεται ἐκ Πιστίρου ἤ ἐκ τῶν ἐ-
[μ]πορίων ἤ 'γ Μαρωνείης εἰς Πίστ-
24 [ιρ]ον ἤ τὰ ἐμπόρια Βελανα Πρασε-
[. ω]ν, τοὺς ἐμπορίταις τὰς ἁ⟨μ⟩άξ-
[ας] καὶ ἀνοίγειν καὶ κλείειν · ἄμα
[καθ]άπερ καὶ ἐπὶ Κότυος · ἄνδρα Μ-
28 [αρω]νίτην οὐ δήσω οὐδὲ ἀποκτ-
[ενέω] οὐδὲ ἀφαιρήσομαι χρήμα-
[τα] οὔτε ζῶντος οὔτε ἀποθανόν-
[τος] οὔτε αὐτὸς οὔτε τῶν ἐμῶν
32 [οὐ]δείς · οὐδὲ Ἀπολλωνιητέων, οὐδ-
[ὲ Θ]ασίων, ὅσοι ἐμ Πιστίρωι εἰσί[ν],
[οὔ]τε ἀποκτενέω οὐδένα, οὔτε
[δήσω] οὔτε ἀφαιρήσομαι χρήμα-
36 [τα οὔ]τε ζῶντος οὔτε ἀποθανό-
[ντος οὔτε] αὐτὸς οὔτε τῶν ἐμῶν
[οὐδείς · εἰ δέ τις] τῶν οἰκητόρων
[———— ca 14–16 ————]ΤΩΝ οὗ ὁ ἐμπορ-
40 [———— ca 14–16 ————]ΟΝ εἰσὶν ΑΙΜ-
[———— ca 14–16 ————]Ν, ἐὰμ μὴ ΑΜ-
[———— ca 14–16 ———— τ]ις ἀδικῆι τὸ
[ν δεῖνα vel υς δεῖνας] τε ΕΨΩΑΛΛΑ
44 [ἀναδο- vel ἀποδο]χεὺς τὴν ΕΠ-
[—— ca 5–6 —— δι' ἑκάστ]ου ἐνιαυτοῦ
[————————————]Α. vacat

[…on whatever matters a resident merchant makes] a cl[aim…*text uncertain*…], but if he [does not recognize them, let him swea]r(?) by Dionysos and let him [not(?)] owe [these things]. And whatever some one of the resident merchants claims, one against the other, let these men be judged among kin and whatever is owed to the resident merchants by the Thracians, let him make no cancellation of these debts. However much land and fodder the resident merchants possess, let him not take these things away. Let him not send troops to billet among the resident merchants. Let him neither establish a garrison at Pistiros nor entrust to another (to establish a garrison). Let him take no hostages from the Pistirenes and let him entrust (the taking of hostages) to no other. And let neither him nor his associates take away [the possessions (or land)] of the resident merchants. And let him not extract taxes on goods arriving by road, however many

goods are imported to Maroneia from Pistiros or from the *emporia*, or from Maroneia to Pistiros or to the *emporia* Belana Praseon. And let the resident merchants both open and close the wagons at the same time just as in the time of Kotys. "I will not arrest a man from Maroneia; I will not kill him and will not take his possessions, neither when he is alive nor after he has died—neither I myself nor any associate of mine [will do any of these things]. I will neither kill nor arrest any of the Apollonians or Thasians, as many as are in Pistiros, nor will I take his possessions, neither while he is alive nor after he has died; neither I myself nor any associate of mine [will do any of these things. And if some-one] of the inhabitants […*text uncertain*…] from whom the resid[ent merchant…*text uncertain*…] they are […*text uncertain*…] if not […*text uncertain*…some]one commits a crime against a[nother…*text uncertain*…] [the one giving (or taking)] security…[*text uncertain*…each] year […*text uncertain*…].[2]

The Pistiros Inscription is among the most sensational epigraphic discoveries of the last half century concerning the ancient Mediterranean. Scholarly debate on the many questions it poses will continue, as will excitement at the dynamic and complex world of inland Thrace in the mid-fourth century BC vividly described therein, which had only been hinted at in material and literary sources prior to 1990.

The inscription was quickly associated with a Classical and Early Hellenistic settlement at Adzhiyiska Vodenitsa, located only two kilometers to the southwest of Asar Dere, where an international team had in 1988 launched a program of systematic excavations under the direction of Mieczysław Domaradzki.[3] The archaeological record at the site, situated on the upper Hebros River, which has shifted course since antiquity (and is now called the Maritsa River), is highly heterogeneous in character, offering a blend of Greek and Thracian elements; imported Greek transport amphorae and coins from a variety of

north Aegean locations, for example, appear alongside evidence for local craft production, including metalwork, and dozens of graffiti recording Greek and Thracian names. The Pistiros mentioned in the inscription is regarded by many scholars to be the site at Adzhiyska Vodenitsa where the Pistiros Inscription is thought to have been initially displayed in antiquity.[4]

The Pistiros Inscription makes Pistiros the site legible as an *emporion*, or trading center, characteristic of the Greek periphery of the Mediterranean world and featuring exchange among diverse cultures.[5] The text mentions groups of Thracians and Greeks—including citizens of Maroneia, Thasos, and Apollonia Pontica—alongside collectives described as resident merchants (*emporitai*) and residents or citizens of Pistiros (Pistirenoi). An unnamed political authority looms, most probably a Thracian king or dynast, who wields considerable power in the region and structures and guarantees these social, economic, and legal relationships.

One such individual is named, Kotys, who seems to have served previously as a guarantor of an earlier version of these regulations (line 27); he has been identified by many scholars with Kotys I, who strengthened the Odrysian state during his rule as king (384/383–360 BC). The Pistiros Inscription renewed and supplemented those earlier regulations and may thus mark a moment of political transition within the region.[6] The inscription has the somewhat unusual form of a unilateral treaty, which has been granted by Kotys's successor to the residents of Pistiros and its environs and those transacting business there; the treaty is guaranteed by an oath.[7]

Specific clauses of the treaty can be found in the first half of the inscription (lines 1–27). These nuanced privileges are sophisticated in their appreciation of the aims of distinct groups working in Pistiros. Should legal conflict arise among resident merchants, for example, the dispute will be settled "among kins," an apparent reference to the use of legal processes familiar to the disputants (lines 4–7). The impression is of a network of exchange, encompassing the coastal north Aegean and possibly Pontic (the location of the Apollonia mentioned

here remains in doubt) Greek city-states and a web of *emporia* including inland sites like Pistiros. Maroneia would seem to enjoy a favored status. Goods are described as moving by road, although precisely what is not mentioned in the inscription—a broad array of raw and finished products are probably to be imagined. Thrace was a major source of slaves, too, and they are likely to have moved through Pistiros to Greek markets.[8]

There follows in the second half of the inscription a treaty oath to be sworn by the issuing authority, who has been identified as a successor of Kotys (lines 27–46). The first eleven lines are particularly well preserved and offer valuable additional perspective on the precarity of those living in and passing through Pistiros. In particular, there are expressed fundamental concerns for the security of person and property of three select groups of Greeks active in the area, hundreds of kilometers from their city-states of origin.

The imposing dimensions of the stele suggest strongly that it was intended for public display at Pistiros, available for consultation by the diverse Greek and Thracian populations residing or trading at the site and within the larger network of *emporia*. •DG

1 Editio princeps: Velkov and Domaradzka 1994 (*SEG* 43, 486). Important reeditions and other critical work on the text: *IGBulg.* V, no. 5557 *ter*; Chankowski and Domaradzka 1999 (*SEG* 49, 911); L. Domaradzka in Martinez et al. 2015, 191–92, no. 152.

2 The text presented here is based on that of Andrzej and Véronique Chankowski, published in L. Domaradzka in Martinez et al. 2015, 191, no. 152. Square brackets in the Greek text, partially rendered in the English translation, represent areas where the surface has been damaged and the original inscription cannot be read. In some cases scholars have plausibly restored these passages; in others no reasonable restoration could be attempted in the current state of evidence. Debate attends even those passages in which the Greek is legible, with considerable controversy regarding the meaning of particular words: the translation offered here attempts to reflect the state of the scholarly questions and to invite new readers into the world described on the stone.

3 Parvoničová and Bouzek 2017.

4 See, e.g., Archibald, "Who Were the Thracians?," in this volume.

5 Demetriou 2012.

6 Graninger 2018, 188–91.

7 Hatzopoulos 2013, 14.

8 Archibald 2013, 118–23.

28–31

SAMOTHRACE AND THE SANCTUARY OF APOLLO AT ZONE

28

28

Kylix Fragments

Greek, made in Athens, ca. 480–450 BC
Terracotta
3.6 × 8.4 × 0.4 cm
Found in the Sanctuary of the Great
Gods, Samothrace, Greece, 1952
Archaeological Museum
of Samothrace, ΑΓΚΜΣ 919

Restored from two fragments, this section of an Attic black-glazed *kylix* preserves portions of the offset vertical lip and body.[1] It comes from the Black Pit beneath the Altar Court (middle of the third century BC) in the Sanctuary of the Great Gods at Samothrace.[2] The Black Pit evidently received its fill from a deposit of discarded material from sacrificial meals and rituals around the great rock altar, which antedated and was contained within the Altar Court.[3]

The *kylix* was made of fine pale-orange clay with a black glaze on the interior and exterior surfaces. The estimated original diameter of the cup is about 13.9 centimeters. On the outside of the lip is a large section of a dedicatory inscription that was incised after firing. It contains eighteen preserved letters with average height of 0.4–0.5 cm.[4] The inscription reads:

→ ΕΠΟΤΕΨΕΝΕΥΣΑΝΤΟΚΑΕ -

The Ψ sign probably had the value [ks]: -]εποτεΨε.[5] The sequence -εΨε- occurs also in Zone.[6] If -]εποτεΨε is the name of the

dedicator, the ending of this name should correspond to the Greek –ος. The next sequence, νευ, is considered to be a possible abbreviated form of the sequence νευες (= Greek νέος, from *newos?) appearing in an inscription on stone in Zone.[7] The following sequence, σαντο, before καε, could be an element of Thracian onomastics,[8] and the final –o of this name should correspond to the Greek –ων. The three proposed sequences above could give the formula: name of a male ending in εΨε + "the young" + σαντο (patronymic?).[9]

The καε is a segmented form of εκαιε/εκαε,[10] which is the third-person singular form of a verb, possibly derivative of a theme, *ka(:)w- "to burn, set on fire." One thinks of the Greek καίω (from *kaw-yo:) with expanded meaning, from an offering to the gods with combustion to a pure and simple offering. This verb, autochthonous in the Thracian of the region or a loan from the local Ionic,[11] would have had the same semantic shift as the Greek verb θύω.[12] In the Sanctuary of the Great Gods, at least three dedications end with καιε/καε (type h of the typology established in Zone);[13] the three graffiti from the open-air Sanctuary of Bendis-Artemis (at the site Mántal' Panayiá) on Samothrace may also be of the same type (h).[14]

Prior to the discoveries at Zone, the only direct testimonies of the non-Greek language of the region came from the Sanctuary of the Great Gods:[15] about seventy-five very fragmentary ex-votos on vases (sixth to fifth century BC),[16] a mutilated graffito

incised in the interior of a coarse bowl (late fifth to early fourth century BC),[17] and a very mutilated stone (late fifth–fourth century BC).[18] The study of the documents from Zone and Samothrace assures the presence of the same language, spoken by the Thracian tribes of the region using an alphabet combining Parian with Eastern elements. The Thracian of Samothrace and Zone presents very particular features with a structure, however, which seems to be very close to that of Greek.[19] •DM

1 Lehmann and Spittle 1964, 225.
2 Lehmann 1960, 45.
3 Lehmann and Spittle 1964, 240.
4 Jeffery 1990, 299, 307, no. 57, 412; Brixhe and Panayotou 1997, 288.
5 Brixhe 2006, 129.
6 C. Brixhe in Brixhe, Zournatzi, and Pardalidou 2015, 221, no. 67.
7 C. Brixhe and A. Zournatzi in Brixhe, Zournatzi, and Pardalidou 2015, 265: IV. ΑΓΚ 6140 + 6143; C. Brixhe in Brixhe, Zournatzi, and Pardalidou 2015, 285.
8 Detschew 1976, 421; Brixhe 2006, 137.
9 C. Brixhe in Brixhe, Zournatzi, and Pardalidou 2015, 297.
10 Brixhe 2006, 134–35.
11 C. Brixhe in Brixhe, Zournatzi, and Pardalidou 2015, 294.
12 Brixhe 2006, 136.
13 Lehmann 1960, nos. 1, 68, 69; C. Brixhe in Brixhe, Zournatzi, and Pardalidou 2015, 288.
14 Matsas 2004, 230, fig. 2; Brixhe 2006, 125, fig. 3.
15 See Brixhe and Panayotou 1997, 287–88.
16 Lehmann 1960, nos. 1, 3–75.
17 Lehmann 1960, no. 2.
18 Fraser 1960, no. 64.
19 Brixhe 2006, 142.

The excavations of the Sanctuary of Apollo in Zone conducted by the 19th Ephorate of Prehistoric and Classical Antiquities of Thrace of the Hellenic Ministry of Culture brought to light, among a rich array of other finds, a remarkable collection of epigraphic documents. Some three hundred graffiti on broken ceramics (ostraca) of sixth- and fifth-century BC dates were recovered, almost all of them from a packed layer of earth and ex-votos between the bedrock and the floor of the *sekos* of the early fourth-century BC renovation of the main temple building (cats. 29, 30). This fill must have been intended not only to enhance the stability and durability of the new structure but also as a (re)foundation deposit.[1] Most of the ostraca come from black-glaze and black-figure pottery.[2] The graffiti were written in Greek letters, but about 220 of them record a non-Greek dialect, which has been interpreted, at least provisionally, as a Thracian idiom closely related to Greek and Phrygian.[3] It has been suggested that the same idiom is represented in at least four of the nine inscriptions on stone found in the area of the sanctuary (cat. 31).[4] Nearly all the graffiti are classified as dedications to Apollo, whose name occurs in a number of the ostraca, often in abbreviated form, and whose importance in Zone is

further documented by a Greek-inscribed dedication on marble[5] as well as by the types of the city's fourth-century BC coinage.[6] The epigraphic finds from the Sanctuary of Apollo present us, as interpreted by Claude Brixhe, with the largest concentration of Thracian inscriptions available to date, enabling scholars to begin to formulate working hypotheses concerning the hitherto virtually unknown Thracian language or at least one of its dialects. Simultaneously, they constitute eloquent testimony to the cohabitation of Thracians and Greeks in this city on the north Aegean Sea, which was established by Greek colonists in the territory of the Thracian Kikones by the early sixth century BC.[7] •AZ

1 P. Tsatsopoulou-Kaloudi in Tsatsopoulou-Kaloudi and Kaloudis 2015, 163–68; P. Tsatsopoulou-Kaloudi in Brixhe, Zournatzi, and Pardalidou 2015, 210.
2 C. Pardalidou in Brixhe, Zournatzi, and Pardalidou 2015, 432–546.
3 Brixhe 2006; C. Brixhe in Brixhe, Zournatzi, and Pardalidou 2015, 211–50, 282–303, 413–24.
4 C. Brixhe in Brixhe, Zournatzi, and Pardalidou 2015, 251–66, 303–6.
5 A. Zournatzi in Brixhe, Zournatzi, and Pardalidou 2015, 278–79, no. VI.
6 Galani-Krikou, Tasaklaki, and Tselekas 2015.
7 See, for instance, Herodotus, *Histories* 7.59.2. For an overview of the written and archaeological testimonies regarding Thracian and Greek presence in the area of Zone, see Tsatsopoulou-Kaloudi 2015.

29

Fragment of a Black-Figure *Skyphos*

Greek, Attic workshop, manner of the potter Hermogenes, 550–525 BC
Terracotta
H: 4 cm; W: 6 cm
Found in the Sanctuary of Apollo at Zone, Greece, 1988
Archaeological Museum of Alexandroupolis, ΑΜΑΛ 1754

The present fragment preserves part of the lip and body of one side of a *skyphos* decorated in the black-figure technique with added purple.[1] Of the figured scene, which was incised and painted on the reserved red field, a standing male figure looking to the right is almost completely preserved. He wears a long *chiton* and *himation*. On the right edge of the fragment, the contour of a leg and the curly lines above it prompt comparison with vase painters' figurations of the Nemean lion in depictions of the first Labor of Herakles or, perhaps less probably,

29

of sphinxes. The large tendril ending in a palmette was a common decorative motif used on either side of the handles.

Only 38 of the 291 ostraca from the Sanctuary of Apollo were inscribed in Greek. On the black-glazed lip of the present fragment was incised, after the vase had been fired, the name Apollo in the genitive case, [Ἀ]πώλλονως.[2] Claude Brixhe observed the conformity of the reverse usage (compared to the Ionic and Attic alphabets) of the vowels omicron and omega with the tradition of writing in the north Aegean region of Zone-Samothrace-Maroneia, which seemingly followed the Parian alphabet brought by colonists from the island of Thasos.[3] •AZ

30

1 C. Pardalidou in Brixhe, Zournatzi, and Pardalidou 2015, 494, no. 226, and figure on p. 539; Pardalidou 2015, 622, no. 36.
2 C. Brixhe in Brixhe, Zournatzi, and Pardalidou 2015, 241, no. 226.
3 Brixhe 2006, 126 §3.3; C. Brixhe in Brixhe, Zournatzi, and Pardalidou 2015, 283 § 3.1.

30

Fragment of a Black-Figure *Kylix*

Greek, Attic workshop, 550–525 BC
Terracotta
H: 8 cm; W: 17 cm
Found in the Sanctuary of Apollo
at Zone, Greece, 1988
Archaeological Museum of
Alexandroupolis, ΑΜΑΛ 1756

On the exterior of the preserved side of this *kylix*, a scene of contest between two naked wrestlers and a decorative tendril ending in a palmette were incised and painted in the black-figure technique (with added purple) on the reserved red band at the height of the handles.[1] Hanging in the background are the wrestlers' *himatia*. The male figure to their right, running or bending toward them with a *himation* hanging over his arm, may be a trainer, referee, or excited onlooker. Of another figure, possibly depicted in a like attitude, to the left of the wrestlers, only

part of an arm with an overhanging *himation* survives.

An incompletely preserved inscription in Greek letters, incised from right to left on the lip after firing, reads: Αβολο · υνεσ[ο ..] πασ[- - -].[2] It has been interpreted as a dedication to Apollo in the non-Greek (conventionally, Thracian) idiom attested in Zone. From the occurrence of αβολο υνεσο κα(ι)ε in a number of the graffiti, Claude Brixhe deduced that the standard formula of dedication would have comprised the Thracian name and epithet of the divinity and the verb of the dedication, with occasional insertion before the dedication verb of the name of a male or female dedicant.[3] Interestingly, in certain examples the dedicants' names are Greek.

It has been suggested that the Thracian form of the theonym, Αβολο, rendered with a Parian form of B (written C) on the *kylix* fragments, corresponds to the Greek dative Ἀπόλλωνι. The incised point after Αβολο served as a word divider. The term υνεσ[ο, would have rendered, in the dative case, an epithet of the god—one that was perhaps derived from the Ionian form *ὄνησος, equivalent to ὀνήσιμος, "useful, helpful."[4] The sequence]πασ[would have belonged to the dedicant's name. There would have followed the typical verb of dedication κα(ι)ε, which is preserved on some forty ostraca from Zone. Brixhe proposed a

connection with Greek καίω, "to burn," and interpreted κα(ι)ε as an equivalent of the Greek verb ἀνέθηκεν, "dedicated."[5]

The great majority (90 percent) of the approximately 220 Thracian graffiti found in the Sanctuary of Apollo at Zone are assignable to the sixth century BC, with the remaining 10 percent dating to the first quarter of the fifth century BC. Their quantity testifies to an important Thracian component in the social life of this city.
•AZ

1 C. Pardalidou in Brixhe, Zournatzi, and Pardalidou 2015, 443, no. 36, and figure on 515; Pardalidou 2015, 615, no. 24.
2 C. Brixhe in Brixhe, Zournatzi, and Pardalidou 2015, 216, no. 36.
3 Brixhe 2006, 129–40 §§ 4–5; C. Brixhe in Brixhe, Zournatzi, and Pardalidou 2015, 287–97 §§ 4–7.
4 Brixhe 2006, 132–33 § 4.3; C. Brixhe in Brixhe, Zournatzi, and Pardalidou 2015, 291–93 § 7.2.
5 Brixhe 2006, 134–36 § 4.5; C. Brixhe in Brixhe, Zournatzi, and Pardalidou 2015, 293–94 § 7.3.

31

Fragmentary Stele with Greek and Thracian Inscriptions

Possibly late 5th–early 4th century BC
Marble
44 × 19 × 14 cm
Found in the Sanctuary of Apollo
at Zone, Greece, in 1988
Archaeological Museum of
Alexandroupolis, AMAΛ 2100

The two joining stele fragments were found northwest of the main temple building, the upper fragment on the surface and the lower fragment at a depth of 1.1 meters. Only five lines of the lower left portion of the Greek text (A) are preserved. The longer (conventionally) Thracian inscription (B), carved in smaller but similarly shaped characters below it, is mutilated on all sides. This fragmentary stele presents us with the "first known example of a Greek public inscription engraved on the same stone as a Thracian document" and "the longest text in the Thracian language discovered so far in the Thracian space."[1]

Greek text (A):[2]

- - - - - - - - - - -
[- - - - - - - - ἀ]-
συλίαν αὐ[τῶι καὶ]
3 ἐκγόνοις ε[ἶναι ἐς]
ἀιίδιον κα[ὶ ἐμ πο]-
λέμωι καὶ ἐ[ν εἰρήν]-
6 ηι.

...let there be for himself (or them-selves?) and his (or their?) descendants inviolability forever in time of war and in time of peace.

Thracian text (B):[3]

- - - - - - - - - - - - - - - - - - - -
υ(?)ο[2]ωδικωδικε(?)ε[1,5]ν[2]γγε . [- - -]
3 νδοι(?)ννε . [2]ευτρ[2]λ[- - -]
σκοκαρτεσικρεσ[1,5]ο[- - -]
[1,5]αρειλεσνευεσερυθρ[- - -]
6 [5]υτορειντοδειολ . [- - -]
[6,5]ω(?)τεριω ε[- - -]
[6]εδειωυαυ . τρα[- - -]
9 [6]ειρεσκωπαιτεγ[- - -]
[6]νυαναυωελεκρ[- - -]
[6]ελιδεονιλωσωι[- - -]
12 [6,5] . νγεγευοεκα[- - -]
[7]πολενιεσιτερε[- - -]
[7,5]πολεδετερεσ[- - -]
15 [6]ονδειωποβλομα[- - -]
[6]εστιντιοσαυεντ[- - -]
[5,5] . ειρεσκεγε[1,5]οε[- - -]
18 [9]ιδιοτιμε[- - -]
[11]οφ . [- - -]

Incomplete though they may be, the five surviving lines of the Greek text (A) allow us to identify an honorary decree granting inviolability (ἀσυλία), perhaps among other privileges that might have been mentioned in the missing earlier part of the inscription. The authority that granted the privilege(s) and the beneficiaries are unknown.

The carving of the Thracian text (B) on the same stone with a Greek honorary inscription would suggest, at the very least, that we are dealing with a public document, a circumstance that would further imply the social and political prominence of the Thracian element in Zone. It also leaves open the possibility that this document was similar in nature to the preceding Greek inscription or even, perhaps, a "translation" of it.[4] No correspondences in terminology are discernible between the surviving portions of A and B, and the Thracian text is largely undecipherable given the current state of our knowledge. According to the interpretive framework proposed by Claude Brixhe, text segmentation and the identification of words and word elements could be possible in some instances, as on line 10, ναυω (Greek ναός/νεώς, "temple"), and line 18, διοτιμε[(Greek Διότιμος, "Diotimos"). •AZ

1 A. Zournatzi in Brixhe, Zournatzi, and Pardalidou 2015, 259–66.
2 A. Zournatzi in Brixhe, Zournatzi, and Pardalidou 2015, 257–59.
3 C. Brixhe in Brixhe, Zournatzi, and Pardalidou 2015, 259–66.
4 C. Brixhe and A. Zournatzi in Brixhe, Zournatzi, and Pardalidou 2015, 263–64, 266–69.

THRACE AND PERSIA

V.

In its expansion westward following the conquest of Asia Minor in 546 BC, the Achaemenid Persian Empire under Darius I (522–486 BC) mounted a campaign in Europe against the Scythians, who lived north of the Istros (Danube) River. Crossing the Hellespont into Thrace in 513 BC, the expedition probably traveled northward along the Black Sea coast. Most Thracian tribes surrendered to the Persians, except for the Getai in northeastern Thrace, who fought fiercely but were defeated. Darius soon withdrew, leaving one of his generals, Megabazos, as commander in Thrace, but military control of the region was not secure until the arrival of the Persian military commander Mardonios in 492 BC. The Thracians appear as a subject nation in Achaemenid royal inscriptions and on the reliefs at the royal capital of Persepolis, in present-day Iran, and the presence of Thracian workers in Iran is well attested by the administrative records known as the Persepolis Fortification Tablets, which date to the years 509–493 BC.

In the early fifth century BC, the city of Doriskos, on the north Aegean coast near the Hebros River, served as the primary Persian garrison, along with Eion, on the Strymon River on the border between Thrace and Macedonia. Doriskos was the staging ground for the massive army mustered by Xerxes in 480 BC for the second invasion of Greece, which included a contingent of Thracians, who are described by Herodotus. The Greeks were already well acquainted with Thracian warriors, and it is likely that the adversaries called "tattooers" on a tombstone of a Greek soldier killed in battle were Thracians.

Following the Greek victories at Plataea and Mykale in 479 BC, the Persian army retreated through Thrace to Asia Minor, and only a small Persian presence remained in Thrace. Eion was taken by the Athenian general Kimon in 476 BC, though Doriskos stayed in Persian hands well into the fifth century BC. It is difficult to judge the influence of Persian culture in the region, but the sheer wealth of the Persians clearly impressed the Thracian aristocracy, as it did the Greeks. A small number of Persian silver vessels have been found in Thrace, but the use of gold and silver drinking vessels at lavish banquets became a marker of aristocratic status, and such vessels are well attested in burials. The exchange of precious-metal vessels as gifts is also a practice likely learned from the Persians. •JS

32

Relief of Two Thracians

Achaemenid, 500–480 BC
Limestone
59 × 52 × 15 cm
From the Apadana, Persepolis, Iran
Staatliche Museen zu Berlin,
Vorderasiatisches Museum, VA 02987

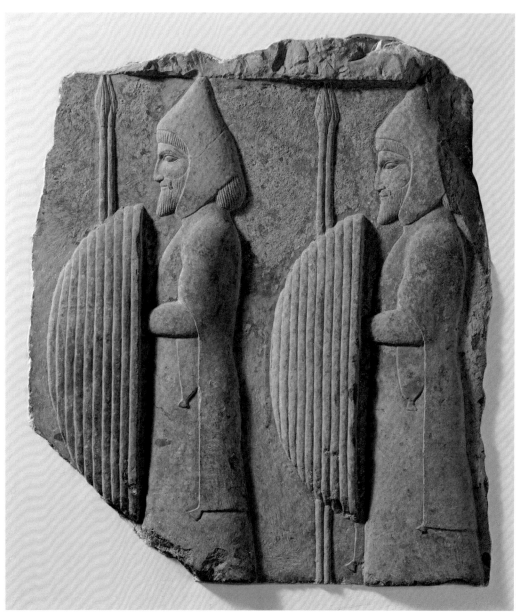

32

As part of his Scythian campaign in 513 BC, the Achaemenid king Darius I invaded Thrace and brought its eastern regions, including the Odrysai and Getai tribes, under his control.[1] Old Persian inscriptions likely identify the Thracians by the term "Skudra," but it is unclear whether Skudra indicated the Thracians as a people or was a place name for an individual satrapy.[2] Together with Macedonia, which also became a Persian vassal, Thrace was an important point of access to mainland Greece, on which Darius set his sights after the Ionian Revolt of 499–494 BC. Thracian soldiers fought on the Persian side in Xerxes's invasion of Greece in 480–479 BC (see cat. 36).

Thracians feature among the peoples represented in the detailed tribute scenes carved on the staircases of the large ceremonial hall known as the Apadana at the Persian capital of Persepolis, which Darius began constructing in about 518 BC. The northern and eastern staircases depict processions of representatives from the various subject peoples of the empire approaching the enthroned king with gifts from their respective lands. A fragmentary panel with two Thracian men, now in Berlin, originally belonged to the northern staircase;[3] the lower portion of the two figures, showing their feet and the ends of their lances, is preserved in situ.[4] Each man wears the distinctive pointed fox-skin cap with side flaps (known in Greek as an *alopekis*) and the long, woolen cloak (*zeira*) familiar from representations of Thracians on Athenian vases (cats. 16, 17).[5] Each carries a pair of spears and a rounded shield, perhaps made of wicker. A similar group of four Thracian men appears on the southern part of the eastern staircase, mirroring the present figures.[6] On the eastern staircase, the first Thracian clasps the hand of a Median guard, who leads the group toward the Great King. The second and third men carry shields and lances, while the fourth

leads a bridled stallion as a gift. The Thracians were noted for their fine horses, as reflected in the Homeric story of King Rhesos (see cat. 9). • SEC

1 For overviews of Thraco-Persian interactions and Persian influences in Thrace, see Rehm 2010b; Vassileva 2015. See also Hammond 1980.
2 The debate is summarized in Rehm 2010b, 147–52; Vassileva 2015, 322–23. Balcer (1988), among others, argues that Skudra denotes Thrace but that it was not an independent satrapy.
3 Sarre and Herzfeld 1910, 50, 51, fig. 17; Schmidt 1953, 89 (where the author designates the men as "Delegation No. 19: The Skudrians?").
4 Schmidt 1953, plate 45. A. Tilia (1972, 284–87, no. 43, plate CXCI, figs. 139–41) argues that a

fragmentary relief from the Persepolis storerooms that was originally part of a stairway facade of Artaxerxes I could represent people from Skudra.
5 See Tsiafaki in this volume.
6 Schmidt 1953, plate 45, B; Tilia 1972, plate CXCIII, fig. 142; Balcer 1988, 20.

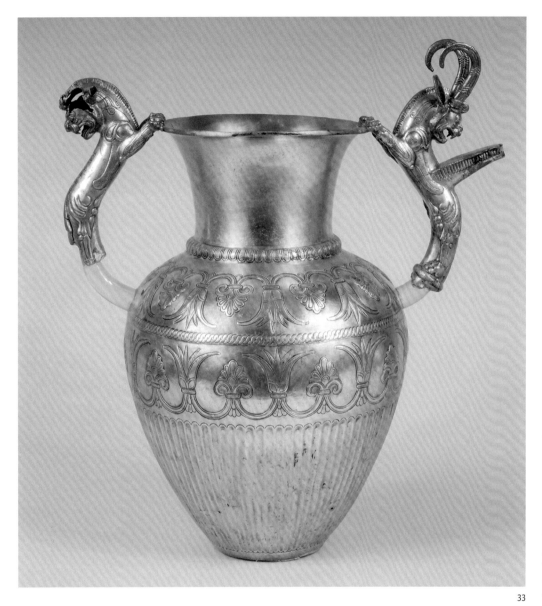

33

33

Amphora

475–450 BC
Silver with partial gilding
H: 27 cm; W with handles: 29.4 cm;
Diam of rim: 13.4 cm; Wt: 1344 grams
Found in Kukova Tumulus, near the village
of Duvanlii, Plovdiv Province, Bulgaria,
in 1925
Sofia, National Archaeological Institute
with Museum, 6137

This vessel has an ovoid body and a conical
neck with concave walls.[1] Two hollow vertical
handles take the form of lion-griffins with
ibex horns and long ears who turn their
heads backward. A long spout is mounted

on the back of one of the lion-griffins.
The flat base is engraved with a twenty-
seven-leaf rosette. An embossed band of
ovuli separates the neck from the body,
the upper half of which is decorated with
two lotus and palmette friezes, turned,
respectively, up and down and separated
by a guilloche, while the lower half is fluted.
The beasts' bodies, limbs, necks, and
heads are modeled with groups of stylized
elements in relief, complemented by
engraved details. All ornaments on the body
of the amphora and the animals are gilded.
In the existing literature, the vase is often
called an amphora-*rhyton*, but this is
misleading; a more correct term would be
"spouted amphora" or simply "amphora."[2]

Bogdan Filov's analysis of the amphora
led him to the opinion that it displays a
Greco-Persian style developed in the Ionian
centers on the coast of Asia Minor, with
Kyzikos as a probable place of production.[3]
The vase quickly became the subject of
scholarly discussions regarding its origin,
context, date, and cultural affiliation.[4] The
apparent similarity to the amphorae carried
by the Armenian and especially the Lydian
gift-bearers on the Apadana reliefs in
Persepolis was the main argument in favor
of its pronounced Achaemenid character.[5]
The lotus and palmette friezes on the body,
however, which appear to be mostly Greek,
have drawn attention to the Greek inspira-
tions in Persian architecture and metalwork.
Another silver amphora of the same shape
and general decorative scheme (with ibexes
instead of lion-griffins)—reportedly from
near Sinope, on the Black Sea—tends to
support such notions and led to the hypoth-
esis that both vases were produced by the
same Anatolian workshop.[6] Some specifics
of the style and decoration also indicate the
product of an important workshop.[7]

Presumably the amphora arrived in
Thrace as a diplomatic gift,[8] although it is
difficult to place it in a specific historical
context since the dates of its production
and arrival in Thrace remain conjectural. The
burial in Kukova Tumulus is believed to be
of a woman, as it contained jewelry, but it
would be unusual to find a prestigious royal
gift in such a context. In fact, the grave
was disturbed, and the information on the
context is incomplete. Thus, the amphora's
function provides grounds to revise the
view of the buried person's gender. •TS

1 Marazov 1998a, 182–83, no. 117; P. Ilieva and
 P. Dupont in Martinez et al. 2015, 234–35, no. 195;
 E. Penkova in E. Penkova, Konova, and Kisyov
 2017, 108–9.
2 Rehm 2010a, 168nn86–88.
3 Filov 1934a, 46–51, 199–206, 233–35, figs. 55–59,
 plate III.
4 On this complex matter in general, see Sideris
 2008.
5 Amandry 1959, 39–40; Venedikov and Gerasimov
 1975, 85–86; Marazov 1978, 27–30; Luschey 1983,
 314–16, 323; Calmeyer 1993, 152–53, plates 43.2,
 44.1.
6 Pfrommer 1990, 192–92; Ortiz 1996, no. 205;
 Boardman 2000, 187–89, n. 129; Summerer 2003,
 28–30, fig. 9.
7 Rehm 2010a, 173nn144–47.
8 Venedikov and Gerasimov 1975, 85; Archibald
 1998, 85.

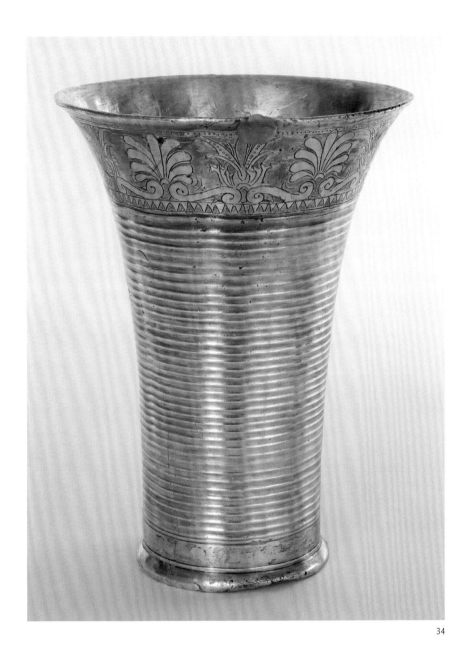

34

34

Beaker (*Kalathos*)

450–425 BC
Silver with gilding
H: 12.2 cm; Diam of rim: 9.2 cm
Found near the village of Bukyovtsi
(Miziya), Vratsa Province, Bulgaria,
in 1935
Sofia, National Archaeological Institute
with Museum, 6694

This beaker has a cylindrical lower body that gradually flares upward, decorated with horizontal ribs. The rim is slightly thickened and outturned. Beneath it is a smooth field with a band of alternating lotus and palmettes with volutes, delimited from above with a dotted line and from below with a band of triangular motifs. Immediately above the low foot, there is another wide gilded band.

Silver beakers of similar shape but with different decoration are known from burials in Macedonia and Thrace, dated from the second half of the sixth to the late fifth century BC.[1] The elegant silhouette, the flaring rim, and the low foot of the Bukyovtsi vase belong to the same morphological lineage, but the selection of ornamental motifs demonstrates a break with the old tradition. The decoration of horizontal ribs, considered one of the hallmarks of Achaemenid metalwork,[2] brings it closer to the beakers "from Erzurum" (now in Oxford),[3] from Vani in Georgia,[4] and from Panderma, on the southern Propontic coast,[5] all of which have a similar decorative scheme but differ in terms of proportions and the treatment of the base.

On the reliefs of the Apadana in Persepolis, delegates of various peoples are depicted carrying such beakers and deep bowls with horizontal ribs,[6] providing evidence for the hypothesis that the scenes reflect the practice of offering uniform prestigious gifts produced by workshops throughout the Achaemenid Empire.[7] In addition, the known examples appear at places that are quite far from one another—also an indication of the decentralized production of such vases as an essential part of the standard Near Eastern drinking set.[8]

The austere monotony of the horizontal ribs on the Bukyovtsi beaker stands in stark contrast to the vitality of the floral band beneath the rim, which is executed in a non-Persian technique. Similar solutions were possible in workshops in the cities on the west coast of Asia Minor, where old Anatolian traditions were often combined with Ionian and Achaemenid palatial–style elements. •RS

1 Trebenishte, Grave VIII: Ardjanliev et al. 2018, 289–90, nos. 132, 133; Staro Selo, Sliven region: Venedikov 1964, 79, figs. 2, 3; Dalboki, Stara Zagora region: Vickers 2002, 69, plate 26; Gorski Izvor, Tumulus 1, Haskovo region: Petrov 1993, 28, figs. 3, 4.
2 M. Miller 1989, 3.
3 Vickers 2000, 262, fig. 1, 263, fig. 2.
4 Guigolachvili 1990, 279, fig. 32.
5 Luschey 1938, 78, fig. 3; Platz-Horster 2005; Niemeyer and Schwarzmaier 2021, 38–40, no. 4.
6 Delegations 12 and 15, after Schmidt 1953, plates 38B, 41B.
7 Calmeyer 1993.
8 M. Miller 2010, 868.

35

Black-Figure Neck Amphora with a Fight between Thracians and a Greek

Greek, made in Athens, attributed to the
Bareiss Painter, Medea Group, 530–520 BC
Terracotta
H: 32.9 cm; Diam: 21.9 cm
Los Angeles, The J. Paul Getty Museum,
Villa Collection, 86.AE.85

On the reverse of this black-figure amphora
made in Athens, two Thracian horseman
battle a Greek hoplite.[1] The hoplite—wearing
a cuirass, greaves, and a helmet with a
tall crest and feathers—falls to his knees,
overcome by the riders' long spears.
Each rider wears the long, colorful Thracian
woolen cloak known as a *zeira*. The horse-
man on the left has red hair, thought by the
Greeks to be characteristic of the Thracians.

The significance of the battle depicted
on the vase is unknown, but Greeks had
long been active in Thrace as colonists
and often came into conflict with the local
people. Athenians had close contact with
the Thracians especially after the mid-
sixth century BC, when the exiled Athenian
tyrant Peisistratos built a power base there
in preparation for his return to Athens
in 546 BC.[2] Around the same time Miltiades
the Elder established himself as tyrant
of the Thracian Chersonese. Admiration
for the Thracians' horsemanship and
skills in battle (and even of their idealized
beauty) led aristocratic Athenian riders
to adopt Thracian dress, but here the
riders are clearly the Thracian enemy.[3]

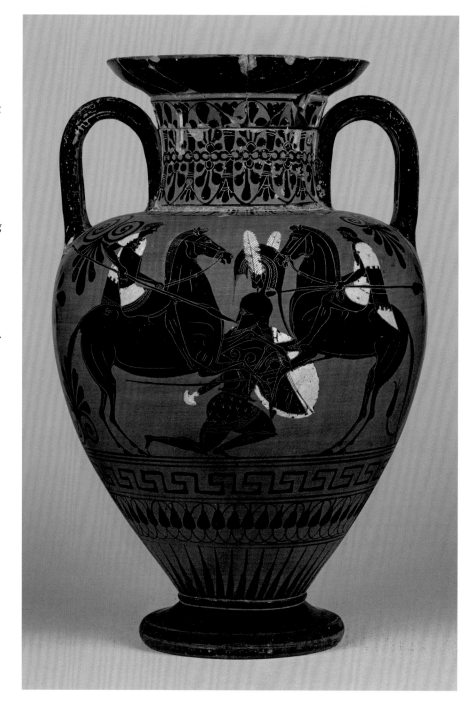

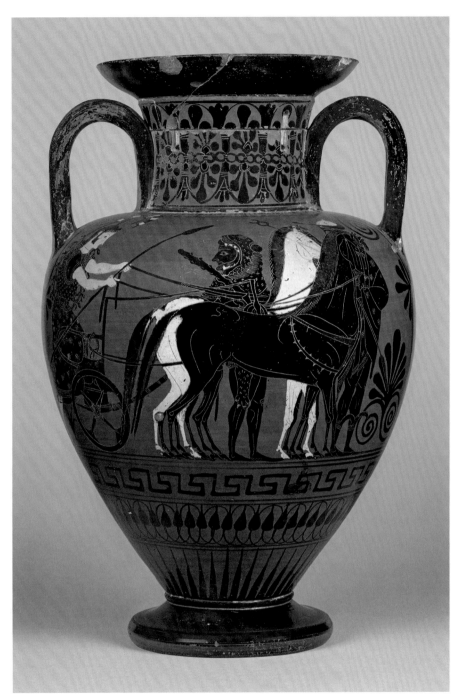

35

The apotheosis of Herakles appears on the front side of the vase. The goddess Athena, Herakles's patron deity, mounts a chariot to lead the hero to Mount Olympos. It has been suggested that this scene, which became popular on Athenian vases in the later sixth century BC, may refer to Peisistratos himself, for Herodotus tells the story of how the tyrant returned from his first exile (around 556 BC) and staged a dramatic entry to the Acropolis accompanied by a statuesque woman named Phye driving a chariot while costumed as Athena.[4] If the scene on this vase was viewed as alluding to Peisistratos, the Thracian battle may well have been, too. •JS

1 Clark 1988, 26–28, plates 27–29; Tsiafaki 2000, 369–71, fig. 14.3; Tsiafaki 2021, 250, fig. 1.
2 Sears 2013, 52–69.
3 Lissarrague 1990, 210–27; Sears 2013, 194–201.
4 Herodotus, *Histories* 1.60; Boardman 1972.

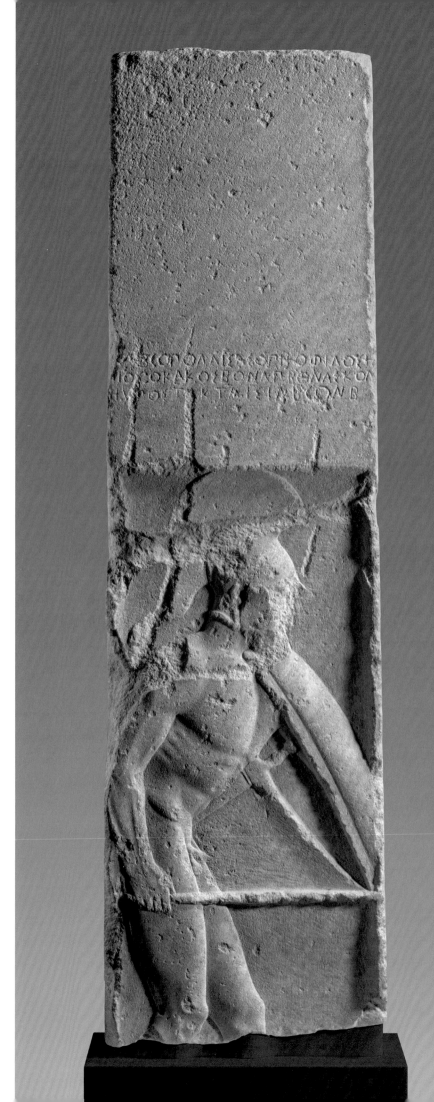

36

Grave Stele of Pollis

Greek, from Megara, ca. 480 BC
Marble
153 × 45.1 × 15.9 cm
Los Angeles, The J. Paul Getty Museum,
Villa Collection, 90.AA.129

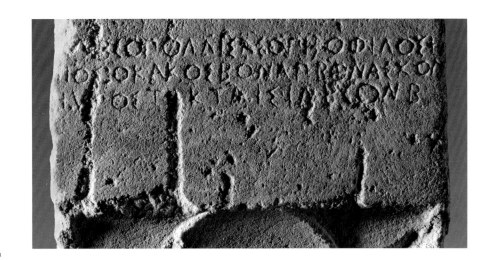

λέγο, Πόλλις Ἀσοπίχο φίλος h|υιός:
ὁ κακὸς ἐὸν ἀπέθνασκον| hυπὸ
στ[ί]κταισιν ἐγόνε

I, Pollis, dear son of Asopichos, speak:
Not being a coward, I, for my part,
perished at the hands of the tattooers.[1]

This narrow rectangular slab without ornamentation or architectural detail is the tombstone of a Greek soldier named Pollis.[2] A brief epigram, inscribed in the largely empty upper zone of the stele using Megarian script and narrated in the deceased's voice, points to the circumstances of his death—the battle wounds inflicted on him by people he calls "the tattooers."[3] In the historical context of the monument, namely the time of the Greco-Persian Wars, the term can be understood as referring to the Thracian warriors who fought against the Greeks under Xerxes in 480 BC.

As a poetic if somewhat derogatory epithet—similar to how British soldiers during World War I labeled their German enemies "Krauts"—"tattooers" reduces Thracians to a cultural practice singled out for its foreignness to the Greeks. While there are no large-scale images of Thracians in Greek art, tattoos can be found in vase painting, employed as ethnic identifiers for both mythical and real-life figures. The women at the fountain on the *hydria* attributed to the Aegisthus Painter now in Paris are a good example (cat. 37).[4]

The stele's image—a tightly cropped composition carved in shallow relief—shows Pollis as a hoplite with a crested helmet, large round shield, sheathed sword, and a spear in his right hand. Apart from this, his muscular, sinewy body appears naked. There are a number of missing details that originally must have been added in paint, including the plumes of the helmet's crest, the sword strap, and the pubic hair, whose absence is more noticeable given that the warrior appears to have been bearded.

In the present context, nudity was an iconological device to emphasize the physical and, by extension, moral superiority of the Greeks vis-à-vis their enemies.[5] Sometimes called heroic nudity, it had no equivalent in actual Greek warfare, with its sophisticated equipment that included body armor such as cuirasses and greaves.

The tombstone of Pollis thus celebrates the warrior and his athletic prowess ("not being a coward") while, by showing his naked body, it invites viewers to mourn his death as a very physical loss rather than a symbolic sacrifice. Mentioning the Thracians in the epigram serves to elevate Pollis's stature for having faced such fierce opponents and gives his death a rare historical specificity. •JMD

1 *SEG* 41, 413.
2 Grossman 2001, 98–100, no. 36 (see the earlier bibliography there). See also Spivey 2013, 122–23, 126, fig. 5.1; Reeves 2018; Østergaard and Schwartz 2022, 11, 14–16, figs. 14–16.
3 Corcella 1995 (who doubts the identification as Thracians); Ebert 1996a; Ebert 1996b, 19–25.
4 For an example in the mythical realm, see the image of Herakles's nurse named Geropso ("old age") on a *skyphos* by the Pistoxenos Painter in Schwerin, Staatliches Museum, 708: Lücken 1972, 19–20, plates 24–28; Huf 2018, 190–91, figs. 73.1–5.
5 For the complex phenomena surrounding the deployment of nonrealistic male nudity in Archaic and Classical Greek art, see, e.g., Daehner 2005; Hurwit 2007.

VI. THE THRACIAN PRESENCE IN ATHENS

Among the various Greek and non-Greek foreign residents of Athens in the Classical period, the Thracians stood out. Though they were portrayed in Attic art and literature as the stereotypical "barbarians," Thracians also enjoyed certain privileges. The number of Thracians in Athens was large, and they ranged from enslaved persons working the mines, to mercenaries complementing the hoplite phalanx, to the son of an Odrysian king.

Thracians made up a great portion of the enslaved population of the polis. Athenian alliances in and encroachment upon the regions to the north of the Aegean from as far back as the days of Peisistratos in the mid-sixth century BC ensured a steady supply of forced labor. The preponderance of Thracians at this lowest rung of the social ladder is demonstrated by, for example, the Attic Stelai, which inventory confiscated property, including human property. Nine of the twenty-eight enslaved persons listed are Thracian, by far the largest ethnic group represented. Such evidence is illustrative of broader trends. Some sources, particularly drama, portray Thracians as the archetypal enslaved persons in Athens. The Thracian Sosias, who worked for the Athenian general Nikias, served as an overseer of hundreds of unfree laborers in the mines at Laurion (Xenophon, *Poroi* 4.14).

Free Thracians also lived in Athens. A famous shrine to the Thracian goddess Bendis was located in the Piraeus, where many of these Thracian *metoikoi*, or free resident aliens, likely dwelled, and its associated festival, the Bendideia, was enjoyed even by prominent Athenians. The Athenians granted the Thracian worshippers of Bendis the right to own property in Athens, a privilege denied other foreigners, for the purpose of building this shrine. Other Thracian deities and mythic figures received cults at Athens and were worshipped by Athenians and resident Thracians alike.

Perhaps the Athenians welcomed and courted Thracian residents because the polis relied on several Thracian rulers as military allies and sources of mercenary soldiers. Thracian mercenaries were present in Athens on several occasions. They participated in atrocities during the Peloponnesian War (431–404 BC), playing to the worst Athenian stereotypes about them, but Thracian soldiers also fought alongside the democrats struggling against the brutal oligarchy that ruled Athens briefly at the end of the war.

At the beginning of that war, the Athenians secured an alliance with the Odrysian Thracian king Sitalkes and brought his son Sadokos to Athens to make him an Athenian citizen. Beyond the necessities of diplomacy, the Athenians also reveal a particular fascination with Thracians through their frequent depictions of Thracians in art and even the adoption of Thracian clothing by some Athenians, making it difficult sometimes to distinguish whether an artist meant to depict a Thracian or an Athenian. •MAS

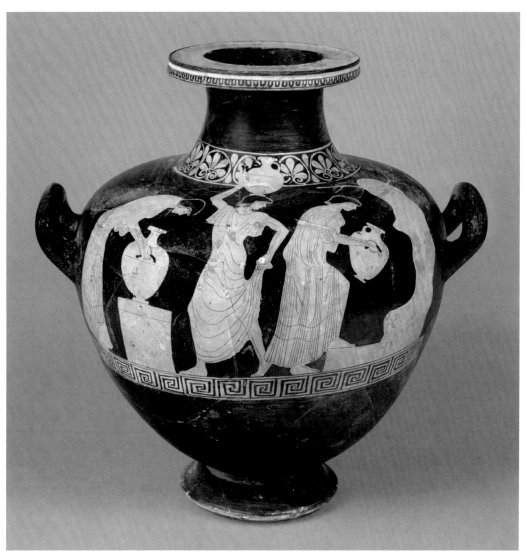

37

37

Red-Figure *Hydria* with Thracian Women at a Well

> Greek, made in Athens, attributed to the Aegisthus Painter, 465–460 BC
> Terracotta
> H: 38.3 cm; W with handles: 36.6 cm
> Paris, Musée du Louvre, Département des antiquités grecques, étrusques et romaines, CA 2587

Three young women fetching water from a fountain decorate the body of this Athenian red-figure *hydria*.[1] The woman at right fills her *hydria*, while the woman in the center carries her jug on her head and looks back over her shoulder. The figure at left rests her *hydria* on a square block. All three women have short, cropped hair and wear simple, loose-fitting *chitons*, indicating they are slaves. Their tattoos identify them as Thracians. The tattoos on their arms are in the pattern of a line running from wrist to shoulder with a long row of shorter, perpendicular strokes. The woman in the center lifts the hem of her garment to reveal tattoos on her leg, and both she and her companion on the right have tattoos on their necks as well.

Thracian domestic slaves carrying water from public fountains would have been a common sight in Athens in the fifth century BC, and contemporary vase painters often noted the contrast between Athenian women and their servants.[2] Athenians were well aware of the tattoos worn by Thracian women, but they had various views of the significance of the markings.[3] Herodotus claimed that in Thrace tattoos were signs of noble birth,[4] but later sources regarded tattoos as marks of punishment, worn by criminals or, as Plutarch fancifully relates, reminders of the cruelty of the Thracian women who murdered Orpheus (see cats. 10, 11).[5] •JS

1 Plaoutine 1938, III.I.D.37–38, plates 50.3–6 (635); Beazley 1963, 1:506, no. 29.
2 Oakley 2000, especially 242, fig. 9.9, for this vase; for Thracian slaves in Athens, see Rosivach 1999, 155–56.
3 Zimmermann 1980a, esp. 194–95, figs. 31a–d, for this vase; Tsiafaki 2015; Huf 2018, 81–114, and 109, 257–58, no. 19, fig. 41.1–5, for this vase; Tsiafaki 2000, 373–74.
4 Herodotus, *Histories* 5.6.
5 Plutarch, *De sera numinis vindicta* 557D.

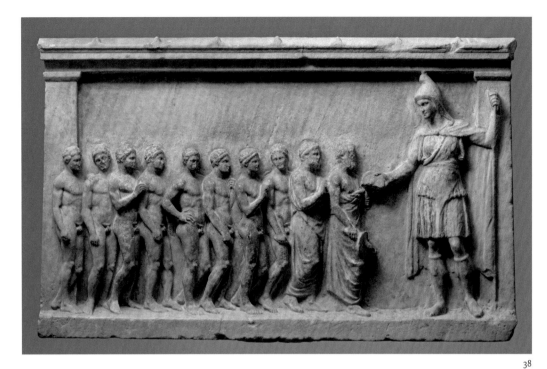

38

38

Votive Relief for Bendis

Greek, made in Athens,
ca. 350–325 BC
Marble
52.1 × 83.8 × 13 cm
London, British Museum, 1895,1028.1

Presumably found in Piraeus, the port of Athens, this marble relief is in a format typical of Classical-era votive reliefs from Attica.[1] Within the architectural frame of a *naiskos* with a flat roof, a group of ten male worshippers approach the figure of a goddess to the right. From her garments she can be recognized as Bendis, a Thracian goddess equated with—but not identical to—the Greek Artemis. She wears a sleeved tunic, an animal skin (*nebris*) tied on her left shoulder, and a long mantle (*zeira*) that is clasped at the neck and falls from the shoulders down her back. Shod with high fawn-skin boots (*embades*), Bendis also sports the *alopekis*, a soft cap made from fox skin that is a signature attribute in Greek depictions of Thracians (see, for example, cat. 10). A goddess of hunting and war, she is leaning on a spear. With her face inclined toward the throng of worshippers, she holds a *phiale* in her outstretched right hand, an iconographic inversion that signified a

divinity as receiving—rather than offering—sacrifices.[2]

The group of mortals standing in front of Bendis is led by two bearded men dressed in *himatia*. The first is holding a torch in his lowered right hand, while the second raises his open hand in the gesture of adoration. Following them are eight naked young men, each with a fillet in his hair. They represent athletes and are led by an older man who holds a torch, indicating that they are the participants in a torch race, or *lampadephoreia*. The relief shows them at the race's conclusion paying respect to the goddess. The man with the torch can be identified as the gymnasiarch, an officer elected annually in Greek poleis, who, among other duties, bore all expenses for torch races and was responsible for the training of his phyle's competitors.

In the famous opening scene of the *Republic*, Plato gives an eyewitness account of Socrates attending the very first celebration of the Bendideia, a festival for Bendis held in Piraeus.[3] Socrates mentions two processions, in which Thracian and Athenian devotees marched separately to the goddess's sanctuary. "The one put on by the Thracian contingent," he says, "seemed no less impressive." Socrates and his party are about to return to Athens when they are made aware of another spectacle. "Are you

telling me that you don't know," Adeimantus added, "that there is to be a torch race on horseback this evening in honor of the goddess?"[4] They decide to stay, and it is this nighttime torch race or, rather, a subsequent edition of it, that is reflected in the votive relief.

The cult of Bendis, a foreign goddess, was officially established in Athens in the later fifth century BC, likely as an act of diplomacy, when the Athenians were intent on cultivating alliances with the Odrysian rulers just before the Peloponnesian War.[5] A sanctuary of Bendis, located on the Munychia Hill in Piraeus, is included in a list of state cults from 429/428 BC.[6] One hundred years later, a document relief (dated 329/328 BC, now in Copenhagen) was set up in the temple of the goddess with a depiction of Bendis very similar to that in the votive relief.[7] Both reliefs would therefore have been created in the same period and may also reflect the appearance of the goddess's cult statue.[8] •JMD

1 A. H. Smith 1904, no. 2155; Gočeva and Popov 1986, 96, no. 3*; Edelmann 1999, 125–26, 222, no. G 25; Tsiafaki 2000, 386–68, fig. 14.10; True et al. 2004, 13, no. 76.
2 See Simon 2016.
3 Plato, *Republic* 327a–328a, as translated in *Republic* 2013, 3, 5. On the Bendideia and the festival's origins, see Sears 2013, 149–56.
4 Translation after Plato 2013, 3, 5.
5 On the cult of Bendis in Athens, see Pache 2001; Deoudi 2007; Janouchová 2013.
6 *IG* I², 310; *IG* II², 1283. For the Piraeus sanctuary, see Papadakis 1937.
7 Copenhagen, Ny Carlsberg Glyptotek, 462: Moltesen 1995, 138–41, no. 73; *IG* II², 1256.
8 The same iconography was also adopted for an image of the youthful Dionysos, best exemplified by the Hope Dionysos (New York, The Metropolitan Museum of Art, 1990.247): Pochmarski 1974, 69–72; Waywell 1986, 72–73, no. 6, plate 49, 1.

COINS OF THE THRACIAN TRIBES AND THE ODRYSIAN KINGDOM

VII.

Precious metal has been used as a highly valued medium of exchange since the Bronze Age, and the abundant deposits of gold, silver, and bronze in southern Thrace and Macedonia were exploited at an early date.[1] Coinage, however, was a much later innovation, first introduced in the regions of Lydia and Ionia, in Asia Minor, in the late seventh century BC with issues in electrum (an alloy of gold and silver) and then widely used throughout Greece beginning in the second half of the sixth century BC. Silver was the primary metal for Greek coinage until the Hellenistic period and served both for local commercial transactions and long-distance trade. Cities with access to silver mines or otherwise skilled in international commerce appear to have been the most active in minting coins.

Greek cities in Thrace and Macedonia, as well as local tribes, issued coins, often in significant quantity and large denominations.[2] Greek inscriptions on the coins name various tribes, including the Derrones, Oreskioi, Edonoi, Bisaltai, Tyntenoi, and Laiaioi. Their ethnicity (variously termed Thracian, Macedonian, or Paionian) is difficult to determine, as is their geographic location. Most appear to have controlled territory close to the north Aegean coast, both west and east of the Strymon River, in proximity to the silver mines. It is unclear how the presence of the Persians in Thrace in the period 513–478 BC influenced the issuance of coinage or whether tribute in coinage was required, but it is likely that the largest numbers of tribal coins were struck in the period 470–450 BC, after the withdrawal of most Persian forces following the defeats in Greece.

The tribal coinage ceased around the middle of the fifth century BC, perhaps because of the increasing power of the Macedonian kingdom under Alexander I (497–454 BC), who appears to have taken control of many of the mines.[3] Greek cities in Macedonia continued to strike silver coins in the later fifth and fourth centuries BC, but only a few in Thrace did so, the most prolific being Abdera, Ainos, Maroneia, and Thasos. Also by the mid-fifth century BC, the Odrysian kingdom became the predominant power in Thrace, its territory reaching from Abdera to the Danube, but despite their considerable wealth (Thucydides states that King Seuthes I collected four hundred talents of silver in tribute each year), the Odrysian kings struck only a limited number of coins for local use.[4] They are, however, notable for their royal imagery, and some bear remarkable portraits. The quantity of coinage diminished in the Hellenistic period and was irregularly issued until the final annexation of the region by the Romans around AD 46.[5] •JS

1 See Popov in this volume.
2 For a concise overview, see Kraay 1976, 131–60; also Price 1987; Wartenberg 2015.
3 Herodotus (*Histories* 5.17) states that the silver mines near Lake Prasias yielded a talent of silver a day for Alexander I.
4 For the extent of the Odrysian territory and its wealth, see Thucydides, *History of the Peloponnesian War* 2.97.1–3; for its coinage, see Yurukova 1992; Topalov 1994; Peter 1997.
5 For an overview, see Paunov 2015.

39

Coin of Abdera

ca. 520 BC
Silver octadrachm
Private collection
Not in exhibition

Obverse: Griffin seated left, with one
foreleg raised
Reverse: Quadripartite incuse square

Abdera, located on the north Aegean coast
facing the island of Thasos, was an early
Greek settlement in Thrace. Colonists from
Klazomenai, in Ionia, had attempted to live
there in the mid-seventh century BC but
were driven away by the local inhabitants.
The site was reoccupied around 545 BC by
Greeks from Teos fleeing the Persian inva-
sion of Ionia, and it flourished thereafter.[1]
Abdera issued an extensive series of coins
beginning around 520/515 BC, including
large-denomination octadrachms; it was the
only Greek city in the region to do so.[2] Coins
of Abdera circulated widely and have been
found in hoards in Egypt and Syria, where
Greek silver was much in demand. •JS

1 Graham 1992.
2 May 1966, esp. 1–4; Kagan 2006;
 Chryssanthaki-Nagle 2007.

40

Coin of the Bisaltai

ca. 465 BC
Silver octadrachm (or tristater)
Wt: 27.43 grams
London, British Museum, 1866,1201.969
Not in exhibition

Obverse: A young man wearing a *petasos*
cap and holding two spears leads a horse;
around, the inscription CIΣAΛTIKON,
"(coin of) the Bisaltai"
Reverse: Quadripartite incuse square

The Bisaltai, the Thracian tribe most often
cited in Greek literary sources, were noted
for being Athenian allies. Herodotus records
that the king of the Bisaltai blinded his sons
for siding with Xerxes and that Pericles later
sent a thousand Athenian settlers to live
with the tribe in Thrace.[1] The large number
of surviving octadrachms datable to the
460s BC, including the one shown here,[2]
suggests that the tribe controlled the silver
mines near Lake Prasias, which were later
taken by Alexander I of Macedon.[3] •JS

1 Herodotus, *Histories* 8.116; Plutarch, *Pericles* 11.5.
2 Head 1879, 140, no. 2.
3 Fried 1987, 1–2, plate 1.1–4; Kagan 1987, 24–25.

41

Coin of Getas, King of the Edonoi, 475–465 BC

Silver octadrachm (or tristater)
Diam: 3.2 cm; Wt: 28.6 grams
Private collection
Not in exhibition

Obverse: A herdsman wearing a *petasos*
cap leads two oxen; around, the inscription
(retrograde) NOMIΣMA EΔONEON
BAΣIΛEOΣ ΓITA, "Coin of Getas, King of
the Edonoi"
Reverse: A wheel within an incuse square

Contemporary with the coinage of the
Bisaltai are octadrachms bearing the name
of Getas, king of the Edonoi, a figure not
otherwise attested in Greek historical
sources.[1] The territory of the Edonoi was
located in the lower Strymon region near
Mount Pangaion. Although the king is
unknown, the Edonian tribe was familiar to
the Greeks in myth as the people ruled by
King Lykourgos and in historical times as a
tribe hostile to the Greeks. Aristagoras, the
leader of Miletos in Ionia and a principal
instigator of the Ionian Revolt against Persia
(499–494 BC), fled to the settlement of
Myrkinos in Edonian territory but was killed
by them there.[2] In 465 BC the Athenians sent
ten thousand settlers to another town of the
region, Ennea Hodoi (the Nine Roads, later
called Amphipolis), but on advancing inland,
they were massacred by the Edonoi.[3] •JS

1 Kraay 1976, 139, plate 26, 483 (a coin in the British
 Museum from the same dies as this example);
 Tacheva 1998.
2 Herodotus, *Histories* 5.124–26; Thucydides, *History
 of the Peloponnesian War* 4.102; Diodorus Siculus,
 Biblioteca historica 12.68.1–2.
3 Herodotus, *Histories* 9.75 (who says the battle was
 for the gold mines); Thucydides, *History of the
 Peloponnesian War* 4.102; Diodorus Siculus,
 Biblioteca historica 12.68.2; Pausanias, *Description
 of Greece* 1.29.4.

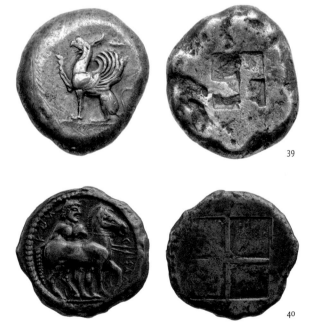

39

40

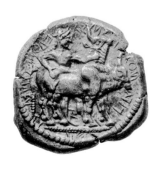

41

42

Coin of Sparadokos, 430–424 BC

Silver tetradrachm
Wt: 16.94 grams
London, British Museum, 1890,0504.2
Not in exhibition

Obverse: A horseman wearing a cloak and holding two spears rides left
Reverse: An eagle and the inscription ΣΠΑΡΑΔΟΚΥΣ, "Sparadokos," within a square incuse

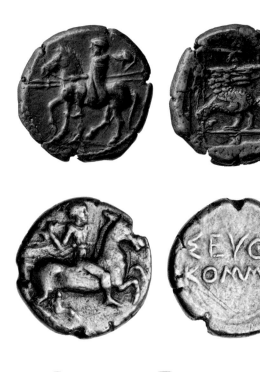

By the mid-fifth century BC, Teres I, followed by his son Sitalkes (ca. 450–424 BC), established the Odrysian dynasty as rulers of Thrace.[1] Neither king minted coins, and the earliest issues of the Odrysians, like this example,[2] bear the name of Sparadokos, who is known to have been the father of Seuthes I (424–ca. 405 BC), the successor to Sitalkes. Sparadokos was likely a son or son-in-law of Teres, but there is no evidence that he was ever king.[3] He probably served as governor of a region within the Odrysian territory. •JS

[1] Archibald 1998, 102–7; Zahrnt 2015, 40–42.
[2] Yurukova 1976, 15–16, 68, nos. 15, 16, plate 27; Peter 1997, 62–75.
[3] Thucydides, *History of the Peloponnesian War* 2.101.5. See Tzvetkova in this volume.

43

Coin of Seuthes I, 424–ca. 405 BC

Silver didrachm
Diam: 2.1 cm; Wt: 8.9 grams
New York, The American Numismatic Society, 2011.21.540
Not in exhibition

Obverse: Armed horseman galloping right
Reverse: The inscription ΣΕΥΘΑ/ ΚΟΜΜΑ, "coin of Seuthes"

King Seuthes himself is likely shown on horseback on this coin.[1] Like his father, Sparadokos, Seuthes issued smaller-denomination coins as well. •JS

[1] Yurukova 1976, 13–14 (as Seuthes II), 70, no. 27, plate 27; Peter 1997, 76–83; Russeva 2016; Wartenberg 2021, 51–54, fig. 9.

44

Coin of Saratokos, ca. 410–384 BC

Silver obol (or trihemiobol)
Diam: 0.9 cm; Wt: 0.86 grams
Private collection
Not in exhibition

Obverse: Head of Saratokos right
Reverse: Bunch of grapes on a vine; the inscription ΣΑΡ, "Sar(atokos)"

The Thracian ruler Saratokos is known only from a series of small silver and bronze coins that bear his name.[1] The portrait of the long-haired, beardless ruler is unusual and with no close parallel, although Achaemenid satrapal portraits begin to appear at this time as well and may have served as a model. •JS

[1] Yurukova 1976, 16, 70, nos. 28, 29, plate 5; Peter 1997, 99–104.

45

46

45

Coin of Kotys I, ca. 384/383–360 BC

Silver obol (or trihemiobol)
Diam: 0.9 cm; Wt: 0.88 grams
Private collection
Not in exhibition

Obverse: Bearded head of Kotys left
Reverse: Two-handled cup; around, the
inscription KOTY, "Kotys"

Kotys I, depicted on the obverse of this
coin,[1] was an aggressive ruler of Thrace,
seizing the Thracian Chersonese and coming
into conflict with both the Persians and
the Athenians; two Greek brothers from
Ainos assassinated him in 360 BC, probably
at the behest of Athens.[2] The kingdom
had considerable wealth, which is attested
by the discovery of inscribed silver ves-
sels (cats. 51b, 51c, 60a), but the issues of
coinage were modest, confined to small
silver and bronze coins. •JS

1 Yurukova 1976, 17, 71–72, nos. 37, 38, plate 7;
 Peter 1997, 112–25.
2 Archibald 1998, 220–22; Zahrnt 2015, 44–45.
 See Tzvetkova in this volume.

46

Coin of Seuthes III, ca. 330–300/295 BC

Bronze
Diam: 2.0 cm; Wt: 4.84 grams
Private collection
Not in exhibition

Obverse: Bearded head of Seuthes right
Reverse: Horseman right; around, the
inscription ΣΕΥΘΟΥ, "(coin) of Seuthes"

Seuthes III issued only small bronze coins,
including some examples, like this, with his
own portrait in fine style.[1] It is remarkably
similar to the bronze portrait head discov-
ered by his tomb (cat. 53). •JS

1 Yurukova 1976, 23, 76–77, nos. 68–74, plates 11, 68,
 72; Peter 1997, 172–202 (see 184 for this die).

THE THRACIAN ELITE AND THEIR TOMBS

VIII.

For the ancient Greeks, the archetype of the Thracian ruler, rich beyond measure, was set by the Homeric *Iliad* and its portrait of King Rhesos, with his chariot "cunningly wrought with gold and silver," and "armour of gold...huge of size, a wonder to behold" (*Iliad* 10.438–39, as translated in *Iliad* 1924, 469). Archaeologists have discovered nothing of such an early date, but the fifth century BC has yielded imposing finds in the burial mounds of the Thracian nobility, undoubtedly related to the rise of the Odrysian kingdom.

Best known are the tumuli of the sprawling necropolis of Duvanlii-Chernozemen, in the western part of the Thracian plain, but the trend extended to the larger territories to the east and the north. Aristocratic men were buried with their insignia, gold pectorals, and finger rings, and panoplies—bronze cuirasses and helmets, iron swords and spears—emphasized their prowess as warriors. Banquet sets of silver and bronze vessels promised an afterlife of blissful merriment. Noble women wore in death their elaborate adornments. There was an apparent taste for luxury goods from the Greek world, and the actual presence of Greek artisans may be presumed.

In the fourth century BC these simple sarcophagus-like tombs gave way to more complex structures, and the corbeled dome was adopted as the trademark of Thracian funerary architecture, culminating in majestic structures. Later fourth-century BC tombs, concentrated in the Kazanlak Valley, often used and combined elements of the Greek architec-

tural orders in manners that would have been unthinkable in Greece. There are also unique designs like the Ostrusha and Golyama Kosmatka Tumuli, which share a monolithic sarcophagus-like burial chamber as their central feature. The Macedonian expansion and the closer inclusion in the Hellenistic world brought to Thrace the barrel-vaulted tomb, which was remodeled to meet local preferences, as illustrated by the Caryatids Tomb at Sveshtari.

Almost all monumental tombs were discovered plundered, the one of Seuthes III in Golyama Kosmatka a spectacular exception. Other aristocratic burials, some of them in faraway corners of Thrace—Mogilanskata Tumulus; Golyamata Tumulus, near Zlatinitsa; and Agighiol—also offer a glimpse of the treasures buried with high-ranking Thracians, including gilded-silver ceremonial armor decorated with striking imagery created by north Thracian workshops. Sets of horse trappings became almost mandatory grave goods—most often of silver in a distinctive Animal Style but also of gold in the early third century BC, combining Thracian and Greek motifs. Horses and carts accompanied the noble dead in the afterlife.

After a peak in the Early Hellenistic period, these lavish funerary practices seemingly faded away, possibly due to the changing historical backdrop and the political fragmentation of Thrace. Some traditions remained alive until Roman times, however, when rich tumuli with buried carriages and horses reappeared. •MD

47
THE BASHOVA TUMULUS

Excavated near Duvanlii, Plovdiv Province, Bulgaria, in 1929

The burial of the aristocratic warrior in the Bashova Tumulus is among the richest not only in the Odrysian necropolis of Duvanlii-Chernozemen but also in all of fifth-century BC Thrace. The structure was a rectangular chamber built of stone slabs and covered with wooden beams. Armor, weapons, and banquet vessels are especially well represented. Items include a bell-shaped cuirass, two iron spearheads, a scabbard(?), and forty bronze arrowheads. The silver vessels—including the decorated and gilded *phiale*, *kylix*, *rhyton*, and mug of Pheidias type—were all placed in a bronze *lekane*. Further vessels deposited in the tomb include a bronze situla, a one-handled cup, and a hemispherical vase, along with a black-glaze Pheidias mug and two Attic red-figure *hydriai*.[1]

A gold pectoral was placed on top of the bronze cuirass (cats. 47a, 47b). It has an oval lower edge and a triangular upper edge with a notch in the middle; an embossed decoration to the left depicts a lion with its head lowered, seen from above. The head, the mane, and the shoulder are stylized in a geometric manner. At both ends there are perforations for attachment to a lost base. Until recently it was presumed that the pectoral, attached to an iron plate, was protecting the upper chest in the manner

of the Mezek-type gorget-pectorals (cat. 50).[2] The restoration of the cuirass from the Svetitsata Tumulus revealed, however, that such cuirasses, designated Type II (from Dalboki, Ruets, and the Bashova Tumulus),

while later than the bell-shaped examples of Type I, had a similar construction: with iron strips attached to the edges of the breastplates and backplates.[3] Thus the gold pectoral, attached to a leather base, was

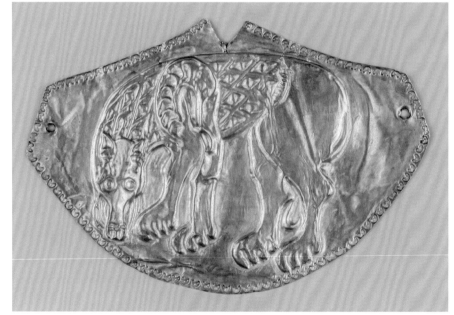

47a

a. Pectoral
ca. 475–425 BC
Gold
9 × 13.8 × 0.2 cm; Wt: 19.62 grams
Plovdiv, Regional Archaeological Museum, 1514

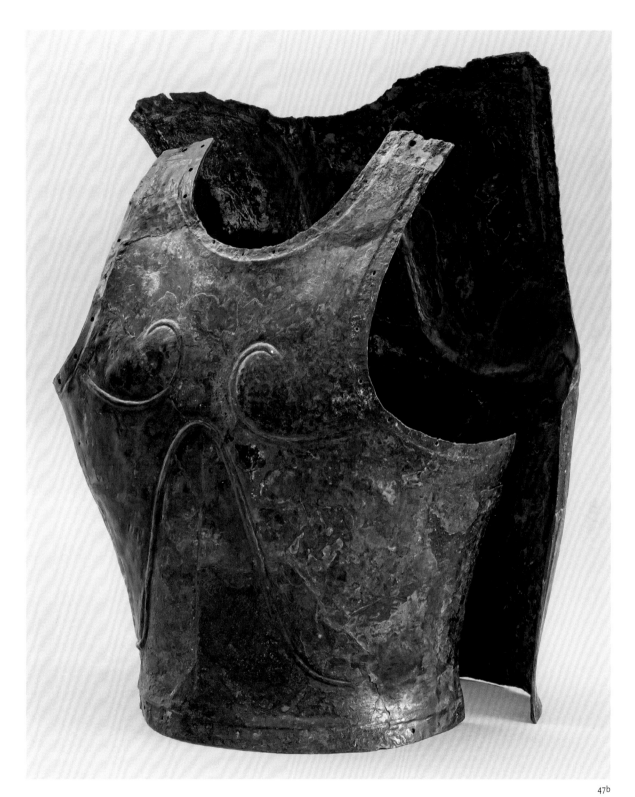

47b

b. Cuirass
ca. 475–425 BC
Bronze and iron
Breastplate: 35 × 33.2 cm;
Backplate: 41 × 33.5 cm; D: 28 cm
Plovdiv, Regional Archaeological Museum,
1524

VIII.

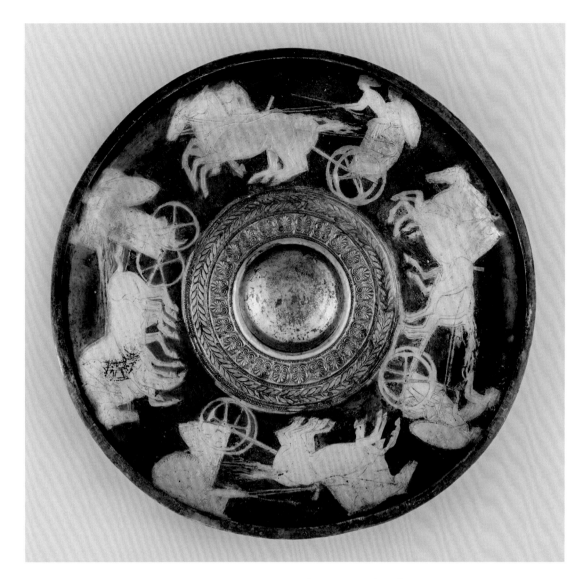

47c

c. *Phiale Mesomphalos* with Chariots
ca. 430 BC
Silver with gilding
H: 3 cm; Diam: 20.5 cm; Wt: 428 grams
Plovdiv, Regional Archaeological Museum,
1515

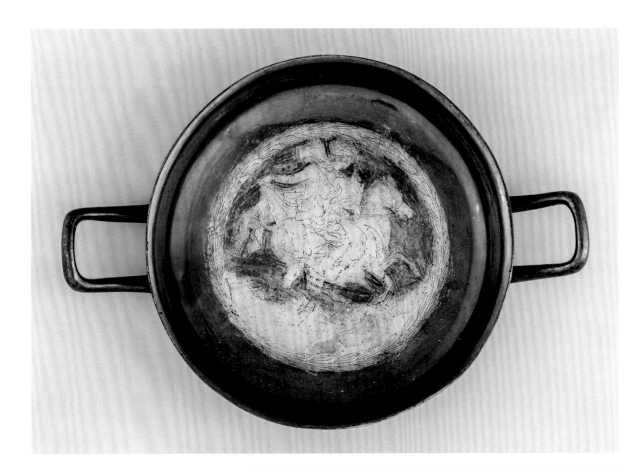

47d

d. *Kylix* with Selene
ca. 425–400 BC
Silver with gilding
H: 3 cm; W with handles: 18.8 cm;
Diam of rim: 13 cm; Wt: 220 grams
Plovdiv, Regional Archaeological Museum,
1516

probably not a functional part of the cuirass but was placed on top of it as a status symbol or perhaps for some ritual purpose.[4]

The placement of the four silver drinking vessels of various shapes in the *lekane*,[5] as well as the deposition of the cremated remains of the deceased in the *phiale*, signify their function for use both at elite banquets and possibly in libation rituals.[6] That they are a set is indicated also by the incised inscription ΔΑΔΑΛΕΜΕ, "Dadaleme," presumably the name of the owner.[7] The *phiale* is of typically Greek shape and proportions, with smooth body and decorated

interior (cat. 47c). Around the omphalos, there are two concentric bands—one of lotuses and palmettes within a laurel wreath, modeled in low relief and gilded, around which is a circular composition of four quadrigae galloping to the left, each one with a charioteer and an *apobates*, an armed warrior who jumped from the moving chariot in a popular contest. The images are engraved and gilded. The iconography and the execution reveal the exceptional skill of the artisan, and the *apobates* contest, part of the Great Panathenaia, points to an Athenian provenance.[8]

47e

47f

e. **Mug (Pheidias Shape)**
 ca. 450–400 BC
 Silver
 H: 8.4 cm; W with handle: 10.5 cm;
 Diam: 8.7 cm; Wt: 236 grams
 Plovdiv, Regional Archaeological Museum,
 1518

f. **Mug (Pheidias Shape)**
 ca. 450–400 BC
 Terracotta
 H: 13.3 cm; W with handle: 15 cm;
 Diam: 12.5 cm
 Plovdiv, Regional Archaeological Museum,
 1530

The tondo of the silver cup of Attic Rheneia type depicts the moon goddess Selene riding a horse over the sea, represented by a wavy line with fish swimming below (cat. 47d). The scene is enclosed in a laurel wreath. The technique is like that of the *phiale*, and again an Athenian provenance is likely.[9]

Another vessel of Athenian provenance is the silver Pheidias mug, a rare metal version of a well-known ceramic shape (cat. 47e). Presumably it was included in the banquet set together with the black-glaze mug of the same type (cat. 47f).[10] The latter is of larger dimensions and probably belongs to a series attested in the Athenian Agora.[11]

The *rhyton* with a protome of a galloping horse is probably the earliest of this type and certainly one of the most elegant (cat. 47g). The horn is long, gradually narrowing and curving toward the joint with the protome. The rim is turned out and downward, decorated with a bead-and-egg motif. A wide band follows, decorated with engraved and gilded palmettes and lotuses. The vertical fluting below reaches to a smooth band on the end of the horn. The rear end of the protome is inserted in the horn and is delimited by a row of beads. The protome is cast and realistically depicts a galloping horse, with incised details on the legs, neck, head, and mane, as well as

on the wide breast strap. The spout for pouring wine is in the middle of the breast. Between the ears the mane is shaped as a large lock, which is thrown back. The mane, the strap, the hoofs, the decorative band, and the rim are gilded.[12]

Some scholars consider the *rhyton* to be a product of an Athenian workshop as well.[13] It should be noted, however, that no *rhyta* have been positively related to workshops in mainland Greece, and no metal *rhyta* are known from banquet sets from Macedonia.[14] Such vases are known to have been made in workshops in the Propontic region and Asia Minor, and their production is attested in Thrace at a later date. The design of the

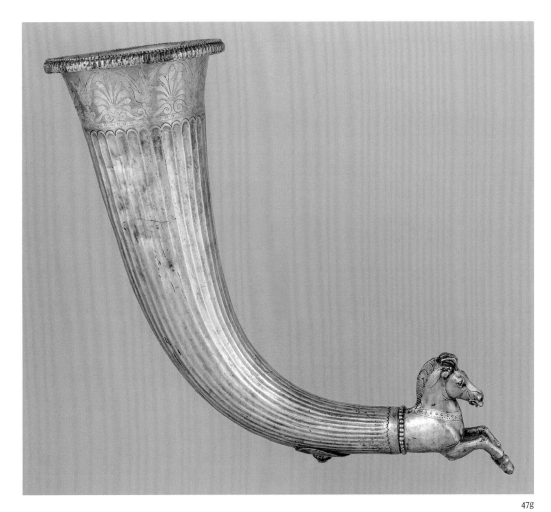

47g

g. ***Rhyton* with Horse Protome**
ca. 425–400 BC
Silver with gilding
H: 22.5 cm; W: 20.2 cm; Diam of rim:
8.4 cm: Wt: 400 grams
Plovdiv, Regional Archaeological Museum,
1517

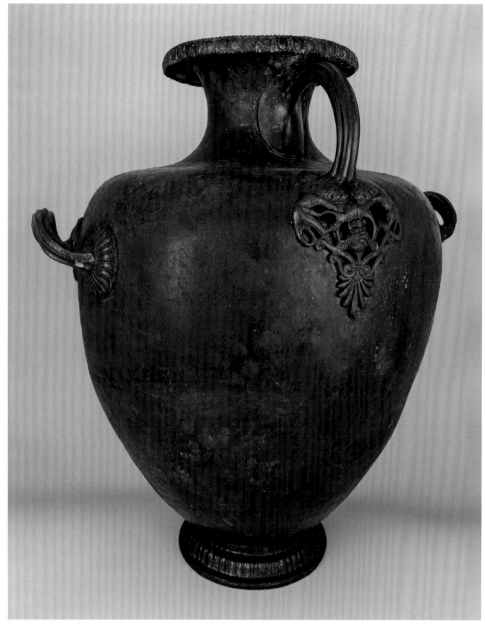

47h

h. *Hydria*

ca. 450–400 BC

Bronze

H: 42 cm; W with handles: 38 cm;
Diam: 30.5 cm

Plovdiv, Regional Archaeological Museum,
1519

lotus-and-palmette band and the gilding of
some details of the *rhyton* from the Bashova
Tumulus also point to this general region.
The specific treatment of the protome's
rear end could indicate a possible center:
Maroneia, on the north Aegean coast. From

the late sixth until the mid-fourth century
BC, its coins feature on the obverse a
protome of a galloping horse, ending in
a beaded border on some issues, very much
like the *rhyton*. On some coins from the
late fifth and especially the early fourth
century BC (ca. 398–385 BC), a large lock
is visible above the forehead, and on the
reverse of some issues from this period,
there is a deer-protome *rhyton* with long
horn (a magistrate's device?).[15] The fact that
such details were featured on the tiny scale
of coins suggests that the engravers were
depicting actual objects.

The bronze *hydria* is similar, in terms
of shape and proportions, to the vases with
Sirens at the base of the vertical handle
that were popular in Thrace, but in this case,
there is a composition of a Silenos head in
the center and above it two lions attacking a
deer (cat. 47h). A palmette with volutes is
added below.[16]

The mythological scene on the Athenian
red-figure *hydria*,[17] attributed to the Kadmos
Painter,[18] has been the subject of various
interpretations (cat. 47i). The composition
is believed to present the meeting of Paris,
Helen, and Aeneas, which is plausible in

i. **Red-Figure** *Hydria*
 Greek, made in Athens, attributed to
 the Kadmos Painter, 430–420 BC
 Terracotta
 H: 45.5 cm; W with handles: 42 cm;
 Diam: 31
 Plovdiv, Regional Archaeological Museum,
 1527

light of the scene on the shoulder of the
vase, widely accepted as the *theoxenia*
of the Dioskouroi, that is, their presence at
the banquets of the gods. Placing a *hydria*
with this mythological scene in the burial
of an Odrysian nobleman could suggest a
connection between the vase's pictorial
program, eschatological beliefs in ancient
Thrace, and the presumed heroization of
the aristocratic warriors.[19]

In a ritual pit above the burial structure,
a fragmentary red-figure *pelike* dating to
about 400 BC was discovered,[20] providing
a *terminus ante quem* for the burial itself.
•TS

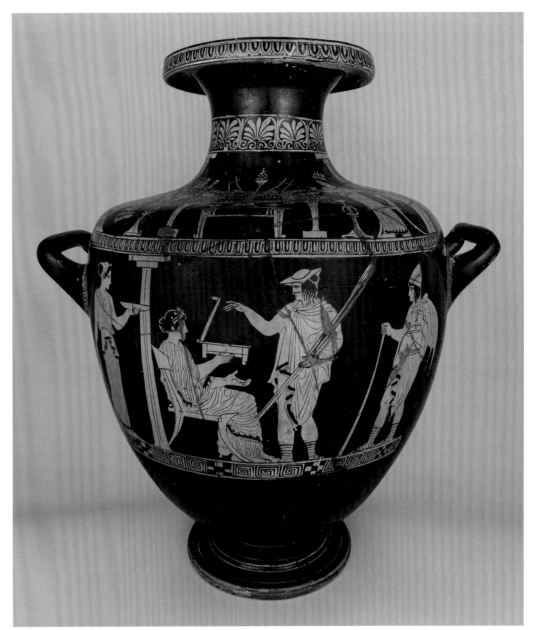

47i

1 Filov 1934a, 62–79, figs. 79–100, plates IV–VI, XIV,
 XV; Marazov 1998a, 187, no. 124 (*rhyton*); K. Kisyov
 in Martinez et al. 2015, 238–43, nos. 196–201;
 E. Penkova in E. Penkova, Konova, and Kisyov
 2017, 118–25, nos. 117–23. The hemispherical
 vessel is the earliest among seven such vases
 from Thrace and most probably served as a
 psykter.
2 Ognenova-Marinova 1961, 527–35.
3 Zlateva et al. 2023, 2–5, figs. 6, 7.
4 Archibald 1998, 172, 198–99.
5 Mutafchieva 2018, 19, 36.
6 The *rhyton* and the *phiale* could be used for
 libations.
7 Filov 1934a, 63–65, fig. 80, plate IV.
8 Vickers and Gill 1994, 40–41, 131, figs. 2.2, 5.22,
 5.23; Archibald 1998, 178; Sideris in this volume.
9 Filov 1934a, 62–65, 209–10, figs. 81, 82, plate V;
 Archibald 1998, 177. Another proposed identifica-
 tion of the figure is as one of the Hesperides:
 Venedikov and Gerasimov 1975, 98, 372.
10 Filov 1934a, 67, 79, figs. 84, 100; Vickers and
 Gill 1994, 119–22, figs. 5.14, 5.15.
11 Sparkes and Talcott 1970, 73, 250, no. 204,
 plate 11.
12 Filov 1934a, 67, 210, fig. 83, plate VI; Marazov 1978,
 30–35, plates 23, 24.
13 Strong 1966, 75, 86; Reho and Ilieva 2006, 91.
14 See Zimi 2011.
15 Schönert-Geiss 1987, periods II–IV, plates 2–4;
 period VII, plates 13, 14, nos. 273–301 (*rhyton*).
16 Filov 1934a, 67–68, figs. 85, 86.
17 Filov 1934a, 73–79, figs. 95–99, plate XIV.
18 Reho 1990, 156, plates XXXXIV, XXXXV.
19 Reho 1989, 13–14, figs. 5–7.
20 Reho 1990, 156.

48

MUSHOVITSA TUMULUS

Excavated near Duvanlii, Plovdiv Province,
Bulgaria, in 1930

The princely necropolis at Duvanlii, investi-
gated in the 1930s, is the most significant
of the Thracian sites of the fifth century BC,
located in what is thought to be the most
important settlement center of the Odrysian
kingdom at the time of its rise to power.
The necropolis consists of some fifty tumuli,
three of which—Kukova, Mushovitsa, and
Arabadzhiiska—are notable for their lavish
finds of gold adornments. Because of the
absence of weapons and armor, the tombs
are believed to be burials of noble Thracian
women.[1]

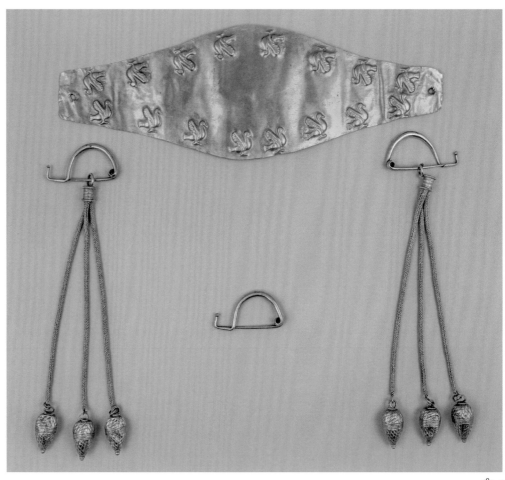

48a–c

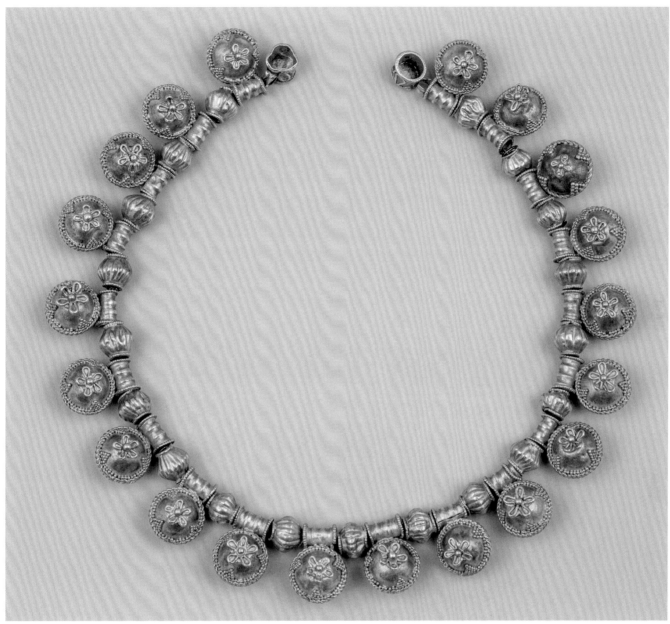

48d

a. **Pectoral**
Mid-5th century BC
Gold
8.6 × 25.8 × 0.6 cm; Wt: 65.5 grams
Plovdiv, Regional Archaeological Museum,
1531

b. **Three Fibulae**
Mid-5th century BC
Gold
H: 2.5 cm; W: 4.7/4.8/4.9 cm;
Wt: 13.1/13.5/14.4 grams
Plovdiv, Regional Archaeological Museum,
1532

c. **Two Chains with Pendants**
Mid-5th century BC
Gold
H: 19/19.3 cm; Wt: 51.8/51.9 grams
Plovdiv, Regional Archaeological Museum,
1533

d. **Necklace**
Mid-5th century BC
Gold
Diam of assembled necklace: 13 cm;
D: 1 cm; Wt: 91.1 grams
Plovdiv, Regional Archaeological Museum,
1534–1536

The Mushovitsa Tumulus, excavated in 1930, was four meters high and thirty-two meters in diameter. A rectangular pit under the center of the mound contained the body, which was placed in a wooden coffin and accompanied by a rich inventory of objects.[2] Exquisite gold adornments found in the tomb include a chest parure comprising a pectoral held by fibulae with chains ending in pendants (cats. 48a–48c), a necklace of two types of beads (cat. 48d), a set of ten hoop earrings (cat. 48e), and two omega-shaped pendants (cat. 48f). The banquet set comprises a silver *phiale* (cat. 48g), a bronze

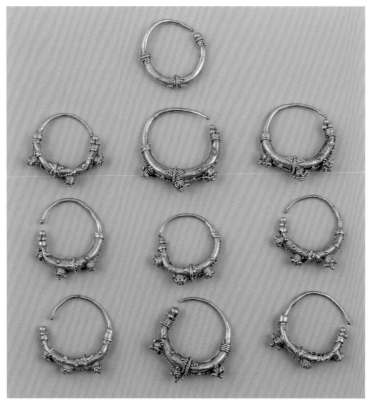

48e

e. **Ten Hoop Earrings**
Mid-5th century BC
Gold
Diam: 2.7–3.2 cm; D: 0.8 cm;
Wt: 7.3–9.9 grams
Plovdiv, Regional Archaeological Museum,
1537

f. **Two Omega-Shaped Pendants**
Mid-5th century BC
Gold
3.6 × 4.2 × 0.7 cm; Wt: 26.1/26.4 grams
Plovdiv, Regional Archaeological Museum,
1538

48f

g. *Phiale*
Early 5th century BC
Silver
H: 4.6 cm; Diam of rim: 11.7 cm;
Wt: 428 grams
Plovdiv, Regional Archaeological Museum,
1539

48g

h. Black-Figure Amphora
Greek, made in Athens, attributed to
the Troilos Painter, ca. 470 BC
Terracotta
H: 42.2 cm; Diam: 26 cm
Plovdiv, Regional Archaeological Museum,
1544

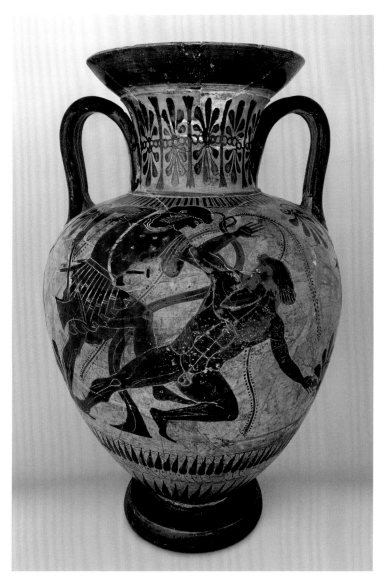
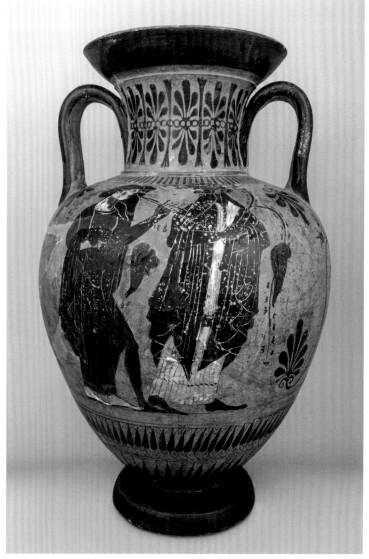

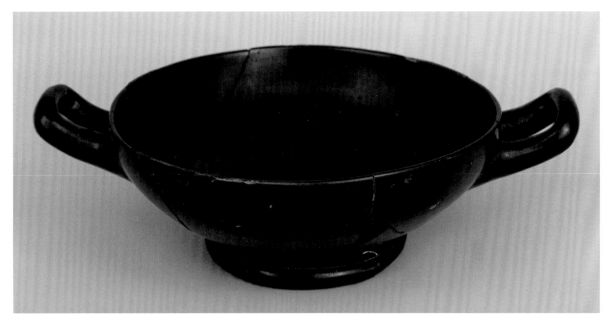

48i

48j

i. **Black-Glaze** *Kylix*
Greek, made in Athens,
mid-5th century BC
Terracotta
H with handles: 6 cm; W with handles:
20.7 cm; Diam of rim: 14.9 cm
Plovdiv, Regional Archaeological Museum,
1545

j. **Three** *Oinochoai*
Mid-5th century BC
Glass
H with handle: 11.3/12.3/13 cm;
W with handle: 7.7/7.4/7.2 cm
Plovdiv, Regional Archaeological Museum,
1549

k. Two *Alabastra*
Mid-5th century BC
Alabaster
H: 14/14.6 cm; Diam: 4.5/4.8 cm
Plovdiv, Regional Archaeological Museum,
1550

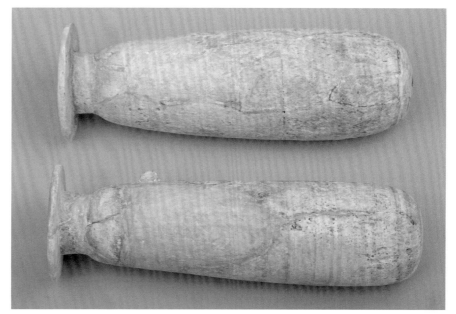

48k

l. Stemmed Vase (*Lydion*)
Mid-5th century BC
Terracotta
H: 15 cm; Diam: 12.5 cm
Plovdiv, Regional Archaeological Museum,
1547

hydria, an Athenian black-figure amphora
depicting Theseus and Prokrustes on one
side and Dionysos with a satyr and a maenad
on the other (cat. 48h), a black-glaze cup
(cat. 48i), and a Chian transport amphora.
There were also a bronze mirror, three small
glass *oinochoai* for perfume (cat. 48j), and
as many as seven *alabastra* (cat. 48k); a
grayware vase has been interpreted as a
type of perfume container known as a *lydion*
(cat. 48l).[3] There were also glass beads
and miniature objects of agate, amber, and
terracotta,[4] perhaps with a magical function.
Their presence served to identify the
deceased as a Thracian priestess.[5] A terra-
cotta female bust with disk-shaped Archaic
earrings is a type known from Greek cities
and necropoleis in central Macedonia but
unique for the Thracian interior (cat. 48m).[6]
This collection of luxury objects was prob-
ably accumulated over the first half of the
fifth century BC, as indicated by the Achae-
menid *phiale* from the beginning of the
century,[7] the bronze *kalpis* of the same date,
and the black-figure amphora attributed
to the Troilos Painter dated about 470 BC.[8]
The latest item is the black-glaze cup from

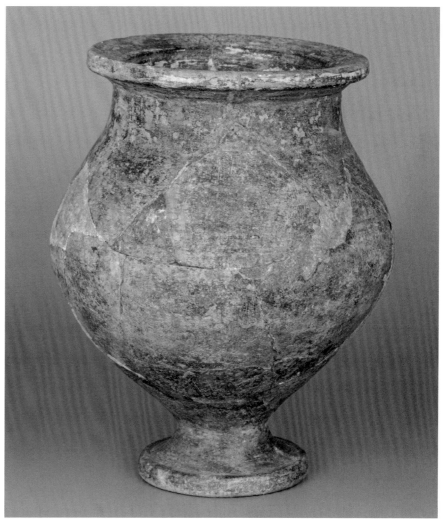

48l

m. Female Bust
Mid-5th century BC
Terracotta
11.2 × 7 × 4.2 cm
Plovdiv, Regional Archaeological Museum,
1543

about the middle of the fifth century BC, suggesting the date of the burial.[9]

The most spectacular of the grave goods are the gold adornments, executed in the same style and apparently designed as a set. Although of types that are known from Greece, their presence in the grave of a noble Thracian woman displays certain peculiarities. The hollow hoop earrings, decorated with filigree and granulation as well as applied rosettes, belong to a popular type, but they were usually worn as a pair, and the discovery of ten in a single grave is quite unusual and might be explained as the objects having a modified function. Presumably they were not worn as earrings but were part of a parure that also included the omega-shaped pendants ending in small pyramids of fine granulation (which are also a variety of earring). The excavator, Bogdan Filov, who observed the skeleton, suggested they were worn not at the ears but as a head ornament in the form of a chain that ran above the forehead and down at the temples, ending in omega-shaped pendants.[10] The contemporaneous burial in the Kukova Tumulus contained an identical set of ten hoop earrings and two pendants. In the slightly later Arabadzhiiska Tumulus, a similar combination of six boat earrings and two spiral-shaped pendants was discovered, again on both sides of the skull. These unique sets are known only in Thrace, suggesting that the Odrysian aristocracy created them as a recognizable insignia, and in fact, in the two following centuries, such parures became widespread throughout the Odrysian territories, although in less lavish versions made of silver and without filigree or granulation.[11]

A necklace was probably composed of alternating gold beads, the larger beads with a spherical body with granulation and a filigree rosette attached to a small tube for threading and the smaller beads biconically fluted.[12] This is a well-known type of Late Archaic and Early Classical Greek jewelry that has prototypes in Macedonia and Greece.[13] The best parallels are again

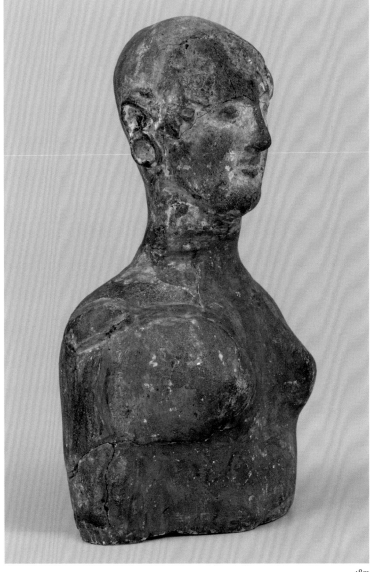

48m

the similar necklaces from the Kukova and Arabadzhiiska burials in the same necropolis, however, and it is likely they were products of the same workshop, perhaps employing Greek artisans who worked for the Odrysian elite.

Also present in the burial was an elliptical gold pectoral with stamped birds along the periphery.[14] Decorated gold plaques of various shapes and designs were found in many rich burials at Duvanlii, and the fact that they were placed on the chest identifies them as pectorals. The custom continued a tradition that was widespread in the Aegean and Macedonia in the Archaic period. Gold pectorals became usual for rich Thracian burials in the fifth century BC

and remained the most typical insignia—a symbol of elevated status and wealth—throughout the Classical period.[15]

The pectoral from the Mushovitsa Tumulus was attached by means of two fibulae. A third one was discovered at the left shoulder and most probably fastened a garment. The fibulae are single-looped and bow-shaped, with a short foot bent at a right angle. They are the earliest examples of this popular type of garment accessory, termed "Thracian," as there are hundreds of Classical and Early Hellenistic finds of this type from Thrace, but these are the only ones made of gold. Fibulae from Olynthos, in Greece, are contemporaneous, indicating that the type's origins can be traced to the

Aegean and the Chalkidike.[16] Three chains
ending in acorn pendants hang from each
fibula. This combination is the earliest
attested in Thrace, again following proto-
types from Macedonia, where such orna-
ments have a long tradition.[17]

The gold adornments from Duvanlii
illustrate the development of Greek jewelry
in the fifth century BC. They may be com-
pared to finds from the littoral of Asia Minor
but have parallels mostly in the Chalkidike
and the necropoleis around the Thermaic
Gulf.[18] The skilled jewelers who crafted the
gold adornments from Duvanlii used this
traditional repertoire to create original
parures that were particular to the Odrysian
aristocracy. Their workshops were located
either in the Greek cities on the Aegean
coast or in the Thracian interior, close
to the Odrysian royal residences.[19] •MT

1 Filov 1934b, 190; Archibald 1998, 158–60. There
 are other hypotheses: see Tonkova 2015, 213, with
 references.
2 K. Kisyov in Martinez et al. 2015, 64–75,
 nos. 16–35; E. Penkova in E. Penkova, Konova,
 and Kisyov 2017, 140–43, nos. 135–41.
3 Stoyanov 2004a, 169.
4 Filov 1934b, 82–97.
5 Archibald 1998, 164.
6 Filov 1934b, 90; Archibald 1998, 164.
7 Archibald 1998, 162.
8 Reho 1990, 154–55, no. 454; Archibald 1998,
 162–63.
9 Archibald 1998, 162.
10 Filov 1934b, 88, 194.
11 Tonkova 1997, 18–20; Tonkova 2015, 213–14.
12 In the grave the fluted beads were discovered
 apart from the rest, above the skull: Filov 1934b,
 86, fig. 108.
13 Archibald 1998, 190.
14 Marazov 1998a, 198, no. 137 (pectoral, fibulae,
 and chains).
15 Filov 1934b, 194–95; Venedikov and Gerasimov
 1973, 103–6; Archibald 1998, 171.
16 Stoyanov 2004a, 170.
17 Amandry 1963, 210.
18 The omega-shaped pendants have good parallels
 in a pair said to be from Kyme: Williams and
 Ogden 1994, 95, no. 47.
19 Tonkova 2000–2001, 281–83.

49

Pair of Snake's-Head Bracelets

Mid-5th century BC
Gold
Diam: 9 cm; Wt: 257.1/298.3 grams
Found in Kukova Tumulus, near the village
of Duvanlii, Plovdiv Province, Bulgaria,
in 1925
Sofia, National Archaeological Institute
with Museum, 6128, 6189

These gold bracelets from the Kukova
Tumulus are solid, with a smooth, open hoop,
round in section and thicker in the middle.
The flat, triangular ends are modeled into
stylized snakes' heads. The details of the
heads are rendered by means of large flat-
tened spheres, smaller globules, and smooth
and twisted wire of rectangular section.
The bracelets were made by casting, forging,
and soldering, with added filigree and
granulation.[1]

This pair represents a later and more
elaborate version of a popular type of the
solid bronze and silver snake's-head brace-
lets typical of northern Greece and most
of Macedonia in the sixth and fifth cen-
turies BC.[2] The solid hoop and the styliza-
tion of the snakes' heads resemble the silver
bracelets from the Chalkidike;[3] from the
necropolis of Demir Kapija, in the valley of
Vardar (Axios);[4] and from a grave at Prilep
(North Macedonia).[5] A similar rendering of
a snake's head is seen on the gold bracelets
from the necropolis at Sindos, dated to
the second quarter of the fifth century BC;
they, however, have band hoops.[6] The large,
flattened globules used for the snakes'
scales are a distinctive feature of the Kukova
mound bracelets, again pointing to proto-
types in Macedonia, where the technique is
observed on various pieces of jewelry.[7] This
pair share the shape of the silver and bronze
bracelets, but the style has evolved. The
distribution of this new variant is limited to
Thrace and the necropolis of Duvanlii.[8] Such
bracelets were probably made by a local
workshop that catered to the Odrysian
elite, re-creating earlier types in a new and
original way.

The bracelets were part of a set of gold
jewelry with a total weight of 1265.4 grams
that includes a head parure of hoops and
omega-shaped pendants, a necklace, a
torque, a pectoral, two finger rings, and
other items.[9] Presumably, such a rich burial
containing numerous pieces of gold jewelry
but no weapons was of a noble Thracian
woman, but other hypotheses have been put
forward.[10] •MT

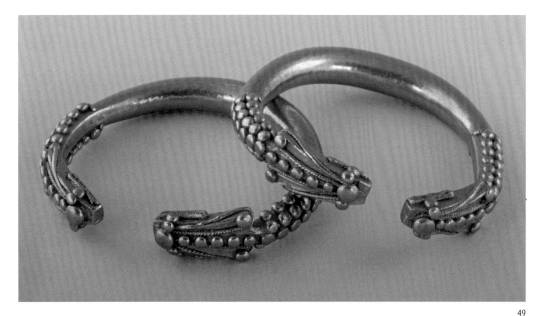

49

1 Filov 1934a, 39–58, 45, no. 9, figs. 51, 52; Venedikov
 and Gerasimov 1973, 102–3, figs. 251, 253; Tonkova
 and Penkova 2009, 202–4, 208, fig. 4, plate 5.
2 Archibald 1998, 192; Tonkova and Penkova 2009,
 204.
3 Amandry 1953, 50–51, nos. 112–19.
4 Ognenova-Marinova 1978a, 991.
5 Garašanin 1952, 268, fig. 1.
6 Despoini 1996, 259, no. 189.
7 Despoini 1996, 224, no. 66; Archibald 1998, 192.
8 There is another pair of gold bracelets in Vassil
 Bojkov's collection (Marazov 2011c, 28, no. 23);
 they lack context, but the style suggests similar
 provenance.
9 Filov 1934a, 39–58; Archibald 1998, 162–64.
10 Filov 1934a, 190; Archibald 1998, 158; Tonkova
 2015, 213. See also cat. 33.

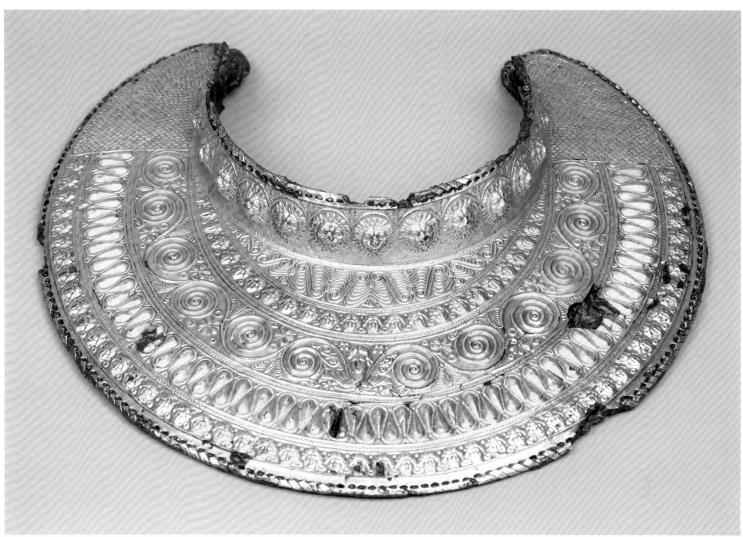

50

Gorget-Pectoral (*Peritrachelion*)

ca. 350 BC
Iron and gilded silver
26.5 × 29 × 4 cm; Diam of opening: 13 cm
Found in the Mal-tepe Tumulus, Mezek,
Haskovo Province, Bulgaria
Sofia, National Archaeological Institute
with Museum, 6401

The pectoral has a semicircular shape with rounded edges and a vertical collar.[1] Preserved at both ends of the collar are parts of the hinges for the two elements (one is partially preserved) that served to clasp the pectoral at the back. The iron base is covered with gilded-silver plate with relief decoration, attached to it by means of a silver band run through holes along the periphery. Traces of fabric and leather are preserved on the lower surface of the pectoral. It was probably worn together with a composite corselet.

The decoration is executed in the repoussé technique by means of punches or a matrix. The collar is decorated with a row of lions' heads, with an arc above each and fernlike palmettes in the spaces between the heads; the space beneath the lions' heads is dotted. The crescent-shaped part is decorated with five concentric bands,[2] which are separated by raised borders with a fishbone pattern. The innermost border consists of fernlike palmettes, alternately turned up and down and separated by S-shaped spirals. The second band consists of schematically rendered facing human heads. The central zone is decorated with wavelike rinceaux springing from an acanthus cup with a female head in the middle. From each coil of the rinceaux, spiral-shaped twigs emerge with a four-petal flower, alternating to the left and right. Fernlike palmettes spring from the offshoots of the twigs. The next band consists of buds alternately turned up and down, and the outermost band is again of human heads. The ends of the pectoral are decorated with a fish-scale pattern with dots in the middle.

The Mezek pectoral is one of thirteen known examples, eight of which were discovered in rich Thracian burials: from Mezek, Varbitsa, Yankovo;[3] the tumuli of Ostrusha, Tsvyatkova, and Golyama Arsenalka, near Kazanlak; Dolno Izorovo; and Dolna Koznitsa.[4] Four others are from Macedonia: examples from Vergina (Tombs II and III), Katerini, and Pydna,[5] as well as one without a documented findspot, now in New York.[6] Their chronology likely spans the period 350–275 BC.

The shape of the pectoral is reminiscent of those made of scales sewn on a leather base but represents another stage in the development of this type of armor. The decoration displays a composite style with elements originating in the toreutic traditions of Greece, Thrace, and the Greek cities in Magna Graecia. Some scholars attribute them to workshops in the Greek colonies on the Thracian coast, while others suggest they are the work of itinerant craftsmen or workshops active in Thracian centers in the fourth century BC or even of local Thracian craftsmen. •MP

1 Filov 1937, 67–72, figs. 75–77.
2 Ognenova-Marinova 1969, 408–14; Archibald 1985.
3 Ognenova-Marinova 1961, 530–35, figs. 15–18.
4 Parvin 2022, 339–40.
5 Faklaris 1985.
6 New York, The Metropolitan Museum of Art, 1996.248.

51
THE MOGILANSKATA TUMULUS

Excavated in Vratsa, Vratsa Province,
Bulgaria, in 1965–66

The Mogilanskata Tumulus is located in
the center of the town of Vratsa, in north-
western Bulgaria. The tumulus is about
sixty meters in diameter and about seven
meters high. Excavations in 1965 and 1966
revealed three burial chambers.[1] The
earliest one, Tomb I, was built at the level
of the ancient terrain early in the second
quarter of the fourth century BC; it had
a circular plan and was built of unwrought
stones. Disturbed human remains were
discovered in it together with four ceramic
vases and the skeletons of four sacrificed
dogs. This earliest structure was covered
by the original mound.

Several decades later, Tomb II was added
to the southern periphery of the tumulus. It
cannot be reconstructed in its entirety, but
numerous iron spikes indicate the existence
of a rectangular wooden structure, around
which stone walls were built. The tomb
collapsed under the mound's weight on top
of the rich grave goods.[2] In the antechamber
the remains of a cart were discovered, along
with the skeletons of a young male and
a saddle horse with a bridle decorated with
elaborate silver fittings. In the chamber, a
woman, younger than twenty years old, was
laid out with a magnificent gold laurel wreath
and exquisite gold earrings. Gold appliqués,
possibly from a richly decorated veil, as
well as pendants and buttons, attest to her
elevated status. Other objects in Tomb II,
however—including iron knives, a sword
in a scabbard, a quiver of arrows, fragments
of a bronze helmet, and a gilded-silver
greave—are typical of a warrior's burial. The
finds suggest that a local ruler was buried
here along with his wife, who was killed
during the funerary ceremony, a practice
vividly described by Herodotus.[3]

Tomb III, the latest chamber, was built
in the southern periphery of the mound
at the end of the third quarter of the fourth
century BC. It was a rectangular structure
with a transverse wall dividing it in two,
built of unwrought river stones without

binding material. Again, iron spikes and nails
were used for a wooden construction. In the
antechamber a disturbed horse skeleton
was discovered, and the remains of a man,
also disturbed, were uncovered in the
main chamber. Next to him there were two
small jugs, one gold and one silver. A
quiver with arrows was also discovered.

Probably after the construction of this
last structure, the entire mound was
enclosed in a stone wall built of large blocks
with a stepped outer face, with up to twenty
courses preserved. This crepis wall would
have turned the tumulus into a mausoleum,
where the rulers of the Triballoi, who
inhabited the northwestern parts of Thrace,
were buried and worshipped.[4]

The most spectacular find from the entire
mound is undoubtedly the single greave
from Tomb II, part of the ruler's ceremonial
armor (cat. 51a). It is for the left leg and is
forged from a single silver sheet and deco-
rated with gilded animal figures and other
motifs in relief. The upper part is modeled
as a female head wearing an ivy wreath; the
left part of the face is covered with parallel
gilded bands, usually interpreted as tattoos,[5]
for which the Thracians were famous.[6]
Beneath it, two antithetical lions are
depicted, and beneath them, two fantastical
snake-bodied beasts face each other. Two
antithetical snake-bodied griffins are below,
with their tails reaching down to the greave's
lower end. One of them is winged, and a
bird is depicted on top of the other. Gilded
ornaments decorate the sides of the greave,
representing stylized bird wings.[7]

The greave is certainly of Thracian origin,
and it is likely that its decoration depicts
the Great Goddess of the Thracians with her
sacred animals.[8] The greave represents a

a. **Greave**
 ca. 350–325 BC
 Silver with partial gilding
 46 × 13 × 15.5 cm
 Found in Tomb II in
 the Mogilanskata Tumulus
 Vratsa, Regional Historical Museum, B 231

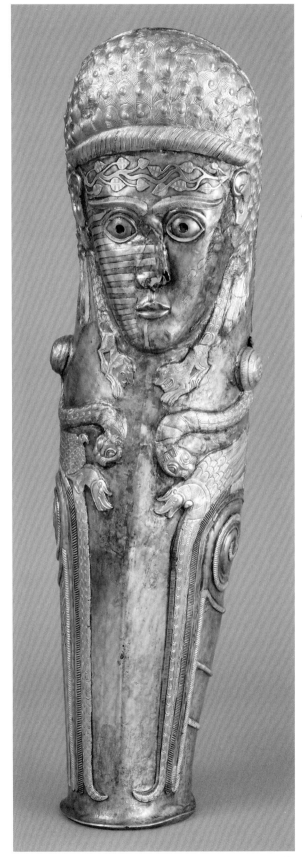

51a

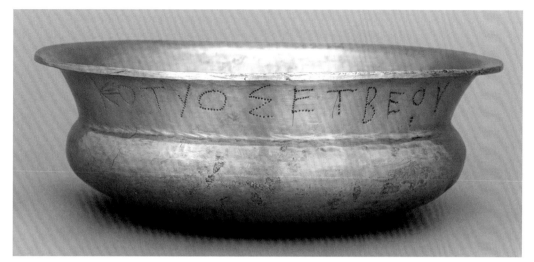

b. *Phiale*
ca. 400–350 BC
Silver
H: 4.6 cm; Diam: 13.5 cm
Found in Tomb II in the
Mogilanskata Tumulus
Vratsa, Regional Historical Museum, B 68

c. *Phiale*
ca. 400–350 BC
Silver
H: 4.6 cm; Diam: 13 cm
Found in Tomb II in the
Mogilanskata Tumulus
Vratsa, Regional Historical Museum, B 69

51b

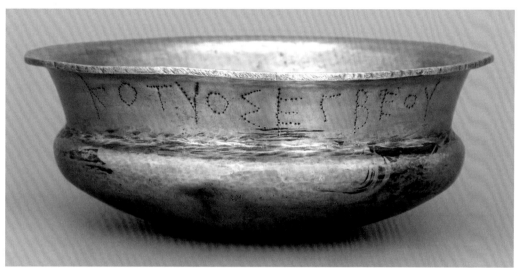

51c

distinctive Thracian style in metalwork that reached its apogee in the second half of the fourth century BC. To the same group of artifacts belong the greaves from the Golyamata Tumulus, near the villages of Malomirovo and Zlatinitsa, in southern Bulgaria (see fig. 41),[9] and from Agighiol, in north Dobruja, Romania (cat. 52b).[10] Like the Mogilanskata Tumulus, the intact grave under Golyamata Tumulus contained a single greave for a left leg.

Tomb II also contained a banquet set, including four *phialai* of Achaemenid type, typical of Thrace. Two of them have plain bodies and identical inscriptions with dotted letters on the necks: ΚΟΤΥΟΣ ΕΓ ΒΕΟΥ, "To Kotys from Beos" (cats. 51b, 51c).[11] Kotys

is likely the powerful Odrysian king Kotys I (384/383–360 BC), and Beos is a toponym, a settlement in the southeastern Thracian lands, near the Propontis. The vessels, initially from the treasury of the Odrysian king, were probably offered as a diplomatic gift to the local ruler.[12]

Silver vessels with such inscriptions are known from the Rogozen and Borovo Treasures (see cats. 60a, 60b; fig. 30), found near Vratsa and Ruse, respectively, and from the rich burials at Alexandrovo, Pleven Province, and Agighiol, as well as from chance finds, also to the north of the Balkan Range,[13] testifying to the active political relations between the Odrysian kingdom and the northern Thracian territories.

The remarkable gold jug from Tomb III has a spherical body, short neck, and flaring rim (cat. 51d).[14] The handle is openwork, made of two gold rods in the form of a Herakles knot, a motif that became particularly popular in the Early Hellenistic period. The rim is decorated with Ionic and Lesbian cymation, and a band of linked palmettes runs around the shoulders. The body of the jug is decorated with two antithetical depictions of two-wheeled winged chariots drawn by four horses each, separated by a large palmette. The charioteers are male, short-haired, and possibly wearing scale armor. While the shape resembles that of a Pheidias mug—an Athenian shape that was popular in Thrace in the fifth

and fourth centuries BC (cats. 47e, 47f)—
and the scene is clearly influenced by Greek
iconography, the jug is undoubtedly of local
Thracian workmanship. Its manufacture in
gold suggests that it had special functions,
possibly related to ritual.[15] •NT

1 Venedikov 1966; Nikolov 1967; Torbov 2005, 11–39.
2 Torbov 2005, 46–91, nos. 5–109; Torbov 2015,
 nos. 230–51.
3 Herodotus, *Histories* 5.5; Venedikov 1966, 12–13.
4 Torbov 2005, 78–79.
5 For example, Farkas 1981, 45.
6 Tsiafaki 2015.
7 Torbov 2005, 59–60.
8 Marazov 1998a, 159, no. 89; N. Torbov in Martinez
 et al. 2015, 278–79, no. 240; L. Konova in
 E. Penkova, Konova, and Kisyov 2017, 149, no. 148.
9 Agre 2011, 45–72.
10 Berciu 1969, 217–19, plates 112–14.
11 Marazov 1998a, 185, no. 122; N. Torbov in Martinez
 et al. 2015, 284, no. 243.
12 Torbov 2005, 74–76.
13 Overview in Stoyanov 2017.
14 Marazov 1998a, 138, no. 63; M. Tonkova in
 Martinez et al. 2015, 199, fig. 6; E. Penkova in
 E. Penkova, Konova, and Kisyov 2017, 190,
 no. 189.
15 Torbov 2005, 78–79.

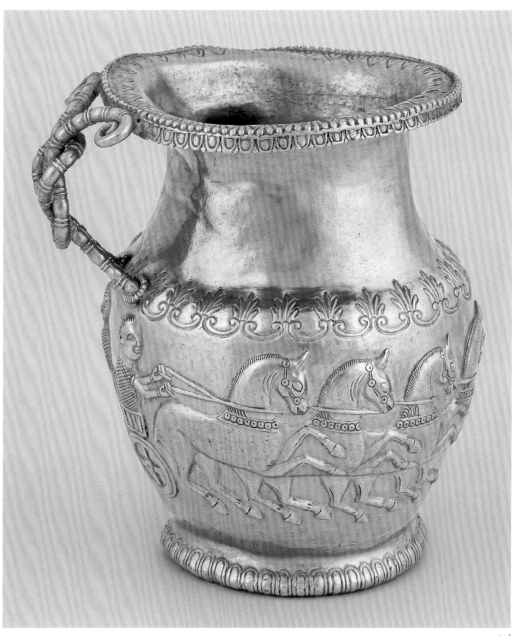

d. Jug
ca. 350–300 BC
Gold
H: 9 cm, W with handle: 8 cm;
Diam: 6.5 cm; Wt: 240 grams
Found in Tomb III in the
Mogilanskata Tumulus
Vratsa, Regional Historical Museum, B 391

51d

52

THE AGIGHIOL TUMULUS

Excavated near Agighiol, Tulcea County, Northern Dobruja, Romania, in 1931

A highly significant north Thracian tumulus burial was discovered at Agighiol, a small village in present-day eastern Romania, just south of the Danube Delta, close to a former estuary that would have provided a direct connection to the Black Sea.[1] The Greek port of Istros lies just to the south. The objects from the tomb—which included silver vessels, armor, and horse trappings—were recovered in 1931, in part through a police inquiry after some finds had already been removed by locals and in part through rescue excavations. Prior to these excavations, the tumulus had been largely destroyed and exploited for its stone blocks. The archaeological context of the discovery is thus not entirely clear and had to be reconstructed partially on the basis of statements by the workers who initially uncovered the tomb when it was used as a stone quarry. One cannot assume that all the objects were recovered, and some were lost later, during World War II.

Nothing remains of the tumulus. At just thirty-one meters in diameter and two meters in height, it can be considered a small to medium-sized mound. The reconstructed plan suggests that the mound covered a two-chambered rectangular tomb built in dry masonry style directly on the ground using dressed blocks, some measuring as much as two meters in length. Greek letters inscribed on some of the blocks indicate that Greek masons worked on-site. The lateral weight of the tomb's walls was, however, supported by a rubble stone mantle, a Thracian technique. The tomb possibly had

a *dromos*. The nature of its roofing is unclear since the tomb was dismantled almost down to the foundations.

The main chamber-tomb contained the skeletal remains of two women, one eighteen to twenty years old, with her skull possibly intentionally elongated, and the other twenty-one years old. Grave offerings included a gilded-silver helmet; two silver greaves; five silver *phialai*; two silver biconical beakers; fragments of an Attic red-figure *lekanis*; three fragmentary amphorae, probably from Thasos; two gold amphora-shaped beads from a necklace; three small

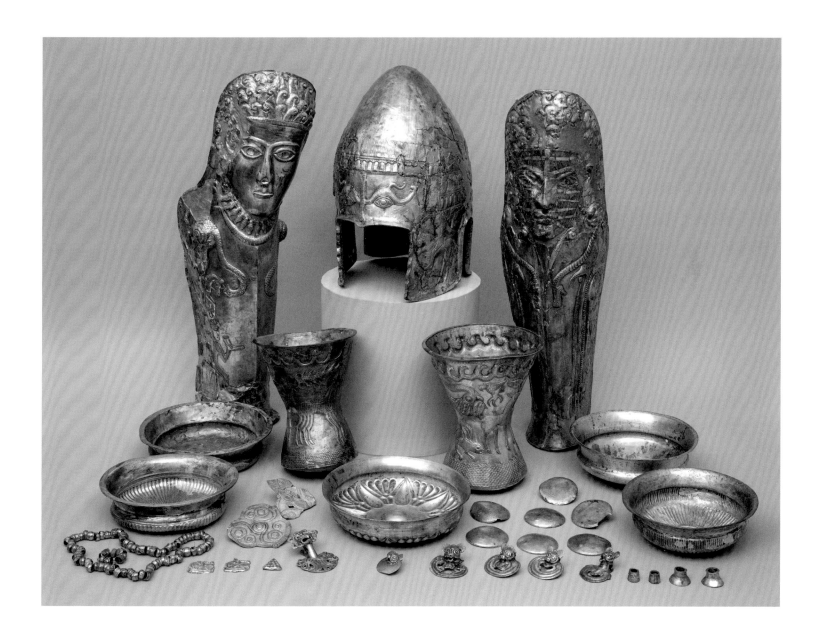

gold-foil appliqués; and bronze arrowheads. Buried in a second chamber-tomb of rubble construction that lay behind the main tomb were three sacrificed horses, along with their trappings, including iron and bronze bridles and silver elements that decorated the leather straps of their headstalls.

On stylistic grounds the tomb should be dated to around 350–330 BC, and connections with silver production further to the west and south are apparent. The presence of silver in Agighiol is perhaps an indication of diplomatic relations and military alliances between the aristocrats residing close to the Danube, who rose to power around the middle of the fourth century BC, the already powerful Triballoi of northwestern Thrace, and the Odrysian kings. Such alliances sealed with offerings of precious diplomatic gifts, such as silver vessels from an Odrysian treasury or horses richly harnessed in Triballian fashion, could have been forged in the context of the political turmoil in the region following the death of the Odrysian king Kotys in 360 BC and the military pressure exerted on local elites by the territorial expansion of the kingdom of Macedon under Philip II.

The set of ceremonial armor consisting of a helmet and two greaves is ornamented in a distinctive style believed to be north Thracian. The rich iconographic decoration of the helmet is executed in gilded repoussé and incision and shows a frieze of bearded horsemen in scale armor throwing their spears, probably hunting (cat. 52a). Their horses are handsomely ornamented. A stylized ivy-leaf wreath, in the Greek tradition, circles the head, and feather-like headgear adorns the forehead. Eyes and ears are prominently detailed within a gilded panel.

The shape of the greaves is derived from earlier Greek bronze examples, but the area of the knee is decorated with a facing head, perhaps a goddess. Stylized snakes or animal-headed serpents ornament the sides. Beside the snake on one of the greaves is a mounted horseman holding a bow, and below are a seated man holding a drinking horn and a bird of prey (cat. 52b). These symbolic images appear to belong to the pictorial realm of the steppe tradition. It is notable that the greaves are not a pair, both being for the right leg. Similar single greaves, both for the left leg, were discovered in the Zlatinitsa-Malomirovo and

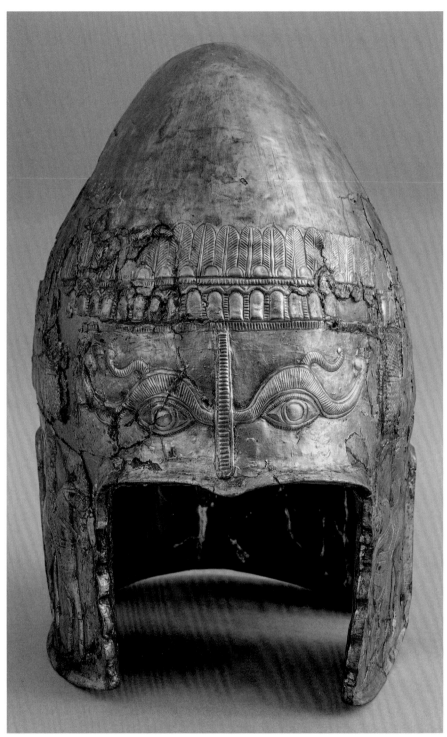

52a

a. Helmet
ca. 350–300 BC
Silver
27 × 19 × 23.5 cm; Wt: 743.53 grams
Bucharest, National History Museum
of Romania, 11181

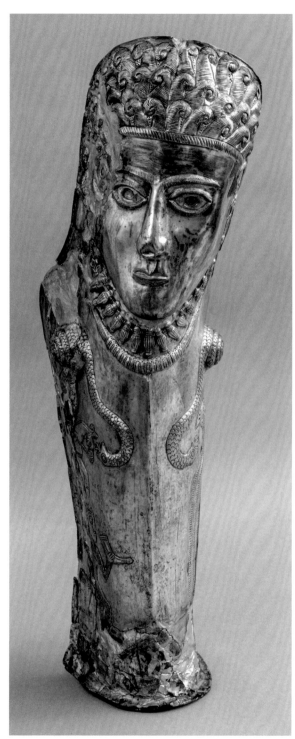

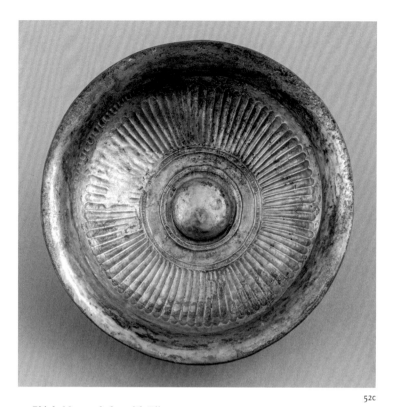

52c

c. *Phiale Mesomphalos* with Ribs
4th century BC
Silver
H: 5.5 cm; Diam: 15.4 cm; Wt: 140.58 grams
Bucharest, National History Museum
of Romania, 8488

Mogilanskata Tumulus burials in south-eastern and northwestern Thrace, respectively (see fig. 41, cat. 51a). Why single examples were included in the burials (and why at Agighiol they were included in a burial for women) is uncertain but likely had ritual significance.

The aristocrats buried in Agighiol shared the south Thracian custom of using silver vessels in banquets and for ritual libations (cats. 52c, 52d). Such vessels also served a political function. The Odrysian kings employed silver vessels to store and circulate wealth in the manner of the Achaemenid Persians. One of the *phialai* from Agighiol (not included here) bears a Greek inscription naming King Kotys (see cats. 51b, 51c, 60a for other examples), suggesting that it was a diplomatic gift. Cups were given at feasts attended by local rulers and warlords participating in joint military actions or hunts. The *phialai* could have reached Agighiol as gifts from the heirs of Kotys to

potential northern allies during their fight for power following the king's death.

In addition to the five *phialai*, the tomb contained two biconical beakers with relief decoration. Around the body of each is a frieze containing an ibex and a stag-like creature with stylized antlers and eight legs. A garland of predator birds' heads circles the rim. The beakers are also decorated on the bottom and thus could not be set down unless empty. One shows a boar attacked by a griffin (cat. 52e). The overall style recalls that of the nomadic peoples of the Eurasian steppes.

Gold appliqués (cats. 52f, 52g) embossed using molds were sewn to garments, head-dresses, or quivers in Scythian contexts and were similarly used by the Achaemenids and Ionian Greeks. The recumbent goat is a particularly popular image throughout the north Aegean and the Eurasian steppes.

52b

b. Greave
ca. 350–300 BC
Silver
47.8 × 12 × 15 cm; Wt: 744 grams
Bucharest, National History Museum
of Romania, 11175

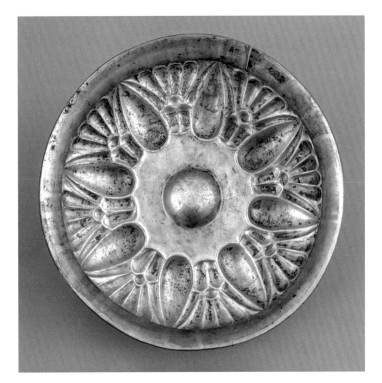

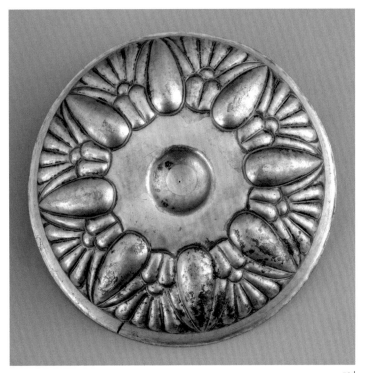

52d

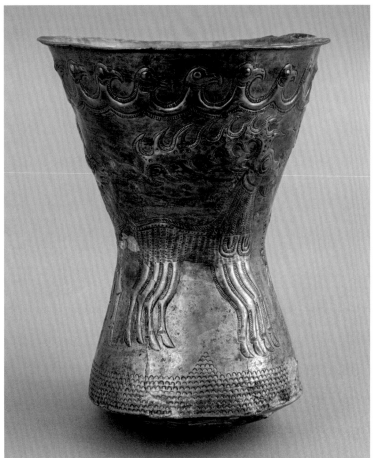

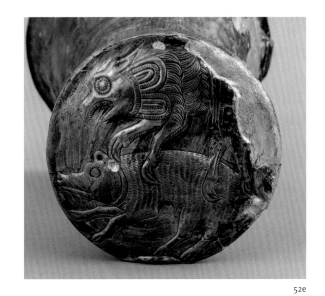

52e

d. *Phiale Mesomphalos* with Water Lily Buds
5th–4th century BC
Silver
H: 4.8 cm; Diam: 17.5 cm; Wt: 250.89 grams
Bucharest, National History Museum
of Romania, 11178

e. Biconical Beaker
4th century BC
Silver
H: 17 cm; Diam of rim: 14 cm;
Wt: 227 grams
Bucharest, National History Museum
of Romania, 11180

f. Ornamental Appliqué
ca. 350–300 BC
Gold
3 × 2.9 × 0.2 cm; Wt: 1.68 grams
Bucharest, National History
Museum of Romania, 11184

g. Ornamental Appliqué
ca. 350–300 BC
Gold
2.5 × 2.2 × 0.2 cm; Wt: 1.06 grams
Bucharest, National History
Museum of Romania, 11185

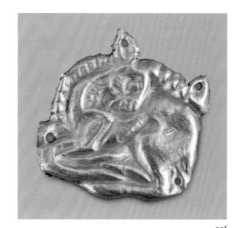

52f

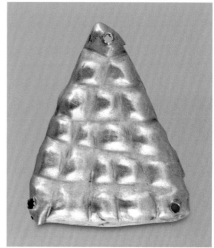

52g

The funerary sacrifice of multiple horses adorned with precious-metal bridle ornaments is attested in several rich Thracian tombs of the mid- to late fourth century BC (including at Peretu, Zlatinitsa-Malomirovo, and Vratsa). Burials of high-status women, too, accompanied by military insignia and horse sacrifices, have been found in both the Triballian tribal region in northwestern Thrace (Vratsa [cat. 51]) and in the territory of the Getai (Sboryanovo, Kralevo [cat. 57], and, far to the north, Cucuteni-Băiceni).

The three horses buried in the chamber behind the main tomb in Agighiol were likely killed with arrows and lances, which were found at the site. The first horse wore an iron bit and decorative iron elements, which are now lost. The second horse wore a bronze bit, and its bridle straps were ornamented with silver fittings (five of which survive) in the form of a frontally facing head of what appears to be bear or a bat (cats. 52h–52j). Some examples add another animal head below the bear or a double-headed snake around it. The bridle straps of the third horse were ornamented with silver cheekpieces in the form of a swirl of horses'(?) heads (cat. 52k), another with

griffin heads (cat. 52l), and two elongated plates engraved with fantastic creatures (perhaps horses with serpent bodies) (cats. 52m, 52n). The distinctive style of the zoomorphic decoration suggests that the production was likely in the Triballian lands, and the discovery of horses wearing entire bridle sets outside this area probably indicates that such items served as high-status gifts. •MMS

1 Berciu 1969; Teleaga 2020.

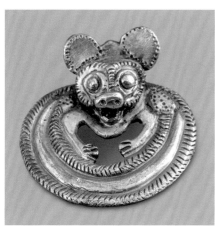

52h

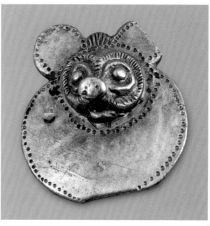

52i

52j

h. Cheek Fitting for a Horse Bridle
Mid-4th century BC
Silver
4 × 4.2 × 1.8 cm; Wt: 27.63 grams
Bucharest, National History Museum
of Romania, 8477

i. Forehead Fitting /
Frontlet for a Horse Bridle
Mid-4th century BC
Silver
5 × 4 × 2.2 cm; Wt: 26.35 grams
Bucharest, National History Museum
of Romania, 8479

j. Cheek Fitting for a Horse Bridle
Mid-4th century BC
Silver
3 × 2.8 × 1.5 cm; Wt: 15.35 grams
Bucharest, National History Museum
of Romania, 8481

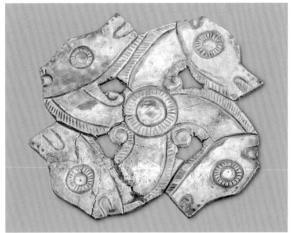

52k

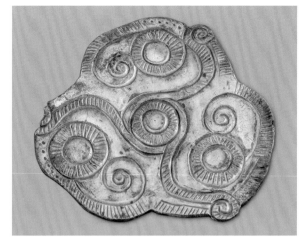

52l

k. **Cheek Fitting for a Horse Bridle**
Mid-4th century BC
Silver
Diam: 7.2 cm; D: 1 cm; Wt: 25.13 grams
Bucharest, National History Museum
of Romania, 8474

l. **Cheek Fitting for a Horse Bridle**
Mid-4th century BC
Silver
Diam: 7.2 cm; D: 1 cm; Wt: 38.27 g
Bucharest, National History Museum
of Romania, 11182

m. **Right Cheek Fitting for a Horse Bridle**
Mid-4th century BC
Silver
12 × 6.4 × 0.5 cm; Wt: 9.14 grams
Bucharest, National History Museum
of Romania, 8476

n. **Left Cheek Fitting for a Horse Bridle**
Mid-4th century BC
Silver
10.5 × 5.7 × 0.7 cm; Wt: 33.7 grams
Bucharest, National History Museum
of Romania, 8473

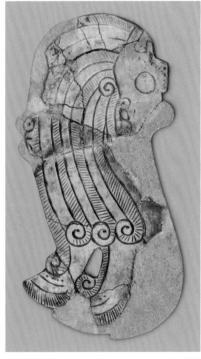

52m

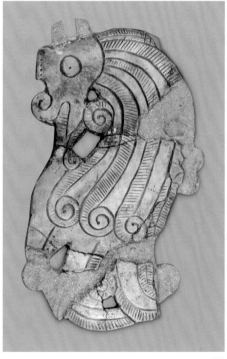

52n

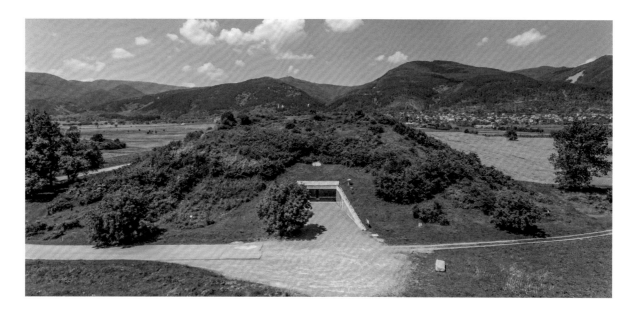

53,54
THE GOLYAMA KOSMATKA TUMULUS

Excavated near the town of Shipka, Stara Zagora Province, Bulgaria, in 2004

In the autumn of 2004, an archaeological expedition led by Georgi Kitov began excavations of the Golyama Kosmatka Tumulus, near the town of Shipka, on the northern side of the Kazanlak Valley. With a diameter of 120 meters and a height of about 21 meters, the mound is the most notable in a sprawling necropolis.[1] In the tumulus's southern half, a monumental tomb was discovered, consisting of several architectural elements aligned along a north-south axis (from the south): a facade, a *dromos*, a second facade, a corbel-vaulted rectangular antechamber, a domed round chamber, and a sarcophagus-like chamber.[2] The broken-off head of a bronze statue, covered with a huge stone cairn (cat. 53), was discovered seven meters south of the outer facade.[3] The massive tomb is believed to be associated with the Thracian king Seuthes III (ca. 330–ca. 300/295 BC), as indicated by the rich assemblage of luxury objects and armor found in the burial chamber (cat. 54), including a bronze helmet and several silver vessels bearing inscriptions with the king's name, as well as a few bronze coins of Seuthes.[4] The archaeologists did not, however, find any human remains or other evidence of an actual burial. •DD JMD

1 D. Dimitrova 2015, 15, 35; D. Dimitrova, M. Reho, and K. Dimitrov in Martinez et al. 2015, 118–43, nos. 82–111a–e; D. Dimitrova in E. Penkova, Konova, and Kisyov 2017, 90–102, nos. 89–106.
2 Kitov 2005b, 42; D. Dimitrova 2015, 45–46, fig. 30.
3 Kitov 2005b, 42; Formigli 2012–13, 180; Saladino 2012–13, 167; Formigli 2015, 15.
4 The coins were discovered in the corridor leading to the tomb facade; see D. Dimitrova 2015, 238–40, nos. 7, 9–11, figs. 120, 121; K. Dimitrov in Martinez et al. 2015, 142–43, nos. 111a–d.

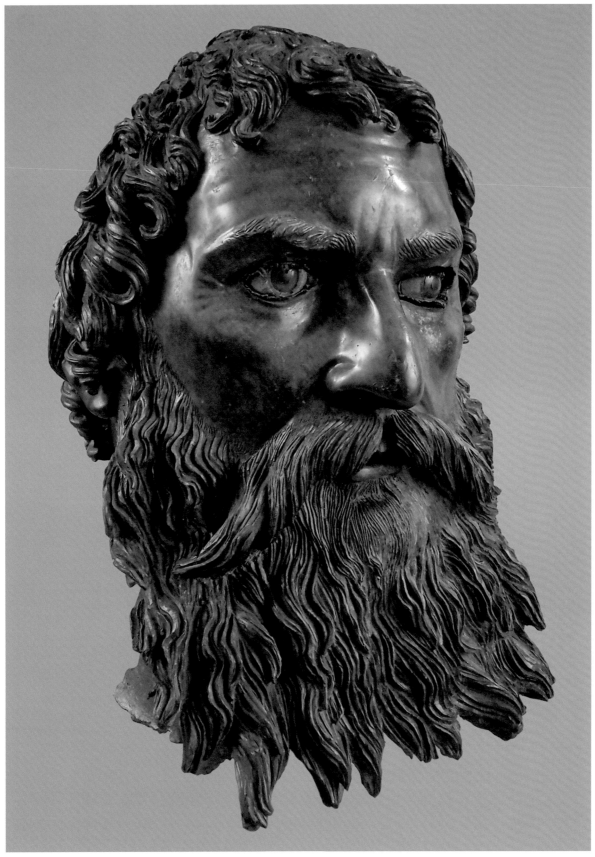

53

Portrait of Seuthes III

ca. 310–300 BC
Bronze, copper, alabaster, and glass
32.5 × 21 × 26 cm
Sofia, National Archaeological Institute
with Museum, 8594

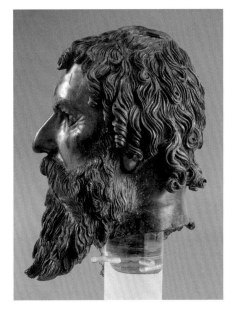
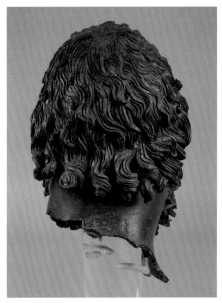

The slightly over-life-size bronze head of a bearded man was found in front of the tomb's facade, in the long entryway known as a *dromos*.[1] Rather than being permanently mounted, it appeared to have been propped up on the ground. As can be seen from the ragged edges of the bronze's neck, the head was crudely separated from the body of a statue, of which no trace was discovered in the tumulus.[2] The excavators have speculated that the comprehensive equipment of the tomb with royal accoutrements despite the absence of human remains, together with the deposition of a reused partial portrait statue, suggests a symbolic rather than physical interment of the king.[3]

The hollow-cast bronze itself is in an exceptional state of preservation. There are virtually no losses apart from the very tips of the beard and the central strand of hair over the forehead. The surfaces of both the hair and the flesh parts display a noble patina,[4] in a palette between malachite green and dark chocolate browns, while the facial skin in particular conveys the impression that the cast only recently left the foundry.[5] Most extraordinary, however, are the composite eyes, made from various materials, including alabaster for the sclera and glass in contrasting colors and opacity levels for the pupils, irises, and lacrimal caruncles.[6] The eyes are inserted into open sockets of the hollow bronze, where they are framed by eyelashes cut from thin sheets of copper.[7] The translucency and reflectiveness of the irises are such that the eyes retain their literal sparkle, giving the portrait an intense gaze that has rarely failed to stun viewers in the twenty years since the portrait's discovery.

The image of a mature man is characterized by an ovoid skull, with a rounded forehead, wide-set eyes under bushy eyebrows, a large and aquiline nose, long handlebar mustache, and an untrimmed, scraggly beard—spade-like and jutting forward. In the combination of these iconographic and physiognomic details, the head is unlike any known portrait of a Greek man, including philosophers or rulers. The context of the head's discovery in the tomb of Seuthes III makes it more than plausible that the portrait indeed represents that Odrysian king. Images of Seuthes III on his coins differ in the length and styling of the hair and beard, but they all show the long handlebar mustache, and those coin portraits closest to the bronze head also feature the king's curved nose (cat. 46).

While distinct from Greek rulers in its appearance, the portrait employs the stylistic vocabulary of Hellenistic art, namely the realism in individual traits and in the depiction of age, as exemplified by the crow's feet, bags under the eyes, furrowed forehead, and presence of a wart on the left cheek, as well as the receding hairline. The texturing of the beard has an almost expressionistic quality in that it appears as if the strands were not molded but combed into the wax model from which the bronze was cast. This effect further enhances the intensity of the pathos that gives the subject his distinctive character.

The casting technique and bronze-specific details—including "cold work" such as chasing of the surface, patination, and the means of assembling the eyes—are all consistent with Greek bronzes produced during the same period.[8] The level of quality further suggests that the portrait—together with the full statue—was produced by a Greek workshop as a royal commission from the Odrysian court.[9]

The head of Seuthes III from Golyama Kosmatka is one of the best-preserved large-scale ancient bronzes to survive and, together with the so-called Terme Ruler and the head of a man from Delos, ranks among the most accomplished bronze portraits in Greek art.[10] More significantly yet, it is perhaps the earliest monumental image of a historic Thracian individual. •JMD

1 See M. Reho in Daehner and Lapatin 2015, 202–3, no. 9; D. Dimitrova 2015, 47, fig. 30, and 117, fig. 91.
2 For a discussion of an inscribed statue base from Seuthopolis that has been suggested as the original location of the complete statue, see Chichikova 2016.
3 D. Dimitrova 2015, 112–14.
4 On the distinction between "noble," or stable, and "vile," or destructive, patinas, see Maish 2015.
5 Compare images of the head at an earlier state of cleaning and conservation in D. Dimitrova 2015, 121–22, figs. 95, 96, and 235, fig. 172.
6 Close-up image of the left eye: Martinez et al. 2015, 119, no. 82.
7 For an interior view of the head with the eye assembly in place, see D. Dimitrova 2015, 236, fig. 173.
8 For a survey of Hellenistic bronze sculpture, see Daehner and Lapatin 2015.
9 Analysis of the remnants of clay core inside the head points to southern Thrace as the location where the cast was made. See Lombardi 2009.
10 Terme Ruler: Himmelmann 1989, 126–49; R. Smith 2015, 96, 98, 101, fig. 7.1. Head of a man from Delos: J. M. Daehner in Daehner and Lapatin 2015, 248–49, no. 29.

VIII.

54

Opulent grave goods were deposited in the tomb's sarcophagus-like chamber, which was hewn out of a huge, monolithic block and covered with a monolithic gable lid with an estimated weight of about sixty metric tons.[1] A burial couch carved from the rock in the chamber runs along the northern wall. A carved rock pillow is at the east end, separating the couch from an extension in the northeastern corner, which probably served as a table.[2] The couch, the table, and the floor of the chamber were covered with an organic fabric interwoven with gold thread, on top of which the grave goods were arranged.[3] No human remains were discovered in the chamber.

Initially, the round chamber of the tomb had a marble double door. At some point, before the deposition of the grave goods, it was broken, and one fragment with a depiction of Helios in relief was placed on the *klinē* with the gold wreath on top of it. Afterward, access to both the circular chamber and the sarcophagus-like chamber was blocked by means of stone walls.

Several groups of artifacts may be distinguished among the grave goods: insignia (the gold wreath), arms and armor, horse trappings, banquet vessels, and items related to the toilette.

The gold wreath placed on the couch's pillow, presumably marking the ruler's head,[4] is the only known example from Bulgaria designed with oak leaves and has an unusually wide hoop (cat. 54a). Many of the gold twigs and leaves were deliberately torn off and crushed, then scattered across the chamber and beyond;[5] a twig was found in the first chamber, and there were leaves

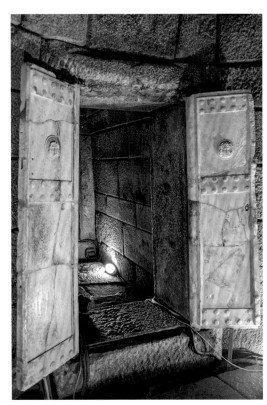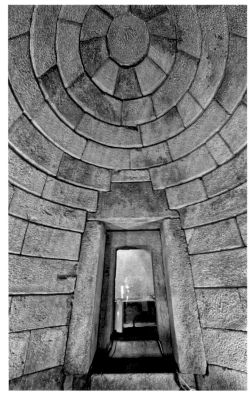

Interior views of the Golyama Kosmatka Tumulus. Left: entrance to the domed chamber with mounted marble doors. Right: domed chamber looking toward the burial chamber

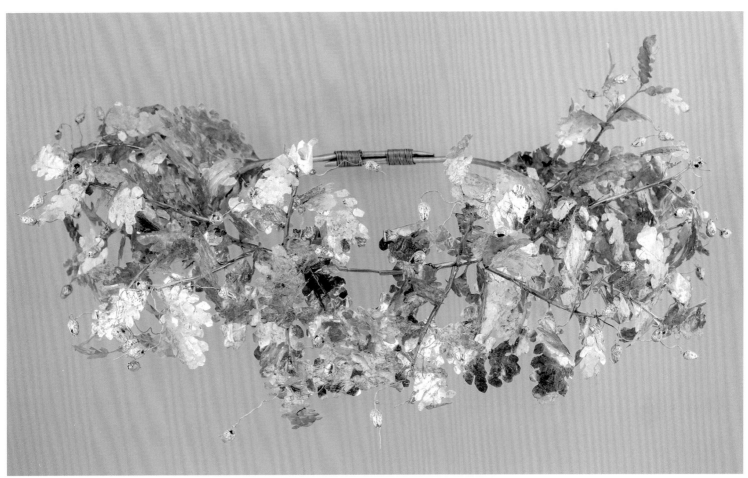

54a

a. Oak Wreath

Late 4th century BC
Gold
Diam of hoop: 28.2 cm; approx.
W: 46 cm; Wt: 260 grams
Kazanlak, Iskra Historical Museum,
MIK A II 1714

between the stones at the southern end of the *dromos*. Similar wreaths are well known from royal and aristocratic burials in Macedonia, such as those from Tombs II and III in the Megali Toumba ("Great Tumulus"),[6] and from a burial at the agora of Aigai,[7] as well as from Grave A at Derveni,[8] all dating from the late fourth century BC. Another close parallel comes from the area of the Hellespont.[9] Based on these parallels, the presence of the wreath in the tomb seems to illustrate the relations between the Odrysian and Macedonian kingdoms in the Early Hellenistic period and suggests the royal status of the deceased.[10]

The armor was probably ceremonial, comprising a bronze helmet, a pair of decorated bronze greaves, a gorget-pectoral, and fragments of a composite (leather?)

corselet.[11] The helmet is of the so-called Chalkidian type, with fixed cheekpieces, and belongs to the "Thracian group" with an outwardly curved nape guard (cat. 54b).[12] In the middle of the pediment-like frontal part, there is a dotted inscription: ΣΕΥΘΟΥ, "(belonging to) Seuthes." Soldered above the inscription is a gilded-silver appliqué depicting the frontally facing head of the goddess Athena wearing a winged helmet terminating in a swan's head at the top. Two silver plume holders were attached above the temples (cat. 54c). The greaves were cast in separate molds for the right and left legs, and additionally forged and chiseled (cat. 54d); the knees are decorated in high relief with heads of Athena wearing an Attic helmet with three crests, supported by figures of a sphinx (the central one)

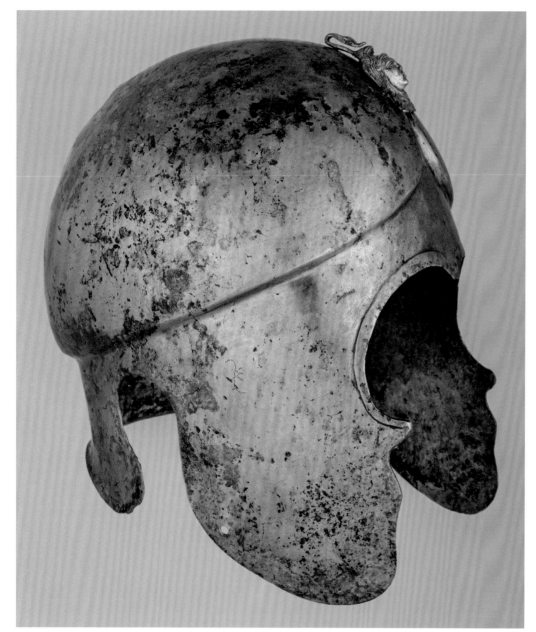

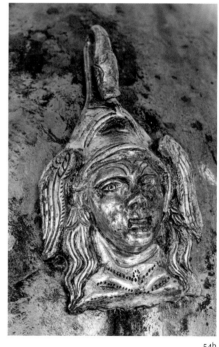

54b

54c

b. **Helmet with Appliqué**
Late 4th century BC
Bronze and silver with partial gilding
26 × 16.5 × 25 cm
Kazanlak, Iskra Historical Museum,
MIK A II 1734 (helmet), 1740 (appliqué)

c. **Plume Holders**
Late 4th century BC
Silver
10.4 × 5.6 × 1 cm
Kazanlak, Iskra Historical Museum,
MIK A II 1739

d. Greaves
Late 4th century BC
Bronze
42.5 × 10 × 17 cm
Kazanlak, Iskra Historical Museum,
MIK A II 1741, 1742

and griffins (the lateral ones). The gorget-pectoral,[13] which is a more elaborate version of the Mezek type that was popular in Thrace in the Early Hellenistic period (see cat. 50),[14] was made of iron, leather, and gold-threaded fabric with rich decoration. There are also examples from Macedonia,[15] and similarities can be found in the rich finds from Scythia.[16] The composite corselet was decorated with gold appliqués: a round one with a lion's head (cat. 54e) and two rectangular plaques depicting a warrior standing facing and leaning on a spear, with helmet, composite corselet, and sword on a shoulder strap (cat. 54f).

The weapons in the tomb include a lavishly decorated iron sword, a second sword, iron knives, and nine spearheads. The single-edged ceremonial sword has an iron grip typical of the *kopis* type, with elaborate inlaid gold decoration consisting of vegetal motifs; the handle is in the shape of a styl-ized griffin's head (cat. 54g). The scabbard is similarly decorated with intricately inlaid gold vegetal and other ornaments and ends in an ivory chape (cat. 54h).

The horse harness fittings made of gold suggest the splendor of the Thracian ruler. The set consists of a frontlet and three sets of appliqués. The frontlet is a figure eight–shaped plate decorated with stylized palmettes in filigree and a lion's head in high relief in the middle (cat. 54i). Two oval appliqués depict facing deer's heads (cat. 54j). A set of four appliqués are in the shape of a four-leaf rosette with a male head in the middle; in two cases the fields of the leaves are decorated with palmettes, while volute-like motifs ornament the other two (cat. 54k). Six small rosette appliqués and other gold elements complete the decoration of the horse harness (cats. 54l–54o). The set from Golyama Kosmatka belongs to a group of finds from rich burials in Thrace, dated in general to the first half of the third century BC, that illustrate a specific fashion in Early Hellenistic Thrace.[17] Two iron spurs and a horse bridle were also discovered.[18]

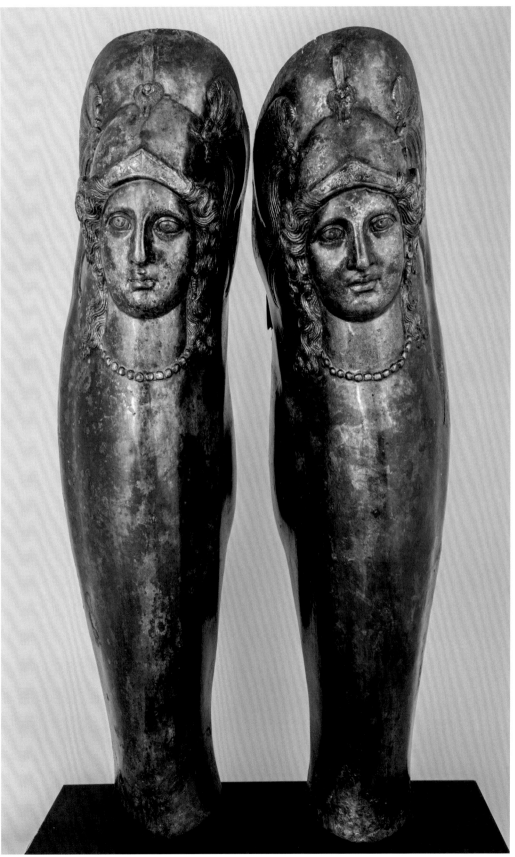

54d

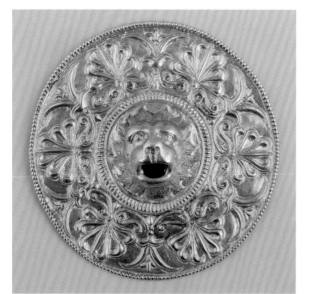

54e

54f

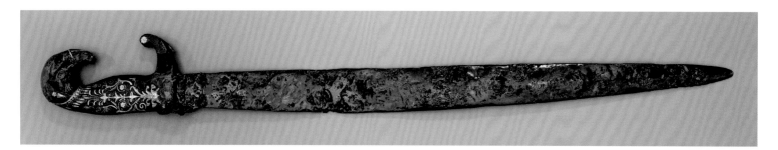

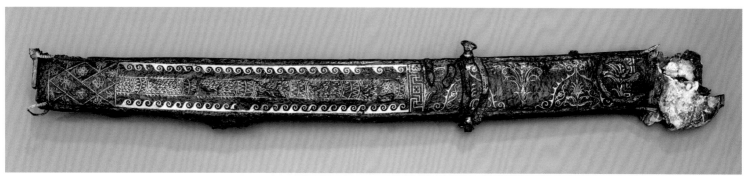

54g, h

e. Corselet Appliqué with Lion's Head
Late 4th–early 3rd century BC
Gold
Diam: 7.6 cm; D: 1.5 cm; Wt: 69 grams
Kazanlak, Iskra Historical Museum,
MIK A II 1720

**f. Two Corselet Appliqués with
Standing Warriors**
Late 4th–early 3rd century BC
Gold
8.7/8.3 × 6.3 × 0.3 cm; Wt: 49/53 grams
Kazanlak, Iskra Historical Museum,
MIK A II 1723, 1724

g. Sword
Late 4th century BC
Iron and gold
L: 66.5 cm; H (at hilt guard): 4.1 cm
Kazanlak, Iskra Historical Museum,
MIK A II 1785

h. Scabbard
Late 4th century BC
Iron, gold, ivory, leather, and fabric
L: 61.5 cm; H: 5.5 cm
Kazanlak, Iskra Historical Museum,
MIK A II 1752

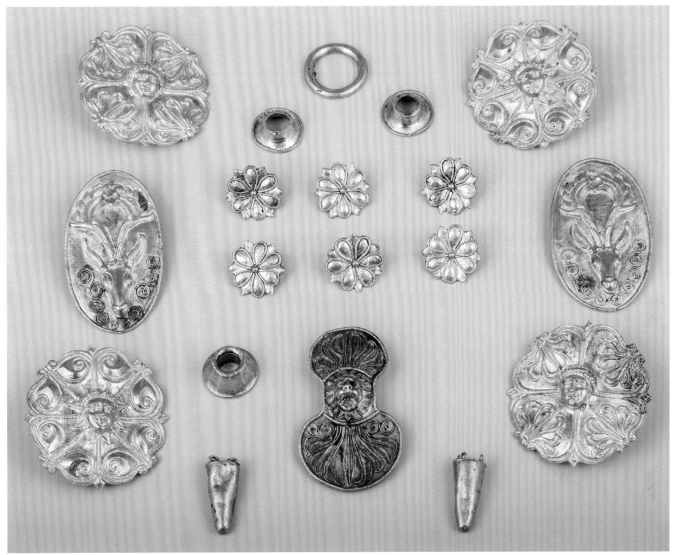

54i–o

i. Horse Harness Frontlet
Late 4th–early 3rd century BC
Gold
5.2 × 3.2 × 1.4 cm; Wt: 20.6 grams
Kazanlak, Iskra Historical Museum,
MIK A II 1716

**j. Two Deer's-Head Horse Harness
Appliqués**
Late 4th–early 3rd century BC
Gold
5.4/5.3 × 3.2/3.3 × 1 cm;
Wt: 20.64/19.78 grams
Kazanlak, Iskra Historical Museum,
MIK A II 1721, 1722

**k. Four Rosette Horse Harness Appliqués
with Male Heads**
Late 4th–early 3rd century BC
Gold
Diam: 4.6; D: 1.5 cm; Wt: 18.55–19.5 grams
Kazanlak, Iskra Historical Museum,
MIK A II 1717–1719, 1780

l. Six Rosette Horse Harness Appliqués
Late 4th–early 3rd century BC
Gold
Diam: 1.8 cm; D: 0.6 cm; Wt: 2.1–2.4 grams
Kazanlak, Iskra Historical Museum,
MIK A II 1725

m. Two End Caps for a Horse Harness
Late 4th–early 3rd century BC
Gold
H: 2 cm; Diam: 0.8/1 cm; Wt: 3.16/3.28 grams
Kazanlak, Iskra Historical Museum,
MIK A II 1727

n. Ring for a Horse Harness
Late 4th–early 3rd century BC
Gold
Diam: 2 cm; D: 0.3 cm; Wt: 8.23 grams
Kazanlak, Iskra Historical Museum,
MIK A II 1726

o. Three Nozzles for a Horse Harness
Late 4th–early 3rd century BC
Gold
Diam: 1.8 cm; D: 0.7 cm;
Wt: 16.5/3.2–3.3 grams
Kazanlak, Iskra Historical Museum,
MIK A II 1728, 1729, 1781

54p

p. **Three Dice**
Late 4th century BC
Bronze
1.2 × 1.2 × 1.2 cm
Kazanlak, Iskra Historical Museum,
MIK A II 1745

q. **Twenty-Three Gaming Counters**
Late 4th century BC
Dark blue, light blue, and colorless glass
Diam: 1.4–1.8 cm; D: 0.6–0.7 cm
Kazanlak, Iskra Historical Museum,
MIK A II 1770, 1784

54q

Other possessions typical of aristocratic men are a set of dice and glass gaming counters (cats. 54p, 54q). There have been numerous such finds in rich burials in ancient Macedonia,[19] as well as in Thrace,[20] dating from the late fourth and early third centuries BC, indicating that games of chance were an integral part of the aristocratic warrior's life and illustrating the adoption of Hellenistic fashions by the local elite.

The banquet set in the tomb consists of gold and silver vases. The gold *kylix* with incised decoration imitating the stamped ornaments on black-glaze pottery, which has close parallels in silver examples in late fourth-century BC Macedonia and elsewhere,[21] is probably the earliest in the series (cat. 54r).[22] Two silver vessels are inscribed. A small *oinochoe* has an inscription in dotted

letters: "Of Seuthes, weighing 14 tetra-drachms and 2 drachms" (cat. 54s).[23] A calyx cup from the late fourth or early third century BC bears a similar inscription: "Of Seuthes, weighing 12 tetradrachms and 2 drachms (or 14 tetradrachms)" (cat. 54t).[24] Together with the helmet, they again provide the name of Seuthes as owner of the objects deposited in the tomb. An *askos* and a *patera*, both made of bronze, complement the set of metal vases (cats. 54u, 54v). The handle of the *askos* is decorated with an ivy leaf at the top and a female head at the base, and that of the *patera* ends in a ram's head.

Among the most spectacular finds in the tomb is the gilded-silver *pyxis* in the shape of a scallop shell (cat. 54w). Actual shells of *Pecten jacobaeus* were used as toilette or

r. *Kylix*
Late 4th century BC
Gold
H: 5.9 cm; W with handles: 15.5 cm;
Diam of rim: 9.5 cm; Wt: 226.38 grams
Kazanlak, Iskra Historical Museum,
MIK A II 1715

s. *Oinochoe*
Late 4th–early 3rd century BC
Silver
H: 9.5 cm; Diam: 7.3 cm; Wt: 243.2 grams
Kazanlak, Iskra Historical Museum,
MIK A II 1732

t. Calyx Cup
Late 4th–early 3rd century BC
Silver
H: 8.9 cm; Diam of rim: 10.6 cm;
Wt: 212.75 grams
Kazanlak, Iskra Historical Museum,
MIK A II 1733

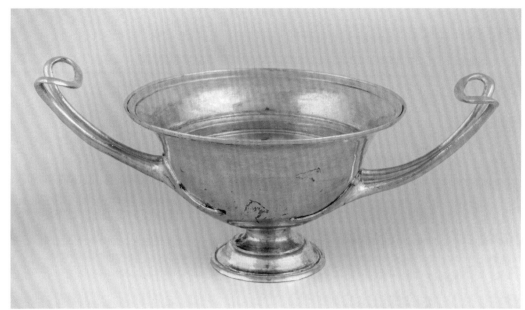

54r

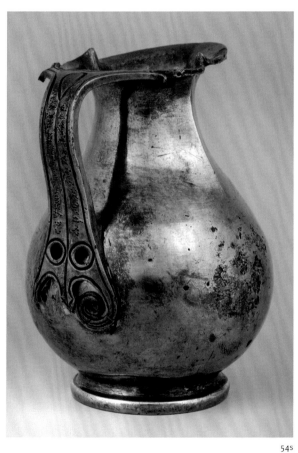

54s

54t

54u

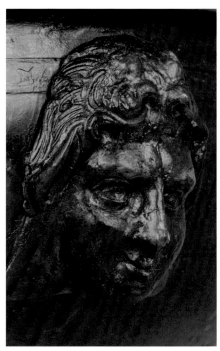

54v (detail)

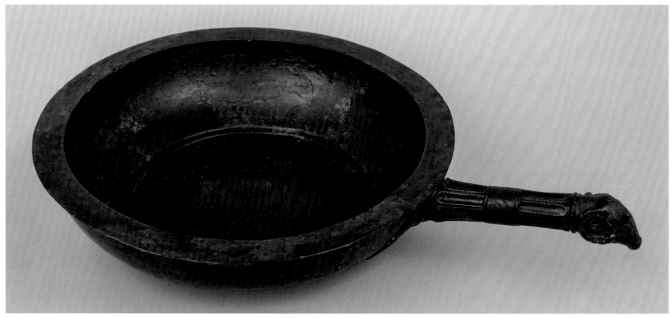

54v

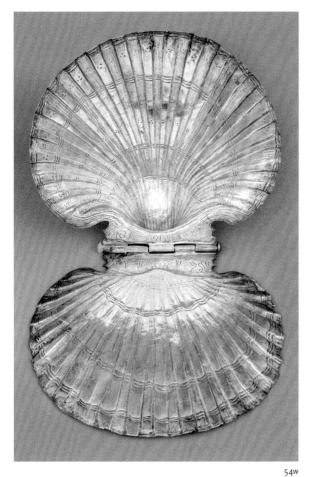

54w

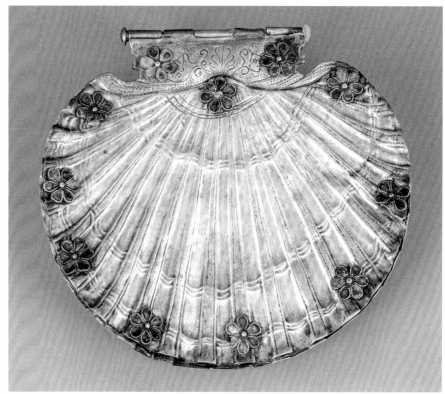

54w

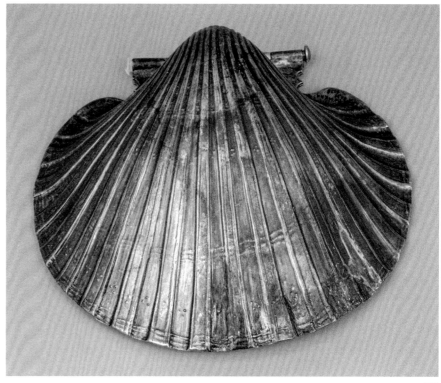

54w

u. *Askos*
Late 4th–early 3rd century BC
Bronze
H: 23.5 cm; W with handle: 22 cm;
Diam: 14.7 cm
Kazanlak, Iskra Historical Museum,
MIK A II 1743

v. *Patera* with Appliqué
Late 4th–early 3rd century BC
Bronze
H: 6.7 cm; W with handle: 39 cm;
Diam of rim: 27 cm
Kazanlak, Iskra Historical Museum,
MIK A II 1744 (*patera*), 1761 (appliqué)

**w. *Pyxis* in the Shape of a Scallop Shell
with Decorative Rosettes**
Late 4th–early 3rd century BC
Silver with partial gilding
4.7 × 17.6 × 16 cm
Kazanlak, Iskra Historical Museum,
MIK A II 1731 (*pyxis*), 1736 (rosettes)

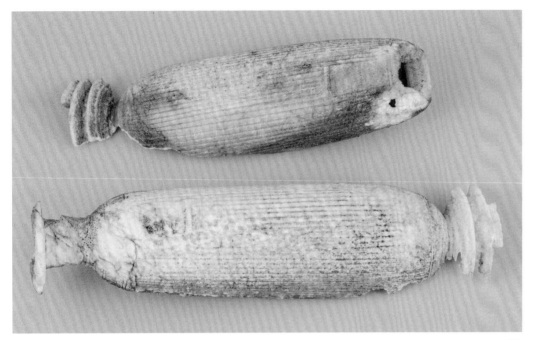

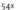

54x

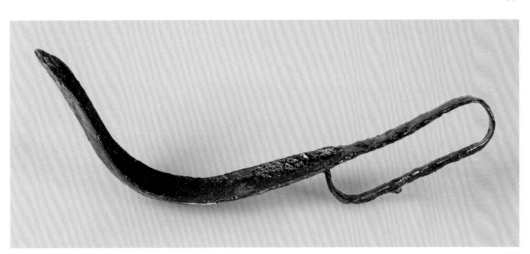

54y

x. **Two** *Alabastra*
Late 4th–early 3rd century BC
Alabaster
H: 23.5/21 cm; Diam: 5.9/5.8 cm
Kazanlak, Iskra Historical Museum,
MIK A II 1768, 1769

y. **Strigil**
Late 4th–early 3rd century BC
Iron
L: 27 cm; H: 4.2 cm; D at handle: 4 cm
Kazanlak, Iskra Historical Museum,
MIK A II 1750

z. **Amphora**
Greek, made in Mesembria,
ca. 300–250 BC
Terracotta
H: 73 cm; Diam: 37 cm
Kazanlak, Iskra Historical Museum,
MIK A II 1772

jewelry boxes in female graves in South Italy and Macedonia, and precious-metal *pyxides* appeared in the Hellenistic period as luxury versions. The presence of this extraordinary personal possession in the tomb may relate to Seuthes's wife, Berenike, who is named in the Seuthopolis Inscription (cat. 55) and was undoubtedly a Macedonian princess.[25] The two footed alabastra are unique for Thrace and are also typical of rich female graves in South Italy and Macedonia, probably forming a set with the *pyxis* (cat. 54x).[26] Two iron strigils also belong to the items related to the toilette (cat. 54y).

Three transport amphorae for wine were present in the tomb.[27] Two of them were

from the city of Mesembria,[28] demonstrating the trade relations between this region in the Thracian interior and the Greek cities on the Black Sea coast (cat. 54z). They are among the latest finds from the tomb, dating from the late first or the second quarter of the third century BC, and are important for establishing the chronology of the entire complex.

The exceptional circumstance that the monolithic chamber in the Golyama Kosmatka Tumulus was discovered intact, along with the evidence gained from some of the finds there, has provided the rare opportunity to relate it to an actual historical figure. The huge tumulus and the extraor-

dinary tomb, its location in the valley of Kazanlak, the inscriptions "of Seuthes" on the helmet and the silver vessels from the burial chamber, the royal gold oak wreath, and the portrait bronze head that bears striking resemblance to the features of Seuthes III on coins indicate that the entire complex should be related to the burial of this ruler. The absence of human remains indicates that it was probably a cenotaph.

The place, date, and circumstances of Seuthes III's death remain unknown, which complicates specifying the chronology of the symbolic burial in the monolithic chamber. Some scholars date the death of the Odrysian ruler to 302/301 or 297/295 BC.[29]

In fact, coin finds from the Golyama Kosmatka mound indicate activities there in the beginning of the third century BC. In the sealed *dromos*, four coins of Seuthes of the star/thunderbolt type,[30] dated either to 320–310 BC,[31] or later, to 305–300/295 BC,[32] were discovered together with a bronze coin of Kassander, which had circulated for a short time and could be dated to 311–306 BC.[33]

The later chronology of some of the finds in the burial chamber, however, to around 280 BC at the earliest, along with other observations, has been offered as an argument for a date of a symbolic reburial of Seuthes III some twenty years later.[34] The presence of typically female objects, such as the *pyxis* and the *alabastra*, also raises questions. However the chronology is established, there were clearly several stages in the construction and use of the tomb in the Golyama Kosmatka Tumulus. •DD

1 Kitov 2005a, 51; Kitov 2005b, 44.
2 D. Dimitrova 2015, 94–96.
3 D. Dimitrova 2015, 133–34, fig. 105.
4 D. Dimitrova 2015, fig. 104
5 D. Dimitrova 2015, 156–57, fig. 125.
6 Andronikos 1992, 222, 232.
7 Paliadeli et al. 2008, 180–81, figs. 9–11.
8 Themelis and Touratsoglou 1997, 57–58, 185, plate 60.
9 Williams and Ogden 1994, 107, no. 60.
10 Tonkova 2013, 425–26.
11 D. Dimitrova 2015, figs. 107, 130.
12 E. Kunze 1967, 136–41; V. Vasilev 1979, 69.
13 D. Dimitrova 2015, 178–82, no. 36.
14 Ognenova-Marinova 2000, 19.
15 Faklaris 1985, 14.
16 Mozolevskyi 1979, 73–93, 214.
17 Tonkova 2010, 56–57.
18 D. Dimitrova 2015, 305, 330, nos. 56, 91.
19 Ignatiadou 1996, 513; Ignatiadou 2019, 147–49.
20 Nankov 2013.
21 Zimi 2011, 64–65, nos. 47, 48.
22 Ignatiadou 2012, 227, 229.
23 Manov 2006, 32, 34.
24 Sideris 2021, 77, no. 186; translation by A. Sideris.
25 Nankov 2011, 15–16.
26 Nankov 2016a.
27 D. Dimitrova 2015, 317–20, nos. 70–72.
28 Stoyanov 2011, 196; Stoyanov 2016, 365.
29 Manov 1998, 10; Tacheva 2006, 184; Yordanov 2007, 184; K. Dimitrov 2008, 67; D. Popov 2011, 123.
30 K. Dimitrov 1984, 73.
31 K. Dimitrov 1984, 64; Yurukova 1976, 90.
32 Yurukova 1992, 262.
33 Draganov 2001, 45.
34 Stoyanov and Stoyanova 2016, 318–22.

55

Oath of Berenike and Her Sons (The Seuthopolis Inscription)

ca. 300–290 BC
Marble
63 × 25 × 6 cm
Found in Seuthopolis, near Kazanlak,
Stara Zagora Province, Bulgaria, in 1953
Sofia, National Archaeological Institute
with Museum, 8408

This pedimental stele is broken into three
parts, but the inscription is well preserved;[1]
only a few letters are lost due to damaged
surfaces at the breaks or near the edges.
The lower part is more roughly cut and
indicates that the stele was originally
inserted within a base. It was found in the
largest building, the so-called Royal Palace,
in Seuthopolis, in one of the rooms that
must have served, according to the text,
as a sanctuary of the Great Gods of
Samothrace. The date, according to both
the historical data and the evidence for the
period in which Seuthopolis existed, can
be assigned to the very beginning of the
third century BC. Initially the inscription
was published only partially (ll. 27–34),[2] and
the rest was given in translation. The com-
plete Greek text was not available to the
scholarly public until nearly forty years after
the discovery of the stone.[3]

Ἀγαθῆι τύχηι. Ὅρκος Ἐπιμένει
Βερενίκης καὶ τῶν υἱῶν· ἐπειδὴ
Σεύθης ὑγιαίνων παρέδωκεν
Ἐπιμένην Σπαρτόκωι καὶ τὰ
5 ὑπάρχοντα αὐτοῦ καὶ Σπάρτοκος
ἐπὶ τούτοις τὰ πιστὰ ἔδωκεν
αὐτῶι, δεδόχθαι Βερενίκη καὶ τοῖς
υἱοῖς αὐτῆς Εβρυζελμει καὶ Τηρει
καὶ Σατοκωι καὶ Σαδαλαι καὶ τοῖς
10 [παρ]εσομένοις δεδόσθαι Ἐπιμένην
[Σπαρ]τόκωι, αὐτὸν καὶ τὰ ὑπάρχοντα
αὐτοῦ εἰς ἅπαντα τὸν βίον,
παρέχεσθαι δὲ καὶ Ἐπιμένην τὴν
χρείαν Σπαρτόκωι ἢ οἷς ἄν
15 Σπάρτοκος συντάσσηι, καθ' ὃ ἄν
δύνηται· ἐξαγαγέτωσαν δὲ οἱ
Βερενίκης υἱοὶ ἐκ τοῦ ἱεροῦ τῶν
θεῶν τῶν Σαμοθραικίων, ἐφ'ὧι
ἀδικήσουσι Ἐπιμένην κατὰ
20 μηθένα τρόπομ μηθέν, ἀλλὰ
παραδότωσαν Σπαρτόκωι αὐτὸν
καὶ τὰ ὑπάρχοντα αὐτοῦ· μηδὲ

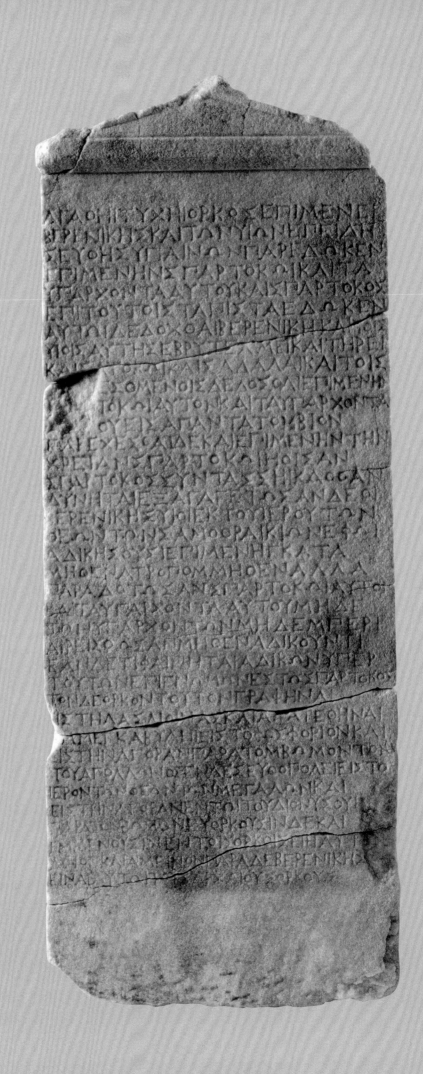

τῶν ὑπαρχόντων μηδὲμ περι-
αιρείσθωσαν μηθὲν ἀδικοῦντι·
25 ἐὰν δέ τι φαίνηται ἀδικῶν, ὑπὲρ
τούτων ἐπιγνώμων ἔστω Σπάρτοκος·
τὸν δὲ ὅρκον τοῦτον γραφῆναι
εἰστήλας λιθίνας καὶ ἀνατεθῆναι
[ἐ]μ μὲγ Καβύληι εἰς τὸ Φωσφόριον καὶ
30 εἰς τὴν ἀγορὰν παρὰ τὸμ βωμὸν τὸν
τοῦ Ἀπόλλωνος, ἐν δὲ Σευθοπόλει εἰς τὸ
ἱερὸν τῶν Θεῶν τῶν Μεγάλων καὶ
εἰς τὴν ἀγορὰν ἐν τῶι τοῦ Διονύσου
ἱ[ερῶι]
παρὰ τὸν βωμόν· εὐορκοῦσιν δὲ καὶ
35 ἐμμένουσιν ἐν τοῖς ὅρκοις εἴη αὐτ[οῖς]
λώιογ καὶ ἄμεινον, παρὰ δὲ Βερενίκης
εἶναι αὐτῶι τοὺς ἀρχαίους ὅρκους.

To Good Fortune!
An oath of Berenike and her sons for
 Epimenes.
Since Seuthes, while in good health,
entrusted Epimenes and what belongs
to him to Spartokos, and Spartokos
gave him his assurance concerning these
matters, let it be decided by Berenike,
her sons Hebryzelmis, Teres, Satokos, and
Sadalas and those who will come after
them, that Epimenes—himself and what
belongs to him—be given to Spartokos
for his entire life and that Epimenes
serve to the benefit of Spartokos or of
whomever Spartokos should order, to
the best of his ability. Let the sons of
Berenike bring Epimenes out of the
sanctuary of the Samothracian Gods, on
the condition that they will do no injustice
to him in any way, but let them entrust
him and what belongs to him to Spar-
tokos. Let them not take away anything
that belongs to him if he does no injus-
tice. And if he appears to have done any
injustice, let Spartokos be the arbiter
concerning these matters. And let this
oath be engraved on stone stelai and set
up in Kabyle in the Phosphorion (sanctu-
ary of Phosphoros) and in the agora
by the altar of Apollo, and in Seuthopolis
in the sanctuary of the Great Gods and
in the agora in the sanctuary of Dionysos
by the altar. If they swear honestly and
keep their oaths, let it be finer and better
for them; and, on Berenike's part, let the
old oaths for him (Epimenes) remain valid.

The primary importance of the inscription
is in attesting the name of the settlement

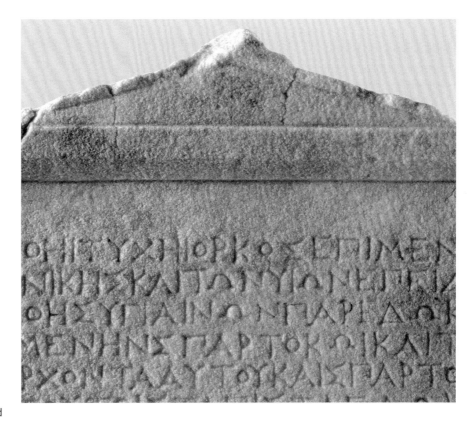

where it was found and several public struc-
tures in both Seuthopolis and Kabyle, as well
as in providing evidence of the Hellenization
and the adoption of Greek administrative
models and language in the short-lived
Hellenistic state ruled by King Seuthes III
(ca. 330–ca. 300/295 BC) and his heirs.[4] It
sheds some light on the history of Thrace
around the turn of the third century BC but
also raises numerous questions regarding
some of the individuals involved in the
events described in the text. While Seuthes
and Spartokos were known from earlier
historical texts, neither Berenike nor
Epimenes are attested elsewhere. The name
of Berenike, apparently the wife or widow of
Seuthes, suggests that she was a Macedo-
nian princess, but it is impossible to identify
her as the offspring of one of the eminent
Macedonian kings of this period. The person
of Epimenes, his status, and his "belongings"
have provoked long—and sometimes
heated—discussions without leading to any
reliable conclusions.

The Sanctuary of the Great Gods of
Samothrace, where Epimenes sought asylum
and where one of the four copies of the
oath had to be displayed, has been identified
with the room where the stele was found.

It is worth noting that the inscribed oath was
preserved and not intentionally erased, as
was done with two other Greek epigraphic
texts in Seuthopolis—a verse inscription on
a statue base apparently connected with
King Seuthes and a dedication by the priest
of Dionysos, Maistas, son of Medistas.[5]
The latter inscription was found in the agora
and confirms the existence of the Sanctuary
of Dionysos mentioned in the oath as the
place for the second copy of the oath in
Seuthopolis. The other copies had to be dis-
played in Kabyle—a city founded by Macedo-
nian colonists in the fourth century BC and
partially revealed through archaeological
excavations near the present village of
Kabile, in the Yambol region. The Sanctuary
of Phosphoros and the altar of Apollo there
have yet to be discovered, but coins minted
in Kabyle prominently feature the goddess
Phosphoros as well as Apollo. •NS

1 *IGBulg.* III.2, 1731 = *IGBulg.* V, 5614; *SEG* 42, 661;
 K. Dimitrov in Martinez et al. 2015, 167–68, no. 116,
 with further references.
2 D. Dimitrov 1957b, 184–87, no. 2, plate XXXI/1;
 D. Dimitrov and Chichikova 1978, 43–48, fig. 71.
3 Velkov 1991, 7–11, no. 1; Elvers 1994; Calder 1996.
4 Graninger 2018.
5 *IGBulg.* III.2, 1732.

56

Architectural Relief

ca. 400–350 BC
Limestone
93 × 107 × 36 cm
Found in the Zhaba Mogila Tomb, near
Strelcha, Pazardzhik Province, Bulgaria,
in 1977
Strelcha, Historical Museum, 360

This block with relief and painted decoration
was discovered, together with other lime-
stone architectural elements, in the Zhaba
Mogila ("Frog Mound") tomb near Strelcha.[1]
The block has a flat base with two fasciae,
an ovolo profile, and a crowning fascia to
the right. The left half has a slanting upper
side. The missing part of the left side can
be reconstructed based on a symmetrically
antithetical second block that was also
discovered. A Lesbian cymation design,
without the darts, is painted on the ovolo
profile. The leaves are dark blue with red
veins on a red background, emphasized
by unpainted bands. On the face, to the left
of the frame's profile, a relief figure of a
male panther paces to the right with his
head turned back. The left front leg is raised,
with the paw resting against the frame.
The mane and other details are articulated
with engraved lines. The panther's pupil is
dark blue, encircled by a black line. The lips
and the tongue are red, and the tip of the
snout is black. Blue was used for the tip
of the tail. Beneath the slanting edge, there
is a painted band of Lesbian leaves above
a bead-and-reel border.

The two symmetrical blocks with anti-
thetical panthers were part of the doorframe
and facade of a tomb that was probably
located outside the Zhaba Mogila Tumulus,
where two more tombs were discovered.[2]
The slanting parts of the blocks enable the
reconstruction of the pediment and the
gabled cover (see below).[3]

The presence of sculpted and painted
decoration on a tomb's facade is unusual for
Thrace. This was undoubtedly a structure
that was strongly influenced by Achaemenid
art in Anatolia,[4] displaying similarities with
iconic tombs, such as Buildings H and F at
the acropolis of Xanthos, Lycia,[5] and another
near Daskyleion.[6]

In the area of Zhaba Mogila, there are
other impressive sites, not only by Thracian
standards. These are the residential for-
tress at Smilovene locality (mid-fourth
century BC),[7] the settlement and the sanc-
tuary with a temple of Greek type at the
village of Krastevich (last quarter of the
fifth or early fourth century BC),[8] the tomb
in the Chetinyova Tumulus at Starosel (last
decades of the fourth century BC),[9] and
the monumental building at the residence at
Kozi Gramadi peak (mid-fourth century BC).[10]
In the architecture of these sites and
of the two tombs under Zhaba Mogila, one
can clearly see the work of architects and
stonecutters from mainland Greece and
Asia Minor. •DS

1 Kitov 1979, 12–13; D. Stoyanova in Martinez et al.
 2015, 233, no. 193; D. Stoyanova and Tzochev
 2016.
2 Kitov 1979, 12–13; Teleaga 2014a, Teleaga 2014b.
3 D. Stoyanova in Martinez et al. 2015, 233, fig. 1.
4 Vassileva 2010, 39; Dupont 2015, 232; Vassileva
 2015, 331.
5 Jenkins 2006, 169–72; Draycott 2015, 112–14,
 128–29, 133–34, figs. 9, 10, 14, 15, 20–22.
6 Karagöz 2007.
7 Agre and Dichev 2011, figs. 1, 2.
8 Madzharov 2016.
9 Tzochev 2021a; Tzochev 2021b.
10 I. Hristov and Stoyanova 2011.

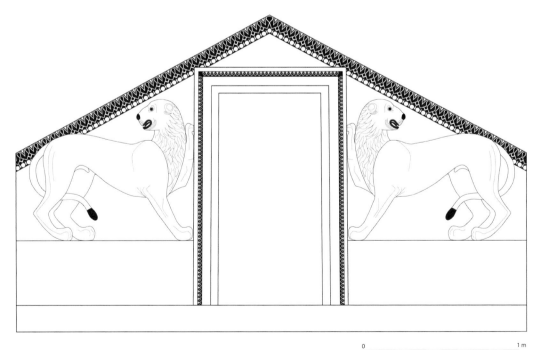

Reconstruction of the tomb facade of Zhaba Mogila

0 1 m

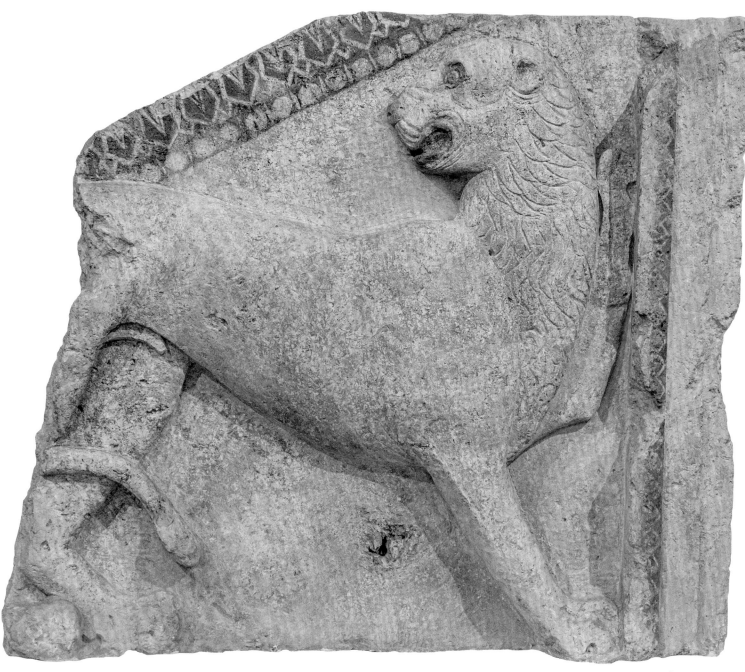

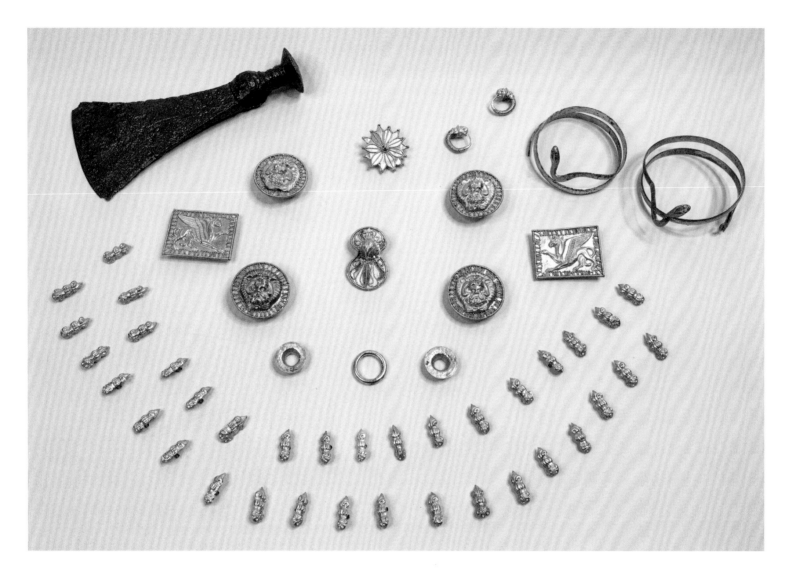

57

TUMULUS 3 AT KRALEVO

Excavated in Kralevo, Targovishte
Province, Bulgaria, in 1979

Tumulus 3 in the necropolis near the village
of Kralevo was excavated in 1979. The
rectangular burial structure was built of split
stones. Grave goods were discovered on the
floor, around a clay *hydria* decorated with
traces of gold foil that contained cremated
remains. The earrings were placed in one of
the bracelets, and all forty-seven appliqués
for a horse harness were found together
with an iron bit near the north wall. Also
found in the tomb were a funerary wreath
of gilded bronze and terracotta, an axe

(cat. 57a), and an iron strigil, as well as clay
objects, including an unguentarium, a jug, a
lamp, and a Thasian amphora. Anthropo-
logical analysis suggests that the cremated
remains were of a woman, and the precious
grave goods and the iron axe indicate an
individual of high status.[1] The burial likely
dates from the second quarter of the third
century BC, based on the Thasian stamp
on the amphora, datable to 274–267 BC.[2]

The personal ornaments from Kralevo—
gold lion's-head earrings and gilded-silver
snake bracelets—are typical of Greek jewelry
of the Early Hellenistic period. The earrings
are of the most common type: ring-shaped,

with a lion's-head terminal at one end, while
the other end is tapered and wrapped in
gold wire (cat. 57b). The collar is made of a
bent plate with decoration of double spirals
of smooth and beaded wire. The type is
widespread in Thrace, both in the Greek
cities on the Black Sea coast (Odessos,
Bizone, Apollonia Pontica, and Mesembria)
and in rich Odrysian and Getic burials in the
interior (Mezek; Seuthopolis; Dragoevo and
Smyadovo, near Shumen; and Sboryanovo).[3]

The bracelets in the shape of a coiled
snake with the head lifted up and a twisted
tail are made of gilded-silver plate (cat. 57c).
The head is modeled, with chiseled scales.

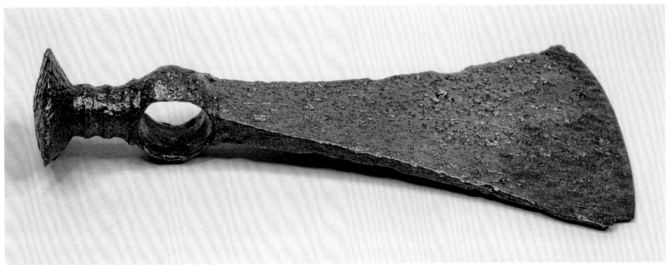

57a

a. **Iron Axe**
 ca. 275–250 BC
 Iron
 17.3 × 9 × 3.5 cm
 Targovishte, Regional Historical Museum,
 2315

b. **Pair of Lion's-Head Earrings**
 ca. 275–250 BC
 Gold
 Diam: 1.4/1.1 cm; Thickness: 0.5 cm;
 Wt: 6.1 grams each
 Targovishte, Regional Historical Museum,
 2309

c. **Pair of Snake Bracelets**
 ca. 275–250 BC
 Silver with gilding
 Diam: 6.5 cm; Thickness: 0.5–0.7 cm;
 Wt: 33.5 grams
 Targovishte, Regional Historical Museum,
 2310

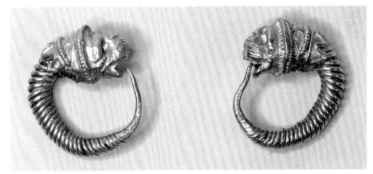

57b

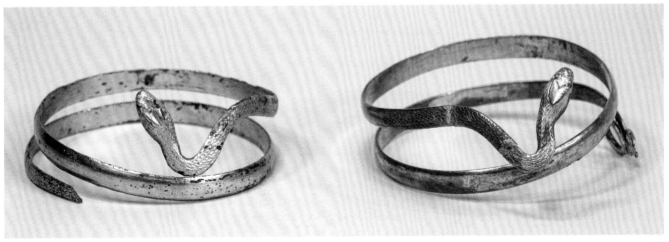

57c

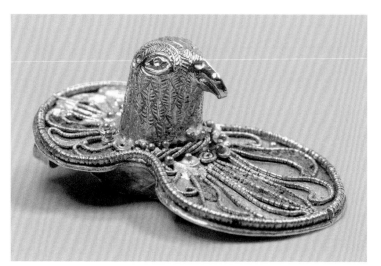

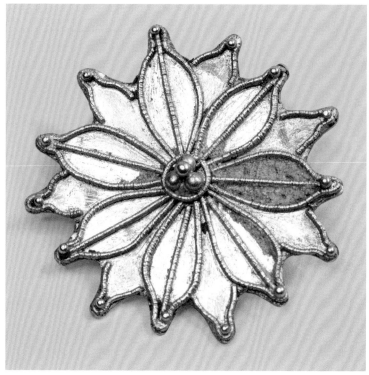

57d

57e

Such snake bracelets, usually made of gold, were very popular in the Hellenistic world. An almost identical gold bracelet is known from Aytos, in Thrace.[4]

The forty-seven gold horse harness appliqués allow for a complete reconstruction of the bridle. The three single appliqués—frontlet, rosette, and ring—decorated a strap running down the middle of the head, and the other appliqués were arranged symmetrically on either side of the headstall to the reins. The frontlet has a figure-eight base with three rings soldered to the underside and is decorated with a hollow eagle's head with chiseled feathers (cat. 57d). The base is ornamented with a border of beaded wire and two filigree palmettes. Every second leaf was filled with colored enamel. At the base of the head, there is a circle of double spirals of smooth wire and granulation.

The rosette-shaped appliqué has two tiers of leaves, with only the tips of the lower ones visible, and its decoration is in the same style—borders of beaded filigree, colored enamel, and granulation (cat. 57e). The four round appliqués with facing Herakles heads are of exceptional quality (cat. 57f). The head of the hero wearing a lion's skin, rendered in high relief, is soldered to a round plate,

surrounded by a border of eggs of beaded filigree with traces of enamel and granulation. The two rectangular appliqués with griffins, one facing left and the other right, also consist of a smooth base with another plate with the image in high relief soldered on top of it (cat. 57g). The anatomical details on the body and the wings are chiseled, and the border has the same decoration of filigree eggs filled with enamel. All the appliqués have loops on the back for attaching to a strap.

The frontlet, the central rosette, and the appliqués with Herakles and griffins are made in Greek style, and the techniques—chiseling, filigree, granulation, and enamel—are typical of the finest examples of Early Hellenistic jewelry. They find parallels in well-known products in Thrace and beyond, most notably the jewelry from the Black Sea coast, but also in horse harness fittings, to be discussed below. It has been suggested that the Kralevo pieces were made in one of the Pontic cities, most probably Mesembria.[5]

A different style is illustrated by the thirty-six small appliqués with embossed lotus flower and palmette and with small rings at the back (cat. 57h). They were probably sewn to the reins. The two conical

d. Horse Harness Frontlet with Eagle's Head
ca. 275–250 BC
Gold with traces of enamel
H: 2 cm; W: 2.8 cm; L: 4.4 cm;
Wt: 18.2 grams
Targovishte, Regional Historical Museum, 2304

e. Rosette Horse Harness Appliqué
ca. 275–250 BC
Gold with traces of enamel
Diam: 3.7 cm; Wt: 8.1 grams
Targovishte, Regional Historical Museum, 2305

f. **Four Horse Harness Appliqués in the
 Shape of Herakles with Lion's Skin**
 ca. 275–250 BC
 Gold with traces of enamel
 Diam: 3.8 cm; Wt: 14.8/17.8/18.9/20.1 grams
 Targovishte, Regional Historical Museum,
 2300–2303

g. **Two Horse Harness Appliqués with
 Griffins**
 ca. 275–250 BC
 Gold with traces of enamel
 H: 3.6 cm; W: 4.6 cm
 Targovishte, Regional Historical Museum,
 2298, 2299

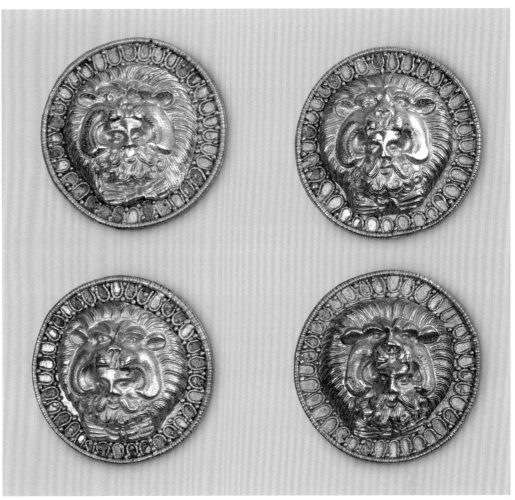

57f

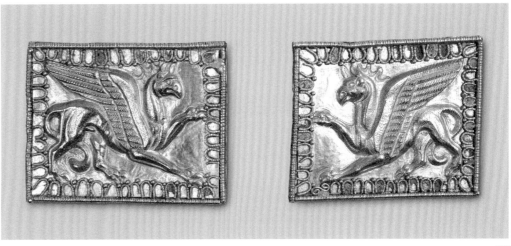

57g

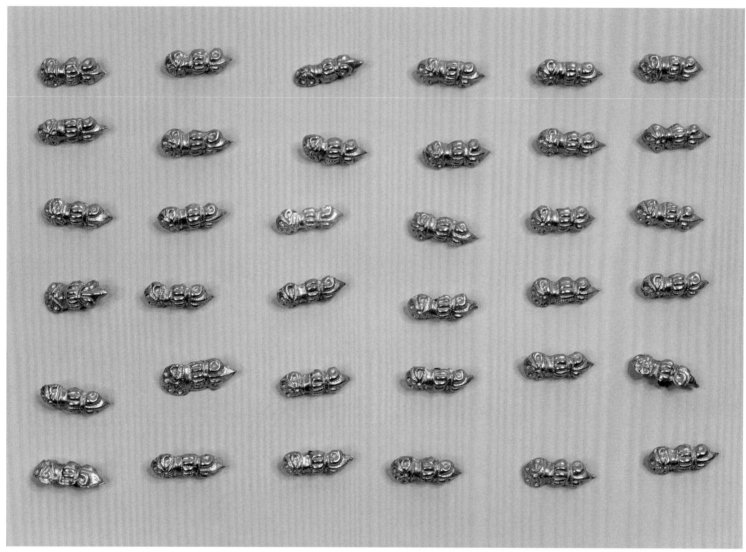

57h

h. **Thirty-Six Lotus Flower Appliqués
for a Horse Harness**
ca. 275–250 BC
Gold
H: 1.8–2.2 cm; W: 0.7–0.9 cm;
Wt: approx. 1 gram each
Targovishte, Regional Historical Museum,
2306

elements for the ends of straps and the gold ring complement the suggested reconstruction (cats. 57i, 57j).[6] This group of objects was probably made in a local workshop. A bronze punch with a similar image and an unfinished stamped gold plate were discovered in the nearby fortress at Dragoevo, Shumen region.[7]

The items from Kralevo belong to a distinctive group of such decorations for horse harnesses made of gold in the so-called Jewelry Style. They differ from earlier examples in terms of material—gold instead of silver—but also in the choice of new images and motifs. They follow a common style attested in the Greek cities and in the interior of Thrace, despite differences in execution by various workshops. The gold horse harness sets were a new phenomenon in the Odrysian and Getic lands, and their appearance in rich burials from the first half of the third century BC could be related to the reign of Lysimachos and the well-attested Macedonian presence.[8] From the Getic lands, there are examples from a burial mound at Kavarna (ancient Bizone),[9] the Tomb of Sveshtari (the Getic capital, Helis),[10] and tumuli related to Thracian fortresses in the northern foothills of the eastern parts of the Balkan Range (Kralevo and Ivanski, Shumen region).[11] To the south, there are the finds from the tomb of Seuthes III in the Golyama Kosmatka Tumulus (cats. 54i–54o),[12] and from the Mal-tepe Tumulus in the village of Mezek (cat. 50).[13] Recently another group was discovered in a burial mound near Primorsko, on the Black Sea coast.[14] More harness sets in gold, also presumably from Thrace, are in private collections.[15] Certainly the exquisite gold decorations for horse harnesses became the new insignia of the Thracian elite in the Hellenistic period, reflecting a cultural symbiosis between Thracians, Greeks, Macedonians, and Celts. •MT

1 Ginev 1983, 5, 9–10, 42–44; Marazov 1998a, 118–21, nos. 37–41; Ginev 2000, 1–36, 42–47; M. Tonkova in Martinez et al. 2015, 58–59, figs. 2a–b.
2 Ginev 1983, 42; Ginev 2000, 16–17, 36–37, 43; Tonkova 2010, 53–54, n. 45.
3 Ginev 1983, 11, 20–22, figs. 21, 22; M. Dimitrova 1989; Ginev 2000, 25–26, 45, fig. 24.
4 Ginev 1983, 11, 20, figs. 17, 18; Ginev 2000, 25, 45, fig. 23.
5 Ginev 1983, 36–42; Ginev 2000, 34–35.
6 Ginev 1983, 13–20, figs. 15, 26–38; Ginev 2000, 26–34, figs. 26–34.
7 Tonkova 2010, 52.
8 For a discussion of the chronology, see Tonkova 2010.
9 Minčev 1983.
10 Gergova 2015.
11 Tonkova 2010, 53–55.
12 D. Dimitrova 2015, 209–18.
13 Filov 1937, 30–33; Tonkova 2010; Tzochev 2014.
14 Balabanov and Pantov 2018.
15 Vladimirova-Paunova 2005; Marazov 2011c, no. 154.

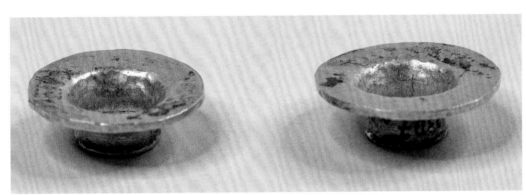

57i

i. **Two Funnel-Shaped Appliqués**
 ca. 275–250 BC
 Gold
 Diam: 2 cm; D: 0.6 cm; Wt: 4.6/3.9 grams
 Targovishte, Regional Historical Museum, 2307

j. **Ring**
 ca. 275–250 BC
 Gold
 Diam: 2.2 cm; D: 0.4 cm; Wt: 9.6 grams
 Targovishte, Regional Historical Museum, 2308

57j

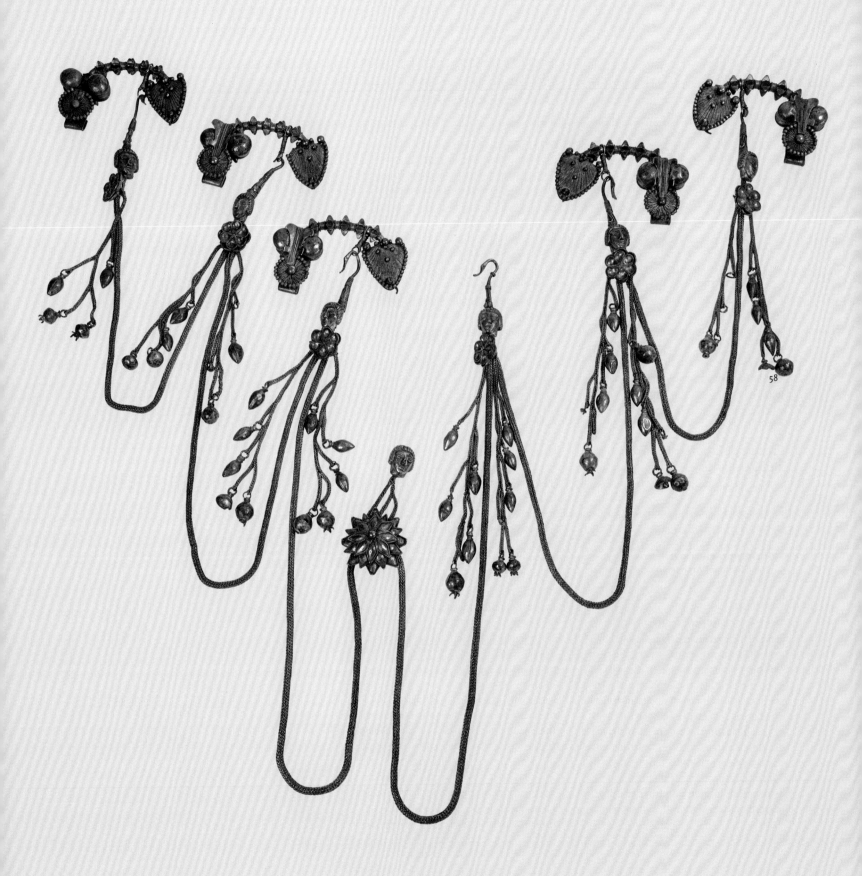

58

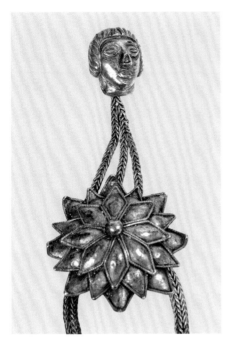

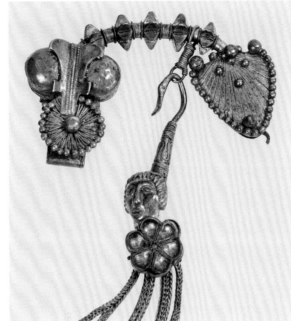

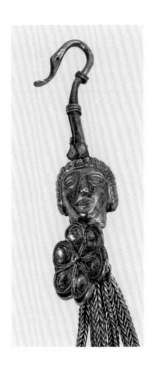

58

Parure of Fibulae, Chains, and Pendants

Late 4th century BC
Silver
Assembled parure: approx. 46 × 46 × 2 cm;
Wt: 642.9 grams
Chance find near Bukyovtsi (Miziya),
Vratsa Province, Bulgaria, in 1925
Sofia, National Archaeological Institute
with Museum, 2558A

This lavish chest parure consists of five identical hinged arched fibulae linked by long chains, along with shorter chains with pendants, including human heads and an elaborate central rosette. There were likely seven fibulae originally (two are now lost): three on each shoulder and one for the central pendant. The bow of each fibula is decorated with six rosettes; the head plate is in the shape of a stylized palmette with beaded edge; and the catch plate is T-shaped, decorated with two hemispherical buttons and a rosette with a beaded edge.

A long chain hangs from the bow of each fibula, with the terminal shaped like a swan's head and decorated with a stylized human head and a rosette. Several shorter and thinner chains are attached to the fibulae, ending in pendants shaped like buds and poppy heads. Various metalworking techniques were employed in the making of the parure: casting, forging, soldering, stamping, chiseling, filigree, and granulation.[1]

The fashion for hinged fibulae linked with long snake chains has its roots in northern Greek traditions.[2] A similar parure from the Sindos necropolis and another one from Elis, in the Peloponnese, but presumably brought from the north, date from the second half of the fifth century BC.[3] The Bukyovtsi parure is later in date, probably late fourth century BC or even later, and illustrates the craftsmanship of a Thracian workshop in the lands of the Triballoi, where most hinged fibulae of this local west Balkan type were discovered, often together with large silver-sheet bracelets.[4] Human-head pendants are typical of the personal adornments and horse trappings of the Triballoi and Getai tribes.[5] Such objects are usually dated to the second half of the fourth century BC, but recent finds point to a chronology as late as the early third century BC.[6] A similar swan's-head terminal is found on a gold necklace and a chest parure from the Kazanlak Valley datable to the late fourth century BC.[7] •MT

1 R. Popov 1922–25, 1–8, figs. 2–10; Venedikov and Gerasimov 1973, 107–8, nos. 210–12; Marazov 1998a, 199, no. 140; Tonkova 2003, 217–18.

2 R. Popov 1922–25, 11, fig. 14; Amandry 1963, 210, fig. 116.

3 Sindos parure: Vokotopoulou et al. 1985, nos. 351–52; Elis parure: Williams and Ogden 1994, 52, no. 6.

4 A. Dimitrova 1966, 124–28; Vasić 1999, 114–17; Tonkova 2017, 19–21; Tonkova 2023, 38–39.

5 Venedikov and Gerasimov 1973, 107–8; Tonkova 2003, 218; Tonkova 2017, 19–21.

6 Tonkova 2003, 218; Tonkova 2017, 21–22; Stamberova 2023, 24; Tonkova 2023, 41–42.

7 Tonkova 2003, 218.

BURIED WEALTH

IX.

An extraordinary number of precious-metal items from Thrace have been discovered, almost exclusively by chance, as parts of hoards without any immediate archaeological context. To this group belong some of the most famous riches associated with the ancient Thracians, notably the magnificent gold and silver vases from Panagyurishte, Rogozen, and Borovo.

The circumstances under which these caches were buried remain unknown. The happy chance that the Rogozen vases were apparently too numerous to be placed in a single pit, however, and were therefore split into two groups, allowed for the second find to be excavated by archaeologists, revealing a tightly packed pile of silver vessels, most probably buried in a sack made from a perishable material. A bronze cauldron was the repository for the Letnitsa Treasure, and a ceramic vessel contained a hoard of silver vases and horse bridle fittings found at Lukovit, in northern Bulgaria.

The contents of the hoards correspond closely to the items excavated in rich tumulus burials from the same period, reflecting the aristocratic way of life of noble Thracians, who banqueted with sets of silver and gold vases and rode horses decorated with lavish trappings. An iron bit accompanied the Letnitsa appliqués, and the Lukovit hoard contained three bits of iron and bronze, corresponding to three separate sets of trappings, indicating that entire bridles were buried.

A number of hypotheses have been put forward to explain the Thracian hoards. It has been suggested that they had ritual purposes, perhaps serving as offerings to please or appease the gods or as a way to lay claim to the land. The contents—precious-metal vessels, horse trappings, or both—do not, however, reveal an obvious pattern that would indicate a specific ritual. Vessels and horse trappings did nevertheless serve as symbols of social status and ultimately as a store of wealth. Their social significance is well illustrated by the dozens of *phialai* and other vases inscribed with the names of Kotys and other Odrysian rulers, which were obtained as gifts or tribute from communities in southeastern Thrace. These were prized possessions, and while a ritual function for the hoards cannot be completely ruled out, hiding them for safekeeping in troubled times is a simpler explanation.

The nature of the Rogozen Treasure—which comprises a huge number of vessels spanning more than a century and a half, some of them damaged and showing signs of long use—is more compatible with bullion value than with a ritual act. The find has been interpreted as war booty in the context of the Thracian campaigns of Philip II of Macedon and his clash with the Triballoi, but the dating of some of the vases points to later periods of turmoil. Similarly, the Panagyurishte Treasure, with its pictorial program that is unrelated to Thrace but reflects the propaganda of the new world created by Alexander the Great and his successors, should also be regarded as a historical marker of the dynamic processes in the region in the Early Hellenistic period. •MD

59
THE PANAGYURISHTE TREASURE

Chance find near Panagyurishte,
Pazardzhik Province, Bulgaria, in 1949

In 1949 a set of nine vessels made of gold,
with a total weight of about 6.2 kilograms,
was unearthed on the southern outskirts of
the town of Panagyurishte, in southern
Bulgaria.[1] The findspot revealed no traces of
a burial, settlement, or any other kind of
archaeological remains. After the discovery
the unique gold hoard became a symbol of
ancient Thracian riches, and over the years it
has drawn much scholarly interest. Various
interpretations of its origin and date, as
well as of the meaning of the figural scenes,
have been proposed.

The Panagyurishte Treasure consists
of an amphora-*rhyton*, two *rhyta* with stags'
heads, one *rhyton* with a ram's head, one
rhyton with a goat protome, three jug-*rhyta*
shaped as female heads, and a *phiale*. All

vases but the *phiale* were made using the
same techniques:[2] their bodies were cast in
one piece, then all additional elements
were made separately. The handles, horns,
and ears of the animal-shaped *rhyta* were
attached (soldered) by means of specially
designated holes. The finer details of the
decoration were chiseled and hammered
from the outside, and the eyes of the ani-
mals and the goddesses were additionally
faceted and inlaid. There are traces of niello
in the dotted letters of the inscriptions,
as well as in the horns and other details.
The *phiale mesomphalos* was made by
hammering a thick sheet of gold in the
repoussé technique. Based on their shape
and decoration, several distinct groups
of vases can be distinguished, although
most of them appear to be closely related
and belong to a carefully planned pictorial
program.

a. **Amphora-*Rhyton***
Late 4th–early 3rd century BC
Gold
H with handles: 29.1 cm; Diam: 14 cm;
Wt: 1693.9 grams
Plovdiv, Regional Archaeological
Museum, 3203

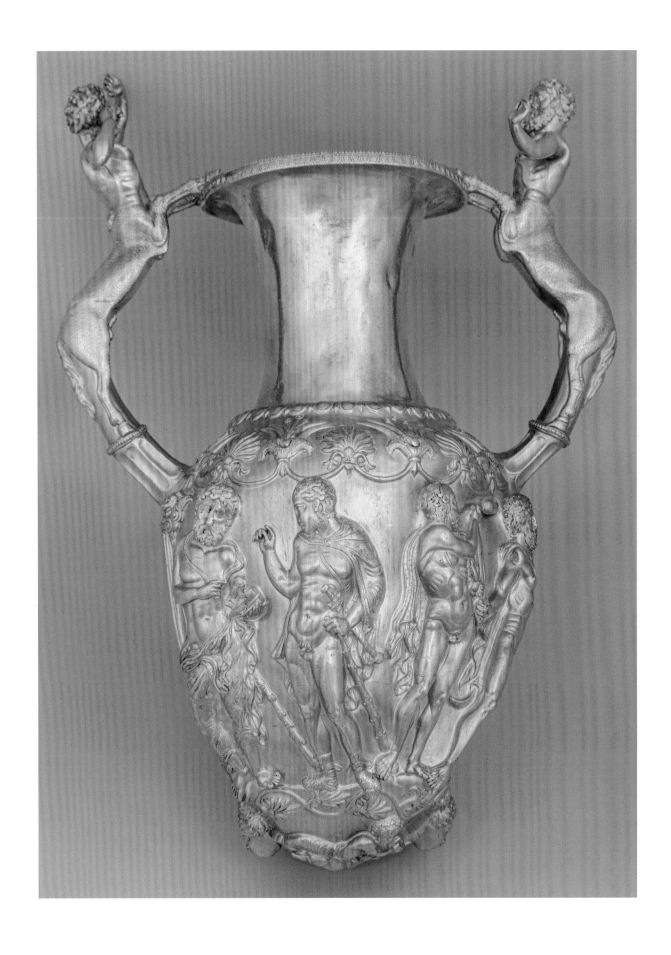

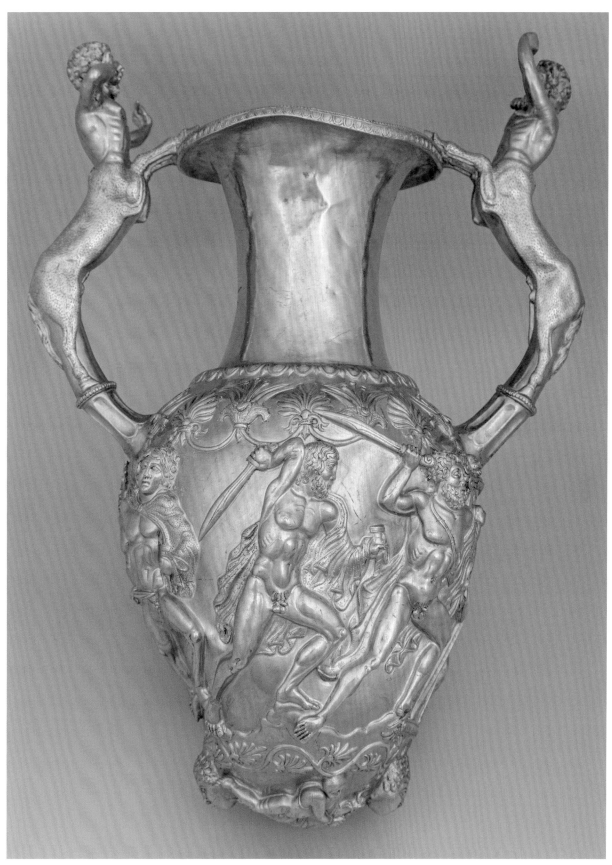

The amphora-*rhyton* (cat. 59a) is the largest and most elaborate vessel of the Panagyurishte Treasure and has attracted the most scholarly attention, as it is considered the key to interpreting the entire set. The shape is of Achaemenid Persian origin, but the decorative and mythological motifs are entirely Greek. Instead of winged animals with heads turned backward, the handles, separately made and attached, depict two centaurs of purely Greek style. The neck is separated from the ovoid body by a band of Ionic cymatium, with a band of palmettes and lotus flowers below. On the body of the amphora is a multifigure composition depicting seven men on an uneven, rocky terrain, four of them moving to the right toward a door. First, at left, there are two figures facing each other—a bearded older man conversing with a young man. The former is dressed in a long *himation* thrown over his shoulders and covering the lower part of his body; the latter is naked, with only a mantle. They both have clubs, and the older man holds an uncertain object (perhaps a liver for divination?) in his left hand. To the right of them are a man blowing a *salpinx* and four warriors with drawn swords of the *kopis* type. They attack a two-winged door from which a man peers out. The warriors and the man with the *salpinx* are nude, with only mantles on their shoulders.

The lower portion of the vessel is decorated with Herakliskos Drakonopnigon, the infant Herakles strangling two snakes, and an old Silenos (Paposilenos) flanked by two African male heads in high relief; their mouths serve as the lower spouts for the amphora, which thus functions as a *rhyton*. On the interior of the neck, close to the rim, two Greek letters are incised, ΣΨ (or ΜΨ); they are interpreted as Greek numerals indicating the weight of the vessel as 200 (Persian) darics and 4 (Attic) obols.

The most commonly accepted interpretation of the scene, first proposed by Erika Simon, is that it presents an episode from the myth of the Seven against Thebes.[3] Corroboration is provided by the presence of other Theban symbols, including the lions' heads above the columns flanking the door and the sphinx at their base. The depictions of the infant Herakles, another myth set in Thebes, and the old Silenos (an allusion to Dionysos) also support such an interpreta-

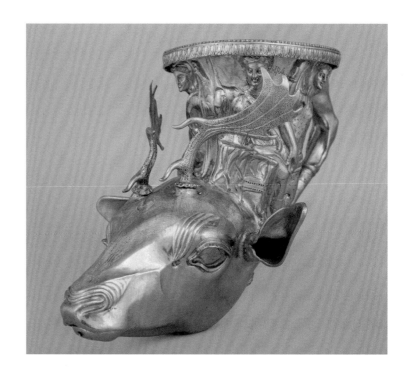

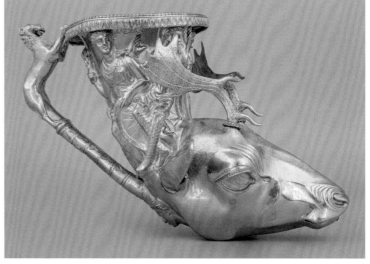

59b

tion. Simon paid special attention to the triplet vessels—the *rhyta* with animal head and handles ending in lions and the jug-*rhyta* with handles ending in sphinxes, symbols associated with Thebes. According to her, the symbolism of the two heads of African men is related to the main ornamental motif of the *phiale*.

Other, less convincing interpretations of the scene have been suggested,[4] including several that see specifically Thracian connotations.[5] The most recent refer to important discoveries in the region of Panagyurishte. When the treasure was discovered, the

b. ***Rhyton* with the Head of a Stag**
Late 4th–early 3rd century BC
Gold
H with handle: 14.7 cm; Diam of rim: 8.8 cm; Wt: 674.3 grams
Plovdiv, Regional Archaeological Museum, 3197

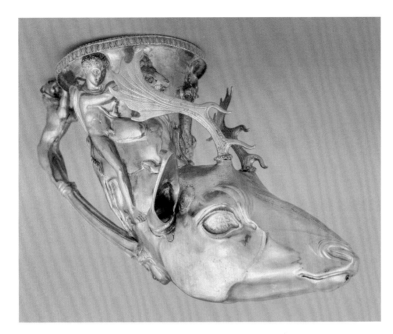

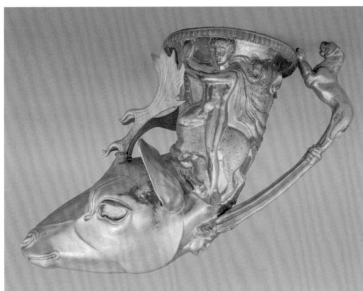

59c

c. *Rhyton* with the Head of a Stag
Late 4th–early 3rd century BC
Gold
H with handle: 14.8 cm; Diam of rim:
8.7 cm; Wt: 688.9 grams
Plovdiv, Regional Archaeological
Museum, 3198

archaeological record of the area was quite meager. Later excavations not far from the findspot brought to light spectacular monumental tombs and rich burials. The discovery of the extremely interesting tomb near the village of Starosel, Plovdiv region, some thirty kilometers away from Panagyurishte, evidently related to the dynastic residence nearby, spurred new hypotheses about the treasure's provenance (see fig. 34). The tomb's excavator, Georgi Kitov, perceived Thracians not only in the figures in front of the door in the scene on the amphora-*rhyton*, which he identified as the

door of a tomb, but also in the two conversing figures, whom he believed were in the burial chamber.[6] Strong objections, however, could be voiced. The heroic nakedness of the men does not suggest that they are Thracians, who are always depicted on toreutic works and tomb paintings as clothed. When they appear in Greek vase painting, they wear the typical *zeira* (cloak) and *alopekis* (fox-skin cap). Also, the identification of the door as belonging to a tomb is problematic, for it is not like tomb doors in Thrace.[7] Furthermore, the men "inside the tomb" stand on the same rocky terrain as the men shown outside.

The *rhyta* in the shape of animal heads—two stags and a ram—form a distinctive group that is related to the amphora-*rhyton* in terms of both technique and decoration. They all have the same general appearance, a short conical horn ending in a realistically depicted head of an animal with the mouth serving as the spout of the *rhyton*, and the necks are decorated with figural friezes in high relief. In all cases, the handles attached to the horn have a lion at the upper end. The beast's front paws rest on the rim, while its rear paws step on a column—in one case with smooth drums rendered in relief and in the other two fluted. The base of the handle is inserted into a facing woman's head, which is made in repoussé integral to the *rhyton*. The flaring rims are decorated with a row of pearls and an Ionic cymatium.

The neck of the first stag's-head *rhyton* (cat. 59b) is decorated with a frieze of four seated figures illustrating the Judgment of Paris: Athena holding a helmet in her right hand and supporting a shield with her left, Paris in Phrygian dress, Hera on a throne, and Aphrodite standing next to her. The names of the characters are written in Greek in dotted letters next to their heads, with Paris being designated as Alexander.

The relief frieze on the second stag's-head *rhyton* (cat. 59c) depicts two antithetical scenes: on the left, Theseus subduing the bull of Marathon and, on the right, Herakles's third Labor, the capture of the Keryneian Hind. The presentation of both heroes together, with clear reference to the legendary history of Athens and Greece, suggests a connection to the great victory over the Persians at Marathon (490 BC).

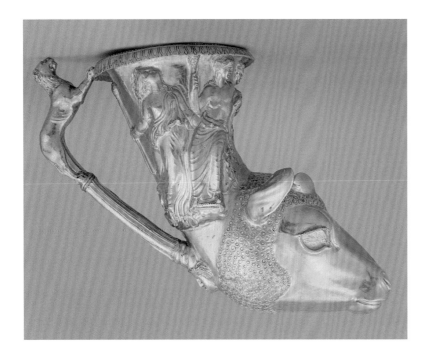

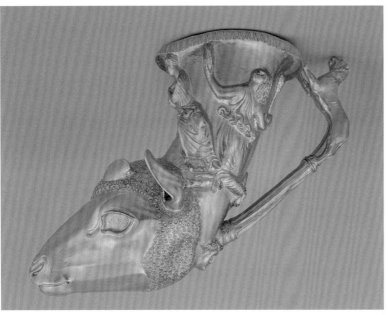

d. **Rhyton with the Head of a Ram**
Late 4th–early 3rd century BC
Gold
H with handle: 13.7 cm;
Diam of rim: 8.9 cm; Wt: 504.1 grams
Plovdiv, Regional Archaeological Museum,
3199

59d

The ram's-head *rhyton* (cat. 59d) displays another composition of four figures. In the center Dionysos is depicted young and beardless, holding a *thyrsos* and seated beside a young woman identified as Eriope by the dotted inscription next to her head. On either side are maenads caught up in a frenzied dance, one holding a *thyrsos* and the other a *tympanon*. The identity of Eriope remains a mystery, as no ancient source mentions a maenad or other companion of Dionysos of this name.[8] One hypothesis, however,

suggests that she may be a nymph associated with Dawn (from *erigeneia*)—a companion of Dionysos in India. She thus may allude to the submission of Asia to Alexander.[9]

To the same group belongs the *rhyton* with he-goat protome (cat. 59e). The body of the *rhyton* is longer and curves slightly upward. It is decorated in high relief with the figures of Apollo, Hera, Artemis, and Nike, each identified by a dotted inscription and depicted with a specific attribute. The flaring rim is decorated with Ionic cymatium. The

two pairs in the composition—Hera and Nike, and Apollo and Artemis—likely symbolize, respectively, continental Greece and Ionian Greece. Hera, the goddess of Argos, was protectress of the victorious Achaeans at Troy, and the divine twins were on the side of the Trojans.[10] The goat protome has replaced the ibex typically found on Achaemenid *rhyta* and may serve as a "talking symbol" representing the Macedonian capital of Aigai (*aigai*, "goats"), as on the coins of the city.[11]

e. ***Rhyton* with Goat Protome**
Late 4th–early 3rd century BC
Gold
H: 14 cm; L of protome: 14 cm; Diam of rim:
8.9 cm; Wt: 439 grams
Plovdiv, Regional Archaeological Museum,
3196

The three jug-*rhyta* in the shape of
female heads form another distinctive group.
They were initially considered heads of
Amazons, but a more convincing interpreta-
tion, proposed by Kamen Kolev, identifies
them as the goddesses Aphrodite, Hera,
and Athena, with reference to the scene
of the Judgment of Paris on the stag's-head
rhyton described above (cat. 59b). Kolev
suggested that there was originally a
fourth jug-*rhyton* with the head of Paris-
Alexander, which was subsequently lost.[12]

The first vase depicts Aphrodite
(cat. 59f).[13] The neck is adorned with a
necklace of beads and spear-shaped
pendants. Although the nose is damaged,
the face retains the goddess's classic
features. Her hair is gathered under
a veil (*sphendone*) tied over the forehead,
its embroidered decoration carefully
detailed. A rectangular diadem can be
seen between the curls on the forehead.
The eyes were originally inlaid with glass
paste, which is now lost.

The second jug-*rhyton* presumably
depicts Hera (cat. 59g).[14] The necklace is
more complex, with two rows of pen-
dants, and the decoration on the diadem
also differs, as does the ornamentation
of the veil.

The final jug-*rhyton* surely depicts the
goddess Athena (cat. 59h). She wears
a helmet with two griffins decorating the
crown. A pediment-shaped diadem with
engraved palmette and tendrils is worn
between the curls of the forehead, and
its ribbons are tied at the nape of the
neck, below the palmette at the base of
the handle, in a Herakles knot.

f. **Jug-*Rhyton* with Head of Aphrodite**
Late 4th–early 3rd century BC
Gold
H with handle: 19.6 cm;
Diam of rim: 7 cm; Wt: 460.8 grams
Plovdiv, Regional Archaeological Museum,
3201

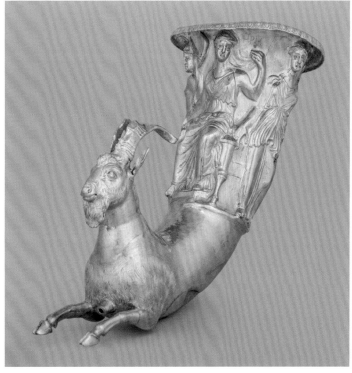

59e

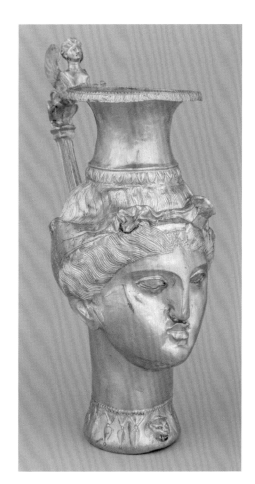

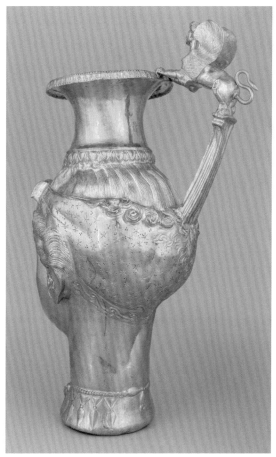

59f

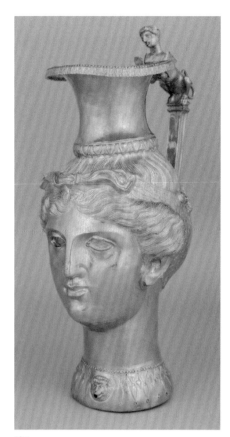

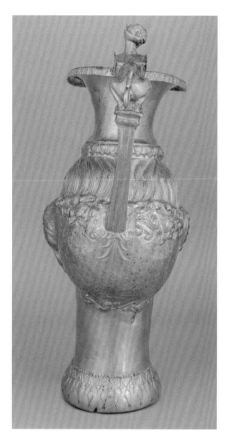

59g

The vases were conceived as a set, a triad of goddesses. The two vases depicting Aphrodite and Hera are almost identical, the head modeled down to the base of her neck, where a lion's head in high relief serves as the spout of the *rhyton*. The third *rhyton* differs, because Athena's helmet modifies the overall silhouette of the vase. The handles on all three vases are similar; they were made separately and consist of a quadrangular fluted column on which stands a sphinx resting its front paws on the mouth of the vase.

The *phiale mesomphalos* (cat. 59i) differs from the rest in terms of technology and decoration. The omphalos is surrounded by twelve rosettes, followed by a circle of twenty-four acorns, followed by three rows, each with twenty-four heads of Black African men of increasing size. The space between the rows and around the heads is filled with various combinations of palmettes, scrolls, and tendrils. Two numerical inscriptions in Greek letters are engraved on the bowl below the rim, indicating the weight of the *phiale* in two different systems: 100 Persian

g. **Jug-*Rhyton* with Head of Hera**
Late 4th–early 3rd century BC
Gold
H with handle: 21.3 cm;
Diam of rim: 7.2 cm; Wt: 462 grams
Plovdiv, Regional Archaeological Museum,
3200

h. **Jug-*Rhyton* with Head of Athena**
Late 4th–early 3rd century BC
Gold
H: 20.2 cm; Diam of rim: 4.5 cm;
Wt: 387.3 grams
Plovdiv, Regional Archaeological Museum,
3202

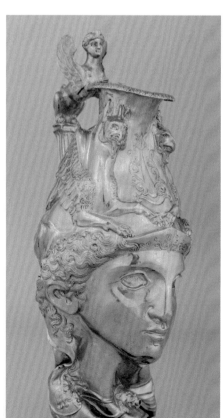

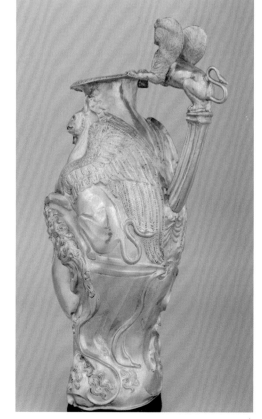

59h

i. *Phiale Mesomphalos*
Late 4th–early 3rd century BC
Gold
H: 3.9 cm; Diam: 24.7 cm; Wt: 845.5 grams
Plovdiv, Regional Archaeological Museum,
3204

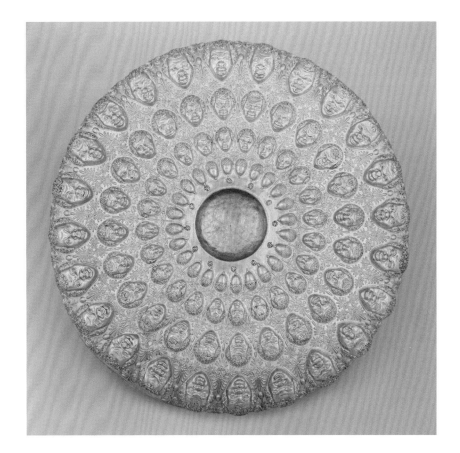

darics (8.457 grams) and 196 1/24 Athenian
drachmai (4.31 grams). The combination
of both systems suggests a date in the late
fourth century BC.[15]

A similar date, between the deaths of
Alexander the Great and his successor in
Thrace, Lysimachos, was proposed by
Dietrich von Bothmer.[16] After a thorough
analysis of the *phiale*'s technical manufac-
ture, along with that of a very similar gold
phiale now in New York,[17] he considered it
"purely Greek in style and technique," while
the other vessels of the treasure were of
"somewhat different style and could hardly
have been made by the same artist."[18] When
the slightly different color of the gold
is taken into account, it appears likely that
the *phiale* did not have the same origin
as the rest of the treasure.

The level of skill involved in the making
of the *phiale* and its decoration with Black
Africans' heads led Simon to suggest as
a possible prototype the *phiale* held by the
famous statue of Nemesis in her temple in
Rhamnous. According to Pausanias, she held
"a *phiale* in the right hand, on which Ethio-
pians have been worked."[19] Similar *phialai
aithiopides* were also offered to Athena,
indicating a specific religious symbolism.[20]

In his exhaustive and well-illustrated
initial publication, Dimitar Tsonchev was
inclined to consider a Late Classical Athenian
provenance for the vessels that make up the
Panagyurishte Treasure.[21] Ivan Venedikov
later postulated that they were made in a
workshop in Lampsakos,[22] a view that is
still maintained by some Bulgarian scholars.
He believed that the use of darics in the
weight inscriptions of the amphora-*rhyton*
and the *phiale* was unique, an opinion that
was subsequently criticized. In fact, many
other poleis based their coinage on the
Persian gold daric,[23] including Abydos,
Halikarnassos, and Salamis, on Cyprus.
Later Venedikov suggested that the vessels
were commissioned by the Thracian king
Seuthes III, based on the erroneous claim
that the treasure was found in the "Valley of
the Roses" (Kazanlak, in fact, is about one

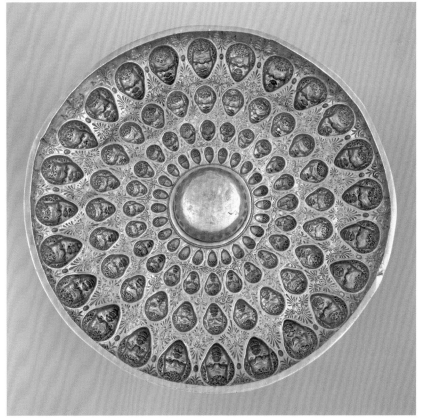

hundred kilometers to the east).[24] The jewelry worn by Aphrodite, Hera, and Athena on the jug-*rhyta*, notably the diadems and necklaces, belongs to types known mainly from the Hellespont and the Propontis (Sea of Marmara) in the Early Hellenistic period and is indicative of the region where the workshop that produced the vessels was located.[25] Although most scholars acknowledge the Greek workmanship of the treasure, a Thracian origin has been suggested, based on the abovementioned interpretation of the scene on the amphora-*rhyton* by Kitov and others.

The Panagyurishte Treasure consists predominantly of various *rhyta*, reflecting the cultural traditions of the regions where such vases were used for ritual and banquet: Thrace and Anatolia, on both sides of the Propontis. The vessels were probably part of a larger set, which was decorated with a carefully planned pictorial program directly related to its ritual function. Simon has explained the interconnections between the mythological scenes on the *rhyta*—the Judgment of Paris (deliberately labeled Alexander), the Labors of Herakles and Theseus, Dionysos with his *thiasos*, and so on—as an expression of the propaganda initiated by Philip II and continued by Alexander the Great aimed at uniting the Greeks, together with the Macedonians, in the campaign against Persia.[26]

Initially the treasure was probably meant for a sanctuary, where it would have had a ceremonial function, rather than for the court of a Hellenistic ruler. In the Early Hellenistic period, the boundary between the precious-metal banqueting sets of the kings and the sacred plate from temple treasures was blurred. For example, in 288/287 BC Seleukos I pledged to the Sanctuary of Apollo at Didyma four *phialai* decorated with acorns, three *rhyta* with deer's heads, a horn, an *oinochoe*, a *psykter*, and a bread platter—all made of gold and with a total weight of about fourteen kilograms.[27] The objects described are quite similar to those from Panagyurishte.

As it is likely that the workshop or workshops that created the treasure were located somewhere between the island of Thasos and the shores of the Propontis,[28] there is one historical figure who best

represents the intersection of this geographic region with the Early Hellenistic period—Lysimachos, the Diadoch to whom the power over Thrace was entrusted after Alexander's death. In 309/308 BC Lysimachos established his capital, Lysimachia, in the area of present-day Bolayir (ancient Agora) on the Thracian Chersonese,[29] and the city quickly became a center of Hellenistic culture. After the Battle of Ipsos in 301 BC, when Lysimachos added western Asia Minor, with its many old Greek cities, to his domain, he took the opportunity to display a pious reverence for the feats of Alexander, including the restoration of the city of Ilion. The most prestigious element of this agenda was the creation, around 300 BC, of a *temenos* dedicated to Athena, with a temple in the Doric order and the establishment of a Panathenaia festival meant to revive the spiritual prestige of Troy.[30] The temple's sculptural decoration glorified the connections between the mythological and the contemporary history of Troy, with clear stylistic influence from Athens.[31]

It is possible that the Panagyurishte Treasure was designed as an offering at the Sanctuary of Athena at Troy and dedicated at the Panathenaia festival. Another possibility, however, is that it was offered at the sanctuary in Lysimachia, where the cult buildings were probably related to the same ideological program. Appian relates that a large altar visible from all sides existed in Lysimachia, apparently referring to a monumental structure like the famous altar of Zeus in Pergamon.[32]

How the Panagyurishte Treasure came to be deep in the Thracian interior is unknown. If once kept in Lysimachos's treasury or in the sanctuary in Lysimachia, Troy, or another city in the Propontic region, then it may have been carried away, after the king's death, during the tumultuous struggle for succession. The murder of Seleukos I Nikator in Lysimachia in 281 BC or the sack of the city by the Celts in 278 BC would be other occasions when the treasure could have been seized. A more likely time, however, might be during the campaign by Antiochos II in southern Thrace in the mid-third century BC, when Seuthopolis was captured and destroyed. •TS

1 Marazov 1998a, 142–48, nos. 68–76; T. Stoyanov in Martinez et al. 2015, 220–29, nos. 184–92; E. Penkova et al. in E. Penkova, Konova, and Kisyov 2017, 205–24, nos. 203–11.
2 Recently, a complex technical study of all the vessels from the Panagyurishte Treasure was carried out: E. Penkova et al. 2015. In addition to the detailed observations on the techniques and stages of production of the vessels, weights were measured with great precision, and the composition of the metal of the vases and the solder were analyzed and published.
3 Simon 1960; Kontoleon 1962; Strong 1966; Daumas 1978; Marazov 1978; Simon 2000; Stoyanov 2004b.
4 Končev 1956; Hoffmann 1957; Roux 1964; Del Medico 1967–68; Hind 1983; Griffith 1985; Dörig 1987; Marazov 2002.
5 K. Kolev 1978; Zazoff 1998; Agre 2003; Kitov 2006, 56–71; E. Penkova et al. 2015, 19; E. Penkova, Konova, and Kisyov 2017, 210.
6 Kitov 2006; similar in Agre 2003.
7 D. Stoyanova 2007.
8 Delev 1986.
9 Kontoleon 1962, 200.
10 Kontoleon 1962, 200.
11 Hammond 1983, 252–53.
12 K. Kolev 1978.
13 K. Kolev 1978, 320–21, figs. 2a, 3a, 6a, 7a.
14 K. Kolev 1978, 321–22, figs. 2b, 3b, 6b, 7b.
15 Cahn 1960, 26–27, plate 3.3; Vickers 1989, 101.
16 Von Bothmer 1962, 162.
17 New York, The Metropolitan Museum of Art, 62.11.1.
18 Von Bothmer 1962, 162.
19 Pausanias, *Description of Greece* 1.33.3; Simon 1960, 5.
20 Backe-Hansen 2016, 244–45.
21 Končev 1956.
22 Venedikov 1958, 82–85; Venedikov 1961, 18–26.
23 Cahn 1960, 27n4; Lewis 1986, 76; Vickers 1991, 31–32.
24 Venedikov and Gerasimov 1975, 86.
25 Tonkova 2005.
26 Simon 1960; Simon 2000.
27 Vickers 1991, 37–38.
28 Stoyanov 2004a, 21–28.
29 Sayar 2014; Lichtenberger, Nieswandt, and Salzmann 2015.
30 Lund 1992, 159–65, 174–77.
31 Webb 1996, 47–51.
32 Appian, *Syrian Wars* 329–34.

60

THE ROGOZEN TREASURE

Chance find with later excavations in the village of Rogozen, Vratsa Province, Bulgaria, in 1985–86

A hoard of 65 silver vessels, buried at a depth of about forty to fifty centimeters, was unearthed by a villager in Rogozen on his property.[1] Excavations led by Bogdan Nikolov of the Regional Historical Museum of Vratsa immediately followed, and a second group of 100 vessels was discovered five meters away from the first one. There were no traces of habitation or an associated burial. Since all the vessels were uncovered compactly lying on top of one another, it is believed that they had been placed in bags made from perishable material and buried in the ground.

Several important aspects of the hoard and its discovery should be noted. For the first time in Bulgaria, it was possible to determine the exact location where a hoard was buried and to investigate the circumstances of the deposit. The sheer number of silver vessels—165, some of them gilded, with a total weight of about twenty kilograms—is unparalleled. Moreover, the decorated vases reveal new motifs in the Thracian visual language but also point to extensive cultural contacts with Greece and Asia Minor. Several vessels also bear inscriptions that provide new insights into the history of the Odrysian kingdom.

The hoard consists exclusively of vessels for pouring or drinking. There are three varieties of cups—goblet (or beaker), *skyphos*, and *kotyle*—as well as 108 bowls (87 *phialai* of various shapes and 21 calyx cups), and 54 jugs.[2] Of particular interest are the decorated vessels. Some of them display simple and repetitive ornaments of geometric patterns, such as fluting, ovoid ornaments, or lobes. Others have more elaborate decoration combining floral motifs (stylized palmettes, lotus flowers, acorns, almonds, and ivy leaves), zoomorphic representations of real or fantastic creatures (lions, deer, dogs, horses' heads, bulls' heads, and griffins), and anthropomorphic representations (human heads). There are also scenes from Greek or Thracian

mythology, including Herakles and Auge (cat. 60f), Herakles and Hippolyte (cat. 60g), a goddess riding a panther (cat. 60d), a goddess in a chariot, and hunting scenes.

The date of the treasure can be determined broadly by inscriptions and stylistic analysis. A number of inscriptions were engraved on some of the *phialai* and jugs.[3] Some of these are simple marks or signs, perhaps denoting the maker, while others record the weight of the vessel.[4] There are, however, sixteen inscriptions naming individuals associated with the Odrysian ruling house. The name Satokos appears on two *phialai*; he could be the son of Sitalkes from the 430s BC.[5] Twelve vessels bear the name of Kotys, likely the Odrysian king who ruled from 384/383 to 360 BC (cat. 60a), and one bears the name of his son and heir, Kersebleptes (cat. 60b), written in a form that seems to be closer to the Thracian language than Kersobleptes, a name found in the speeches of the Greek orator Demosthenes. Considering the chronology of the attested Odrysian rulers, scholars initially suggested that the hoard was accumulated in the period between the late fifth century and the 340s BC. Its deposition was therefore believed to have been shortly after the reign of Kersebleptes, around 340–330 BC, at the time of political turbulence following the Macedonian conquest of Thrace. Although attractive, this interpretation of the find's final date has long been questioned.[6] The so-called Auge *phiale* appears to be later in style, probably belonging to the first decades or even the second quarter of the third century BC (cat. 60f).[7]

How this enormous treasure was accumulated is unknown and how it reached the lands of the Triballoi tribe in northwestern Thrace remains unclear. The repeated appearance of Odrysian royal names has led to the suggestion that the hoard was initially part of the Odrysian treasury. This interpretation was based on the formula attested in some inscriptions, indicating that the vessels were given to Kotys (and Kersebleptes), probably as a tribute, by various named settlements, including

Apros, Beos, Ergiske (Argiske), Geistoi, and Sauthaba.[8] Scholars assumed further that after the conquest of Kersebleptes's realm, the royal treasury fell into the hands of Philip II, who lost it in the unsuccessful battle against the Triballoi during his northern campaign in 339 BC. Such an interpretation is not entirely convincing, although it seems certain that some of the vessels are of Odrysian origin and were transferred in one way or another to the northern Thracian regions that remained outside Macedonian control. It does seem, however, that the treasure was enriched with new additions during the Early Hellenistic period, probably up to the time of the Celtic invasion of the Balkans in the third century BC, when political instability forced its burial. •JT

1 Nikolov 1986; Fol 1989a; Fol 1989b; Marazov 1996b.
2 Nikolov 1986; Kull 1997.
3 Fol 1989a; Mihailov 1989; Zournatzi 2000.
4 Vickers 1989.
5 See Tzvetkova in this volume.
6 Tacheva 1987.
7 Treister 2022.
8 Stoyanov 2017.

a. *Phiale* with Inscription

ca. 400–350 BC
Silver
H: 5 cm; Diam of rim: 13.5 cm;
Wt: 128.4 grams
Vratsa, Regional Historical Museum,
B 475

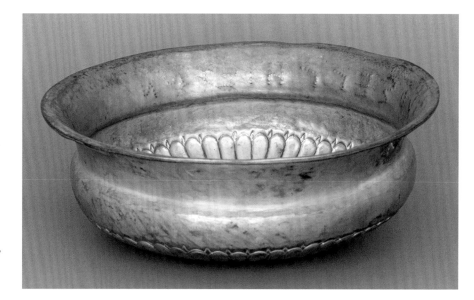

This silver cup is a local Thracian interpretation of a popular type of Near Eastern drinking vessel.[1] With its small omphalos, rounded lower body, and flaring rim, the shape is very close to Achaemenid Persian prototypes,[2] and at the same time the decoration of radial tongues is close to examples from centers in Asia Minor. In view of its style, however, this work is clearly a local product. Such *phialai* became popular in Thrace in the late fifth to the first half of the fourth century BC. While there are earlier indications of the emergence of a taste for Eastern goods among the Thracian nobility,[3] the fact that the selective imitation of Achaemenid vases in the territories under Odrysian control started only after the withdrawal of the last Persian troops excludes the possibility that it was an aesthetic imposed by force. The presence of such Achaemenid-inspired shapes in the local repertoire seems to mark a new stage in the development of the Thracian elite's conception of luxury.

There are two inscriptions with punched, dotted letters on the outside, beneath the rim: ΚΟΤΥ and ΚΟΤΥΟΣ ΕΓ ΓΗΙΣΤΩΝ. The first one was scratched with a thin blade and appears to be unfinished. A more confident hand used another tool to punch the letters of the second inscription. It reads, "(*phiale*) of Kotys from Geistoi."[4] Geistoi is the name of a settlement in southeastern Thrace.[5] Kotys was the Odrysian king who ruled from 384/383 to 360 BC.

Twenty-one vessels from Thrace bear the name of Kotys accompanied by a toponym.[6] The connection between these objects and the Odrysian court is beyond doubt, but there are various theories as to why these vessels were inscribed.[7] The orthography of the inscriptions is Attic,[8] but in Greek tradition such formulae were used on objects destined for gods, not rulers.[9] The Odrysian practice is closer to the Achaemenid one of offering gifts to the king as a token of respect, although there are no

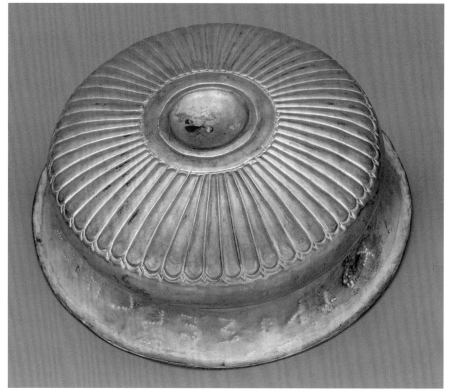

60a

exact parallels among the existing inscriptions.[10] Probably the specific historical circumstances in Thrace led to a focus on the ruler's prestige, which would explain not only the inscriptions naming the king but also the production of "Achaemenid-like" vessels in the lands under Odrysian control.

b. *Phiale* **with Inscription**
Mid-4th century BC
Silver
H: 3.5 cm; Diam of rim: 13.2 cm;
Wt: 124.3 grams
Vratsa, Regional Historical Museum,
B 474

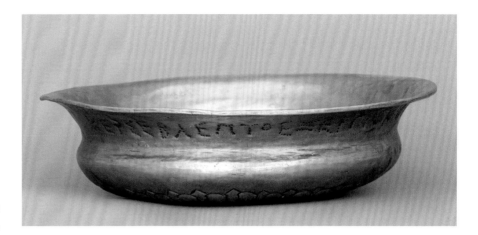

This *phiale* has an S-shaped profile, everted rim, flaring neck, and a low, rounded body with a flat base. It was raised from a relatively thick silver plate and is in very good condition.[11] The elements of the shape are poorly defined, perhaps even unfinished, and the craftsmanship is mediocre, which holds true of the decoration as well. The artisan chose a simple and popular design for the bottom of the vessel, a circle of tongues that widen outward around a large omphalos. In the space between their rounded tips, there is a motif of two lines touching at an angle, possibly an attempt to present a second tier of tongues and to achieve depth. The decoration is executed carelessly from the outside, freehand and without use of a preliminary sketch.

The cup is, however, highly significant for the roughly made inscription of dotted letters beneath the rim, ΚΕΡΣΕΒΛΕΠΤΟ ΕΞ ΕΡΓΙΣΚΗΣ, "(*phiale*) of Kersebleptes, from Ergiske."[12] Ergiske was a settlement in southeastern Thrace known from Philip II's campaigns in this part of the Balkans between 346 and 341 BC.[13] Kersebleptes, the son of the Odrysian king Kotys I, inherited the kingdom after his father's death in 360 BC and reigned until ca. 341/340 BC, after which date his name disappears from the historical sources.

Such inscribed vessels are usually regarded as tribute paid to the ruler by the settlement mentioned in the inscription. This hypothesis is also supported by the letters ΠΤΤΤΤ, which were engraved by another hand and would make sense only as numerals indicating weight. This is the only occurrence of Kersebleptes's name on a vessel, but there are more than twenty mentioning his father, Kotys, from Rogozen and elsewhere (cats. 51b, 51c, 60a).

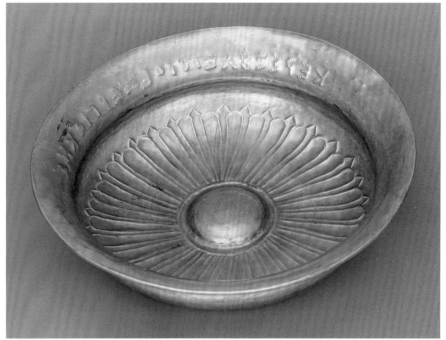

60b

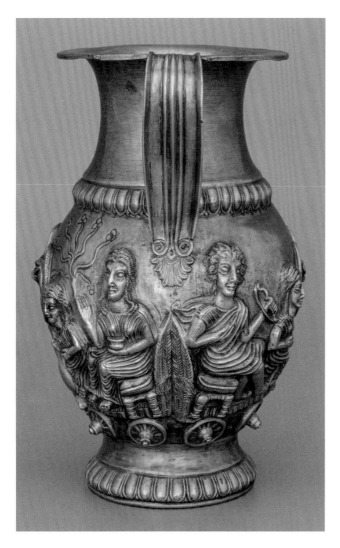
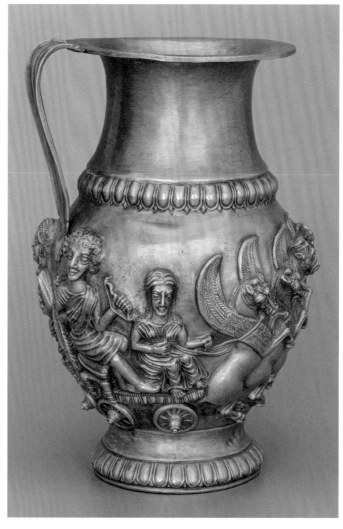

c. **Jug with Deities in Chariots**
330–300 BC
Silver
H: 13 cm; Diam: 9 cm; Wt: 134.8 g
Vratsa, Regional Historical Museum,
B 446

Made by a skillful artisan, this stocky jug
has an outturned rim that stays within the
limits of the body's maximum diameter, a
plain, inwardly curving neck bordered with a
carefully executed egg-and-dart band, a
convex body with figures in high relief, and
a broad foot, again decorated with an egg-
and-dart pattern.[14] The wide handle with
three vertical ribs starts from the rim and
follows a smooth curve to join the body,
attached by means of a decorative plate
consisting of volutes and an upturned pal-
mette with rounded leaves.

The complex composition on the body of
the jug depicts two antithetical four-wheeled
quadrigae drawn by winged horses. Each
quadriga carries two figures. In front, there
is a barefoot female in a long *chiton* stooping
forward with arms bent at the elbows, hold-
ing the reins. Behind her on the first chariot,
there is a male holding a bow and arrow
seated on a stool with carved legs. He is
young and beardless, and his curly hair,
rising from the forehead and parted in the
middle, resembles a hairstyle that became
popular in the Greek world in the time of
Alexander the Great. He wears a short *chiton*
and shoes with upturned toes. Behind the
charioteer of the other quadriga, a female
figure is seated in a calm posture, holding
a large branch with small, round fruits
in one hand and a cup with a high neck and
rounded body in the other. Like the chari-

oteer, she is barefoot and wears a *chiton*
reaching down to her feet. Her hair is
braided. The fantastic elements (winged
horses drawing chariots) clearly indicate a
mythological scene, and the figures must
be deities. Their specific attributes—bow
and arrow, branch and cup—should identify
them, but too little is known today of
Thracian mythological beliefs to make this
possible.[15]

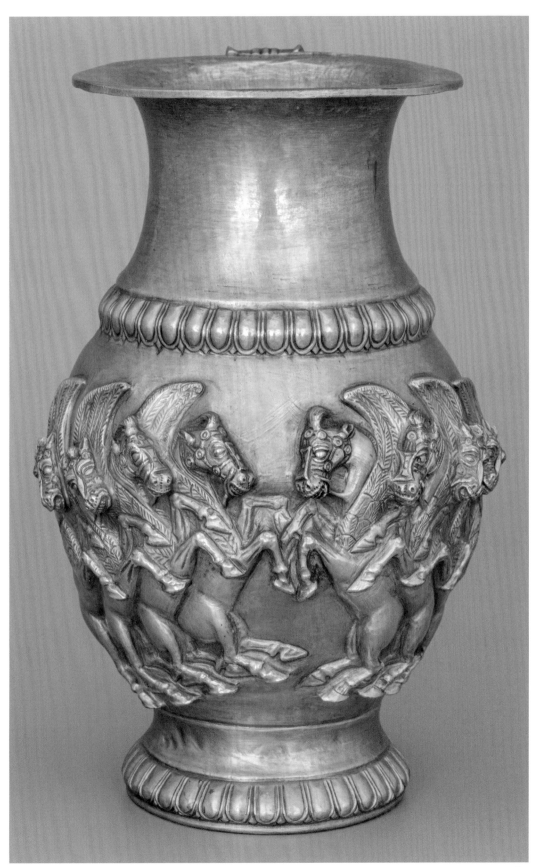

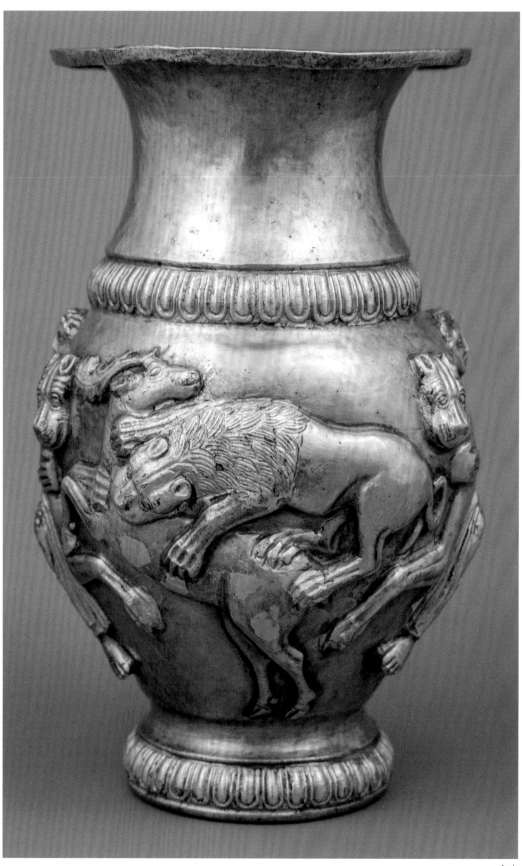

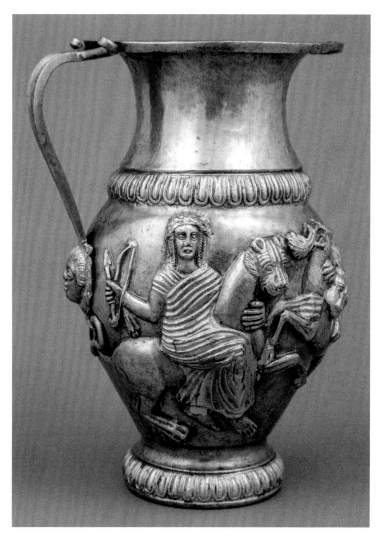
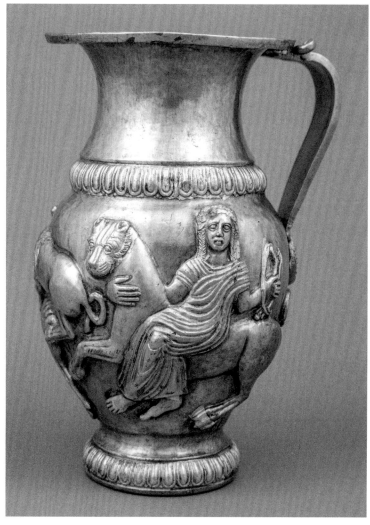

d. Jug with Goddess on Panther
340–300 BC
Silver with gilding
H: 13.5 cm; Diam: 8.5 cm; Wt: 234.9 grams
Vratsa, Regional Historical Museum,
B 447

Like the jug with deities in chariots drawn
by winged horses (cat. 60c), this vessel has
squat proportions, with a simple neck and
a bulbous body with figures in high relief,
bordered with bands of egg-and-dart above
and on the foot.[16] This shape came into
fashion around the middle of the fourth
century BC. The bold combination of various
motifs and the extensive gilding used to
emphasize them are typical of the period.

At this time the human figure became a
focus in Thracian art.[17] In their attempts to
express local concepts, Thracian artisans

adapted Greek and Achaemenid icono-
graphic schemes, transforming each image
into a complex system of symbols that are
difficult to decipher in view of the absence of
information about Thracian mythology.

The artisan who designed the decoration
of this jug implemented an eclectic ap-
proach. In addition to the ornaments along
the handle, a facing head of a beardless
young man framed by a gilded "mane" and
with an ornament at the neck was added at
its base. Because of the "mane," an associa-
tion with Herakles seems possible,[18] but its
relation to the other images eludes us.

A lion attacking a deer occupies the
center of the body. The animals may appear
stereotypical and without intensity, but by
means of their poses—the predator leaping
on the back of the prey, which rears in terror—
the artist succeeded in conveying the scene's

drama. The motif has its origin in the Near
East,[19] where it is related to the cycle of sea-
sons, but it is also common in Archaic Greek
art.[20] Scenes of fighting animals became very
popular in Thrace in the fourth century BC,
but nothing is known of their meaning.

On either side of the fighting animals,
there are mirror images of a woman riding
astride a panther.[21] She holds a bow and
arrow in one outstretched hand and grasps
the animal's neck with the other. She wears a
long *chiton* that reaches to her ankles,
leaving exposed only her bare feet and her
arms to above the elbows. The elaborate
hairstyle and the wreath that holds it
indicate her special status. The attributes of
the female figure—bow, arrow, wreath, and
beast—clearly define her as a deity, although
it is difficult to identify her without known
parallels.[22]

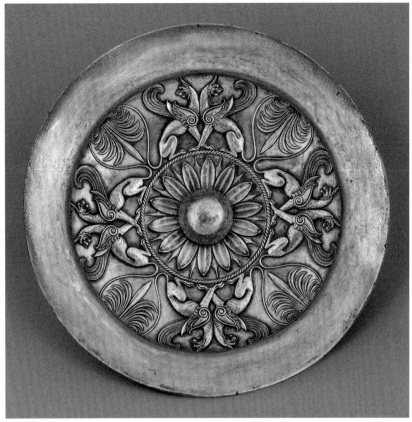

60e

e. *Phiale* with Lion-Griffins
ca. 400–350 BC
Silver with gilding
H: 4 cm; Diam: 19 cm; Wt: 281.7 grams
Vratsa, Regional Historical Museum,
B 465

This shallow *phiale* has a gentle profile, with
a low body and a sharply flaring rim.[23] The
shape suggests Achaemenid influence, if
not origin, and is very close to a particularly
delicate vase from the city of Ur, in present-
day Iraq.[24] The carefully balanced combina-
tion of floral and zoomorphic motifs makes it
one of the finest *phialai* from the Rogozen
Treasure.

In the center, around a gilded omphalos,
is an exquisite rosette with leaves in relief
with upturned tips, alternately gilded,
covering other leaves with long, pointed
tips. A gilded cord-like border surrounds
the rosette and serves as a base for the
main field, in which four pairs of antithetical
horned lion-griffins alternate with four
upturned gilded palmettes, set in frames

shaped by the curving and joined tails of
the beasts.

The horned lion-griffin has a special
place in the repertoire of Near Eastern
iconography,[25] the mythological world of the
East being generally rich in such composite
creatures, but the images on the Rogozen
vase display two different styles. The linear
stylization of the separate body parts—for
example, the spiral-like shoulder—is Eastern,
and the wings that curve up and toward
the heads, their rendering lacking any
naturalism,[26] also belong to the art of
western Anatolia, both before and during
Achaemenid rule in that region. The bodies
of the fantastic beasts are rendered with
a softness that is typical of Greek art, how-
ever, and the hind legs have lion paws, as in
Greek representations, not the bird claws
often found on objects from the Near East.[27]
Adapting traditional Eastern motifs was
a popular practice in the cosmopolitan art
from centers in Asia Minor, where Greek
artisans could draw without constraint from
that rich artistic tradition. It was in one
of those centers that the *phiale* was made.

f. *Phiale* with Herakles and Auge
330–280 BC
Silver with gilding
H: 2 cm; Diam: 13.6 cm; Wt: 182.8 grams
Vratsa, Regional Historical Museum,
B 464

This is one of the most intriguing objects in
the Rogozen Treasure,[28] for the technologi-
cal examination indicates that the *phiale* and
the medallion with the mythological scene
soldered to the inside were made inde-
pendently and that the combination of the
two is in fact secondary.[29] The *phiale* is
raised from silver sheet; on the outside the
centering dot that also served for designing
the decoration is still preserved. It is difficult
to define the original shape, for at some
point the walls were altered to accommodate
the medallion. It was a relatively shallow
bowl with an outturned, thickened rim and
a flat bottom without an omphalos, a shape
more typical of the later stages of the
development of the Greek *phiale*.

The base of the bowl is elaborately
decorated in low relief. Around the central

rosette, gilded palmettes with flame-like incurving leaves alternate with lotus flowers with delicate tendrils sprouting from their bases. The style of the decoration of the base, with its emphasis on elegance and lavishness, finds its closest parallels in the last quarter of the fourth century BC or even slightly later.[30] At this time there was also a stylistic trend of replacing the central omphalos with various appliqués and relief images. This fashion probably led to the inexpertly executed combination of bowl and medallion that is most probably of Early Hellenistic date.[31]

The relief scene on the medallion depicts the encounter of Herakles with the princess Auge during the nighttime celebrations of the goddess Athena Alea at Tegea.[32] According to one version of the myth, the drunken hero did not recognize the goddess's priestess, sworn to celibacy, and raped her. From this union, Telephos, the ancestor of the Pergamene kings, was born. The scene is modeled with exceptional skill, turning the medallion into an artistic masterpiece. The figures are graceful, with carefully reproduced anatomical features and meticulously rendered details. Gilding adds color without affronting the eye. The seated Herakles is naked, leaning on a rock to support himself and reaching with his right hand toward the young woman. The tilted head, the facial expression, the shaggy beard, and the disheveled hair hiding the leaves of a wreath clearly indicate that the hero is inebriated. Twisting her delicate half-naked body, Auge resists and struggles to break free from her aggressor. To the left, above her head, there is the inscription ΑΥΓΕ, and next to Herakles's head, another one reads ΔΗΛΑΔΗ, "clearly (who this is)." Both inscriptions are carefully made, unlike the dotted inscription ΔΙΔΥΚΑΙΜΟ (probably the owner's name) on the inner side of the rim.[33]

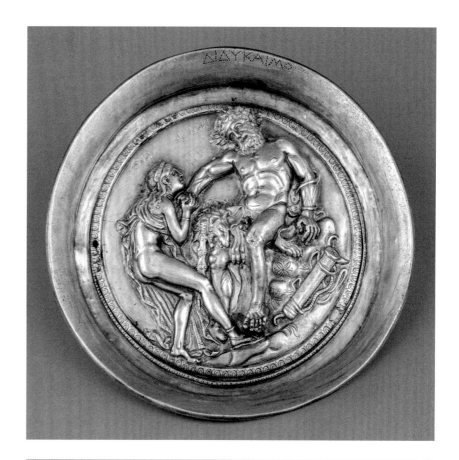

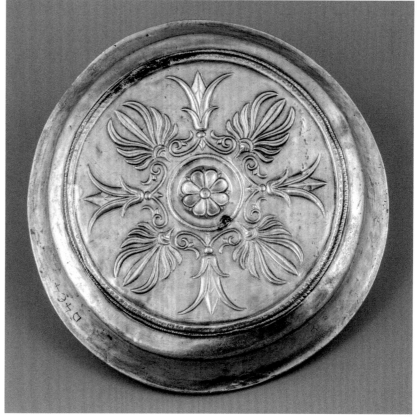

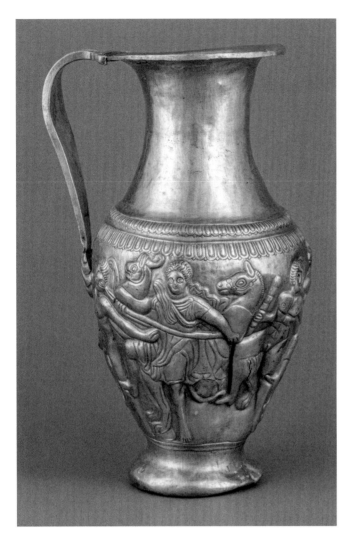
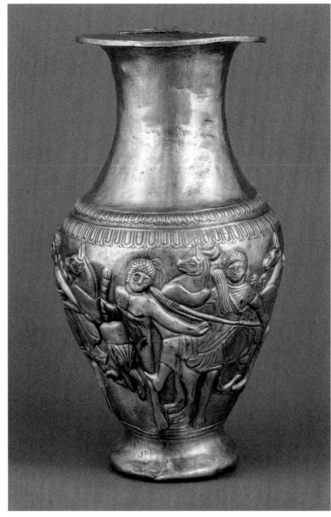

g. **Jug with Herakles and an Amazon**
ca. 350–300 BC
Silver
H: 14.3 cm; Diam: 7.5 cm; Wt: 128 grams
Vratsa, Regional Historical Museum,
B 460

Similar in shape and size to the previous
two jugs (cats. 60c, 60d), this example is
somewhat more elongated, with a plain
neck, a body decorated with figures in high
relief, and an undecorated foot.[34] Between
the neck and the body of the jug are two
borders of egg-and-dart bands. The upper
end of the curved handle with two wide
longitudinal grooves splits to wrap around
the back of the outturned rim, and the
lower end terminates in a simple upturned
palmette with rounded leaves.

 On the body of the jug are three identical
repetitions of the same scene. The naked

male figure to the left may be identified as
Herakles because of the club he holds and
the lion skin partly visible between his legs.
The hero is beardless, the head is facing, and
the upper body is turned three quarters to
the viewer. His right leg is bent at the knee,
probably to indicate a step backward, but
hangs in the air, as there is no groundline.
With his left hand, Herakles pushes away
the female figure,[35] dressed in a short *chiton*
held at the shoulder by a round clasp and
a flying *chlamys*. In her outstretched hands,
she holds a spear pointed at the hero's
head and steps with her right foot on his
knee. In the spaces between the human
figures are a rearing horned lion-griffin and
a bridled horse.

 Two interpretations have been suggested
for the scene, the more probable being
the fight between Herakles and the Amazon
Hippolyte.[36] In the myth the hero fights not

the queen of the Amazons, however, but
the swift-as-the-wind Aella, the powerful
Melanippe, and seven more female war-
riors. Also, it is difficult to read the scene
in one way only,[37] as the vase and its deco-
ration were made by a Thracian artisan
who borrowed but then to a great extent
simplified the scheme of popular Greek
depictions of an Amazonomachy. The desire
to fill all spaces with symbols (in this case
the figure of the griffin and the horse)
and a repeated composition is typical of
Thracian art and opens a semantic labyrinth
of diverging interpretations. •RS

1 N. Torbov in Martinez et al. 2015, 187, no. 151.
2 In some cases without omphalos but usually with
 sharply delimited parts of the shape: Abka'i-
 Khavari 1988.
3 Probably the best example is the silver amphora
 from Kukova Tumulus at Duvanlii (cat. 33).
4 After Mihailov 1987, 29.

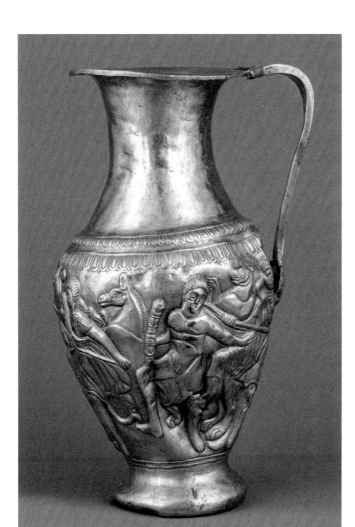

60g

5 Stoyanov 2017, 26–27.
6 Stoyanov 2017, 19, table 1.
7 An overview in Zournatzi 2000, 690–92.
8 Mihailov 1987, 30.
9 Zournatzi 2000, 692, with references.
10 See Curtis, Cowell, and Walker 1995, 150.
11 N. Torbov in Martinez et al. 2015, 186–87, no. 148.
12 After Mihailov 1987, 28.
13 Stoyanov 2017, 23–26.
14 Marazov 1998a, 155, no. 84; N. Torbov in Martinez
 et al. 2015, 352, no. 311; E. Penkova in E. Penkova,
 Konova, and Kisyov 2017, 188–89, no. 188.
15 Rabadjiev 2012, 700–701; also Rabadjiev 2014,
 38–40, with an overview of the proposed interpre-
 tations of the figures.
16 Marazov 1998a, 186, no. 123; N. Torbov in Martinez
 et al. 2015, 352–53, no. 312.
17 For example, on several jugs from Rogozen:
 Vratsa, Regional Historical Museum, B 446
 (cat. 60c), B 447 (cat. 60d), B 448, and B 460
 (cat. 60g); Nikolov, Mashov, and Ivanov 1987, 118,
 no. 154, 119–20, nos. 157–59.
18 Marazov 1988, 35.
19 Ewigleben 1989, 28.

20 Lions attacking a deer are depicted on the bronze
 hydria from the Bashova Tumulus at Duvanlii
 (cat. 47h).
21 A lioness according to Marazov (1988) but a
 panther according to Stoyanov (1991).
22 The Great Goddess according to Nikolov, Mashov,
 and Ivanov (1987, 118) and Marazov (1988, 36);
 Bendis according to Hoddinott (1986, 31–32); and
 Cybele according to Stoyanov (1991, 30).
23 Marazov 1998a, 156, no. 85; L. Konova in
 E. Penkova, Konova, and Kisyov 2017, 186, no. 185.
24 Abka'i-Khavari 1988, 119, fig. 3, F1d13.
25 Goldman 1960, 321.
26 Marazov 1996a, 31.
27 Paspalas 2008, 305, fig. 3, 310, fig. 4. A combina-
 tion of stylistically similar images of lion-griffins
 and palmettes could be seen in late fourth-
 century BC Macedonian funerary painting:
 Paspalas 2008, 303, fig. 2.
28 Marazov 1998a, 176, no. 107; N. Torbov in Martinez
 et al. 2015, 338–39, no. 285.
29 Inkova, Tsaneva, and Draganova 1994, 28–45.
30 Treister 2022, 12–16, fig. 8.
31 Treister 2022, 16–19, figs. 9, 10.

32 See, most recently, Ambrosini 2020, 89–95.
33 On the inscriptions, see Mihailov 1987, 28; on
 delade, see Hind 1989, 38–39; Stafford 2012,
 114–15.
34 Marazov 1998a, 141, no. 67; N. Torbov in Martinez
 et al. 2015, 340, no. 286; E. Penkova in E. Penkova,
 Konova, and Kisyov 2017, 187, no. 187.
35 The gesture is conventional and could be
 interpreted in other ways as well.
36 For an overview of the various representations,
 see Rabadjiev 1996, 64.
37 Marazov 1987, 28.

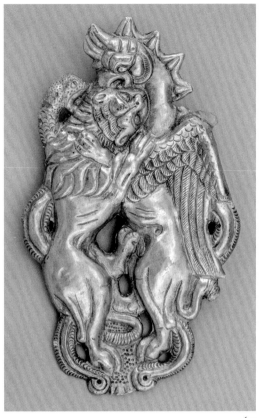

61a

a. Horse Harness Appliqué
Late 4th century BC
Silver with gilding
8 × 4.9 × 1 cm; Wt: 23 grams
Lovech, Regional Historical Museum,
592 A

61

THE LETNITSA TREASURE

Chance find near Letnitsa, Lovech
Province, Bulgaria, in 1963

This treasure consists of twenty-three
gilded-silver horse harness appliqués and an
iron bit, which had been buried in a bronze
cauldron.[1] Two groups can be distinguished
by their decoration, their style, and the
technique used for their manufacture. To the
first group belong eight openwork pieces,
executed in the local version of the so-called
Animal Style, typical of the second half
of the fourth century BC, derived from the
contact zone in the north Pontic region.
The second comprises fifteen mostly
rectangular appliqués, the majority with
human figures in unusual compositions.
The style displays a naive rendering of
human anatomy, unnatural proportions for
both human and animal figures, rigid and
conventional gestures, oversimplified
perspective, avoidance of empty spaces,
and no context for the setting of each
composition. Instead the focus is on the
details, including elements of costume and
hairstyle, as well as attributes like weapons,
armor, vessels, and adornments, some of
which correspond to actual archaeological
finds. In all likelihood, the appliqués deco-
rated the bridle and breast collar of the
horse. They were made by a local artisan
around the middle of the fourth century BC
and were likely designed as a group.[2]

This openwork appliqué (cat. 61a) is
part of the first group from the Letnitsa
Treasure.[3] It is made in the repoussé tech-
nique, and the contours of the images define
the shape of the object. The front side is
gilded. The position of the hoop at the back
indicates that it decorated one of the straps
of the bridle. Despite the object's small
size, the artisan succeeded in creating an
expressive image: a rearing lion and a griffin
fight each other, with two huge snakes
wriggling at the sides. The animals' anatomy
is presented with extreme precision. Both
the scene and some elements—such as
the flame-like stylization of the lion's mane,

the griffin's horns, the serrated crest, the
curved beak, and the feathers—reflect Greek
prototypes, but here the beasts are depicted
standing, a composition that occurs only
rarely in Greek art.

The second appliqué is almost square
(cat. 61b), made of relatively thick silver
plate, with a loop on the back.[4] In the field,
two females and one male are modeled
in low relief. The man is bearded, with his
hair tied into a crest at the crown (the
so-called *akrokomos* hairstyle). He wears
a long garment that covers the thighs but
leaves his erect phallus and knees uncov-
ered. A barefoot woman is seated on top
of his legs, lifting the front of her richly
decorated dress in order to have inter-
course with him. To the left of the embrac-
ing couple, another female figure holds
a narrow-necked vessel in her right hand
and a branch in her left, with the leaves
falling between the faces of the lovers. The
depiction of sexual intercourse suggests
a sacred marriage (hierogamy) between
the Great Mother Goddess and her son,
according to one interpretation.[5] Another
possibility is that the vase and branch are
attributes denoting the primary female
deity of the Thracians,[6] in this case serving
as a protectress of marriage.

Within the rectangular field of the third
appliqué (cat. 61c), bordered on three
sides with gilded ovules, a standing human
figure is depicted turned to the right toward
a wriggling three-headed creature.[7] The
lavishly decorated dress and the hairstyle
suggest that the figure is female. Her
arms are bent at the elbows, the left hand
touching the monster and the right one
holding an object that resembles a mirror.
The beast has the flexible body of a snake,
with three identical heads with oval eyes
and ears adhering to the scaly neck. The
hair, parts of the face, and the dress of the
human figure are gilded. The meaning of
the image is elusive, especially with so little
known of Thracian mythology. The figure
has been interpreted as a goddess of wild

b. Breast Collar Appliqué
Mid-4th century BC
Silver with gilding
5.8 × 5.1 × 1.5 cm; Wt: 35 grams
Lovech, Regional Historical Museum,
604 A

c. Breast Collar Appliqué
Mid-4th century BC
Silver with gilding
6.2 × 4.5 × 1.5 cm; Wt: 30 grams
Lovech, Regional Historical Museum,
605 A

nature,[8] but in many mythological tradi-
tions, the mirror has both nuptial and
chthonic connotations. Its presence has
provided grounds for interpreting the
scene as a marriage between a maiden
and a dragon.[9] **•RS**

1 K. Rabadjiev in Martinez et al. 2015, 342–49,
 nos. 288–306; E. Penkova in E. Penkova,
 Konova, and Kisyov 2017, 66–75, nos. 54–73.
2 Rabadjiev 2014, 297.
3 K. Rabadjiev in Martinez et al. 2015, 348–49,
 no. 306; E. Penkova in E. Penkova, Konova, and
 Kisyov 2017, 67, no. 56.
4 Marazov 1998a, 162–63, no. 92; K. Rabadjiev
 in Martinez et al. 2015, 347, no. 299; E. Penkova
 in E. Penkova, Konova, and Kisyov 2017, 72,
 no. 66.
5 Venedikov 1974, 31.
6 Marazov 1976, 3.
7 Marazov 1998a, 160–61, no. 90; K. Rabadjiev
 in Martinez et al. 2015, 344, no. 291; E. Penkova
 in E. Penkova, Konova, and Kisyov 2017, 70–71,
 no. 64.
8 Venedikov 1996, 12.
9 Marazov 1998b, 60.

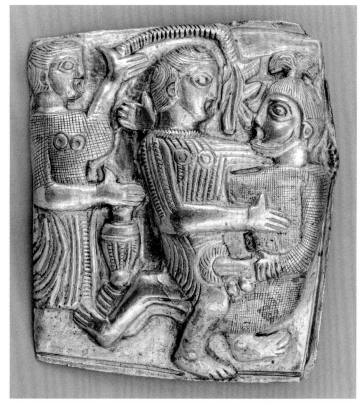

61b

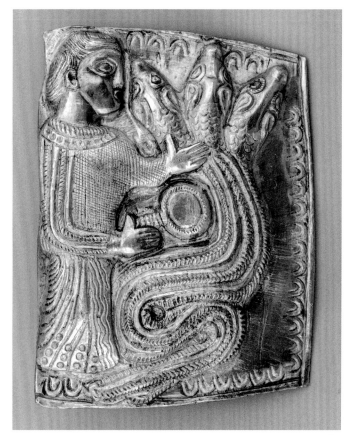

61c

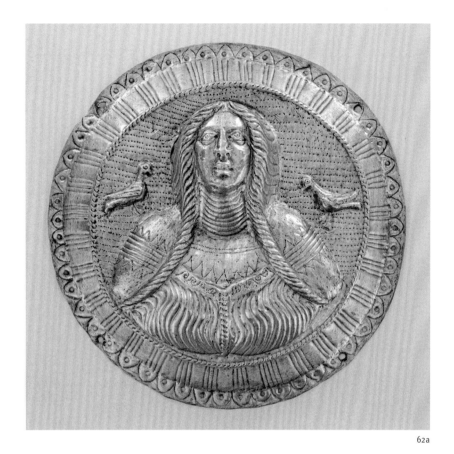

62a

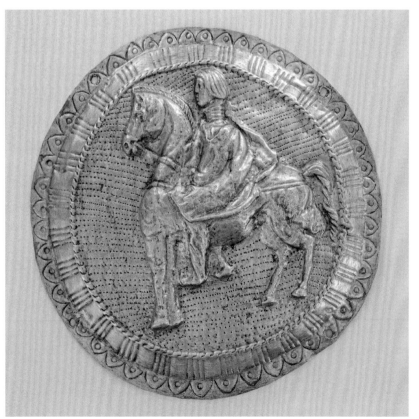

62b

62

THE GALICHE TREASURE

Chance find in Galiche, Vratsa Province, Bulgaria, in 1918

The hoard allegedly consisted of twenty-four *phalerae*, ten of which were given away by the discoverer and later destroyed.[1] The remaining fourteen were preserved in the collection of the National Archaeological Institute with Museum in Sofia. A number of Late Hellenistic monuments show similar objects attached to the straps of the girths and breast collar of a saddle horse. This fashion appears to have emerged with changes in the construction of the horse saddle in the late third century BC.[2] Decorations of this type became particularly popular with the north Pontic nomads at this time,[3] and most scholars follow Michael Rostovtzeff in relating the new fashion to the movements of the various tribes known under the common ethnonym Sarmatians.[4]

In terms of shape and style, the preserved *phalerae* may be divided into two groups. The first one comprises three pieces—one with floral decoration and two with human figures. They were probably made in the same workshop, as indicated by the subsidiary decoration. The iconography of these *phalerae* illustrates a distinct style that differs from that of contemporaneous examples from the Eurasian steppes. The main emphasis is on the human figure, which is executed in a distinctively stylized manner, as exemplified by the finds from Galiche and from Surcea and Bucureşti-Herestrău,

a. ***Phalera* with Female Bust**
 ca. 125–50 BC
 Silver with gilding
 Diam: 18.3 cm; D: 4.4 cm; Wt: 105 grams
 Sofia, National Archaeological Institute with Museum, 5876

b. ***Phalera* with Rider**
 ca. 125–50 BC
 Silver with gilding
 Diam: 15.8 cm; D: 2.5 cm; Wt: 70.8 grams
 Sofia, National Archaeological Institute with Museum, 5877

c. *Phalera* **with Lotus Buds and Flowers**
ca. 125–50 BC
Silver with gilding
Diam: 13 cm; D: 2.5 cm; Wt: 53.3 grams
Sofia, National Archaeological Institute
with Museum, 5878

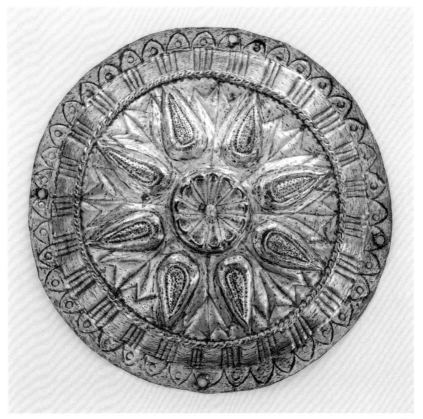

62c

in Romania.[5] Its origins can be traced to the art of the workshops to the north of the Balkan Range, where the artisans brought together elements from several artistic traditions: local, central European, and Greek.

The largest *phalera* of this group is in the shape of a convex disk with outturned edge (cat. 62a).[6] It is made of a thin silver sheet and completely gilded on the outside. The image was made in the repoussé technique with additionally emphasized details. Four evenly spaced holes for attachment are pierced on the rim, which is bordered with a band of ovules with a central dot around a triglyph-and-metope–like pattern. In the center a female bust is modeled in high relief. She has long hair, parted above the forehead and braided into two thick plaits that fall in front over her breast. The woman wears a lavishly detailed low-necked dress and eight torques around her neck, probably denoting her high status. On either side above her shoulders, a bird is perched. The background is filled with rows of tiny dots. The artist realistically rendered the shape of the woman's face and torso. Her identity is uncertain, but she has been interpreted

as the Great Goddess.[7] The birds are likely specific attributes, but their significance is unknown.[8]

The second *phalera*, which is only slightly smaller than the first, depicts a rider facing left, wearing a cloak that covers his body, trousers, and pointed shoes (cat. 62b).[9] The man is beardless, and his straight hair falls down to the top of his unnaturally elongated neck, around which he wears four torques. The horse is rendered more realistically, with a graceful head, wide chest, and muscular body. The image of the rider gained popularity in Thracian art in the fourth century BC. With time, the iconography evolved, and the rider as deity occupied a special place in the local pantheon.

The final *phalera* of this group is ornamented with a small twenty-leaf rosette in the center surrounded by eight stylized lotus buds alternating with lotus flowers (cat. 62c). The motif is of Eastern origin but has a long history in Thrace.

The second group comprises eleven *phalerae* with simpler floral decoration. They are made of thin silver sheet, hammered into a hemispherical shape with flat edges,

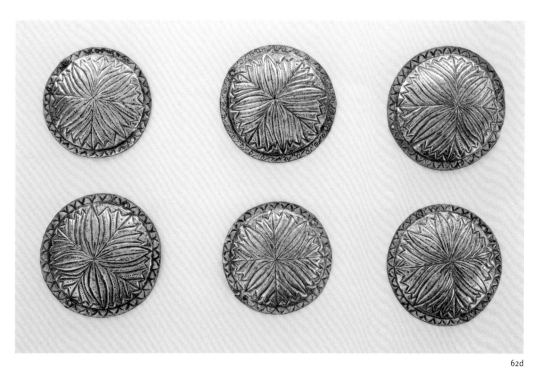

62d

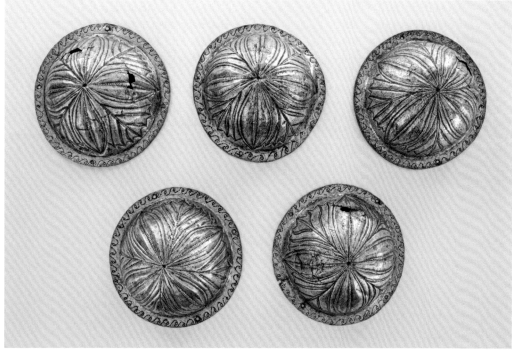

62e

d. Six *Phalerae* with Rosettes

ca. 125–50 BC
Silver with gilding
Diam: 8.8–9.9 cm; D: 1.1-2 cm;
Wt: 30.3–38 grams
Sofia, National Archaeological Institute
with Museum, 5880 a–f

e. Five *Phalerae* with Rosettes

ca. 125–50 BC
Silver with gilding
Diam: 15–15.7 cm; D: 4.8–6 cm;
Wt: 97.9–114.6 grams
Sofia, National Archaeological Institute
with Museum, 5879 a–e

and gilded. These *phalerae* are stylistically close to the examples from Yanchokrak, in Ukraine,[10] and Zhutovo, in Russia,[11] of the so-called Graphic Style of the Black Sea region, characterized by rosettes of floral motifs in combination with geometric patterns.[12] On the bulging body of the six smaller *phalerae*, an elaborate rosette is modeled in low relief consisting of acanthus leaves that sprout from the center with pointed tips that descend toward the base (cat. 62d). The edge is decorated with ovules. The five larger *phalerae* display a slightly different combination of motifs: four symmetrical laurel leaves partially overlap the pointed tips of the acanthus leaves between them, and the edge is decorated with a dotted running-wave motif (cat. 62e). •RS

1 Torbov 2012, 725, with further references.
2 Pfrommer 1993, 11.
3 For an overview, see Dedyulkin 2015a, 134–35.
4 Rostovtzeff 1922, 136–38; but see Mordvintseva 2008 for arguments against Rostovtzeff's views.
5 Sîrbu and Bârca 2016, 311, fig. 9.11, 1, 3.
6 Marazov 1998a, 178, no. 108.
7 Torbov 2012, 730.
8 Aphrodite and her Eastern prototypes are most often depicted with birds.
9 Marazov 1998a, 179, no. 109.
10 Mordvintseva 2001, plates 39, 40.
11 Treister 2023, 248, fig. 4.1–2.
12 Mordvintseva 2001, 37.

THRACE UNDER ROMAN RULE

X.

In 148 BC the Romans utterly defeated the Macedonian kingdom and transformed the region into a Roman province with a considerable military presence on the Thracian border. At this time various Thracian tribal kingdoms existed, of which relatively little is known. Ancient historians record numerous conflicts between Rome and Thracian groups, but Thracians also served as Roman allies in the Mithridatic Wars (89–63 BC). Under the first emperor, Augustus (27 BC–AD 14), the Thracian tribes were united in a single client kingdom under Rhoemetalkes I (15 BC–AD 12), which survived until about AD 46, when Thrace was incorporated into the Roman provincial system.

Roman rule encouraged the Thracian elite to take a prominent political role in the local administration through the introduction of the "assembly of the Thracians," centered in Philippopolis (Plovdiv,

Bulgaria). Thracian aristocrats became increasingly Romanized, speaking Greek and Latin, adopting Roman names, and participating in Roman Imperial institutions by holding a variety of civic offices and priestly positions.

Thracian cultural traditions continued, however, well into the Roman Imperial period. Although the aristocracy tended to Romanize their identities, Thracian names are well attested in the many funerary and honorific inscriptions that have been discovered. Some inscriptions are remarkable for alluding to the shared origins of the Greeks and the Thracians, which for the most part are mythical. Perhaps the most striking continuity of aristocratic Thracian ritual practice is the interring of sacrificed horses, along with wagons and trappings, in tombs, many of which have been discovered in the region. •JS

63

Funerary Stele of Iulia

2nd century AD
Marble
156 × 49.5 × 9.5 cm
Found in Aheloy, Burgas Province,
Bulgaria, in 1928
Burgas, Regional Historical Museum, 521

This stele has rich decoration divided into four zones. Artemis occupies the center of the pediment, flanked by a dog, a doe(?), and two eagles in the corners. The upper relief depicts the deceased, Iulia, as the goddess Hekate. She appears in a frontal view, holding blazing torches turned downward. Two female attendants to the right hold a mirror and a basket of wool. In the lower relief, Iulia, again holding two torches, rides in a two-wheeled chariot drawn by two horses. A man with a spear strides behind, and another one leads the horses by the reins. A hunting scene with two dogs chasing a hare appears beneath. Between the reliefs there is a Greek inscription:

Ἐνθάδε ἐγὼ κεῖμε Ἑκάτη
θεὸς ὡς ἐσορᾷς. ἤμην τὸ
πάλαι βροτὸς νῦν δὲ ἀθάνα-
τος καὶ ἀγήρως· Ἰουλία Νεικίου
θυγάτηρ μεγαλήτορος ἀνδρός.
Μεσεμβρία δέ μυ πατρὶς, ἀπὸ
[Μέ]λσα καὶ βρία· ζήσασα ἔτη ὅσα
μοι στήλη κατέχει· τρὶς πέντε,
δὶς [ε]ἴκοσι καὶ δέκα πέντε.
εὐτυχεῖτε παροδῖται.

Here I lie, deified as Hekate, as you can see. Once I was mortal but now I am immortal and ageless. I, Iulia, the daughter of the great-hearted man Nikias. And my native city is Mesembria—from *Melsa* and *bria*. I lived as many years as my stele tells you, three times five, two times twenty, and fifteen. Be happy, passersby.

The stele belongs to the type with two or more separate relief fields, a design that was adopted from Greco-Persian art and continued by workshops along the shores of Asia Minor and Thrace in Hellenistic and Roman times.[1] The monuments of this type were quite imposing.

The figural composition follows established iconographic models typical of Greek funerary art before the Roman Imperial period, conveying the idea of Iulia's deification by means of images and text. She is depicted as Hekate and explicitly referred to as the goddess in the inscription. This is the only unambiguous example of a deification of a deceased person from Thrace.[2] Although depicted as Hekate in the upper field, Iulia is presented in a composition that is characteristic of Greek funerary relief, with two attendants carrying attributes of female beauty and virtue. The lower field offers an allusion to her journey to the afterlife, where she achieves immortality.[3]

The additional reliefs on the pediment and the bottom frieze are related to the goddess Artemis and may suggest Iulia's status as unmarried, for which reason she is identified by her father's name in the inscription. She may have belonged to a religious community devoted to the cult of Hekate that required celibacy.[4] The irregular metrical epitaph reveals Homeric influences.[5] In addition to personal information, it also offers an intriguing etymology of Mesembria's name from the name of the mythical Thracian founder Melsas and the Thracian word *bria*, "town."[6] Two centuries earlier, Strabo recorded this local legend,[7] which was probably a Hellenistic invention.[8] It is notable that Iulia claimed such a distinctive Thracian identity.
•MI

1 Cremer 1991, 17–27; Slawisch 2007, 54.
2 Wrede 1981, 55; Slawisch 2007, 61.
3 Katsarov 1930, 114.
4 *IGBulg*. I², 307; Marazov 1972, 21.
5 Katsarov 1930, 112–13.
6 Katsarov 1930, 113; *IGBulg*. I², 307–8.
7 Strabo, *Geography* 7.6.1.
8 Nawotka 1994.

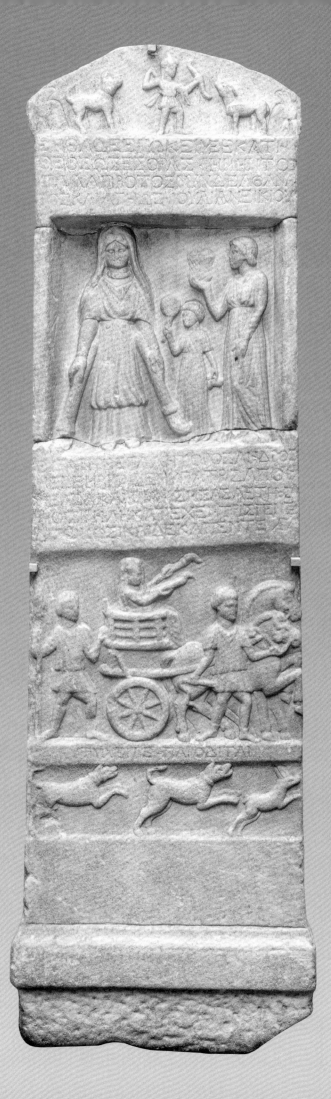

64

Votive Relief of the Soldier Moukianos

Mid-2nd–early 3rd century AD
Marble
60 × 44 × 9 cm
Found at the Sanctuary of Apollo in Denikli (present-day Lozen), Haskovo Province, Bulgaria, in 1893
Sofia, National Archaeological Institute with Museum, 209

This votive relief depicts a hunter galloping to the right on a rearing horse within an arched *naiskos* with two lateral acroteria.[1] The horse has a muscular body and its forelock is tied and lifted above the forehead. Under the horse's front leg, a dog chases a boar. The foreshortened body of the rider is turned three-quarters to the right. He wears a belted *chiton*, a billowing *chlamys* clasped at his right shoulder, and soft shoes (*calcei*). His right arm is lifted high above his head with the hand closed as if brandishing a spear.

The image of the so-called Thracian Rider is common on votive and funerary reliefs from the private sphere, but this man's voluminous and mannerist hairstyle distinguishes him from standard depictions of this genre. It is very similar to the hairstyle found on portraits of Alexander the Great, particularly his depictions as Helios Kosmokratos—the all-powerful sun god, ruler of the universe. In this case the subject seems to combine the Thracian Rider with images of Alexander as a rider.[2]

The soft and rounded outlines of the figure and his dreamy and slightly smiling expression—achieved by his upward gaze, with the iris touching the upper eyelid— are typical of the late Hadrianic and early Antonine periods. These stylistic features indicate that the relief can be dated to the period between the middle of the second and the beginning of the third centuries AD.

The Greek inscription beneath the image names a Roman soldier with the Thracian appellation Moukianos, who dedicated the plaque to Apollo Geikesenos.[3]

Ἀπόλλωνι Γεικεσηνῶ εὐχαριστή (ς)-
ριον ἀνέθηκε Μουκιανὸς στρα-
τιώτης

Moukianos, soldier, in gratitude, dedicates this to Apollo Geikesenos.

In the Roman period the Thracian Rider was a popular image, and particularly in eastern Thrace, his cult was syncretic with that of Apollo.[4] The emergence of the rider can be traced to the Hellenistic period,[5] when many elements of Alexander the Great's iconography were incorporated into local representations. •KP

1 The monument was published for the first time by Dobruski (1894, 75) and was included in the comprehensive study on the Thracian Rider by Katsarov (Katsarov 1938, 51, no. 208, plate XIX, fig. 112).
2 Popova-Moroz 2002, 12.
3 On dedications of soldiers and veterans in Lower Moesia and Thrace, see Boteva-Boyanova 2005.
4 Valchev 2015, 344.
5 On portraits of Alexander the Great and their imitations in the pre-Roman period, see Stoychev 2020.

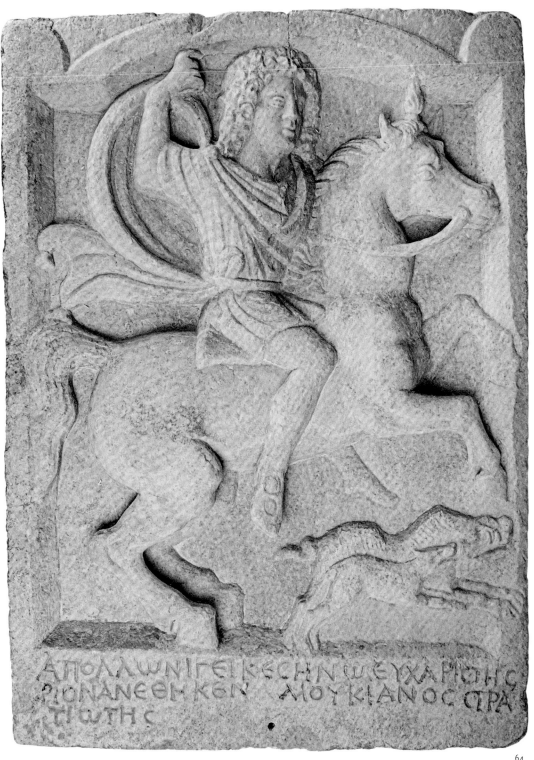

64

65

FITTINGS FOR A FOUR-WHEELED CARRIAGE YOKE AND A HORSE

Found near the village of Shishkovtsi, Kyustendil Province, Bulgaria, in 1954

This set of fittings for a yoke and horse harness belongs to a two-horse carriage that was discovered in a burial mound dating from the Roman Imperial period. It was among the first unearthed in archaeological investigations in Bulgaria and provides an opportunity to reconstruct the design and decorations of such carriages in the province of Thrace.[1] The fittings were both functional and ornamental. Most of them served to prevent tangling of the horses' reins. The solid bronze fittings were cast, and their upper surfaces were silver-plated. Round appliqués depicting deities and mythological characters were soldered on top of each element.

Most of the pieces decorated the double yoke. In the center, where the pole was

a. **Central Yoke Ring with Appliqués
 of Dionysos and Two Maenads**
 3rd century AD
 Bronze, silver with gilding
 Diam: 19 cm; D: 21 cm; Wt: 488.2 grams
 Sofia, National Archaeological Institute
 with Museum, 7992 (4, 10, 11, 14)

b. **Yoke Fitting with Herakles Appliqué**
 3rd century AD
 Bronze, silver with gilding
 Diam: 14 cm; D: 20.5 cm; Wt: 550.1 grams
 Sofia, National Archaeological Institute
 with Museum, 7992 (13)

attached, there was a conical umbo ending
in a hexagonal prism with concave walls and
a round disk on top, which is decorated with
a silver appliqué with the head of Dionysos
facing frontally (cat. 65a). The lower conical
element is decorated with two appliqués
with maenads. On both sides of the central
piece, there were large bronze spikes with
octagonal heads, decorated with round silver
appliqués with the bust of a young wreathed
Herakles, his lion skin thrown across his
left shoulder and a strap across his right
one (cat. 65b). The curved parts of the
yoke were decorated with rings attached to
soldered hexagonal bronze pieces decorated
with silver appliqués with heads of maenads
turned slightly to the right, wreathed with
ivy and with a ribbon holding their wild hair
(cat. 65c). The ends of the yoke were deco-
rated with elongated hexagonal bronze
elements with rings (cat. 65d). On the upper
surface are two bulging disks decorated
with silver appliqués with heads of maenads
facing frontally.

Similar images decorated the horse har-
ness, forming a set. The collars of the two
horses were composed of bronze elements
of irregular shape, with openwork orna-
ments at the upper and lower ends (cat. 65e).
In the middle, soldered to a bulging disk
on a hexagonal base, is an appliqué with
the head of a maenad. One of the maenads
turns to the left, the other to the right.
Four chains served to hang the fittings. The
flanks of the horses were decorated with
bronze elements of irregular shape, with
a relief hexagon in the middle and a bulging
disk decorated with an appliqué with the
head of Dionysos facing frontally (cat. 65f).

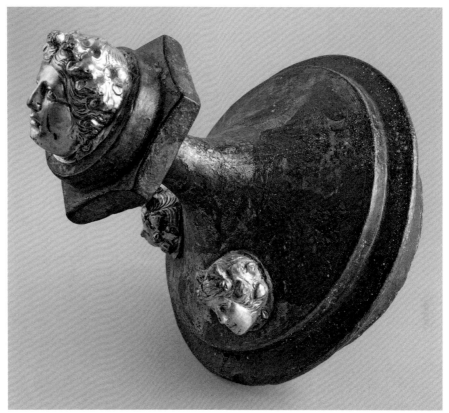

65a

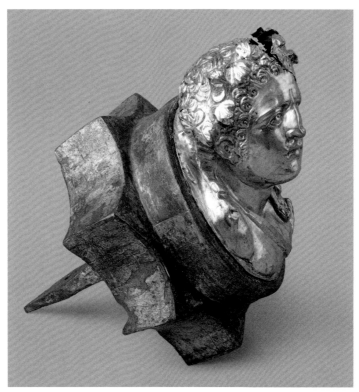

65b

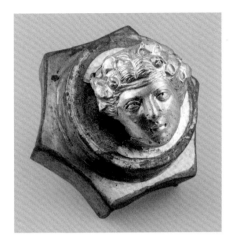

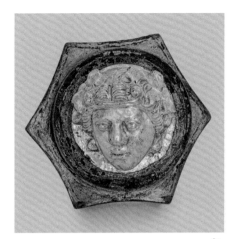

65c

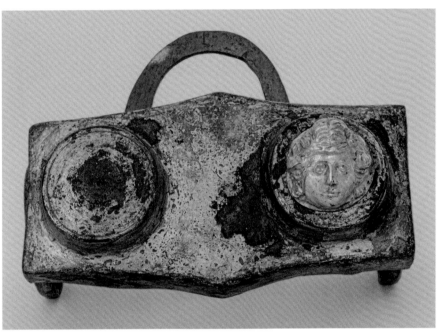

65d

The silver appliqués were made by hammering thin silver plates and are among the finest examples of the Roman applied arts discovered in Thrace.[2] The heads of Dionysos and the maenads are rendered rather schematically and illustrate a highly specialized but nonetheless mass-scale production. The bust of Herakles is similar in style, but an expressiveness was achieved in his posture and facial expression. The gilding of certain details—including the hair, the eyes, and the lips—add to the lavish appearance of the deities and heroes. Here, the Bacchic and heroic traditions in Thracian religion are manifested in iconographic models of Hellenistic origin. Among the many gods in the Greco-Roman pantheon,

Dionysos was the most favored for decoration of carriages in Thrace in the Roman period,[3] as indicated by the evidence of more than two hundred vehicles discovered so far in the province.[4] Placing a carriage as a grave good was a sign of high social and economic status among the Thracians in the first to third centuries AD. The skill of local artisans in working with various metals transformed the carriage fittings into demonstrations of wealth, luxury, and style. •VK

1 Venedikov 1960, 21–29.
2 Venedikov 1960, 28–29.
3 Cholakov 2004.
4 Ignatov 2018, 47–54.

c. **Three Yoke Rings with Maenad Appliqués**
3rd century AD
Bronze, silver with gilding
Diam: 10 cm; D: 11 cm;
Wt: 165.1–189.5 grams
Sofia, National Archaeological Institute
with Museum, 7992 (19–21)

d. **Yoke Endpiece with Maenad Appliqué**
3rd century BC
Bronze, silver with gilding
9 × 12.8 × 9.8 cm; Wt: 341.6 grams
Sofia, National Archaeological Institute
with Museum, 7992 (26, 12)

e. **Two Horse Harness Collar Fittings
with Maenad Appliqués**
3rd century BC
Bronze, silver with gilding
H with chains: 29 cm; W: 12.5 cm;
D: 6/5.5 cm; Wt: 146.3/198.6 grams
Sofia, National Archaeological Institute
with Museum, 7992 (22, 23)

f. **Two Horse Harness Side Fittings
with Dionysos Appliqués**
3rd century AD
Bronze, gilded silver
21 × 15 × 9.5 cm; Wt: 269.4/275 grams
Sofia, National Archaeological Institute
with Museum, 7992 (24, 25)

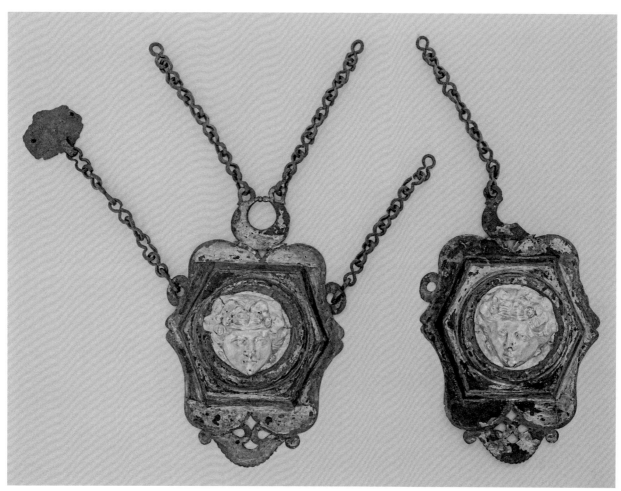

65e

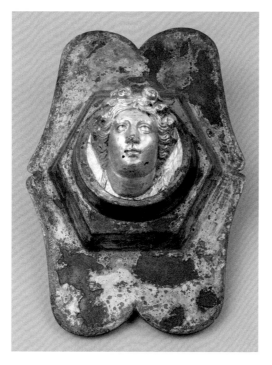

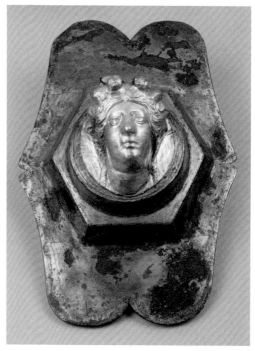

65f

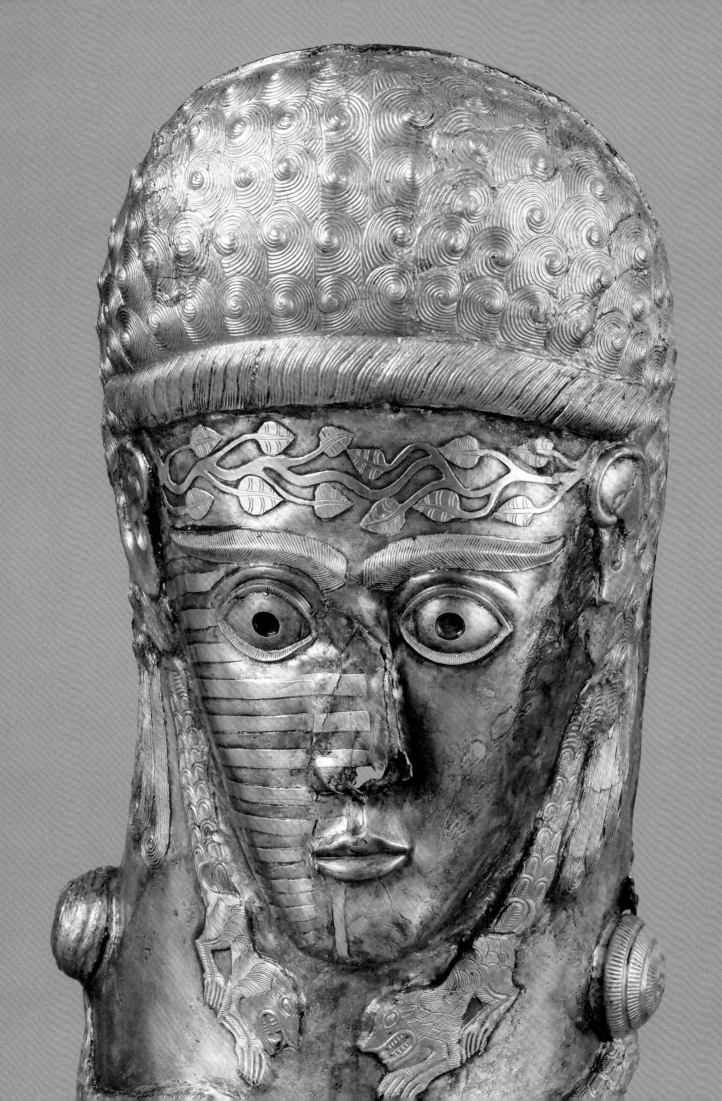

REFERENCES CITED

Abka'i-Khavari 1988
Abka'i-Khavari, Manijeh. "Die achämenidischen Metallschalen." *Archaeologische Mitteilungen aus Iran* 21 (1988): 91–137.

Abramišvili 2001
Abramišvili, Michael. "Transcaucasian Rapiers and Their Origin." In *Lux Orientis: Archäologie zwischen Asien und Europa; Festschrift für Harald Hauptmann zum 65. Geburtstag*, edited by Rainer Michael Boehmer and Joseph Maran, 1–9. Rahden, Germany: Verlag Marie Leidorf, 2001.

Adam-Veleni 2012
Adam-Veleni, Polyxeni. *Αρχαιοκαπηλία τέλος / Trafficking Antiquities: Stop It.* Exh. cat. Thessaloniki: Archaeological Museum of Thessaloniki, 2012.

Agre 2003
Agre, Daniela. "A New Interpretation of Scenes Decorating the Amphora-Rhyton from the Panagyurishte Treasure." *Thracia* 15 (2003): 545–58.

Agre 2011
Agre, Daniela. *Голямата могила, край Маломирово и Златица / The Tumulus of Golyamata Mogila, near the Villages of Malomirovo and Zlatinitsa.* Sofia: Avalon, 2011.

Agre 2015
Agre, Daniela. "Le tombeau de Zlatiniza–Malomirovo." In Martinez et al. 2015, 88–115.

Agre and Dichev 2011
Agre, Daniela, and Deyan Dichev. "Археологически разкопки на тракийски укрепен обект в м. 'Смиловене' в землището на град Копривщица." *Археологически открития и разкопки през 2010 г.*, 2011, 194–96.

Alexandrescu 1966
Alexandrescu, Petre. "Necropola Tumulară: Săpături 1955–1961." In *Histria*, 2:133–294. Bucharest: Editura Academiei Republicii Socialiste România, 1966.

Alexandrescu 1994
Alexandrescu, Petre. "Un rituel funéraire homérique à Istros." In *Nécropoles et sociétés antiques (Grèce, Italie, Languedoc)*, edited by Juliette de la Genière, 15–32. Naples: Centre Jean Bérard, 1994.

Alexandrescu 2005
Alexandrescu, Petre, ed. *La zone sacrée d'époque grecque (fouilles 1915–1989).* 2 vols. Vol. 7 of *Histria.* Bucharest: Editura Academiei Române; Paris: De Boccard, 2005.

Alexandrescu and Eftimie 1959
Alexandrescu, Petre, and Victoria Eftimie. "Tombes thraces d'époque archaïque dans la nécropole tumulaire d'Histria." *Dacia*, n.s., 3 (1959): 143–64.

Alexandrov 2018
Alexandrov, Stefan. "The Early and Middle Bronze Age in Bulgaria: Chronology, Periodization, Cultural Contacts and Precious Metal Finds." In Alexandrov et al. 2018, 85–95.

Alexandrov 2020
Alexandrov, Stefan. "Gold and Silver Ornaments in Early and Middle Bronze Age Bulgaria." In Maran et al. 2020, 251–64.

Alexandrov et al. 2018
Alexandrov, Stefan, et al., eds. *Злато & бронз: Метали, технологии и междурегионални контакти на територията на Източните Балкани през Бронзовата епоха / Gold & Bronze: Metals, Technologies and Interregional Contacts in the Eastern Balkans during the Bronze Age.* Sofia: National Archaeological Institute with Museum, 2018.

Amandry 1953
Amandry, Pierre. *Collection Hélène Stathatos.* Vol. 1, *Les bijoux antiques.* Strasbourg: n.p., 1953.

Amandry 1959
Amandry, Pierre. "Toreutique achéménide." *Antike Kunst* 2, no. 2 (1959): 38–56.

Amandry 1963
Amandry, Pierre, ed. *Collection Hélène Stathatos.* Vol. 3, *Objets antiques et byzantins.* Strasbourg: n.p., 1963.

Ambrosini 2020
Ambrosini, Laura. "La violenza di Herakles su Auge: Studio del procedimento produttivo di pissidi in ceramica argentata e dorata da Lipari derivate da specchi a teca di bronzo." *Mediterranea* 17 (2020): 87–106.

Ancillotti 1986
Ancillotti, Augusto. "Una nuova lettura dell'iscrizione trace di Kjolmen." *Archivio glottologico italiano* 71 (1986): 1–14.

Andreou and Vavelidis 2014
Andreou, Stylianos, and Michail Vavelidis. "So Rich and Yet So Poor: Investigating the Scarcity of Gold Artifacts in Bronze Age Northern Greece." In Meller, Risch, and Pernicka 2014, 451–67.

Andrieşescu 1925
Andrieşescu, Ioan. "Consideraţiuni asupra tezaurului dela Vâlci-Trân, lângă Plevna (Bulgaria)." *Academia Română, Memorii Sectiunii Istorice*, 3rd ser., 5, no. 2 (1925): 7–48.

Andronikos 1992
Andronikos, Manolis. *Βεργίνα: Οι βασιλικοί τάφοι και οι άλλες αρχαιότητες.* Athens: Ekdotike Athenon, 1992.

Archibald 1985
Archibald, Zosia H. "The Gold Pectoral from Vergina and Its Connections." *Oxford Journal of Archaeology* 4, no. 2 (1985): 165–85.

Archibald 1998
Archibald, Zosia H. *The Odrysian Kingdom of Thrace: Orpheus Unmasked.* Oxford: Clarendon Press, 1998.

Archibald 1999
Archibald, Zosia H. "Thracian Cult—from Practice to Belief." In *Ancient Greeks West and East*, edited by Gocha R. Tsetskhladze, 427–68. Leiden: Brill, 1999.

Archibald 2013
Archibald, Zosia H. *Ancient Economies of the Northern Aegean, Fifth to First Centuries BC.* Oxford: Oxford University Press, 2013.

Archibald 2015
Archibald, Zosia H. "L'émergence de l'aristocratie odryse." In Martinez et al. 2015, 54–57.

271

Archibald 2016
Archibald, Zosia H. "Moving Upcountry: Ancient Travel from Coastal Ports to Inland Harbours." In *Ancient Ports: The Geography of Connections; Proceedings of an International Conference at the Department of Archaeology and Ancient History, Uppsala University, 23–25 September 2010*, edited by Kerstin Höghammer, Brita Alroth, and Adam Lindhagen, 37–64. Uppsala: Uppsala Universitet, 2016.

Archibald, forthcoming
Archibald, Zosia H. "Macedonia." In *The Oxford History of the Archaic Greek World*, edited by Paul Cartledge and Paul Christesen. Vol. 4. Oxford University Press, forthcoming.

Ardjanliev et al. 2018
Ardjanliev, Pero, et al., eds. *100 Years of Trebenishte*. Exh. cat. Sofia: National Archaeological Institute with Museum, 2018.

Arrington et al. 2022
Arrington, Nathan T., et al. "The Classical City on the Molyvoti Peninsula (Aegean Thrace): Landscape, Urban Development, and Economic Networks." In *The Riverlands of Aegean Thrace: Production, Consumption and Exploitation of the Natural and Cultural Landscapes*, edited by Eurydice Kefalidou, 21–31. Heidelberg: Propylaeum, 2022.

Arrington et al. 2023
Arrington, Nathan T., et al. "The Molyvoti, Thrace, Archaeological Project (MTAP): Discovering and Recording a Diachronic Landscape." In *Surveying Aegean Thrace in the Digital Era*, edited by Amalia Avramidou and Jamieson C. Donati, 79–98. Komotini: Democritus University of Thrace, 2023.

Atanasov 1995
Atanasov, Georgi. "Тракийско въоръжение от фонда на Исторически музей–Шумен." In *Въоръжение от Древна Тракия*, 29–91. Exh. cat. Shumen: Istoricheski muzei–Shumen, 1995.

Atanasov 2006
Atanasov, Georgi. "Шпори от късножелязната епоха, открити в Шуменския регион." *Известия на историческия музей–Шумен* 13 (2006): 25–48.

Athanassov et al. 2020
Athanassov, Bogdan, et al. "A New Look at the Late Bronze Age Oxhide Ingots from the Eastern Balkans." In Maran et al. 2020, 299–357.

Avram 1990
Avram, Alexandru. "Das histrianische Territorium in griechisch-römischer Zeit." In *Histria: Eine Griechenstadt an der rumänischen Schwarzmeerküste*, edited by Petre Alexandrescu and Wolfgang Schuller, 9–43. Konstanz: Universitätsverlag Konstanz, 1990.

Avram 1996
Avram, Alexandru. "Les cités grecques de la côte Ouest du Pont-Euxin." In *Introduction to an Inventory of* Poleis, edited by Mogens Herman Hansen, 288–316. Copenhagen: Royal Danish Academy of Sciences and Letters, 1996.

Avram 2003
Avram, Alexandru. "Histria." In *Ancient Greek Colonies in the Black Sea*, edited by D. V. Grammenos and E. K. Petropoulos, 1:279–340. Thessaloniki: Archaeological Institute of Northern Greece, 2003.

Avram 2006
Avram, Alexandru. "Pont." In "Bulletin épigraphique," by Philippe Gauthier et al. *Revue des études grecques* 119, no. 2 (2006): 683–93.

Avram 2007
Avram, Alexandru. "Das Territorium von Istros in archaischer Zeit." In *Frühes Ionien: Eine Bestandsaufnahme*, edited by Justus Cobet et al., 487–97. Mainz: Philipp von Zabern, 2007.

Avram 2011
Avram, Alexandru. "Marginalien zu griechisch beschrifteten Schleudergeschossen (I)." In *Scripta Classica: Radu Ardevan Sexagenario Dedicate*, edited by Ioan Piso et al., 195–99. Cluj-Napoca, Romania: Mega, 2011.

Avram 2012
Avram, Alexandru. "Le rôle des époikoi dans la colonisation grecque en mer Noire: Quelques études de cas." *Pallas*, no. 89 (2012): 197–215.

Avram, Hind, and Tsetskhladze 2004
Avram, Alexandru, John Hind, and Gocha R. Tsetskhladze. "The Black Sea Area." In Hansen and Nielsen 2004, 924–73.

Avramidou 2011
Avramidou, Amalia. *The Codrus Painter: Iconography and Reception of Athenian Vases in the Age of Pericles*. Madison: University of Wisconsin Press, 2011.

Avramidou 2019
Avramidou, Amalia. "An Unusual Sympotic Scene on a Silver Cup from Ancient Thrace: Questions of Iconography and Manufacture." In *Greek Art in Motion: Studies in Honour of Sir John Boardman on the Occasion of His 90th Birthday*, edited by Rui Morais et al., 127–35. Oxford: Archaeopress, 2019.

Avramidou and Tsiafaki 2015
Avramidou, Amalia, and Despoina Tsiafaki. *Αττική Κεραμική: Συμβολή στις Επαφές Αθήνας και Θράκης*. Thessaloniki: Kallipos, Open Academic Editions, 2015. https://repository .kallipos.gr/handle/11419/3616.

Bäbler 1998
Bäbler, Balbina. *Fleissige Thrakerinnen und wehrhafte Skythen: Nichtgriechen im klassischen Athen und ihre archäologische Hinterlassenschaft*. Stuttgart: B. G. Teubner, 1998.

Backe-Hansen 2016
Backe-Hansen, Wendy K. "Nemesis: A Concept of Retribution in Ancient Greek Thought and Cult." PhD diss., University of New England, Maine, 2016.

Badian 1967
Badian, E. "Agis III." *Hermes* 95, no. 2 (1967): 170–92.

Baitinger 2004
Baitinger, Holger. "Hellenistisch-frühkaiserzeitliche Reitersporen aus dem Zeusheiligtum von Olympia." *Germania* 82, no. 2 (2004): 351–79.

Balabanov and Pantov 2018
Balabanov, Petar, and Daniel Pantov. "Treasure of Gold Appliqués for Horse Harness from Primorsko." *Bulgarian e-Journal of Archaeology* 8, no. 1 (2018): 1–16. https://be-ja.org/index .php/journal/article/view/be-ja-8 -1-2018-1-16/154.

Balcer 1988
Balcer, Jack M. "Persian Occupied Thrace (Skudra)." *Historia* 37, no. 1 (1988): 1–21.

BAPD
Beazley Archive Pottery Database. Classical Art Research Centre. University of Oxford. http://www .beazley.ox.ac.uk.

Baralis, Gyuzelev, and Panayotova 2021
Baralis, Alexandre, Martin Gyuzelev, and Krastina Panayotova. "Between Crisis and Conflicts: The Territory of Apollonia Pontica in the Late Classical and Early Hellenistic Periods." In Tsetskhladze, Avram, and Hargrave 2021, 99–110.

Baralis, Panayotova, and Nedev 2019
Baralis, Alexandre, Krastina Panayotova, and Dimitar Nedev, eds. *Sur les pas des archéologues: Apollonia du Pont; Collections du Louvre et des musées de Bulgarie*. Exh. cat. Sofia: Éditions Faber, 2019.

Beazley 1963
Beazley, J. D. *Attic Red-Figure Vase-Painters*. 2nd ed. 3 vols. Oxford: Clarendon Press, 1963.

Bengtson 1937
Bengtson, Hermann. *Die Strategie in der hellenistischen Zeit: Ein Beitrag zum antiken Staatsrecht*. Vol. 1. Munich: C. H. Beck, 1937.

Bengtson 1944
Bengtson, Hermann. *Die Strategie in der hellenistischen Zeit: Ein Beitrag zum antiken Staatsrecht*. Vol. 2. Munich: C. H. Beck, 1944.

Berciu 1969
Berciu, Dumitru. "Das thrako-getische Fürstengrab von Agighiol in Rumänien." *Bericht der Römisch-Germanischen Kommission des Deutschen Archäologischen Instituts* 50 (1969): 209–65.

Berve 1926
Berve, Helmut. *Das Alexanderreich auf prosopographischer Grundlage.* 2 vols. Munich: C. H. Beck, 1926.

Beševliev 1965
Beševliev, Veselin. "Inschrift in unbekannter Sprache aus Nord-bulgarien." *Glotta* 43, nos. 3–4 (1965): 317–22.

Best 1969
Best, Jan G. P. *Thracian Peltasts and Their Influence on Greek Warfare.* Groningen: Wolters-Noordhoff, 1969.

Bingen 2007
Bingen, Jean. "The Thracians in Ptolemaic Egypt." In *Hellenistic Egypt: Monarchy, Society, Economy, Culture*, edited by Roger S. Bagnall, 83–93. Berkeley: University of California Press, 2007.

Bîrzescu 2012
Bîrzescu, Iulian. "Die archaische Siedlung von Tariverde." *Dacia*, n.s., 56 (2012): 77–89.

Bîrzescu and Ionescu 2016
Bîrzescu, Iulian, and Mihai Ionescu. "Recherches sur la fondation de Callatis: L'apport de la documentation archéologique." In *Mégarika: Nouvelles recherches sur Mégare et les cités de la Propontide et du Pont-Euxin; Archéologie, épigraphie, histoire*, edited by Adrian Robu and Iulian Bîrzescu, 381–91. Paris: Éditions de Boccard, 2016.

Boardman 1970
Boardman, John. *Greek Gems and Finger Rings: Early Bronze Age to Late Classical.* London: Thames & Hudson, 1970.

Boardman 1972
Boardman, John. "Herakles, Peisistratos and Sons." *Revue archéologique*, n.s., fasc. 1 (1972): 57–72.

Boardman 1980
Boardman, John. *The Greeks Overseas.* London: Thames & Hudson, 1980.

Boardman 1985
Boardman, John. *Greek Sculpture: The Classical Period.* London: Thames & Hudson, 1985.

Boardman 1987
Boardman, John. "Silver Is White." *Revue archéologique* 2 (1987): 279–95.

Boardman 1989
Boardman, John. *Athenian Red Figure Vases: The Classical Period.* London: Thames & Hudson, 1989.

Boardman 2000
Boardman, John. *Persia and the West: An Archaeological Investigation of the Genesis of Achaemenid Art.* London: Thames & Hudson, 2000.

Den Boer 1969
Den Boer, W. "Theseus: The Growth of a Myth in History." *Greece & Rome*, 2nd ser., 16, no. 1 (1969): 1–13.

Bogdanov 1987
Bogdanov, Bogdan. *Медните находища в България.* Sofia: Tehnika, 1987.

Bondoc 2006
Bondoc, Dorel. "Un disc de tip Vălcitrăn descoperit la Călăraşi (jud. Dolj)." *Studii şi cercetări de istorie veche şi arheologie* 54–56 (2006): 279–85.

Bonev 1984
Bonev, Aleksander. "Datierung des Goldschatzes von Valchitran." *Studia Prehistorica* 7 (1984): 164–77.

Bonev 1988
Bonev, Aleksander. *Тракия и Егейският свят през втората половина на II хилядолетие пр. н. е.* Sofia: Arheologicheski institut s muzei pri Bŭlgarska akademiia na naukite, 1988.

Bonev 2003
Bonev, Aleksander. *Ранна Тракия: Формиране на тракийската култура-края на второто-началото на първото хилядолетие пр. Хр.* Sofia: Arheologicheski institut s muzei pri Bŭlgarska akademiia na naukite, 2003.

Bonias and Perreault 2009
Bonias, Zisis, and Jacques Y. Perreault, eds. Έλληνες και Θράκες στην παράλια ζώνη και την ενδοχώρα της Θράκης στα χρόνια πριν και μετά τον μεγάλο αποικισμό: Πρακτικά του Διεθνούς Συμποσίου Θάσος, 26–27 Σεπτεμβρίου 2008 / *Greeks and Thracians along the Coast and in the Hinterland of Thrace during the Years before and after the Great Coloniza-tion: Acts of the International Symposium, Thasos, 26–27 September 2008.* Thasos: Dráseis Allilengýis stin Mesógeio kai ta Valkánia Mi Kyvernitikós Organismós 2008, 2009.

Borg 2002
Borg, Barbara E. *Der Logos des Mythos: Allegorien und Personifikatio-nen in der frühen griechischen Kunst.* Munich: Wilhelm Fink, 2002.

Borislavov 2010
Borislavov, Borislav. "The Izvorovo Gold: A Bronze Age Tumulus from Harmanli District, Southeastern Bulgaria (Preliminary Report)." *Archaeologia Bulgarica* 14, no. 1 (2010): 1–33.

Borislavov 2018
Borislavov, Borislav. "Izvorovo— Bronze Age Settlement and Cemetery in Southern Sakar Mountain." In Alexandrov et al. 2018, 371–77.

Boshnakov 2004
Boshnakov, Konstantin. *Pseudo-Skymnos (Semos von Delos?): Τα αριστερά του Πόντου; Zeugnisse griechischer Schriftsteller über den westlichen Pontosraum.* Stuttgart: Franz Steiner, 2004.

Boteva-Boyanova 2005
Boteva[-Boyanova], Dilyana. "Soldiers and Veterans Dedicating Votive Monuments with a Representation of the Thracian Horseman within the Provinces of Lower Moesia and Thrace." In *Römische Städte und Festungen an der Donau: Akten der regionalen Konferenz, 16–19 Oktober 2003*, edited by Miroslava Mirković, 199–210. Belgrade: Filozofski fakultet, 2005.

Boteva-Boyanova 2011
Boteva[-Boyanova], Dilyana. "Re-reading Herodotus on the Persian Campaigns in Thrace." In *Herodot und das persische Weltreich / Herodotus and the Persian Empire: Akten des 3. Internationalen Kolloquiums zum Thema "Vorderasien im Spannungsfeld klassischer und altorientalischer Überlieferungen," Innsbruck, 24.–28. November 2008*, edited by Robert Rollinger, Brigitte Truschnegg, and Reinhold Bichler, 735–59. Wiesbaden: Harrassowitz, 2011.

Boteva-Boyanova 2021
Boteva-Boyanova, Dilyana. "Thrace." In *A Companion to the Achaemenid Persian Empire*, edited by Bruno Jacobs and Robert Rollinger, 1:649–56. Hoboken, NJ: John Wiley & Sons, 2021.

Bouguet 1929
Bouguet, Émile. *Fouilles de Delphes.* Vol. 3, *Épigraphie*, fasc. 1, *Inscriptions de l'entrée du sanctuaire au trésor des Athéniens.* Paris: É. de Boccard, 1929.

Bouzek 1997
Bouzek, Jan. *Greece, Anatolia and Europe: Cultural Interrelations during the Early Iron Age.* Jonsered, Sweden: Paul Åström, 1997.

Bouzek 2002
Bouzek, Jan. "Addenda to Pistiros I." In *Pistiros II: Excavations and Studies*, edited by Jan Bouzek, Lidia Doma-radzka, and Zosia H. Archibald, 343–48. Prague: Karolinum, 2002.

Boyadzhiev, Popov, and Chukalev 2018
Boyadzhiev, Kamen, Hristo Popov, and Krastyu Chukalev, eds. *Спасени съкровища на България / Rescued Treasures of Bulgaria.* Exh. cat. Sofia: National Archaeological Institute with Museum–Bulgarian Academy of Sciences, 2018.

Boyadzhiev, Stamberova, and Vasileva 2013
Boyadzhiev, Kamen, Miglena Stamberova, and Zheni Vasileva, eds. *130 избрани експоната от колекцията на Националния археологически музей.* Sofia: Izdatelstvo na BAN "Prof. Marin Drinov," 2022.

274 | References Cited

Bozhinova, Jung, and Mommsen 2013
Bozhinova, Elena, Reinhard Jung, and Hans Mommsen. "Eine spätbronzezeitliche Höhensiedlung in den bulgarischen Rhodopen mit importierter mykenischer Keramik." *Mitteilungen des Deutschen Archäologischen Instituts: Athenische Abteilung* 125 (2013): 45–97.

Bozkova 2017
Bozkova, Anelia. *Антична керамика между Хемус, Родопа и Евксинския Понт (VII–I в. пр. Хр.): Характеристика, разпространение и употреба.* Veliko Tarnovo: Faber, 2017.

Bozkova and Kiyashkina 2013
Bozkova, Anelia, and Petya Kiyashkina. "Бронзова погребална хидрия от Несебър." *Археология* 54, no. 1 (2013): 22–30.

Bozkova and Nikov 2009
Bozkova, Anelia, and Krassimir Nikov. "La céramique monochrome en Thrace et ses prototypes anatoliens: Problèmes de chronologie." In *Les productions céramiques de Pont-Euxin à l'époque grecque: Actes du Colloque international, Bucarest, 18–23, septembre 2004,* edited by Pierre Dupont and Vasilica Lungu, 47–55. Rome: Quasar, 2009.

Bravo and Chankowski 1999
Bravo, Benedetto, and Andrzej Chankowski. "Cités et emporia dans le commerce avec les barbares, à la lumière du document dit à tort 'inscription de Pistiros.'" *Bulletin de correspondance hellénique* 123, no. 1 (1999): 275–317.

Brijder and Stibbe 1997
Brijder, H. A., and C. M. Stibbe. "A Bronze Cup in the Allard Pierson Museum." *Bulletin antieke beschaving* 72 (1997): 21–35.

Brixhe 2006
Brixhe, Claude. "Zônè et Samothrace: Lueurs sur la langue thrace et nouveau chapitre de la grammaire comparée?" *Comptes rendus des séances de l'Académie des Inscriptions et Belles-Lettres* 150, no. 1 (2006): 121–46.

Brixhe and Panayotou 1997
Brixhe, Claude, and Anna Panayotou. "Le thrace." In *Langues indo-européennes*, edited by Françoise Bader, 276–315. Paris: CNRS Éditions, 1997. doi.10.4000/books.editionscnrs.41422.

Brommer 1982
Brommer, Frank. *Theseus: Die Taten des griechischen Helden in der antiken Kunst und Literatur.* Darmstadt: Wissenschaftliche Buchgesellschaft, 1982.

Buchholz 1988
Buchholz, Hans-Günter. "Der Metallhandel des zweiten Jahrtausends im Mittelmeerraum." In *Society and Economy in the Eastern Mediterranean (c. 1500–1000 B.C.): Proceedings of the International Symposium Held at the University of Haifa from the 28th of April to the 2nd of May, 1985,* edited by M. Heltzer and E. Lipiński, 187–228. Leuven: Peeters, 1988.

Buiskikh 2016
Buiskikh, Alla. "A Sub-Geometric Skyphos from Borysthenes: On the Question of Pre-Colonial Ties in the North Pontic Region." *Ancient Civilizations from Scythia to Siberia* 22 (2016): 1–17.

Bundrick 2005
Bundrick, Sheramy D. *Music and Image in Classical Athens.* Cambridge: Cambridge University Press, 2005.

Bundrick 2014
Bundrick, Sheramy D. "Selling Sacrifice on Classical Athenian Vases." *Hesperia* 83, no. 4 (2014): 653–708.

Burkert 1985
Burkert, Walter. *Greek Religion.* Oxford: Basil Blackwell, 1985.

Burn 1987
Burn, Lucilla. *The Meidias Painter.* Oxford: Clarendon Press, 1987.

Buyukliev 1991
Buyukliev, Hristo. "Използването на лъка и стрелата в Древна Тракия през ранножелязната епоха." *Известия на музеите от Югоизточна България* 14 (1991): 7–22.

Buyukliev 1994
Buyukliev, Hristo. "Към проблема за тракийското въоръжение в хинтерланда на Севтополис." In Kitov et al. 1994, 1:157–64.

Cahn 1960
Cahn, Herbert A. "Die Gewichte der Goldgefässe." *Antike Kunst* 3 (1960): 26–29.

Cahn 1988
Cahn, Herbert A. "Okeanos, Strymon und Atlas auf einer rotfiguren Spitzamphora." In *Proceedings of the 3rd Symposium on Ancient Greek and Related Pottery, Copenhagen, August 31–September 4, 1987,* edited by Jette Christiansen and Torben Melander, 107–16. Copenhagen: Nationalmuseet, Ny Carlsberg Glyptotek, Thorvaldsens Museum, 1988.

Calder 1996
Calder, William M., III. "The Seuthopolis Inscription: IGBR 1731; A New Edition." In *Transitions to Empire: Essays in Greco-Roman History, 360–146 B.C. in Honor of E. Badian,* edited by Robert W. Wallace and Edward M. Harris, 167–78. Norman: University of Oklahoma Press, 1996.

Calmeyer 1993
Calmeyer, Peter. "Die Gefässe auf den Gabenbringer-Reliefs in Persepolis." *Archäologische Mitteilungen aus Iran* 26 (1993): 147–60.

Carradice 1987
Carradice, Ian, ed. *Coinage and Administration in the Athenian and Persian Empires: The Ninth Oxford Symposium on Coinage and Monetary History.* Oxford: B.A.R., 1987.

Casevitz 2001
Casevitz, Michel. "Le vocabulaire du mélange démographique: Mixobarbares et mixhellènes." In *Origines Gentium,* edited by Valérie Fromentin and Sophie Gotteland, 41–47. Pessac: Ausonius, 2001.

Chankowski and Domaradzka 1999
Chankowski, Véronique, and Lidia Domaradzka. "Réédition de l'inscription de Pistiros et problèmes d'interprétation." *Bulletin de correspondance hellénique* 123, no. 1 (1999): 246–58.

Chernykh 1975
Chernykh, Evgenij. "Аи-бунарский медный рудник IV тысячилетия до н.э. на Балканах (исследования 1971, 1972 и 1974 гг.)." *Советская археология* 4 (1975): 132–53.

Chernykh 1978
Chernykh, Evgenij. *Горное дело и металлургия в Древнейшей Болгарии.* Sofia: Bŭlgarska akademiia na naukite, 1978.

Chernykh 1992
Chernykh, Evgenij. *Ancient Metallurgy in the USSR: The Early Metal Age.* Translated by Sarah Wright. Cambridge: Cambridge University Press, 1992.

Chichikova 1969
Chichikova, Maria. "Тракийска могилна гробница от с. Калояново, Сливенски окръг (IV в. пр. н. е.)." *Известия на Археологическия институт* 31 (1969): 45–89.

Chichikova 2012
Chichikova, Maria. *Царската гробница с кариатидите край село Свещари: 30 години от откриването / The Caryatids Royal Tomb at Sveshtari: 30 Years of Discovery.* In collaboration with Daniela Stoyanova and Totko Stoyanov. Isperih: Istoricheski Isperih, 2012.

Chichikova 2016
Chichikova, Maria. "The Royal Palace in Seuthopolis." *Thracia* 21 (2016): 31–47.

Chichikova and Dimitrov 2016
Chichikova, Maria, and Kamen Dimitrov. *Севтополис, градът на Севт III.* Plovdiv: Letera, 2016.

Chimbuleva 1962
Chimbuleva, Zhana. "Две новооткрити бронзови хидрии от Несебър." *Археология* 4, no. 3 (1962): 38–41.

Chimbuleva 1988
Chimbuleva, Zhana. "Надгробни плочи със седнали фигури от Несебър." *Известия на музеите от Югоизточна България* 11 (1988): 7–21.

Cholakov 2004
Cholakov, Ivo. "Chariot Bronze from Thrace." In *The Antique Bronzes: Typology, Chronology, Authenticity; Acta of the 16th International Congress of Antique Bronzes, Organized by the Romanian National History Museum, Bucharest, May 26th–31st 2003*, edited by Crişan Muşeţeanu, 105–18. Bucharest: Editura Cetatea de Scaun, 2004.

Chryssanthaki-Nagle 2007
Chryssanthaki-Nagle, Katerina. *L'histoire monétaire d'Abdère en Thrace (VIᵉ s. avant J.-C.–IIᵉ s. après J.-C.)*. Athens: Research Centre for Greek and Roman Antiquity, National Hellenic Research Foundation, 2007.

Chukalev and Dimitrova 2018
Chukalev, Krastyu, and Yana Dimitrova. "Valchitran Treasure." In Alexandrov et al. 2018, 378–82.

Clark 1988
Clark, Andrew J. *Corpus Vasorum Antiquorum: The J. Paul Getty Museum 1 (USA 23)*. Malibu, CA: J. Paul Getty Museum, 1988.

Cohen 2000
Cohen, Beth, ed. *Not the Classical Ideal: Athens and the Construction of the Other in Greek Art*. Leiden: Brill, 2000.

Končev 1956
Končev, Dimiter. "Der Goldschatz von Panagjuriste." With the assistance of Peter Gorbanov. In *Neue Denkmäler antiker Toretik / Nové památky antické toretiky*, edited by Bedřich Svoboda and Dimiter Končev, 126–57. Prague: Československá akademie věd, 1956.

B. Cook 1989
Cook, B. F., ed. *The Rogozen Treasure: Papers of the Anglo-Bulgarian Conference, 12 March 1987*. London: British Museum Publications, 1989.

R. Cook 1933–34
Cook, Robert M. "Fikellura Pottery." *Annual of the British School at Athens* 34 (1933–34): 3–98.

R. Cook 1981
Cook, Robert M. *Clazomenian Sarcophagi*. Mainz: Philipp von Zabern, 1981.

R. Cook and Dupont 1998
Cook, Robert M., and Pierre Dupont. *East Greek Pottery*. London: Routledge, 1998.

Corcella 1995
Corcella, Aldo. "Pollis and the Tattooers." *Zeitschrift für Papyrologie und Epigraphik* 109 (1995): 47–48.

Cremer 1991
Cremer, Marielouise. *Hellenistisch-römische Grabstelen im nordwestlichen Kleinasien*. Vol. 1, *Mysien*. Bonn: Dr. Rudolf Habelt, 1991.

Crişan 1978
Crişan, Ion Horarţiu. *Burebista and His Time*. Bucharest: Editura Academiei Republicii Socialiste România, 1978.

Crowfoot 1897
Crowfoot, J. W. "A Thracian Portrait." *Journal of Hellenic Studies* 17 (1897): 321–26.

Curtis, Cowell, and Walker 1995
Curtis, John E., Michael R. Cowell, and Christopher B. F. Walker. "A Silver Bowl of Artaxerxes I." *Iran* 33 (1995): 149–53.

Daehner 2005
Daehner, Jens M. "Grenzen der Nacktheit: Studien zum nackten männlichen Körper in der griechischen Plastik des 5. und 4. Jahrhunderts v. Chr." *Jahrbuch des Deutschen Archäologischen Instituts* 120 (2005): 155–300.

Daehner and Lapatin 2015
Daehner, Jens M., and Kenneth Lapatin, eds. *Power and Pathos: Bronze Sculpture of the Hellenistic World*. Exh. cat. Los Angeles: J. Paul Getty Museum, 2015.

Damyanov 2003
Damyanov, Margarit. "On the Local Population around the Greek Colonies in the Black Sea Area (5th–3rd Centuries BC)." *Ancient West & East* 2, no. 2 (2003): 253–64.

Damyanov 2015a
Damyanov, Margarit. "An Early Hellenistic Xiphos from Apollonia Pontica." *Archaeologia Bulgarica* 19, no. 3 (2015): 23–36.

Damyanov 2015b
Damyanov, Margarit. "The Greek Colonists." In Valeva, Nankov, and Graninger 2015, 295–307.

Damyanov 2018
Damyanov, Margarit. "First Encounters and Further Developments: Greeks Meeting Thracians on the Western Pontic Coast." In *Archaeology across Frontiers and Borderlands: Fragmentation and Connectivity in the North Aegean and the Central Balkans from the Bronze Age to the Iron Age*, edited by Stefanos Gimatzidis, Magda Pieniążek, and Sila Mangaloğlu-Votruba, 243–68. Vienna: Verlag der Österreichischen Akademie der Wissenschaften, 2018.

Damyanov 2022
Damyanov, Margarit. "Attic Painted Pottery on the West Pontic Coast: Across the Gaps." In Tsiafaki et al. 2022, 288–306.

Damyanov, Nankov, and Stoyanova 2021
Damyanov, Margarit, Emil Nankov, and Daniela Stoyanova. "Inconspicuous Presence? Macedonians on the West Pontic Coast in the Early Hellenistic Period." In Manoledakis 2021, 113–27.

Damyanov and Panayotova 2020
Damyanov, Margarit, and Krastina Panayotova. "Apollonia Pontica and the South-Western Black Sea Coast in the Thracian and Antique Periods (Late 2nd Millennium BC to Early 1st Millennium AD)." In Krauss et al. 2020, 247–94.

Damyanov, Reho, and Panayotova 2021
Damyanov, Margarit, Maria Reho, and Krastina Panayotova. "Cold Case Reopened: A Late Classical Tomb in Apollonia Pontica." In Tsetskhladze, Avram, and Hargrave 2021, 493–500.

Damyanov and Stoyanova 2019
Damyanov, Margarit, and Daniela Stoyanova. "La frise architecturale aux hoplites." In Baralis, Panayotova, and Nedev 2019, 64–72.

D. Dana 2014
Dana, Dan. *Onomasticon Thracicum: Répertoire des noms indigènes de Thrace, Macédoine Orientale, Mésies, Dacie et Bithynie*. Athens: Centre de recherche de l'antiquité grecque et romaine, Fondation nationale de la recherche scientifique, 2014.

D. Dana 2015
Dana, Dan. "Inscriptions." In Valeva, Nankov, and Graninger 2015, 243–64.

D. Dana 2018
Dana, Dan. "Retour sur les catalogues de Kalindoia: Échantillons onomastiques des Thraces de Macédoine." In *Βορειοελλαδικά: Tales from the Lands of the Ethne; Essays in Honour of Miltiades B. Hatzopoulos / Histoires du monde des ethné; Études en l'honneur de Miltiade B. Hatzopoulos*, edited by Myrina Kalaitzi et al., 53–67. Athens: National Hellenic Research Foundation / Institute of Historical Research, 2018.

M. Dana 2021
Dana, Madalina. "Greeks and Non-Greeks in Contact: Commercial and Epigraphical Practices according to the Lead and Ostracon Letters from the Northern Black Sea." In Manoledakis 2021, 31–41.

Danov 1952
Danov, Christo M. "Към историята на Тракия и Западното Черноморие от втората половина на III век до средата на I век преди н. е." *Годишник на Софийския университет, Философско-исторически факултет* 47, no. 2 (1952): 105–66.

Danov 1979
Danov, Christo M. "Die Thraker auf dem Ostbalkan von der hellenistischen Zeit bis zur Gründung Konstantinopels." In *Aufstieg und Niedergang der Römischen Welt*. Teil 2, *Principat*, edited by Hildegard Temporini and Wolfgang Haase, Band 7, Halbband 1, 21–85. Berlin: Walter de Gruyter, 1979.

Darbandi and Zournatzi 2008
Darbandi, Seyed Mohammad Reza, and Antigoni Zournatzi. *Ancient Greece and Ancient Iran: Cross-Cultural Encounters; First International Conference, Athens, 11–13 November 2006.* Athens: National Hellenic Research Foundation; Hellenic NationalCommission for UNESCO; Cultural Center of the Embassy of the Islamic Republic of Iran, 2008.

Daumas 1978
Daumas, Michèle. "L'amphore de Panagurišté et les Sept contre Thèbes." *Antike Kunst* 21, no. 1 (1978): 23–31.

Davie 1982
Davie, John N. "Theseus the King of Fifth-Century Athens." *Greece & Rome*, 2nd ser., 29, no. 1 (1982): 25–34.

Dedyulkin 2015a
Dedyulkin, Anton. "К вопросу о генезисе и хронологии наплечных фаларов эллинистической эпохи." *Восток (Oriens)* 5 (2015): 127–37.

Dedyulkin 2015b
Dedyulkin, Anton. "'Пращевые' камни в погребениях скифской эпохи." In *Война и военное дело в скифо-сарматском мире: Материалы международной научной конференции памяти А. И. Мелюковой (Кагальник, 26–29 апреля 2014 г.)*, edited by S. I. Lukyashko, 48–52. Rostov-on-Don: Izdatelstvo IuNTS RAN, 2015.

Delev 1986
Delev, Peter. "Eriope." In *Lexicon Iconographicum Mythologiae Classicae.* Vol. 3, pt. 1, 843. Zurich: Artemis, 1986.

Delev 2000
Delev, Peter. "Lysimachus, the Getae, and Archaeology." *Classical Quarterly* 50, no. 2 (2000): 384–401.

Delev 2002
Delev, Peter. "Some Greeks in Thrace." In *Thrace and the Aegean: Proceedings of the Eighth International Congress of Thracology, Sofia–Yambol, 25–29 September, 2000*, edited by Alexander Fol, 1:301–9. Sofia: International Foundation Europa Antiqua, 2002.

Delev 2003
Delev, Peter. "From Corupedion towards Pydna: Thrace in the Third Century." In "In Honorem Annorum LXX Alexandri Fol," edited by Kiril Jordanov, Kalin Porozhanov, and Valeria Fol. Special issue, *Thracia* 15 (2003): 107–20.

Delev 2004
Delev, Peter. *Лизимах.* Sofia: Universitetsko izdatelstvo "Sv. Kliment Ohridski," 2004.

Delev 2005
Delev, Peter. "Stratifying Herodotus: Local Tribes between the Lower Axios and the Nestos." *Thracia* 16 (2005): 105–21.

Delev 2014
Delev, Peter. *История на племената в Югозападна Тракия през I хил. пр. Хр.* Sofia: Universitetsko izdatelstvo "Sv. Kliment Ohridski," 2014.

Delev 2015a
Delev, Peter. "From Koroupedion to the Beginning of the Third Mithridatic War (281–73 BCE)." In Valeva, Nankov, and Graninger 2015, 59–74.

Delev 2015b
Delev, Peter. "Thrace from the Assassination of Kotys I to Koroupedion (360–281 BCE)." In Valeva, Nankov, and Graninger 2015, 48–58.

Delev 2016a
Delev, Peter. "Cotys Son of Rhascuporis." In Slavova and Sharankov 2016, 119–29.

Delev 2016b
Delev, Peter. "За генеалогията на Сапейската династия." In *ΣΥΜΠΟΣΙΟΝ: Сборник в памет на проф. Димитър Попов*, edited by Peter Delev, 148–73. Sofia: Universitetsko izdatelstvo "Sv. Kliment Ohridski," 2016.

Delev 2018
Delev, Peter. "Did a 'Late' Odrysian Kingdom Ever Exist?" In "Stephanos Archaeologicos ad 80 Annum Professoris Ludmili Getov." Supplement, *Studia Archaeologica Universitatis Serdicensis* 4 (2018): 191–96.

Delev 2023
Delev, Peter. "Ancient Thrace." In H. Popov et al. 2023, 14–26.

Delev et al. 2022
Delev, Peter, et al., eds. *Ancient Thrace: Myth and Reality; The Proceedings of the Thirteenth International Congress of Thracology, Kazanlak, September 3–7, 2017.* 2 vols. Sofia: St. Kliment Ohridski University Press, 2022.

Del Medico 1967–68
Del Medico, Henri E. "À propos du trésor de Panaguriste: Un portrait d'Alexandre par Lysippe." *Persica* 3 (1967–68): 37–67.

Demetriou 2012
Demetriou, Denise. *Negotiating Identity in the Ancient Mediterranean: The Archaic and Classical Greek Multiethnic Emporia.* Cambridge: Cambridge University Press, 2012.

Deoudi 2007
Deoudi, Maria. "Bendis—kulturell geprägtes Gesicht einer thrakischen Göttin." In Iakovidou 2007, 120–29.

Deoudi 2019
Deoudi, Maria. "Bendis: Ethnisches Symbol oder Göttin weiblicher Fertilität." In *Género y mujeres en el Mediterráneo Antiguo: Iconografías y literaturas*, edited by Pedro David Conesa Navarro, Rosa María Gualda Bernal, and José Javier Martínez García, 393–400. Murcia, Spain: Centro de Estudios del Próximo Oriente y la Antigüedad Tardía, Universidad de Murcia, 2019.

Desbals 1997
Desbals, Marie-Anne. "La Thrace et les Thraces dans l'imaginaire grec aux époques archaïque et classique: Littérature et iconographie." PhD diss., Université Paris 10, Nanterre, 1997.

Despoini 1996
Despini [Despoini], Aikaterini. *Ancient Gold Jewellery.* Athens: Ekdotike Athenon, 1996.

Despoini et al. 2016
Despoini, Aikaterini, et al. *Σίνδος II: Το Νεκροταφείο; Ανασκαφικές Έρευνες 1980–1982.* Athens: Archailogike Etaireia, 2016.

Dessau 1913
Dessau, Hermann. "Reges Thraciae qui fuerint imperante Augusto." *Ephemeris Epigraphica* 9 (1913): 696–706.

Detschew 1976
Detschew, Dimiter. *Die thrakischen Sprachreste.* 2nd ed. Vienna: Österreichische Akademie der Wissenschaften, 1976.

Dimitriu 1966
Dimitriu, Suzana. "Cartierul de locuințe din zona de vest a cetătei, în epoca arhaică (Săpături 1955–1960)." In *Histria*, 2:19–131. Bucharest: Editura Academiei Republicii Socialiste România, 1966.

D. Dimitrov 1942–43
Dimitrov, Dimiter P. "Нови наблюдения върху надгробната стела на Анаксандър от Аполония." *Годишник на Софийския университет, Историко-философски факултет* 39 (1942–43): 3–14.

D. Dimitrov 1957a
Dimitrov, Dimiter P. "Към въпроса за религията на траките от раннолинистическата епоха." *Исторически преглед* 13, no. 2 (1957): 65–81.

D. Dimitrov 1957b
Dimitrov, Dimiter P. "Neuentdeckte epigraphische Denkmäler über die Religion der Thraker in der frühhellenistischen Epoche." In *Hommages à Waldemar Deonna*, 181–93. Brussels: Latomus, 1957.

D. Dimitrov and Chichikova 1978
Dimitrov, Dimiter P., and Maria Čičikova [Chichikova]. *The Thracian City of Seuthopolis.* Translated by Marguerite P. Alexieva. Oxford: British Archaeological Reports, 1978.

K. Dimitrov 1984
Dimitrov, Kamen. "Античните монети от Севтополис." *Севтополис* 2 (1984): 7–136.

K. Dimitrov 1987
Dimitrov, Kamen. "Concerning the Iconography of the Thracian Royal Portrait in the Early Hellenistic Age." *Bulgarian Historical Review* 15, no. 2 (1987): 63–68.

K. Dimitrov 1988a
Dimitrov, Kamen. "Images of Thracian Rulers of the Pre-Hellenistic Epoch." *Bulgarian Historical Review* 16, no. 1 (1988): 56–59.

K. Dimitrov 1988b
Dimitrov, Kamen. "Изображение на тракийски владетел от Свещарската гробница." *Terra Antiqua Balcanica* 3 (1988): 161–64.

K. Dimitrov 1989
Dimitrov, Kamen. "Dynastic Coinages in Thrace in the Early Hellenistic Age (340–270 B.C.): Images, Traditions, Ideology." *Bulgarian Historical Review* 17, no. 2 (1989): 67–74.

K. Dimitrov 2008
Dimitrov, Kamen. "Севтополската царска династия в древните текстове: Факти и спекулации." *Проблеми и изследвания на тракийската култура* 3 (2008): 64–87.

K. L. Dimitrov 2002
Dimitrov, Kalin. "Die Metallfunde aus den Gräberfeldern von Durankulak." In *Durankulak*. Vol. 2, *Die prähistorischen Gräberfeldern von Durankulak*, edited by Henrieta Todorova, pt. 1, 127–58. Sofia: Deutsches Archäologisches Institut in Berlin, 2002.

K. L. Dimitrov 2007
Dimitrov, Kalin. "Медната металургия по Западния бряг на Черно море (средата на V–началото на IV хил. пр. Хр." PhD diss., University "Sv. Kliment Ohridski," Sofia, 2007.

K. L. Dimitrov 2013
Dimitrov, Kalin. "Technological Development of the Old Working Techniques in Varna." In *Where Are the Sites? Research, Protection and Management of Cultural Heritage; Proceedings of International Conference, Ahtopol, 5–8. December 2013*, edited by Hristina Angelova and Mehmet Özdoğan, 53–80. Sozopol: Centre for Underwater Archaeology, 2013.

K. L. Dimitrov 2020
Dimitrov, Kalin. "Notes on the Landscape and Geology of the Investigated Area South of Burgas." In Krauss et al. 2020, 15–28.

K. L. Dimitrov and Stoychev 2018
Dimitrov, Kalin, and Ruslan Stoychev. "The East Balkan Region as a Source of Precious and Non-ferrous Metals from Prehistory to the Roman Period." In Alexandrov et al. 2018, 43–57.

P. Dimitrov 2003
Dimitrov, Peter A. "The 6th Century BC Inscription from Kjolmen, District of Preslav, North-Eastern Bulgaria (Archaeological Museum of Sofia, Inv. No. 6558)." *Thracia* 15 (2003): 345–54.

S. Dimitrov 2005
Dimitrov, Stanimir. "За тракийската ромфея." In *МИФ 9: Тракия и околният свят; Научна конференция Шумен, 2004*, 285–94. Sofia: Nov Bŭlgarski Universitet, 2005.

S. Dimitrov 2010
Dimitrov, Stanimir. "Бронзови брони от Тракия." In *Великотърновският университет "Св. св. Кирил и Методий" и българската археология*, edited by Boris Borisov, 1:217–24. Veliko Tarnovo: Universitetsko izdatelstvo "Sv. sv. Kiril i Metodii," 2010.

A. Dimitrova 1966
Dimitrova, Aleksandra. "Сребърно съкровище от с. Владиня, Ловешко." *Известия на Археологическия институт* 29 (1966): 115–31.

D. Dimitrova 2003
Dimitrova, Diana, ed. *Пътят: Сборник научни статии, посветен на живота и творчеството на д-р Георги Китов*. Sofia: Geo Pres, 2003.

D. Dimitrova 2008a
Dimitrova, Diana, ed. *По пътя на миналото: Сборник научни статии по повод 65-годишнината на д-р Георги Китов*. Sofia: Aros, 2008.

D. Dimitrova 2008b
Dimitrova, Diana. "Якимова могила (предварително съобщение)." In D. Dimitrova 2008a, 221–25.

D. Dimitrova 2012
Dimitrova, Diana. "Рачева могила при Мъглиж." In *Василка Герасимова-Томова in Memoriam*, edited by Metodi Manov, 177–89. Sofia: Natsionalen arheologicheski institut s muzei–BAN, 2012.

D. Dimitrova 2015
Dimitrova, Diana. *Гробницата на цар Севт III в могила Голяма Косматка / The Tomb of King Seuthes III in Golyama Kosmatka Tumulus*. Sofia: Aros, 2015.

D. Dimitrova 2017
Dimitrova, Diana. "Ruler's Grave in Dalakova Tumulus, the Village of Topolchane, Sliven Region." In E. Penkova, Konova, and Kisyov 2017, 47–57.

D. Dimitrova 2019
Dimitrova, Diana. "Некропол Косматките в землището на гр. Шипка: Изследвания и проблеми." *Проблеми и изследвания на тракийската култура* 9 (2019): 65–107.

M. Dimitrova 1989
Dimitrova, Milena. "Обеци с лъвски глави от елинистическата епоха (по материали от България)." *Археология* 31, no. 3 (1989): 1–14.

Y. Dimitrova, forthcoming
Dimitrova, Yana. "Late Bronze Age Pottery in the Eastern Rhodope Mountains." In H. Popov and Jung, forthcoming.

Dobrov 1993
Dobrov, Gregory. "The Tragic and the Comic Tereus." *American Journal of Philology* 114, no. 2 (1993): 189–234.

Dobruski 1894
Dobruski, Vatslav. "Материали по археологията на България." *Сборник народни умотворения, наука и книжнина* 11 (1894): 68–103.

Domaradzki 1984
Domaradzki, Mieczysław. *Келтите на Балканския полуостров, IV–I в. пр. н. е.* Sofia: Nauka i izkustvo, 1984.

Domaradzki 1988
Domaradzki, Mieczysław. "Тракийски богати погребения." *Terra Antiqua Balcanica* 3 (1988): 78–86.

Domaradzki 1994
Domaradzki, Mieczysław. "Les lieux de culte thraces (deuxième moitié du IIᵉ–Iᵉʳ mill. av. J.–C.)." *Helis* 3, no. 1 (1994): 69–99.

Domaradzki 1997
Domaradzki, Mieczysław. "Rich Thracian Graves." In *Glorie di Tracia: L'oro più antico, i tesori, i miti / The Glories of Thrace: The Most Ancient Gold, the Treasures, the Myths*, 93–98. Exh. cat. Florence: Ermes, 1997.

Domaradzki 1998a
Domaradzki, Mieczysław. "Погребения и гробни съоръжения." In Domaradzki and Taneva 1998, 2:44–63.

Domaradzki 1998b
Domaradzki, Mieczysław. "Тракийската култура в прехода към елинистическата епоха." In Domaradzki and Taneva 1998, 11–76.

Domaradzki and Taneva 1998
Domaradzki, Mieczysław, and Valentina Taneva. *Емпорион Пистирос*. Vol. 2, *Тракийската култура в прехода към елинистическата епоха*. Septemvri: IK "Belloprint," 1998.

Doncheva 2012
Doncheva, Diana. "The Northern 'Journey' of Late Bronze Age Copper Ingots." In *ΗΡΑΚΛΕΟΥΣ ΣΩΤΗΡΟΣ ΘΑΣΙΩΝ: Studia in Honorem Iliae Prokopov Sexagenario ab Amicis et Discipulis Dedicata*, edited by Evgeni Paunov and Svetoslava Filipova, 671–714. Veliko Tarnovo: Faber, 2012.

Doonan 2006
Doonan, Owen. "Exploring Community in the Hinterland of a Black Sea Port." In *Surveying the Greek Chora: Black Sea Region in a Comparative Perspective*, edited by Pia Guldager Bilde and Vladimir F. Stolba, 47–58. Aarhus: Aarhus University Press, 2006.

Dörig 1982
Dörig, José. "Το πρόγραμμα της γλυπτικής διακοσμήσεως του Παρθενώνα: Σκέψεις πάνω στην ιστορική συνείδηση των Αθηναίων της κλασικής εποχής." *Archaiologike Ephemeris* 121 (1982): 187–214.

Dörig 1987
Dörig, José. *Les trésors d'orfèvrerie Thrace*. Rome: Bretschneider, 1987.

Draganov 2001
Draganov, Dragomir. *Монетите на македонските царе*. Pt. 2, *От Филип II Аридей до Персей*. Yambol: YA, 2001.

Draycott 2015
Draycott, Catherine. "'Heroa' and the City: Kuprlli's New Architecture and the Making of the 'Lycian Acropolis' of Xanthus in the Early Classical Period." *Anatolian Studies* 65 (2015): 97–142.

Dremsizova-Nelchinova 1970
Dremsizova-Nelchinova, Tsvetana. "Тракийски могилни погребения край с. Кьолмен, Шуменски окръг." *Известия на Археологическия институт* 32 (1970): 207–29.

Drougou 1975
Drougou, Stella. *Der attische Psykter.* Würzburg: K. Triltsch, 1975.

Dumont 1892
Dumont, Albert. *Mélanges d'archéologie et d'épigraphie.* Compiled by Théophile Homolle. Paris: Ernest Thorin, 1892.

Dupont 2015
Dupont, Pierre. "Le règne des 'persianismes.'" In Martinez et al. 2015, 230–32.

Dupont and Lungu 2021
Dupont, Pierre, and Vasilica Lungu. "Orgame Necropolis: A Contextual Study of the Earliest Pottery Imports." In Tsetskhladze, Avram, and Hargrave 2021, 69–77.

Dyakovich 1906–7
Dyakovich, Boris. "Тракийската гробница при Пловдив и некрополът на древния град." *Сборник за народни умотворения* 22–23 (1906–7): 1–55.

Dzis-Raiko and Chernyakov 1981
Dzis-Raiko, G. A., and Ivan T. Chernyakov. "Золотая чаша Вылчетрыновского типа из Северо-Западного Причерноморья." *Советская археология* 1 (1981): 151–61.

Ebert 1996a
Ebert, Joachim. "Das Grabepigramm für den Hopliten Pollis." *Zeitschrift für Papyrologie und Epigraphik* 112 (1996): 66.

Ebert 1996b
Ebert, Joachim. "Neue griechische historische Epigramme." In *ΕΝΕΡΓΕΙΑ: Studies on Ancient History and Epigraphy, Presented to H. W. Pleket,* edited by Johann H. M. Strubbe, 19–33. Leiden: Brill, 1996.

Edelmann 1999
Edelmann, Martina. *Menschen auf griechischen Weihreliefs.* Munich: Tuduv, 1999.

Edmonds 2013
Edmonds, Radcliffe G., III. *Redefining Ancient Orphism: A Study in Greek Religion.* Cambridge: Cambridge University Press, 2013.

Ehrhardt 1983
Ehrhardt, Norbert. *Milet und seine Kolonien: Vergleichende Untersuchung der kultischen und politischen Einrichtungen.* Frankfurt: Lang, 1983.

Elvers 1994
Elvers, K.-L. "Der 'Eid der Berenike und ihrer Söhne': Eine Edition von IGBulg. III 2, 1731." *Chiron* 24 (1994): 241–66.

Ewigleben 1989
Ewigleben, Cornelia. "An Atelier of Silversmiths in Western Thrace: The Jug Cat. No. 155 from Rogozen and Its Connections to the Vessels with Figural Reliefs from Poroina, Strelča, Loukovit and Vratsa." In B. Cook 1989, 28–32.

Faklaris 1985
Faklaris, Panagiotis. "Περιτραχήλιον." *Αρχαιολογικόν δελτίον* 40 (1985): 1–16.

Farkas 1981
Farkas, Ann. "Style and Subject Matter in Native Thracian Art." *Metropolitan Museum Journal* 16 (1981): 33–48.

Fenik 1964
Fenik, Bernard. *"Iliad X" and the "Rhesus": The Myth.* Brussels-Berchem: Latomus, Revue d'études latines, 1964.

Filov 1913
Filov, Bogdan. "Златен пръстен с тракийски надпис." *Известия на Българското археологическо дружество* 3, no. 2 (1913): 202–23.

Filov 1930–31
Filow [Filov], Bogdan. "Античната гробница при с. Дълбоки, Старозагорско." *Известия на Българския археологически институт* 6 (1930–31): 45–56.

Filov 1934a
Filow [Filov], Bogdan. *Die Grabhügelnekropole bei Duvanlij in Südbulgarien.* With the assistance of Ivan Velkov and Vasil Mikov. Sofia: Staatsdruckerei, 1934.

Filov 1934b
Filov, Bogdan. *Надгробните могили при Дуванлий в Пловдивско.* With the assistance of Ivan Velkov and Vasil Mikov. Sofia: Dŭrzhavna pechatnitsa, 1934.

Filov 1937
Filov, Bogdan. "Куполните гробници при Мезек." *Известия на Българския археологически институт* 11, no. 1 (1937): 1–116.

Finglass 2016
Finglass, P. J. "A New Fragment of Sophocles' *Tereus.*" *Zeitschrift für Papyrologie und Epigraphik* 200 (2016): 61–85.

Fol 1969
Fol, Alexander. *Тракийско военно изкуство.* Sofia: Dŭrzhavno voenno izdatelstvo, 1969.

Fol 1986
Fol, Alexander. *Тракийският орфизъм.* Sofia: Universitetsko izdatelstvo "Sv. Kliment Ohridski," 1986.

Fol 1989a
Fol, Alexander. "The Royal Inscriptions on the Silver Vessels from Rogozen." In B. Cook 1989, 33–37.

Fol 1989b
Fol, Alexander, ed. *Der thrakische Silberschatz aus Rogozen Bulgarien.* Exh. cat. Sofia: Internationalen Stiftung Ljudmila Zhiwkowa, 1989.

Fol et al. 1986
Fol, Alexander, et al. *The Thracian Tomb near the Village of Sveshtari.* Sofia: Svyat, 1986.

Formigli 2012–13
Formigli, Edilberto. "I danneggiamenti antichi al ritratto in bronzo di Seuthes III." *Jahrbuch des Deutschen Archäologischen Instituts* 127–28 (2012–13): 180–86.

Formigli 2015
Formigli, Edilberto. "The Restoration of the Early Hellenistic Shipka Bronze Head." *Archaeologia Bulgarica* 19, no. 3 (2015): 1–22.

Fowler 2013
Fowler, Robert L. *Early Greek Mythography.* Vol. 2, *Commentary.* Oxford: Oxford University Press, 2013.

Fraser 1960
Fraser, Peter Marshall. *The Inscriptions on Stone.* Vol. 2, pt. 1, of *Samothrace: Excavations Conducted by the Institute of Fine Arts, New York University,* edited by Karl Lehmann and Phyllis Williams Lehmann. New York: Pantheon, 1960.

Fried 1987
Fried, Sallie. "The Decadrachm Hoard: An Introduction." In Carradice 1987, 1–19.

Galabov 1950
Galabov, Ivan. "Един новооткрит надпис от Несебър." *Известия на Народния музей Бургас* 1 (1950): 7–22.

Galani-Krikou, Tasaklaki, and Tselekas 2015
Galani-Krikou, Mina, Marina Tasaklaki, and Panagiotis Tselekas. *Αρχαία Ζώνη.* Vol. IVα, *Η νομισματοκοπία της Ζώνης.* Komotini: Hellenic Ministry of Culture and Sports–Ephorate of Antiquities of Evros, Region of Eastern Macedonia–Thrace, 2015.

Gantz 1993
Gantz, Timothy. *Early Greek Myth: A Guide to Literary and Artistic Sources.* Baltimore: Johns Hopkins University Press, 1993.

Garašanin 1952
Garašanin, Milutin V. "Bracelets à extrémités en têtes de serpents de la Macédoine." *Artibus Asiae* 15 (1952): 268–76.

Garašanin 1978
Garašanin, Milutin V. "Betrachtungen zum Schatz von Vălči Tran." In *Studia in Honorem Veselini Beševliev,* edited by Vladimir Georgiev et al., 284–87. Sofia: Academia Litterarum Bulgarica, 1978.

Garezou 1994
Garezou, Maria-Xeni. "Orpheus." In *Lexicon Iconographicum Mythologiae Classicae.* Vol. 7, pt. 2, 81–105. Zurich: Artemis, 1994.

Gebauer 2002
Gebauer, Jörg. *Pompe und Thysia: Attische Tieropferdarstellungen auf schwarz- und rotfigurigen Vasen.* Münster: Ugarit-Verlag, 2002.

G. Georgiev 1987
Georgiev, Georgi. *Полезните изкопаеми от времето на траките.* Sofia: Bŭlgarska akademiia na naukite, 1987.

V. Georgiev 1966
Georgiev, Vladimir. "Die Deutung der altertümlichen thrakischen Inschrift aus Kjolmen." *Linguistique balkanique* 11, no. 1 (1966): 9–23.

V. Georgiev 1977
Georgiev, Vladimir. *Траките и техният език.* Sofia: Izdatelstvo na BAN, 1977.

V. G. Georgiev 2012
Georgiev, Vladimir G. *Металогения на Източните Родопи.* Sofia: Izdatelstvo na Bŭlgarska akademiia na naukite "Prof. Marin Drinov," 2012.

Georgieva 2005
Georgieva, Rumjana. "Каничка от Карнобат с изображение на тракийски воини." *Археология* 46, nos. 1–4 (2005): 32–40.

Georgieva 2009
Georgieva, Rumjana. "Céramique grecque dans des tombes thraces du VIᵉ–Vᵉ s. av. J.-C. de la région de Karnobat (Bulgarie du sud-est)." In Bonias and Perreault 2009, 253–61.

Georgieva 2016
Georgieva, Rumjana. "Riders' Burials in Thrace." In Henry and Kelp 2016, 1:269–80.

Gergova 1987
Gergova, Diana. "Съкровищата от Тракия и хиперборейския мит." In *Доклади на Втория международен конгрес по българистика.* Vol. 6, *Българските земи в древността; България през Средновековието,* edited by Hristo Hristov, 53–74. Sofia: Bŭlgarska akademiia na naukite, 1987.

Gergova 1994
Gergova, Diana. "The Treasure from Vulchitrun and the Amber Route in the Balkans." In *The Early Hallstatt Period (1200–700 BC) in South-Eastern Europe: Proceedings of the International Symposium from Alba Iulia, 10–12 June 1993,* edited by Horia Ciugudean and Nikolaus Boroffka, 67–79. Alba Iulia: Muzeul Naţional al Unirii Alba Iulia, 1994.

Gergova 2000
Gergova, Diana. "The Tripartite Vessel from Vulchitrun—Epoch and Function." *Thracia* 13 (2000): 137–47.

Gergova 2015
Gergova, Diana. "Le trésor en or du tumulus Golyama Sveshtarska Mogila." In Martinez et al. 2015, 258–65.

Ginev 1983
Ginev, Georgi. *Съкровището от Кралево.* Sofia: Bŭlgarski hudozhnik, 1983.

Ginev 2000
Ginev, Georgi. *Тракийските могили при село Кралево, Търговищко.* Varna: Zograf, 2000.

Gočeva and Popov 1986
Gočeva, Zlatozara, and Dimitŭr Popov. "Bendis." In *Lexicon Iconographicum Mythologiae Classicae.* Vol. 3, pt. 1, 95–97. Zurich: Artemis, 1986.

Gočeva et al. 1981
Gočeva, Zlatozara, et al. *Fontes Historiae Thraciae Thracumque.* Vol. 1 of *Извори за историята на Тракия и траките.* Sofia: Izdatelstvo na BAN, 1981.

Goldman 1960
Goldman, Bernard. "The Development of the Lion-Griffin." *American Journal of Archaeology* 64, no. 4 (1960): 319–28.

Gorbunova 1971
Gorbunova, Kseniia Sergeevna. "Серебряные килики с гравированными изображениями из Семибратных курганов." In *Культура и искусство античного мира,* edited by Kseniia Sergeevna Gorbunova, 18–33. Leningrad: "Aurora," 1971.

Goušchin 1999
Goušchin, Valerij. "Athenian Synoikism of the Fifth Century B.C., or Two Stories of Theseus." *Greece & Rome,* 2nd ser., 46, no. 2 (1999): 168–87.

Graf 1987
Graf, Fritz. "Orpheus: A Poet among Men." In *Interpretations of Greek Myth,* edited by Jan Bremmer, 80–106. London: Croom Helm, 1987.

Graham 1992
Graham, A. J. "Abdera and Teos." *Journal of Hellenic Studies* 112 (1992): 44–73.

Graninger 2015
Graninger, Denver. "Ethnicity and *Ethne.*" In Valeva, Nankov, and Graninger 2015, 22–32.

Graninger 2018
Graninger, Denver. "New Contexts for the Seuthopolis Inscription (IGBulg 3.2 1731)." *Klio* 100, no. 1 (2018): 178–94.

Green 1994
Green, J. R. *Theatre in Ancient Greek Society.* London: Routledge, 1994.

Greenhalgh 1973
Greenhalgh, Peter. *Early Greek Warfare: Horsemen and Chariots in the Homeric and Archaic Ages.* Cambridge: Cambridge University Press, 1973.

Griffith 1985
Griffith, John. "Further Thoughts on the Amphora-Rhyton from Panagjurischte." *Terra Antiqua Balcanica* 2 (1985): 171–76.

Grossman 2001
Grossman, Janet Burnett. *Greek Funerary Sculpture: Catalogue of the Collections at the Getty Villa.* Los Angeles: J. Paul Getty Museum, 2001.

Guigolachvili 1990
Guigolachvili, Elena. "Les coupes en argent de Vani." In *Le Pont-Euxin vu par les Grecs: Sources écrites et archéologie; Symposium de Vani (Colchide), septembre–octobre 1987,* edited by Otar Lordkipanidzé and Pierre Lévêque, 279–81. Besançon: Université de Franche-Comté, 1990.

Hagerman 2014
Hagerman, Chris. "Weapons: Catapult Bolts, Arrowheads, Javelin and Spear Heads, and Sling Bullets." In *Stymphalos: The Acropolis Sanctuary,* edited by Gerald P. Schaus, 1:79–102. Toronto: University of Toronto Press, 2014.

Hall 1989
Hall, Edith. *Inventing the Barbarian: Greek Self-Definition through Tragedy.* Oxford: Clarendon Press; New York: Oxford University Press, 1989.

Hamel 2012
Hamel, Debra. *The Mutilation of the Herms: Unpacking an Ancient Mystery.* North Haven, CT: CreateSpace Independent Publishing Platform, 2012.

Hammond 1980
Hammond, N. G. L. "The Extent of Persian Occupation in Thrace." *Chiron* 10 (1980): 53–61.

Hammond 1983
Hammond, N. G. L. "The Lettering and the Iconography of 'Macedonian' Coinage." In *Ancient Greek Art and Iconography,* edited by Warren G. Moon, 245–58. Madison: University of Wisconsin Press, 1983.

Hänsel 1970
Hänsel, Bernhard. "Bronzene Griffzungenschwerter aus Bulgarien." *Prähistorische Zeitschrift* 45 (1970): 26–41.

Hänsel 1976
Hänsel, Bernhard. *Beiträge zur regionalen und chronologischen Gliederung der älteren Hallstattzeit an der unteren Donau.* 2 vols. Bonn: Habelt, 1976.

Hansen and Nielsen 2004
Hansen, Mogens Herman, and Thomas Heine Nielsen, eds. *An Inventory of Archaic and Classical Poleis.* Oxford: Oxford University Press, 2004.

Harding 2013
Harding, Anthony. "Fernbeziehungen im bronzezeitlichen Europa." In Piotrovski 2013, 170–81.

Harris 1995
Harris, Diane. *The Treasures of the Parthenon and Erechtheion.* Oxford: Clarendon Press, 1995.

Hatzopoulos 2013
Hatzopoulos, Miltiades B. "Τὰ τῶν ἐμποριτῶν φιλάνθρωπα: Observations on the Pistiros Inscription (SEG XLIII 486)." In *Epigraphical Approaches to the Post-Classical Polis: Fourth Century BC to Second Century AD,* edited by Paraskevi Martzavou and Nikolaos Papazarkadas, 13–21. Oxford: Oxford University Press, 2013.

Head 1879
Head, Barclay V. *Catalogue of Greek Coins: Macedonia, Etc.* London: British Museum, 1879.

Heckel 1992
Heckel, Waldemar. *The Marshals of Alexander's Empire.* London: Routledge, 1992.

Heckel 2006
Heckel, Waldemar. *Who's Who in the Age of Alexander the Great: Prosopography of Alexander's Empire.* Malden, MA: Blackwell, 2006.

Heinemann 2013
Heinemann, Alexander. "Performance and the Drinking Vessel: Looking for an Imagery of Dithyramb in the time of the 'New Music.'" In *Dithyramb in Context*, edited by Barbara Kowalzig and Peter Wilson, 282–309. Oxford: Oxford University Press, 2013.

Henry and Kelp 2016
Henry, Olivier, and Ute Kelp, eds. *Tumulus as Sema: Space, Politics, Culture and Religion in the First Millennium BC.* 2 vols. Berlin: De Gruyter, 2016.

Hermary 2010
Hermary, Antoine. "Les vases et leur décor à l'époque classique: Transfert de formes et d'images entre grecs et Thraces (V^e s. av. J.-C.)." In *Grecs et indigènes de la Catalogne à la mer Noire*, edited by Henri Tréziny, 481–86. Paris: Édition Errance, 2010.

Hermary et al. 2010
Hermary, Antoine, et al. *Apollonia du Pont (Sozopol): La nécropole de Kalfata (V^e–III^e s. av. J.-C.): Fouilles franco-bulgares (2002–2004).* Paris: Errance; Aix-en-Provence: Centre Camille-Jullian, 2010.

Heskel 1997
Heskel, Julia. *The North Aegean Wars, 371–360 B.C.* Stuttgart: Franz Steiner, 1997.

Higham et al. 2015
Higham, Tom, et al. "New Perspectives on the Varna Cemetery (Bulgaria)—AMS Dates and Social Implications." *Antiquity* 81 (2015): 640–54.

Hiller 1975
Hiller, Hilde. *Ionische Grabreliefs der ersten Hälfte des 5. Jahrhunderts v. Chr.* Tübingen: Wasmuth, 1975.

Himmelmann 1989
Himmelmann, Nikolaus. *Herrscher und Athlet: Die Bronzen vom Quirinal.* Exh. cat. Milan: Olivetti, 1989.

Hind 1983
Hind, John. "The Scene on the Gold Amphora of Panagyurishte, Once More." In Poulter 1983, 1:253–74.

Hind 1989
Hind, John. "The Inscriptions on the Silver Phialai and Jug from Rogozen." In B. Cook 1989, 38–43.

Höck 1891
Höck, Adelbert. "Das Odryssenreich in Thrakien im fünften und vierten Jahrhundert v. Chr." *Hermes* 26, no. 1 (1891): 76–117.

Hoddinott 1986
Hoddinott, R. F. "The Thracians and Their Religion." In *The New Thracian Treasure from Rogozen, Bulgaria*, edited by Alexander Fol, Bogdan Nikolov, and R. F. Hoddinott, 21–33. Exh. cat. London: British Museum Publications, 1986.

Hoffmann 1957
Hoffmann, Herbert. "The Date of the Panagyurishte Treasure." *American Journal of Archaeology* 61 (1957): 389–92.

Holleaux 1919
Holleaux, Maurice. "Décret de Chérronée relatif à la première guerre de Mithradates." *Revue des études grecques* 32 (1919): 320–37.

Horejs and Jung 2018
Horejs, Barbara, and Reinhard Jung. "Networks and Cultural Contacts with the Aegean." In Alexandrov et al. 2018, 233–39.

I. Hristov and Stoyanova 2011
Hristov, Ivan, and Daniela Stoyanova. "Monumental Building." In Кози Грамади: Проучване на одриска владетелска резиденция и светилища в Средна Гора, VIII–I в. пр. Хр. / *Kozi Gramadi: Studies of an Odrysian Ruler's Residence and Sanctuaries in Sredna Gora Mt., 8th–1st Centuries BC*, edited by Ivan Hristov, 1:81–115. Sofia: Unicart, 2011.

M. Hristov 2016
Hristov, Martin. "Dabene and Its Probable Contacts with the Aegeo-Anatolian Region." In *Early Bronze Age Troy: Chronological, Cultural Development and Interregional Contacts*, edited by Ernst Pernicka, Sinan Ünlüsoy, and Stephan W. E. Blum, 229–37. Bonn: Verlag Dr. Rudolf Habelt, 2016

M. Hristov 2018
Hristov, Martin. "Bronze Age Archaeological Site near the Village of Dabene, Karlovo Region." In Alexandrov et al. 2018, 335–40.

Hristova 2018
Hristova, Tanya. "Hoards and Metal Assemblages on the Lower Danube during the Late Bronze Age." In Alexandrov et al. 2018, 161–69.

Huf 2018
Huf, Leonie. *Frauen jenseits der Konvention: Alterszüge, Tätowierungen und afrikanische Physiognomien im Frauenbild attischer Vasen des 5. Jahrhunderts v. Chr.* Munich: Propylaeum, 2018.

Hurwit 2007
Hurwit, Jeffrey M. "The Problem with Dexileos: Heroic and Other Nudities in Greek Art." *American Journal of Archaeology* 111, no. 1 (2007): 35–60.

Iakovidou 2007
Iakovidou, Athena, ed. *Thrace in the Graeco-Roman World: Proceedings of the 10th International Congress of Thracology, Komotini–Alexandroupolis, 18–23 October, 2005.* Athens: National Hellenic Research Foundation, 2007.

IG I²
Inscriptiones Graecae. Vol. 1, *Inscriptiones Atticae Euclidis Anno Posteriores.* Edited by Friedrich Hiller von Gaertringen. 2nd ed. Berlin: De Gruyter, 1924.

IG II²
Inscriptiones Graecae. Vols. 2–3, *Inscriptiones Atticae Euclidis Anno Posteriores.* Pt. 1, fasc. 1, *Decreta Annorum 403–229 a. Chr.* Edited by Johannes Kirchner. 2nd ed. Berlin: De Gruyter, 1967.

IGBulg. I²
Mihailov, Georgi. *Inscriptiones Graecae in Bulgaria Repertae.* Vol. 1, *Inscriptiones orae Ponti Euxini.* 2nd ed. Serdicae: In aedibus typographicis Academiae Litterarum Bulgaricae, 1970.

IGBulg. III.1
Mihailov, Georgi. *Inscriptiones Graecae in Bulgaria Repertae.* Vol. 3, *Inscriptiones inter Haemum et Rhodopem Repertae.* Fasc. 1, *Territorium Philippopolis.* Serdicae: In aedibus typographicis Academiae Litterarum Bulgaricae, 1961.

IGBulg. III.2
Mihailov, Georgi. *Inscriptiones Graecae in Bulgaria Repertae.* Vol. 3, *Inscriptiones inter Haemum et Rhodopem Repertae.* Fasc. 2, *A territorio Philippopolitano usque ad oram Ponticam.* Serdicae: In aedibus typographicis Academiae Litterarum Bulgaricae, 1964.

IGBulg. V
Mihailov, Georgi. *Inscriptiones Graecae in Bulgaria Repertae.* Vol. 5, *Inscriptiones Novae, Addenda et Corrigenda.* Serdicae: In aedibus tipographicis Rivae, 1997.

Ignatiadou 1996
Ignatiadou, Despina. "Ελληνιστικό επιτραπέζιο παιχνίδι με γυαλινούς πέσσους." In *Ancient Macedonia: Sixth International Symposium*, 1:507–22. Thessaloniki: Hidryma Meletōn Chersonēsou tou Haimou, 1996.

Ignatiadou 2012
Ignatiadou, Despina. "Pottery, Metalware and Glassware." In *Topics on Hellenistic Pottery in Ancient Macedonia*, edited by Stella Drougou and Ioannis Touratsoglou, 214–46. Athens: Archaeological Receipts Fund, 2012.

Ignatiadou 2019
Ignatiadou, Despina. "Luxury Board Games for the Northern Greek Elite." In "Jouer dans l'antiquité: Identité et multiculturalité / Games and Play in Antiquity: Identity and Multiculturality," edited by Véronique Dasen and Ulrich Schädler. Special issue, *Archimède* 6 (2019): 144–59.

Ignatov 2018
Ignatov, Veselin. *Погребални комплекси с коли в римската провинция Тракия (средата на I–III в.)*. Sofia: Natsionalen arheologicheski institute s muzei, 2018.

IGRom. 1901
Cagnat, René, and Jules Toutain, eds. *Inscriptiones Graecae ad res Romanas Pertinentes*. Vol. 1, fasc. 1. Paris: Ernest Leroux, 1901.

Iliad 1924
Homer. *The Iliad*. Translated by A. T. Murray. Revised by William F. Wyatt. Vol. 1. London: William Heinemann, 1924.

Iliev 2020
Iliev, Stanislav. "Антични златодобивни рудници в землищата на селата Стремци и Рани лист, общ. Кърджали." *Археологически открития и разкопки през 2019 г.*, 2020, 1078–80.

Iliopoulou 2015
Iliopoulou, Sophia. *Αρχαία Ζώνη*. Vol. 3a, *Το νεκροταφείο: Ταφικά έθιμα και πρακτικές*. Komotini: Hellenic Ministry of Culture and Sports–Ephorate of Antiquities of Evros, Region of Eastern Macedonia–Thrace, 2015.

Iliopoulou and Pardalidou 2022
Iliopoulou, Sophia, and Chrysafenia Pardalidou. "Attic Painted Pottery from Ancient Zone." In Tsiafaki et al. 2022, 228–44.

Inkova, Tsaneva, and Draganova 1994
Inkova, Veselina, Svetla Tsaneva, and Kunka Draganova. "Принос към изследването на фиала № 4 от Рогозенското съкровище." *Проблеми на изкуството* 4 (1994): 28–45.

Iozzo 2014
Iozzo, Mario. "Theseus and Periphetes by the Sabouroff Painter?" In *Approaching the Ancient Artifact: Representation, Narrative, and Function; A Festschrift in Honor of H. Alan Shapiro*, edited by Amalia Avramidou and Denise Demetriou, 77–90. Berlin: De Gruyter, 2014.

Isaac 1986
Isaac, Benjamin. *The Greek Settlements in Thrace before the Macedonian Conquest*. Leiden: Brill, 1986.

ISM I
Pippidi, Dionisie. *Inscriptiones Scythiae Minoris Graecae et Latinae*. Vol. 1, *Inscriptiones Histriae et Viciniae*. Bucharest: Editura Academiei Republicii Socialiste România, 1983.

IThr.Aeg.
Loukopoulou, Louisa D., et al., eds. *Επιγραφές της Θράκης του Αιγαίου: Μεταξύ των ποταμών Νέστου και Έβρου (Νομοί Ξάνθης, Ροδόπης και Έβρου)*. Athens: Ethnikon Hidryma Ereunōn, Kentron Hellēnikēs kai Rhōmaïkēs Archaiotētos, 2005.

G. Ivanov 2023
Ivanov, Georgi, ed. *Некропол от ранноелинистическата епоха при с. Бохот / Early Hellenistic Cemetery at the Village of Bohot*. Sofia: National Archaeological Institute with Museum, 2023.

Y. Ivanov 2019
Ivanov, Yavor. "L'univers masculin: Le monde de la guerre." In Baralis, Panayotova, and Nedev 2019, 198–207.

Ivantchik 2006
Ivantchik, Askold. "'Scythian' Archers on Archaic Attic Vases: Problems of Interpretation." *Ancient Civilizations from Scythia to Siberia* 12 (2006): 197–271.

Janouchová 2013
Janouchová, Petra. "The Cult of Bendis in Athens and Thrace." *Graeco-Latina Brunensia* 18, no. 1 (2013): 95–106.

Jeffery 1990
Jeffery, Lilian Hamilton. *The Local Scripts of Archaic Greece: A Study of the Origin of the Greek Alphabet and Its Development from the Eighth to the Fifth Centuries B.C.* Rev. ed. Oxford: Clarendon Press, 1990.

Jenkins 2006
Jenkins, Ian. *Greek Architecture and Its Sculpture in the British Museum*. London: British Museum Press, 2006.

Jockenhövel 2018
Jockenhövel, Albrecht. "Casting and Forging in Bronze Age Bulgaria." In Alexandrov et al. 2018, 171–79.

Jovanović 1982
Jovanović, Borislav. *Rudna Glava: Najstarije rudarstvo bakra na Centralnom Balkanu*. Belgrade: Arheološki Institut; Bor, Serbia: Muzej rudarstva i metalurgije, 1982.

Jovanović 1995
Jovanović, Borislav, ed. *Ancient Mining and Metallurgy in Southeast Europe: Proceedings of International Symposium, Donji Milanovac, May 20–25, 1990*. Belgrade: Archaeological Institute; Bor: Museum of Mining and Metallurgy, 1995.

Jung 2013
Jung, Reinhard. "Das mykenische Griechenland und seine Kontakte zu anderen europäischen Regionen." In Piotrovski 2013, 182–88.

Jung 2018
Jung, Reinhard. "Warriors and Weapons in the Central and Eastern Balkans." In Alexandrov et al. 2018, 241–53.

Jung et al. 2017
Jung, Reinhard, et al. "Mykenische Keramik in der Rhodopenregion: Herkunft, regionaler Kontext und sozialökonomische Grundlagen." *Archaeologia Austriaca* 101 (2017): 269–302.

Kacharava and Kvirkvelia 2009
Kacharava, Darejan, and Guram Kvirkvelia. *Από τη χώρα του χρυσόμαλλου δέρατος: Θησαυροί της αρχαίας Κολχίδας*. Athens: Benaki Museum, 2009.

Kaempf-Dimitriadou 1979
Kaempf-Dimitriadou, Sophia. *Die Liebe der Götter in der attischen Kunst des 5. Jhs. v. Chr.* Bern: Francke, 1979.

Kagan 1987
Kagan, Jonathan H. "The Decadrachm Hoard: Chronology and Consequences." In Carradice 1987, 21–28.

Kagan 2006
Kagan, Jonathan H. "Small Change and the Beginning of Coinage at Abdera." In *Agoranomia: Studies in Money and Exchange Presented to John H. Kroll*, edited by Peter G. Van Alfen, 49–60. New York: American Numismatic Society, 2006.

Karadzhinov 2013
Karadzhinov, Ivailo. "Оригиналност и влияния в тракийската бронзова пластика през ранножелязната епоха (X–VI в. пр. Хр.)—статуетката на елен от Севлиевско." In *Сборник в памет на академик Д. П. Димитров*, edited by Kostadin Rabadjiev et al., 75–86. Sofia: Bulvest Print, 2013.

Karagöz 2007
Karagöz, Şehrazat. "Neue Ansichten zu einem freistehenden Grabbau aus Daskyleion." In *The Achaemenid Impact on Local Populations and Cultures in Anatolia (Sixth–Fourth Centuries B.C.): Papers Presented at the International Workshop, Istanbul, 20–21 May 2005*, edited by İnci Delemen et al., 195–214. Istanbul: Turkish Institute of Archaeology, 2007.

Karathanasis 2019
Karathanasis, Konstantinos. "A Game of Timber Monopoly: Atheno-Macedonian Relations on the Eve of the Peloponnesian War." *Hesperia* 88 (2019): 707–26.

Karayotov 1978
Karayotov, Ivan. "Критски меден слитък от село Черково, Бургаски окръг." *Нумизматика* 12, no. 1 (1978): 12–17.

Kassel and Austin 1984
Kassel, Rudolf, and Colin Austin. *Poetae Comici Graeci*. Vol. 3, *Aristophanes Testimonia et Fragmenta*. Berlin: De Gruyter, 1984.

Katsarov 1911
Katsarov, Gavril. "Находка в Месемврия." *Известия на Българското археологическо дружество* 2 (1911): 264–65.

Katsarov 1913
Katsarov, Gavril. "Битът на старите траки според класическите писатели." *Сборник на БАН* 1 (1913): 1–72.

Katsarov 1930
Kazarow, Gawril [Katsarov, Gavril]. "Grabstele von Mesembria." *Jahreshefte des Österreichischen Archäologischen Institutes in Wien* 26 (1930): 111–14.

Katsarov 1938
Kazarow, Gawril [Katsarov, Gavril]. *Die Denkmäler des thrakischen Reitergottes in Bulgarien*. Budapest: Institut für Münzkunde und Archäologie der P. Pázmány-Universität; Leipzig: Harrassowitz, 1938.

Kefalidou 2009
Kefalidou, Eurydice. "The Iconography of Madness in Attic Vase-Painting." In *Athenian Potters and Painters: Volume II*, edited by John H. Oakley and Olga Palagia, 90–99. Oxford: Oxbow Books, 2009.

Kerschner 2006
Kerschner, Michael. "Zum Beginn und zu den Phasen der griechischen Kolonisation am Schwarzen Meer: Die Evidenz der ostgriechischen Keramik." *Eurasia Antiqua* 12 (2006): 227–50.

Kilian-Dirlmeier 1993
Kilian-Dirlmeier, Imma. *Die Schwerter in Griechenland (ausserhalb der Peloponnes), Bulgarien und Albanien*. Stuttgart: Franz Steiner, 1993.

Kilian-Dirlmeier 2005
Kilian-Dirlmeier, Imma. *Die bronzezeitlichen Gräber bei Nidri auf Leukas: Ausgrabungen von W. Dörpfeld 1903–1913*. Mainz: Verlag des Römisch-Germanischen Zentralmuseums, 2005.

Kisyov 2005
Kisyov, Kostadin. *Тракия и Гърция в древността / Thrace and Greece in Ancient Times*. Pt. 1, *Могилни гробници от класическата епоха в община Калояново / Classical Age Tumuli in the Municipality of Kaloyanovo*. Plovdiv: Avtospektar, 2005.

Kisyov 2015
Kisyov, Kostadin. "Le tumulus n° 1 de Chernozem-Kaloyanovo." In Martinez et al. 2015, 76–87.

Kisyov and Davidova 2014
Kisyov, Kostadin, and Desislava Davidova. "Спасителни археологически разкопки на могила №1 (Памуклия)—Брестовица, община Родопи, Пловдивска област." *Археологически открития и разкопки през 2013 г.*, 2014, 191–94.

Kitov 1979
Kitov, Georgi. *Тракийските могили край Стрелча*. Sofia: n.p., 1979.

Kitov 2003a
Kitov, Georgi. "The Thracian Cult Complex near Starosel: Chetinyova Mogila in Light of the Investigations in 2000." In *Early Symbolic Systems for Communication in Southeast Europe*, edited by Lolita Nikolova, 505–18. Oxford: Archaeopress, 2003.

Kitov 2003b
Kitov, Georgi. *The Valley of the Thracian Rulers*. Varna: Slavena, 2003.

Kitov 2005a
Kitov, Georgi. "More Discoveries in the Valley of the Thracian Kings." *Orpheus* 15 (2005): 43–65.

Kitov 2005b
Kitov, Georgi. "The Newly Discovered Tomb of the Thracian Ruler Seuthes III." *Archaelogia Bulgarica* 9, no. 2 (2005): 39–54.

Kitov 2005c
Kitov, Georgi. "Thracian Tumular Burial with Gold Mask near the City of Shipka, Central Bulgaria." *Archaeologia Bulgarica* 9, no. 3 (2005): 23–37.

Kitov 2005d
Kitov, Georgi. *The Valley of the Thracian Rulers*. 2nd ed. Varna: Slavena, 2005.

Kitov 2006
Kitov, Georgi. *The Panagyurishte Treasure*. Varna: Slavena, 2006.

Kitov 2008
Kitov, Georgi. *Могили, храмове, гробници: Записки на един "могилар."* Sofia: TEMP, 2008.

Kitov 2009
Kitov, Georgi. *The Tomb of Aleksandrovo*. Varna: Slavena, 2009.

Kitov and Dimitrov 2008
Kitov, Georgi, and Peter Dimitrov. "A 4th Century BC Thracian Signet-Ring from the Dalakova Tumulus (SE Bulgaria)." *Archaeologia Bulgarica* 12, no. 2 (2008): 25–32.

Kitov et al. 1994
Kitov, Georgi, et al., eds. *Първи международен симпозиум "Севтополис": "Надгробните могили в Югоизточна Европа," Казанлък, 4–8 юни 1993*. 2 vols. Veliko Tarnovo: PIK, 1994.

K. Kolev 1978
Kolev, Kamen. "Nouvelle opinion sur les trois vases-rhytons à forme de tête de femme du trésor thrace en or de Panagurichte." *Pulpudeva* 2 (1978): 315–35.

P. Kolev 1975
Kolev, Panto. "Проблеми на тракийското военно дело." *Векове* 6 (1975): 15–22.

Koleva 2017
Koleva, Marina. *Римска идеална скулптура от България*. Sofia: Institut za izsledvane na izkustvata, 2017.

Kontoleon 1962
Kontoleon, Nikolaos. "The Gold Treasure of Panagurishte." *Balkan Studies* 3 (1962): 185–200.

Kotova 2013a
Kotova, Dobriela. "Sparadokos: Bruder oder Schwager des Odrysenkönigs Sitalkes?" In *The Thracians and Their Neighbors in the Bronze and Iron Ages: Proceedings of the 12th International Congress of Thracology, Târgoviște, 10th–14th September 2013*. Vol. 1, *Settlements, Fortresses, Artifacts*, edited by Cristian Schuster et al., 207–11. Târgoviște: Editura Cetatea de Scaun, 2013.

Kotova 2013b
Kotova, Dobriela. *Жената в Древна Тракия (според античните текстове)*. Sofia: Ral Kolobar, 2013.

Kotova 2023
Kotova, Dobriela. "Was, wenn Sparadokos kein Sohn von Teres war?" *Bulgarian Numismatic Journal* 1, no. 1 (2023): 85–96. https://doi.org/10.5281/zenodo.7750724.

Kovachev et al. 2011
Kovachev, Veselin, et al. "Archaeometric Study of Hellenistic Roof-Tiles and Amphorae from Apollonia and Mesambria: An Attempt at Identifying Local Production." In Tzochev, Stoyanov, and Bozkova 2011, 203–44.

Kraay 1976
Kraay, Colin M. *Archaic and Classical Greek Coins*. London: Methuen, 1976.

Krasteva 2021
Krasteva, Zornitsa. "Decorated Clay Hearths from Hellenistic Thrace." In *Around the Hearth: Ritual and Commensal Practices in the Mediterranean Iron Age from the Aegean World to the Iberian Peninsula*, edited by Jérémy Lamaze and Maguelone Bastide, 137–81. Berlin: De Gruyter, 2021.

Krauss 2020
Krauss, Raiko. "The Eastern Balkans in the Neolithic and Chalcolithic." In Krauss et al. 2020, 29–65.

Krauss et al. 2017
Krauss, Raiko, et al. "Chronology and Development of the Chalcolithic Necropolis of Varna I." *Documenta Praehistorica* 44 (2017): 282–305.

Krauss et al. 2020
Krauss, Raiko, et al., eds. *Prehistoric Mining and Metallurgy at the Southeast Bulgarian Black Sea Coast*. Tübingen: Tübingen University Press, 2020.

Kryzhitskii, Rusyaeva, and Nazarchuk 2006
Kryzhitskii, Sergei, Anna Rusyaeva, and Volodymyr Nazarchuk. "Архитектурная терракота эллинистического времени." In *Древнейший теменос Ольвии Понтийской*, edited by Viktor N. Zinko, 114–16. Simferopol: BF Demetra, 2006.

Kull 1997
Kull, Brigitte. "Orient und Okzident: Aspekte der Datierung und Deutung des Hortes von Rogozen." In *Chronos: Beiträge zur prähistorischen Archäologie zwischen Nord-und Südosteuropa; Festschrift für Bernhard Hänsel*, edited by Cornelia Becker et al., 689–710. Leidorf: Espelkamp, 1997.

E. Kunze 1967
Kunze, Emil. "Halkidische Helme."
In *Bericht über die Ausgrabungen in Olympia*. Vol. 8, by Emil Kunze, 136–58. Berlin: W. de Gruyter, 1967.

R. Kunze and Pernicka 2020
Kunze, René, and Ernst Pernicka. "The Beginning of Copper and Gold Metallurgy in the Old World." In Krauss et al. 2020, 67–86.

Laffineur 2008
Laffineur, Robert. "Aspects of Early Bronze Age Jewellery in the Aegean." In *The Aegean in the Neolithic, Chalcolithic and the Early Bronze Age*, edited by Hayat Erkanal et al., 323–32. Ankara: AU Sualti Arkeolojik Arastirma ve Uygulama Merkezi (ANKUSAM), 2008.

Landucci Gattinoni 1992
Landucci Gattinoni, Franca. *Lisimaco di Tracia: Un sovrano nella prospettiva del primo ellenismo*. Milan: Jaca Book, 1992.

Launey 1987
Launey, Marcel. *Recherches sur les armées hellénistiques*. 2nd ed. 2 vols. Paris: De Boccard, 1987.

Lawrence (1935) 1991
Lawrence, T. E. *Seven Pillars of Wisdom: A Triumph*. New York: Doubleday, 1991. First published 1935.

Lazarov 1990
Lazarov, Mihail. *Антична рисувана керамика от България*. Sofia: Bŭlgarski hudozhnik, 1990.

Lear 2008
Lear, Andrew. "*Kalos*-Inscriptions." In *Images of Ancient Greek Pederasty: Boys Were Their Gods*, edited by Andrew Lear and Eva Cantarella, 164–73. London: Routledge, 2008.

Lee 2001
Lee, John W. I. "Urban Combat at Olynthus, 348 BC." In *Fields of Conflict: Progress and Prospect in Battlefield Archaeology*, edited by P. W. M. Freeman and A. Pollard, 11–22. Oxford: Archaeopress, 2001.

Lehmann 1960
Lehmann, Karl. *The Inscriptions on Ceramics and Minor Objects*. Vol. 2, pt. 2, of *Samothrace: Excavations Conducted by the Institute of Fine Arts, New York University*, edited by Karl Lehmann and Phyllis Williams Lehmann. New York: Pantheon, 1960.

Lehmann and Spittle 1964
Lehmann, Karl, and Denys Spittle. *The Altar Court*. Vol. 4, pt. 2, of *Samothrace: Excavations Conducted by the Institute of Fine Arts, New York University*, edited by Karl Lehmann and Phyllis Williams Lehmann. New York: Pantheon, 1964.

Lenk 1936
Lenk, B. "Thrake, Thraker (3), Landes- u. Volksbegriff v. schwankender Ausdehnung, B. Stammesübersicht." In *Real-Encyclopädie der klassischen Altertumswissenschaft*. Band 6a, Halbband 11, *Thesauros–Timomachos*, edited by Wilhelm Kroll, 404–7. Stuttgart: J. B. Metzler, 1936.

K. Leshtakov 2006
Leshtakov, Krassimir. "Бронзовата епоха в Горнотракийската низина." *Годишник на Софийския университет "Св. Климент Охридски," Исторически факултет* 3 (2006): 141–216.

K. Leshtakov 2007
Leshtakov, Krassimir. "The Eastern Balkans in the Aegean Economic System during the LBA: Ox-Hide and Bun Ingots in Bulgarian Lands." In *Between the Aegean and Baltic Seas: Prehistory across Borders; Proceedings of the International Conference Bronze and Early Iron Age Interconnections and Contemporary Developments between the Aegean and the Regions of the Balkan Peninsula, Central and Northern Europe, University of Zagreb, 11–14 April 2005*, edited by Ioanna Galanaki et al., 447–58. Liège: Université de Liège, Histoire de l'art et archéologie de la Grèce antique; Austin: University of Texas at Austin, Program in Aegean Scripts and Prehistory, 2007.

K. Leshtakov 2009
Leshtakov, Krassimir. "The Second Millennium BC in the Northern Aegean and the Adjacent Balkan Lands: Main Dynamics of Cultural Interaction." In Bonias and Perreault 2009, 53–82.

L. Leshtakov 2018a
Leshtakov, Ljuben. "The Metallurgy of the Eastern Balkans and the Contacts with Central Europe and the Northern Black Sea Region in the Second Half of the Late Bronze Age." In Alexandrov et al. 2018, 277–85.

L. Leshtakov 2018b
Leshtakov, Ljuben. "Pobit Kamak Hoard." In Alexandrov et al. 2018, 383–87.

L. Leshtakov 2019
Leshtakov, Ljuben. "Der Gussformen-Depotfund bei Pobit Kamak und die Entwicklung der Metallurgie in Nordostbulgarien in der zweiten Hälfte der Spätbronzezeit." *Eurasia Antiqua* 22, 2016 (2019): 185–247.

P. Leshtakov 2013
Leshtakov, Peter. "Archeometallurgical Research in the Southern Bulgarian Black Sea Coast: The Site of Akladi Cheiri." In *Where Are the Sites? Research, Protection and Management of Cultural Heritage; Proceedings of International Conference, Ahtopol, 5–8. December 2013*, edited by Hristina Angelova and Mehmet Özdoğan, 35–54. Sozopol: Centre for Underwater Archaeology, 2013.

P. Leshtakov et al. 2020
Leshtakov, Peter, et al. "The Prehistoric Site Akladi Cheiri, Chernomorets." In Krauss et al. 2020, 89–119.

Leusch, Pernicka, and Armbruster 2014
Leusch, Verena, Ernst Pernicka, and Barbara Armbruster. "Chalcolithic Gold from Varna—Provenance, Circulation, Processing and Function." In Meller, Risch, and Pernicka 2014, 165–82.

Levick 2000
Levick, Barbara. *The Government of the Roman Empire: A Sourcebook*. 2nd ed. London: Routledge, 2000.

Lewis 1986
Lewis, David M. "Temple Inventories in Ancient Greece." In *Pots & Pans: A Colloquium on Precious Metals and Ceramics in the Muslim, Chinese and Graeco-Roman Worlds, Oxford 1985*, edited by Michael Vickers, 71–81. Oxford: Oxford University Press, 1986.

Lezzi-Hafter 1988
Lezzi-Hafter, Adrienne. *Der Eretria-Maler: Werke und Weggefährten*. Mainz: Philipp von Zabern, 1988.

Lezzi-Hafter 1997
Lezzi-Hafter, Adrienne. "Offerings Made to Measure: Two Special Commissions by the Eretria Painter for Apollonia Pontica." In *Athenian Potters and Painters*, edited by John H. Oakley, William D. E. Coulson, and Olga Palagia, 353–69. Oxford: Oxbow Books, 1997.

Lichtenberger, Nieswandt, and Salzmann 2015
Lichtenberger, Achim, Helge Nieswandt, and Dieter Salzmann. "Die hellenistische Residenzstadt Lysimacheia: Feldforschungen in der Zentralsiedlung und der Chora." In *Urbane Strukturen und bürgerliche Identität im Hellenismus*, edited by Albrecht Matthaei and Martin Zimmermann, 163–92. Heidelberg: Verlag Antike, 2015.

LIMC 1994
Lexicon Iconographicum Mythologiae Classicae. Vol. 7, pt. 1. Zurich: Artemis, 1994.

Lissarrague 1990
Lissarrague, François. *L'autre guerrier: Archers, peltastes, cavaliers dans l'imagerie attique*. Paris: La Découverte; Rome: École française de Rome, 1990.

Lissarrague 1999
Lissarrague, François. "Publicity and Performance: *Kalos* Inscriptions in Attic Vase-Painting." In *Performance Culture and Athenian Democracy*, edited by Simon Goldhill and Robin Osborne, 359–73. Cambridge: Cambridge University Press, 1999.

Lombardi 2009
Lombardi, Gianni. "The Casting Core Composition and Provenance of the Goljamata Kosmatka (Bulgaria) Bronze Head." *Journal of Archaeological Science* 36 (2009): 520–27.

Lo Schiavo et al. 2009
Lo Schiavo, Fulvia, et al., eds. *Oxhide Ingots in the Central Mediterranean.* Cyprus: A. G. Leventis Foundation; Rome: Istituto di Studi sulle Civiltà dell'Egeo e del Vicino Oriente del Consiglio Nazionale delle Ricerche, 2009.

Loukopoulou 1987
Loukopoulou, Louisa D. "Provinciae Macedoniae finis orientalis: The Establishment of the Eastern Frontier." In *Two Studies in Ancient Macedonian Topography,* by Miltiades B. Hatzopoulos and Louisa D. Loukopoulou, 61–100. Athens: Research Centre for Greek and Roman Antiquity, National Hellenic Research Foundation, 1987.

Loukopoulou 1999
Loukopoulou, Lousia D. "Sur le statut et l'importance de l'*emporion* de Pistiros." *Bulletin de correspondance hellénique* 123, no. 1 (1999): 359–71.

Lücken 1972
Lücken, Gottfried von. *Corpus Vasorum Antiquorum: Deutsche Demokratische Republik, 1: Schwerin, Stattliches Museum.* Berlin: Akademie-Verlag, 1972.

Lund 1992
Lund, Helen S. *Lysimachus: A Study in Early Hellenistic Kingship.* London: Routledge, 1992.

Lungu 2000–2001
Lungu, Vasilica. "La tombe d'un ἥρως et l'organisation de la nécropole d'une cité milésienne du Pont Euxin: Le tumulus T-A95 d'Orgamé." *Talanta* 32–33 (2000–2001): 171–88.

Luschey 1938
Luschey, Heinz. "Griechischpersische Metall-Arbeiten im Antiquarium." *Berliner Museen* 59 (1938): 76–80.

Luschey 1983
Luschey, Heinz. "Thrakien als ein Ort der Begegnung der Kelten mit der iranischen Metallkunst." In *Beiträge zur Altertumskunde Kleinasiens: Festschrift für Kurt Bittel,* edited by R. M. Boehmer and H. Hauptmann, 313–29. Mainz: Philipp von Zabern, 1983.

Maas and Snyder 1989
Maas, Martha, and Jane McIntosh Snyder. *Stringed Instruments of Ancient Greece.* New Haven, CT: Yale University Press, 1989.

Madzharov 2016
Madzharov, Mitko. "Светилище и храм от V в. пр. Хр. при с. Кръстевич, община Хисаря (предварително съобщение)." *Проблеми и изследвания на тракийската култура* 8 (2016): 105–58.

Maehler 2004
Maehler, H., ed. *Bacchylides: A Selection.* Cambridge: Cambridge University Press, 2004.

Maish 2015
Maish, Jeffrey. "Bronze Patinas, Noble and Vile." J. Paul Getty Trust, Los Angeles. September 2, 2015. getty.edu/news/bronze-patinas-noble-and-vile/.

Makiewicz 1987
Makiewicz, Tadeusz. *Formy kultu bóstw domowich na terenie Europy w starożytności.* Poznań: Wydawnictwo Naukowe Uniwersytetu im. Adama Mickiewicza, 1987.

Manetta, Stoyanova, and Luglio 2016
Manetta, Consuelo, Daniela Stoyanova, and Giampaolo Luglio. "Нови наблюдения върху архитектурата и живописта на саркофаговидната камера в могила Оструша, гр. Шипка." *Проблеми и изследвания на тракийската култура* 8 (2016): 31–88.

Mannack 2001
Mannack, Thomas. *The Late Mannerists in Athenian Vase-Painting.* Oxford: Oxford University Press, 2001.

Manoledakis 2021
Manoledakis, Manolis, ed. *Peoples in the Black Sea Region from the Archaic to the Roman Period: Proceedings of the 3rd International Workshop on the Black Sea in Antiquity Held in Thessaloniki, 21–23 September 2018.* Oxford: Archaeopress, 2021.

Manov 1998
Manov, Metodi. "Големият надпис от Севтополис." *Археология* 39, nos. 1–2 (1998): 8–15.

Manov 2006
Manov, Metodi. "Die Inschriften auf den Silbergefässen und dem Bronzehelm von Seuthes III. aus dem Grabhügel Goljama Kosmatka." *Archaeologia Bulgarica* 10, no. 3 (2006): 27–34.

Mantsevich 1987
Mantsevich, А. Р. *Курган Солоха.* Leningrad: Iskusstvo, 1987.

Mănucu-Adameşteanu 2008
Mănucu-Adameşteanu, Mihaela. *Orgame / Argamum.* Vol. 2, *Ceramica arhaică.* Bucharest: AGIR, 2008.

Manzova 1970
Manzova, Liudmila. "Нови проучвания върху стелата на Анаксандър от Аполония." *Известия на археологическия институт* 32 (1970): 254–74.

Maran et al. 2020
Maran, Joseph, et al., eds. *Objects, Ideas and Travelers: Contacts between the Balkans, the Aegean and Western Anatolia during the Bronze and Early Iron Age; Volume to the Memory of Alexandru Vulpe; Proceedings of the Conference in Tulcea, 10–13 November, 2017.* Bonn: Verlag Dr. Rudolf Habelt, 2020.

Marazov 1972
Marazov, Ivan. "Характер на античното влияние в стелата на Юлия." *Изкуство* 2 (1972): 21–25.

Marazov 1976
Marazov, Ivan. "Хиерогамията от Летница." *Археология* 18, no. 4 (1976): 1–13.

Marazov 1978
Marazov, Ivan. *Ритоните в Древна Тракия.* Sofia: Bŭlgarski hudozhnik, 1978.

Marazov 1987
Marazov, Ivan. "Героят в изображенията от Рогозенското съкровище." *Проблеми на изкуството* 2 (1987): 27–32.

Marazov 1988
Marazov, Ivan. "Богинята, яздеща лъвица: Каничка № 155 от Рогозенското съкровище." *Изкуство* 1 (1988): 34–48.

Marazov 1992
Marazov, Ivan. *Мит, ритуал и изкуство у траките.* Sofia: Universitetsko izdatelstvo "Sv. Kliment Ohridski," 1992.

Marazov 1994
Marazov, Ivan. *Митология на траките.* Sofia: Sekor, 1994.

Marazov 1996a
Marazov, Ivan. *Рогозенското съкровище.* Sofia: Sekor, 1996.

Marazov 1996b
Marazov, Ivan. *The Rogozen Treasure.* Sofia: Secor, 1996.

Marazov 1998a
Marazov, Ivan, ed. *Ancient Gold: The Wealth of the Thracians; Treasures from the Republic of Bulgaria.* New York: Harry N. Abrams, in association with the Trust for Museum Exhibitions, in cooperation with the Ministry of Culture of the Republic of Bulgaria, 1998.

Marazov 1998b
Marazov, Ivan. "Between Ares and Orpheus: Myth, Kingship, and Art in Ancient Thrace." In Marazov 1998a, 32–71.

Marazov 2002
Marazov, Ivan. "Култът на Кабирите и Панагюрското съкровище." *Jubileus* 5 (2002): 256–63.

Marazov 2005
Marazov, Ivan. *Thracian Warrior.* Sofia: Publishing House "Christo Botev," 2005.

Marazov 2011a
Marazov, Ivan. *Мистериите на Кабирите в Древна Тракия*. Sofia: Zaharii Stoyanov, 2011.

Marazov 2011b
Marazov, Ivan. *Thrace and the Ancient World: Vassil Bojkov Collection*. Exh. cat. Sofia: Thrace Foundation, 2011.

Marazov 2011c
Marazov, Ivan. *Тракия и древният свят XV–I в. пр. Хр.: Колекция Васил Божков*. Exh. cat. Sofia: Fondatsiia "Trakiia," 2011.

Marazov 2013
Marazov, Ivan. "Орфей в Тракия." In *Сборник в памет на академик Д. П. Димитров / Studies in Memory of Academician D. P. Dimitrov*, edited by Kostadin Rabadjiev et al., 218–26. Sofia: Universitetsko izdatelstvo "Sv. Kliment Ohridski," 2013.

Marazov 2019
Marazov, Ivan. "Властелинът и пръстените." *Проблеми и изследвания на тракийската култура* 9 (2019): 36–59.

Martinez et al. 2015
Martinez, Jean-Luc, et al., eds. *L'épopée des rois thraces: Des guerres médiques aux invasions celtes, 479–278 av. J.-C.; Découvertes archéologiques en Bulgarie*. Exh. cat. Paris: Somogy and Musée de Louvre, 2015.

Marvakov 2011
Marvakov, Todor. "Спасителни археологически проучвания в УПИ VI–147 и УПИ VII–147 по плана на град Несебър." *Археологически открития и разкопки през 2010 г.*, 2011, 250–52.

Matheson 1995
Matheson, Susan B. *Polygnotos and Vase Painting in Classical Athens*. Madison: University of Wisconsin Press, 1995.

Matsas 2004
Matsas, Dimitris. "Η Σαμοθράκη στην Πρώιμη Εποχή του Σιδήρου." In *Το Αιγαίο στην Πρώιμη Εποχή του Σιδήρου: Πρακτικά του Διεθνούς Συμποσίου, Ρόδος, 1–4 Νοεμβρίου 2002*, edited by Nikos Stampolidis and Angeliki Giannikouri, 227–57. Athens: Archaiologikó Institoúto Aigaiakón Spoudón, Panepistímio Krítis, 2004.

May 1966
May, J. M. F. *The Coinage of Abdera (540–345 B.C.)*. Edited by C. M. Kraay and G. K. Jenkins. London: Royal Numismatic Society, 1966.

Mehofer, Penkova, and Pernicka, forthcoming
Mehofer, Mathias, Petya Penkova, and Ernst Pernicka. "The Vălčitrăn Hoard: Production Technology and Chemical Analyses." In H. Popov and Jung, forthcoming.

Meller, Risch, and Pernicka 2014
Meller, Harald, Roberto Risch, and Ernst Pernicka, eds. *Metalle der Macht—Frühes Gold und Silber: 6. Mitteldeutscher Archäologentag vom 17. bis 19. Oktober 2013 in Halle (Saale)*. Halle: Landesamt für Denkmalpflege und Archäologie Sachsen-Anhalt, Landesmuseum für Vorgeschichte, 2014.

Messerschmidt 2003
Messerschmidt, Wolfgang. *Prosopopoiia: Personifikationen politischen Charakters in spätklassischer und hellenistischer Kunst*. Cologne: Vandenhoeck & Ruprecht, 2003.

Metzger 1951
Metzger, Henri. *Les représentations dans la céramique attique du IVe siècle*. Paris: É. de Boccard, 1951.

Mihailov 1955
Mihailov, Georgi. "Към историята на Тракия през IV–III в. пр. н. е." *Известия на Археологическия институт* 19 (1955): 149–65.

Mihailov 1987
Mihailov, Georgi. "Надписите от Рогозенското съкровище." *Археология* 29, по. 3 (1987): 26–36.

Mihailov 1989
Mihailov, Georgi. "The Inscriptions." In *The Rogozen Treasure*, edited by Alexander Fol, 46–71. Sofia: Publishing House of the Bulgarian Academy of Sciences, 1989.

Mihailov 2015
Mihailov, Georgi. *Траките*. 2nd ed. Edited by Maya Vassileva and Vladimir Marinov. Sofia: Nov bŭlgarski universitet, 2015.

R. Mikov 2010
Mikov, Rumen. "Ромфеята от Кабиле в контекста на проблемите, свързани с датирането на оръжията от тази категория: Разпространение и производство." In *Stephanos Archaeologicos in Honorem Professoris Stephcae Angelova*, edited by Elena Pencheva, 207–27. Sofia: Universitetsko izdatelstvo "Sv. Kliment Ohridski," 2010.

V. Mikov 1954
Mikov, Vasil. *Le tombeau antique près de Kazanlak*. Sofia: Académie bulgare des sciences, 1954.

V. Mikov 1958
Mikov, Vasil. *Златното съкровище от Вълчитрън*. Sofia: Bŭlgarska akademiia na naukite, 1958.

Milchev 1955
Milchev, Atanas. "Трако-кимерийски находки от българските земи." *Известия на Археологическия институт* 19 (1955): 359–73.

Milev et al. 2007
Milev, Vasil, et al. *Златните находища в България*. Sofia: Zemia '93, 2007.

M. Miller 1989
Miller, Margaret C. "Peacocks and Tryphe in Classical Athens." *Archaeological News* 15, nos. 1–4 (1989): 1–10.

M. Miller 1997
Miller, Margaret C. *Athens and Persia in the Fifth Century B.C.: A Study in Cultural Receptivity*. Cambridge: Cambridge University Press, 1997.

M. Miller 2010
Miller, Margaret C. "Luxury Toreutic in the Western Satrapies: Court-Inspired Gift-Exchange Diffusion." In *Der Achämenidenhof / The Achaemenid Court: Akten des 2. Internationalen Kolloquiums zum Thema "Vorderasien im Spannungsfeld klassischer und altorientalischer Überlieferungen," Landgut Castelen bei Basel, 23–25 Mai 2007*, edited by Bruno Jacobs and Robert Rollinger, 853–97. Wiesbaden: Harrassowitz, 2010.

S. Miller 2014
Miller, Stella G. "Hellenistic Painting in the Eastern Mediterranean, Mid-Fourth to Mid-First Century BC." In *The Cambridge History of Painting in the Classical World*, edited by J. J. Pollitt, 170–237. New York: Cambridge University Press, 2014.

Minčev 1983
Minčev, Alexander. "Ein verschwundener thrakischer Schatz aus Kavarna und einige Bemerkungen über die Goldschmiedenkunst Thrakiens im IV.–III. Jh. v.u.Z." *Pulpudeva* 4 (1983): 310–23.

Mladenova 1991
Mladenova, Yanka. *Античната вила Армира край Ивайловград*. Sofia: Izdatelstvo na Bŭlgarskata akademiia na naukite, 1991.

Moltesen 1995
Moltesen, Mette. *Greece in the Classical Period: Catalogue, Ny Carlsberg Glyptotek*. Copenhagen: Ny Carlsberg Glyptotek, 1995.

Mommsen 1875
Mommsen, Theodor. "Observationes epigraphicae: XVII. Reges Thraciae inde a Caesare dictatore." *Ephemeris Epigraphica* 2 (1875): 250–63.

Moon and Berge 1979
Moon, Warren G., and Louise Berge. *Greek Vase-Painting in Midwestern Collections*. Exh. cat. Chicago: Art Institute of Chicago, 1979.

Mordvintseva 2001
Mordvinceva [Mordvintseva], Valentina A. *Sarmatische Phaleren*. Rahden, Germany: Verlag Marie Leidorf, 2001.

Mordvintseva 2008
Mordvintseva, Valentina A. "Фалары из вотивных кладов Северного Причерноморья III–I вв. до н.э. и сарматская парадигма." *Вестник древней истории* 3 (2008): 162–83.

Mozolevskyi 1979
Mozolevskyi, Borys. *Товста могила*. Kyiv: Naukova dumka, 1979.

Mutafchieva 2018
Mutafchieva, Yana. "Бронзови съдове от Тракия от V–IV в. пр. Хр." PhD diss., Natsionalen arheologicheski institut s muzei, Sofia, 2018.

Nankov 2007
Nankov, Emil. "An Ivory Scabbard Chape from Seuthopolis Rediscovered: Evidence for a Xiphos from Early Hellenistic Thrace?" *Archaeologia Bulgarica* 11, no. 1 (2007): 37–46.

Nankov 2008
Nankov, Emil. "The Fortifications of the Early Hellenistic City of Seuthopolis: Breaking the Mold." *Archaeologia Bulgarica* 12, no. 3 (2008): 15–56.

Nankov 2010
Nankov, Emil. "Why One Needs 'The Odd Man Out'? The Deer Hunter with Lagobolon from the Frescoes in the Thracian Tomb near Alexandrovo." *Archaeologia Bulgarica* 14, no. 1 (2010): 35–55.

Nankov 2011
Nankov, Emil. "Berenike Bids Farewell to Seuthes III: The Silver-Gilt Scallop Shell Pyxis from the Golyama Kosmatka Tumulus." *Archaeologia Bulgarica* 15, no. 3 (2011): 1–22.

Nankov 2013
Nankov, Emil. "Playful in Life and after Death: Board Games in Early Hellenistic Thrace." In Sîrbu and Ştefănescu 2013, 277–88.

Nankov 2015
Nankov, Emil. "The Mobility of Macedonian Army in Thrace during the Reign of Philip II and the Inscribed Lead Sling Bullets from Kozi Gramadi." *Bulgarian e-Journal of Archaeology* 5, no. 1 (2015): 1–13. https://be-ja.org/index.php/journal/article/view/be-ja-5-1-2015-1-13/102.

Nankov 2016a
Nankov, Emil. "Berenike Bids Farewell to Seuthes III, Part II: The South Italian Alabastra from the Golyama Kosmatka Tumulus." In *Abstracts of the International Conference Graves, Tombs, Necropoleis in Their Settlement Environment in the Eastern Mediterranean Context—Classical to Hellenistic Period, Kazanlak and Isperih, 9th–14th October, 2016*, 5–6. Sofia: American Research Center in Sofia, 2016. https://arcsofia.org/sites/default/files/Abstracts_0.pdf.

Nankov 2016b
Nankov, Emil. "Inscribed Lead Sling Bullets from the Regional Museum of History in Shumen: New Data on the Macedonian Campaigns in the Lands of the Getae in the Time of Philip II and Alexander III." In *Тракия и околният свят: Сборник с доклади от Национална научна конференция, 27–29 октомври 2016 г.*, edited by Ivan Marazov et al., 282–93. Shumen: Faber, 2016.

Nankov 2023
Nankov, Emil. *Markers of Military Mobility: Toward an Archaeology of the Sling in Ancient Thrace (5th c. BC–4th c. AD) with a Corpus of the Inscribed Lead Sling Projectiles from Bulgaria*. Sofia: Izdatelstvo na BAN "Prof. Marin Drinov," 2023.

Nawotka 1994
Nawotka, Krzysztof. "Melsas, the Founder of Mesambria?" *Hermes* 122 (1994): 320–26.

Nefedkin 2009
Nefedkin, Alexander. "On the Origin of Greek Cavalry Shields in the Hellenistic Period." *Klio* 91, no. 2 (2009): 356–66.

Nessel and Pernicka 2018
Nessel, Bianka, and Ernst Pernicka. "The Rise of Tin Bronze in Southeastern Europe in the 3rd and 2nd Millennia BC." In Alexandrov et al. 2018, 133–140.

Neuser 1982
Neuser, Kora. *Anemoi: Studien zur Darstellung der Winde und Windgottheiten in der Antike*. Rome: G. Bretschneider, 1982.

Nieling and Rehm 2010
Nieling, Jens, and Ellen Rehm, eds. *Achaemenid Impact in the Black Sea: Communication of Powers*. Aarhus: Aarhus University Press, 2010.

Niemeyer and Schwarzmaier 2021
Niemeyer, Barbara, and Agnes Schwarzmaier. *Silber aus zwei Jahrtausenden in der Berliner Antikensammlung*. Exh. cat. Berlin: Verlag Schnell & Steiner, 2021.

Nikolov 1967
Nikolov, Bogdan. "Гробница III от Могиланската могила във Враца." *Археология* 9, no. 1 (1967): 11–18.

Nikolov 1986
Nikolov, Bogdan. "The Thracian Silver Treasure from Rogozen." *Southeastern Europe* 13, no. 1 (1986): 1–23.

Nikolov, Mashov, and Ivanov 1987
Nikolov, Bogdan, Spas Mashov, and Plamen Ivanov. "Тракийско сребърно съкровище от Рогозен." *Известия на музеите в Северозападна България* 12 (1987): 9–135.

Nikov 2012
Nikov, Krassimir. *Grey Monochrome Pottery from Apollonia Pontica*. Veliko Tarnovo: Faber, 2012.

Nikov 2023
Nikov, Krassimir. "The Triumph of Silver: Influences and Originality." In H. Popov et al. 2023, 70–75.

Oakley 2000
Oakley, John H. "Some 'Other' Members of the Athenian Household: Maids and Their Mistresses in Fifth-Century Athenian Art." In Cohen 2000, 227–47.

Obrador-Cursach 2020
Obrador-Cursach, Bartomeu. *The Phrygian Language*. Leiden: Brill, 2020.

Ognenova-Marinova 1961
Ognenova[-Marinova], Lyuba. "Les cuirasses de bronze trouvées en Thrace." *Bulletin de correspondance hellénique* 85 (1961): 501–38.

Ognenova-Marinova 1969
Ognenova-Marinova, Lyuba. "Les motifs décoratifs des armures en Thrace au IV siècle av. n. ère." In *Actes du Iᵉʳ Congrès international des études balkaniques et sud-est européennes*, 2:397–418. Sofia: Éditions de l'Académie Bulgare des Sciences, 1969.

Ognenova-Marinova 1976
Ognenova-Marinova, Lyuba. "Sur l'origine de la statuette en bronze de Sevlievo." *Pulpudeva* 1 (1976): 132–34.

Ognenova-Marinova 1978a
Ognenova-Marinova, Lyuba. "Notes sur les parures de la Thrace et de l'Anatolie." In *Proceedings of the 10th International Congress of Classical Archaeology*, edited by Ekrem Akurgal, 2:989–94. Ankara: Türk Tarih Kurumu, 1978.

Ognenova-Marinova 1978b
Ognenova-Marinova, Lyuba. "Le trésor de Valčitran—un jalon dans l'étude de la religion Thrace." *Pulpudeva*, supplement 2 (1978): 240–44.

Ognenova-Marinova 1980
Ognenova-Marinova, Lyuba. "Tuiles et terres cuites architecturales." In *Nessebre*, vol. 2, edited by Velizar Velkov, 110–55. Sofia: Éditions de l'Académie Bulgare des Sciences, 1980.

Ognenova-Marinova 2000
Ognenova-Marinova, Lyuba. "L'armure des Thraces." *Archaeologia Bulgarica* 4, no. 3 (2000): 11–24.

Ognenova-Marinova 2005
Ognenova-Marinova, Lyuba. "L'architecture domestique à Messambria IVᵉ–IIᵉ s. av. J.-C." In *Nessebre*, vol. 3, edited by Velizar Velkov, 11–29. Burgas: Spring, 2005.

Oppermann 2004
Oppermann, Manfred. *Die westpontischen Poleis und ihr indigenes Umfeld in vorrömischer Zeit*. Langenweißbach, Germany: Beier & Beran, 2004.

Oppermann 2017
Oppermann, Manfred. "Der Kybelekult an der Westküste des Schwarzen Meeres (Westpontos) in vorrömischer Zeit." *Pontica* 50 (2017): 17–47.

Orel 1997
Orel, Vladimir E. "The Inscription from Kjolmen." *Mediterranean Language Review* 9 (1997): 77–82.

Ortiz 1996
Ortiz, George. *Faszination der Antike: The George Ortiz Collection*. Exh. cat. Bern: Benteli, 1996.

Osborne 1985
Osborne, Robin. "The Erection and Mutilation of the Hermai." *Proceedings of the Cambridge Philological Society* 211, no. 31 (1985): 47–73.

Østergaard and Schwartz 2022
Østergaard, Jan Stubbe, and Adam Schwartz. "A Late Archaic / Early Classical Greek Relief with Two Hoplites (Ny Carlsberg Glyptotek IN 2787)." *Jahrbuch des Deutschen Archäologischen Instituts* 137 (2022): 1–37.

Pache 2001
Pache, Corinne Ondine. "Barbarian Bond: Thracian Bendis among the Athenians." In *Between Magic and Religion: Interdisciplinary Studies in Ancient Mediterranean Religion and Society*, edited by Sulochana R. Asirvatham, Corrine Ondine Pache, and John Watrous, 3–11. Lanham, MD: Rowman & Littlefield, 2001.

Palagia 2009
Palagia, Olga. "Archaism and the Quest for Immortality in Attic Sculpture during the Peloponnesian War." In *Art in Athens during the Peloponnesian War*, edited by Olga Palagia, 24–51. Cambridge: Cambridge University Press, 2009.

Palagia 2021
Palagia, Olga. "The Coronation of the Deceased in Hellenistic Funerary Painting in Macedonia and Thrace." In *Ancient Macedonia, VIII: Macedonia from the Death of Philip II to Augustus' Rise to Power; Papers Read at the Eighth International Symposium Held in Thessaloniki, November 21–24, 2017*, 667–78. Thessaloniki: Institute for Balkan Studies, 2021.

Paliadeli et al. 2008
Paliadeli, Chrysoula, et al. "Παλαιές υποχρεώσεις και νέα ευρήματα στις Αιγές." *Το Αρχαιολογικό Έργο στη Μακεδονία και στη Θράκη* 22 (2008): 177–82.

Panayotov 1980
Panayotov, Ivan. "Bronze Rapiers, Swords and Double Axes from Bulgaria." *Thracia* 5 (1980): 173–98.

Panayotova, Stoyanova, and Damyanov 2021
Panayotova, Krastina, Daniela Stoyanova, and Margarit Damyanov. "Late Archaic Relief Plaques with Warriors from Apollonia Pontica." In Tsetskhladze, Aram, and Hargrave 2021, 598–611.

Panayotova et al. 2014
Panayotova, Krastina, et al. "Apollonia Pontica: The Archaic Temenos and Settlement on the Island of St. Kirik." In *Centre and Periphery in the Ancient World: Proceedings of the XVIIIth International Congress of Classical Archaeology*, edited by José María Álvarez Martínez, Trinidad Nogales Basarate, and Isabel Rodà, 1:595–98. Merida: Museo Nacional de Arte Romano, 2014.

Papadakis 1937
Papadakis, Nikolaos G. "Ιερος Νομος Βενδιδειου." *Archaiologike Ephemeris*, 1937, 808–23.

Pardalidou 2015
Pardalidou, Chrysafenia. "4.1. Κεραμική." In Tsatsopoulou-Kaloudi et al. 2015, 566–705.

Parker 1996
Parker, Robert. *Athenian Religion: A History*. Oxford: Clarendon Press, 1996.

Parvin 2008
Parvin, Meglena. "Параден нагръдник от инвентара на погребението в могила Голяма Косматка." In D. Dimitrova 2008a, 163–66.

Parvin 2010
Parvin, Meglena. "Биметални брони от Тракия." In *Великотърновският университет "Св. Св. Кирил и Методий" и българската археология*, 1:225–30. Veliko Tarnovo: Universitetsko izdatelstvo "Sv. sv. Kiril i Metodii," 2010.

Parvin 2022
Parvin, Meglena. "New Observations on the Inventory from the Southwestern Chamber of the Ostrusha Tumulus Complex." In Delev et al. 2022, 1:339–48.

Parvoničová and Bouzek 2017
Parvoničová, Lenka, and Jan Bouzek. "Thirty Years of Interdisciplinary Research at the Site of Pistiros." *Studia Hercynia* 21 (2017): 27–39.

Paspalas 2008
Paspalas, Stavros A. "The Achaemenid Lion-Griffin on a Macedonian Tomb Painting and on a Sicyonian Mosaic." In Darbandi and Zournatzi 2008, 301–27.

Paunov 2005
Paunov, Evgeni. "Ромфея—новооткрит тракийски меч от Западните Родопи." In Rabadjiev 2005b, 368–75.

Paunov 2014
Paunov, Evgeni. "The Coinage of the Thracian King Mostis: Recent Finds, Chronology, Distribution and Localisation." In *Proceedings of the First International Congress of the Anatolian Monetary History and Numismatics*, edited by Kayhan Dörtlük et al., 457–80. Istanbul: Suna–İnan Kıraç Research Institute on Mediterranean Civilizations, 2014.

Paunov 2015
Paunov, Evgeni. "Introduction to the Numismatics of Thrace, ca. 530 BCE–46 CE." In Valeva, Nankov, and Graninger 2015, 265–92.

Pavúk 2018
Pavúk, Peter. "Thrace, Troy and Anatolia: Troy and Its Contacts to the Balkans." In Alexandrov et al. 2018, 265–75.

Paxson 1994
Paxson, James J. *The Poetics of Personification*. Cambridge: Cambridge University Press, 1994.

Peatfield 1999
Peatfield, Alan. "The Paradox of Violence: Weaponry and Martial Arts in Minoan Crete." In *Polemos: Le contexte guerrier en Égée à l'âge du Bronze; Actes de la 7ᵉ Rencontre égéenne internationale, Université de Liège, 14–17 avril 1998*, edited by Robert Laffineur, 67–74. Liège: Université de Liège, Histoire de l'art et archéologie de la Grèce antique; Austin: University of Texas at Austin, Program in Aegean Scripts and Prehistory, 1999.

E. Penkova, Konova, and Kisyov 2017
Penkova, Elka, Lyubava Konova, and Kostadin Kisyov, eds. *Legends in Gold: Thracian Treasures from Bulgaria*. Bergen: Bergen City Museum, 2017.

E. Penkova et al. 2015
Penkova, Elka, et al. *Мистерии и истини за Панагюрското съкровище*. Sofia: Unicart, 2015.

P. Penkova and Mehofer 2018
Penkova, Petya, and Mathias Mehofer. "The Treasure of Valchitran: Production Technique." In Alexandrov et al. 2018, 208–14.

Pernicka 2013
Pernicka, Ernst. "Die Ausbreitung der Metallurgie in der Alten Welt." In Piotrovski 2013, 66–78.

Pernicka 2018
Pernicka, Ernst. "The Chemical Composition of the Gold Finds from Valchitran Treasure." In Alexandrov et al. 2018, 215–22.

Pernicka et al. 1997
Pernicka, Ernst, et al. "Prehistoric Copper in Bulgaria: Its Composition and Provenance." *Eurasia Antiqua* 3 (1997): 41–180.

Perrot 1868
Perrot, Georges. "Deux inscriptions de Thrace." *Bulletin de la Société des antiquaires de France*, 1868, 74–82.

Perrot 1875
Perrot, Georges. *Mémoires d'archéologie, d'épigraphie et d'histoire*. Paris: Librairie académique, 1875.

Peter 1997
Peter, Ulrike. *Die Münzen der thrakischen Dynasten (5.–3. Jahrhundert v. Chr.): Hintergründe ihrer Prägung*. Berlin: Akademie, 1997.

Peter 2005
Peter, Ulrike. "Religious-Cultural Identity in Thrace and Moesia Inferior." In *Coinage and Identity in the Roman Provinces*, edited by C. J. Howgego, Volker Heuchert, and Andrew Burnett, 107–14. Oxford: Oxford University Press, 2005.

Petrov 1993
Petrov, Irko. "Тракийски могилен некропол край село Горски Извор, Хасковско." *Известия на музеите от Югоизточна България* 16 (1993): 7–36.

Petrova 2015
Petrova, Aneta. *Funerary Reliefs from the West Pontic Area (6th–1st Centuries BC)*. Leuven: Peeters, 2015.

Pfrommer 1990
Pfrommer, Michael. "Ein achämenidisches Amphorenrhyton mit ägyptischem Dekor." *Archäologische Mitteilungen aus Iran* 23 (1990): 191–209.

Pfrommer 1993
Pfrommer, Michael. *Metalwork from the Hellenized East: Catalogue of the Collections.* Malibu, CA: J. Paul Getty Museum, 1993.

Pfuhl and Möbius 1977
Pfuhl, Ernst, and Hans Möbius. *Die ostgriechischen Grabreliefs.* Vol. 1. Mainz: Philipp von Zabern, 1977.

C. Picard 1940
Picard, Charles. "Trois urnes cinéraires sculptées du Musée Condé à Chantilly." *Monuments et mémoires de la Fondation Eugène-Piot* 37 (1940): 73–103.

O. Picard 1999
Picard, Olivier. "Le commerce de l'argent dans la charte de Pistiros." *Bulletin de correspondance hellénique* 123, no. 1 (1999): 331–46.

Pilhofer 2009
Pilhofer, Peter. *Philippi.* Vol. 2, *Katalog der Inschriften von Philippi.* 2nd ed. Tübingen: Mohr Siebeck, 2009.

Piotrovski 2013
Piotrovski, Juri Ju., ed. *Bronzezeit: Europa ohne Grenzen, 4.–1. Jahrtausend v. Chr. / Бронзовый век. Европа без границ: Четвертое—первое тысячелетия до новой эры.* Exh. cat. St. Petersburg: Tabula Rasa, 2013.

Plaoutine 1938
Plaoutine, Nicolas. *Corpus Vasorum Antiquorum: France 14, Musée du Louvre 9.* Paris: H. Champion, 1938.

Platz-Horster 2005
Platz-Horster, Gertrud. "Die Silberfunde von Panderma in der Antikensammlung Berlin." In *Otium: Festschrift für Volker Michael Strocka,* edited by Thomas Ganschow and Matthias Steinhart, 295–303. Remshalden, Germany: B. A. Greiner, 2005.

Pochmarski 1974
Pochmarski, Erwin. *Das Bild des Dionysos in der Rundplastik der klassischen Zeit Griechenlands.* Vienna: Verband der Wissenschaftlichen Gesellschaften Österreichs, 1974.

Polomé 1982
Polomé, E. C. "Balkan Languages (Illyrian, Thracian and Daco-Moesian)." In *The Cambridge Ancient History.* Vol. 3, pt. 1, *The Prehistory of the Balkans, the Middle East and the Aegean World, Tenth to Eighth Centuries B.C.*, edited by John Boardman et al., 866–98. 2nd ed. Cambridge: Cambridge University Press, 1982.

Popescu 2020
Popescu, Anca-Diana. "Prestige Artefacts during the Bronze Age: The Perşinari Hoard and the Precious Metals Weapons in the Area between the Middle Danube and Mesopotamia." In Maran et al. 2020, 221–49.

Popescu and Oanţă-Marghitu 2018
Popescu, Anca-Diana, and Rodica Oanţă-Marghitu. "Gold Finds from Southern Romania during the 3rd and 2nd Millennia BC." In Alexandrov et al. 2018, 105–21.

D. Popov 2010
Popov, Dimitŭr. *Тракийската религия.* Sofia: LIK, 2010.

D. Popov 2011
Popov, Dimitŭr. *Траки: Исторически и културен обзор.* Sofia: Iztokzapad, 2011.

H. Popov 2017
Popov, Hristo. "За одриските резиденции в Средна гора." In *КРАТΙΣΤΟΣ: Сборник в чест на професор Петър Делев / Volume in Honour of Professor Peter Delev,* edited by Hristo Popov and Julia Tzvetkova, 469–82. Sofia: Universitetsko izdatelstvo "Sv. Kliment Ohridski," 2017.

H. Popov 2018
Popov, Hristo. "Ada Tepe near Krumovgrad, Eastern Rhodope Mountain." In Alexandrov et al. 2018, 402–15.

H. Popov and Jockenhövel 2018
Popov, Hristo, and Albrecht Jockenhövel. "The Late Bronze Age Gold Mine at Ada Tepe." In Alexandrov et al. 2018, 193–205.

H. Popov and Jung, forthcoming
Popov, Hristo, and Reinhard Jung, eds. *Searching for Gold: Resources and Networks in the Bronze Age of the Eastern Balkans.* Vienna: Verlag der Österreichischen Akademie der Wissenschaften, forthcoming.

H. Popov, Nikov, and Jockenhövel 2015
Popov, Hristo, Krassimir Nikov, and Albrecht Jockenhövel. "Ada Tepe (Krumovgrad, Bulgarien)—ein neu entdecktes spätbronzezeitliches Goldbergwerk im balkanisch-ägäischen Kommunikationsnetz." In *Kontaktzone Balkan: Beiträge des internationalen Kolloquiums "Die Donau-Balkan-Region als Kontaktzone zwischen Ost-West und Nord-Süd,"* edited by Gerda von Bülow, 45–62. Bonn: Verlag Dr. Rudolf Habelt, 2015.

H. Popov et al. 2011
Popov, Hristo, et al. "Montanarchäologische Forschungen in den Ostrhodopen." In *Interdisziplinäre Forschungen zum Kulturerbe auf der Balkanhalbinsel: Beiträge des Humboldt-Kollegs "Interdisziplinäre Forschungen zum Kulturerbe auf der Balkanhalbinsel," 19–22 November, 2009, Sofia,* edited by Vassil Nikolov, Krum Bacvarov, and Hristo Popov, 253–90. Sofia: "Nice AN" EOOD, 2011.

H. Popov et al. 2017
Popov, Hristo, et al. "Das Goldbergwerk auf dem Ada Tepe: Zu Topografie, Stratigrafie, Chronologie und Interpretation des Nordareals." *Archaeologia Austriaca* 101 (2017): 161–204.

H. Popov et al. 2023
Popov, Hristo, et al., eds. *Silver Thrace.* Exh. cat. Sofia: National Archaeological Institute with Museum—Bulgarian Academy of Sciences, 2023.

H. Popov et al., forthcoming
Popov, Hristo, et al. "Dating the Early Mining and Settlement Activities at Ada Tepe: Contributions to the Absolute and Relative Chronology." In H. Popov and Jung, forthcoming.

R. Popov 1922–25
Popov, Rafail. "Сребърното съкровище от Букьовци." *Годишник на Народния музей* 4 (1922–25): 1–22.

Popova-Moroz 1987
Popova-Moroz, Vanya. *24 древни мозайки от България.* Sofia: Bŭlgarski hudozhnik, 1987.

Popova-Moroz 2002
Popova-Moroz, Vanya. "Портретите на Александър Велики и техните имитации в римска Тракия." *Проблеми на изкуството* 1 (2002): 7–15.

Popova-Moroz 2022
Popova[-Moroz], Vanya. "Roman and Late Antique Portraiture of Augusta Traiana—Beroe and Its Territory." In *Изкуство и памет: Сборник в чест на 80-годишнината на Иван Маразов,* edited by Oksana Minaeva and Irena Bokova, 257–94. Sofia: Nov Bŭlgarski Universitet, 2022.

Porozhanov 2021
Porozhanov, Kalin. *The Odrysian Kingdom, the Poleis along Its Coasts, and Athens from the End of the 6th Century until 341 BC.* 2nd rev. ed. Sofia: Ral-Kolobar, 2021.

Posamentir 2022
Posamentir, Richard. "Dog Not Important, Only Staff Important!" In *Connecting the Ancient West and East: Studies Presented to Prof. Gocha R. Tsetskhladze,* edited by John Boardman et al., 665–82. Leuven: Peeters, 2022.

Poulter 1983
Poulter, A. G., ed. *Ancient Bulgaria: Papers Presented to the International Symposium on the Ancient History and Archaeology of Bulgaria, University of Nottingham, 1981.* 2 vols. Nottingham: University of Nottingham, Department of Classical and Archaeological Studies, Archaeology Section, 1983.

Pownall 2013
Pownall, Frances. "Hekataios of Miletos (1)." In *Jacoby Online: Brill's New Jacoby, Part I,* edited by Ian Worthington. Brill: Leiden, 2013. http://dx.doi.org/10.1163/1873-5363_bnj_a1.

Prange 1989
Prange, Mathias. *Der Niobidenmaler und seine Werkstatt: Untersuchungen zu einer Vasenwerkstatt frühklassischer Zeit.* Frankfurt: P. Lang, 1989.

Price 1987
Price, M. Jessop. "The Coinages of the Northern Aegean." In Carradice 1987, 43–52.

Pritchett 1991
Pritchett, W. Kendrick. *The Greek State at War*. Vol. 5. Berkeley: University of California Press, 1991.

Psoma 2002
Psoma, Selene. "Le monnayage de Sparadocos des Odryses: Un état de la question." In *Proceedings of the 8th International Congress of Thracology, Sofia–Yambol, 25–29 September 2000*, 513–21. Sofia: Institute of Thracology, 2002.

Pulak 1998
Pulak, Cemal. "The Uluburun Shipwreck: An Overview." *International Journal of Nautical Archaeology* 27, no. 3 (1998): 188–224.

Rabadjiev 1996
Rabadjiev, Kostadin. "Херакъл и Хиполита: Към интерпретацията на каничка № 154 от Рогозенското съкровище." *Археология* 38, nos. 2–3 (1996): 64–72.

Rabadjiev 2001
Rabadjiev, Kostadin. "Herakles, Diomedes, and Thrace." *Archaeologica Bulgarica* 5, no. 3 (2001): 9–21.

Rabadjiev 2002
Rabadjiev, Kostadin. *Елински мистерии в Тракия: Опит за археологически прочит.* Sofia: Universitetsko izdatelstvo "Sv. Kliment Ohridski," 2002.

Rabadjiev 2005a
Rabadjiev, Kostadin. "Орфей в изобразителните паметници от Тракия." In Stoyanov et al. 2005, 72–79.

Rabadjiev 2005b
Rabadjiev, Kostadin, ed. *Stephanos Archaeologicos in Honorem Professoris Ludmili Getov*. Sofia: Universitetsko izdatelstvo "Sv. Kliment Ohridski," 2005.

Rabadjiev 2012
Rabadjiev, Kostadin. "Божествената колесница в Тракия." In Rabadjiev et al. 2012, 696–708.

Rabadjiev 2014
Rabadjiev, Kostadin. *Конят, колесницата и конникът: Към интерпретацията на образа в тракийската култура.* Sofia: Universitetsko izdatelstvo "Sv. Kliment Ohridski," 2014.

Rabadjiev 2015
Rabadjiev, Kostadin. "Thracian Religion." In Valeva, Nankov, and Graninger 2015, 443–56.

Rabadjiev 2016
Rabadjiev, Kostadin. "The Thracian Tomb as Ritual Space of the Beyond." In Henry and Kelp 2016, 1:281–312.

Rabadjiev 2017
Rabadjiev, Kostadin. "Theoi Samothrakes at Pontos Euxeinos." *Archaeologia Bulgarica* 21, no. 2 (2017): 11–25.

Rabadjiev 2018
Rabadjiev, Kostadin. "Статуята в тракийския свят: Размисли за отсъствието й." In "Stephanos Archaeologicos ad 80 Annum Professoris Ludmili Getov." Supplement, *Studia Archaeologica Universitatis Serdicensis* 4 (2018): 169–89.

Rabadjiev et al. 2012
Rabadjiev, Kostadin, et al., eds. *Изкуство и идеология.* Sofia: Universitetsko izdatelstvo "Sv. Kliment Ohridski," 2012.

Radivojević et al. 2010
Radivojević, Miljana, et al. "On the Origins of Extractive Metallurgy: New Evidence from Europe." *Journal of Archaeological Science* 37 (2010): 2775–87.

Radivojević et al. 2019
Radivojević, Miljana, et al. "The Provenance, Use, and Circulation of Metals in the European Bronze Age: The State of Debate." *Journal of Archaeological Research* 27 (2019): 131–85.

Raeck 1981
Raeck, Wulf. *Zum Barbarenbild in der Kunst Athens im 6. und 5. Jahrhundert v. Chr.* Bonn: R. Habelt, 1981.

Reeves 2018
Reeves, Jonathan. "οὐ κακὸς ἐών: Megarian Valour and Its Place in the Local Discourse at Megara." In *Megarian Moments: The Local World of an Ancient Greek City-State*, edited by Hans Beck and Philip J. Smith, 176–79. Montreal: McGill University Library and Archives, 2018.

Rehm 2010a
Rehm, Ellen. "The Classification of Objects from the Black Sea Region Made or Influenced by the Achaemenids." In Nieling and Rehm 2010, 161–94.

Rehm 2010b
Rehm, Ellen. "The Impact of the Achaemenids on Thrace: A Historical Review." In Nieling and Rehm 2010, 137–60.

Reho 1989
Reho, Maria. "Атическа рисувана керамика в тракийски погребен контекст: Наблюдения върху съдовете, открити в България." *Археология* 31, no. 2 (1989): 11–19.

Reho 1990
Reho, Maria. *La ceramica attica a figure nere e rosse nella Tracia bulgara*. Rome: Bretschneider, 1990.

Reho and Ilieva 2006
Reho, Maria, and Pavlina Ilieva. *Thracian Treasures from Bulgaria*. Sofia: Borina, 2006.

Rehren, Leshtakov, and Penkova 2016
Rehren, Thilo, Peter Leshtakov, and Petya Penkova. "Reconstructing Chalcolithic Copper Smelting at Akladi Cheiri, Chernomorets, Bulgaria." In *Der Schwarzmeerraum vom Neolithikum bis in die Früheisenzeit (6000–600 v.Chr.)*, edited by Vassil Nikolov and Wolfram Schier, 205–14. Rahden, Germany: Verlag Marie Leidorf, 2016.

Rehren, Penkova, and Pernicka 2020
Rehren, Thilo, Petya Penkova, and Ernst Pernicka. "The Chalcolithic Copper Smelting at Akladi Cheiri." In Krauss et al. 2020, 141–60.

Reiterman 2016
Reiterman, Amanda S. "Keimêlia: Objects Curated in the Ancient Mediterranean (8th–5th Centuries B.C.)." PhD diss., University of Pennsylvania, Philadelphia, 2016.

Republic 2013
Plato. *Republic (Books 1–5)*. Edited and translated by Chris Emlyn-Jones and William Preddy. Cambridge, MA: Harvard University Press, 2013.

Richter 1936
Richter, Gisela M. A. *Red-Figured Athenian Vases in the Metropolitan Museum of Art*. 2 vols. New Haven, CT: Yale University Press, 1936.

Richter 1946
Richter, Gisela M. A. "A Fourth-Century Bronze Hydria in New York." *American Journal of Archaeology* 50 (1946): 361–67.

Ridgway 1971
Ridgway, Brunilde S. "The Man-and-Dog Stelai." *Jahrbuch des Deutschen Archäologischen Instituts* 86 (1971): 60–79.

Robert 1933
Robert, Louis. "Inscriptions d'Érythrai." *Bulletin de correspondance hellénique* 57 (1933): 467–84.

Rolley 1999
Rolley, Claude. *La sculpture grecque*. Vol. 2, *La période classique*. Paris: Picard, 1999.

Rosivach 1999
Rosivach, Vincent J. "Enslaving 'Barbaroi' and the Athenian Ideology of Slavery." *Historia* 48 (1999): 129–57.

Rostovtzeff 1922
Rostovtzeff, Michael I. *Iranians and Greeks in South Russia*. Oxford: Clarendon Press, 1922.

Roux 1964
Roux, George. "Meurtre dans un sanctuaire sur l'amphore de Panagurishte." *Antike Kunst* 7 (1964): 30–40.

Rubel 2014
Rubel, Alexander. *Fear and Loathing in Ancient Athens: Religion and Politics during the Peloponnesian War*. London: Routledge, 2014.

Russeva 2016
Russeva, Boryana. "Кой от одриските владетели—династът Севт I (424–ок. 405) или парадинастът Севт II (ок. 405–ок. 378), сече династичното сребро с надписи ΣΕΥΘΑ ΑΡΓΥΡΙΟΝ и ΣΕΥΘΑ ΚΟΜΜΑ." *Нумизматика, сфрагистика и епиграфика* 12 (2016): 1–20.

Ryndina 1971
Ryndina, Natalija. *Древнейшее металлообрабатывающее производство Восточной Европы.* Moscow: Izdatelstvo Moskovskogo universiteta, 1971.

Ryndina 1998
Ryndina, Natalija. *Древнейшее металлообрабатывающее производство Юго-Восточной Европы (истоки и развитие в неолите-энеолите).* Moscow: Editorial URSS, 1998.

Rządkiewicz 2006
Rządkiewicz, Małgorzata. "The Thracian Inscription from Ezerovo: An Attempt to a New Interpretation." *Linguistique balkanique* 45, no. 3 (2006): 455–64.

Said 1979
Said, Edward W. *Orientalism.* New York: Vintage, 1979.

Saladino 2012–13
Saladino, Vincenzo. "Il ritratto di Seuthes III." *Jahrbuch des Deutschen Archäologischen Instituts* 127–28 (2012–13): 125–206.

Salviat 1999
Salviat, François. "Le roi Kersobleptès, Maronée, Apollonia, Thasos, Pistiros et l'histoire d'Hérodote." *Bulletin de correspondance hellénique* 123, no. 1 (1999): 259–73.

Sandars 1963
Sandars, Nancy K. "Later Aegean Bronze Swords." *American Journal of Archaeology* 67 (1963): 118–43.

Sarre and Herzfeld 1910
Sarre, Friedrich, and Ernst Herzfeld. *Iranische Felsreliefs: Aufnahmen und Untersuchungen von Denkmälern aus alt- und mittelpersischer Zeit.* Berlin: E. Wasmuth, 1910.

Sayar 1992
Sayar, Mustafa Hamdi. "Der thrakische König Mostis." *Tyche* 7 (1992): 187–95.

Sayar 1998
Sayar, Mustafa Hamdi. *Perinthos-Herakleia (Marmara Ereğlisi) und Umgebung.* Vienna: Verlag der Österreichischen Akademie der Wissenschaften, 1998.

Sayar 2014
Sayar, Mustafa Hamdi. "Lysimacheia: Eine hellenistische Hauptstadt zwischen zwei Kontinenten und zwei Meeren; Ein Ort der Interkonnektivität." In *Interconnectivity in the Mediterranean and Pontic World during the Hellenistic and Roman Periods*, edited by Victor Cojocaru, Altay Coşkun, and Madalina Dana, 363–82. Cluj-Napoca, Romania: Editura Mega, 2014.

Schmid 1987
Schmid, Wolfgang P. "Zur thrakischen Grabinschrift aus Kölmen." *Zeitschrift für vergleichende Sprachforschung* 100, no. 2 (1987): 351–57.

Schmidt 1953
Schmidt, Erich F. *Persepolis.* Vol. 1, *Structures, Reliefs, Inscriptions.* Chicago: University of Chicago Press, 1953.

Schmitt 1969
Schmitt, Hatto H. *Die Staatsverträge des Altertums.* Vol. 3, *Die Verträge der griechisch-römischen Welt von 338 bis 200 v. Chr.* Munich: C. H. Beck, 1969.

Schmitt-Brandt 1967
Schmitt-Brandt, Robert. "Die thrakischen Inschriften." *Glotta* 45, nos. 1–2 (1967): 40–60.

Schneider 2000
Schneider, Carsten. "Herr und Hund auf archaischen Grabstelen." *Jahrbuch des Deutschen Archäologischen Instituts* 115 (2000): 1–36.

Schoeller 1969
Schoeller, Felix M. "Darstellungen des Orpheus in der Antike." PhD diss., Albert-Ludwigs-Universität, Freiburg, 1969.

Schönert-Geiss 1987
Schönert-Geiss, Edit. *Griechisches Münzwerk: Die Münzprägung von Maroneia.* Berlin: Akademie, 1987.

Sears 2013
Sears, Matthew A. *Athens, Thrace, and the Shaping of Athenian Leadership.* Cambridge: Cambridge University Press, 2013.

Sears 2015
Sears, Matthew A. "Athens (Influence and Interaction)." In Valeva, Nankov, and Graninger 2015, 308–19.

SEG 38
Supplementum Epigraphicum Graecum. Vol. 38 (1988). Edited by Henri W. Pleket and Ronald S. Stroud. Amsterdam: J. C. Gieben, 1991.

SEG 41
Supplementum Epigraphicum Graecum. Vol. 41 (1991). Edited by Henri W. Pleket and Ronald S. Stroud. Amsterdam: J. C. Gieben, 1994.

SEG 42
Supplementum epigraphicum Graecum. Vol. 42 (1992). Edited by Henri W. Pleket, Ronald S. Stroud, and Johan H. M. Strubbe. Amsterdam: J. C. Gieben, 1995.

SEG 43
Supplementum Epigraphicum Graecum. Vol. 43 (1993). Edited by Henri W. Pleket, Ronald S. Stroud, and Johan H. M. Strubbe. Amsterdam: J. C. Gieben, 1996.

SEG 49
Supplementum Epigraphicum Graecum. Vol. 49 (1999). Edited by Henri W. Pleket et al. Amsterdam: J. C. Gieben, 2002.

SEG 59
Supplementum Epigraphicum Graecum. Vol. 59 (2009). Edited by Angelos Chaniotis et al. Leiden: Brill, 2013.

Sekunda 1983
Sekunda, N. "The *Rhomphaia*: A Thracian Weapon of the Hellenistic Period." In Poulter 1983, 1:275–88.

Shalganova 2003
Shalganova, Tatyana. "Скъпоценните съдове от бронзовата епоха на Балканския полуостров." *Митология, изкуство, фолклор* 8 (2003): 76–96.

Shapiro 1983
Shapiro, H. A. "Amazons, Thracians, and Scythians." *Greek, Roman and Byzantine Studies* 24 (1983): 105–14.

Shapiro 1988
Shapiro, H. A. "The Marathonian Bull on the Athenian Acropolis." *American Journal of Archaeology* 92 (1988): 373–82.

Shapiro 1992
Shapiro, H. A. "Theseus in Kimonian Athens: The Iconography of Empire." *Mediterranean Historical Review* 7, no. 1 (1992): 29–49.

Shapiro 1993
Shapiro, H. A. *Personifications in Greek Art: The Representation of Abstract Concepts, 600–400 B.C.* Zurich: Akanthus, 1993.

Shapiro 1994
Shapiro, H. A. *Myth into Art: Poet and Painter in Classical Athens.* New York: Routledge, 1994.

Shapiro 2021
Shapiro, H. A. "#Leagros: An Athenian Life." In *The Cambridge Companion to Ancient Athens*, edited by Jenifer Neils and Dylan K. Rogers, 7–20. Cambridge: Cambridge University Press, 2021.

Sharankov 2002
Sharankov, Nicolay. "Лукиан и феноменът лъжефилософия." *Критика и хуманизъм* 13, no. 1 (2002): 233–44.

Sharankov 2005a
Sharankov, Nicolay. "Метричните надписи от територията на Августа Траяна." In *Културните текстове на миналото: Носители, символи и идеи*, 3:40–50. Sofia: Universitetsko izdatelstvo "Sv. Kliment Ohridski," 2005.

Sharankov 2005b
Sharankov, Nicolay. "Надписът на филипополския герусиаст Аврелий Сосрат и проблемът за елинизацията на тракийското население." In *ТЕΧΝΗ ΓΡΑΜΜΑΤΙΚΗ: Сборник изследвания в чест на Стойна Пороманска*, edited by Kiril Pavlikyanov, 278–89. Veliko Tarnovo: Faber, 2005.

Sharankov 2005c
Sharankov, Nikolay. "Statue-Bases with Honorific Inscriptions from Philippopolis." *Archaeologia Bulgarica* 9, no. 2 (2005): 55–71.

Sharankov 2006
Sharankov, Nicolay. "Virdii, Munatii, Antii: Знатните римски родове във Филипопол и провинция Тракия." In *Societas Classica: Култури и религии на Балканите, в Средиземноморието и Изтока*, 179–204. Veliko Tarnovo: Universitetsko izdatelstvo "Sv. sv. Kiril i Metodii," 2006.

Sharankov 2007
Sharankov, Nicolay. "The Thracian κοινόν: New Epigraphic Evidence." In Iakovidou 2007, 518–38.

Sharankov 2009
Sharankov, Nicolay. "Notes on Ancient and Mediaeval Latin and Greek Inscriptions from Bulgaria." *Archaeologia Bulgarica* 13, no. 3 (2009): 47–61.

Sharankov 2011
Sharankov, Nicolay. "Language and Society in Roman Thrace." In *Early Roman Thrace: New Evidence from Bulgaria*, edited by Ian P. Hayes, 135–55. Portsmouth, RI: Journal of Roman Archaeology, 2011.

Sharankov 2013
Sharankov, Nicolay. "Каталог на религиозно сдружение от Августа Траяна (Стара Загора)." In *Сборник в чест на проф. Руска Гандева (1911–2001)*, edited by Zlatozara Gočeva et al., 390–402. Sofia: Universitetsko izdatelstvo "Sv. Kliment Ohridski," 2013.

Sharankov 2014
Sharankov, Nicolay. "Надпис за реконструкция на Филипополския театър." *Годишник на Регионален археологически музей–Пловдив* 12 (2014): 276–92.

Sharankov 2015
Sharankov, Nicolay. "Нови данни за тракийските стратези." *Археология* 56, no. 1–2 (2015): 62–78.

Sharankov 2017
Sharankov, Nicolay. "Епиграфски открития през 2016 г." *Археологически открития и разкопки през 2016 г.*, 2017, 779–82.

Sharankov 2018
Sharankov, Nicolay. "Notes on Governors of Roman Thrace." In "Proceedings of the First International Roman and Late Antique Thrace Conference 'Cities, Territories and Identities' (Plovdiv, 3rd–7th October 2016)," edited by Lyudmil F. Vagalinski et al. Special issue, *Bulletin of the National Archaeological Institute* 44 (2018): 97–109.

Sherratt and Taylor 1989
Sherratt, Andrew, and Timothy Taylor. "Metal Vessels in Bronze Age Europe and the Context of Vulchetrun." In *Thracians and Mycenaeans: Proceedings of the Fourth International Congress of Thracology, Rotterdam, 24–26 September 1984*, edited by Jan G. P. Best and Nanny M. W. De Vries, 2:106–34. Leiden: Publications of the Henri Frankfort Foundation, 1989.

Sideris 2000
Sideris, Athanasios. "Les tombes de Derveni: Quelques remarques sur la toreutique." *Revue archéologique*, n.s., fasc. 1 (2000): 3–36.

Sideris 2008
Sideris, Athanasios. "Achaemenid Toreutics in the Greek Periphery." In Darbandi and Zournatzi 2008, 339–53.

Sideris 2015
Sideris, Athanasios. *Theseus in Thrace: The Silver Lining on the Clouds of the Athenian-Thracian Relations in the 5th Century BC*. Sofia: Thrace Foundation, 2015.

Sideris 2016
Sideris, Athanasios. *Metal Vases and Utensils in the Vassil Bojkov Collection*. Vol. 1, *Achaemenid, Greek, Etruscan and Thracian*. Sofia: Thrace Foundation, 2016.

Sideris 2020
Sideris, Athanasios. "A Bronze Hydria with Two Inscriptions." *Zeitschrift für Papyrologie und Epigraphik* 215 (2020): 104–12.

Sideris 2021
Sideris, Athanasios. *Metal Vases and Utensils in the Vassil Bojkov Collection*. Vol. 2, *Thracian, Achaemenid, Greek and Hellenistic*. Sofia: Thrace Foundation, 2021.

Sideris 2022
Sideris, Athanasios. "Athenian Silver and Bronze Ware in Thrace." In Tsiafaki et al. 2022, 322–43.

Sieveking 1913
Sieveking, Johannes. *Die Bronzen der Sammlung Loeb*. Munich: n.p., 1913.

Simon 1960
Simon, Erika. "Der Goldschatz von Panagjurischte—eine Schöpfung der Alexanderzeit." *Antike Kunst* 3 (1960): 3–29.

Simon 2000
Simon, Erika. "Theban Mythology in the Time of Alexander the Great." In *Periplous: Papers on Classical Art and Archaeology Presented to Sir John Boardman*, edited by Gocha R. Tsetskhladze, A. J. N. W. Prag, and Anthony M. Snodgrass, 284–90. London: Thames & Hudson, 2000.

Simon 2016
Simon, Erika. *Opfernde Götter*. 2nd rev. ed. Dettelbach: J. H. Röll, 2016.

Sîrbu and Bârca 2016
Sîrbu, Valeriu, and Vitalie Bârca. "Figurative Representations on the Phalerae Found between the Ural, the Caucasus and the Balkan Mountains (2nd–1st Century BC)." In *Western-Pontic Culture Ambience and Pattern: In Memory of Eugen Comşa*, edited by Lolita Nikolova, Marco Merlini, and Alexandra Comşa, 272–320. Berlin: De Gruyter, 2016.

Sîrbu and Ştefănescu 2013
Sîrbu, Valeriu, and Radu Ştefănescu, eds. *The Thracians and Their Neighbors in the Bronze and Iron Ages: Proceedings of the 12th International Congress of Thracology, Târgovişte, 10th–14th September 2013*. Vol. 2, *Necropolises, Cult Places, Religion, Mythology*. Braşov: Editura Istros, 2013.

Slater 1999
Slater, Niall W. "The Vase as Ventriloquist: *Kalos*-Inscriptions and the Culture of Fame." In *Signs of Orality: The Oral Tradition and Its Influence in the Greek and Roman World*, edited by E. Anne Mackay, 143–61. Leiden: Brill, 1999.

Slavova and Sharankov 2016
Slavova, Mirena, and Nicolay Sharankov, eds. "Monuments and Texts in Antiquity and Beyond: Essays for the Centenary of Georgi Mihailov (1915–1991)." Special issue, *Studia Classica Serdensia* 5 (2016).

Slawisch 2007
Slawisch, Anja. *Die Grabsteine der römischen Provinz Thracia*. Langenweißbach: Baier & Beran, 2007.

A. C. Smith 2011
Smith, Amy C. *Polis and Personification in Classical Athenian Art*. Leiden: Brill, 2011.

A. H. Smith 1904
Smith, A. H. *A Catalogue of Sculpture in the Department of Greek and Roman Antiquities, British Museum*. Vol. 3. London: Printed by order of the Trustees, 1904.

R. Smith 2015
Smith, R. R. R. "*Eikōn chalkē*: Hellenistic Statue Honors in Bronze." In Daehner and Lapatin 2015, 94–109.

Sourvinou-Inwood 2003
Sourvinou-Inwood, Christiane. *Tragedy and Athenian Religion: Greek Studies*. Lanham, MD: Lexington Books, 2003.

Sparkes and Talcott 1970
Sparkes, Brian A., and Lucy Talcott. *Black and Plain Pottery of the 6th, 5th, and 4th Centuries B.C.* 2 vols. Princeton, NJ: American School of Classical Studies at Athens, 1970.

Spivey 2013
Spivey, Nigel. *Greek Sculpture*. Cambridge: Cambridge University Press, 2013.

Stafford 2000
Stafford, Emma. *Worshipping Virtues: Personification and the Divine in Ancient Greece*. Swansea: Duckworth, 2000.

Stafford 2012
Stafford, Emma. *Herakles*. London: Routledge, 2012.

Stafford and Herrin 2005
Stafford, Emma, and Judith Herrin, eds. *Personification in the Greek World: From Antiquity to Byzantium*. Aldershot, England: Ashgate, 2005.

Stamberova 2023
Stamberova, Miglena. "Silver Hinged Fibulae from Burial 4 C." In G. Ivanov 2023, 21–25.

Stefanova 2018
Stefanova, Morena. "Valchitran Type Disks: Reviewing Some Aspects of Their Interpretation and the Cultural Interconnections in the 2nd Millenium [sic] BC Thrace." In Alexandrov et al. 2018, 223–31.

Stewart 2003
Stewart, Andrew. "Alkamenes at Ephesos and in Athens." *Zeitschrift für Papyrologie und Epigraphik* 143 (2003): 101–3.

Stewart et al. 2021
Stewart, Andrew, et al. "Classical Sculpture from the Athenian Agora, Part 3: The Pediments, Metopes, and Akroteria of the Temple of Ares (Temple of Athena Pallenis)." *Hesperia* 90, no. 3 (July–September 2021): 533–604.

Stolyarik 2001
Stolyarik, Elena. "Scythians in the West Pontic Area: New Numismatic Evidence." *American Journal of Numismatics* 13 (2001): 21–34.

Stos-Gale 2014
Stos-Gale, Zofia Anna. "Silver Vessels in the Mycenaean Shaft Graves and Their Origin in the Context of the Metal Supply in the Bronze Age Aegean." In Meller, Risch, and Pernicka 2014, 183–208.

Stos-Gale and Băjenaru 2020
Stos-Gale, Zofia Anna, and Radu Băjenaru. "The Aegean and the Black Sea Connecting Southeast Europe and Anatolia during the Early Bronze Age: Evidence from Metal Finds in Bulgaria, Greece and Western Turkey." In Maran et al. 2020, 265–86.

Stoyanov 1991
Stoyanov, Totko. "За интерпретацията на каничка No155 от Рогозенското съкровище." *Археология* 4 (1991): 16–34.

Stoyanov 1998
Stoyanov, Totko. "Who Was Buried in the Caryatids' Tomb at Sveshtari?" In "Studia in Honorem Christo M. Danov." Special issue, *Thracia* 12 (1998): 103–7.

Stoyanov 2003
Stoyanov, Totko. "On the Spurs' Development in Thrace, Macedonia and Illyria during the Early Hellenistic Times." In D. Dimitrova 2003, 198–203.

Stoyanov 2004a
Stoyanov, Totko. "Още за ранните контакти на Вътрешна Тракия с Егеида." *Годишник на Департамент "Средиземноморски и източни изследвания"* 2 (2004): 167–74.

Stoyanov 2004b
Stoyanov, Totko. "Панагюрското съкровище—изобразителна програма и принадлежност." In *Панагюрското съкровище и тракийската култура: Доклади от Втори международен симпозиум (Панагюрище, 8–9 декември 1999 г.)*, edited by Daniela Agre and Georgi Kitov, 11–30. Sofia: Fondatsiia "Trakiiska drevnost," 2004.

Stoyanov 2007
Stoyanov, Totko. "Late Classical and Early Hellenistic Pottery Imitations of Metal Tableware from Thrace." In Iakovidou 2007, 561–74.

Stoyanov 2008a
Stoyanov, Totko. "Бележки за въоръжението и снаряжението представени в люнета на царската гробница при Свещари." In *Погребални практики и ритуали: Есенни четения Сборяново*, 5:59–77. Varna: Slavena, 2008.

Stoyanov 2008b
Stoyanov, Totko. "За изобразителната програма на гробницата от Александрово." *Археология* 49, nos. 1–4 (2008): 57–67.

Stoyanov 2008c
Stoyanov, Totko. "За обсадната и отбранителна техника в Ранноелинистическа Тракия." In *Проблеми и изследвания на тракийската култура*, 2:46–63. Kazanlak: Irita, 2008.

Stoyanov 2011
Stoyanov, Totko. "New Evidence of Amphorae Production in Early Hellenistic Mesambria Pontica." In Tzochev, Stoyanov, and Bozkova 2011, 191–201.

Stoyanov 2015a
Stoyanov, Totko. "Warfare." In Valeva, Nankov, and Graninger 2015, 426–42.

Stoyanov 2015b
Stoyanov, Totko. "The White Lotus (*Nelumbo nucifera*) Decorated, Silver Jug from Naip in Local Context." In "I Traci tra geografia e storia," edited by Paola Schirripa. Special issue, *Artistonothos* 9 (2015): 227–48.

Stoyanov 2016
Stoyanov, Totko. "More on the Amphorae Production in Early Hellenistic Mesambria Pontica." In Slavova and Sharankov 2016, 362–70.

Stoyanov 2017
Stoyanov, Totko. "The Toponyms in the Inscriptions from Rogozen and the Historical Geography of Southeastern Thrace in the Classical and the Hellenistic Periods." In *Cities in Southeastern Thrace: Continuity and Transformation*, edited by Daniela Stoyanova, Grigor Boykov, and Ivaylo Lozanov, 19–28. Sofia: St. Kliment Ohridski University Press, 2017.

Stoyanov 2022
Stoyanov, Totko. "Urbanization in Early Hellenistic Thrace: The Case of Getic Capital Helis in North-Eastern Thrace." In Delev et al. 2022, 1:451–59.

Stoyanov and Borislavov 2018
Stoyanov, Totko, and Borislav Borislavov. "The Model of Transition to the Culture of Iron in Thrace." In Alexandrov et al. 2018, 287–97.

Stoyanov, Mikov, and Dhzanfezova 2013
Stoyanov, Totko, Rumen Mikov, and Tanya Dhzanfezova. "Надгробна могила от ранната елинистическа епоха край с. Кабиле, Ямболско." *Bulgarian e-Journal of Archaeology* 3, no. 2 (2013): 245–314. https://be-ja.org/index.php/journal/article/view/be-ja-3-2-2013-245-314/76.

Stoyanov and Stoyanova 2016
Stoyanov, Totko, and Daniela Stoyanova. "Early Tombs of Thrace: Questions of Chronology and the Cultural Context." In Henry and Kelp 2016, 1:313–37.

Stoyanov and Tonkova 2015a
Stoyanov, Totko, and Milena Tonkova. "La nécropole royale thrace de Shipka–Sheynovo–Kran." *Comptes rendus des séances de l'Académie des Inscriptions et Belles-Lettres* 159, no. 2 (2015): 913–43.

Stoyanov and Tonkova 2015b
Stoyanov, Totko, and Milena Tonkova. "Les nécropoles aristocratiques de la vallée de Kazanlak." In Martinez et al. 2015, 116–17.

Stoyanov et al. 2005
Stoyanov, Totko, et al., eds. *Heros Hephaistos: Studia in Honorem Liubae Ognenova-Marinova*. Veliko Tarnovo: Faber, 2005.

D. Stoyanova 2007
Stoyanova, Daniela. "The Greek Door in the Tomb Architecture of Macedonia, Thrace and Asia Minor." In *Ancient Macedonia VII: Macedonia from the Iron Age to the Death of Philip II*, 531–50. Thessaloniki: Institute for Balkan Studies, 2007.

D. Stoyanova 2008
Stoyanova, Daniela. "Строителна керамика и архитектурна теракота от Одесос." In *Нумизматични, сфрагистични и епиграфски приноси към историята на черноморското крайбрежие: Международна конференция в памет на ст. н. с. Милко Мирчев, Варна, 15–17 септември 2005 г.*, 215–46. Varna: Zograf, 2008.

D. Stoyanova 2015
Stoyanova, Daniela. "Tomb Architecture." In Valeva, Nankov, and Graninger 2015, 158–79.

D. Stoyanova 2022
Stoyanova, Daniela. *Строителна керамика и архитектурна теракота от Аполония Понтика (VI в. пр. Хр.–III в. пр. Хр.).* Sofia: Universitetsko izdatelstvo "Sv. Kliment Ohridski," 2022.

D. Stoyanova and Damyanov 2021
Stoyanova, Daniela, and Margarit Damyanov. "Late Archaic and Early Classical Monumental Architecture on the Island of St. Kirik, Apollonia Pontike." In *Environment and Habitation around the Ancient Black Sea*, edited by David Braund, Vladimir F. Stolba, and Ulrike Peter, 7–38. Berlin: De Gruyter, 2021.

D. Stoyanova and Manetta 2019
Stoyanova, Daniela, and Consuelo Manetta. "Каменните акротерии от саркофаговидната камера в могила Оструша." *Проблеми и изследвания на тракийската култура* 9 (2019): 108–20.

D. Stoyanova and Tzochev 2016
Stoyanova, Daniela, and Chavdar Tzochev. "The Tomb with the Panthers in Zhaba Mogila, Strelcha: Preliminary Observations." *Proceedings of the National Museum of History* 28 (2016): 99–122.

G. Stoyanova 2015
Stoyanova, Galina. "'Богати гробни комплекси' на воини-конници от началото на IV–до средата на III в. пр. Хр. в Южна Тракия." In "Филови четения: Културно-историческото наследство—проучване и опазване; Доклади от докторантска конференция 15–16 декември 2014 г.," edited by Maria Gurova, Kostadin Rabadjiev, and Totko Stoyanov. Supplement. *Bulgarian e-Journal of Archaeology* 4 (2015): 109–30. https://be-ja.org/index.php/supplements/article/view/21/14.

Stoychev 2020
Stoychev, Ruslan. "Ловецът върху апликациите от Луковит: Към проблема за иконографията на конника в Тракия след смъртта на Александър Велики." *Проблеми и изследвания на тракийската култура* 10 (2020): 56–81.

Van Straten 1995
Van Straten, F. T. *Hierà kalá: Images of Animal Sacrifice in Archaic and Classical Greece*. Leiden: Brill, 1995.

Strong 1966
Strong, David. *Greek and Roman Gold and Silver Plate*. London: Thames & Hudson, 1966.

Summerer 2003
Summerer, Lâtife. "Achämenidische Silberfunde aus der Umgebung von Sinope." *Ancient Civilizations from Scythia to Siberia* 9 (2003): 17–42.

Suvandzhiev 2023
Suvandzhiev, Ivan. *Преходният период между енеолита и бронзовата епоха в България*. Veliko Tarnovo: Faber, 2023.

Syll.³
Dittenberger, Wilhelm, ed. *Sylloge Inscriptionum Graecarum*. 3rd ed. 4 vols. Leipzig: Hirzel, 1915–24.

Tacheva 1971
Tacheva-Hitova [Tacheva], Margarita. "Извори за военното дело на траките." *Военноисторически сборник* 1 (1971): 51–63.

Tacheva 1987
Tacheva, Margarita. "Археологически данни за датиране на Рогозенското съкровище: Проблеми и становища." *Археология* 29, по. 4 (1987): 1–11.

Tacheva 1992
Tačeva [Tacheva], Margarita. "On the Problems of the Coinages of Alexander I Sparadokos and the So-Called Thracian-Macedonian Tribes." *Historia* 41, no. 1 (1992): 58–74.

Tacheva 1994
Tacheva, Margarita. "Надгробните могили при Дуванлий в Пловдивско—родов некропол на одриската династия на Терес (5.–4. в.)." In Kitov et al. 1994, 1:145–48.

Tacheva 1997
Tacheva, Margarita. *История на българските земи в древността през елинистическата и римската епоха*. 2nd ed. Sofia: Universitetsko izdatelstvo "Sv. Kliment Ohridski," 1997.

Tacheva 1998
Tatscheva [Tacheva], Margarita. "ΓΕΤΑΣ ΗΔΟΝΕΟΝ ΒΑΣΙΛΕΥΣ." In *Stephanos Nomismatikos: Edith Schönert-Geiss zum 65. Geburtstag*, edited by Ulrike Peter, 613–26. Berlin: Akademie, 1998.

Tacheva 2006
Tacheva, Margarita. *Царете на Древна Тракия*. Sofia: Agato, 2006.

Teleaga 2008
Teleaga, Emilian. *Griechische Importe in den Nekropolen an der unteren Donau, 6. Jh.–Anfang des 3. Jhs. v. Chr.* Rahden, Germany: Verlag Marie Leidorf, 2008.

Teleaga 2014a
Teleaga, Emilian. "Neue Untersuchungen zu der Kragkuppelkonstruktion der frühhellenistischen Zeit unter der Žaba-Mogila." *CAЁTE ARA (Architectură, Restaurare, Archeologie)* 5 (2014): 55–86.

Teleaga 2014b
Teleaga, Emilian. "Vorbericht über die Untersuchungen des Wagengrabes in einer Kragkuppelkonstruktion der frühhellenistischen Zeit unter der Žaba Mogila (bei Strelča, Zentralbulgarien)." *Archaeologia Bulgarica* 18, no. 2 (2014): 19–51.

Teleaga 2020
Teleaga, Emilian. *Studien zu den thrakischen Prunkgräbern des 4. Jhs. v. Chr.* Vol. 1, *Agighiol und Peretu (Rumänien)*. Rahden, Germany: Verlag Marie Leidorf, 2020.

Themelis and Touratsoglou 1997
Themelis, Petros, and Ioannis Touratsoglou. *Οι τάφοι του Δερβενίου*. Athens: Tameio Archaiologikōn Porōn kai Apallotriōseōn, 1997.

Tilia 1972
Tilia, Ann Britt. *Studies and Restorations at Persepolis and Other Sites of Fārs*. Vol. 1. Rome: Istituto Italiano per il Medeo ed Estremo Oriente, 1972.

Tiverios 1991
Tiverios, Michalis. "Ikonographie und Geschichte (Überlegungen anlässlich einer Abbildung des Strymon im Garten der Hesperiden)." *Athenische Mitteilungen* 106 (1991): 129–36.

Tiverios 2008
Tiverios, Michalis. "Greek Colonisation of the Northern Aegean." In *Greek Colonisation: An Account of Greek Colonies and Other Settlements Overseas*, edited by Gocha R. Tsetskhladze, 2:1–154. Leiden: Brill, 2008.

Tiverios 2019
Tiverios, Michalis. "Αττικά αγγεία (πήλινα και μεταλλικά) στην αρχαία Θράκη: Η παράμετρος της εικονογραφίας τους και το εργαστήριο του Ζωγράφου της Ερέτριας." In *Classical Pottery of the Northern Aegean and Its Periphery (480–323/300 BC): Proceedings of the International Archaeological Conference, Thessaloniki, May 17–20, 2017*, edited by Eleni Manakidou and Amalia Avramidou, 189–206. Thessaloniki: University Studio Press, 2019.

Tiverios 2023
Tiverios, Michalis. "Από την εικονογραφία του αττικού Κεραμεικού στα χρόνια του Κίμωνα." In *Έτος ήλθε περιπλομένων ενιαυτών εκατοστόν: Τιμητικός τόμος για τον καθηγητή-Ακαδημαϊκό*, edited by A. Mavroudis and A. Rengakos, 151–84. Athens: N. Ch. Konomí, 2023.

I. Todorov 2008
Todorov, Ivan. "Златен пръстен с желязно покритие от Рачева могила в околностите на град Мъглиж, Старозагорско." In *Phosphorion: Studia in Honorem Mariae Čičikova*, edited by Diana Gergova, 219–24. Sofia: Akademichno izdatelstvo "Prof. Marin Drinov," 2008.

Y. Todorov 1933
Todorov, Yanko. "Тракийските царе." *Годишник на Софийския университет, Историко-филологически факултет* 29, по. 7 (1933): 1–80.

Todorova 1993
Todorova, Henrieta. "Klima und Strandverschiebungen in der postglazialen Zeit Bulgariens." In *The Fourth Millennium B.C.: Proceedings of the International Symposium, Nessebar, 28–30 August 1992*, edited by Petya Georgieva, 77–81. Sofia: New Bulgarian University, 1993.

Todorova 1999
Todorova, Henrieta. "Die Anfänge der Metallurgie an der westlichen Schwarzmeerküste." In *The Beginnings of Metallurgy: Proceedings of the International Conference, Bochum 1995*, edited by Andreas Hauptmann et al., 237–46. Bochum: Dt. Bergbau-Museum, 1999.

Tonkova 1997
Tonkova, Milena. "Traditions and Aegean Influences on the Jewellery of Thrace in Early Hellenistic Times." *Archaeologia Bulgarica* 1, no. 2 (1997): 18–31.

Tonkova 2000–2001
Tonkova, Milena. "Classical Jewellery in Thrace: Origins and Development, Archaeological Contexts." *Talanta* 32–33 (2000–2001): 277–88.

Tonkova 2003
Tonkova, Milena. "Произведения на тракийската ювелирна школа от втората половина на IV в. пр. Хр." In D. Dimitrova 2003, 216–25.

Tonkova 2005
Tonkova, Milena. "Изображения на накити върху каничките-ритони с женски глави от Панагюрското съкровище." In Stoyanov et al. 2005, 262–75.

Tonkova 2010
Tonkova, Milena. "Les parures d'harnachement en or de Thrace et l'orfèvrerie de la haute époque hellénistique." Special issue, *Bollettino di archeologia on line*, C/C10/4, no. 1 (2010): 44–63.

Tonkova 2013
Tonkova, Milena. "Gold Wreaths from Thrace." In Sîrbu and Ștefănescu 2013, 413–45.

Tonkova 2015
Tonkova, Milena. "Adornments." In Valeva, Nankov, and Graninger 2015, 212–28.

Tonkova 2017
Tonkova, Milena. "Silver in the Jewelry Sets in Thrace." In *Среброто на траките / The Silver of the Thracians*, edited by Margarit Damyanov, 16–24. Exh. cat. Sofia: National Archaeological Institute with Museum, 2017.

Tonkova 2023
Tonkova, Milena. "Gold, Silver and Bronze Ornaments from Burial 4D." In G. Ivanov 2023, 27–44.

Topalilov 2018
Topalilov, Ivo. "Върху един феномен от градския живот в Тракия през IV век." *Thracia* 23 (2018): 217–30.

Topalilov 2020
Topalilov, Ivo. "On the Perinthos-Heraklea 37." *Studia Antiqua et Archaeologica* 26, no. 1 (2020): 59–68.

Topalov 1994
Topalov, Stavri. *The Odrysian Kingdom from the Late 5th to the Mid-4th C. B.C.: Contributions to the Study of Its Coinage and History.* Sofia: Nasko, 1994.

Topper 2015
Topper, Kathryn R. "Dionysos Comes to Thrace: The Metaphor of Corrupted Sacrifice and the Introduction of Dionysian Cult in Images of Lykourgos's Madness." *Arethusa* 48 (2015): 139–71.

Torbov 1998
Torbov, Nartsis. "Spurs from the 2nd Century BC–1st Century AD Found in Northwestern Bulgaria." *Archaeologia Bulgarica* 2, no. 1 (1998): 54–63.

Torbov 2005
Torbov, Nartsis. *Могиланската могила във Враца.* Vratsa: Mayobo, 2005.

Torbov 2012
Torbov, Nartsis. "Съкровището от Галиче." In Rabadjiev et al. 2012, 725–37.

Torbov 2015
Torbov, Nartsis. "Le tumulus Mogui-lanska Moguila." In Martinez et al. 2015, 271–87.

Torbov 2016
Torbov, Nartsis. *Антично въоръжение: От камъка до барута.* Plovdiv: Ton, 2016.

Touloumdzidou 2011
Touloumdzidou, Annareta. "Μεταλλινα αγγεια του 4ου–2ου αι. π.Χ. απο τον Ελλαδικο χωρο: Διδακτορικη διατριβη." PhD diss., Aristotle University of Thessaloniki, 2011.

Treister 2022
Treister, Mikhail. "Some Reflections Concerning the Phiale with the Images of Heracles and Auge from the Rogozen Treasure." *Материалы по археологии и истории античного и средневекового Причерноморья*, no. S1 (2022): 9–37.

Treister 2023
Treister, Mikhail. "A Treasure of the Late Hellenistic Phalerae from the Vicinities of Taganrog (1897): New Data." In *Изкуство и памет: Сборник в чест на 80-годишнината на Иван Маразов*, edited by Oksana Minaeva and Irena Bokova, 229–54. Sofia: Nov bŭlgarski universitet, 2023.

Trofimova 2007
Trofimova, Anna A., ed. *Greeks on the Black Sea: Ancient Art from the Hermitage.* Exh. cat. Los Angeles: J. Paul Getty Museum, 2007.

Trohani 2013
Trohani, George. "Tesaurul de la Agigiol, com. Valea Nucarilor, jud. Tulcea." In *Aurul și Argintul Antic al României,* edited by Rodica Oanța-Marghitu, 253–59. Exh. cat. Bucharest: Muzeul Național de Istorie a României, 2013.

True 1995
True, Marion. "The Murder of Rhesos on a Chalcidian Neck-Amphora by the Inscription Painter." In *The Ages of Homer: A Tribute to Emily Townsend Vermeule,* edited by Jane B. Carter and Sarah P. Morris, 415–29. Austin: University of Texas Press, 1995.

True 1997
True, Marion. "Rhesos." In *Lexicon Iconographicum Mythologiae Classicae.* Vol. 8, pt. 1, 1044–47. Zurich: Artemis, 1997.

True et al. 2004
True, Marion, et al. "Greek Processions." In *Thesaurus Cultus et Rituum Antiquorum (ThesCRA),* 1:1–20. Los Angeles: J. Paul Getty Museum; Basel: Fondation pour Le Lexicon Iconographicum Mythologiae Classicae, 2004.

Tsatsopoulou-Kaloudi 2015
Tsatsopoulou-Kaloudi, Polyxeni. "Εισαγωγή." In Tsatsopoulou-Kaloudi et al. 2015, 16–112.

Tsatsopoulou-Kaloudi and Kaloudis 2015
Tsatsopoulou-Kaloudi, Polyxeni, and Konstantinos Kaloudis. "Το ιερό του Απόλλωνα στη Ζώνη." In Tsatsopoulou-Kaloudi et al. 2015, 113–208.

Tsatsopoulou-Kaloudi et al. 2015
Tsatsopoulou-Kaloudi, Polyxeni, et al. *Αρχαία Ζώνη*, Vol. 1, *Το ιερό του Απόλλωνα.* Komotini: Hellenic Ministry of Culture and Sports–Ephorate of Antiquities of Evros, Region of Eastern Macedonia–Thrace, 2015.

Tsetskhladze, Avram, and Hargrave 2021
Tsetskhladze, Gocha R., Alexandru Avram, and James Hargrave, eds. *The Greeks and Romans in the Black Sea and the Importance of the Pontic Region for the Graeco-Roman World (7th Century BC–5th Century AD): 20 Years On (1997–2017); Proceedings of the Sixth International Congress on Black Sea Antiquities (Constanța–18–22 September 2017).* Oxford: Archeopress Archaeology, 2021.

Tsiafaki 1998
Tsiafaki, Despoina. *Η Θράκη στην αττική εικονογραφία του 5ου αι. π.Χ: Προσεγγίσεις στις σχέσεις Αθήνας και Θράκης.* Komotini: Morfotikos Omilos Komotinis–Kentro Thrakikon Meleton, 1998.

Tsiafaki 2000
Tsiafakis [Tsiafaki], Despoina. "The Allure and Repulsion of Thracians in the Art of Classical Athens." In Cohen 2000, 364–89.

Tsiafaki 2015
Tsiafakis [Tsiafaki], Despoina. "Thracian Tattoos." In *Bodies in Transition: Dissolving the Boundaries of Embodied Knowledge,* edited by Dietrich Boschung, Alan Shapiro, and Frank Wascheck, 89–118. Paderborn: Wilhelm Fink, 2015.

Tsiafaki 2016a
Tsiafaki, Despoina. "Ancient Thrace and the Thracians through Athenian Eyes." *Thracia* 21 (2016): 261–82.

Tsiafaki 2016b
Tsiafaki, Despoina. "Ο Φινέας στην αττική αγγειογραφία." In *Ἠχάδιν: Τιμητικός τόμος για τη Στέλλα Δρούγου,* edited by Mimika Giannopoulou and Chrysanthi Kallini, 2:726–40. Athens: Tameio Archaiologikōn Porōn kai Apallotriōseōn, 2016.

Tsiafaki 2020
Tsiafaki, Despoina. "The Northern Aegean." In *A Companion to Greeks across the Ancient World*, edited by Franco De Angelis, 409–30. Hoboken, NJ: Wiley-Blackwell, 2020.

Tsiafaki 2021
Tsiafaki, Despoina. "Thracian Warriors Linking(?) Greeks and Thracians." In *Griechische Vasen als Medium für Kommunikation: Ausgewählte Aspekte; Akten des internationalen Symposions im Kunsthistorischen Museum Wien, 5.–7. Oktober 2017*, edited by Claudia Lang-Auinger and Elisabeth Trinkl, 249–61. Vienna: Verlag der Österreichischen Akademie der Wissenschaften, 2021.

Tsiafaki 2022
Tsiafaki, Despoina. "Exploring the Reality through Myths and Archaeological Evidence." In Delev et al. 2022, 2:343–48.

Tsiafaki et al. 2022
Tsiafaki, Despoina, et al., eds. *AtticPOT: Αττική γραπτή κεραμική στην αρχαία Θράκη (6ος–4ος αι. π.Χ.); Νέες προσεγγίσεις και ψηφιακά εργαλεία / Attic Painted Pottery in Ancient Thrace (6th–4th Century BC); New Approaches and Digital Tools.* Xanthi: Athena Research and Innovation Center in Information, Communication and Knowledge Technologies, 2022.

Tsintsov 2005
Tsintsov, Zdravko. "Gold Artefacts from the Alluvial Sediments of Bulgaria—Indicator for Gold Mining and Metallurgy during the Bronze Age." *Review of the Bulgarian Geological Society* 66 (2005): 217–20.

Tsintsov 2018
Tsintsov, Zdravko. "The Long Guarded 'Precious' Secrets from the Alluvial Sediments: The Placer Gold in Present-Day Bulgaria." In Alexandrov et al. 2018, 59–69.

Tzamalis 2012
Tzamalis, Alexandros Reginald. "Les *ethné* de la région 'Thraco-Macédonienne': Étude d'histoire et de numismatique (fin du VIᵉ–Vᵉ siècle)." PhD diss., Université Paris IV–Sorbonne, 2012.

Tzochev 2009
Tzochev, Chavdar. "Notes on the Thasian Amphora Stamps Chronology." *Archaeologia Bulgarica* 13, no. 1 (2009): 55–72.

Tzochev 2011a
Tzochev, Chavdar. "Archaic Amphora Import from Thracian Sites around the Bay of Burgas." In Tzochev, Stoyanov, and Bozkova 2011, 73–86.

Tzochev 2011b
Tzochev, Chavdar. "The Date of the Tholos Tomb in Chetinyova Tumulus, Starosel." *Archaeologia Bulgarica* 15, no. 1 (2011): 13–19.

Tzochev 2014
Tzochev, Chavdar. "The Hellenistic Tomb of Mal Tepe in Thrace: A Reconsideration of Burial Sequence and Dating." *Ancient West and East* 13 (2014): 49–62.

Tzochev 2016a
Tzochev, Chavdar. "Accounts from the Treasury of Seuthes III: Inscribed Silver Plate Found in the Tomb of the Golyama Kosmatka Mound." *Hesperia* 85 (2016): 779–94.

Tzochev 2016b
Tzochev, Chavdar. *Amphora Stamps from Thasos.* Princeton, NJ: American School of Classical Studies at Athens, 2016.

Tzochev 2021a
Tzochev, Chavdar. "The Architecture of the 4th Century B.C. Monumental Tomb at Starosel." *Archäologischer Anzeiger* 2 (2021): 97–167.

Tzochev 2021b
Tzochev, Chavdar. "A Slight Change of Plan: Setting Lines as Evidence for the Building Process of the 4th Century BC Tomb at Starosel." *Bulletin de correspondance hellénique* 145 (2021): 65–86.

Tzochev, Stoyanov, and Bozkova 2011
Tzochev, Chavdar, Totko Stoyanov, and Anelia Bozkova, eds. *PATABS II: Production and Trade of Amphorae in the Black Sea; Acts of the International Round Table Held in Kiten, Nessebar and Sredetz, September 26–30, 2007.* Sofia: National Archaeological Institute with Museum–Bulgarian Academy of Sciences and St. Kliment Ohridski University, 2011.

Tzvetkova 2007
Tzvetkova, Julia. "'The War over the Chersonese': Zur Chronologie und Periodisierung des athenisch-odrysischen Konflikts um die Thrakische Chersones." In Iakovidou 2007, 657–68.

Tzvetkova 2016
Tzvetkova, Julia. "Земите на Месад." *Thracia* 21 (2016): 17–29.

Tzvetkova 2018a
Tzvetkova, Julia. *ГИС и тракология: Приложения на Географските информационни системи в изследванията на тракийската история.* Sofia: Universitetsko izdatelstvo "Sv. Kliment Ohridski," 2018.

Tzvetkova 2018b
Tzvetkova, Julia. "Одриси и перси: Политически взаимоотношения по времето на Котис I (384–360 г. пр. Хр.)." In *Society, Kings, Gods: In Memoriam Professoris Margaritae Tachevae*, edited by Dilyana Boteva-Boyanova, Peter Delev, and Julia Tzvetkova, 63–68. Sofia: Universitetsko izdatelstvo "Sv. Kliment Ohridski," 2018.

Unger 1987
Unger, Heinz J. "Das Pangaion, ein altes Bergbauzentrum in Ostmakedonien." *Prähistorische Zeitschrift* 62 (1987): 87–112.

Ustinova 2001
Ustinova, Yulia. "Apollo Iatros: A Greek God of Pontic Origin." In *Griechen und ihre Nachbarn am Nordrand des Schwarzen Meers*, edited by Klaus Stähler and Gabriele Gudrian, 245–99. Münster: Ugarit-Verlag, 2001.

Vachtina 2007
Vachtina, Marina. "Greek Archaic Orientalising Pottery from the Barbarian Sites of the Forest-Steppe Zone of the Northern Black Sea Coastal Region." In *The Black Sea in Antiquity: Regional and Interregional Economic Exchanges*, edited by Vincent Gabrielsen and John Lund, 23–37. Aarhus: Aarhus University Press, 2007.

Vagalinski 2010
Vagalinski, Lyudmil F., ed. *In Search of Celtic Tylis in Thrace (III c. BC).* Sofia: NOUS, 2010.

Valchev 2015
Valchev, Ivan. *Извънградските светилища в римската провинция Тракия.* Sofia: Universitetsko izdatelstvo "Sv. Kliment Ohridski," 2015.

Valeva 1992
Valeva, Julia. "Изображения на шлемове и каузия в Казанлъшката гробница." *Проблеми на изкуството* 2 (1992): 19–26.

Valeva 2005
Valeva, Julia. *The Painted Coffers of the Ostrusha Tomb.* Sofia: Bŭlgarski hudozhnik, 2005.

Valeva 2015
Valeva, Julia. "Gold, Silver, and Bronze Vessels." In Valeva, Nankov, and Graninger 2015, 197–211.

Valeva 2023
Valeva, Julia. "La scène du banquet dans le tombeau Thrace d'Alexandrovo." In *Regards croisés sur le décor antique: Hommages à Nicole Blanc et Hélène Eristov*, edited by Alexandra Dardenay et al., 247–51. Paris: Hermann, 2023.

Valeva, Nankov, and Graninger 2015
Valeva, Julia, Emil Nankov, and Denver Graninger, eds. *A Companion to Ancient Thrace.* Malden, MA: Wiley Blackwell, 2015.

Varbanova 1994
Varbanova, Maya. "За тройния съд и двата големи диска от Вълчитрънското съкровище." *Археология* 36, nos. 3–4 (1994): 25–29.

Vasić 1999
Vasić, Rastko. *Die Fibeln im Zentralbalkan: Vojvodina, Serbien, Kosovo und Mazedonien.* Stuttgart: Franz Steiner, 1999.

M. Vasilev 2021
Vasilev, Miroslav Ivanov. "The Inhospitable and Dangerous Salmydessus." In Tsetskhladze, Avram, and Hargrave 2021, 662–82.

V. Vasilev 1979
Vasilev, Vasil. "Шлемът от Върбица, Преславско, и шлемовете халкидски тип в Тракия." *Векове* 8, no. 6 (1979): 65–71.

V. Vasilev 1989
Vasilev, Vasil. "Тракийска бронзова пластика." *Изкуство* 8 (1989): 20–24.

Vasileva and Minkov 2018
Vasileva, Zheni, and Petar Minkov. "Cultural Influences and Long-Distance Contacts during the 3rd Millennium BC." In Alexandrov et al. 2018, 97–103.

Vassileva 2010
Vassileva, Maya. "Achaemenid Interfaces: Thracian and Anatolian Representations of the Elite Status." In "Roma 2008—International Congress of Classical Archaeology: Meetings between Cultures in the Ancient Mediterranean." Special issue, *Bollettino di archeologia on line*, G/G1/4 (2010): 37–46.

Vassileva 2015
Vassileva, Maya. "Persia." In Valeva, Nankov, and Graninger 2015, 320–36.

Vassileva 2018
Vassileva, Maya. "Late Bronze Age Scepter-Maces." In Alexandrov et al. 2018, 253–63.

Vavelidis and Andreou 2008
Vavelidis, Michail, and Stylianos Andreou. "Gold and Gold Working in Late Bronze Age Northern Greece." *Naturwissenschaften* 95, no. 4 (2008): 361–66.

Velkov 1991
Velkov, Velizar. "Надписи от Кабиле." In *Кабиле*, edited by Velizar Velkov, 2:7–53. Sofia: Izdatelstvo na Bǔlgarskata akademiia na naukite, 1991.

Velkov 2005
Velkov, Velizar. "Inscriptions antiques de Messambria (1964–1984)." In *Nessèbre*, vol. 3, edited by Velizar Velkov, 159–93. Burgas: Spring, 2005.

Velkov and Domaradzka 1994
Velkov, Velizar, and Lidia Domaradzka. "Kotys I (383/382–359 av. J.-C.) et l'emporion Pistiros de Thrace." *Bulletin de correspondance hellénique* 118 (1994): 1–15.

Velkov and Fol 1977
Velkov, Velizar, and Alexander Fol. *Les Thraces en Égypte gréco-romaine.* Sofia: Academia Litterarum Bulgarica, Institutum Thracicum, 1977.

Venedikov 1948
Venedikov, Ivan. "Разкопките в некропола на Аполония през 1946 г." In *Разкопки и проучвания*. Vol. 2, *Аполония на Черно море*, 7–27. Sofia: Dǔrzhavna pechatnitsa, 1948.

Venedikov 1958
Venedikov, Ivan. "Sur la date et l'origine du trésor de Panagurichte." *Acta Antiqua Academiae Hungaricae* 6, nos. 1–2 (1958): 67–86.

Venedikov 1960
Venedikov, Ivan. *Тракийската колесница.* Sofia: Izdatelstvo na Bǔlgarskata akademiia na naukite, 1960.

Venedikov 1961
Venedikov, Ivan. *Le trésor de Panagurichte.* Sofia: Balgarski Houdojnik, 1961.

Venedikov 1963
Venedikov, Ivan, ed. *Аполония: Разкопките в некропола на Аполония през 1947–1949 г.* Sofia: Bǔlgarska akademiia na naukite, 1963.

Venedikov 1964
Venedikov, Ivan. "Находката от Старо село, Сливенско." *Известия на Археологическия институт* 27 (1964): 77–109.

Venedikov 1966
Venedikov, Ivan. "Новооткрито тракийско могилно погребение във Враца." *Археология* 8, no. 1 (1966): 7–15.

Venedikov 1974
Venedikov, Ivan. *Съкровището от Летница.* Sofia: Bǔlgarski hudozhnik, 1974.

Venedikov 1980
Venedikov, Ivan. "L'inscription de Sadala." *Epigraphica* 42 (1980): 7–12.

Venedikov 1987
Venedikov, Ivan. *The Vulchetrun Treasure.* Sofia: Svyat, 1987.

Venedikov 1996
Venedikov, Ivan. *Тракийското съкровище от Летница.* Sofia: Universitetsko izdatelstvo "Sv. Kliment Ohridski," 1996.

Venedikov and Gerasimov 1973
Venedikov, Ivan, and Todor Gerasimov. *Тракийското изкуство.* Sofia: Bǔlgarski hudozhnik, 1973.

Venedikov and Gerasimov 1975
Venedikov, Ivan, and Todor Gerassimov [Gerasimov]. *Thracian Art Treasures.* Sofia: Bulgarski Houdozhnik; London: Caxton, 1975.

Verdelis 1951
Verdelis, Nikolaos M. "Χαλκη Τεφροδοχος Καλπις εκ Φαρσαλων." *Αρχαιολογικη Εφεμερις* (1951): 80–105.

Vickers 1989
Vickers, Michael. "Panagyurishte, Dalboki, Lukovit and Rogozen: Questions of Metrology and Status." In B. Cook 1989, 101–11.

Vickers 1991
Vickers, Michael. "Persian, Thracian and Greek Gold and Silver: Questions of Metrology." In *Achaemenid History VI: Asia Minor and Egypt; Old Cultures in a New Empire. Proceedings of the Groningen 1988 Achaemenid History Workshop*, edited by Heleen Sancisi-Wedenburg and Amélie Kuhrt, 31–39. Leiden: Nederlands Instituut voor het Nabije Oosten, 1991.

Vickers 2000
Vickers, Michael. "Lapidary Shock: Meditations on an Achaemenid Silver Beaker 'from Erzerum' in the Ashmolean Museum, Oxford." *Archäologische Mitteilungen aus Iran und Turan* 32 (2000): 261–73.

Vickers 2002
Vickers, Michael. *Scythian and Thracian Antiquities in Oxford.* Oxford: Ashmolean Museum, 2002.

Vickers and Gill 1994
Vickers, Michael, and David Gill. *Artful Crafts: Ancient Greek Silverware and Pottery.* Oxford: Clarendon Press; New York: Oxford University Press, 1994.

Vickers, Impey, and Allan 1986
Vickers, Michael, Oliver Impey, and James Allan. *From Silver to Ceramic: The Potter's Debt to Metalwork in the Graeco-Roman, Oriental and Islamic Worlds.* Oxford: Ashmolean Museum, 1986.

Vivliodetis 2019
Vivliodetis, Evangelos. *Corpus Vasorum Antiquorum: Greece 15, Athens, National Archaeological Museum, 8; Attic Black and Red-Figure Pyxides.* Athens: Academy of Athens, 2019.

Vladimirova-Paunova 2005
Vladimirova-Paunova, Vasilka. "Pars pro toto: За пет апликации от конска сбруя и още нещо." In Rabadjiev 2005b, 102–15.

Vlassopoulos 2013
Vlassopoulos, Kostas. *Greeks and Barbarians.* Cambridge: Cambridge University Press, 2013.

Vokotopoulou et al. 1985
Vokotopoulou, Ioulia, et al. *Σίνδος: Κατάλογος της έκθεσης.* Athens: Tameio Archaiologikōn Porōn kai Apallotriōseōn, 1985.

Von Bothmer 1962
Von Bothmer, Dietrich. "A Gold Libation Bowl." *Metropolitan Museum of Art Bulletin*, n.s., 21, no. 4 (1962): 154–66.

Vos 1963
Vos, M. F. *Scythian Archers in Archaic Attic Vase-Painting.* Groningen: J. B. Wolters, 1963.

Vulpe and Mihăilescu-Bîrliba 1985
Vulpe, Alexandru, and Virgil Mihăilescu-Bîrliba. "Der Goldschatz von Rădeni, Jud Neamţ, in der Westmoldau, Rumänien." *Prähistorische Zeitschrift* 60 (1985): 47–69.

Walbank 1981
Walbank, F. W. "Prelude to Spartacus: The Romans in Southern Thrace, 150–70 B.C." In *Spartacus: Symposium Rebus Spartaci Gestis Dedicatum 2050 A.*, edited by Christo M. Danov and Alexander Fol, 14–27. Sofia: Éditions de l'Académie bulgare des sciences, 1981.

Walker 1995
Walker, Henry J. *Theseus and Athens.* Oxford: Oxford University Press, 1995.

Wartenberg 2015
Wartenberg, Ute. "Thraco-Macedonian Bullion Coinage in the Fifth Century BC: The Case of Ichnai." In *ΚΑΙΡΟΣ: Contributions to Numismatics in Honor of Basil Demetriadi,* edited by Ute Wartenberg and Michel Amandry, 347–64. New York: American Numismatic Society, 2015.

Wartenberg 2021
Wartenberg, Ute. "Thracian Identity and Coinage in the Archaic and Classical Period." In *Thrace: Local Coinage and Regional Identity*, edited by Ulrike Peter and Vladimir F. Stolba, 45–59. Berlin: Edition Topoi, 2021.

Waywell 1986
Waywell, Geoffrey B. *The Lever and Hope Sculptures: Ancient Sculptures in the Lady Lever Art Gallery, Port Sunlight and a Catalogue of the Ancient Sculptures Formerly in the Hope Collection, London and Deepdene.* Berlin: Mann, 1986.

Webb 1996
Webb, Pamela. *Hellenistic Architectural Sculpture: Figural Motifs in Western Anatolia and the Aegean Islands.* Madison: University of Wisconsin Press, 1996.

Webber 2011
Webber, Christopher. *The Gods of Battle: The Thracians at War 1500 BC–150 AD.* Barnsley, England: Pen and Sword Military, 2011.

West 1983
West, M. L. *The Orphic Poems.* Oxford: Clarendon Press; New York: Oxford University Press, 1983.

Williams 1991
Williams, Dyfri. "The Invention of the Red-Figure Technique and the Race between Vase-Painting and Free Painting." In *Looking at Greek Vases*, edited by Tom Rasmussen and Nigel Spivey, 101–31. Cambridge: Cambridge University Press, 1991.

Williams and Ogden 1994
Williams, Dyfri, and Jack Ogden. *Greek Gold: Jewelry of the Classical World.* Exh. cat. New York: Abrams, 1994.

Winkler 1990
Winkler, John J. "Phallos Politikos: Representing the Body Politic in Athens." In "Sexuality in Greek and Roman Society," edited by David Konstan and Martha Nussbaum. Special issue, *Differences* 2, no. 1 (1990): 29–45.

Wohl 1999
Wohl, Victoria. "The Eros of Alcibiades." *Classical Antiquity* 18, no. 2 (1999): 349–85.

Woudhuizen 2000–2001
Woudhuizen, Fred C. "The Earliest Inscription from Thrace." *Talanta* 32–33 (2000–2001): 289–305.

Wrede 1981
Wrede, Henning. *Consecratio in Formam Deorum: Vergöttlichte Privatpersonen in der römischen Kaiserzeit.* Mainz: Philipp von Zabern, 1981.

Yalçın, Pulak, and Slotta 2005
Yalçın, Ünsal, Cemal Pulak, and Rainer Slotta, eds. *Das Schiff von Uluburun: Welthandel vor 3000 Jahren; Katalog der Ausstellung des Deutschen Bergbau-Museums Bochum vom 15. Juli 2005 bis 16. Juli 2006.* Bochum: Deutsches Bergbau-Museum, 2005.

Yordanov 2007
Yordanov, Kiril. Йорданов, Кирил. "Одриският династичен дом през IV в. пр. Хр." *Нумизматика, епиграфика и сфрагистика* 3, no. 2 (2007): 179–86.

Yurukova 1976
Youroukova [Yurukova], Yordanka. *Coins of the Ancient Thracians.* Translated by V. Athanassov. Oxford: British Archaeological Reports, 1976.

Yurukova 1992
Yurukova, Yordanka. *Монетите на тракийските племена и владетели.* Vol. 1 of *Монетни съкровища от българските земи.* Sofia: Petŭr Beron, 1992.

Zacharia 2001
Zacharia, Katerina. "'The Rock of the Nightingale': Kinship Diplomacy and Sophocles' *Tereus*." In *Homer, Tragedy and Beyond: Essays in Greek Literature in Honour of P. E. Easterling*, edited by Felix Budelmann and Pantelis Michelakis, 91–112. London: Society for the Promotion of Hellenic Studies, 2001.

Zahrnt 2015
Zahrnt, Michael. "Early History of Thrace to the Murder of Kotys I (360 BCE)." In Valeva, Nankov, and Graninger 2015, 35–47.

Zavatin-Coman 1972
Zavatin-Coman, Elena. "La tombe grecque avec kalpis de Mangalia." *Dacia*, n.s., 16 (1972): 271–80.

Zazoff 1998
Zazoff, Peter. "Mythos oder ritual? Zum Amphora-rhyton von Panagjuriste." *Pulpudeva* 6, suppl. 1 (1998): 90–103.

Zhivkova 1975
Zhivkova, Lyudmila. *The Kazanluk Tomb.* Recklinghausen: Verlag Aurel Bongers, 1975.

Zimi 2011
Zimi, Eleni. *Late Classical Hellenistic Silver Plate from Macedonia.* Oxford: Oxford University Press, 2011.

Zimmermann 1980a
Zimmermann, Konrad. "Tätowierte Thrakerinnen auf griechischen Vasenbildern." *Jahrbuch des Deutschen Archäologischen Instituts* 95 (1980): 163–96.

Zimmermann 1980b
Zimmermann, Konrad. "Thraker-Darstellungen auf griechischen Vasen." In *Actes du IIᵉ Congrès international de thracologie, Bucarest, 4–10 septembre 1976*, edited by Radu Vulpe, 1:429–46. Bucharest: Editura Academiei Republicii Socialiste România, 1980.

Zlateva et al. 2023
Zlateva, Boika, et al. "The Armour of the Thracian Warriors—an Archaeometrical Approach." *Archaeologia Bulgarica* 27, no. 1 (2023): 1–12.

Zlotogorska 1997
Zlotogorska, Maria. *Darstellungen von Hunden auf griechischen Grabreliefs.* Hamburg: Verlag Dr. Kovač, 1997.

Zournatzi 2000
Zournatzi, Antigoni. "Inscribed Silver Vessels of the Odrysian Kings: Gifts, Tribute, and the Diffusion of the Forms of 'Achaemenid' Metalware in Thrace." *American Journal of Archaeology* 104, no. 4 (2000): 683–706.

Zuchtriegel 2018
Zuchtriegel, Gabriel. *Colonization and Subalternity in Classical Greece: Experience of the Nonelite Population.* Cambridge: Cambridge University Press, 2018.

CONTRIBUTORS

ZOSIA H. ARCHIBALD
Senior Lecturer of Classical Archaeology,
University of Liverpool, United Kingdom

KRASTYU CHUKALEV (KC)
Curator, Depositories, National
Archaeological Institute with Museum–
Bulgarian Academy of Sciences, Sofia

SARA E. COLE (SEC)
Associate Curator, Antiquities Department,
J. Paul Getty Museum, Los Angeles

JENS M. DAEHNER (JMD)
Acting Senior Curator, Antiquities
Department, J. Paul Getty Museum,
Los Angeles

MARGARIT DAMYANOV (MD)
Associate Professor, Department of
Thracian Archaeology, National
Archaeological Institute with Museum–
Bulgarian Academy of Sciences, Sofia

PETER DELEV
Professor Emeritus, Department of Ancient
History, Thracian Studies, and Medieval
History, Sofia University "St. Kliment
Ohridski," Bulgaria

DIANA DIMITROVA (DD)
Researcher, Department of Thracian
Archaeology, National Archaeological
Institute with Museum–Bulgarian Academy
of Sciences, Sofia

YANA DIMITROVA (YD)
Chief Assistant Professor, Exhibitions,
National Archaeological Institute with
Museum–Bulgarian Academy of Sciences,
Sofia

DENVER GRANINGER (DG)
Associate Professor of History,
University of California, Riverside

MARIO IVANOV (MI)
Associate Professor, Department of
Classical Archaeology, National
Archaeological Institute with Museum–
Bulgarian Academy of Sciences, Sofia

VESELKA KATSAROVA (VK)
Chief Assistant Professor, Department
of Classical Archaeology, National
Archaeological Institute with Museum–
Bulgarian Academy of Sciences, Sofia

LYUBEN LESHTAKOV (LL)
Chief Assistant Professor, Department
of Thracian Archaeology, National
Archaeological Institute with Museum–
Bulgarian Academy of Sciences, Sofia

DIMITRIS MATSAS (DM)
Honorary Ephor of Antiquities, Hellenic
Ministry of Culture, Greece

YANA MUTAFCHIEVA (YM)
Chief Assistant Professor, Department
of Thracian Archaeology, National
Archaeological Institute with Museum–
Bulgarian Academy of Sciences, Sofia

EMIL NANKOV
Chief Assistant Professor, Head of
Department of Thracian Archaeology,
National Archaeological Institute
with Museum–Bulgarian Academy of
Sciences, Sofia

MEGLENA PARVIN (MP)
Curator, Antiquity Department, Iskra
Historical Museum, Kazanlak, Bulgaria

KALINA PETKOVA (KP)
Chief Assistant Professor, Depositories,
National Archaeological Institute with
Museum–Bulgarian Academy of Sciences,
Sofia

ANETA PETROVA (AP)
Senior Expert, National Museum of
Military History, Sofia, Bulgaria

HRISTO POPOV (HP)
Associate Professor, Director, National
Archaeological Institute with Museum–
Bulgarian Academy of Sciences, Sofia

TIMOTHY POTTS
Maria Hummer-Tuttle and Robert Tuttle
Director, J. Paul Getty Museum, Los Angeles

KOSTADIN RABADJIEV
Professor Emeritus, Department of
Archaeology, Sofia University "St. Kliment
Ohridski," Bulgaria

MATTHEW A. SEARS (MAS)
Associate Professor of Classics and Ancient
History, University of New Brunswick, Canada

NIKOLAY SHARANKOV (NS)
Assistant Professor, Department of Classical
Studies, Sofia University "St. Kliment
Ohridski," Bulgaria

ATHANASIOS SIDERIS
Affiliated Professor of Classical Archaeology,
Charles University in Prague

JEFFREY SPIER (JS)
Former Anissa and Paul John Balson II Senior
Curator of Antiquities, J. Paul Getty Museum,
Los Angeles

MIGLENA STAMBEROVA (MS)
Chief Assistant Professor, Exhibitions,
National Archaeological Institute with
Museum–Bulgarian Academy of Sciences,
Sofia

MARIA-MAGDALENA ŞTEFAN (MMŞ)
Archaeologist, Romanian National History
Museum, Bucharest

TOTKO STOYANOV (TS)
Professor Emeritus, Department of
Archaeology, Sofia University "St. Kliment
Ohridski," Bulgaria

DANIELA STOYANOVA (DS)
Associate Professor, Department of
Archaeology, Sofia University "St. Kliment
Ohridski," Bulgaria

RUSLAN STOYCHEV (RS)
Chief Assistant Professor, Institute of Art
Studies–Bulgarian Academy of Sciences,
Sofia

MILENA TONKOVA (MT)
Associate Professor, Department of
Thracian Archaeology, National
Archaeological Institute with Museum–
Bulgarian Academy of Sciences, Sofia

IVO TOPALILOV
Associate Professor, Institute of Balkan
Studies–Bulgarian Academy of Sciences,
Sofia

NARTSIS TORBOV (NT)
Associate Professor, Department of
Culture, Heritage, and Tourism, University
of Library Studies and Information
Technologies, Sofia

DESPOINA TSIAFAKI
Director of Research, Cultural Heritage Unit,
"Athena" Research Center, Thessaloniki, Greece

JULIA TZVETKOVA (JT)
Associate Professor, Department of Ancient
History, Thracian Studies, and Medieval
History, Sofia University "St. Kliment
Ohridski," Bulgaria

SLAVA VASILEVA (SV)
Chief Assistant Professor, Depositories,
National Archaeological Institute with
Museum–Bulgarian Academy of Sciences,
Sofia

ANTIGONI ZOURNATZI (AZ)
Research Director, Institute of Historical
Research, National Hellenic Research
Foundation, Thessaloniki, Greece

ILLUSTRATION CREDITS

Pp. xvi–xvii, xix: David Fuller

Fig. 1: Regional Historical Museum, Varna / photo: Kalin Dimitrov

Figs. 2, 3: National Historical Museum, Sofia, Bulgaria / photo: Krasimir Georgiev

Fig. 4: Image courtesy of Hristo Popov

Fig 5: Regional Historical Museum, Varna, 1.3772, 1.3773; Ruse, Ruse Province, Bulgaria: Regional Historical Museum, Ruse, IV 429; Cherkovo, Burgas Province, Bulgaria: Regional Historical Museum, Burgas, 2874; Chernozem, Yambol Province, Bulgaria: Ethnographical and Archaeological Museum, Elhovo A–458 / photo: Krasimir Georgiev

Fig. 6: National Archaeological Institute with Museum–Bulgarian Academy of Sciences, Sofia, and Regional History Museum, Razgrad / photo: Krasimir Georgiev

Fig. 7: Andrew Mayovskyy / Alamy Stock Photo

Fig. 8: Photo 256842079 © Ioan Vartaci | Dreamstime.com

Figs. 9–11: Image courtesy of Margarit Damyanov

Fig. 12: Image courtesy of Classical Numismatic Group

Fig. 13: GL Archive / Alamy Stock Photo

Fig. 14: © President and Fellows of Harvard College

Figs. 15, 17, 25: Staatliche Antikensammlungen und Glyptothek München / photo: Renate Kühling

Fig. 16: © Acropolis Museum / photo: Socratis Mavrommatis, 2013

Figs. 18, 20: © Antikenmuseum Basel und Sammlung Ludwig

Fig. 19: bpk Bildagentur / Antikensammlung, Staatliche Museen, Berlin / photo: Johannes Laurentius / Art Resource, NY

Fig. 21: Photo copyright © Governorate of the Vatican City State–Directorate of the Vatican Museums. All rights reserved

Fig. 22: Museo Archeologico Nazionale di Napoli

Fig. 23: National Museum, Krakow

Fig. 24: Museo Nazionale Etrusco di Villa Giulia

Fig. 26; cats. 29, 30, 31: Ephorate of Antiquities of Evros, Ministry of Culture–Organization for the Management and Development of Cultural Resources / Archaeological Museum of Alexandroupolis

Fig. 27: © Universität Tübingen, Antikensammlung

Fig. 28: Image courtesy of G. Toncheva

Fig. 30; cats. 60a–60g: © Regional Historical Museum, Vratsa / photo: Todor Dimitrov

Fig. 31: National History Museum of Romania

Fig. 32: Image courtesy of D. Dimitrov and M. Chichikova

Fig. 33: Nicola Kota / Alamy Stock Photo

Fig. 34: Image courtesy of Dr. Tzochev

Figs. 35–39; p. 207: Photo: Todor Dimitrov

Fig. 40: Regional History Museum, Sliven

Fig. 41: National Historical Museum, Sofia, Bulgaria

Figs. 42, 43: © Ivo Hadjimishev

Fig. 44: Photograph © The State Hermitage Museum / photo: Svetlana Suetova, Konstantin Sinyavsky

Figs. 45–47, 58, 59; cats. 47a–47i: Regional Archaeological Museum, Plovdiv

Fig. 48; cats. 5–7, 21, 33, 34, 49, 50, 58: National Archaeological Institute with Museum–Bulgarian Academy of Sciences, Sofia

Fig. 49: Regional Museum of History, Ruse

Fig. 50: Iskra Historical Museum, Kazanlak / photo: A. Ivanov

Fig. 51: National Archaeological Institute with Museum–Bulgarian Academy of Sciences, Sofia / photo: Krasimir Georgiev

Fig. 52: Image courtesy of Daniela Agre

Fig. 53: © Hellenic Ministry of Culture / Hellenic Organization of Cultural Resources Development / National Archaeological Museum, Athens

Fig. 54: Courtesy of Regional Museum of History–Haskovo

Fig. 55: Regional History Museum, Blagoevgrad, Blagoevgrad Province, Bulgaria / photo: Miglena Raykovska

Fig. 56: Archaeological Museum, Sozopol

Fig. 57; cats. 54b, 54h, 54j–54m, 54o, 54y: Iskra Historical Museum, Kazanlak

Fig. 60: Gianni Dagli Orti / Shutterstock

Fig. 61: Archaeological Museum, Plovdiv / photo: Kostadin Kissiov

Fig. 62: Regional Historical Museum, Stara Zagora / photo: Maria Kamisheva

Fig. 63: tihomir_todorov / iStock Getty Images

Fig. 64: Orca collection–Nikolay Malchev FL, USA

Cats. 1a–1m, 4, 8, 14, 53, 62a–62e; p. 210: National Archaeological Institute with Museum–Bulgarian Academy of Sciences, Sofia / photo: Todor Dimitrov

Cats. 2, 25, 26, 63: Regional Historical Museum, Burgas / photo: Todor Dimitrov

Cats. 3, 19: National Historical Museum, Sofia, Bulgaria / photo: Todor Dimitrov

Cat. 10: © The Metropolitan Museum of Art. Image source: Art Resource, NY

Cat. 12: Regional Historical Museum, Veliko Tarnovo / photo: Krasimir Georgiev

Cat. 13; p. 132: National Archaeological Institute with Museum–Bulgarian Academy of Sciences, Sofia

Cats. 15, 16, 18, 20: Archaeological Museum, Sozopol / photo: Todor Dimitrov

Cat. 17: Historical Museum, Karnobat

Cats. 21, 65d, 65e: National Archaeological Institute with Museum–Bulgarian Academy of Sciences, Sofia / photo: Miglena Raykovska

Cats. 22, 37: © RMN-Grand Palais / Art Resource, NY

Cats. 23, 24: Ancient Nessebar Museum / photo: Todor Dimitrov

Cat. 27: Archaeological Museum, Septemvri / photo: Todor Dimitrov

Cat. 28: Ephorate of Antiquities of Evros, Ministry of Culture–Organization for the Management and Development of Cultural Resources / Archaeological Museum of Samothrace / photo courtesy of Dimitris Matsas

Cat. 32: bpk Bildagentur / Staatliche Museen zu Berlin, Vorderasiatisches Museum / photo: Olaf M. Teßmer / Art Resource, NY

Cats. 38, 40, 42, 43: © The Trustees of the British Museum

INDEX